Intelligent Video Surveillance

Systems and Technology

Intelligent Video Surveillance

Systems and Technology

Edited by Yunqian Ma and Gang Qian

CRC Press
Taylor & Francis Group
Boca Raton London New York

CRC Press is an imprint of the
Taylor & Francis Group, an **informa** business

CRC Press
Taylor & Francis Group
6000 Broken Sound Parkway NW, Suite 300
Boca Raton, FL 33487-2742

© 2010 by Taylor and Francis Group, LLC
CRC Press is an imprint of Taylor & Francis Group, an Informa business

No claim to original U.S. Government works

Printed in the United States of America on acid-free paper
10 9 8 7 6 5 4 3 2 1

International Standard Book Number: 978-1-4398-1328-7 (Hardback)

Library of Congress Cataloging-in-Publication Data

Intelligent video surveillance : systems and technology / edited by Yunqian Ma, Gang Qian.
 p. cm.
 Includes bibliographical references and index.
 ISBN 978-1-4398-1328-7
 1. Video surveillance. I. Ma, Yunqian. II. Qian, G. (Gang), 1973- III. Title.

TK6680.3.I58 2010
621.389'28--dc22 2009027792

**Visit the Taylor & Francis Web site at
http://www.taylorandfrancis.com**

**and the CRC Press Web site at
http://www.crcpress.com**

Contents

Part I Background, Introduction, and Foundation

Part II Detection and Tracking

Part III Activity Recognition

Part IV Camera Networks

Part V Systems and Applications

Preface

This book presents state-of-the-art technologies and systems on intelligent video surveillance. More than just a collection of individual research articles, this book brings together key research and application themes of intelligent video surveillance in an integrated manner by exploring interconnections and relationships among and common theoretical foundations underlying these themes.

Nowadays, surveillance cameras are omnipresent in our daily lives. We are amazed by the fact that surveillance cameras are present at almost every moment of our everyday lives, and by the fast pace at which more of such cameras are being added. From streets in London to subway stations in New York City, from taxis in Redditch to nursing homes in Pittsburgh, hundreds of thousands of surveillance cameras are collecting videos, many of them 24/7, for crime preventing/alarming/evidencing, traffic/parking monitoring, and health/safety monitoring. A question that has come to us is how such vast volumes of video data are stored, analyzed, indexed, and searched. This book is the result of our effort in trying to partially answer the question, that is, what the most recent advances are in automated intelligent analysis of surveillance video.

In our journey to answer this question, it became clear that although numerous algorithms and systems have been reported in prestigious conferences and journals, what is lacking is a book that examines the fundamental principles of existing intelligent video

surveillance systems, and provides a solid theoretical and practical treatment to the algorithmic design and system implementation for intelligent video surveillance, and a book that can be found useful by practitioners and researchers, as well as educators and students in the area. From the very beginning, this book was planned to fulfill this need.

This book delivers a unique treatment to state-of-the-art intelligent video surveillance technologies and systems, including computational principles behind and connections among these technologies and systems, important system implementation issues, and examples of successful applications of these technologies. For readers who are new to video surveillance, this book provides an excellent entry point with a high-level introductory view of the topic as well as an in-depth discussion of key technical details. For researchers already engaged in this field of work, this book is a handy reference summarizing the up-to-date advances and future directions. For practitioners, this book addresses practical implementation issues for intelligent video surveillance and offers examples of successful systems.

We would like to sincerely thank all the contributors of this book for presenting their research in an easily accessible manner, and for putting such discussion into a historical context. We would like to thank Mark Listewnik, Richard A. O'Hanley, and Amy Blalock of Auerbach Publications/CRC Press of Taylor & Francis Group for their strong support of this book. Yunqian Ma would like to thank his numerous colleagues at Honeywell Labs for providing a research and development environment. Gang Qian would like to thank his colleagues at the School of Arts, Media and Engineering and the School of Electrical, Computer and Energy Engineering at Arizona State University, Tempe, and the National Science Foundation for their continuing support of his research.

Yunqian Ma
Golden Valley, Minnesota

Gang Qian
Tempe, Arizona

MATLAB® is a registered trademark of The MathWorks, Inc. For product information, please contact:

The MathWorks, Inc.
3 Apple Hill Drive
Natick, MA 01760-2098 USA
Tel: 508 647 7000
Fax: 508-647-7001
E-mail: info@mathworks.com
Web: www.mathworks.com

MATLAB® is a registered trademark of The MathWorks, Inc. For product information, please contact:

The MathWorks, Inc.
3 Apple Hill Drive
Natick, MA 01760-2098 USA
Tel: 508 647 7000
Fax: 508-647-7001
E-mail: info@mathworks.com
Web: www.mathworks.com

Editors

Yunqian Ma is currently a principal research scientist in Honeywell Labs at the Honeywell International Inc., Golden Valley, Minnesota. He received his PhD in electrical engineering from the University of Minnesota at Twin Cities, Minneapolis, in 2003. He received the International Neural Network Society Young Investigator Award in 2006. He is a senior member of the IEEE.

Gang Qian obtained his PhD in electrical engineering from the University of Maryland at College Park in 2002. He is currently an assistant professor with the School of Arts, Media and Engineering and the School of Electrical, Computer and Energy Engineering at Arizona State University, Tempe. His main research interests are in multimodal sensing and analysis of human activities for nonverbal communication, embodied learning and training, and movement rehabilitation.

Contributors

Nadeem Anjum
School of Electronic Engineering and Computer Science
Queen Mary, University of London
London, United Kingdom

Bir Bhanu
Center for Research in Intelligent Systems
University of California at Riverside
Riverside, California

Russell Bobbitt
IBM Thomas J. Watson Research Center
Hawthorne, New York

Lisa Brown
IBM Thomas J. Watson Research Center
Hawthorne, New York

Andrea Cavallaro
School of Electronic Engineering and Computer Science
Queen Mary, University of London
London, United Kingdom

Larry S. Davis
Department of Computer Science
University of Maryland
College Park, Maryland

Guoliang Fan
School of Electrical and Computer Engineering
Oklahoma State University
Stillwater, Oklahoma

Xin Fan
Information Science and Technology College
Dalian Maritime University
Dalian, China

Rogerio S. Feris
IBM Thomas J. Watson Research Center
Hawthorne, New York

Gian Luca Foresti
Department of Mathematics and Computer Science
University of Udine
Udine, Italy

Jan-Michael Frahm
Department of Computer Science
University of North Carolina at Chapel Hill
Chapel Hill, North Carolina

Yun Fu
Computer Science and Engineering Department
The State University of New York at Buffalo
Buffalo, New York

Feng Guo
Applied Research and Technology Center
Motorola
Schaumburg, Illinois

Guodong Guo
Department of Computer Science and Electrical Engineering
West Virginia University
Morgantown, West Virginia

Arun Hampapur
IBM Thomas J. Watson Research Center
Hawthorne, New York

Bohyung Han
Advanced Project Center
Mobileye Vision Technologies
Princeton, New Jersey

Joseph P. Havlicek
School of Electrical and Computer Engineering
University of Oklahoma
Norman, Oklahoma

Thomas S. Huang
Beckman Institute
University of Illinois at Urbana–Champaign
Urbana, Illinois

Baoxin Li
Department of Computer Science and Engineering
Arizona State University
Tempe, Arizona

Yiming Li
Center for Research in Intelligent Systems
University of California, Riverside
Riverside, California

Yuping Lin
Institute for Robotics and Intelligent Systems
University of Southern California
Los Angeles, California

Haowei Liu
Department of Electrical Engineering
University of Washington
Seattle, Washington

Yunqian Ma
Honeywell International Inc.
Golden Valley, Minnesota

Gérard Medioni
Institute for Robotics and Intelligent Systems
University of Southern California
Los Angeles, California

Justin Muncaster
Department of Computer Science
University of California, Santa Barbara
Santa Barbara, California

Ram Nevatia
Institute for Robotics and Intelligence Systems
University of Southern California
Los Angeles, California

Sangho Park
Department of Computer Science
University of Rochester
Rochester, New York

Marc Pollefeys
Department of Computer Science
University of North Carolina at Chapel Hill
Chapel Hill, North Carolina

and

Department of Computer Science
Swiss Federal Institute of Technology Zurich
Zurich, Switzerland

Gang Qian
School of Arts, Media and Engineering
and
School of Electrical, Computer and Energy Engineering
Arizona State University
Tempe, Arizona

Lauro Snidaro
Department of Mathematics and Computer Science
University of Udine
Udine, Italy

Ming-Ting Sun
Department of Electrical Engineering
University of Washington
Seattle, Washington

Ying-li Tian
Department of Electrical Engineering
City University of New York
New York, New York

Mohan M. Trivedi
Department of Electrical and Computer Engineering
University of California, San Diego
La Jolla, California

Matthew Turk
Department of Computer Science
University of California, Santa Barbara
Santa Barbara, California

Daniel A. Vaquero
Department of Computer Science
University of California, Santa Barbara
Santa Barbara, California

Vijay Venkataraman
School of Electrical and Computer Engineering
Oklahoma State University
Stillwater, Oklahoma

Ingrid Visentini
Department of Mathematics and Computer Science
University of Udine
Udine, Italy

Bo Wu
Google Inc.
Mountain View, California

Xinyu Xu
SHARP Laboratories of America
Camas, Washington

Qian Yu
Sarnoff Corporation
Princeton, New Jersey

Yun Zhai
IBM Thomas J. Watson Research Center
Hawthorne, New York

Part I

Background, Introduction, and Foundation

1

Introduction

Yunqian Ma and Gang Qian

CONTENTS

1.1 BACKGROUND

Imagine that you are a security guard of a nuclear facility. One of your duties is to detect suspect intruders and activities, by viewing live video streams captured by surveillance cameras installed inside and around the facility, and to take immediate actions in response to potential threats. Assume that you suddenly notice a suspect man who wears a white T-shirt and sunglasses in a restricted area of the facility. You want to quickly browse through the recorded videos by the surveillance cameras to see where this person has been and what he has done in the facility, and when, where, and how he entered

the building. Manually examining hour-long surveillance videos from a large number of cameras is tedious, time consuming, and error prone. An intelligent video surveillance system capable of people search (Chapter 14) can help you to find the person from these videos in just a few minutes. In addition, automated multi-camera tracking systems (Chapters 11 through 13) can continually track this person and return his 3D coordinates in the building.

Let us consider another example. Suppose that you need to track moving objects in a large volume of videos collected by an unmanned aerial vehicle (UAV) and to determine their geo-locations in a global map. Due to the large data quantity and tiny target sizes in aerial video, to accomplish this task manually is challenging and error-prone. Fortunately, the intelligent video surveillance system introduced in Chapter 16 tackles such target tracking and geo-registration from a moving platform. The use of such intelligent video surveillance systems can greatly expedite the processing, increase the target tracking and localization accuracy, and substantially save human effort.

Both of these examples show that an *intelligent video surveillance* is the key to automated, fast, and accurate analysis of a large volume of video data. In this book, *intelligent video surveillance* is simply defined as an automated process of video analysis and information extraction for surveillance. Intelligent video surveillance is a fast-growing area overlapping image and video processing, computer vision, pattern recognition, machine learning, and artificial intelligence. Being intelligent or automated is the largest difference between intelligent video surveillance and traditional video surveillance. In traditional video surveillance, human operators are usually required to monitor video streams, sent through closed-circuit television systems, to detect events of interest at surveillance sites. In contrast, intelligent video surveillance systems provide automated, robust, accurate, and real-time video analysis and information extraction with performance comparable to, if not better than, that of the traditional video surveillance, without or with little involvement of a human operator.

Intelligent video surveillance has been exploited by both government contracts and commercial solutions. For example, in 1997, the Defense Advanced Research Projects Agency began a Video Surveillance and

Monitoring program to develop an automated video understanding technology for use in urban and battlefield surveillance applications in future. Technology developed under this project enable human operators to monitor activities over a broad area using a distributed network of active video cameras. In 2004, the Homeland Security Advanced Research Projects Agency initialized an Automated Scene Understanding program to develop technologies to help monitor and interpret increasingly complex information. Moreover, the Video Analysis and Content Extraction program in the Disruptive Technology Office is developing automated video analysis technologies for surveillance video, UAV, meeting and conference, ground reconnaissance, and broadcast news. On the other hand, the mature technologies are commercialized with applications in private site surveillance, shoplifting prevention and evidencing, and safety monitoring of the elderly.

Many challenges exist in developing practically useful intelligent video surveillance technology and systems. For example, to handle appearance changes of objects/people caused by changing viewpoints, illumination, and expression and movement (for people) is a challenge for visual tracking and recognition in video surveillance. The presence of self/cross-body occlusions is another challenge for tracking. The modeling of cluttered background capable of efficient background subtraction for object detection is also a challenge. Multiple cameras are often used to enlarge the field of view of the sensing network. The deployment of multiple cameras introduces additional challenges such as temporal and spatial alignment of these cameras, and dynamic camera selection/switching and data fusion for a particular surveillance task. Moreover, a practically useful intelligent video surveillance system needs to be scalable so that a large amount of video data can be handled in real time. This book presents a palette of recent research attempting to address these challenges. It covers the fundamental building elements of an intelligent video surveillance system such as background modeling, object detection and tracking, activity recognition, and multi-camera fusion. It also provides four exemplar working intelligent video surveillance systems in urban surveillance, people search, tracking and geo-registration from UAV video, and 3D surveillance site reconstruction.

1.2 ORGANIZATION

This book includes five parts. Part I provides an overview of the fundamentals in intelligent video surveillance and a real-life functioning surveillance system as an example. Part II presents low-level video surveillance modules such as background modeling, object/people detection, and tracking. Part III describes state-of-the-art techniques for activity recognition as high-level video surveillance modules. Part IV covers multi-camera systems and finally Part V presents a few exemplar applications of intelligent video surveillance systems.

Each part is composed of a few chapters discussing relevant topics. A chapter usually includes sections on motivation for the topic, techniques addressing the issue, and examples showing the efficacy of the presented techniques using synthetic and real data. In addition, most chapters also have a separate section on historical remarks and bibliography at the end. The historical remarks give the relationship between the presented techniques and other existing techniques addressing the same or similar topic. The bibliography lists classical readings relevant to the topic of the chapter, which allows readers to learn more about this topic.

This book can be easily adopted as a textbook for a course on intelligent video surveillance. An instructor may organize the entire course following the book or selectively use the book materials relevant to a specific topic. The following sections present an overview of the parts and chapters of this book.

1.2.1 Part I: Background, Introduction, and Foundation

Part I presents the foundation of intelligent video surveillance (Chapter 2). It also gives a real-life functioning example of an intelligent video surveillance system (Chapter 3).

Chapter 2 provides fundamentals of intelligent video surveillance. These technical foundations come from four established technical areas: image feature extraction, multiple view geometry, probabilistic inference, and pattern recognition and machine learning.

Chapter 3 gives an example of a video surveillance system, the IBM Smart Surveillance System. This system performs a variety of video analytics tasks, including moving object detection and tracking, object classification, people search and automatic detection of user-defined events in urban surveillance scenarios. Large-scale data indexing methods and scalability issues are also covered in this chapter.

1.2.2 Part II: Detection and Tracking

Object detection and tracking is a critical processing task in intelligent video surveillance. Normally, the word *objects* include both pedestrians and vehicles. Part II starts with motion detection using background modeling (Chapter 4). Chapters 5 and 6 present the detection and tracking of pedestrians and vehicles. Articulated human motion tracking is discussed in Chapter 7.

Background modeling and subtraction is a very useful technique for motion detection in video. Chapter 4 describes a pixel-wise density-based background modeling and subtraction algorithm using multiple features such as color and Haar-like features. Background model is trained for each feature independently as a Gaussian mixture based on kernel density approximation.

The detection of static object needs more complex processing. Chapter 5 presents a shape-based pedestrian detection and tracking method with part-based representation of object classes. An object is represented as an assembly of parts. For each part, a part detector is learned by boosting local shape features. Tree-structured part detectors are built using boosting to detect pedestrians from different viewpoints and poses.

Vehicle detection and tracking is discussed in Chapter 6. A nonlinear tensor decomposition method is used to develop an appearance generative model for multi-pose target representation. In addition, a target-dependent kinematic model is invoked to capture different target dynamics. Both generative models are integrated into a graphical model, where integrated tracking and recognition is formulated as a joint estimation of the kinematics, pose, and identity of the target.

Certain surveillance scenarios require the recovery of articulated human motion from video. Chapter 7 presents a robust computational framework for monocular 3D tracking of articulated human movement. It exploits the underlying data structures of body silhouettes and poses by constructing low dimensional silhouette and pose manifolds, establishes inter-manifold mappings, and performs tracking in such manifolds using a particle filter. A novel vectorized silhouette descriptor is introduced to achieve low dimensional and noise-resilient silhouette representation. This articulated motion tracker is view-independent, self-initializing, and capable of maintaining multiple kinematic trajectories.

1.2.3 Part III: Activity Recognition

Part III describes activity recognition in intelligent video surveillance. After object detection and tracking, a natural extension is to infer the behavior of the individuals and groups according to a predefined or learned activity dictionary. Chapter 8 starts with action recognition. Chapter 9 discusses recognizing complex activity of a single person, as the combination of multiple simple activities. Chapter 10 presents activity recognition of multiple persons, referred to as human interaction recognition.

Feature extraction is an important step for activity recognition. Activity recognition can then be viewed as a classification problem in the feature space. Chapter 8 uses the discriminative Gaussian process dynamical models for classification of high-dimensional sequential data. The activity recognition method includes latent manifold discovery, dynamic modeling, and discriminative learning in the latent space.

Chapter 9 discusses more complex activities than those involved in Chapter 8, in the sense that these complex activities can be viewed as combinations of simple activities. A complex activity is recognized using a hierarchical dynamic Bayesian network (DBN). Clustering is used to automatically define simple atom activities corresponding to the states of the observable levels in the hierarchical DBN.

Beside single-person activity recognition, understanding human interaction in video is important as well. Multi-person interaction raises

challenging issues regarding occlusion and body deformation. Chapter 10 presents a multi-view multilevel analysis framework for understanding human interactions. The track-level analysis and the body-level analysis are synergistically integrated in a distributed vision system to achieve a robust and informative understanding of human interactions.

1.2.4 Part IV: Camera Networks

The field of view of a single camera is limited. An ensemble of multiple cameras can monitor activities at a much wider scale than what a single camera can do. Key challenges in multi-camera surveillance are discussed in Part IV.

Temporal and spatial alignments are important to integrate information obtained from multiple cameras. Temporal alignment across multiple cameras allows for image frames from these cameras to be captured simultaneously and indexed along a common time axis. Temporal alignment is easily obtained using a common synchronization clock. Additional software and hardware solutions (e.g., the Sync Unit and MultiSync™ from Point Grey Research) also exist that can synchronize cameras on same/different system buses/computers. Spatial alignment finds the locations and orientations of multiple cameras in a common 3D coordinate system. For cameras with overlapping field of views the spatial alignment can be obtained based on the image locations of common 3D points in different camera views using techniques in multi-view geometry. However, it remains a challenging problem to calibrate cameras with non-overlapping field of views. To address this issue, Chapter 11 presents a generalized framework for camera-network calibration including the case of a nonoverlapping field of view. In addition, Chapter 11 also solves for the reconstruction of global trajectories across the entire monitored area by integrating the fused trajectory segments in overlapping regions and the estimated trajectory segments in unobserved regions.

The seamless tracking of moving objects across neighboring cameras is an important issue in multi-view tracking. When tracking is only affordable in one camera, accurate cross-camera tracking can be achieved by finding the next best camera to see the target object when it is leaving the field-of-view of the current camera. Chapter 12

tackles this camera selection problem using the bargaining mechanism in game theory.

Often times, an object can be tracked from more than one camera when the necessary computational resource is available. It remains a challenge to optimally integrate tracking results from multiple cameras. To address this issue, Chapter 13 presents a multi-camera fusion approach according to the tracking performance of different cameras.

1.2.5 Part V: Systems and Applications

Following the introduction of intelligent video surveillance techniques in Parts I through IV, Part V presents four real-world surveillance systems using these techniques. These systems tackle intriguing surveillance tasks ranging from searching for people in surveillance videos (Chapter 14), to soft biometrics (Chapter 15), to target tracking and geo-localization from an airborne platform (Chapter 16), and to robust 3D urban surveillance site reconstruction (Chapter 17).

Finding suspects or missing people is an important task in video surveillance. Chapter 14 approaches the problem of people search based on the parsing of human parts and their attributes, including facial hair type, eyewear type, and clothing color. These attributes can be extracted using detectors learned from large amounts of training data. At the interface, the user can specify a set of personal characteristics, and the system then retrieves events that match the provided description. Additional attributes of gender and age can also be integrated to enhance people search. This part-based people search approach is similar in spirit to the pedestrian detection method introduced in Chapter 5.

In the realm of biometrics, gender and age estimation from video belongs to soft biometrics. Chapter 15 describes state-of-the-art techniques and systems in soft biometrics for video surveillance, including age estimation from face, gender recognition from face, and gender recognition from human body.

Up to this point, intelligent video surveillance has been conducted using static cameras. Certain practical scenarios require video surveillance from moving cameras. Chapter 16 describes such a system for moving object detection and tracking from a UAV. Using a satellite

image as the global map, this system can locate and track targets in geo-coordinates. A two-step geo-registration approach is used to stitch images acquired by satellite and UAV cameras. After this, hierarchical tracking is performed with local level tracklets linked by their appearance and spatiotemporal consistence on the global map. The graphics processing unit (GPU) techniques are exploited to achieve real-time performance of the system.

The 3D reconstruction of buildings and landscapes of the surveillance site is important to information visualization, constrained tracking, and unconstrained navigation. A real-time, large-scale 3D reconstruction system is introduced in Chapter 17. This system is able to incorporate multi-view videos with data from a global positioning system and an inertial navigation system to obtain a geo-registered 3D model. The real-time performance of the system is also achieved by using the GPU for 2D tracking and dense scene reconstruction.

<div align="right">

2

</div>

Fundamentals of Intelligent Video Surveillance

Gang Qian and Yunqian Ma

CONTENTS

2.1 IMAGE FEATURE EXTRACTION

In this section, we briefly review important image feature extraction techniques commonly used in intelligent video surveillance, including feature point detection, edge detection, scale invariance feature transform, and representation of color features. Key notations used in this chapter are listed in Table 2.1.

2.1.1 Feature Point Detection

Feature points are often used for image registration, video stabilization and image mosaicing, and tracking. A feature point is an image point with a pixel value clearly distinct from its neighbors', for example, the intersection of two lines. The Harris corner detector (Harris and Stephens 1988) is one of the most commonly used feature point detection algorithms. For example, the well-known Kanade–Lucas–Tomasi feature tracker (Shi and Tomasi 1994) makes use of the Harris corner detector to identify feature points before tracking.

The intuition behind the Harris corner detector is straightforward: around a good feature point, neighboring image blocks in the same size in any direction always have large block differences. Let $I(x, y)$ be an image function defined over the entire image plane where (x, y) represent the pixel location. Let p be a point of interest. To determine

TABLE 2.1 Notations of Symbols Used in the Chapter

Symbols	Notations
I, $I(x, y)$	An image plane, the pixel value at location (x, y) on the image plane
$I_x(x, y)$, $I_y(x, y)$	The image derivatives along x and y directions at location (x, y) on the image plane
p, $\tilde{\mathbf{x}}$, \mathbf{x}	A 2D point on an image plane, its nonhomogenous and homogeneous coordinates
P, $\tilde{\mathbf{X}}$, \mathbf{X}	A 3D point in a Euclidean space, its nonhomogenous and homogeneous coordinates
\mathbf{I}	The identity matrix
\mathbf{P}	A camera projection matrix
\mathbf{F}	A fundamental matrix
\mathbf{K}	A camera calibration matrix
\mathbf{R}	A rotation matrix
e, \mathbf{e}	An epipole and its homogenous coordinate
\mathbf{H}	A homography matrix
det \mathbf{M}, trace \mathbf{M}	The determinate and trace of the matrix \mathbf{M}
$[\mathbf{x}]_\times \mathbf{y}$	The cross product of two 3-vectors \mathbf{x} and \mathbf{y}
π	A plane
\mathbf{T}	The normalization matrix used in \mathbf{F} matrix estimation
U	The unknown factors of a system
Z	The observed data

whether p is a good feature point, we consider the block difference function $E_p(u, v)$ defined as follows:

$$E_p(u,v) = \sum_{(x,y)} w_p(x,y)[I(x+u, y+v) - I(x,y)]^2 \qquad (2.1)$$

where

(u, v) is a small shift vector

$w_p(x, y)$ is a window/weight function matrix centered at the point of interest p

$w_p(x, y)$ can be either flat or in a 2D Gaussian shape. Obviously, $E_p(u, v)$ is the block difference between two blocks apart from each other by (u, v). For small shifts (u, v), we use a *bilinear* approximation:

$$E_p(u,v) \approx [u,v]\mathbf{M}_p \begin{bmatrix} u \\ v \end{bmatrix} \tag{2.2}$$

\mathbf{M}_p is a 2×2 matrix formed by image derivatives

$$\mathbf{M}_p = \sum_{(x,y)} w_p(x,y) \begin{bmatrix} I_x^2 & I_x I_y \\ I_x I_y & I_y^2 \end{bmatrix} \tag{2.3}$$

Let the eigen-decomposition of \mathbf{M}_p be

$$\mathbf{M}_p = \begin{bmatrix} e_1 & e_2 \end{bmatrix} \begin{bmatrix} \lambda_1 & \\ & \lambda_2 \end{bmatrix} \begin{bmatrix} e_1^{\mathrm{T}} \\ e_2^{\mathrm{T}} \end{bmatrix}$$

After the following coordinate transformation

$$\begin{bmatrix} u_1 \\ v_1 \end{bmatrix} = \begin{bmatrix} e_1 & e_2 \end{bmatrix}^{\mathrm{T}} \begin{bmatrix} u \\ v \end{bmatrix}$$

the block difference $E_p(u, v)$ is given by

$$E_p(u,v) = E_p(u_1,v_1) = \begin{bmatrix} u_1 & v_1 \end{bmatrix} \begin{bmatrix} \lambda_1 & \\ & \lambda_2 \end{bmatrix} \begin{bmatrix} u_1 \\ v_1 \end{bmatrix} = \lambda_1 u_1^2 + \lambda_2 v_1^2 \tag{2.4}$$

The eigenvalues of \mathbf{M}_p characterize the increasing rate of the block difference in the two eigenvector directions. Recall that for p to be a good feature, small shift vector (u, v) in any direction should result in large block difference $E_p(u, v)$, which requires both eigenvalues of \mathbf{M}_p be large. Based on the eigenvalues of \mathbf{M}_p, the point of interest p can be classified into three categories: flat areas, edges, and corner features, as shown in Table 2.2.

In addition, the variable $R_p = \det \mathbf{M}_p - k \, (\text{trace } \mathbf{M}_p)^2$ is often used to measure the corner response at p to avoid the computation of the eigenvalues of \mathbf{M}_p. Recall that det $\mathbf{M}_p = \lambda_1 \lambda_2$ and trace $\mathbf{M}_p = \lambda_1 + \lambda_2$. In the computation of R_p, k is empirical constant and ranges in [0.04, 0.06]. Large positive values of R_p indicate good corner points, negative values with large magnitudes correspond to edge points, and values close to zero imply points in flat region.

TABLE 2.2 Categories of Point of Interest According to the Eigenvalues

Properties of Eigenvalues λ_1, λ_2 of M_p	Classifications of Point of Interest p
Both λ_1, λ_2 are large and comparable	p is a good corner feature and $E_p(u, v)$ is large in all directions.
λ_2 is small and $\lambda_1 \gg \lambda_2$	p is an edge point and the direction of the edge aligned with e_2, the eigenvector of M_p corresponding to λ_2. $E_p(u, v)$ is close to zero in the direction of e_2.
Both λ_1, λ_2 are small	p is in a flat region and $E_p(u, v)$ remains close to zero in all directions.

2.1.2 Scale Invariant Feature Transform

Scale invariant feature transform (SIFT) (Lowe 2004) is a reliable local image feature extraction framework. SIFT can detect and represent image features in a way that is invariant to image scaling and rotation, and partially invariant to changes in illumination and 3D camera viewpoint. SIFT has been used in feature matching and object recognition across wide baseline stereo cameras. There are four major steps involved in SIFT. The first step is known as *scale-space extrema detection*, which includes the extraction of extrema (maxima/minima) points (aka keypoints in SIFT) from the difference of Gaussian images at different scales. The Gaussian images are obtained by convolving the original image with 2D Gaussian filters with certain scale parameters. In the second step, *keypoint localization*, the set of keypoints is refined by removing candidates with low contrast in the scale-space neighborhood and those close to edges. The remaining keypoints are described by their locations and scales, that is, their coordinates in the scale-space. Then in the third step *orientation assignment* the orientations of the remaining keypoints are found as the prominent (i.e., peak) orientations of the weighted gradient orientations histogram in the neighborhood of the keypoints in the Gaussian image at the same scale as the keypoint. Finally, a set of weighted histograms of relative gradient orientations with respect to the keypoint orientation is established as the *keypoint descriptor*

for a particular keypoint. Details of the SIFT algorithm can be found in Lowe (2004). In addition, an excellent review and comparison of many commonly used local invariant features, including SIFT, can be found in Tuytelaars and Mikolajczyk, 2008.

2.1.3 Edge Detection

Edge detection is a fundamental task in image analysis. Edges can be considered to be the boundaries of regions in an image. In intelligent video surveillance, edges are informative features for object/people tracking. A good edge detector possesses the following properties (Canny 1986): (1) good detection, that is, the detector responds only to edge points but not noise, (2) good localization with detected edges near the true edges, and (3) single response so that there is one detection per true edge point.

Consider an image $I(x, y)$ to be a pixel value function defined over a 2D grid. Edges are characterized by abrupt changes of pixel values between adjacent regions. Therefore, edges have been detected based on derivatives of pixel values. For example, edge points carry large gradient magnitudes due to abrupt shift of pixel values. Hence, a basic edge detector can be obtained by first finding the gradient of the image $\nabla I(x, y) = (I_x, I_y)$ through common gradient operators such as Roberts, Prewitt, Sobel, and Isotropic operators, and then identifying edge points as pixel positions where magnitudes of the gradients, computed using Equation 2.5, are above certain pre-chosen thresholds. Such edge detection methods are computationally efficient; however, they can result in thick detected edges when the transition of pixel values between two adjacent regions is smooth, leading to poor edge localization.

$$|\nabla I(x, y)| = \sqrt{I_x^2 + I_y^2} = \text{rate of change of } I(x, y) \qquad (2.5)$$

$$\angle \nabla I(x, y) = \tan^{-1}\left(\frac{I_y}{I_x}\right) = \text{orientation of change of } I(x, y) \qquad (2.6)$$

Meanwhile, edge points manifest as zero-crossings in the second-order image derivatives. Note that similar to the first-order derivatives, the second-order derivatives of an image are also directional. The second-order derivatives at one pixel location in different directions can vary. To be specific, the second-order derivation along a direction r with a directional angle θ is given by

$$\frac{\partial^2 I}{\partial r^2} = I_{xx} \cos^2\theta + 2I_{xy} \cos\theta \sin\theta + I_{yy} \sin^2\theta \qquad (2.7)$$

If a pixel site is a zero-crossing in any direction and the first-order derivative in this direction is large, then this pixel site must be an edge point when the image noise is ignorable. The Laplacian of an image $\nabla^2 I(x, y) = I_{xx} + I_{yy}$ is often used to represent/approximate the second-order derivatives of the image. Given the Laplacian of an image, edge points can be found as zero-crossings in the Laplacian. In practice, pixel sites that have high-gradient magnitudes and at the same time zeros in the Laplacian are detected as edge points. The Laplacian of an image is the sum of the second-order derivatives in the two coordinate directions of the image coordinate system. Hence, the Laplacian is only an approximation to the second-order derivatives. As a result, edge detection based on zero-crossings of the Laplacian cannot reliably find the direction of the edge and it suffers poor localization at corners. Given a digital image defined on a 2D grid, the gradient and the Laplacian operation can both be done in the form a linear filtering through 2D convolution.

In practice, observed images are corrupted by noise. It is important to design edge detectors responsive to desired edges and at the same time resilient to image noise. An edge detector with such property is said to have *good detection*. This is critical since derivative operations are sensitive to noise. A common practice to suppress noise in edge detection is to low-pass filter the input image, for example, using a Gaussian spatial filter. Figure 2.1a shows a Gaussian filter sitting at origin with unit variance in both directions. An important tuning parameter for the Gaussian low-pass filter is its scale, that is, the standard deviation of the relative Gaussian distribution. Related to the selection of the scale, there is a trade-off between the detection of fine edges of the image and the suppression of noise. When the scale is large,

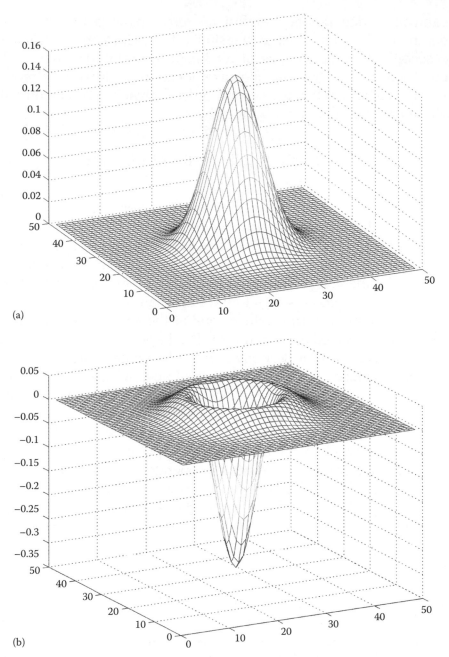

(a)

(b)

Figure 2.1 (See color insert following page 332.) (a) Gaussian and (b) Laplacian of Gaussian.

image noise can be effectively removed in edge detection; however, at the same time, detailed, fine edges are lost as well. When the scale is small, fine edges are preserved, so does image noise.

Since low-pass filtering, gradient, and Laplacian operations are all linear filtering, these operations can be combined so that low-pass filtering and gradient/Laplacian operation can be done through a single 2D convolution using a corresponding linear filter. When the low-pass filter and the Laplacian filter are integrated, a 2D linear filter shown in Figure 2.1b is obtained. Such integrated 2D filters are often referred to as the Laplacian of Gaussian.

$$\nabla^2 G_\sigma(x,y) = \left(\frac{1}{2\pi\sigma^4}\right)\left[\frac{x^2+y^2}{\sigma^2}-2\right]e^{-\frac{x^2+y^2}{2\sigma^2}} \qquad (2.8)$$

As introduced earlier, edge detection based on zero-crossings of Laplacian suffers from loss of edge direction, and poor localization at corners. Gradient-based edge detection using a simple thresholding returns thick edge strips when the pixel values change smoothly between two image regions. The Canny edge detector (Canny 1986) has been proposed to improve the gradient-based edge detection. The Canny edge detector is a popular and robust edge detection method using image gradient. The basic idea in Canny edge detection to improve edge localization is to find candidate edge points where the gradient magnitude is maximized along the direction of the gradient and then suppress all the other points by setting their gradient to be zero. This procedure is called *non-maximum suppression*. Due to image noise, there can still be other non-edge points surviving the non-maximum suppression. To identify true edge points from the results of non-maximum suppression, an *edge-following* procedure using two gradient magnitude thresholds through a hysteresis method is taken. A high threshold is used to start an edge trace and a low threshold to continue the trace along the edge direction (i.e., perpendicular to the gradient direction at the point). The intuition behind such a hysteresis procedure is that a true edge trace must have strong gradient somewhere along the edge (so that an edge can be detected using a high threshold), and that true edge points of the same edge should be

adjacent to each other along the edge direction (so that a started edge can be followed by finding neighbor edge points along the edge direction with gradient magnitudes above the low threshold).

2.1.4 Color Features

The color histogram provides an effective feature to represent the appearance of an object since it is computationally efficient, robust to partial occlusion, and invariant to rotation and scale. A common practice is to use the hue, saturation, value (HSV) color space because it separates out the hue channel from the saturation and brightness channels, and the hue channel is relatively reliable to identify objects in different colors. The color histogram $\mathbf{h}=(h_1, ..., h_u, ..., h_U)$ of an object image is a vector with U bins/elements. Assume that a hue-to-bin mapping $b(q)$ exits and it maps a hue value q to its corresponding bin index. For each bin u, there is an associated hue value $q(u)$. In the histogram vector \mathbf{h}, h_u is the number of pixels on the object in the image with corresponding hue values close to $q(u)$. In practice, given an object image h_u is found as follows according to the hue-to-bin mapping $b(q)$

$$h_u = \sum_{n=1}^{N} \delta(b(q_n) - u) \tag{2.9}$$

where
 δ is the Kronecker delta function
 $n=1, ..., N$ is the pixel index over the image region of the object

The histogram representation of color distribution is computationally efficient. However, the spatial information is lost in such a representation. To preserve the spatial color distribution, a mixture of Gaussian (MoG) has been proposed (Greenspan et al. 2001). The color distribution of an object can be represented as an MoG in the XY-HSV space.

$$p(\xi) = \sum_{k=1}^{K} \frac{\alpha_k}{\sqrt{(2\pi)^5 |\Sigma_k|}} \exp\left\{-\frac{1}{2}(\xi - \mu_k)^{\mathrm{T}} \Sigma_k^{-1}(\xi - \mu_k)\right\} \tag{2.10}$$

Each mixture component is a 5D Gaussian in the XY-HSV space with mean μ_k and covariance matrix Σ_k. In addition, α_k's are positive mixture coefficients and they add up to one to ensure that $p(\xi)$ is a valid probability density function. These parameters can be learned using the expectation-maximization (EM) algorithm from training images of an object.

2.2 MULTIPLE VIEW GEOMETRY

Knowledge on camera models and multiple view geometry is often needed in intelligent video surveillance, for example, when multiple cameras are involved. This section presents the basics on this subject. To know more, please see Hartley and Zisserman (2004) for a complete treatment.

2.2.1 Perspective Projection Camera Model

A camera is a projection device that maps a 3D scene onto a 2D image plane. Among many others, the pinhole camera model (Figure 2.2), aka the prospective projection model, is the most commonly used camera model.

Consider the case when the camera frame and the world frame coincide. Let P be a 3D point at location (X, Y, Z) in the 3D metric world frame O. On the image plane, a 2D metric coordinate system o can be defined as shown in Figure 2.2. Assume that the 3D point P is projected to a 2D image point p on the image plane.

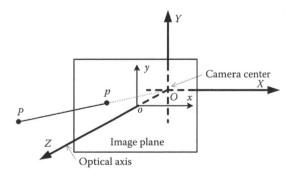

Figure 2.2 Pinhole camera model.

Let $\tilde{\mathbf{x}}$ be the coordinate of p in o and it is given by

$$\tilde{\mathbf{x}} = f\left(\frac{X}{Z}, \frac{Y}{Z}\right)^{\mathrm{T}},$$

where f is the metric focal length of the camera. In homogenous representations, the 3D point P is represented by a 4-vector $\mathbf{X} = [X, Y, Z, 1]^{\mathrm{T}}$ and the 2D point p by a 3-vector $\mathbf{x} = [fX, fY, Z]^{\mathrm{T}}/Z$. Note that in homogenous representations, \mathbf{X} and $\alpha\mathbf{X}$ are equivalent, that is, $\mathbf{X} = \alpha\mathbf{X}$, for any nonzero scalar α.

Using such homogeneous coordinates \mathbf{x} can be found as the following:

$$\mathbf{x} = \begin{pmatrix} fX \\ fY \\ Z \end{pmatrix} = \begin{bmatrix} f & & & 0 \\ & f & & 0 \\ & & 1 & 0 \end{bmatrix} \begin{pmatrix} X \\ Y \\ Z \\ 1 \end{pmatrix} = \mathbf{PX} \qquad (2.11)$$

In addition, \mathbf{P} is the projection matrix given by

$$\mathbf{P} = \begin{bmatrix} f & & & 0 \\ & f & & 0 \\ & & 1 & 0 \end{bmatrix} = \mathbf{K}[\mathbf{I} \mid \mathbf{0}] \qquad (2.12)$$

where $\mathbf{K} = \mathrm{diag}(f, f, 1)$ is the camera calibration matrix.

In reality, it is common that the world frame O is different from the camera-centered coordinate system (aka the camera frame) C by a Euclidean transformation specified by a rotation matrix \mathbf{R} and a translation vector \tilde{C}, as shown in Figure 2.3.

Let \mathbf{R} be the rotation matrix from O to C, so that the rows of \mathbf{R} are given by the directional cosines of the three coordinate axes of C in O. Let \tilde{C} be coordinates of the origin of C in O. To find the image

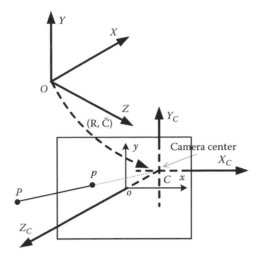

Figure 2.3 Camera model undergoing a Euclidean transformation.

projection p of a point P (Figure 2.3) with known world coordinates in O, we can first find \tilde{X}_C the coordinates of P in C and then map P onto the image plane using the projection matrix introduced earlier by Equation 2.12. According to the definition of \mathbf{R} and \tilde{C},

$$\tilde{X}_C = \mathbf{R}(\tilde{X} - \tilde{C}) = \begin{bmatrix} \mathbf{r}^{1T} \\ \mathbf{r}^{2T} \\ \mathbf{r}^{3T} \end{bmatrix} (\tilde{X} - \tilde{C}) = \begin{bmatrix} \mathbf{r}_1 & \mathbf{r}_2 & \mathbf{r}_3 \end{bmatrix} (\tilde{X} - \tilde{C}) = \mathbf{R}\tilde{X} - \mathbf{R}\tilde{C}$$

$$(2.13)$$

In homogenous representations, we have

$$\mathbf{X}_C = \begin{bmatrix} \mathbf{R} & -\mathbf{R}\tilde{C} \\ \mathbf{0}^T & 1 \end{bmatrix} \begin{pmatrix} X \\ Y \\ Z \\ 1 \end{pmatrix} = \begin{bmatrix} \mathbf{R} & -\mathbf{R}\tilde{C} \\ \mathbf{0}^T & 1 \end{bmatrix} \mathbf{X} \qquad (2.14)$$

Thus, the image projection of P is

$$\mathbf{x} = \mathbf{K}[\mathbf{I} \mid \mathbf{0}]\mathbf{X}_C = \mathbf{K}[\mathbf{I}|\mathbf{0}]\begin{bmatrix} \mathbf{R} & -\mathbf{R}\tilde{C} \\ \mathbf{0}^\mathsf{T} & 1 \end{bmatrix}\mathbf{X} = \mathbf{K}\mathbf{R}[\mathbf{I} \mid -\tilde{C}]\mathbf{X}.$$

Hence, in the case of general camera placement in the world frame, the projection matrix mapping a point in O onto the image plane is given by $\mathbf{P} = \mathbf{K}\mathbf{R}[\mathbf{I} \mid -\tilde{C}]$, which is specified by the camera calibration matrix \mathbf{K}, and (\mathbf{R}, \tilde{C}) the Euclidean transformation between the world frame O and the camera frame C.

2.2.1.1 Projection onto Pixel Coordinates

In practice, a point in an image is often indexed by its pixel location in a pixel coordinate system on the image plane. The mapping from the metric image coordinate \mathbf{x} (e.g., measured in mm) to the pixel coordinate \mathbf{x}_p measured in the number of pixels is given by a 2D projective transformation, which is also known as a homography: $\mathbf{x}_p = \mathbf{H}\mathbf{x}$, where \mathbf{H} is given by

$$\mathbf{H} = \begin{bmatrix} m_x & & p_x \\ & m_x & p_y \\ & & 1 \end{bmatrix} \tag{2.15}$$

In \mathbf{H}, p_x and p_y are the pixel coordinates of the center of the metric image coordinate system in the pixel coordinate system, and m_x, m_y are the numbers of pixels per unit length in the width and height dimensions of the pixel coordinate system. Thus, the projection matrix from the 3D world frame to the pixel image plane is given by $\mathbf{P} = \mathbf{H}\mathbf{K}\mathbf{R}\begin{bmatrix} \mathbf{I} \mid -\tilde{C} \end{bmatrix} = \mathbf{K}_p\mathbf{R}\begin{bmatrix} \mathbf{I} \mid -\tilde{C} \end{bmatrix}$. \mathbf{K}_p is the camera calibration matrix with respect to the pixel image coordinates given by

$$\mathbf{K}_p = \mathbf{H}\mathbf{K} = \begin{bmatrix} m_x & & p_x \\ & m_x & p_y \\ & & 1 \end{bmatrix}\begin{bmatrix} f_x & & \\ & f_x & \\ & & 1 \end{bmatrix} = \begin{bmatrix} \alpha_x & & p_x \\ & \alpha_y & p_y \\ & & 1 \end{bmatrix} \tag{2.16}$$

where α_x, α_y are the focal lengths measured in, respectively, pixel widths and pixel heights. The camera calibration matrix \mathbf{K}_p can be found through a camera calibration process.

2.2.1.2 Projection/Mapping through 2D Homography

In general, camera projection is a many-to-one mapping, that is, all points on the same ray passing through the camera center and a 3D point are projected to the same image point. However, an exception exists when a planar scene is considered. In this case, there is a one-to-one mapping between a scene plane point and its projection on the image plane. Consider a scene plane π (Figure 2.4).

Assume that a 2D coordinate system s exists on π. Let $\mathbf{x}_s = (X, Y, 1)^\mathsf{T}$ be the homogeneous coordinates of a point P on π in the 2D coordinate system s. Without loss of generality, a world frame O can be constructed in the scene on top of s by introducing the third Z-axis perpendicular to π while obeying the right-hand rule. In so doing, the homogeneous coordinate of P in O is then given by $\mathbf{X} = [X, Y, 0, 1]^\mathsf{T}$. The projection matrix can be written as $\mathbf{P} = [\mathbf{p}_1, \mathbf{p}_2, \mathbf{p}_3, \mathbf{p}_4]$. The image projection of P is given by

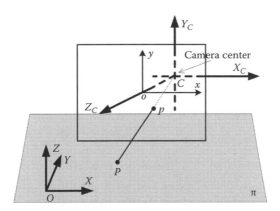

Figure 2.4 Homography introduced by a planar scene.

$$\mathbf{x} = \mathbf{PX} = [\mathbf{p}_1, \mathbf{p}_2, \mathbf{p}_3, \mathbf{p}_4] \begin{bmatrix} X \\ Y \\ 0 \\ 1 \end{bmatrix} = [\mathbf{p}_1, \mathbf{p}_2, \mathbf{p}_3, \mathbf{p}_4] \begin{bmatrix} 1 & 0 & 0 \\ 0 & 1 & 0 \\ 0 & 0 & 0 \\ 0 & 0 & 1 \end{bmatrix} \begin{bmatrix} X \\ Y \\ 1 \end{bmatrix}$$

$$= [\mathbf{p}_1, \mathbf{p}_2, \mathbf{p}_4] \begin{bmatrix} X \\ Y \\ 1 \end{bmatrix} = \mathbf{Hx}_s \tag{2.17}$$

Hence, points on a scene plane are related to their image projections through a homography \mathbf{H}. Given two cameras looking at the same planar scene, the projections of scene points are obtained through two homography matrices. As a result, corresponding points on the two image planes are also related by a homograph: if $\mathbf{x}_0 = \mathbf{H}_0 \mathbf{x}_s$, $\mathbf{x}_1 = \mathbf{H}_1 \mathbf{x}_s$, $\mathbf{x}_1 = \mathbf{H}_1 \mathbf{H}_0^{-1} \mathbf{x}_0$.

When a camera is undergoing pure rotational motion described by a rotation matrix \mathbf{R}, the corresponding points in the images before and after the rotation are also related by a homography. Before the rotation, $\mathbf{x}_0 = \mathbf{P}_0 \mathbf{X}$ and $\mathbf{P}_0 = \mathbf{K}_p \mathbf{R}_0 [\mathbf{I} \mid -\tilde{C}]$. After the rotation, $\mathbf{x}_1 = \mathbf{P}_1 \mathbf{X}$ and $\mathbf{P}_1 = \mathbf{K}_p \mathbf{R} \mathbf{R}_0 [\mathbf{I} \mid -\tilde{C}]$. Thus, $\mathbf{x}_1 = \mathbf{K}_p \mathbf{R} \mathbf{K}_p^{-1} \mathbf{x}_0$.

2.2.2 Epipolar Geometry

The epipolar geometry is the most general relationship existing for any scene structure and relative camera placements with different camera centers.

2.2.2.1 Epipolar Plane and Epipolar Lines

Consider a 3D point P and two cameras with different camera centers C and C' and image planes I and I' (see Figure 2.5). Let p and p' be the projection of P in I and I', respectively. When P, C, and C' are noncollinear, the plane π formed by these three points is the *epipolar plane* with respect to P and the two camera centers. This epipolar

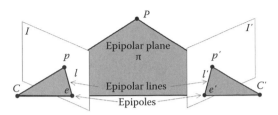

Figure 2.5 Epipolar plane, epipolar lines, and epipoles.

plane intersects I and I' at lines l and l', respectively, which are referred to as the *epipolar lines*. In addition, the line connecting the two camera centers CC' intersects the two image planes at e and e', which are called *epipoles*.

2.2.2.2 Fundamental Matrix

The epipolar geometry is often used to relate corresponding image points on two image planes. Let \mathbf{X} be the homogenous coordinates of P, and \mathbf{x} and \mathbf{x}' the homogenous coordinates of p and p'. When only \mathbf{x} is given, without knowing where P is along the ray through C and p, the location of p' cannot be uniquely determined in I'. The only thing known about the location of p' is that it is on the epipolar line l' related to p in I'. This is because all the points on π are projected on this line in I'. When the cameras are fully calibrated with known intrinsic and extrinsic camera parameters, given an image point p and its location \mathbf{x} on the first image plane I, its corresponding epipolar line l' in I' can be found as follows.

Assume that the first camera frame is identical to the world frame, and let \mathbf{t} be the position of the first camera center in the second camera frame. Let $\mathbf{P} = \mathbf{K}\,[\mathbf{I}|\mathbf{0}]$ and $\mathbf{P}' = \mathbf{K}'\,[\mathbf{R}|\mathbf{t}]$ be the two camera projection matrices. In the homogenous representation, a line is given by the cross product of any two points on the line (Hartley and Zisserman 2004). Hence, the epipolar line l' can be found as the cross product of \mathbf{e}' and \mathbf{x}'', which are the homogenous coordinates of the epipole e' and an arbitrary point p'' on l'. The location

of epipole e' in I' can be found as the projection of C on I' as shown in Figure 2.5, given by

$$e' = \mathbf{K}'[\mathbf{R} \mid \mathbf{t}]\begin{bmatrix} \mathbf{0} \\ 1 \end{bmatrix} = \mathbf{K}'\mathbf{t} \qquad (2.18)$$

Now the question is how to find p''. Consider the ray through the first camera center C and p, the projection of P in I. This ray intersects the plane at infinity at a point P_∞. Since the ray through C and p is on the epipolar plane π, P_∞ is also on π. Therefore, the projection of P_∞ on I' is on I' and it can be chosen as p''. All the points on the plane at infinity can be represented as a 4-vector $(\mathbf{d}^T, 0)^T$ (Hartley and Zisserman 2004). Given \mathbf{x} and $\mathbf{P}=\mathbf{K}\,[\mathbf{I}|\mathbf{0}]$, it follows that

$$\mathbf{x} = \mathbf{K}[\mathbf{I} \mid \mathbf{0}]\begin{bmatrix} \mathbf{d} \\ 0 \end{bmatrix} = \mathbf{K}\mathbf{d} \Rightarrow \mathbf{d} = \mathbf{K}^{-1}\mathbf{x} \qquad (2.19)$$

Therefore,

$$\mathbf{x}'' = \mathbf{K}'[\mathbf{R} \mid \mathbf{t}]\begin{bmatrix} \mathbf{d} \\ 0 \end{bmatrix} = \mathbf{K}'\mathbf{R}\mathbf{d} = \mathbf{K}'\mathbf{R}\mathbf{K}^{-1}\mathbf{x} \qquad (2.20)$$

Hence, \mathbf{l}' the homogenous representation of l' can be obtained as follows.

$$\mathbf{l}' = [\mathbf{e}']_\times \mathbf{x}'' = [\mathbf{K}'\mathbf{t}]_\times \mathbf{K}'\mathbf{R}\mathbf{K}^{-1}\mathbf{x} = \mathbf{K}'^{-T}[\mathbf{t}]_\times \mathbf{R}\mathbf{K}^{-1}\mathbf{x} \qquad (2.21)$$

where $[\cdot]_\times$ presents a skew-symmetric matrix useful for computing cross product. Given two 3-vectors \mathbf{a} and \mathbf{b}, their cross product is given by

$$[\mathbf{a}]_\times \mathbf{b} = \begin{bmatrix} 0 & -\mathbf{a}_z & \mathbf{a}_y \\ \mathbf{a}_z & 0 & -\mathbf{a}_x \\ -\mathbf{a}_y & \mathbf{a}_x & 0 \end{bmatrix}\begin{bmatrix} \mathbf{b}_x \\ \mathbf{b}_y \\ \mathbf{b}_z \end{bmatrix} \qquad (2.22)$$

The fundamental matrix related to two cameras C and C' is then given by $\mathbf{F}=\mathbf{K}'^{-T}[\mathbf{t}]_\times \mathbf{R}\mathbf{K}^{-1}$. Since \mathbf{x}' is on l', we have $\mathbf{x}'^T \mathbf{l}'=0$, leading

to $\mathbf{x}'^T\mathbf{F}\mathbf{x}=0$, which is often referred to as the *epipolar constraint*. The fundamental matrix \mathbf{F} is completely determined by the camera calibration parameters and it is independent of the image point.

2.2.2.3 Estimation of Fundamental Matrix

Given eight noncollinear pairs of point correspondences between two cameras, the fundamental matrix can be found by solving a linear system. Let \mathbf{f} be a column vector obtained by concatenating rows of the fundamental matrix \mathbf{F}. According to the epipolar constraint, it follows that

$$
\begin{bmatrix}
x_1'x_1 & x_1'y_1 & x_1' & y_1'x_1 & y_1'y_1 & y_1' & x_1 & y_1 & 1 \\
\vdots & \vdots & \vdots & \vdots & \vdots & \vdots & \vdots & \vdots & \vdots \\
x_n'x_n & x_n'y_n & x_n' & y_n'x_n & y_n'y_n & y_n' & x_n & y_n & 1
\end{bmatrix} \mathbf{f} = \mathbf{A}\mathbf{f} = \mathbf{0}
$$

(2.23)

\mathbf{A} is the data matrix defined in Equation 2.23, where (x_i, y_i) and (x_i', y_i'), $i=1, \ldots, n$, are locations of a pair of corresponding points between the two camera views. To reliably estimate \mathbf{f}, a critical step is data normalization (Hartley 1997). For a point cloud in each camera view, the following data normalization is carried out. First, shift the point cloud so it is centered at the origin, and then scale the shifted data points by a factor proportional to the average distance from the data points to their centroid. Essentially, for each camera view, we apply the following linear transformation to the original data points:

$$
\hat{\mathbf{x}} = \mathbf{T}\mathbf{x}, \quad \mathbf{T} = \begin{bmatrix} s & & -sx_0 \\ & s & -sy_0 \\ & & 1 \end{bmatrix}
$$

(2.24)

where (x_0, y_0) is the centroid of points on the image, and $s=\sqrt{2}/d$, where d is the average distance from these data points to their centroid. This data normalization step is important since it can greatly improve the numerical condition of the data matrix \mathbf{A}. Otherwise, there can be infinite number of solutions of \mathbf{F}. Using points after data

normalization, a new data matrix \mathbf{A}' can be found. The fundamental matrix $\hat{\mathbf{F}}$ corresponding to the normalized data points can be easily solved to be the smallest right singular vector (i.e., the right singular vector corresponding to the smallest singular value) of \mathbf{A}'. Once $\hat{\mathbf{F}}$ is found, the fundamental matrix associated to the original data can be easily recovered. Obviously, $\hat{\mathbf{x}}^{\mathrm{T}}\hat{\mathbf{F}}\hat{\mathbf{x}} = 0$ is equivalent to $\mathbf{x}'^{\mathrm{T}}\mathbf{T}'^{\mathrm{T}}\hat{\mathbf{F}}\mathbf{Tx} = 0$. Thus $\mathbf{F} = \mathbf{T}'^{\mathrm{T}}\hat{\mathbf{F}}\mathbf{T}$.

2.3 PROBABILISTIC INFERENCE

In this section, we introduce the concept of probabilistic inference, which has been widely used for many algorithms in the intelligent video surveillance.

Probabilistic inference refers to the process of recovering some unknown random factors of a system from some observed data. We denote U as the unknown factors of the system, for example, it could be the unobservable hidden random variables, the parameters of the probabilistic model, which represents the system, and the models themselves. And we denote Z as the observed data. Then, the probabilistic inference algorithms intend to compute useful probabilistic quantities, for example, the posterior probability

$$p(U \mid Z) \tag{2.25}$$

Based on some optimal criteria, for example, the maximum a posterior estimation

$$U^* = \arg\max_{U} p(U \mid Z) \tag{2.26}$$

According to the property of U, there are three basic problems in probabilistic inference.

The first problem is the hidden variable inference. Here U represents the unobservable state X of the system. We assume that the probabilistic model and the model parameters are known. We observed that $Z=z$. In order to recover the posterior probability $p(X \mid Z=z)$, the Bayesian rule can be used $p(X \mid Z=z)=P(X, Z=z)/P(Z=z)$, where $p(Z=z)$ is called evidence.

The second problem is the parameter estimation. We can assume that the probabilistic model is known. Here U represents model parameters θ, which are unknown. We have the likelihood probability $p(Z \mid \theta)$. A common technique for estimating θ is the maximum likelihood (ML) estimation. Suppose we have sample data (z_1, \ldots, z_n) independent and identically distributed from $p(Z \mid \theta)$, then the likelihood of observing these samples is $L(\theta) = \prod_{i=1}^{n} p(z_i \mid \theta)$. The ML estimate θ is

$$\theta^* = \arg\max_{\theta} L(\theta) \tag{2.27}$$

The third problem is the model selection problem. Here U represents the probabilistic model h, which can be chosen from a set of models. We want to determine which model might be the best one given the observed data Z. An EM algorithm (Dempster et al. 1977) can be used for the ML from the incomplete data.

The problem of parameter estimation is highly correlated to model selection in the sense that different parameters do represent different models. But the context of model selection is much larger because we may select among models of different types. The parameter estimation could only be performed after the type of the model has been specified. Next, we focus on the inference algorithms. For the parameters and structures estimation, interested reader can refer to (MacKay 2003). Next, we first discuss probabilistic graphical models, which have been very popular in probabilistic inference and probabilistic learning due to their elegance in visualizing and representing probabilistic models. Then, we discuss the most commonly used probabilistic inference algorithms in three categories, namely, exact inference, variational methods, and the sampling methods.

2.3.1 Graphical Models

A probabilistic system is usually encoded by its joint probability. In most real applications, it can be represented in a factorized form due to the conditional independence of random variables in a probabilistic system. Graphical models have wide popularity in representing probabilistic

systems because they can neatly present and visualize the conditional independence.

Graphical models use graphs to represent joint probability. The graph has nodes and links. Each node represents a random variable, and the link represents the relationships between these variables. The graph may be directed, in which case the model is often called a Bayesian network. The graph can also be undirected, in which case the model is called a Markov random field.

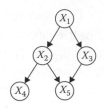

FIGURE 2.6 An example of the Bayesian network.

First, we present a Bayesian network, a directed graphical model. Each conditional distribution corresponds to a directed link to the graph. Figure 2.6 shows a Bayesian network of five random variables. There is a directed link from node x_1 to node x_2 in Figure 2.6. Then the node x_1 is called the parent of the node x_2. The joint distribution defined by a Bayesian network is given by the product over all the nodes of the graph with the conditional distribution for each node corresponding to the parent of the node in the graph as follows:

$$p(\mathbf{x}) = \prod_{i=1}^{n} p(x_i \mid \text{par}(x_i)) \tag{2.28}$$

where $\text{par}(x_i)$ represents the set of all parent nodes of x_i.

Second, we present a Markov random field, an undirected graphical model. The links are undirected. Such a graphical model is naturally suited to model images. We consider a graphical concept called a clique. The set of nodes in a clique is fully connected. We denote a general potential function $\phi_C(\mathbf{x}_C)$ on the cliques of the neighborhood system, where \mathbf{x}_C are the nodes in the clique. The potential function assigns a positive real number to each configuration \mathbf{x}_C. The joint distribution is written as a product of the potential functions as follows:

$$p(\mathbf{x}) = \frac{1}{Z_\Omega} \prod_{C \in \Omega} \phi_C(\mathbf{x}_C) \tag{2.29}$$

where

 Ω is the set of cliques in the graph

 Z_Ω is a normalization factor to make sure $\sum p(\mathbf{x}) = 1$

Both the directed graph and the undirected graph can be converted into a factor graph (Bishop 2006). The factor graph has two types of nodes, the variable node and the factor node. The variable node represents every variable in the distribution. The factor node is a function of a corresponding set of variables. Moreover, a directed Bayesian network could be converted to an undirected high order Markov network through the process called moralization. A broad discussion could be found in Jordan and Weiss (2002).

2.3.2 Sequential Data Processing

In this section, we consider sequential data coming from the measurement of a time series so the data are not independent and identically distributed. For example, the tracking data are sequential data. The trajectory based activity recognition also uses sequential data.

 A simple model is a Markov model. Consider a sequence data (x_1, \ldots, x_N), the first-order Markov chain has the following property $p(x_N | x_1, \ldots, x_{N-1}) = p(x_N | x_{N-1})$. We can add a latent variable, and the Markov model becomes a state space model. If the latent variables are discrete, then we have a hidden Markov model; if both the latent and the observed variables are Gaussian, then we have a Kalman filter.

 We first describe the hidden Markov model, as shown in Figure 2.7. The conditional distribution on the latent variable is called transition probabilities $p(x_n | x_{n-1}, A)$. And the conditional distribution from the latent variable to the observed variable is called emission probabilities $p(z_n | x_n, \phi)$. Consider an observe dataset $Z = (z_1, \ldots, z_N)$, the corresponding latent variable $X = (x_1, \ldots, x_N)$, and $\theta = \{\pi, A, \phi\}$ represents the set of parameters, the joint probability distribution for a hidden Markov model is given by

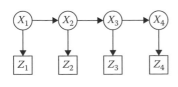

FIGURE 2.7 A hidden Markov model.

$$p(Z, X \mid \theta) = p(x_1 \mid \pi) \left[\prod_{n=2}^{N} p(x_n \mid x_{n-1}, A) \right] \prod_{m=1}^{N} p(z_m \mid x_m, \phi) \quad (2.30)$$

The initial latent node x_1 does not have a parent node.

Next, we discuss the Kalman filter (Kalman 1963), which shares the same graphical model shown in Figure 2.7. The Kalman filter has been widely used in tracking problem. For example, suppose we want to track an object using a noisy sensor that returns an observation representing the position of the object in addition to zero mean Gaussian noise. The position of the object changes over time. We can have observation $Z = (z_1, \dots, z_N)$ and we want to find the position of the object $X = (x_1, \dots, x_N)$. The transition probability model $p(x_{k+1} \mid x_k)$ in Figure 2.7 can be written as $x_{k+1} = A_k x_k + w_k$, where w_k is a white Gaussian noise, that is, $w_k \sim N(0, Q_k)$ and is a linear transformation. The observation model $p(z_k \mid x_k)$ can be written as $z_k = H_k x_k + v_k$, where v_k is a white Gaussian noise, that is, $v_k \sim N(0, R_k)$ and H_k is a linear transformation, and x_1 is governed by a Gaussian distribution. The Kalman filter is a two-step procedure, time update and measurement update. The Kalman filter tracking algorithm has been implemented by most existing computer vision software library, such as OpenCV library.

The Kalman filter is applicable when A_k and H_k are both linear transformations. For nonlinear transformations, the extended Kalman filter and the unscented Kalman filter (Anderson and Moore 1979, Julier et al. 2000) can be used. However, the Kalman filter and its extension are based on the assumption of Gaussian distributions. For a general, non-Gaussian distribution probabilistic system, the inference problem can be achieved by a particle filter algorithm, which is derived from importance sampling.

One of the particle filter algorithms is the CONDENSATION (conditional density propagation) algorithm (Isard and Blake 1998). Under the particle representation, any arbitrary probability distribution can be represented as a set of N weighted particles, $\left\{ s_t^{(n)}, \pi_t^{(n)} \right\}, \sum_{n=1}^{N} \pi_t^{(n)} = 1$. In the CONDENSATION algorithm, both prior and posterior distributions are encoded in such a particle representation. Let $\left\{ s_{t-1}^{(n)}, \pi_{t-1}^{(n)}, n = 1, \dots, N \right\}$ denote the posterior distribution obtained from time $t - 1$. At successive

time-steps, the number of particles is fixed to N. The first step is to sample N times from the set $\{s_{t-1}^{(n)}\}$ according to the weight $\pi_{t-1}^{(n)}$. Some particles with high weight may be chosen multiple times and some particles with low weight may not be chosen at all. Then, each chosen particle is subjected to the predictive step: first, it undergoes a deterministic drift (consider transition A_k in Kalman filter); and then it undergoes its own random walk according to the noise term in the transition probability (consider w_k in Kalman filter). After that, the observation step from factored sampling is applied, generating weights from the observation density $p(z_t \mid x_t)$ to obtain the sample-set $\{s_t^{(n)}, \pi_t^{(n)}, n = 1, ..., N\}$ representation of posterior density for time t.

2.3.3 Exact Inference, Variational Approach, and Sampling Method

For most real applications, the hidden variable inference is usually an essential part of the solution. In this section, we discuss the inference algorithms for the hidden variable inference.

First, we discuss the exact inference algorithm. If there is no loop in the graphical model, that is, the graphical model is tree structured. There are efficient propagation algorithms to perform the exact inference of the marginal distributions, which is the sum–product algorithm or the belief propagation algorithm. For example, the forward–backward algorithm for the hidden Markov model is a special case of the sum–product algorithm. If there are loops in the graphical model, directly applying the sum–product or belief propagation algorithm cannot achieve the exact inference results. However, there is a more general algorithm, called the junction-tree algorithm, which perform exact inference by the message passing process among clusters of nodes in the graphical model. The junction-tree algorithm usually involves the following steps. Readers can refer to MacKay (2003) for more details.

- If the graphical model is directed, moralize it to be an undirected graphical model.
- Determine an elimination order of the node in the graphical model, that is, triangulate the undirected graph.

- Construct the junction tree from the elimination order, this involves clustering the nodes as several sets called super-node and weight the edge between different node sets by the separator node set.
- Pass message among super-node and separator node in the junction tree to perform the inference.

Next, we discuss variational approach. Exact inferences on complex probabilistic systems are not always possible to achieve. Variational approach provides a way for the approximate inference. Instead of trying to recover the marginal posteriori distribution directly, it usually involves the construction of a variational distribution. Then a lower-bound of the likelihood will be maximized by minimizing the Kullback–Leibler (KL) divergence between the variational distribution and the true posterior distributions. The key of the theoretic deduction of the variational inference methods is based on the Jensen's inequality, maximizing the lower bound with respect to the free distribution $Q(X)$ (actually, it is achieved when the equality holds) will result in $Q(X)=P(X|Z)$, which is exactly the posterior distribution we would want to estimate. The most widely used approximate distribution $Q(X)$ might be the fully factorized form, that is, assume $Q(X) = \prod_{i=1}^{n} Q_i(x_i)$, which is also called the mean field approximation.

The sampling method is another type of approximate probabilistic inference algorithm. It is based on the strong law of large numbers, that is, when the number of samples from a certain probabilistic distribution is large enough, any order of the sample will converge, with probability one, to the same order of distribution statistics. We start from basic uniform sampling algorithms to more complex sampling methods, Markov chain Monte Carlo (MCMC).

The uniform sampling technique is to uniformly sample the states space of x and evaluate $p(x)$, from which we would want to sample, at each sample point. However, for probabilistic distributions in a high dimensional state space, the number of samples for uniform sampling would be fairly huge to obtain satisfactory results.

Instead of sampling from $p(x)$ directly, the importance sampling samples x from an importance function $Q(x)$ which is easy to sample from, then it assigns a rectifying weight to x, that is, $p(x)/Q(x)$. The

problem for importance sampling, especially in the high-dimensional case, is that the importance function $Q(x)$ must be as close to $p(x)$ to efficiently achieve a satisfactory sample set.

MCMC comes from the field of applied statistics. It usually involves the construction of a Markov chain whose stationary distribution is the probabilistic distribution from which we want to sample, and then we can generate samples by simulating the transition of the Markov chains. After discarding the first certain number of samples (the samples in the burn-in stage), the sample set can represent the distribution well. To guarantee that the stationary distribution of a Markov chain converges to the desired distribution, one sufficient condition for, that is, the detailed balance, $Q(x_0|x)P(x)=Q(x|x_0)P(x_0)$, where $P(x)$ is the distribution we would want to sample from and $Q(x_0|x)$ is the transition probability of the Markov chain. Metropolis–Hasting algorithm is one generally used MCMC method. Suppose the current state of the Markov chain is x, we then generate a proposal transition sample x' from a proposal distribution $q(x'|x)$, then accept x' according to the probability of $\min(1, q(x'|x)p(x)/q(x|x')p(x'))$, otherwise the Markov chain stays at the same state x. It can be easily shown that the acceptance transition defined earlier satisfies the condition of detailed balance. Note that any proposal distribution $q(x'|x)$ can be used, such as uniform distribution or Gaussian distribution, but an informative proposal distribution will enable the Markov chain to converge quickly. Metropolis–Hasting algorithm can be extended to trans-dimensional spaces where the solution spaces may consist of different subspaces with different dimensionalities. We refer the readers to Gilks et al. (1996) for a broad discussion of the MCMC algorithms.

Gibbs sampling is a special case of Metropolis–Hasting algorithm. It can be applied when the conditional probability $p(x_i|x_1, \ldots, x_{i-1}, x_{x+1}, \ldots, x_L)$ of a high-dimensional system is easy to acquire, where L is the dimension.

2.4 PATTERN RECOGNITION AND MACHINE LEARNING

Pattern recognition and machine learning is widely used in the intelligent video surveillance. In general, we need to learn a function from

training data $(\mathbf{x}_i,\ y_i)$, $i=1, 2, ..., n$, and use the learned function to predict the output for the new test input. This setting can be interpreted as a form of inductive–deductive reasoning process, where the induction step corresponds to the learning or estimation of a general rule from specific instances and the deduction step corresponding to the prediction of specific instances from a general rule (Cherkassky and Mulier 2007).

2.4.1 Basic Concepts and Learning Methods

Traditionally, there are two types of learning: one is supervised learning, and the other is unsupervised learning. For the supervised learning, the training data includes examples of correct outputs that are used for model estimation. For the unsupervised learning, there is no output label in the training data. Recently, semi-supervised learning is applied in many applications. Semi-supervised learning is between the supervised learning and unsupervised learning. There are some labeled data in the training data, not for all the training data for the semi-supervised learning. In this section, we mainly discuss supervised learning and unsupervised learning.

For the supervised learning, there are two types of problems: regression and classification. In the regression setting, the output y is real-valued, and the quality of prediction $\hat{y} = f(\mathbf{x})$ is usually measured using squared-loss error $L(y,\ f(\mathbf{x})) = (y - f(\mathbf{x}))^2$. In the classification setting, the output y is categorical. Consider binary classification problems, the indicator function $f(\mathbf{x})$ has two values (0 or 1). This binary function separates the input space into two regions corresponding to different classes. In this case, the quality of prediction is usually measured using a 0/1 loss function, such that the error is zero if a classifier $f(\mathbf{x})$ predicts the class label correctly, and the error is 1 otherwise.

There are two goals of the supervised learning: the explanation of the training data, and the prediction of testing data. Using the notion of loss function $L(y,\ f(x))$ or discrepancy measure between the predicted output $f(\mathbf{x})$ and the actual output y, we can measure the quality of explanation and prediction. The average fitting error or empirical risk is

$$R_{emp} = \frac{1}{n}\sum_{i=1}^{n} L\left(y_i, f(\mathbf{x}_i)\right)$$ (2.31)

The empirical risk describes how well a model $f(\mathbf{x})$ explains (or fits) available training data (\mathbf{x}_i, y_i) $i=1, 2, ..., n$. The quality of prediction is much more difficult to evaluate, since by definition, the future data are not known. However, assuming such hypothetical future data, called *test data*, are available, it can be used for estimating the prediction accuracy of a model $f(\mathbf{x})$. Denote this test data as (\mathbf{x}_t, y_t) $t=1, ..., T$. Then the quality of prediction is simply average test error aka *prediction risk*:

$$R = \frac{1}{T}\sum_{t=1}^{T} L\left(y_t, f(\mathbf{x}_t)\right)$$ (2.32)

The test data should not be used for estimating a model; it is only used for the estimation of its prediction accuracy. Also, the number of test samples should be large. Otherwise, the test error may be significantly affected by just a few random test samples, and this measure would have little objective value.

Next, we discuss the unsupervised learning. There are no labeled data in the sample data. There are two types of unsupervised learning: clustering and dimensionality reduction. Usually the quality of a model is measured by its approximation accuracy for the training data, and not for the future samples. The available data in the unsupervised learning appears in the form of n multivariate input samples $(\mathbf{x}_1, ..., \mathbf{x}_n)$ in d-dimensional sample space. These samples originate from some distribution. The goal is to approximate the unknown distribution so that samples produced by the approximation model are "close" (in some well-defined sense) to samples from the generating distribution. In the cluster analysis, the goal is to partition a given data set into a small number of groups (clusters), where each cluster is often represented by its center or "prototype." These clusters are meaningful for data understanding, or useful for some other purpose. In the

dimensionality reduction, for example, a 2D data set can be reduced to a 1D representation. In this case, the model is suitably chosen line, such that the squared sum of the distances between data points and this line is minimized.

All these problems have common goals of (a) explaining available data and (b) predicting new (test) data. However, these problems differ in the type of predicted function (i.e., real-valued vs. categorical output), and in a specific loss (discrepancy) measure $L(y, f(\mathbf{x}))$ used. Hence, the specification of each learning problem quantifies the goal of learning and provides a measure of prediction accuracy, but it does not describe *how to find* a good model. These basic approaches are implemented in thousands of existing learning algorithms developed in machine learning, statistics, data mining, neural networks, pattern recognition, and signal processing. The description of these algorithms is often obscured by specialized (statistical, pattern recognition, neural networks, etc.) terminology.

The general idea behind all modeling approaches is to specify a wide set of possible (admissible) models $f(\mathbf{x}, \omega)$ indexed by some abstract set of parameters ω. The interpretation of $f(\mathbf{x}, \omega)$ depends on a particular type of the learning problem. For example, consider a univariate regression problem where a set of possible models is limited to second-order polynomials, that is, $f(x, \omega) = w_0 + w_1 x + w_2 x^2$, so ω is just a set of coefficients $\{w_0, w_1, w_2\}$. So, under parametric modeling approach, a set of possible models is defined via some explicit parameterization.

Under the nonparametric or local estimation modeling approach, the model is estimated for each given input \mathbf{x}_0, as a "local average" of the training data in the vicinity of \mathbf{x}_0. The concrete meaning of terms "local" and "average" are explained next via an example of local estimation method called k-nearest neighbors regression. For a given integer k, the output y at input \mathbf{x}_0 is estimated as an average of y values of k training samples closest to point \mathbf{x}_0. Note that the value of k determines the size of a local region (near \mathbf{x}_0) from which a subset of training samples is selected. The estimated value \hat{y} depends only on a subset of training samples in a local region around \mathbf{x}_0. From the "nonparametric" point of view, the modeling does not explicitly specify parametric model being estimated. Two important design characteristics of a local

method include (a) procedure for selecting an optimal size of a local region and (b) provision for (nonuniform) weighting of samples in a local region.

2.4.2 Two Popular Classifiers: Support Vector Machines and AdaBoost

The first popular classifier is the Support Vector Machine (SVM) classifier. Conceptually, SVM approach provides a new form of parameterization of approximating functions, so that model complexity can be controlled independently of the problem dimensionality. This opens a possibility for specifying appropriate structures for a given data set, where one can achieve small empirical risk using low-complexity parameterizations. Such models provide good generalization for future test data. In other words, SVM methodology may enable good generalization with sparse high-dimensional data. Let us consider standard (binary) classification formulation under the general setting for predictive learning (Vapnik 1995). The set of approximating functions $f(\mathbf{x}, \mathbf{w})$, $\mathbf{w} \in \Omega$ is a set of indicator functions (e.g., $f(\mathbf{x}) = \text{sign}(g(\mathbf{x}))$, where $g(\mathbf{x})$ is a decision function. For given data set, SVM approach considers an *optimal* separating hyperplane, for which the *margin* (the distance between the closest data points to the hyperplane) is maximized. SVM implements structural risk minimization inductive principle by keeping the value of empirical risk fixed (i.e., zero for separable case) and minimizing the confidence interval (by maximizing the margin). The maximization of margin is equivalent to the minimization of $\|\mathbf{w}\|$. The notion of margin can be also extended to the linearly non-separable case, by introducing nonnegative slack variables $\xi_i \geq 0$, as shown in Figure 2.8. In this formulation, called "soft margin" SVM classifier, the goal is to minimize the following functional:

$$\text{minimize} \quad \frac{1}{2} \|\mathbf{w}\|^2 + C \sum_{i=1}^{n} \xi_i$$

$$\text{subject to} \quad y_i (\mathbf{w} \cdot \mathbf{x}_i + b) \geq 1 - \xi_i, \quad i = 1, \ldots, n$$

(2.33)

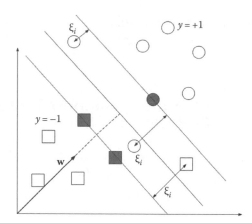

Figure 2.8 Binary classification problem, where "O" denotes samples from one class, and "□" denote samples from another class. The margin is the distance between the closest data points to the hyperplane. Slack variables ξ_i correspond to the deviation from the margin borders.

Regularization parameter C is a constant determining the trade-off between two conflicting goals: minimizing the training error, and maximizing the margin. Parameter C controls the margin, that is, larger C value result in SVM models with a smaller margin.

The second popular classifier is the AdaBoost classifier (Freund and Schapire 1996, Viola and Jones 2001). One cascade-structured classifier consists of a series of classifiers, called *layers*. Only when an input sample is accepted by one layer as an object, is it sent to the next layer for further processing. In the work of Viola and Jones (2001), each layer of the cascade is trained by a learning algorithm called AdaBoost (Freund and Schapire 1996). The input of the AdaBoost algorithm consists of a labeled training sample set and a weak learning algorithm, called *weak learner*. The output of AdaBoost is an ensemble classifier that is a combination of several weak classifiers from the weak learner. The performance of the ensemble classifier is expected to be better than any single weak classifier. The AdaBoost algorithm is an iterative procedure. At the beginning, the ensemble classifier is empty, and all training samples are given an equal weight (a uniform distribution). At each round, the weak learner is called to learn one weak classifier based on the current weight distribution. The newly learned weak classifier is added to the current ensemble classifier with a voting weight, which is computed based on the new weak

classifier's accuracy. Higher accuracy results in higher weight. After the new weak classifier is added, the sample weights are modified according to the current classification results. If one sample is classified correctly by the new weak classifier, its weight will be decreased; otherwise increased. The weight modification strategy is essential for the AdaBoost algorithm. It makes the learning procedure focus on the difficult part of the sample space. When the weak learning algorithm is based on a subset of features in a large feature space, the AdaBoost algorithm can also work as a good feature selector. For the recent development for the cascade classifier, interested reader can refer Zhang and Viola (2007).

2.5 SUMMARY

This chapter provides a brief review in four areas: image and video processing, multiple view geometry, probabilistic inference, and pattern recognition and machine learning. Nowadays, these technologies serve as theoretical fundamentals of intelligent video surveillance and are extensively referred to in this book. For example, image and video processing allows for low level processing in Chapters 4, 5, 14, and 17. Multiple view geometry is helpful to the readers to grasp ideas in Chapters 10 through 12, 16, and 17. Applications of probabilistic inference can be found in Chapters 5, 6, 9, 16, and 17 in the area of tracking and activity recognition. Chapters 4, 5, 7, 8, 13, and 15 make extensive use of pattern recognition and machine learning techniques. We recommend readers of this book to have a clear understanding of materials in this chapter before going into technical details of the following chapters.

REFERENCES

Anderson, B. and J. Moore. 1979. *Optimal Filtering.* Prentice Hall, New York.

Bishop, C. 2006. *Pattern Recognition and Machine Learning.* Springer, New York.

Canny, J. 1986. A computational approach to edge detection. *IEEE Transactions on Pattern Analysis and Machine Intelligence,* 8(6): 679–698.

Cherkassky, V. and F. Mulier, 2007. *Learning from Data: Concepts, Theory, and Methods,* 2nd ed. John Wiley & Sons, New York.

Dempster, A. P., N. M. Laird, and D. B. Rubin. 1977. Maximum likelihood from incomplete data via the EM algorithm. *Journal of the Royal Statistical Society, Series B,* 39(1): 1–38.

Freund, Y. and R. E. Schapire. 1996. Experiments with a new boosting algorithm. *Proceedings of the 13th International Conference on Machine Learning*, Bari, Italy, pp. 148–156.

Gilks, W. R., S. Richardson, and D. J. Spiegelhalter. 1996. *Markov Chain Monte Carlo in Practice*. Chapman & Hall/CRC, Boca Raton, FL.

Greenspan, H., J. Goldberger, and L. Ridel. 2001. A continuous probabilistic framework for image matching. *Computer Vision and Image Understanding*, 84(3): 384–406.

Harris, C. and M. Stephens. 1988. A combined corner and edge detector. *Proceedings of the 4th Alvey Vision Conference*, Manchester, U.K., pp. 147–151.

Hartley, R. 1997. In defense of the eight-point algorithm. *IEEE Transactions on Pattern Analysis and Machine Intelligence*, 19(6): 580–593.

Hartley, R. and A. Zisserman. 2004. *Multiple View Geometry in Computer Vision*, 2nd ed. Cambridge University Press, Cambridge, U.K.

Isard, M. and A. Blake. 1998. Condensation—Conditional density propagation for visual tracking. *International Journal of Computer Vision*, 29(1): 5–28.

Jordan, M. and Y. Weiss. 2002. Graphical models: Probabilistic inference. *The Handbook of Brain Theory and Neural Network*, 2nd ed. MIT Press, Cambridge, MA, pp. 243–266.

Julier, S., J. Uhlmann, and H. F. Durrant-Whyte. 2000. A new method for the nonlinear transformation of means and covariances in filters and estimators. *IEEE Transactions on Automatic Control*, 45(3): 477–482.

Kalman, R. E. 1963. New methods in Wiener filtering theory. *Proceedings of the 1st Symposium on Engineering Applications of Random Function Theory and Probability*, J. L. Bogdanoff and F. Kozin, eds. Wiley, New York, pp. 270–388.

Lowe, D. 2004. Distinctive image features from scale-invariant keypoints. *International Journal of Computer Vision*, 60(2): 91–110.

Tuytelaars, T. and K. Mikolajczyk. 2008. Local invariant feature detectors: a survey. *Foundation and Trends in Computer Graphics and Vision*, 3(3): 177–280.

MacKay, D. 2003. *Information Theory, Inference, and Learning Algorithms*. Cambridge University Press, Cambridge, U.K.

Shi, J. and C. Tomasi. 1994. Good features to track. *IEEE Conference on Computer Vision and Pattern Recognition*, Seattle, WA, pp. 593–600.

Vapnik, V. 1995. *The Nature of Statistical Learning Theory*. Springer, New York.

Viola, P. and M. Jones. 2001. Rapid object detection using a boosted cascade of simple features. *IEEE Computer Vision and Pattern Recognition*, 1, 511–518.

Zhang, C. and P. Viola. 2007. Multiple-instance pruning for learning efficient cascade detectors. *Neural Information Processing System Conference*, Vancouver, Canada.

3

Case Study: IBM Smart Surveillance System

**Rogerio S. Feris, Arun Hampapur, Yun Zhai,
Russell Bobbitt, Lisa Brown, Daniel A. Vaquero,
Ying-li Tian, Haowei Liu, and Ming-Ting Sun**

CONTENTS

Urban environments present unique challenges from the perspective of surveillance and security. High volumes of activity data, different weather conditions, crowded scenes, widespread geographical areas, and many other factors pose serious problems to traditional video analytics algorithms and opens up opportunities for novel applications. In this chapter, we present the IBM Smart Surveillance System (IBM SSS), including our latest computer vision algorithms for automatic event detection in urban surveillance scenarios. We cover standard video analysis methods based on tracking and also present non-tracking-based analytics specifically designed to handle crowded environments. Large-scale data indexing methods and scalability issues are also covered. Our experimental results are reported on various datasets and real-world deployments.

3.1 INTRODUCTION

Security incidents in urban environments span a wide range, starting from property crimes to violent crimes and terrorist events. Many large urban centers are currently in the process of developing security infrastructures geared mainly to counter terrorism with secondary applications for police and emergency management purposes.

Applying video analytics in urban scenarios involves many challenges. Urban surveillance systems generally encompass a large number of cameras spanning different geographical areas and capturing hundreds of millions of events per day. Storing and enabling search for events in these large-scale settings is a difficult task. In addition, video analytics algorithms need to be robust to many typical urban environment conditions, such as weather changes (e.g., rain, snow, and strong shadow effects), day/night times, and crowded scenes. The need to minimize cost by maximizing the number of video feeds per machine also imposes critical constraints in the time and memory complexity of the algorithms.

In this chapter, as part of the IBM SSS, we present our latest video analytics methods for monitoring urban environments. We also analyze scalability factors and large-scale indexing for event search. Next, we describe the main architecture of IBM SSS and give an overview of the main sections of this chapter.

3.1.1 IBM Smart Surveillance System Architecture

Figure 3.1 shows the architecture of the IBM Smart Surveillance Solution. IBM SSS is designed to work with a number of video management systems from partner companies. The video analytics technology within the SSS provides two distinct functionalities:

- *Real-time user-defined alerts:* The user defines the criteria for alerting with reference to a specific camera view, for example, parked car detection, tripwire, etc. (see Section 3.3).
- *Indexed event search:* The system automatically generates descriptions of events that occur in the scene and stores them in an indexed database to allow the user to perform rapid search (see Section 3.4).

The video analytics–based index refers to specific clips of video that are stored in the video management system. The SSS has video analysis engines called SSEs (smart surveillance engines), which host a number

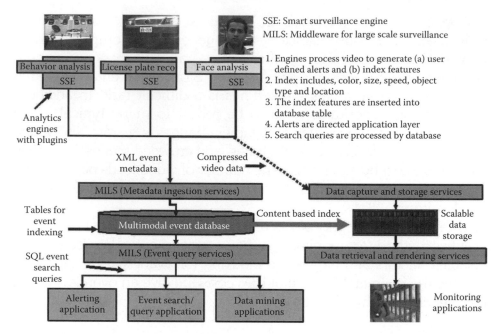

Figure 3.1 (See color insert following page 332.) IBM SSS architecture.

of video-processing algorithms. The SSEs generate metadata, which gets automatically uploaded into the backend database system through a Web-based service-oriented architecture. The application layer of SSS combines the metadata from the database with video from the video management system, to provide the user with a seamless view of the environment of interest. Details of IBM SSS can be found in several previous publications (Shu et al. 2005).

3.1.2 Chapter Overview

This chapter is organized as follows. In Section 3.2, we describe our video analytics modules for urban surveillance, including moving object detection, tracking, object classification, two approaches for color retrieval targeting low- and high-activity-level scenarios, and a people search method based on fine-grained human parts and attributes. In Section 3.3, we present a set of real-time alerts that work well

in crowded scenes, including parked car detection and non-tracking-based virtual boundary crossing. Finally, we cover our database design for large-scale searching of video in Section 3.4 and analyze practical challenges with respect to scalability issues in Section 3.5.

3.2 VIDEO ANALYTICS FOR URBAN SURVEILLANCE

3.2.1 Moving Object Detection

Background subtraction (BGS) is a conventional and effective approach to detect moving objects in videos captured by fixed cameras. In urban environments, more sophisticated background modeling algorithms are required to handle snow, rain, shadows, reflections, quick lighting changes, day and night transitions, slow-moving objects, and other difficult conditions that naturally arise in city surveillance scenarios.

In order to address these issues, we use an adaptive BGS technique similar to the method proposed by Stauffer and Grimson (1999), which relies on a Gaussian mixture model for each pixel in the scene. In this way, multimodal backgrounds can be described by the pixel-wise mixture models. For instance, during snow conditions, a particular background pixel may be represented by two Gaussian encodings, for example, the mode "road" and another mode "snow," respectively, so that only objects of interest are detected.

In contrast to Stauffer and Grimson (1999), our method is improved to remove shadows and to enable the algorithm to work for quick lighting changes by combining the intensity and texture information of the foreground pixels. In addition, the foreground regions are classified as moving objects, abandoned objects, or removed objects without using any tracking or motion information (see Tian et al. (2005) for details). This capability not only can avoid a common problem in BGS—fragmentation (one object is partitioned into multiple parts)—but also allows real-time alert detection such as abandoned and removed object detection alerts (see more details in Section 3.3.1).

3.2.2 Object Tracking

After a number of moving objects are detected by our BGS algorithm, we track them along the video sequence so that each object is given a unique identification number. This is a prerequisite for other higher level modules, such as object and color classification, and several real-time alerts. As we will show later, in crowded urban environments, tracking turns out to be a very difficult and computationally expensive task, so it can be intentionally disabled at specific hours of the day when the activity level is high. In these cases, analytics that do not rely on tracking are enabled (see, e.g., Sections 3.2.4.3 and 3.3.2).

The first step of our tracking method consists of simple association of foreground blobs across the temporal domain. In each frame, we create a list of the foreground blobs found by the BGS algorithm. From preceding frames, we have a list of recent tracks of objects, together with their bounding boxes. Each foreground blob in the current frame is then matched against all existing object tracks based on the distance and areas of the corresponding bounding boxes, so that tracks can be updated, created, or deleted.

In a simple scene, with well-separated tracks, the association gives a one-to-one mapping between tracks and the foreground regions in the current frame, except when tracks are created or deleted. In more complex scenes, however, we may have situations where a single track is associated with more than one foreground blob (object split), or the opposite—several tracks can be associated with a single foreground region (object merge). In addition, when one object passes in front of another, partial or total occlusion takes place, with BGS detecting a single moving region. The tracking method should be able to segment this region, label each part appropriately, and label the detected objects when they separate.

We resolve these issues using an *online appearance model* that consists of a 2D array of color values with an associated probability mask, as described in Senior et al. (2006). This appearance model is used to resolve object splits and merges, handle occlusions, and provide depth ordering. We refer the reader to Senior et al. (2006) for more details and performance evaluation.

3.2.3 Object Classification with Calibration

Classifying objects in urban surveillance scenes is an important task that allows searches and alerts based on object type. In this section, we address a simplified two-class object recognition problem: Given a moving object in the scene, our goal is to classify the object into either a person (including groups of people) or a vehicle. This is a very important problem in city surveillance, as many existing cameras are pointing to areas where the majority of moving objects are either humans or vehicles. The classification problem is very challenging as we desire to satisfy the following requirements:

- Real-time processing and low memory consumption
- The system should work for arbitrary camera views
- Correct discrimination under different illumination conditions and shadow effects
- Able to distinguish similar objects (such as vehicles and groups of people)

Our approach to address these issues consists of three elements: (1) an interactive interface to set regions of interest (ROIs) and correct for perspective distortions; (2) discriminative features, including a novel effective measurement based on differences of histograms of oriented gradients (DHOGs); and (3) estimation and adaptation based on a probabilistic framework for feature fusion. We briefly describe these modules in the following text.

3.2.3.1 Interactive Interface for Calibration

In many situations, objects of one class are more likely to appear in certain regions in the camera view. For instance, in the city street environment, people usually walk along the sidewalk, while on the other hand vehicles mainly run in the middle of the road. This is a strong cue in the object classification process. In our system, we classify tracked objects into two classes, people and vehicles, and users can specify the ROIs of each object class in the camera view through our calibration tool. In this interactive calibration tool, one or multiple ROIs for the target class

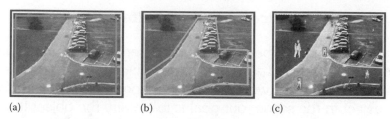

(a) (b) (c)

Figure 3.2 Calibration tool interface: (a) ROI for people—entire camera view, (b) ROI for vehicles—driveways, and (c) person-sized models specified by the user. In (c), the user can create, move, and resize a target size sample (the largest box in the figure).

can be created, modified, and deleted as needed. Screenshots of the interface are shown in Figure 3.2a and b. Note that this information is just used as a prior for the location feature. The final class estimation is based on probabilistic fusion of multiple features, as we will describe later.

Another purpose of our calibration tool is to correct for perspective distortions by specifying different sizes in different locations of the camera field of view (FOV). A continuous, interpolated size map is then created from the sample sizes specified by the user. Since we use view-dependent features such as object size and velocity, among others, for classification, the use of this information in our system allows it to normalize these features and thus work for arbitrary camera viewpoints, while significantly improving the accuracy of classification. Figure 3.2c shows our interface.

3.2.3.2 Feature Extraction

Given the limited computational resources and the real-time requirement in practical video surveillance applications, the features used for object classification must be low cost and efficient for computation. In our framework, we have used four object features: object size, velocity direction, object location, and DHOGs.

The purpose of using *object size* is that size information is the most distinctive feature to distinguish single persons from vehicles

since persons possess much smaller shapes than vehicles at the same location in the FOV. The size of an object at a specific frame is computed as the area of the corresponding foreground blob and then normalized by the size obtained from the interpolated size map (Section 3.2.3.1) at the same position.

In many scenarios, *velocity direction* of moving objects can be a distinctive feature. For instance, at a street intersection, pedestrians typically walk along the zebra crossings that are perpendicular to vehicle movements. We equally discretize the velocity direction measurement into 20 bins and normalize it in a similar way to the object size feature.

There is an additional straightforward yet very informative feature: the *location* of the moving object. The location feature relates to the context of the environment, and its usage is applied through the settings of ROIs specified by our calibration tool. This is a strong cue for identifying people in views such as roads and building entrances where vehicles seldom appear.

Lastly, we have developed a novel view-independent feature— DHOGs. Given an input video image with a foreground blob mask generated by the BGS module, the histogram of oriented gradients (HOG) is computed. It is well known that the HOG is robust to lighting condition changes in the scene. The HOG of the foreground object is computed at every frame in the track, and the DHOG is calculated in terms of the difference between HOGs obtained in consecutive frames in terms of histogram intersection. The DHOG models the intra-object deformation in the temporal domain. Thus, it is invariant to different camera views. In general, vehicles produce smaller DHOG than people since vehicles are more rigid when in motion. This feature is useful to distinguish large groups of people from vehicles, in which case they have similar shapes and sizes. Examples are shown in Figure 3.3 to demonstrate the effectiveness of using DHOG to distinguish vehicles from people (both single persons and groups of people). DHOG features have similar motivation as the recurrent motion image method (Javed and Shah 2002), but offer advantages as no precise object alignment is required.

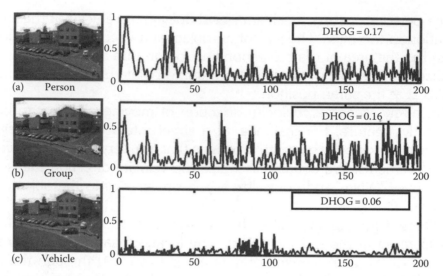

Figure 3.3 DHOG plots for three types of objects: (a) person, (b) group of people, and (c) vehicle. Horizontal axis represents the track length of the samples, and vertical axis represents the DHOG values. Note that the overall DHOG values for person and group of people are much higher than the one for vehicle, and thus, it is a very discriminative feature to separate people from vehicles.

3.2.3.3 Estimation and Adaptation

We pose the moving object classification task as a maximum a posteriori (MAP) problem. The classification is performed by analyzing the features of the entire object track, that is, the classification decision is made after the tracking is finished. We refer the reader to Chen et al. (2008) for a detailed explanation of our MAP inference and probabilistic feature fusion. In that work, we also provide details about our model adaptation mechanism, which makes use of high confidence predictions to update our probabilistic model in an online fashion.

3.2.3.4 Results

To demonstrate the effectiveness of our proposed object classification framework in far-field urban scenarios, we have tested our system on a variety of video data, including different scenes and

different views of the same scene. There are two urban datasets used in our experiments. The first set is the PETS 2001 dataset. The second dataset is a collection of videos obtained from different sources, ranging from 15 min to 7 h long.

Figure 3.4 presents the object classification results on both testing datasets and shows a few key frames of testing videos. The overall classification accuracy is 97.7% for over 1100 moving objects. Currently, our framework assumes tracking results are perfect before performing object classification. Thus, if the BGS and/or tracking module fail to produce reliable results, the object classifier will also fail due to incorrect input data. This is the main reason for the lower performance on the sequences "PETS D3TeC1" and "PETS D3TeC2."

3.2.3.5 Discussion

Similar to far-field object classification approaches such as Bose and Grimson (2004) and Brown (2004), our method relies on BGS and

Videos	Ground Truth		People Detection		Vehicle Detection	
	People	*Vehicles*	*True Positives*	*False Positives*	*True Positives*	*False Positives*
PETS D1TeC1	6	2	6	0	2	0
PETS D1TeC2	5	1	5	0	1	0
PETS D2TeC1	6	3	6	0	3	0
PETS D2TeC2	7	2	6	0	2	1
PETS D3TeC1	16	0	10	0	0	6
PETS D3TeC2	13	0	6	0	0	7
Sequence HW1	16	82	14	1	81	2
Sequence HW2	67	22	66	0	22	1
Traffic complex	125	696	121	0	696	4
Traffic video D	44	46	40	1	45	4
Shadow	3	1	3	0	1	0

Figure 3.4 (See color insert following page 332.) Results for our object classification approach and some testing video frames.

object tracking to perform object classification. This works reasonably well in urban scenes with low or medium activity. However, crowded scenarios pose serious problems for our approach as many objects can be merged together in a single foreground blob, causing features like object size to be unreliably estimated from BGS. An alternative solution to this problem is to use appearance-based detectors such as those proposed by Dalal and Triggs (2005) or Viola and Jones (2001). The disadvantage of these approaches is that they often require large amounts of data to learn a robust classifier and suffer from object pose variability.

3.2.4 Color Classification

In this section, we describe our method to retrieve objects of specified colors. We start with our color quantization algorithm that operates on a frame by frame level. Then, we describe our algorithm for color classification that is built on top of the tracking module, thus providing a specific color for each object track in the scene. Finally, we show a method that enables color search without relying on tracking, which is appropriate for crowded urban environments where tracking is not reliable.

3.2.4.1 Bi-Conic Color Quantization

In our system, color information is quantized into six colors: black, white, red, blue, green, and yellow. For each video frame, we first convert the 24 bit RGB pixels to the bi-conic hue, saturation, lightness (HSL) space. This color space is used because Euclidean distances in this space closely map to human perception color differences. Figure 3.5 shows an illustration of the HSL space—the vertical axis represents "lightness"; this ranges from white (full brightness) to black. Hues are represented at different angles and color saturation increases radially.

In order to quantize this space into a small number of colors, we determine the angular cutoffs between colors. Since we use six colors (black, white, yellow, green, blue, and red), we need only four cutoffs between the hues: yellow/green, green/blue, blue/red, and red/yellow. Empirically, we determined the following effective cutoffs: 60°, 150°, 225°, and −15°, which worked for most outdoor urban scenes.

Figure 3.5 (See color insert following page 332.) HSL color space showing saturation/lightness curves and threshold points.

Since the time of day and weather conditions affect the brightness and corresponding color saturation, we also need to specify lightness and saturation cutoffs. It is interesting to note, here, that saturation and intensity are related. Both properties can make the hue of a pixel indiscernible. For intensity, this occurs when the light is too bright or too dark. For saturation, it happens when there is insufficient saturation. However, as the brightness (we refer to the intensity as the "lightness" or "brightness" interchangeably) gets too low or too high, the necessary saturation increases. In general, as intensity increases from zero up to halfway (the central horizontal cross section of the bi-conic) or decreases from the maximum (white) down to halfway, the range of pixels with visible or discernable hue increases.

This is shown by the 2D intensity/saturation curves in Figure 3.5. These 2D curves represent 3D curves, which are circularly symmetric since they are independent of hue. Because of this symmetry and the coarse quantization needed, these curves can be represented by a small number of 2D (lightness and saturation) points that are marked on the curve. Above the horizontal plane (i.e., for sufficient lightness), points whose intensity and saturation lie outside the curve are considered white. Below the horizontal plane, they are considered black.

In summary, we first quantize HSL space based on hue. We subsequently relabel pixels either white or black depending on whether they lie outside the lightness/saturation curve above or below the horizontal mid-plane. This is related to earlier work in color segmentation performed by Tseng and Chang (1994).

3.2.4.2 Tracking-Based Color Retrieval

Each moving object is tracked as it moves across the scene. The object is first detected by BGS and tracked using an appearance-based tracker, as described previously. For each track, the color classifier creates an accumulated histogram of the six quantized colors and then selects the dominant color of the object, that is, the color with the largest number of votes in the histogram. Because of the computational cost, we do not consider every frame of the tracked object. The system is performing real-time BGS and tracking as well as other high-level analysis such as object classification and alert notification; consequently, it is important to conserve resources and computational cost. Instead, the classifier subsamples the frames of the object track in real time. Since we do not know ahead of time how long the track will be, the classifier initially acquires color information frequently and gradually decreases this frequency as the track's life continues. In this way, we ensure that there are sufficient samples for short tracks, and periodically update the samples so that a spread of data throughout the track life of the track is considered for longer tracks.

We ran tests of the color classifier for tracked objects on two datasets with low or medium activity. The first video is a 12 min scene of 194 vehicles driving along in one direction on a two-lane highway. The second scene is from a live video from a parking lot. In this scene, we captured 72 vehicles driving by. Note that in these scenes, object tracking was feasible although the actual segmentation of the vehicle from the background did include significant portions of the road. Figure 3.6 shows results for these two datasets and Figure 3.7 shows sample key frames. The results are pretty good, but there is still some confusion between black and white on the second test data. We believe this is due to the variable amount of road (that appeared white) that was present in the tracked objects.

3.2.4.3 Non-Tracking-Based Color Retrieval

In order to handle high-activity scenes, which are typical in certain hours of the day in urban scenarios, our system also has the capability to perform color retrieval without object tracking. Our method relies

	True Positives	False Positives	Bad Segments
Red	11	0	0
Yellow	2	0	0
Green	4	0	0
Blue	0	0	0
White	83	0	3
Black	94	0	2
Total	194	0	5
Percent	**100%**	**0%**	

(a)

	True Positives	False Positives	Bad Segments
Red	4	0	0
Yellow	0	0	0
Green	1	0	0
Blue	4	0	0
White	24	4	1
Black	29	6	2
Total	62	10	3
Percent	**86%**	**14%**	

(b)

Figure 3.6 Results of tracking-based color classification on low/medium activity scenes. (a) Highway test set. (b) Parking lot test set.

(a) (b)

Figure 3.7 (a) Parking lot sample frame with tracking information superimposed. (b) Sample key frame of the highway scene.

on color segmentation inside the foreground objects detected using BGS. The system uses a time interval, typically 2 or 3 s, and a size threshold per color, set by the user.

For each foreground object, we quantize the colors, as described in Section 3.2.4.1, and perform segmentation using connected component analysis for each color. In each time interval (say, 3 s), we detect, for each color, if a connected component of that color is found that is bigger than the predefined size threshold. If such a component is found, we store the largest component for that color in the time interval as the key frame for color retrieval.

We tested our method in a crowded street intersection, as shown in Figure 3.8a. As it is difficult to obtain ground truth data for these

(a) (b)

Figure 3.8 (a) Crowded scene. (b) Examples of non-tracker-based color retrieval, where bag parts and hats with specific colors can be found by the user.

scenes, we only compute the precision for our method. We obtained 78% accuracy with few false alarms, mostly due to slow-moving objects, which generate multiple events, since tracking is not applied. Note that the method described in Section 3.2.4.2 is not suitable for this crowded scenario, due to unreliable tracking. Another advantage of our non-tracking-based color retrieval is the capability of finding colored parts of objects, such as hats and bag parts, as shown in Figure 3.8b.

3.2.5 Face Capture and Human Parsing

In urban environments, there are several scenarios in which it is desirable to monitor people's activities. Applications such as finding suspects or locating missing people involve searching through large amounts of video and looking for events where people are present. This process can be tedious, resource consuming, and prone to error, incurring high costs of hiring security personnel. In a previous work (Feris et al. 2007), we described our face capture system that automatically detects the presence of people in surveillance scenes by using a face detector. The system is suitable for environments where there is enough resolution to detect faces in images. Examples include cameras placed at ATM cabins or entrances of buildings.

The face capture system greatly reduces the search time by enabling the user to browse only the video segments that contain faces; however, finding a specific person among the extracted video clips can still be time consuming, especially in high traffic environments. Research on finding people in videos has been focused on approaches based on face recognition (Sivic et al. 2005), which is still a very challenging problem,

especially in low-resolution images with variations in pose and lighting. State-of-the-art face recognition systems (http://www.frvt.org/) require a fair amount of resolution in order to produce reliable results, but in many cases this level of detail is not available in surveillance applications.

As a solution to overcome these difficulties, we have developed an approach for people search based on fine-grained personal attributes such as facial hair type, eyewear type, hair type, presence of hats, and clothing color. We leverage the power of machine learning techniques (Viola and Jones 2001) by designing attribute detectors from large sets of training images. Our technique enables queries such as "show me the people who entered the IBM Hawthorne building last Saturday wearing a hat, sunglasses, a blue jacket, and black pants," and is based on parsing the human body in order to locate regions from which attributes are extracted. Our approach is described in detail in Chapter 14 of this book.

3.3 REAL-TIME ALERTS

In this section, we describe a set of real-time alerts provided by our system, which are useful to detect potential threats in urban environments. Later, in Section 3.4, we describe another mode of operation—indexing and search—that allows the user to find after-the-fact events for forensics.

3.3.1 Parked Car Detection

Automatically detecting parked cars in urban scenarios can help security guards to quickly identify illegal parking, stopped vehicles in a freeway, or suspicious cars parked in front of security buildings at certain times. We developed a robust parked car detection system, which is currently running in the city of Chicago, using various video cameras capturing images under a wide variety of conditions, including rain, day/night scenarios, etc. Our approach is similar to the technique presented in Tian et al. (2008), but has novel aspects, which substantially reduce the rate of false alarms, as we will see next.

We use the background modeling algorithm described in Section 3.2.1 to detect foreground blobs in the scene. We also detect when

these foreground blobs are static for a period of time, since our goal is to detect stopped vehicles. An important observation is that static foreground blobs may arise in the scene due to abandoned objects (e.g., parked cars) or due to removed objects (e.g., a car leaving a parking lot). As described in Tian et al. (2008), we provide a method to classify whether a static foreground region is abandoned or removed by exploiting context information about the static foreground regions. In case the region is classified as abandoned object, then a set of user-defined requirements is verified (e.g., minimum blob size and ROI) and a template-matching process is started to confirm that the object is parked for a user-defined period of time. If these conditions are satisfied, a parked car detection alert is triggered.

The method described above (Tian et al. 2008) is enhanced in two novel ways. First, we use a naïve tracking algorithm (only across a user-defined alert ROI) to improve the classification of whether an object is abandoned or removed, for example, by looking at direction of movement and object speed as features. The second improvement addresses nighttime conditions where the template-matching process can fail due to low-contrast images. Note that this matching scheme is designed to verify whether the vehicle is parked for the minimum time specified by the user. In many nighttime cases, the car leaves the scene before this specified time, but the matcher still reports the car is there due to low contrast. To handle this problem, we verify whether we have removed object notifications during the matching step, and, if so, we remove the candidate parked car alert.

Our approach substantially reduces the number of false alarms in challenging conditions, involving high volumes of data and weather changes, while keeping high detection rates. We tested our system in 53 h of data split into five different videos. Figure 3.9 shows our results, comparing with the method presented in Tian et al. (2008). We are not allowed to show sample key frames of our test data due to customer-related agreements.

3.3.2 Virtual Boundary Crossing

Virtual boundaries (often referred as tripwires) are defined as continuous lines or curves drawn in the image space to capture directional

	Video 1		Video 2		Video 3		Video 4		Video 5		Total	
	Tian et al.(2008)	Our method	Tian et al.(2008)	Our method	Tian et al.(2008)	Our method	Tian et al.(2008)	Our method	Tian et al.(2008)	Our method	Tian et al.(2008)	Our method
TP	5	5	13	12	10	8	16	16	22	20	66	61
FP	5	3	10	3	16	0	8	5	14	5	53	16
FN	1	1	1	2	0	2	8	8	5	7	15	20
Detect rate	0.83	0.83	0.93	0.86	1	0.8	0.66	0.66	0.81	0.74	0.81	0.75
FP/h	0.47	0.28	0.90	0.27	1.5	0	0.76	0.47	1.33	0.38	1	0.3

Figure 3.9 Parked car detection evaluation in the city of Chicago, using 53 h of video data captured under challenging conditions (day, night, rain, etc.).

crossings of target objects. Due to their intuitive concepts and reliable performance under well-controlled conditions, they are widely used in many surveillance applications, such as detecting illegal entries in border security and display effectiveness estimation in the retail sector.

In urban surveillance, we mainly utilize the tripwires for vehicle counting, wrong-way traffic detection, building perimeter protection, etc. Different attribute-based filters can be applied to the tripwire definition to constrain the search range. For instance, the object size range specifies the type of objects to be counted, that is, single persons have much smaller sizes than vehicles, and vehicles like buses and 18-wheeler trucks are much larger than regular personal vehicles. Other types of features are also deployed, including object type (person/vehicle), object color, and minimum and maximum object speeds. The tripwire is configured as an alert feature in the IBM Smart Surveillance Solution, and a graphical user interface for setting up the tripwire alert is shown in Figure 3.10.

In heavy traffic situations, vehicles are often occluded from each other and also piled up together if a traffic light is present or congestion occurs. In this case, reliable object detection and tracking are very difficult to achieve. Consequently, the tripwire crossing detections that are based on tracking results are erroneous and barely meaningful. To overcome this shortcoming, particularly in the urban surveillance applications, we developed a new type of tripwire, called appearance-based tripwire (ABT), to replace the conventional tracker-

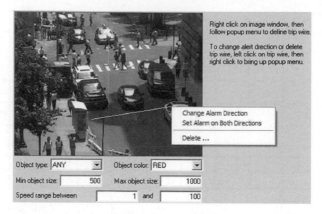

Figure 3.10 Graphical user interface of IBM SSS tripwire alert.

based tripwires. The ABT does not rely on the explicit object tracking output. Instead of considering object trajectories in the entire camera FOV, the ABT reduces its focus of analysis to the surrounding area of the tripwire. This significantly eliminates the interference of the noisy data in the tripwire crossing detection inference. In the ABT, a set of *ground patches* are sampled around the tripwire's envelope, which covers a spatial extension of the tripwire (a graphical illustration is shown in Figure 3.11).

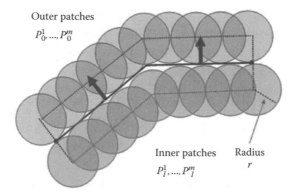

Figure 3.11 (See color insert following page 332.) A graphical illustration of the ABT. Ground patches are generated to model the appearance and motion patterns of the tripwire region.

Appearance and motion direction features are extracted from each patch region over a history of time. Patches on the opposite sides of the tripwire are compared against each other. Tripwire crossings are detected by analyzing the patch matching candidates with spatiotemporal constraints. The ABT is compared with the conventional tracking-based tripwire in both low-traffic and crowded scenes. In low-traffic scenes, the object detection module is able to achieve good spatiotemporal segmentation of objects. Thus, both tripwire types have similar high accuracy of more than 90% at the equal error rate. The superior performance of ABT is demonstrated in crowded scenes where tracking does not work well. Based on a comparison set for vehicle counting tasks, the proposed ABT presents its ability to capture over 20% more vehicles than tracking-based tripwires, in average. Therefore, the ABT can be a replacement for the conventional tripwire in high-activity scenarios, maintaining the system's performance.

3.3.3 Motion and Region Alerts

Motion detection and region alerts are two other important features offered by the IBM Smart Surveillance Solution. Motion detection alerts are triggered when the target ROI possesses a sufficient amount of motion energy that lasts within the desired temporal interval. Applications of this feature include loitering detection, ROI occupancy estimation, and object access detection. In urban scenes, it could be used as a simplified version of the abandoned object alert, where the parked vehicles are detected by specifying an ROI around the parking area. One thing to note is that motion detection alerts consider the global motion energy of the ROI without distinction of individual objects.

The region alert, on the other hand, provides a set of different functionalities that are based on the object tracking output. An ROI is configured to represent the target region. Different rules can be specified to capture the region alert, such as object initiated inside/outside the region, object passing through the region, object entering the region from outside, or object is ever being inside of the region. The location relativity can be inferred by different parts of the object, including

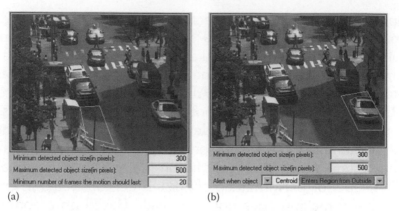

(a) (b)

Figure 3.12 User interfaces for configuring (a) motion detection and (b) region alerts.

the object's head (topmost point), centroid, foot part (lowest point), and whole (entirety of the object). In addition, a sizing threshold can be applied to the target objects in order to trigger alerts. Figure 3.12 shows the graphical user interfaces for configuring the motion detection and region access alerts.

3.3.4 Composite Alert Detection

The above-mentioned alerts (referred to as primitive alerts) are generated based on the visual analysis of single camera views. Given the rapid improvement of digital video technologies, large-scale surveillance networks are becoming more practical and affordable. With hundreds (or even thousands) of camera inputs, cross-camera analytics are attracting increasing attention. Due to the current development in this area and the complex settings of the scenes, direct operational multi-camera event modeling still remains a very challenging problem. In addition to this, a new trend in surveillance networks nowadays is the effective integration of non-video signals, such as combining speed detection radars with video capture from a nearby camera to determine a speeding violation. To address these problems, we have developed an open infrastructure to detect composite events with multiple cameras and auxiliary sensors.

The proposed framework combines the primitive alerts to formulate high-level composite events using logical operators with applicable spatiotemporal constraints. The primitives can occur on the same camera as well as being distributed among different machines in a network. Logically, composite events are formulated as multilevel full-binary trees, where the root node represents the target composite event, the leaf nodes represent the primitive events, and the middle nodes represent the rule operators that combine the primitives. Intuitively, rules are composed of binary operators with operands that could be either primitives and/or other rules. The multilevel and distributive design enables the extensibility and scalability of the proposed system.

In our system, we incorporate four different binary operators in the rules: AND, OR, FOLLOWED BY, and WITHOUT. Other binary operators can also be easily added to the system without significantly changing its basic infrastructure. Each rule also possesses a spatial and a temporal constraint to represent the physical occurrence locations and the occurrence temporal distance, respectively. A standardized XML event language is developed for the efficient storage and transmission of the composite event and its primitives.

3.4 SEARCHING SURVEILLANCE VIDEOS

In addition to providing real-time alerts, IBM SSS also allows the user to search for data based on attributes extracted from analytics modules such as object type (person and vehicle), color, size, speed, human body parts, and many others. These attributes are constantly ingested as XML metadata into a DB2 database as new events are detected. In this way, our system also allows composite search by combining different visual attributes or even nonvisual data captured from multiple data sources.

Figure 3.13 shows examples of composite search results. Note that simple attribute combinations can lead to very powerful retrieval of events. If we search by [object type=car, color=yellow, size>1500 pixels], we can find all DHL trucks in the scene. Searching by [object type=person, track duration>30 s], we can find people loitering in front of a building.

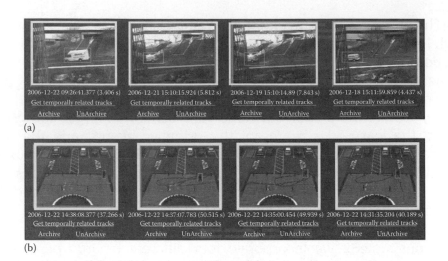

Figure 3.13 (See color insert following page 332.) Composite search in our system: (a) Finding DHL trucks based on object type, size, and color, and (b) finding people loitering based on object type and duration.

3.4.1 Large-Scale Data Indexing

A large urban surveillance system typically has the profile depicted in Figure 3.14. Hundreds of billions of events need to be archived per month, which is a very challenging task. Next, we describe our approach to handle high volumes of real-time transactions and how we minimize the transaction/inquiry response time.

3.4.1.1 Approach to High-Volume Scaling

Given the event volume in Figure 3.14, the data management layer (Web application server and database) is required to support an

Estimated events from vehicle traffic in a metro city	
Number of pole mounted street cameras in a large metro city	1,000–5,000
Number of events per camera. **Vehicle traffic only**	50,000/day/camera
Total number of events generated by the surveillance system/day	50 M–250 M
Number of events archived per month	**150 B–750 B**

Figure 3.14 Typical number of events in urban environments.

ingestion rate of millions of events per day. IBM SSS accomplishes this by using a combination of Web application server clustering and database partitioning. In a clustered implementation of the Web application server, a central node redirects traffic from cameras to secondary nodes to balance the load. As the number of cameras in the system increases, the system can be scaled by adding new Web application server nodes that run on independent hardware, thus allowing scaling. At a secondary level, a similar philosophy is used to scale the database server using database partitioning where a single logical view of the database is supported by multiple instances of the software running on independent servers.

3.4.1.2 Minimizing Transaction/Inquiry Response Time

Most transaction and inquiry response delays can be attributed to either a nonoptimized physical design or an insufficient disk storage layout for the data store. In a high-volume environment, the characteristics of the metadata are highly important when designing the appropriate table and indexing mix for a highly scalable solution. We use the 20/80 rule to optimize access to the 20% of the metadata that supports 80% of the customer queries.

It is also important to utilize a disk array, which has been configured to accommodate the amount of information that is being written from the data store. The following tasks need to be reviewed and implemented prior to installation: (1) hardware disk controller with an adequate amount of cache to easily handle the known transaction volume, (2) total size of the data store with respect to the number of physical disks in the storage array, (3) maximize the number of disk "spindles" to handle the current storage requirements, and (4) ability to add more storage space in the event that the number of cameras in scope increases.

In addition to using the above design principles, we leverage the hardware-driven scalability of the database platform (DB2). This approach has resulted in event indexing systems that can handle hundreds to thousands of cameras on high-activity urban environments.

3.5 PRACTICAL CHALLENGES: SCALABILITY ISSUES

As the need for intelligent video surveillance systems grows, with customers requiring analytics on hundreds or even thousands of cameras, scalability becomes more and more of a concern. Often, there are very strict space and cost constraints that limit the computing resources that can be deployed at a given site, so we must scale our algorithms accordingly.

We have found that the CPU consumption of our system is strongly related to the amount of activity that is taking place in the scene. We characterize activity level at a point in time as a function of the number of moving objects in the camera view and the foreground occupancy (the ratio of foreground area to background area). We provide rough definitions for three activity levels in terms of these metrics:

1. Low: Less than three moving objects AND/OR less than .05 foreground occupancy.
2. Medium: Between 3 and 10 moving objects AND/OR between .05 and .2 foreground occupancy.
3. High: Greater than 10 moving objects AND/OR greater than .2 foreground occupancy.

We purposely make the categories ambiguous in the definitions above to allow some flexibility for human judgment during the categorization process. For example, a scene may be considered to have a medium level of activity if there are three moving objects and .3 foreground occupancy by applying OR in the 2nd rule while applying AND in the 3rd rule.

In medium- and high-activity scenarios, the scene is often cluttered due to high traffic volume and crowds of people that cluster together. These situations not only create a challenging task for our object tracking, but also result in a larger computational burden. In Figure 3.15, total CPU usage is shown for 4, 8, 12, and 16 channels over a 45 min interval of a typical urban surveillance scene with activity levels that range from medium to high. The test was performed on Windows 2003 Server Service Pack 2 with Intel Xeon 2.33 GHz dual quad-core processor and 2 GB memory. Measurements were taken

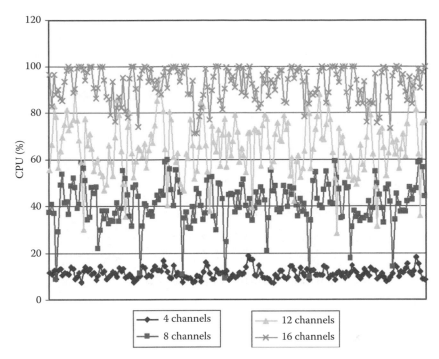

Figure 3.15 (See color insert following page 332.) CPU load according to the number of channels in a single IBM blade.

using Windows Performance Monitor at 15 s intervals. As can be seen, CPU usage steadily rises as more channels are added, with the CPU often saturated at 16 channels. We believe the relatively large variance observed with increased numbers of channels is related to higher cache fault and page fault rates.

When the CPU becomes saturated, we begin to experience more dropped frames and decoding errors. In Figure 3.16, we show CPU usage for all 16 channels on a similar scene with frame drop rates for three of these channels. Frame drop rate is defined as

$$\text{Frame drop rate} = 1 - \frac{\text{Actual frame rate}}{\text{Requested frame rate}}$$

In this experiment, we request 15 fps from the video decoder. We have found that we often begin to experience decreases in accuracy when

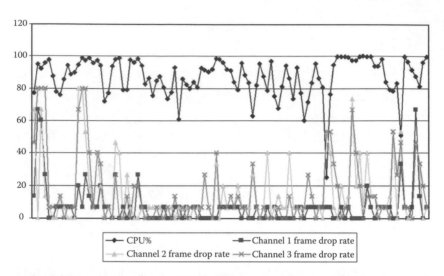

Figure 3.16 (See color insert following page 332.) CPU load according to
frame drop rate.

we fall below 10 fps, meaning that frame drop rates that are greater
than .33 may result in accuracy degradations.

3.6 SUMMARY

We have presented our video analytics algorithms specifically designed
to handle urban environments. Although we have already described
several computer vision modules that work well under high-activity-level
scenarios, our current work addresses a complete framework to maxi-
mize the efficiency and accuracy in low-activity and crowded scenes.

 The framework being developed has an activity-level predictor module
that can automatically switch the system to low- or high-activity modes.
In the low-activity mode, we use object tracking based on detected fore-
ground blobs by BGS, and higher level analytics built on top of track-
ing. In the high-activity mode, we use non-tracking-based analytics that
are more efficient and accurate in crowded scenes. Some of the non-
tracking-based modules have been described in this chapter, but we are
working on more algorithms such as appearance-based detectors for
object classification, motion flow analysis, and others.

3.7 BIBLIOGRAPHICAL AND HISTORICAL REMARKS

In this chapter, we covered a broad range of video analytics for urban surveillance, as part of the IBM SSS. Many other commercial systems for intelligent urban surveillance exist in the market. Examples include the systems of companies such as Siemens (http://www.siemens.com), ObjectVideo (http://www.objectvideo.com), and Honeywell (http://www.honeywell.com), to mention just a few. One of the key advantages of the IBM system is its ability to index and search large amounts of video data, leveraging IBM cutting-edge technology on data storage and retrieval.

Although the main focus of this chapter was on urban surveillance, intelligent video analytics can be applied to enhance security in many other areas. As an example, IBM has developed video analytics for retail stores with the goal of loss prevention (returns fraud and cashiers fraud), store operations (customer counting), and merchandising (display effectiveness). We refer the reader to Senior et al. (2007) and Fan et al. (2009) for more information. Other application areas include fraud detection in Casinos, monitoring airports, etc.

REFERENCES

Bose, B. and Grimson, E. 2004. Improving object classification in far-field video. *IEEE Conference on Computer Vision and Pattern Recognition (CVPR'04)*, Washington DC.

Brown, L. 2004. View-independent vehicle/person classification. *ACM International Workshop on Video Surveillance and Sensor Networks*, New York.

Chen, L., Feris, R., Zhai, Y., Brown, L., and Hampapur, A. 2008. An integrated system for moving object classification in surveillance videos. *IEEE International Conference on Advanced Video and Signal-Based Surveillance*, Santa Fe, NM.

Dalal, N. and Triggs, B. 2005. Histograms of oriented gradients for human detection. *IEEE Conference on Computer Vision and Pattern Recognition (CVPR'05)*, Washington, DC.

Fan, Q., Bobbitt, R., Zhai, Y., Yanagawa, A., and Pankanti, S. 2009. Recognition of repetitive sequential human activity. *IEEE Conference on Computer Vision and Pattern Recognition (CVPR'09)*, Miami, FL.

Feris, R., Tian, Y., and Hampapur, A. 2007. Capturing people in surveillance videos. *IEEE International Workshop on Visual Surveillance*, Minneapolis, MN.

Javed, O. and Shah, M. 2002. Tracking and object classification for automated surveillance. *European Conference on Computer Vision (ECCV'02)*, Copenhagen, Denmark.

Senior, A., Brown, L., Hampapur, A., Shu, C., Zhai, Y., Feris, R.S., Tian, Y., Borges, S., and Carlson, C. 2006. Appearance models for occlusion handling. *J. Image Vision Comput.*, 24(11), 1233–1243.

Senior, A. et al. 2007. Video analytics for retail: The IBM smart surveillance retail solution. *IEEE International Conference on Advanced Video and Signal-Based Surveillance*, London, U.K.

Shu, C. et al. 2005. IBM smart surveillance system: An open and extensible framework for event based surveillance. *IEEE Conference on Advanced Video and Signal Based Surveillance*, Como, Italy.

Sivic, J., Everingham, M., and Zisserman, A. 2005. Person spotting: Video shot retrieval for face sets. *International Conference on Image and Video Retrieval*, Singapore.

Stauffer, C. and Grimson, E. 1999. Adaptive background mixture models for real-time Tracking. *IEEE Conference on Computer Vision and Pattern Recognition (CVPR'99)*, Ft. Collins, CO.

Tian Y., Lu, M., and Hampapur, A. 2005. Robust and efficient foreground analysis for real-time video surveillance. *IEEE Conference on Computer Vision and Pattern Recognition (CVPR'95)*, San Diego, CA.

Tian, Y., Feris, R., and Hampapur, A. 2008. Real-time detection of abandoned and removed objects in complex environments. *IEEE International Workshop on Visual Surveillance (in conjunction with ECCV'08)*, Marseille, France.

Tseng, D. and Chang, C. 1994. Color segmentation using UCS perceptual attributes. *Proc. Natl. Sci. Counc.*, 18(3), 305–314.

Viola, P. and Jones, M. 2001. Rapid object detection using a boosted cascade of simple features. *IEEE Conference on Computer Vision and Pattern Recognition (CVPR'01)*, Kauai, HI.

Part II

Detection and Tracking

4

Adaptive Background Modeling and Subtraction: A Density-Based Approach with Multiple Features

Bohyung Han and Larry S. Davis

CONTENTS

Object detection is a critical preprocessing step in intelligent visual surveillance systems, and background modeling and subtraction is a natural technique for object detection in video captured by a static camera. We propose a pixel-based density-based background modeling and subtraction algorithm using multiple features, where generative and discriminative techniques are combined for classification. In our algorithm, color and Haar-like features are integrated to handle spatiotemporal variations effectively for each pixel. A background model is trained for each feature independently with a Gaussian mixture based on kernel density approximation (KDA), where all the parameters for the Gaussian mixture are determined automatically and adaptively. Background subtraction is performed using a support vector machine (SVM) over the background likelihood vector for a set of features. The algorithm is robust to the spatial variations of background and shadow. We compare the performance of the algorithm with other density-based background subtraction methods quantitatively and qualitatively with several challenging videos.

4.1 INTRODUCTION

The goal of visual surveillance systems is to monitor human activities and understand high-level events in a site, which typically require various lower level computer vision tasks such as object detection and recognition, segmentation, target tracking, human body part labeling, and human behavior analysis. In computer vision applications including visual surveillance, one or more cameras are utilized to monitor a scene, real-time video data are acquired and transmitted to processing units, and various algorithms are applied to the visual data. The first step in visual surveillance is typically to identify regions of interest within a frame. A general object detection algorithm may be desirable, but it is extremely difficult to properly handle unknown objects or objects

with significant variations in color, shape, and texture. Therefore, many visual surveillance systems assume a fixed camera environment, which makes the object-detection process much more straightforward; a background model is trained with data obtained from empty scenes and foreground regions are identified using the dissimilarity between the trained model and new observations. This procedure is called background subtraction. Since background subtraction is a general preprocessing step for detecting objects in a scene imaged by a stationary camera, it is also related to many high-level applications even outside visual surveillance, such as event detection, gesture recognition and human motion analysis, object tracking, robotics, video retrieval and annotation, and so on.

Model-based approaches involving probability density functions are very common in background subtraction, but we aim for a more flexible and efficient method for representing density functions. In contrast to previous approaches, this chapter presents a new strategy for adaptive and automatic learning of mixture models. The modes of a density function represent regions with higher local probability; hence, their preservation is important to maintain a low approximation error. We represent a density as a weighted sum of Gaussians, whose number, weights, means, and covariances are determined automatically based on the given data. The covariance of each Gaussian is derived from the Hessian matrix computed at the corresponding mode location. Using this mode-based representation, the memory requirements are low, similar to all methods that use mixture densities, but we have a principled way to determine the number of Gaussian components. This technique is called KDA, and was originally proposed in [Han:04, Han:08]. In our background modeling and subtraction framework, each visual feature is modeled with a mixture of Gaussians independently and every density function is one-dimensional. By utilizing the properties of the 1D mean-shift mode-finding procedure, the KDA can be implemented much faster because we need to compute the convergence locations for only a small set of data.

As described earlier, background subtraction algorithms have been given relatively little attention to potential features for background modeling. The study of new features for background modeling may overcome or reduce the limitations of frequently used features and the combination

of several heterogeneous features can improve performance, especially when they are complementary and not correlated. There are several previous methods for using texture for background modeling; they employ filter responses—a feature whose computation is typically very expensive. Instead of complex filters, we select Haar-like filters that can be easily computed by integral images and have been successfully applied to detection problems [Viola:01].

When the background is modeled with probability density functions, the probability of a foreground pixel is expected to be very low and that of a background pixel relatively high. However, this is not always true. Specifically, the foreground/background probabilities between features may be inconsistent due to illumination changes, shadow, and foreground objects similar in features to the background. Also, some features are highly correlated, that is, RGB color features. So, we employ an SVM for nonlinear classification, which mitigates the correlation problem among features. The final classification between foreground and background is based on the outputs of the SVM.

The chapter is organized as follows. Section 4.2 reviews the KDA procedure and its evaluation. In Section 4.3, we discuss our background modeling and subtraction algorithm; integrated features, efficient density-based modeling, and background/foreground segmentation procedure are described in detail. After that, experimental results are illustrated.

4.2 KERNEL DENSITY APPROXIMATION

This section describes how to approximate a density function with a mixture of Gaussians, which was originally proposed in [Han:04, Han:08]. In this section, we first present the mean-shift mode finding algorithm [Comaniciu:01, Comaniciu:02], and discuss a covariance estimation technique based on curvature fitting around the density mode. The accuracy of the KDA is demonstrated through various simulations.

4.2.1 Mean-Shift Mode Finding

The first step for the KDA is to find the mode locations in the underlying density function. Suppose that an original density function is

given by weighted kernel density estimation (KDE) based on Gaussian kernels. Denote by \mathbf{x}_i $(1, \ldots, n)$ a set of means of Gaussians in \mathbf{R}^d and by \mathbf{P}_i a covariance matrix associated with the corresponding Gaussian. Let each Gaussian has a weight κ_i with $\sum_{i=1}^{n} \kappa_i = 1$. The estimated density function is given by

$$\hat{f}(\mathbf{x}) = \frac{1}{(2\pi)^{d/2}} \sum_{i=1}^{n} \frac{\kappa_i}{|\mathbf{P}_i|^{1/2}} \exp\left(-\frac{1}{2}(\mathbf{x} - \mathbf{x}_i)^{\mathrm{T}} \mathbf{P}_i^{-1}(\mathbf{x} - \mathbf{x}_i)\right). \quad (4.1)$$

The sample point density estimator computed at point \mathbf{x} is obtained as the weighted average of Gaussian densities with the mean locations \mathbf{x}_i and the covariance \mathbf{P}_i. The variable-bandwidth mean-shift vector at location \mathbf{x} in the underlying density function (Equation 4.1) is defined by

$$\mathbf{m}(\mathbf{x}) = \left(\sum_{i=1}^{n} \omega_i(\mathbf{x})\mathbf{P}_i^{-1}(\mathbf{x})\right)^{-1} \sum_{i=1}^{n} \omega_i(\mathbf{x})\mathbf{P}_i^{-1}\mathbf{x}_i - \mathbf{x}, \quad (4.2)$$

where the weights

$$\omega_i(\mathbf{x}) = \frac{\kappa_i |\mathbf{P}_i|^{-1/2} \exp\left(-\frac{1}{2}(\mathbf{x} - \mathbf{x}_i)^{\mathrm{T}} \mathbf{P}_i^{-1}(\mathbf{x} - \mathbf{x}_i)\right)}{\sum_{i=1}^{n} \kappa_i |\mathbf{P}_i|^{-1/2} \exp\left(-\frac{1}{2}(\mathbf{x} - \mathbf{x}_i)^{\mathrm{T}} \mathbf{P}_i^{-1}(\mathbf{x} - \mathbf{x}_i)\right)}, \quad (4.3)$$

satisfy $\sum_{i=1}^{n} \omega_i = 1$.

The mode location (local maximum) for each sample point \mathbf{x}_i is obtained by translating the current location \mathbf{x}, which is initially \mathbf{x}_i, by the mean-shift vector $\mathbf{m}(\mathbf{x})$ in Equation 4.2 iteratively until it converges to a stationary point of the density function in Equation 4.1 [Comaniciu:01, Comaniciu:02]. Although most of stationary points are the local maxima that we seek to simplify the original density function, the convergence points may also be located at local minima or saddle points. So, it is necessary to check the Hessian matrix at the convergence location \mathbf{x},

$$\hat{\mathbf{Q}}(\mathbf{x}) = (\nabla\nabla^{\mathrm{T}})\hat{f}(\mathbf{x})$$

$$= \frac{1}{(2\pi)^{d/2}} \sum_{i=1}^{n} \frac{\kappa_i}{|\mathbf{P}_i|^{1/2}} \exp\left(-\frac{1}{2}D^2(\mathbf{x}, \mathbf{x}_i, \mathbf{P}_i)\right) \mathbf{P}_i^{-1}((\mathbf{x}_i - \mathbf{x})(\mathbf{x}_i - \mathbf{x})^{\mathrm{T}} - \mathbf{P}_i)\mathbf{P}_i^{-1}$$

$$(4.4)$$

which should be a negative definite. If the converged location is confirmed to be a local maximum, all the sample points associated with the mode are merged with a single Gaussian centered at the mode location. Otherwise, they remain unchanged to avoid a high error.

For density approximation, a Gaussian component is assigned to each detected mode,[*] where the mean of the Gaussian is equal to the converged mode location, and the weight of each Gaussian is equal to the sum of the kernel weights of the data points that converge to the mode.

Figure 4.1 illustrates the mean-shift mode-finding procedure, where each sample point converges to its associated mode location after several iterations. Note that the original density function is constructed by KDE with 100 Gaussian kernels with equal weights and a white circle in Figure 4.1a indicates the initial location of each sample. All samples converge to the associated mode locations and four modes are finally detected after the 14th time step.

4.2.2 Covariance Estimation

The mean-shift mode-finding procedure described in Section 4.2.1 determines the number of Gaussians and provides the mean and weight of each component for the approximate mixture density function. This section presents a technique to estimate the covariance associated with each Gaussian, $\tilde{\mathbf{P}}_j$, by curvature fitting around the mode location using the Hessian matrix.

Suppose that the approximate density has m unique Gaussian components at $\tilde{\mathbf{x}}_j$ $(1, \ldots, m)$ with associated weights $\tilde{\kappa}_j$ after the mode-finding

[*] Mean-shift mode finding procedure may not be able to detect all the mode locations in the underlying density functions in multidimensional cases because the number of modes is more than the number of samples in rare cases. However, it has very little impact to the accuracy of the approximated density function in general.

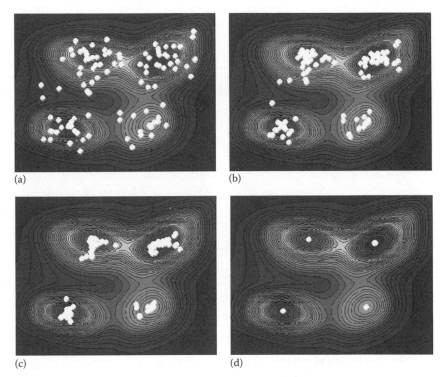

(a) (b)

(c) (d)

Figure 4.1 (See color insert following page 332.) Illustration of mean-shift mode-finding procedure in 2D space. The original density function is constructed with 100 Gaussian kernels and 4 modes are detected after convergence (a) Initial density function. (b) $t=1$. (c) $t=2$. (d) $t=14$. (From Han, B. et al., *IEEE Trans. Pattern Anal. Mach. Intell.*, 30(7), 1186, 2008. With permission.)

procedure. The Hessian matrix $\hat{\mathbf{H}}(\tilde{\mathbf{x}}_j)$ at a mode $\tilde{\mathbf{x}}_j$ of the original density function in Equation 4.1 is given in Equation 4.4. Also, the Hessian matrix at the mean of a Gaussian distribution centered at $\tilde{\mathbf{x}}_j$ with weight $\tilde{\kappa}_j$ and covariance $\tilde{\mathbf{P}}_j$ is given by

$$\mathbf{H}(\tilde{\mathbf{x}}_j) = -\frac{\tilde{\kappa}_j}{(2\pi)^{d/2}\left|\tilde{\mathbf{P}}_j\right|^{1/2}}\tilde{\mathbf{P}}_j^{-1}. \qquad (4.5)$$

By equalizing these two expressions for the Hessian matrices at the mode in the original density and the single Gaussian distribution, we

solve for the estimated covariance matrix $\tilde{\mathbf{P}}_j$. The estimated covariance matrix is finally given by

$$\tilde{\mathbf{P}}_j = -\kappa^{\frac{2}{d+2}} \left| 2\pi(-\hat{\mathbf{H}}(\mathbf{x}))^{-1} \right|^{\frac{1}{d+2}} \hat{\mathbf{H}}(\tilde{\mathbf{x}}_j)^{-1}. \tag{4.6}$$

The detailed derivation procedure is described in [Han:08].
 The final result by the KDA is

$$\hat{f}(\tilde{\mathbf{x}}_i) = \frac{1}{(2\pi)^{d/2}} \sum_{i=1}^{m} \frac{\tilde{\kappa}_i}{\left| \tilde{\mathbf{P}}_i \right|^{1/2}} \exp\left(-\frac{1}{2} D^2(\mathbf{x}, \tilde{\mathbf{x}}_i, \tilde{\mathbf{P}}_i) \right), \tag{4.7}$$

where the number of components in the new density function, m is much smaller than n in most cases.

4.2.3 Evaluation of Kernel Density Approximation

The performance of KDA is tested with various simulations. We are given a set of samples obtained from an unknown distribution, which is a mixture of Gaussians with arbitrary parameters, and the density function is reconstructed by KDE, expectation maximization (EM) algorithm, and our KDA. The mean integrated squared error (MISE) between the ground truth and estimated densities are compared.

 Three different density functions are tested and the results are presented in Table 4.1 and Figure 4.2; Cases 1 and 2 are relatively well-separated Gaussian mixtures, and the density function in Case 3 involves nonsymmetric modes and heavy-tailed regions. Note that $N(w, \mathbf{m}, \mathbf{P})$ represents a Gaussian distribution, where w, \mathbf{m}, and \mathbf{P} are weight, mean, and covariance, respectively. KDE and KDA have the same bandwidth for each kernel, and the correct number of Gaussian components is given to the EM algorithm. The average MISE is computed based on 50 realizations for reliability.

 Table 4.1 shows that the errors in KDA are comparable to both KDE and EM. The accuracy of KDA tends to degrade in areas far

TABLE 4.1 Error of KDE and KDA to the Ground Truth

MISE ($\times 10^{-5}$)	Case 1[a]	Case 2[b]	Case 3[c]
E_{KDA}	2.6024	2.1003	3.7344
E_{KDE}	2.2691	0.9387	0.9765
E_{EM}	6.0664	2.0302	2.4773

Source: Han, B. et al., *IEEE Trans. Pattern Anal. Mach. Intell.*, 30(7), 1186, 2008. With permission.

[a] N (0.15, 12, 5), N (0.1, 50; 4), N (0.35, 70, 8), N (0.25, 90, 16), N (0.15, 119, 32).

[b] N (0.15, 25, 10), N (0.1, 37, 8), N (0.15, 65, 16), N (0.25, 77, 9), N (0.15, 91; 30), N (0.2, 15, 15).

[c] N (0.2, 8, 100), N (0.25, 30, 100), N (0.15, 60, 64), N (0.2, 100, 256), N (0.2, 145, 576).

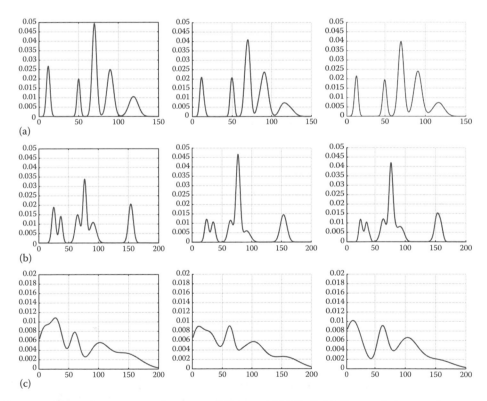

Figure 4.2 Comparison between KDA and KDE. (left) Original density function, (middle) KDE, (right) KDA. For the approximation, 200 samples are drawn from the original distribution. (a) Case 1. (b) Case 2. (c) Case 3. (From Han, B. et al., *IEEE Trans. Pattern Anal. Mach. Intell.*, 30(7), 1186, 2008. With permission.)

from the mode locations because it assigns only one Gaussian kernel to each detected mode and the covariance is estimated based on the curvature around the mode. However, the density functions obtained by KDA typically contains a small number of Gaussian components without any predefined parameters, and the estimation is still as reliable as KDE and EM. Note that KDE is not scalable due to its memory requirement. Also, the performance of the EM algorithm is severely degraded by the wrong number of components and/or inappropriate parameter initialization, although it is powerful when the number of Gaussian components is known. Some examples of inaccurate density estimation by the EM algorithm are illustrated in Figure 4.3, where the reconstructed density functions incur high error mainly because of bad parameter initialization. As seen in Figure 4.3, this problem is aggravated when the wrong number of Gaussian components is given, as in Figure 4.3a and c.

The performance comparison between KDE and KDA for multidimensional density estimation is illustrated in Figure 4.4; again, KDA results in reasonably accurate estimations with a small number of Gaussian components for the density function, which includes both well-separated Gaussian components and non-Gaussian areas.

Kernel density approximation is a framework to estimate a density function with a mixture of Gaussians. Even though KDA provides accurate estimation with a small number of Gaussians and all relevant parameters are determined automatically, the approximation error is relatively high in areas where density modes are

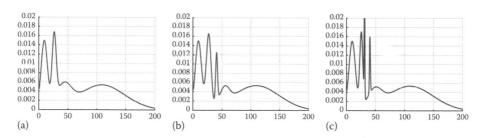

Figure 4.3 Examples of bad approximation by EM algorithm (Case 3 in Table 4.1). (a) Four components. (b) Five components. (c) Six components. (From Han, B. et al., *IEEE Trans. Pattern Anal. Mach. Intell.*, 30(7), 1186, 2008. With permission.)

Figure 4.4 (See color insert following page 332.) Comparison between KDE and KDA with 200 samples in 2D. (a) Original. (b) KDE. (MISE$=1.6684 \times 10^6$). (c) KDA. (MISE$=3.0781 \times 10^6$). (From Han, B. et al., *IEEE Trans. Pattern Anal. Mach. Intell.*, 30(7), 1186, 2008. With permission.)

nonsymmetric and/or there are heavy-tailed areas. This is because only a single Gaussian is assigned to each detected mode and the covariance for each Gaussian is estimated based only on the curvature around the mode. KDA has one free parameter—kernel bandwidth, as does KDE. Fortunately, there are several approaches to determine the kernel bandwidth as [Cleveland:79, Abramson:82, Cleveland:96, Comaniciu:03] although no ideal solution for determining optimal bandwidth is known yet.

4.2.4 Optimization in One Dimension

In our application, we are only interested in one-dimensional density functions, and the convergence of each sample point can be obtained much faster than the general case. Suppose that a set of one-dimensional samples x_i $(1, \ldots, n)$ are given and then a density function created by KDE has following properties:

$$x_i \le x_j \le \hat{x}_i \Rightarrow \hat{x}_i = \hat{x}_j \quad \text{and} \quad \hat{x}_i \le x_j \le x_i \Rightarrow \hat{x}_i = \hat{x}_j \quad (1 \le i \le n, \ 1 \le j \le n)$$

where \hat{x}_i and \hat{x}_j are the convergence locations of x_i and x_j, respectively. So, every convergence location in the underlying density function can be found without the actual mode-finding procedure of all the sample points. This section describes a simple method to find all the convergence points by a single linear scan of samples using the properties mentioned earlier.

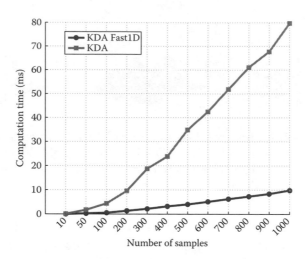

Figure 4.5 Computation time comparison between the original KDA and KDA with 1D optimization.

We sort the sample points in ascending order, and start to perform mean-shift mode finding procedure from the smallest sample. When the current sample passes another sample's location during the iterative mean-shift algorithm, we set the convergence point of the current sample to the convergence location of the sample just passed*, and terminate the iteration to move on to the next smallest sample. If a mode is found during the mean-shift iterations, the mode location is stored and the next sample is considered. After finishing the scan of all samples, each sample is associated with a mode location and the mode-finding procedure is complete. This strategy is simple, but improves the speed of mean-shift mode finding significantly, especially when many samples are involved. Figure 4.5 illustrates the impact of 1D optimization for the mode-finding procedure, where a huge difference in computation time between two algorithms is evident.

* It should be implemented with a reference variable because the convergence location is unknown yet when the current sample is moving forward. In this case, the convergence locations within the trajectory of the current sample will be set later by the reference variable at the same time.

4.3 BACKGROUND MODELING AND SUBTRACTION ALGORITHM

This section describes our background modeling and subtraction algorithm based on the one-dimensional KDA using color and Haar-like features. For background subtraction, we employ the SVM, which takes a vector of probabilities from each density function as an input.

4.3.1 Multiple Feature Combination

The most popular features for background modeling and subtraction are probably pixel-wise color (or intensity) since they are directly available from image and reasonably discriminative. Although it is natural to monitor color variations at each pixel for background modeling, pixel-wise color features have several significant limitations. First, they are not invariant to illumination changes and shadow. Second, color channels may be significantly correlated and joint probability modeling of multidimensional color feature may not be advantageous in practice. Third, it relies on local information only and cannot handle structural variations in neighborhood.

We integrate color and Haar-like feature together to alleviate the disadvantage of pixel-wise color modeling. The strength of Haar-like features lies in their simplicity and the ability to capture neighborhood information. Each Haar-like feature is extremely weak by itself, but the collection of weak features has a significant classification power [Schapire:90, Viola:01]. So, the integration of these features is expected to improve the accuracy of background subtraction. We have nine features altogether, three for RGB color and six for Haar-like feature. The Haar-like features employed in our implementation are illustrated in Figure 4.6.

Figure 4.6 Haar-like feature set for our background modeling.

4.3.2 Density Modeling

For each feature, we first construct a one-dimensional density function at each pixel by KDE with data from n frames as follows:

$$\hat{f}_F(x) = \frac{1}{\sqrt{2\pi}} \sum_{i=1}^{n} \frac{\kappa_{F,i}}{\sigma_{F,i}} \exp\left(-\frac{(x - x_{F,i})^2}{2\sigma_{F,i}^2}\right),$$

(4.8)

where $x_{F,i}$, $\sigma_{F,i}^2$ and $\kappa_{F,i}$ are the mean, variance, and weight of the ith sample for feature F, respectively, and the index for pixel location is omitted for the simplicity. From the density function originally constructed by KDE, an approximate density function by the method described in Section 4.2 is obtained as

$$\tilde{f}_F(x) = \frac{1}{\sqrt{2\pi}} \sum_{i=1}^{m_F} \frac{\tilde{\kappa}_{F,i}}{\tilde{\sigma}_{F,i}} \exp\left(-\frac{(x - \tilde{x}_{F,i})^2}{2\tilde{\sigma}_{F,i}^2}\right),$$

(4.9)

where all the parameters including the number of Gaussian components are automatically determined, and the number of components in the approximate density function, m_F, is much smaller than the original density in most cases.

One remaining issue is scale selection—initialization of $\sigma_{F,i}$—to create the original density function by KDE. Although there is no optimal solution for scale selection in non-parametric density estimation, we initialize the kernel bandwidth based on the median absolute deviation over the temporal neighborhood of the corresponding pixels. This idea is almost identical with the one proposed in [Elgammal:02]. Specifically, the initial kernel bandwidth of the ith sample for feature F is given by

$$\sigma_{F,i} = \max\left(\sigma_{\min}, \underset{t=i-t_w:i+t_w}{\text{median}} | x_{F,t} - x_{F,t-1}|\right),$$

(4.10)

where t_w is the temporal window size and σ_{\min} is the predefined minimum kernel bandwidth to avoid too narrow kernels. The motivation for this

strategy is that multiple objects may be projected into the same pixel but feature values from the same object would be observed for a short period; the absolute difference between two consecutive frames jumps not so frequently.

4.3.3 Foreground and Background Segmentation

After background modeling, each pixel is associated with k one-dimensional Gaussian mixtures, where k is the number of features integrated, and the background/foreground classification for a new frame is performed with the distributions. The background probability of a feature value is computed by Equation 4.9, and k probability values are obtained for each pixel, which are represented with a k-dimensional vector. We denote the vector by \mathbf{y}_j ($j = 1, ..., N$), where N is the number of data.

In most density-based background subtraction algorithms, the probabilities associated with each pixel are combined in a straightforward way either by computing the average probability or by voting for the classification. However, such simple methods may not work well under many real-world situations. For example, pixels in the shadow will have a low background probability in color modeling unless shadows are explicitly considered, but high background probability in texture modeling. Also, the foreground color in a pixel can be similar to the corresponding background model, which makes the background probability higher although texture probability is probably low. As seen in these examples, there exists significant nonlinearity even after computing foreground/background probabilities, so we train a classifier over the background probability vectors for the feature set, \mathbf{y}_j. Another advantage to integrate a classifier over probability vectors for the background/foreground segmentation is to reduce the dependency problem between features; otherwise, highly correlated features may dominate the decision process regardless of the states of other features.

We select SVM for the classification between background and foreground, which receives k-dimensional vector as an input and produces a scalar output. Based on a set of input and output pairs,

$D = \{(\mathbf{y}_i, c_i) \mid \mathbf{y}_i \in \mathbf{R}^k, c_i \in \{-1, 1\}\}$, the following objective function needs to be optimized for \mathbf{w} and b:

$$\min \frac{1}{2} \|\mathbf{w}\|^2$$

$$\text{subject to } c_i \left(\mathbf{w}^T \mathbf{y}_i - b \right) \geq 1 \quad (i = 1, ..., N)$$

Instead of linear SVM, the radial basis function is used as kernel in our implementation to handle nonlinearity of the input data. The output of the SVM is compared with predefined threshold and a binary background/foreground image is created. Note that only one SVM is used in our method for entire sequences—not for each pixel or each sequence; this is possible because we learn the classifier with probability vectors instead of feature vectors directly.

4.3.4 Sequential Update of Background Model

Although the proposed method handles multimodal density function for each feature, it is still not sufficient to handle long-term backgrounds and it is required to update background models periodically or incrementally, which is done by sequential kernel density approximation (SKDA) [Han:08]. The density function at the time step $t+1$ is obtained by the weighted average of the density function at the previous time step and a new observation, which is given by

$$\tilde{f}_F^{t+1}(x) = (1-r) \frac{1}{\sqrt{2\pi}} \sum_{i=1}^{m_F} \frac{\tilde{\kappa}_{F,i}^t}{\tilde{\sigma}_{F,i}^t} \exp\left(-\frac{\left(x - \tilde{x}_{F,i}^t\right)^2}{2\left(\tilde{\sigma}_{F,i}^t\right)^2} \right)$$

$$+ r \frac{\kappa_{F,i}^{t+1}}{\sqrt{2\pi}\sigma_{F,i}^{t+1}} \exp\left(-\frac{\left(x - x_{F,i}^{t+1}\right)^2}{2\left(\sigma_{F,i}^{t+1}\right)^2} \right), \tag{4.11}$$

where r is a learning rate (forgetting factor). To prevent the number of components from increasing by this procedure, the KDA procedure is applied at each time step. The detailed procedure and analysis are

described in [Han:08]. Since we are dealing with only one-dimensional vector, the sequential procedure is also much simpler and similar to the one introduced in Section 4.2.4; it is sufficient to compute the new convergence points of the mode locations immediately before and after the new data in the density function at each time step[*].

4.3.5 Examples

In this section, we illustrate the performance of our background modeling and subtraction algorithm using real video sequences. We selected three different sequences for testing and representative frames used for background modeling are presented in Figure 4.7. Each sequence involves some challenges; the "subway" sequence has significant pixel-wise noises, the "fountain" sequence includes dynamic background of water fountain, and the "caviar" sequence [Caviar] contains wide areas with reflections and shadows.

We compare our algorithm with other density-based techniques such as Gaussian mixture model (GMM) [Zivkovic:06] and KDE [Elgammal:02]. For the GMM method, we downloaded the code from [Zivkovic:06] and tested two versions—with and without shadow detection. The first 50 frames are used to train background model for the three sequences.

In addition to the four algorithms (with two versions for GMM), we also implemented two other variations of our algorithm; one is KDA modeling with RGB and Haar-like feature without SVM

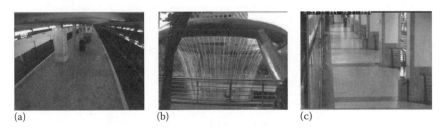

(a) (b) (c)

Figure 4.7 A representative frame for each sequence used for training background. (a) Subway sequence. (b) Fountain sequence. (c) Caviar sequence.

[*] Strictly speaking, it may be sometimes necessary to compute the convergences of more locations due to cascaded merges.

(KDA+RGB+Haar), and the other is KDA modeling with only RGB feature with SVM (KDA+SVM+RGB). The quantitative performance of six different methods is compared in Figure 4.8, where precision–recall curves are presented. In our evaluation, the precision and the recall are defined as

$$\text{Precision} = \frac{n(B_T \cap B_{BGS})}{n(B_T)} \quad \text{and} \quad \text{Recall} = \frac{n(F_T \cap F_{BGS})}{n(F_T)}$$

respectively, where F_T and B_T are the ground truth of foreground and background, and F_{BGS} and B_{BGS} denote foreground and background by background subtraction. As seen in Figure 4.8, our algorithm (KDA+SVM+RGB+Haar) has the best performance for all three

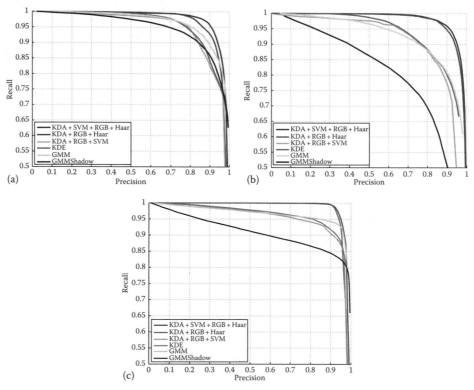

Figure 4.8 (See color insert following page 332.) Precision–recall curve for six algorithms. (a) Subway sequence. (b) Fountain sequence. (c) Caviar sequence.

sequences, and we observe that KDA+RGB+Haar are noticeably better than GMM with and without shadow detection. Actually, shadow detection seems to degrade the performance in the GMM implementation. It is interesting that the performance of KDA+SVM+RGB is not so good; it is probably because the SVM does not help in classification due to the correlation of RGB color features. Although not presented in Figure 4.8, we tested how the performance of SVM changes with different kernel bandwidths for the radial basis function, but could not observe any noticeable difference.

Qualitative results are presented in Figure 4.9. The threshold for each algorithm is set to have 95% precision in classification. Figure 4.9 shows that our algorithm also has good qualitative performance compared with the other two.

4.4 SUMMARY

We have introduced KDA for background modeling and subtraction, which is a basic preprocessing step in visual surveillance systems. KDA is used to represent a probability density function of the background for each pixel, where RGB and Haar-like features are utilized. Instead of multidimensional modeling, we adopt one-dimensional independent density functions for simplicity and optimize mean-shift mode-finding procedure in KDA significantly. For the background/foreground classification, the SVM based on the probability vector for the given feature set is employed. Our algorithm demonstrates better performance than other density-based techniques such as Gaussian mixture and KDE.

4.5 BIBLIOGRAPHICAL AND HISTORICAL REMARKS

Due to the general applicability of background subtraction, this problem has been studied intensively in the last decade; the main objective is to obtain an effective and efficient background model. In early years, simple statistics, such as frame differences and median filtering were used to detect foreground objects. Some techniques utilized a combination of local statistics [Haritaoglu:00] and vector quantization [Kim:05] based on intensity or color at each pixel.

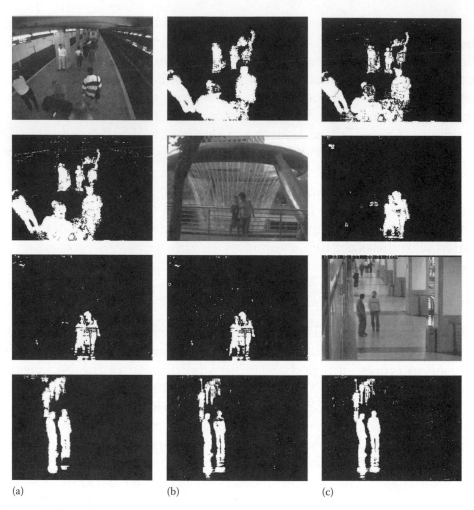

Figure 4.9 Background subtraction results of three algorithms. From top to bottom, original image, KDA, KDE, and GMM. (a) Subway sequence. (b) Fountain sequence. (c) Caviar sequence.

More advanced background modeling methods are density based, where the background model for each pixel is defined by a probability density function based on the visual features observed at that pixel during a training period. Density-based background modeling algorithms can be classified into a few categories based on the complexity of the density function. In general, the underlying probability

density can be described using a parametric or non-parametric representation. These representations create a trade-off between the flexibility of the model and its data summarization property; non-parametric models, for example, are very flexible and can accommodate complex densities, but require large amounts of memory for their implementation.

[Wren:97] modeled the background in a YUV color space using a Gaussian distribution for each pixel. However, this method cannot handle multimodal density functions, so is not robust in dynamic environments. A mixture of Gaussians is another popular method, which is designed for dealing with multiple backgrounds. Three Gaussian components representing the road, the shadow, and the vehicle are employed to model the background in traffic scenes in [Friedman:97], and a simple update strategy for Gaussian mixtures is introduced in [Mittal:00]. Stauffer and Grimson [Stauffer:00] proposed an adaptive GMM, where maximum K Gaussian components for each pixel are allowed but the number of Gaussians is determined dynamically. Recently, more elaborate, recursive update techniques for mixture models are discussed in [Lee:05, Zivkovic:06]. Various heuristics are applied for updating a mixture of Gaussians in [Harville:02]. However, none of the GMMs have any principled way to determine the number of Gaussians. They either fix the maximum number of components or employ an ad hoc method for parameter setting.

Kernel density estimation is a non-parametric density estimation technique that has been successfully applied to background subtraction [Elgammal:02, Mittal:04]. Although it is a very powerful representation for general density functions, it requires many samples for the accurate estimation of the underlying density functions and is computationally expensive in general.

Most background subtraction algorithms are based on pixel-wise processing, but multilayer approaches are also introduced in [Toyoma:99, Javed:02], where background models are constructed at the pixel, region and frame levels, and information from each layer is combined for discriminating foreground and background. In [Paragios:01], several modalities based on different features and algorithms are integrated and a Markov random field is utilized for the inference procedure. The co-occurrence of visual features within

neighborhood pixels is used for robust background subtraction in dynamic scenes in [Seki:03].

Some research on background subtraction has focused more on features than the algorithm itself. Various visual features may be used to model backgrounds, which include intensity, color, gradient, motion, texture, other general filter responses, and so on. Color or intensity is probably the most popular feature for background modeling, but the following works employed other features to overcome the limitations of color or intensity. Motion is obviously a strong cue to detect foreground regions, and there are a couple of motion-based background modeling algorithms [Monnet:03, Mittal:04]. Texture and gradients have also been successfully integrated for background modeling [Zhong:03, Heikkila:06] since they are somewhat invariant to illumination changes.

Among many background modeling and subtraction algorithms, we are particularly interested in density-based methods. The EM algorithm [Dempster:77, Redner:84] is frequently used to learn multimodal density models such as a mixture of Gaussians. Also, variants of incremental EM algorithms have been employed in practice to deal with real-time adaptation constraints [Neal:98, Jepson:01]. However, a major challenge for online adaptation in EM framework is the absence of strategy to determine the number of components; it is also generally difficult to add or remove components from the mixture [Priebe:93]. Therefore, most real-time applications rely on models with a fixed number of mixtures or apply ad hoc strategies to adapt the number of mixtures over time [Mckenna:99, Mittal:00, Stauffer:00, Harville:02, Lee:05, Zivkovic:06]. On the other hand, non-parametric density estimation techniques such as KDE [Elgammal:02] are computationally expensive and require huge memory space in general, and they are not appropriate for real-time applications, especially when high-dimensional features are involved. There have been a couple of attempts to reduce computational complexity such as the fast Gauss transform [Elgammal:03, Yang:03], but they do not provide a general solution. Another similar idea is [Cham:99], where piecewise Gaussian approximation is used to represent the density modes characterizing a tracker state. The density at a certain location is determined by the

Gaussian component providing the largest contribution at the location. Nevertheless, this is a crude approximation to the density function, and it is not clear how to apply the piecewise Gaussian representation to high-dimensional data.

REFERENCES

[Abramson:82] I. Abramson, On bandwidth variation in kernel estimates—A square root law, *Ann. Statist.*, 10(4), 1217–1223, 1982.

[Caviar] http://homepage.inf.ed.ac.kr/rfb/CAVIAR

[Cham:99] T. J. Cham and J. M. Rehg, A multiple hypothesis approach to figure tracking, in *Proceedings of the IEEE Conference on Computer Vision and Pattern Recognition*, Fort Collins, CO, vol. II, pp. 239–219, 1999.

[Cleveland:79] W. Cleveland, Robust locally weighted regression and smoothing scatterplots, *J. Am. Statist. Assoc.*, 74, 829–836, 1979.

[Cleveland:96] W. Cleveland and C. Loader, Smoothing by local regression: Principles and methods, *Statistical Theory and Computational Aspects of Smoothing*, pp. 10–49. Physica-Verlag, Heidelberg, Germany, 1996.

[Comaniciu:03] D. Comaniciu, An algorithm for data-driven bandwidth selection, *IEEE Trans. Pattern Anal. Mach. Intell.*, 25(2), 281–288, 2003.

[Comaniciu:02] D. Comaniciu and P. Meer, Mean shift: A robust approach toward feature space analysis, *IEEE Trans. Pattern Anal. Mach. Intell.*, 24(5), 603–619, 2002.

[Comaniciu:01] D. Comaniciu, V. Ramesh, and P. Meer, The variable bandwidth mean shift and data-driven scale selection, in *Proceedings of the Eighth International Conference on Computer Vision*, Vancouver, Canada, vol. I, pp. 438–445, July 2001.

[Dempster:77] A. P. Dempster, N. M. Laird, and D. B. Rubin, Maximum likelihood from incomplete data via the EM algorithm, *J. Roy. Statist. Soc. B*, 39, 1–38, 1977.

[Elgammal:02] A. Elgammal, R. Duraiswami, D. Harwood, and L. S. Davis, Background and foreground modeling using nonparametric kernel density estimation for visual surveillance, *Proc. IEEE*, 90, pp. 1151–1163, 2002.

[Elgammal:03] A. M. Elgammal, R. Duraiswami, and L. S. Davis, Efficient kernel density estimation using the fast gauss transform with applications to color modeling and tracking, *IEEE Trans. Pattern Anal. Mach. Intell.*, 25(11), 1499–1504, 2003.

[Friedman:97] N. Friedman and S. Russell, Image segmentation in video sequences: A probabilistic approach, in *Proceedings of the 13th Conference on Uncertainty in Artificial Intelligence (UAI)*, Providence, RI, 1997.

[Han:04] B. Han, D. Comaniciu, and L. S. Davis, Sequential kernel density approximation through mode propagation: Applications to background modeling, *Sixth Asian Conference on Computer Vision*, Jeju, Korea, pp. 813–818, 2004.

[Han:08] B. Han, D. Comaniciu, Y. Zhu, and L. S. Davis, Sequential kernel density approximation and its application to real-time visual tracking, *IEEE Trans. Pattern Anal. Mach. Intell.*, 30(7), 1186–1197, 2008.

[Haritaoglu:00] I. Haritaoglu, D. Harwood, and L. S. Davis, W4: Real-time surveillance of people and their activities, *IEEE Trans. Pattern Anal. Mach. Intell.*, 22(8), 809–830, 2000.

[Harville:02] M. Harville, A framework for high-level feedback to adaptive, Per-pixel, Mixture-of-Gaussian background models, *European Conference on Computer Vision*, Copenhagen, Denmark, pp. 543–560, 2002.

[Heikkilä:06] M. Heikkilä and M. Pietikäinen, A texture-based method for modeling the background and detecting moving objects, *IEEE Trans. Pattern Anal. Mach. Intell.*, 28(4), 657–662, 2006.

[Javed:02] O. Javed, K. Shafique, and M. Shah, A hierarchical approach to robust background subtraction using color and gradient information, *IEEE Workshop on Motion and Video Computing*, Orlando, FL, pp. 22–27, December 5–6, 2002.

[Jepson:01] A. D. Jepson, D. J. Fleet, and T. F. El-Maraghi, Robust online appearance models for visual tracking, in *Proceedings of the IEEE Conference on Computer Vision and Pattern Recognition*, Hawaii, vol. I, pp. 415–422, 2001.

[Kim:05] K. Kim, T. H. Chalidabhongse, D. Harwood, and L. S. Davis, Real-time foreground-background segmentation using codebook model, *Real-Time Imag.*, 11(3), 172–185, 2005.

[Lee:05] D.-S. Lee, Effective Gaussian mixture learning for video background subtraction, *IEEE Trans. Pattern Anal. Mach. Intell.*, 27(5), 827–832, May, 2005.

[McKenna:99] S. J. McKenna, Y. Raja, and S. Gong, Tracking colour objects using adaptive mixture models, *Image Vision Comput. J.*, 17, 223–229, 1999.

[Mittal:00] A. Mittal and D. Huttenlocher, Scene modeling for wide area surveillance and image synthesis, in *Proceedings of the IEEE Conference on Computer Vision and Pattern Recognition*, Hilton Head, SC, 2, 160–167, 2000.

[Mittal:04] A. Mittal and N. Paragios, Motion-based background subtraction using adaptive kernel density estimation, in *Proceedings of the IEEE Conference on Computer Vision and Pattern Recognition*, Washington, DC, 2, 302–309, 2004.

[Monnet:03] A. Monnet, A. Mittal, N. Paragios, and V. Ramesh, Background modeling and subtraction of dynamic scenes. in *Proceedings of IEEE International Conference on Computer Vision*, Nice, France, 2, pp. 1305–1312, 2003.

[Neal:98] R. M. Neal and G. E. Hinton, A view of the EM algorithm that justifies incremental, sparse, and other variants, in *Learning in Graphical Models*, M. I. Jordan, ed. MIT Press, Cambridge, MA, pp. 355–368, 1998.

[Paragios:01] N. Paragios and V. Ramesh, A MRF-based approach for real-time subway monitoring, in *Proceedings of the IEEE Conference on Computer Vision and Pattern Recognition*, Kauai, Hawaii, vol. I, pp. 1034–1040, 2001.

[Priebe:93] C. E. Priebe and D. J. Marchette, Adaptive mixture density estimation, *Pattern Recog.*, 26(5), 771–785, 1993.

[Redner:84] R. A. Redner and H. F. Walker, Mixture densities, maximum likelihood and the EM algorithm, *SIAM Rev.*, 26, 195–239, 1984.

[Seki:03] M. Seki, T. Wada, H. Fujiwara, and K. Sumi, Background subtraction based on cooccurrence of image variations, in *Proceedings of the IEEE Conference on Computer Vision and Pattern Recognition*, Madison, WI, 2003.

[Schapire:90] R. Schapire, The strength of weak learnability, *Machine Learn.*, 5(2), 197–227, 1990.

[Stauffer:00] C. Stauffer and W. E. L. Grimson, Learning patterns of activity using real-time learning, *IEEE Trans. Pattern Anal. Mach. Intell.*, 22(8), 747–757, 2000.

[Toyoma:99] K. Toyama, J. Krumm, B. Brumitt, and B. Meyers, Wallflower: Principles and practice of background maintenance, in *Proceedings of the IEEE Conference on Computer Vision*, Kerkyra, Greece, pp. 255–261, 1999.

[Viola:01] P. A. Viola and Michael J. Jones, Rapid object detection using a boosted cascade of simple features, in *Proceedings of the IEEE Conference on Computer Vision and Pattern Recognition*, Kauai, Hawaii, pp. 511–518, 2001.

[Wren:97] C. Wren, A. Azarbayejani, T. Darrell, and A. Pentland, Pfinder: Real-time tracking of the human body, *IEEE Trans. Pattern Anal. Mach. Intell.*, 19, pp. 780–785, 1997.

[Yang:03] C. Yang, R. Duraiswami, N. A. Gumerov, and L. S. Davis, Improved fast Gauss transform and efficient kernel density estimation, in *Proceedings of the IEEE Conference on Computer Vision*, Nice, France, pp. 464–471, 2003.

[Zhong:03] J. Zhong and S. Sclaroff, Segmenting foreground objects from a dynamic textured background via a robust Kalman filter, in *Proceedings of the IEEE Conference on Computer Vision*, Nice, France, 2003.

[Zivkovic:06] Z. Zivkovic and F. van der Heijden, Efficient adaptive density estimation per image pixel for the task of background subtraction, *Pattern Recogn. Lett.*, 27(7), 773–780, 2006.

5

Pedestrian Detection and Tracking

Bo Wu and Ram Nevatia

CONTENTS

The detection and tracking of pedestrians are the basic components of a visual surveillance system. In this chapter, we describe a boosting-based detection and tracking method developed by the University of Southern California computer vision group.

5.1 INTRODUCTION

The detection and tracking of objects of a known class is a fundamental problem of computer vision. The class of pedestrians is particularly important for visual surveillance applications. The two principal sources of difficulties in performing this task are (a) changes in appearance of the objects with viewpoint, illumination, and possible articulation and (b) the partial occlusions of the target objects by other objects. For pedestrians, there are additional difficulties in tracking after initial detection. The image appearance of humans changes not only with the changing viewpoint but even more strongly with the visible parts

(a) (b)

Figure 5.1 Sample frames (a) from the CAVIAR set* and (b) from the data we have collected. (From Wu, B. and Nevatia, R., *Int. J. Comput. Vision*, 75, 247, 2007. With permission.)

of the body and clothing. In addition, it is difficult to maintain the identities of pedestrians during tracking when they are close to each other. Figure 5.1 shows two examples where such difficulties can be expected.

We propose a shape-based detection and tracking method with part-based representation of object classes. For the class of pedestrians, because of a tremendous variation in clothing, silhouette, or contour is the most consistent feature. Compared to many existing motion based methods, the main advantages of shape-based methods are

1. Shape-based methods are discriminative. They can apply to the situation where there are multiple object classes that cannot be distinguished by motion. For example, for an outdoor surveillance system, pedestrians and cars are the two classes of greatest interest, and both of them are moving objects. A motion blob–based detector cannot differentiate them.
2. Shape-based methods can work without motion information. The situation where motion segmentation is not applicable or gives very noisy output is not a problem for shape-based methods. For example, when the camera of a driving assistance system moves with the car, the motion segmentation is not very robust.

* http://homepages.inf.ed.ac.uk/rbf/CAVIAR/

However, shape-based methods have their own limitations. The 2D appearance can be very different due to viewpoints and poses. It is hard to train a classifier to cover a large inner-class variation. Though some divide-and-conquer strategies can be used, the current shape-based methods usually cover only a limited range of viewpoints and poses.

When pedestrians are moving together or interacting with each other, they could occlude each other. In addition, the pedestrians could be occluded by other scene objects, such as a human standing behind a bush. Our human eyes can recognize the object even when some parts of the object are invisible. This suggests that a part-based representation may be more appropriate. Compared to holistic representations, the main advantages of part-based representations are

1. Part-based representations can work with partial occlusions. When we know that some parts are not visible in the image, we need only look for the evidence of the visible parts.
2. Part-based representations are more robust to articulation and viewpoint changes, as the constraints of the spatial relation of the parts are flexible.
3. Part-based representations result in more robust detector and tracker, as the final decision is made based on evidence from multiple parts.

However, it is more difficult to build a part-based model than a holistic model. An appropriate part definition is needed. Too many small parts will result in classifiers with poor accuracy, as one part can be too small to be distinguishable; a few big parts will not be very robust to heavy partial occlusion.

In developing a pedestrian detection and tracking system based on these two principles, several issues arise. First, how to learn the part detectors? This includes defining the body parts, covering different viewpoints. Second, how to combine the part detection results into final object hypotheses, especially when there are partial occlusions? Third, how to track objects given detection responses with classification errors? This includes building a discriminative model for a particular object, as well as automatic initialization and termination of

trajectories. All these questions are open and their answers may not be unique.

We have implemented an automatic pedestrian detection and tracking system. This system consists of three main components: a learning component, a detection component, and a tracking component. Figure 5.2 shows an overview diagram. In the learning stage, several part detectors are trained by a supervised learning algorithm. When detecting and tracking in videos, the frames are first fed into the detection module, whose output is a number of bounding boxes; then the frame by frame detection responses are sent to the tracking module, whose output is a number of object trajectories.

We represent an object as an assembly of parts. For each part, we learn a detector by boosting local shape features. To cover multiple viewpoints and different poses, we build tree-structured part detectors using a boosting approach.

In the detection process, an image is scanned by the part detectors. The responses of part detectors are combined based on a joint image likelihood function for multiple, possibly inter-occluded objects. We formulate the multiple object–detection problem as a MAP estimation problem, and search the solution space to find the best interpretation of the image observation.

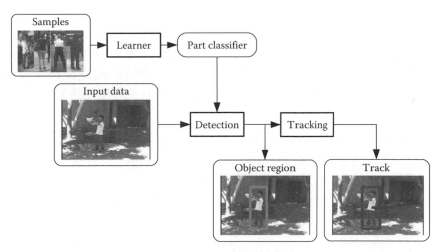

Figure 5.2 Overview diagram of our approach.

Our tracking method is based on tracking parts of the object. The detection responses from the part detectors and the combined detector are taken as inputs for the tracker. We track objects by data association, i.e., matching the object hypotheses with the detection responses. A trajectory is initialized when evidence from new observations cannot be explained by the current hypotheses. Similarly, a trajectory is terminated when it is lost by the detectors for a certain period. Part of this chapter was pervious published in Wu and Nevatia (2007a,b).

The rest of this chapter is organized as follows: Section 5.2 describes our body part detection method; Section 5.3 describes our joint analysis method to combined part detection responses; Section 5.4 describes our part-based tracking method; Section 5.5 summarizes this chapter; Section 5.6 introduces some related work.

5.2 PEDESTRIAN DETECTION BY BOOSTING LOCAL SHAPE FEATURES

Our approach detects objects by combining part detection responses. For individual object parts, we learn tree-structured classifiers based on local shape features by boosting methods. The image features used are a novel type of shape oriented local features.

5.2.1 Tree Learning Algorithm*

5.2.1.1 Formulation of Tree-Structured Classifier

We begin this section with a formal definition of a tree-structured classifier. The input of such a classifier is an image sample (an image patch), $\mathbf{x} \in \chi$, where χ is the sample space, and the output is a vector. Let

$$H(\mathbf{x}) = [H_1(\mathbf{x}), \ldots, I\,I_C(\mathbf{x})] \tag{5.1}$$

be the tree classifier, where C is the number of subcategories, called *channels*. Each channel is an ensemble classifier:

$$H_k(\mathbf{x}) = \sum_{t=1}^{T} h_{k,t}(\mathbf{x}), \quad k = 1, \ldots, C \tag{5.2}$$

* From Wu, B. and Nevatia, R., Cluster boosted tree classifier for multi-view, multi-pose object detection, *International Conference of Computer Vision*, Rio de Janeiro, Brazil, 2007a.

where

$h_{k,t}(\mathbf{x})$ is called *weak* classifier

T is the number of weak classifiers, i.e., the depth of the tree

The input of a weak classifier is an image sample \mathbf{x}, and the output is a real-valued number, whose sign is the class prediction (positive for object and negative for non-object). Each weak classifier is built based on one image feature f. The weak classifiers at the same level may share the same feature. Figure 5.3 gives an illustration of the tree structure. The tree shown has three levels and three channels. At the first level, all the weak classifiers of the three channels share the same feature, indicated by the round-corner box, though they may have different classification functions. At the second level, the third channel stops sharing features with the other two channels; this is called a splitting operation. At the third level, the first and second channels split. Feature sharing has proven to be an efficient strategy for multi-view object detection (Huang et al. 2005, Lin and Liu 2005).

To integrate with cascade decision strategy, a threshold $b_{k,t}$ is learned for each weak classifier $h_{k,t}$. Let $h_{k,t}$ be the partial sum of the first t weak classifiers of channel k, i.e.,

$$H_{k,t}(\mathbf{x}) = \sum_{j=1}^{t} h_{k,j}(\mathbf{x}) \qquad (5.3)$$

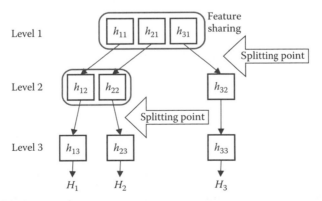

Figure 5.3 Illustration of tree structure. (From Wu, B. and Nevatia, R., Cluster boosted tree classifier for multi-view, multi-pose object detection, in *International Conference of Computer Vision*, Rio de Janeiro, Brazil, 2007. With permission.)

A sample is accepted by channel k, if and only if

$$\forall t \subset \{1,...T\}, \quad H_{k,l} > b_{k,t} \tag{5.4}$$

A sample is classified as an object, if and only if it is accepted by at least one channel.

Our learning algorithm is based on the real AdaBoost algorithm (Schapire and Singer 1999). An image feature can be seen as a function from the image space to a real-valued range, $f: \chi \mapsto [0, 1]$. The weak classifier based on f is a function from the image space χ to a real valued object/non-object classification confidence space. Given a labeled sample set $S = \{(\mathbf{x}_i, y_i)\}$, where $\mathbf{x} \in \chi$ is the image patch, and $y = \pm 1$ is the class label of \mathbf{x}, in real AdaBoost we first divide the sample space into several disjointed parts:

$$\chi = \bigcup_{j=1}^{n} X_j \tag{5.5}$$

where n is the size of the partition. Then the weak classifier h is defined as a piecewise function based on the partition

$$\text{if } \mathbf{x} \in X_j, \ h(\mathbf{x}) = \ln\left(\frac{W_+^j + \varepsilon}{W_-^j + \varepsilon}\right), \quad j = 1,...,n \tag{5.6}$$

where

 ε is a smoothing factor (Schapire and Singer 1999)

 W_\pm is the probability distribution of positive/negative samples on the partition, implemented as a histogram

$$W_\pm^j = P(\mathbf{x} \in X_j, y = \pm 1), \quad j = 1,...,n \tag{5.7}$$

In practice, following (Huang et al. 2005) the partition of the sample space is achieved by dividing the feature space into n equal sized sub-ranges, i.e.,

$$X_j = \left\{ \mathbf{x} \mid f(\mathbf{x}) \in \left(\frac{j-1}{n}, \frac{j}{n} \right) \right\}, \quad j = 1, \dots, n \tag{5.8}$$

In our experiments, we set $n = 32$.

5.2.1.2 Splitting Sample Space

As our purpose is to construct tree classifiers without a predefined intra-class subcategorization, we need to answer two questions: when is the subcategorization necessary, and how to divide the sample space? In real AdaBoost (Schapire and Singer 1999), the classification power of the weak classifier is measured by a Z value:

$$Z = 2 \sum_j \sqrt{W_+^j W_-^j} \tag{5.9}$$

when W_\pm is normalized, $Z \in [0, 1]$ is the Bhattacharyya distance between the distributions of the object and non-object classes. The smaller Z is, the more discriminative the weak classifier is. At each boosting round, the weak classifier with the smallest Z is selected. Due to the cascade decision strategy, the classifier gradually focuses on the difficult part of the sample space. Thus, it becomes more and more difficult to find weak classifiers with small Z values during the boosting procedure. When Z gets very close to 1, its contribution to the whole classifier is small, or in other words, the current problem is beyond its ability. This suggests a division. In practice, we set a threshold θ_Z, and if the Z values of three consecutive weak classifiers are all larger than θ_Z, the splitting operation is triggered.

Because our method is a discriminative approach based on image features, we use a bottom-up splitting strategy to facilitate the classification, instead of top-down. Suppose, up to the splitting point, K features have been selected, then the vector $\mathbf{f} = \{f_1, \dots, f_K\}$ is fed into an unsupervised clustering algorithm to divide the sample space into two parts. In practice, we use the standard k-mean algorithm with Euclidean distance. Although there are many other clustering algorithms, we find this serves our purpose well.

5.2.1.3 Retraining with Subcategorization

During the training procedure, without predefined subcategorization, one leaf node of the tree always corresponds to one single channel. Suppose the current tree has t levels and c channels. When a leaf node $h_{k,t}$ splits, two branches with a new channel are generated, $h_{k,t+1}$ and $h_{c+1,t+1}$. The new subcategorization information is sent upstream to all the ancestors of $h_{k,t+1}$ and $h_{c+1,t+1}$ to refine their classification functions. For example, $h_{k,t}$ changes to a pair $\{h_{k,t}, h_{c+1,t}\}$. The entire boosting procedure is then rerun from the beginning for the two changed channels, k and $c+1$. As opposed to a standard boosting algorithm, in the retraining we do not do feature selection and only recompute the classification functions, i.e., $h_{k,t}$ and $h_{c+1,t}$ share the original feature for $h_{k,t}$ and their classification functions are retrained on the samples of the new subcategories.

Our complete learning algorithm is given in Figure 5.4 and Figure 5.5. The output classifier of our learning algorithm has the same structure as that in Huang et al. (2005), while our algorithm does not require a predefined intra-class subcategorization. We call this learning method *Cluster Boosted Tree* (CBT) method.

5.2.2 Edgelet Features*

We developed a new class of local shape features that we call *edgelet* features. An edgelet is a short segment of a line or a curve. Denote the positions and normal vectors of the points in an edgelet E, by $\{\mathbf{u}_i\}_{i=1}^{k}$ and $\{\mathbf{n}_i^E\}_{i=1}^{k}$, where k is the length of the edgelet, see Figure 5.6 for an illustration. Given an input image I, denote the edge intensity and normal at position \mathbf{p} of I by $M^I(\mathbf{p})$ and $\mathbf{n}^I(\mathbf{p})$. The affinity between the edgelet E and the image I at position \mathbf{w} is calculated by

$$f(E;I,\mathbf{w}) = \frac{1}{k}\sum_{i=1}^{k} M^I(\mathbf{u}_i + \mathbf{w})\left|\left\langle \mathbf{n}^I(\mathbf{u}_i + \mathbf{w}), \mathbf{n}_i^E \right\rangle\right| \qquad (5.11)$$

Note: \mathbf{u}_i in the above equation is in the coordinate frame of the sub-window, and \mathbf{w} is the offset of the sub-window in the image frame. The

* From Wu, B. and Nevatia, R., *IJCV*, 75(2), 247, 2007b. With permission.

Cluster boosted tree learning algorithm

Input: Initial sample set $S = S_{+1} \cup S_{-1} = \{(\mathbf{x}_i, +1)\} \cup \{(\mathbf{x}_i, -1)\}$, and a negative images set; the algorithm parameters: the maximum weak classifier number T, the positive passing rates $\{P\}_{t=1}^T$, the target false alarm rate F, the maximum channel number C, the splitting threshold θ_Z, and the threshold for bootstrapping θ_B

Output: Tree structured classifier $\{h_{k,t}, b_{k,t}\}$

1. Initialize the weights $D_0(\mathbf{x}) = \|S\|^{-1}$ for all samples, the current false alarm rate of the current channel $F_{1,0} = 1$, the current channel number $c = 1$, and $t = 0$;

2. Construct the weak classifier pool, \mathcal{H}, from the image features;

3. While $t < T$ do
 - For all channels, $k = 1, ..., c$ do
 - If $F_{k,t} < F$, continue
 - For every weak classifier in \mathcal{H}, learn the classification function from the sample sets $S_{\pm k}$ by Equation 5.6;
 - Compute the Z values for all weak classifiers by Equation 5.9, and select the weak classifier with the smallest Z, denoted by $h_{k,t}$ and its corresponding feature $f_{k,t}$;
 - Update sample weights by

$$D_{t+1}(\mathbf{x}) = D_t(\mathbf{x}) \exp[-y h_{k,t}(\mathbf{x})], \quad \forall \mathbf{x} \in S_{\pm k} \tag{5.10}$$

 and normalize D_{t+1} to a probability distribution;
 - Select the threshold $b_{k,t}$ for the partial sum $H_{k,t}$, so that a portion of P_t positive samples are accepted; and reject as many negative samples as possible;
 - Remove the rejected samples from $S_{\pm k}$. If the remaining negative samples are less than θ_B percent of the original, recollect S_{-k} by bootstrapping on the negative image set and update $F_{k,t}$;
 - If Z of $h_{k,t}$, $h_{k,t-1}$, and $h_{k,t-2}$ are all larger than θ_Z, and $c < C$, perform splitting and retraining
 i. $\forall \mathbf{x} \in S_{+k}$, compute the feature descriptor $\mathbf{f}(\mathbf{x}) = [f_{k,1}(\mathbf{x}), ..., f_{k,t}(\mathbf{x})]$;
 ii. Based on $\mathbf{f}(\mathbf{x})$, do k-mean clustering on S_{+k} to divide it into two parts, and assign the labels k and $c+1$ to the two new subcategories, i.e., $S_{+k} \rightarrow S_{+k} \cup S_{+(c+1)}$;
 iii. Retrain all the previous weak classifiers for channel k with the algorithm in Figure 5.5;
 iv. c++;
 v. t++;

Figure 5.4 Cluster boosted tree learning algorithm. In our experiments, $T = 2000$, $F = 10^{-6}$, $C = 8$, $\theta_Z = 0.985$, and $\theta_B = 75\%$. The setting of $\{P_t\}$ is similar to the original cascade's layer acceptance rates. The cascade is divided into 20 segments, the lengths of which grow gradually. The weak classifiers at the end of the segments have a positive passing rate of 99.8%, and the other weak classifiers have a passing rate of 100.0%. (From Wu, B. and Nevatia, R., Cluster boosted tree classifier for multi-view, multi-pose object detection, in *International Conference of Computer Vision*, Rio de Janeiro, Brazil, 2007. With permission.)

edgelet affinity function captures both intensity and shape information of the edge.

In our experiments, the edge intensity $M^I(\mathbf{p})$ and normal vector $\mathbf{n}^I(\mathbf{p})$ are calculated by 3×3 Sobel kernel convolution applied to gray level images. We do not use color information for detection. Since we use the edgelet features only as weak features in the boosting algorithm,

Weak classifiers retraining algorithm

Input: The sample sets of the new channels S_{+k} and $S_{+(c+1)}$; Inherit all the parameters from the main algorithm in Figure 5.4;

Output: Retrained weak classifiers $\{h_{k,t}, b_{k,t}\}$ and $\{h_{c+1,t}, b_{c+1,t}\}$

1. Randomly collect the initial negative sample sets for the new channels, S_{-k} and $S_{-(c+1)}$;
2. Reset the weights $\forall \mathbf{x} \in S_{+k} \cup S_{+(c+1)}$, $D_0(\mathbf{x}) = \|S\|^{-1}$;
3. For $t' = 1$ to t do
 - Split the original $h_{k,t'}$ into two, $h_{k,t'}$ and $h_{c+1,t'}$, which share the same feature, i.e., $f_{k,t'} = f_{c+1,t'}$;
 - Retrain $h_{k,t'}$ with the following steps:
 - ○ Learn the classification function from the new sample sets $S_{\pm k}$ by Equation 5.6;
 - ○ Update the sample weights by Equation 5.10;
 - ○ Select the threshold $b_{k,t'}$ for the partial sum $H_{k,t'}$, so that a portion of $P_{t'}$ positive samples is accepted; and reject as many negative samples as possible;
 - ○ Remove the rejected samples from $S_{\pm k}$. If the remaining negative samples are less than θ_B percent of the original, recollect S_{-k} by bootstrapping on the negative image set;
 - Retrain $h_{c+1,t'}$ with $S_{\pm(c+1)}$ by the same steps for $h_{k,t'}$.

Figure 5.5 Retraining weak classification functions of ancestor nodes with intra-class subcategorization. (From Wu, B. and Nevatia, R., Cluster boosted tree classifier for multi-view, multi-pose object detection, in *International Conference of Computer Vision*, Rio de Janeiro, Brazil, 2007. With permission.)

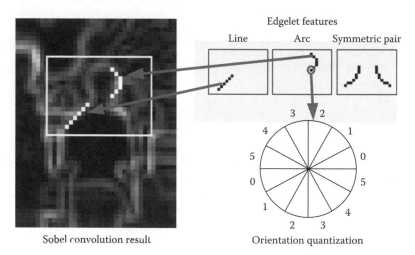

Figure 5.6 Edgelet features. (From Wu, B. and Nevatia, R., *Int. J. Comput. Vision*, 75, 247, 2007. With permission.)

we simplify them for computational efficiency. First, we quantize the orientation of the normal vector into six discrete values (see Figure 5.6). The range $[0, \pi)$ is divided into six bins evenly, which correspond to the integers from 0 to 5, respectively. An angle θ within range $[\pi, 2\pi)$ has

the same quantized value as $\theta - \pi$. Second, the dot product between two normal vectors is approximated by the following function

$$l[x] = \begin{cases} 1 & x = 0 \\ 4/5 & x = \pm 1, \pm 5 \\ 1/2 & x = \pm 2, \pm 4 \\ 0 & x = \pm 3 \end{cases} \tag{5.12}$$

where the input x is the difference between two quantized orientations. Denote by V_i^E and V^I the quantized edge orientations of the edgelet and the input image I, respectively. The simplified affinity function is

$$\tilde{f}(E; I, \mathbf{w}) = \frac{1}{k} \sum_{i=1}^{k} M^I(\mathbf{u}_i + \mathbf{w}) \cdot l\left[V^I(\mathbf{u}_i + \mathbf{w}) - V_i^E\right] \tag{5.13}$$

The computation of edgelet features therefore only includes short integer operations.

In our experiments, the possible length of one single edgelet is from 4 pixels to 12 pixels. The edgelet features we use consist of single edgelets, including lines, 1/8 circles, 1/4 circles, and 1/2 circles, and their symmetric pairs. One single edgelet is defined by the locations of its two ends and its shape, and is rendered by the Bresenham algorithm (Bresenham 1965). A symmetric pair is the union of a single edgelet and its mirror, see Figure 5.6.

5.2.3 Examples*

In this section, we evaluate our edgelet+CBT method compared with some previous methods. For pedestrian detection, there have been several data sets publicly available, e.g., the INRIA pedestrian set (Dalal and Triggs 2005).† The INRIA set covers multiple viewpoints and a large variation of poses. It contains 2478 positive samples and 1218 negative

* From Wu, B. and Nevatia, R., Cluster boosted tree classifier for multi-view, multi-pose object detection, *International Conference of Computer Vision*, Rio de Janeiro, Brazil, 2007a. With permission.
† http://pascal.inrialpes.fr/data/human/

Figure 5.7 Examples of pedestrian training samples.

images for training, and 1128 positive samples and 453 negative images for testing. As the INRIA set contains segmented samples, it is appropriate for a comparison of learning algorithms. However, for multi-view pedestrians, there is no public set for evaluating the *detection* performance of the whole system. Hence, we collected our own multi-view pedestrian test set. The pedestrian samples in our experiments have been resized to 24×58 pixels. Figure 5.7 shows some examples of the training samples of pedestrians. The overall number of possible edgelet features for pedestrians is 857,604.

5.2.3.1 Comparison on Data without Predefined Subcategorization

First, we compare our method with some previous work (Dalal and Triggs 2005, Zhu et al. 2006, Tuzel et al. 2007) on the INIRA set that does not have view/pose labels. For our method, three runs are performed with different settings. In the first run, we set the maximum number of channels to one ($C=1$), which reduces the classifier

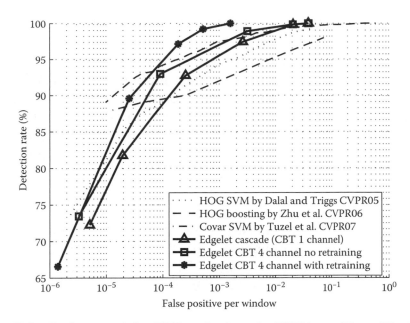

Figure 5.8 Evaluation of the CBT method on the INRIA set. (From Wu, B. and Nevatia, R., Cluster boosted tree classifier for multi-view, multi-pose object detection, in *International Conference of Computer Vision*, Rio de Janeiro, Brazil, 2007. With permission.)

to a cascade structure. In the second run, we set $C=4$ and disable the retraining module. In the last run, we set $C=4$ and enable the retraining module. The other parameters of the three runs are the same. Figure 5.8 gives the ROC curves.

From the results, it can be seen that for our method, four channel with no retraining CBT classifier outperforms the cascade one, while the four channel with retraining CBT classifier outperforms both. This shows the effectiveness of the splitting and retraining modules. Our method is comparable to Tuzel et al. (2007), Dalal and Triggs (2005), and Zhu et al. (2006).

5.2.3.2 Comparison on Data with View-Based Subcategorization

In Huang et al. (2005), the intra-class subcategorization of face samples is based on viewpoint, which is a common solution for multi-view

object detection. In this experiment, we compare our unsupervised subcategorization-based method with the predefined subcategorization-based method. We divide the pedestrian class into three view-based subcategories: left profile, frontal/rear, and right profile. As the INRIA set does not have viewpoint information, we use our own collection from the Internet for this experiment. Our training set contains 1120 positive samples for left profile, 1742 positive for frontal/rear, 1120 positive for right profile, and 7000 negative images without humans. For the view-based classifier, we use the Vector Boosting algorithm (Huang et al. 2005) to train a three-channel cascade as root.

For the CBT method, we set $C=8$; however, the resulting tree has only four channels. To evaluate the detection performance, we collect a test set containing 100 images with 232 multi-view pedestrians. We call this set "USC pedestrian set C."* Figure 5.9 shows the precision-recall curves of the two tree classifiers on this test set.

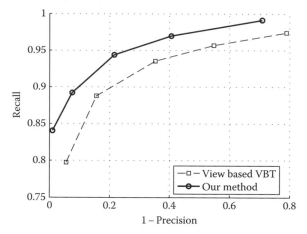

Figure 5.9 Evaluation of the CBT method on the USC pedestrian set C. (VBT is short for Vector Boosting Tree. Recall is equal to detection rate; precision is defined as the number of correctly detected objects divided by the number of all detection.) (From Wu, B. and Nevatia, R., Cluster boosted tree classifier for multi-view, multi-pose object detection, in *International Conference of Computer Vision*, Rio de Janeiro, Brazil, 2007. With permission.)

* http://iris.usc.edu/~bowu/DatasetWebpage/dataset.html

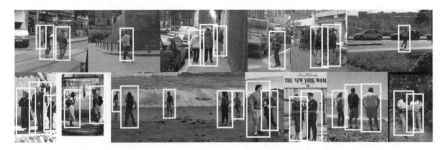

Figure 5.10 Example full-body pedestrian detection results. (From Wu, B. and Nevatia, R., Cluster boosted tree classifier for multi-view, multi-pose object detection, in *International Conference of Computer Vision*, Rio de Janeiro, Brazil, 2007. With permission.)

From the results, it can be seen that the CBT detector dominates the view-based VBT detector. One possible reason is that the view-based subcategorization is not optimal for the pedestrian class as the articulation is also an important factor that affects the appearance.

Our program is coded in C++ using OpenCV functions without any code level optimization or parallel computing. The experimental machine used is a 2.8 GHz 32-bit Pentium PC. The detection speed depends on the size of the object and the image. It usually requires a few hundreds milliseconds for one image. Our detectors search humans with a minimum width of 24 pixels. Figure 5.10 shows some examples of detection.

5.3 OCCLUDED PEDESTRIAN DETECTION BY PART COMBINATION*

For the detection of objects with partial occlusions, part-based representations can be used.

5.3.1 Part Definition

We divide human body into three parts: head-shoulder, torso, and legs. The CBT algorithm described in the previous section is used to learn detector for each part. Besides the three part detectors, a full-body detector is also learned. Figure 5.11 shows the spatial relations of the

* From Wu, B. and Nevatia, R., *IJCV*, 75(2), 247, 2007b. With permission.

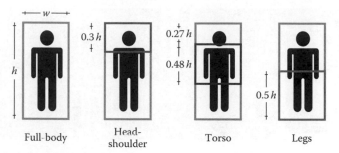

Figure 5.11 Part definition. (From Wu, B. and Nevatia, R., *Int. J. Comput. Vision*, 75, 247, 2007. With permission.)

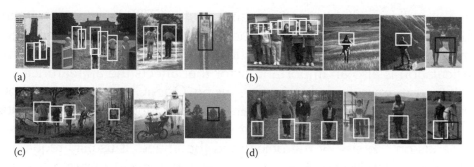

Figure 5.12 Example of part detection results. (White boxes are successful detections, and black boxes are false alarms.) (From Wu, B. and Nevatia, R., *Int. J. Comput. Vision*, 75, 247, 2007. With permission.)

body parts, and Figure 5.12 shows some examples of part detection results.

5.3.2 Joint Part Combination

To combine the results of the part detectors, we compute the likelihood of the presence of multiple humans at the hypothesized locations. If inter-object occlusion is present, the assumption of conditional independence between individual human appearances given the state, as in Mikolajczyk et al. (2004), is not valid and a more complex formulation is necessary.

5.3.2.1 Inter-Object Occlusion Model

To model inter-object occlusion, we assume that humans are on a plane, and that the camera looks down to the plane (with a tilt angle smaller than 45°), see Figure 5.13. This assumption is valid for common surveillance systems. This configuration brings two observations: (1) if a human in the image is visible then at least his/her head is visible and (2) the farther the human is from the camera, the smaller is the y-coordinate of his/her feet's image position.

With the second observation, we can find the relative depth of humans by comparing their y-coordinates and build an occupancy map, which defines which pixel comes from which human, see Figure 5.15b. The overall image shape of an individual human is modeled as an ellipse, which is tighter than the box obtained by part detectors. From the occupancy map ratio of the visible area to the overall area of the part is calculated as a visibility score v. If v is larger than a threshold, θ_v (set to 0.7 in our experiments), then the part is classified as visible, otherwise occluded.

5.3.2.2 Joint Likelihood of Multiple Objects

A part hypothesis is represented as a four-tuple $\mathbf{z}=\{l, \mathbf{p}, s, v\}$, where l is a label indicating the part type, \mathbf{p} is the image position, s is the size, and v is the visibility score. A human hypothesis in one image frame, H consists of four parts, $H=\{\mathbf{z}_i | l_i \in Part\}$, where $Part=\{FB, HS, T, L\}$ is the set of part types (FB, HS, T, L stand for full body, head shoulder, torso, and legs, respectively). The set of all human hypotheses in one

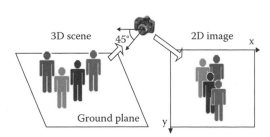

Figure 5.13 3D scene structure assumption. (From Wu, B. and Nevatia, R., *Int. J. Comput. Vision*, 75, 247, 2007. With permission.)

frame is $Z = \{H_i\}_{i=1}^m$, where m is the number of humans. We represent the set of all visible part hypotheses as

$$\tilde{Z} = \left\{ \mathbf{z}_i \in Z \mid v_i > \theta_v \right\} \tag{5.14}$$

\tilde{Z} is a subset of Z by removing all occluded part hypotheses. We assume that the likelihoods of the visible part hypotheses in \tilde{Z} are conditionally independent. Let $R = \{\mathbf{r}_i\}_{i=1}^n$ be the set of all part detection responses, where n is the overall number of the responses, and \mathbf{r}_i is a single response, which is in the same space as \mathbf{z}_i. The Hungarian algorithm (Kuhn 1955) is used to match the detection responses and hypotheses. Given an affinity matrix between two sets, the Hungarian algorithm can find the best assignment between them in polynomial time. After matching, the responses in R and the hypotheses in \tilde{Z} are classified into three categories: successful detections (SD, responses that have matched hypotheses), false alarms (FA, responses that do not have matched hypotheses), and false negative (FN, hypotheses that do not have matched responses), i.e., missing detections, denoted by T_{SD}, T_{FA}, and T_{FN} respectively. With R as the observation and \tilde{Z} as the state, we define the following likelihood to interpret the outcome of the part detectors for an image I:

$$P(I \mid Z) = P(R \mid \tilde{Z}) = \prod_{(\mathbf{r},\mathbf{z}) \in T_{SD}} P_{SD} P(\mathbf{r} \mid \mathbf{z}) \prod_{\mathbf{r} \in T_{FA}} P_{FA}(\mathbf{r}) \prod_{\mathbf{z} \in T_{FN}} P_{FN}(\mathbf{z}) \tag{5.15}$$

where

(\mathbf{r}, \mathbf{z}) is a pair of matched response and hypothesis,
P_{SD} is the reward of a successful detection,
P_{FA} and P_{FN} are the penalties of a false alarm and a false negative, respectively.

In practice, we assume that for a match (\mathbf{r}, \mathbf{z}), the distribution of \mathbf{r} given \mathbf{z} is Guassian distribution, i.e., $P(\mathbf{r} \mid \mathbf{z}) = \exp\left[-\dfrac{\|\mathbf{p_r} - \mathbf{p_z}\|^2}{\sigma_\mathbf{p}^2} \right] \exp\left[-\dfrac{(s_\mathbf{r} - s_\mathbf{z})^2}{\sigma_s^2} \right].$

Denote by N_{FA}, N_{SD}, and N_G the number of false alarms, the number of successful detections, and the number of ground-truth objects respectively.

P_{FA} and P_{SD} are calculated by

$$P_{FA} = \frac{1}{\alpha} e^{-\beta} \frac{N_{FA}}{N_{FA} + N_{SD}}, \quad P_{SD} = \frac{1}{\alpha} e^{\beta} \frac{N_{SD}}{N_{FA} + N_{SD}} \qquad (5.16)$$

where α is a normalization factor so that $P_{FA} + P_{SD} = 1$ and β is a factor to control the relative importance of detection rate versus false alarms (set to 0.5 in our experiments). P_{FN} is calculated by $P_{FN} = (N_G - N_{SD})/N_G$. N_{FA}, N_{SD}, N_G, and $P(\mathbf{r}|\mathbf{z})$ are all learned from a verification set. For different part detectors, they are different.

5.3.2.3 Searching for the Best Configuration

Finally, we need a method to propose the hypotheses to form the candidate state Z and search the solution space to maximize the posterior probability $P(Z|I)$. According to Bayes' rule

$$P(Z \mid I) \propto P(I \mid Z)P(Z) = P(R \mid \tilde{Z})P(Z) \qquad (5.17)$$

Assuming a uniform distribution of the prior $P(Z)$, the above MAP estimation is equal to maximizing the joint likelihood $P(R|\tilde{Z})$. In our method, the initial set of hypotheses Z is proposed from the responses of the head-shoulder and full-body detectors. Each full-body or head-shoulder response generates one human hypothesis. Then, the hypotheses are verified with the above likelihood model in their depth order. The steps of this procedure are listed in Figure 5.14.

Figure 5.15 gives an example of the results of the combination algorithm. At the initial state, there are two false alarms, which do not get enough evidence and are discarded later. The legs of the human in the middle are occluded by another human and missed by the legs

Searching algorithm for combining part detection responses

Input: Part detection responses.

Output: Combined detection responses.

1. Propose the initial object hypotheses from the head-shoulder and full-body detection responses.
2. Sort the hypotheses such that the y-coordinates of their feet are in descending order.
3. Examine the hypotheses one by one from front to back
 - For one hypothesis H, compute the joint occlusion maps with and without H.
 - Match the detection responses with visible objects parts.
 - Compute the image likelihood with H, $P_w(H)$, and without H, $P_{w/o}(H)$.
 - If $P_w(H) > P_{w/o}(H)$, accept the hypothesis; otherwise reject it.

Figure 5.14 Searching algorithm for combining part detection responses. (From Wu, B. and Nevatia, R., *Int. J. Comput. Vision*, 75, 247, 2007. With permission.)

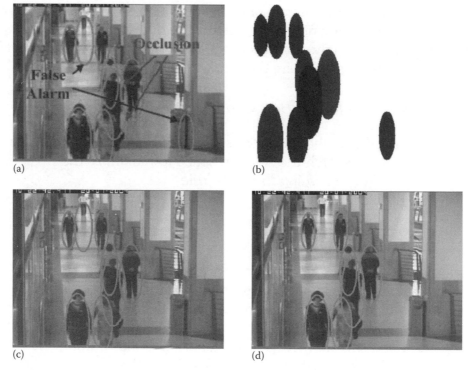

(a)

(b)

(c)

(d)

Figure 5.15 Example of combined part detection: (a) initial state, (b) occupancy map of the initial state, (c) an intermediate state, and (d) final state. (From Wu, B. and Nevatia, R., *Int. J. Comput. Vision*, 75, 247, 2007. With permission.)

detector, but this missing part can be explained by inter-object occlusion, so no penalty is put on it. In our combination algorithm, the detectors of torso and legs are not used to propose human hypotheses. This is because the detectors used for initialization have to scan

the whole image, while the detectors for verification only need to scan the neighborhood of the proposed hypotheses. So, if we use all the four part detectors, the system will be at least two times slower. Also, we found that the union of the full-body and head-shoulder detection responses already gives very high detection rates and that most of the time, the part that is occluded is the lower body. We call the above Bayesian combination algorithm a *combined detector*, whose outputs are *combined responses*.

5.3.3 Examples

The part samples are generated from the full-body samples used in Section 5.2.3.2 based on their definition in Figure 5.11. For each part, a multi-view detector is trained by the CBT method. To evaluate our combined detector with occlusion, we use 54 frames with 271 humans from the CAVIAR sequences.* In this set, 75 humans are partially occluded by others, and 18 humans are partially out of the scene. The CAVIAR data is not included in our training set. Figure 5.16 shows the precision-recall curves of our part, full body, and

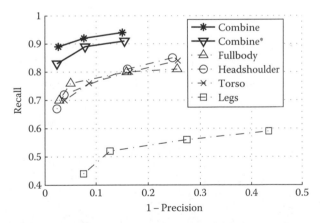

Figure 5.16 Recall-precision curves on the CAVIAR test set (54 images with 271 humans). Combine* is the detection rate on the 75 partially occluded humans. (From Wu, B. and Nevatia, R., *Int. J. Comput. Vision*, 75, 247, 2007. With permission.)

* http://iris.usc.edu/~bowu/DatasetWebpage/dataset.html

the combined detectors on this set. The curve labeled "Combine*" in Figure 5.16 shows the performance on the 75 occluded humans, and Table 5.1 lists the detection rates on different degrees of occlusion. Figure 5.17 shows some image results on the CAVIAR test set.

It can be seen that for the crowded scene: (1) the performance of full-body and legs detectors decreases greatly, as lower body is more likely to be occluded; (2) the combined detector outperforms the individual detectors; (3) the detection rates on partially occluded humans is only slightly lower than the overall detection rate and declines slowly with the degree of occlusion. In the first example of Figure 5.17, the occluded person is detected just from the head-shoulder detector output. Note that even though the head-shoulder detector by itself may create several false alarms, this results in a false alarm for the combined result only if the head shoulder is found in the right relation to another human.

TABLE 5.1 Detection Rates on Different Degrees of Occlusion (with 19 False Alarms)

Occlusion degree (%)	25–50	50–75	>70
Human no.	34	31	10
Detection rate (%)	91.2	90.3	80

Source: Wu, B. and Nevatia, R., *Int. J. Comput. Vision*, 75, 247, 2007. With permission.

Figure 5.17 Examples of combined detection results on the CAVIAR test set. (Rectangles are part detection results and eclipses are combined detection results.) (From Wu, B. and Nevatia, R., *Int. J. Comput. Vision*, 75, 247, 2007. With permission.)

5.4 PEDESTRIAN TRACKING BY ASSOCIATING DETECTION RESPONSES*

Tracking objects in videos is one step beyond the detection problem, as the object identities need to be maintained. For an automatic multiple object–tracking system, three main issues need to be addressed: (1) when to initialize a trajectory; (2) how to track an object; and (3) when to terminate a trajectory. Our approach relies on single frame human detection responses to answer these questions. We do not rely on background modeling, and hence our method does not require any special preprocessing for moving and/or zooming cameras.

5.4.1 Part-Based Detection Responses

The output of the detection system consists of three levels. The first level is a set of the *original responses* of the detectors. In this set, one object may have multiple corresponding responses. The second level is that of the *merged responses*, which are the result of applying an agglomerative clustering algorithm to the original responses. In the set of merged responses, one object has at most one corresponding response. The third level is that of the combined responses. One combined response has several matched part responses. The detection responses may not have a high spatial accuracy, because the training samples include some parts of the background regions in order to cover some position and size variations.

5.4.2 Part-Based Tracking Module

Both the original and the merged detection responses are part responses. In this section, we represent a part response by: $\mathbf{rp} = \{l, \mathbf{p}, s, v, \zeta, \mathbf{c}\}$, where l, \mathbf{p}, s, and v are the same as those in Section 5.3, ζ is a classification confidence from the boosted classifier, and \mathbf{c} is an appearance model. The first five elements are obtained directly from the detection process. The appearance model \mathbf{c} is implemented as a color histogram. The representation of a combined response is the union of the representations of its parts $\mathbf{rc} = \{\mathbf{rp}_i | l_i \in Part\}$.

* From Wu, B. and Nevatia, R., *IJCV*, 75(2), 247, 2007b. With permission.

5.4.2.1 Affinity for Detection Responses

Object parts are detected frame by frame. In order to decide whether two part responses, \mathbf{rp}_1 and \mathbf{rp}_2, of the same part type from different frames belong to one object, an affinity measure is defined by

$$A(\mathbf{rp}_1, \mathbf{rp}_2) = A_{\text{pos}}(\mathbf{p}_1, \mathbf{p}_2) A_{\text{size}}(s_1, s_2) A_{\text{appr}}(\mathbf{c}_1, \mathbf{c}_2) \qquad (5.18)$$

where A_{pos}, A_{size}, and A_{appr} are affinities based on position, size, and appearance respectively. Their definitions are

$$A_{\text{pos}}(\mathbf{p}_1, \mathbf{p}_2) = \gamma_{\text{pos}} \exp\left[-\frac{(x_1 - x_2)^2}{\sigma_x^2}\right] \exp\left[-\frac{(y_1 - y_2)^2}{\sigma_y^2}\right]$$

$$A_{\text{size}}(s_1, s_2) = \gamma_{\text{size}} \exp\left[-\frac{(s_1 - s_2)^2}{\sigma_s^2}\right]$$

$$A_{\text{appr}}(\mathbf{c}_1, \mathbf{c}_2) = B(\mathbf{c}_1, \mathbf{c}_2) \qquad (5.19)$$

where
$B(\mathbf{c}_1, \mathbf{c}_2)$ is the Bhattacharyya distance between two histograms
γ_{pos} and γ_{size} are normalizing factors

The affinity between two combined responses, \mathbf{rc}_1 and \mathbf{rc}_2, is the average of the affinities between their common visible parts

$$A(\mathbf{rc}_1, \mathbf{rc}_2) = \frac{\sum_{l_i \in \text{Prt}} A(\mathbf{rp}_{1,i}, \mathbf{rp}_{2,i}) I(v_{1,i}, v_{2,i} > \theta_v)}{\sum_{l_i \in \text{Prt}} I(v_{1,i}, v_{2,i} > \theta_v)} \qquad (5.20)$$

where
$\mathbf{rp}_{j,i}$ is the response of the part i of the combined response \mathbf{rc}_j
$v_{j,i}$ is the visibility score of $\mathbf{rp}_{j,i}$
$j = 1, 2$
I is an indicator function

The above affinity functions encode the information on the position, size, and appearance. Given the affinity, we match the detection responses with the object hypotheses by the Hungarian algorithm (Kuhn 1955).

5.4.2.2 Trajectory Initialization and Termination

The basic idea of the initialization strategy is to start a trajectory when enough new evidence is collected from the detection responses. Define the precision, pr, of a detector as the ratio between the number of successful detections and the number of all positive responses. If pr is constant for all frames, and the detection procedures in different frames are fully independent, then during consecutive T time steps, the probability that the detector outputs T consecutive false alarms is $P_{FA} = (1 - pr)^T$. However, this inference is not accurate for real videos, where the inter-frame dependence is not negligible. If the detector outputs a false alarm at a certain position in one frame, the probability is high that a false alarm will appear around the same position in the next frame. We call this the *persistent false alarm* problem. Even here, the real P_{FA} should be an exponentially decreasing function of T, and we model it as $e^{-\lambda_{init}\sqrt{T}}$.

Suppose we have found T (>1) consecutive responses, $\{\mathbf{rc}_1, \ldots, \mathbf{rc}_T\}$, corresponding to one object hypothesis H. The confidence of initializing a trajectory for H is then defined by

$$\text{InitConf}(H; \mathbf{rc}_{1\ldots T}) = \underbrace{\frac{1}{T-1} \sum_{t=1}^{T-1} A\left(\widehat{\mathbf{rc}}_{t+1}, \mathbf{rc}_{t+1}\right)}_{(1)} \cdot \underbrace{\left(1 - e^{-\lambda_{init}\sqrt{T}}\right)}_{(2)} \qquad (5.21)$$

where $\widehat{\mathbf{rc}}_{t+1}$ is the prediction of \mathbf{rc}_t at the next frame. The first term in the left side of Equation 5.21 is the average affinity of the T responses, and the second term is based on the combined detector's accuracy. The more accurate the combined detector is, the larger the parameter λ_{init}. Our trajectory initialization strategy is the following: if InitConf(H) is larger than a threshold, θ_{init}, a trajectory is started from H, and H is considered to be a *confident trajectory*; otherwise H is

considered to be a *potential trajectory*. A trajectory is represented as a triple

$$\left\{\{\mathbf{rc}_t\}_{t=1,\ldots,T}, \mathbf{D}, \{\mathbf{C}_i\}_{i \in \text{Part}}\right\}$$

where
 $\{\mathbf{rc}_t\}$ is a series of responses
 $\{\mathbf{C}_i\}$ is the appearance model of the parts
 \mathbf{D} is a dynamic model

In practice, \mathbf{C}_i is the average of the appearance models of all detection responses of part i, and \mathbf{D} is modeled by a Kalman filter for constant speed motion.

The strategy of terminating a trajectory is similar to that of initializing it. If no detection responses are found for an object hypothesis H for consecutive T time steps, we compute a termination confidence to determine whether to end it; we call it a *dead trajectory*, or otherwise an *alive trajectory*.

5.4.2.3 Trajectory Growth

After a trajectory is initialized, an object is tracked by two strategies: data association and mean-shift tracking. Given a new frame, for all existing hypotheses, we first look for their corresponding detection responses. If there is a new detection response that matches a hypothesis H, then H grows by data association; otherwise, a mean-shift tracker (Comaniciu et al. 2001) is applied. The data association itself has two steps. First, all the hypotheses are matched with the combined responses by the method described in Section 5.4.2.1. Second, all the hypotheses that are not matched in the first step are associated with the remaining part responses that do not belong to any combined response. Matching part responses with hypotheses is a simplified version of the method for matching combined responses with hypotheses. Instead of the affinity measure in Equation 5.20 for combined responses, the affinity for part responses in Equation 5.18 is used. At least one part must be detected for an object to be tracked by data association. We do not associate the

part responses with the tracks directly, because occlusion reasoning, completed before association from the detection responses in the current frame is more robust than from the predicted hypotheses, which are not very reliable.

Whenever data association fails (i.e., the detectors cannot find the object or the affinity is low), a mean-shift tracker (Comaniciu et al. 2001) is applied to track the parts individually. The results are then combined to form the final estimation. The basic idea of the mean-shift technique is to track a probability distribution. Although the mean-shift technique is typically used to track a color-based distribution, there is no constraint on the type of the distribution. In our method, we combine the appearance model \mathbf{C}, the dynamic model \mathbf{D}, and the detection confidence ζ to build a likelihood map that is then fed into the mean-shift tracker. A dynamic probability map, $P_{\mathrm{dyn}}(\mathbf{u})$, where \mathbf{u} represents the image coordinates, is calculated from the dynamic model \mathbf{D}, see Figure 5.18d. Denote the original responses of one part detector at the frame j by \mathbf{rp}_j, the detection probability map $P_{\mathrm{det}}(\mathbf{u})$ is defined by

$$P_{\mathrm{det}}(\mathbf{u}) = \sum_{j:\mathbf{u}\in\mathrm{Reg}(\mathbf{rp}_j)} \zeta_j + ms \qquad (5.22)$$

where
- $\mathrm{Reg}(\mathbf{rp}_j)$ is the rectangular image region corresponding to \mathbf{rp}_j
- ζ_j is a real-valued detection confidence of \mathbf{rp}_j
- ms is a constant corresponding to the missing rate (the ratio between the number of missed objects and the total number of objects)

ms is calculated after the detectors are learned. If one pixel belongs to multiple positive detection responses, then we set the detection score of this pixel as the sum of the confidences of all these responses; otherwise, we set the detection score as the average missing rate, which is a positive number. The detection score reflects the object salience based on shape cues. Note, the original responses are used here to avoid the effects of errors in the clustering algorithm (see Figure 5.18e).

Let $P_{\mathrm{appr}}(\mathbf{u})$ be the appearance probability map. As \mathbf{C} is a color histogram (the dimension is $32 \times 32 \times 32$ for r, g, b channels), $P_{\mathrm{appr}}(\mathbf{u})$

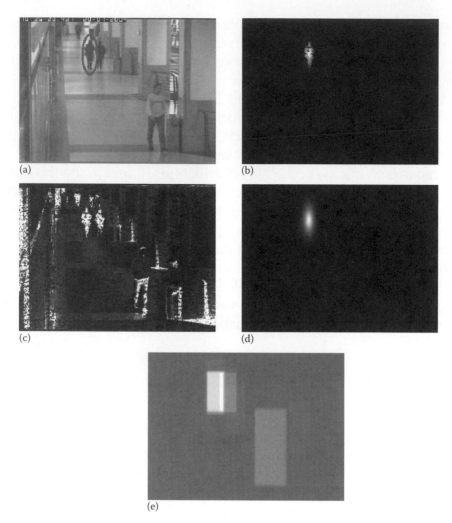

Figure 5.18 Probability map for the mean-shift tracker: (a) is the original frame; (b) is the final probability map; (c), (d), and (e) are the probability maps for appearance, dynamic, and detection, respectively. (The object concerned is marked by an ellipse.) (From Wu, B. and Nevatia, R., *Int. J. Comput. Vision*, 75, 247, 2007. With permission.)

is the bit value of **C** (see Figure 5.18c). To estimate **C**, we need the object to be segmented so that we know which pixels belong to the object; the detection response rectangle is not accurate enough for this purpose. Also, for articulated objects, it is difficult to build a constant

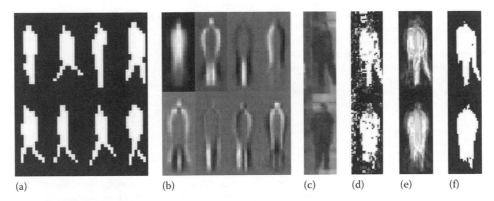

Figure 5.19 PCA-based body part segmentation: (a) training samples; (b) eigenvectors. The top left is the mean vector; (c) original human samples; (d) color probability map; (e) PCA reconstruction; (f) thresholded segmentation map. (From Wu, B. and Nevatia, R., *Int. J. Comput. Vision*, 75, 247, 2007. With permission.)

segmentation mask. We propose a simple PCA-based approach. At the training stage, examples are collected and the object regions are labeled by hand (see Figure 5.19a). A PCA model is then learned from the training data (see Figure 5.19b). Suppose we have an initial appearance model C_0, given a new sample (Figure 5.19c) we first calculate its color probability map from C_0 (Figure 5.19d), then use the PCA model as a global shape constraint by reconstructing the probability map (Figure 5.19e). The thresholded reconstruction map (Figure 5.19f) is taken as the final object segmentation, which is used to update C_0. The mean vector, the first of Figure 5.19b, is used to compute C_0 at the beginning. For each part, we learn a PCA model. Though this segmentation method is far from perfect, it is very fast and adequate enough to update the appearance model.

5.4.2.4 The Combined Tracker

We now put the above three modules, namely, trajectory initialization, tracking, and termination, together. Figure 5.20 shows the full *forward* tracking algorithm (it only looks ahead). Trajectory initialization has a delay; to compensate we also apply a *backward* tracking procedure, which is the exact reverse of the forward tracking. After a trajectory is initialized, it may grow in both the forward and backward directions.

Forward part-based combined object-tracking algorithm

Input: Part detection responses
Output: Object trajectories
Let the set of hypotheses be S, initially $S = \Phi$.
For each time step t (denote by S_t the set of all alive trajectories in S at time t)
1. Static detection:
 - Detect parts. Let the result set be RP_t.
 - Combine part detection responses, including inter-object occlusion reasoning. Let the result set be RC_t.
 - Subtract the parts used in RC_t from RP_t.
2. Data association:
 - Associate hypotheses in S_t with combined responses in RC_t. Let the set of matched hypotheses be S_{t1}.
 - Associate hypotheses in $S_t - S_{t1}$ with part responses in RP_t. Let the set of matched hypotheses be S_{t2}.
 - Build a new hypothesis H from each unmatched response in RC_t, and add H into S and S_t.
3. Pure tracking: For each confident trajectory in $S_t - S_{t1} - S_{t2}$, grow it by mean-shift tracking.
4. Model update:
 - For each hypothesis in $S_{t1} + S_{t2}$, update its appearance model and dynamic model.
 - For each potential trajectory in S_{t1}, update its initialization confidence.
 - For each trajectory in $S_{t1} + S_{t2}$, reset its termination confidence to 0.
 - For each trajectory in $S_t - S_{t1} - S_{t2}$, update its termination confidence.

Figure 5.20 Forward part-based combined object tracking algorithm. (From Wu, B. and Nevatia, R., *Int. J. Comput. Vision*, 75, 247, 2007. With permission.)

A simplified version of the combined tracking method is to track only a single part, e.g., the full body. Later in Section 5.4.3, we show that the combined tracking outperforms the single part tracking. The combined tracking method is robust because

- The combined tracker uses combined detection responses, which have high precision, to start trajectories. This results in a very low false alarm rate at the trajectory initialization stage.
- The combined tracker attempts to find the corresponding part responses of an object hypothesis. The probability that at least one part detector finds the object is relatively high.
- The combined tracker tries to follow the object by tracking its parts, either by data association or by mean-shift technique. This enables the tracker to work with both the scene and inter-object occlusions.
- The combined tracker takes the average of the part tracking results as the final human position. Hence, even if the tracking of one part drifts, the position of the human can still be accurately tracked.

5.4.3 Examples

We evaluated our pedestrian tracker on three video sets. The first set consists of the 26 "shopping center corridor view" sequences of the CAVIAR video corpus. The second set, called the "skate board set," is captured from a camera held by a person standing on a moving skateboard. The third set, called the "building top set," is captured from a camera held by a person standing on the top of a four-story building looking down toward the ground. The camera motions in the skateboard set include both translation and panning, while those of the building top set are mainly panning and zooming. The frame size of these two sets is 720×480 pixels, and the sampling rate is 30 FPS. We compare our results on the CAVIAR set with a previous system from our group (Zhao et al. 2008).

5.4.3.1 Track Level Evaluation Criteria

To evaluate the performance of our system quantitatively, we define the following five track level criteria:

1. Number of "mostly tracked" trajectories (more than 80% of the trajectory is tracked)
2. Number of "mostly lost" trajectories (more than 80% of the trajectory is lost)
3. Number of "fragments" of trajectories (a result trajectory that is less than 80% of a ground-truth trajectory)
4. Number of false trajectories (a result trajectory corresponding to no real object)
5. The frequency of identity switches (identity exchanges between a pair of result trajectories)

Figure 5.21 illustrates these definitions. Although these five categories are not a complete classification, they cover most of the typical errors observed in our experiments.

5.4.3.2 Results on the CAVIAR Set

In this experiment, we compared our method with that in Zhao et al. (2008). This method is based on background subtraction and requires

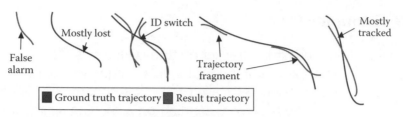

Figure 5.21 Track level evaluation criteria. (From Wu, B. and Nevatia, R., *Int. J. Comput. Vision*, 75, 247, 2007. With permission.)

a calibrated stationary camera. We test our method and that of Zhao et al. (2008) on the 26 CAVIAR sequences. The scene of this set is relatively uncluttered; however, the inter-object occlusion is intensive. Frequent interactions between humans, such as talking and shaking hands, make this set challenging for tracking. Our detectors require the width of humans to be larger than 24 pixels. In the CAVIAR set, there are 40 humans, which are usually less than 24 pixels wide, and 6 humans, which are mostly out of the scene. We mark these small humans and out-of-sight humans in the ground-truth as "do not care." Table 5.2 shows the scores. It can be seen that our method outperforms the method of Zhao et al. (2008) when the resolution is not very low. This comes from the low false alarm rate of the combined detector. Some example results on this set are shown in Figure 5.22. However, on the small humans, our shape-based method does not work well (the combined tracker gets only one out of the 40 small humans tracked) while the motion-based tracker gets 21 small humans mostly tracked.

TABLE 5.2 Tracking Performance of the Combined Tracker on the CAVIAR Set

	GT	MT	ML	Fgmt	FAT	IDS
Zhao et al. (2008)	189	121	8	73	27	20
This method		140	8	40	4	19

Source: Wu, B. and Nevatia, R., *Int. J. Comput. Vision*, 75, 247, 2007. With permission.

Note: GT, ground-truth; MT, mostly tracked; ML, mostly lost; Fgmt, trajectory fragment; FAT, false alarm trajectory; IDS, ID switch.

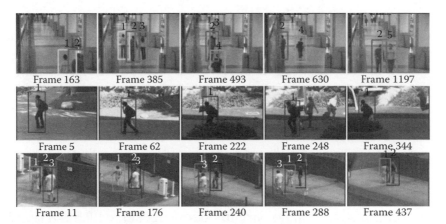

Figure 5.22 Example results of our combined. (The numbers on the top of the boxes represent the object identities. The first row is from the CAVIAR set; the second row is from the skateboard set; and the third row is from the building top set.)

This better performance of the motion-based tracker at low resolution is because the motion-based method does not rely on a discriminative model.

5.4.3.3 Results on the Skate Board Set

The main difficulties of the skateboard set are small abrupt motions due to the uneven ground, and some occlusions. This set contains 29 sequences, 9537 frames overall. Only 13 have no occlusion at all. The combined tracking method is applied. Table 5.3 gives the tracking performance of this method. Some example results on this set are shown in Figure 5.22.

TABLE 5.3 Tracking Performance of the Combined Tracker on the Skateboard Set

GT	MT	ML	Fgmt	FAT	IDS
50	39	1	16	2	3

Source: Wu, B. and Nevatia, R., *Int. J. Comput. Vision*, 75, 247, 2007. With permission.
Note: See Table 5.2 for abbreviations.

TABLE 5.4 Comparison between the Single Part Tracker and the Combined Tracker on a Subset of the Skateboard Set

	GT	MT	ML	Fgmt	FAT	IDS
Part tracking	21	14	2	7	13	3
Combined tracking		19	1	5	2	2

Source: Wu, B. and Nevatia, R., *Int. J. Comput. Vision*, 75, 247, 2007.
 With permission.
Note: See Table 5.2 for abbreviations.

For comparison, a single part (full-body) tracker, which is a simplified version of the combined tracker, is applied to the 13 videos that have no occlusions. Because the part detection does not have occlusion reasoning, it is not expected to work on the other 16 sequences. Table 5.4 shows the comparison results. It can be seen that the combined tracker gives fewer false alarms than the single part tracker, because the full-body detector has more persistent false alarms than the combined detector. The combined tracker also has more fully tracked objects, because it uses cues from all parts.

5.4.3.4 Results on the Building Top Set

The building top set contains 14 sequences, 6038 frames overall. The main difficulty of this set is due to the frequency of occlusions, both scene and object. No single part tracker works well on this set. The combined tracker is applied to this set. Table 5.5 shows the tracking performance. It can be seen that the combined tracker obtains very

TABLE 5.5 Tracking Performance of the Combined Tracker on the Building Top Set

GT	MT	ML	Fgmt	FAT	IDS
40	34	3	3	2	3

Source: Wu, B. and Nevatia, R., *Int. J. Comput. Vision*, 75, 247, 2007. With permission.
Note: See Table 5.2 for abbreviations.

few false alarms and a reasonable success rate. Some example results on this set are shown in Figure 5.22.

5.4.3.5 Tracking Performance with Occlusions

We characterize the occlusion events in these sets with two criteria: if the occlusion is by a target object, i.e., a human, we call it an object occlusion; otherwise, a scene occlusion. If the period of the occlusion is longer than 50 frames, it is considered to be a long-term occlusion; otherwise, a short-term one. Overall, we have the following four categories: short-term scene, long-term scene, short-term object, and long-term object occlusions. Table 5.6 shows the tracking performance on occlusion events. The tracking success of an occlusion event means that no object is lost, no trajectory is broken, and no ID switch occurs during the occlusion. It can be seen that our method can work reasonably well in the presence of the scene and object occlusions, even those that are long term. The performance on the CAVIAR set is not as good as those on the other two sets. This is because 19 out of 96 occlusion events in the CAVIAR set are fully occluded (more than 90% of the object is occluded), while the occlusions in the other two sets are all partial.

For tracking, on average, about 50% of the successful tracking is due to the data association with combined responses, i.e., the object is "seen" by the combined detector; about 35% is due to the

TABLE 5.6 Frequency and Tracking Performance on Occlusion Events

Video Set		SS	LS	SO	LO	Overall
CAVIAR	Zhao et al. (2008)	0/0	0/0	40/81	6/15	46/96
	This method	0/0	0/0	47/81	10/15	57/96
Skate board		6/7	2/2	11/16	0/0	19/25
Building top		4/7	11/13	15/18	4/4	34/42

Source: Wu, B. and Nevatia, R., *Int. J. Comput. Vision*, 75, 247, 2007. With permission.

Note: n/m, n successfully tracked among m occlusion events. SS, short scene; LS, long scene; SO, short object; LO, long object.

data association with part responses; the remaining 15% is from the mean-shift tracker. Although the detection rate of any individual part detector is not high, the tracking level performance of the combined tracker is significantly better. The speed of the entire system is about 1 FPS.

5.5 SUMMARY

We have described a human detection and tracking method based on body part detection. Body part detectors are learned by boosting edgelet feature–based weak classifiers. We defined a joint likelihood for multiple humans based on the responses of part detectors and the explicit modeling of inter-object occlusion. The responses of the combined human detector and the body part detectors are taken as the observations of the human hypotheses and fed into the tracker. Both the trajectory initialization and the termination are based on the evidence collected from the detection responses. To track the objects, most of the time data association works, while a mean-shift tracker fills in the gaps between data association. It can work under both partial scene and inter-object occlusion conditions reasonably well.

5.6 BIBLIOGRAPHICAL AND HISTORICAL REMARKS

The literature on human detection in static images and on human tracking in videos is abundant. Many methods for static human detection represent a human as an integral whole, e.g., Papageorgiou et al.'s SVMs detectors (Papageorgiou et al. 1998), Felzenszwalb's shape models (Felzenszwalb 2001), Wu et al.'s Markov random field–based representation (Wu et al. 2005), and Gavrila et al.'s edge templates (Gavrila 2000). The object detection framework proposed by Viola and Jones (Viola and Jones 2001) has proved very efficient for the face-detection problem. The basic idea of this method is to select weak classifiers, which are based on simple features, e.g., Haar wavelets, by AdaBoost (Freund and Schapire 1996) to build a cascade-structured detector. Viola et al. (Viola et al. 2003) report that applied to human detection, this approach does not work very well using the static Haar features. They augment their system by using local motion features to achieve much

better performance. Overall, holistic representation-based methods do not work well with large spatial occlusion, as they need evidence for most parts of the whole body.

Some methods for representation as an assembly of body parts have also been developed. Table 5.7 gives a summary of the part representations. Mohan et al. (Mohan et al. 2001) report that the part-based human model is much better than the holistic model in Papageorgiou et al. (1998) for detection task. The methods of Shashua et al. (2004) and Mikolajczyk et al. (2004) using more parts both achieved better results than that of Mohan et al. (2001). Recently, several methods are developed, e.g., Lin et al. (2007) and Shet et al. (2007), to do joint part combination of multiple humans to detect humans with inter-occlusions. However, these part-based systems do not use the parts for tracking nor consider occlusions.

Several types of features have been applied to capture the pattern of humans. Some methods use spatially global features as in Felzenszwalb (2001), Gavrila (2000), and Leibe et al. (2005); others use spatially local features as in Papageorgiou et al. (1998), Mohan et al. (2001), Viola et al. (2003), Mikolajczyk et al. (2004), and Dalal and Triggs (2005). The local feature-based methods are less sensitive to occlusions as only some of the features are affected by occlusions. Dalal and Triggs (2005) compared several local features, including SIFT, wavelets, and Histogram of Oriented Gradient (HOG) descriptors for pedestrian detection. Their experiments show that the HOG descriptors outperform the other types of features on this task.

TABLE 5.7 Summary of Part Representations

Method	Part Representation
Mohan et al. (2001)	Four parts: head-shoulder, legs, left/right arm
Shashua et al. (2004)	Nine regions
Mikolajczyk et al. (2004)	Seven parts: face/head for frontal view, face/head for profile view, head-shoulder for frontal and rear view, head-shoulder for profile view, and legs
Lin et al. (2007)	Four parts: head, torso, thighs, and lower legs
Shet et al. (2007)	Head/shoulder, torso, legs

For tracking of human, some early methods, e.g., Zhao and Nevatia (2004), track motion blobs and assume that each individual blob corresponds to one human. These early methods usually do not consider multiple objects jointly and tend to fail when blobs merge or split. Some of the recent methods, e.g., Isard and MacCormick (2001), Peter et al. (2005), and Zhao et al. (2008), try to fit multiple object hypotheses to explain the foreground or motion blobs. These methods deal with occlusions by computing joint image likelihood of multiple objects. Because the joint hypotheses space is usually of high dimension, an efficient optimization algorithm, such as a particle filter (Isard and MacCormick 2001), MCMC (Zhao et al. 2008), or EM (Peter et al. 2005) is used. All of these methods have shown experiments with a stationary camera only, where the background subtraction provides relatively robust object motion blobs. The foreground blob–based methods are not discriminative. They assume all moving pixels are from humans. Although this is true in some environments, it is not in more general situations. Some discriminative methods, e.g., (Davis et al. 2000), build deformable silhouette models for pedestrians and track the models from edge features. The silhouette matching is done frame by frame. These methods are less dependent on the camera motion. However, they have no explicit occlusion reasoning.

Notation Table

A	Affinity function between a hypothesis and a detection response
b_t	Classification threshold of the tth layer in tree classifier
B	Bhattacharyya distance
\mathbf{c}, \mathbf{C}	Appearance model of an object/trajectory
C	Number of channels in tree classifier
\mathbf{D}	Dynamic model of a trajectory
D_t	Sample weights at the tth round of boosting learning
E	One edgelet feature
f, \mathbf{f}	Image feature, a vector of several image features
F, F_t	Target false alarm rate, the false alarm rate at the tth round in tree learning
h, \mathcal{H}	Weak classifier, weak classifier pool
H	Tree classifier in Section 5.2; object hypothesis in Section 5.3, 5.4
I	Affinity function of two quantized edge orientations in Section 5.2; part type in Section 5.3, 5.4

m	Number of human hypotheses
ms	Detection missing rate
M	Edge intensity
n	Size of sample space partition in Section 5.2; number of part detection responses in Sections 5.3 and 5.4
\mathbf{n}	Edge normal vector
N_{FA}, N_{SD}, N_G	Number of false alarms, number of successful detections, and number of ground-truth objects
pr	Detection precision
P_t	Positive sample passing rate for the tth layer in tree learning
P_{SD}, P_{FA}, P_{FN}	Reward of successful detection, penalty of false positive, penalty of false negative
$P_{dyn}, P_{det},$ P_{appr}	Tracking probability map based on dynamics, detection, and appearance.
\mathbf{r} $(\mathbf{rp}), \mathbf{rc},$ R $(RP), RC$	Part detection response, combined detection response, set of part detection responses, set of combined detection responses
s	Size of a detection response
S	Sample set in Section 5.2; set of trajectory hypotheses in Section 5.4
T	Number of weak classifiers in Section 5.2; number of time steps in Section 5.4
T_{SD}, T_{FA}, T_{FN}	Sets of successful detection, false positive, false negative
$\mathbf{u}, \mathbf{w}, \mathbf{p}$	Coordinates of 2D point/pixel
v	Visibility score of a part hypothesis
V	Quantized edge orientation
W	Sample weight distribution on a sample space partition
\mathbf{x}, χ, X	Image sample, sample space, one set of samples
y	Sample label
\mathbf{z}	Part hypothesis
Z	Discriminative power measure for weak classifiers in Section 4.2; set of part hypotheses in Sections 5.3 and 5.4.
α, β	Parameters used to compute reward/penalty of successful detection/false positive
ε	Smoothing factor for weak classifier learning
ζ	Classification confidence
θ_B	Parameter controlling bootstrapping in tree classifier learning
θ_v	Parameter determining the visibility of part hypotheses
θ_Z	Parameter controlling node splitting in tree classifier learning
$\lambda_{init}, \theta_{init}$	Parameters controlling trajectory initialization

REFERENCES

Bresenham, J. E. 1965. Algorithm for computer control of a digital plotter. *IBM Systems Journal* 4(1):25–30.

Comaniciu, D., Ramesh, V., and Meer, P. 2001. The variable bandwidth mean shift and data-driven scale selection. *International Conference of Computer Vision*, Vancouver, Canada.

Dalal, N. and Triggs, B. 2005. Histograms of oriented gradients for human detection. *Computer Vision and Pattern Recognition*, San Diego, CA.

Davis, L., Philomin, V., and Duraiswami, R. 2000. Tracking humans from a moving platform. *International Conference of Pattern Recognition*, Barcelona, Spain.

Felzenszwalb, F. 2001. Learning models for object recognition. *Computer Vision and Pattern Recognition*, Kauai, HI.

Freund, Y. and Schapire, R. E. 1996. Experiments with a new boosting algorithm. *Machine Learning: Proceedings of the 13th International Conference*, Bari, Italy.

Gavrila, D. 2000. Pedestrian detection from a moving vehicle. *European Conference on Computer Vision*, Dublin, Ireland.

Huang, C., Ai, H., Li, Y., and Lao, S. 2005. Vector boosting for rotation invariant multi-view face detection. *International Conference of Computer Vision*, Beijing, China.

Isard, M. and MacCormick, J. 2001. BraMBLe: A Bayesian multiple-blob tracker. *International Conference of Computer Vision*, Vancouver, Canada.

Kuhn, H. W. 1955. The Hungarian method for the assignment problem. *Naval Research Logistics Quarterly* 2:83–87.

Leibe, B., Seemann, E., and Schiele, B. 2005. Pedestrian detection in crowded scenes. *Computer Vision and Pattern Recognition*, San Diego, CA.

Lin, Y.-Y. and Liu, T.-L. 2005. Robust face detection with multi-class boosting. *Computer Vision and Pattern Recognition*, San Diego, CA.

Lin, Z., Davis, L. S., Doermann, D., and DeMenthon, D. 2007. Hierarchical part-template matching for human detection and segmentation. *International Conference of Computer Vision*, Rio de Janeiro, Brazil.

Mikolajczyk, C., Schmid, C., and Zisserman, A. 2004. Human detection based on a probabilistic assembly of robust part detectors. *European Conference of Computer Vision*, Prague, Czech Republic.

Mohan, A., Papageorgiou, C., and Poggio, T. 2001. Example-based object detection in images by components. *IEEE Transactions on Pattern Analysis and Machine Intelligence* 23(4):349–361.

Papageorgiou, C., Evgeniou, T., and Poggio, T. 1998. A trainable pedestrian detection system. *IEEE Intelligent Vehicles Symposium*, Stuttgart, Germany.

Peter, J. R., Tu, H., and Krahnstoever, N. 2005. Simultaneous estimation of segmentation and shape. *Computer Vision and Pattern Recognition*, San Diego, CA.

Schapire, R. E. and Singer, Y. 1999. Improved boosting algorithms using confidence-rated predictions. *Machine Learning* 37:297–336.

Shashua, A., Gdalyahu, Y., and Hayun, G. 2004. Pedestrian detection for driving assistance systems: Single-frame classification and system level performance. *IEEE Intelligent Vehicles Symposium*, Parma, Italy.

Shet, V. D., Neumann, J., Ramesh, V., and Davis, L. S. 2007. Bilattice-based logical reasoning for human detection. *Computer Vision and Pattern Recognition*, Minneapolis, MN.

Tuzel, D., Porikli, F., and Meer, P. 2007. Human detection via classification on Riemannian manifolds. *Computer Vision and Pattern Recognition*, Minneapolis, MN.

Viola, P. and Jones, M. 2001. Rapid object detection using a boosted cascade of simple features. *Computer Vision and Pattern Recognition*, Kauai, HI.

Viola, P., Jones, M., and Snow, D. 2003. Detecting pedestrians using patterns of motion and appearance. *International Conference of Computer Vision*, Nice, France.

Wu, B. and Nevatia, R. 2007a. Cluster boosted tree classifier for multi-view, multi-pose object detection. *International Conference of Computer Vision*, Rio de Janeiro, Brazil.

Wu, B. and Nevatia, R. 2007b. Detection and tracking of multiple, partially occluded humans by Bayesian combination of edgelet based part detectors. *International Journal of Computer Vision* 75(2): 247–266.

Wu, Y., Yu, T., and Hua, G. 2005. A statistical field model for pedestrian detection. *Computer Vision and Pattern Recognition*, San Diego, CA.

Zhao, T. and Nevatia, R. 2004. Tracking multiple humans in complex situations. *IEEE Transactions on Pattern Analysis and Machine Intelligence* 26(9): 1208–1221.

Zhao, T., Nevatia, R., and Wu, B. 2008. Segmentation and tracking of multiple humans in crowded environments. *IEEE Transactions on Pattern Analysis and Machine Intelligence* 30(7):1198–1211.

Zhu, Q., Avidan, S., Yeh, M.-C., and Cheng, K.-T. 2006. Fast human detection using a cascade of histograms of oriented gradients. *Computer Vision and Patter Recognition*, New York.

<div align="right">

6

</div>

Vehicle Tracking and Recognition

Guoliang Fan, Xin Fan, Vijay Venkataraman, and Joseph P. Havlicek

CONTENTS

6.1 INTRODUCTION

Tracking and recognition refers to the process of being able to identify and continuously follow the movement of a specified target based on the data obtained from a variety of sensors, such as a video camera, forward-looking infrared (FLIR), and synthetic aperture radar (SAR). Tracking and recognition tasks are of great importance in military applications and are incorporated into a number of systems that aid in keeping track of a large number of targets over vast spaces. They are also used in sensor-based missile guidance systems. Civilian applications include highway traffic monitoring, restricted area surveillance, border security, etc. The task of tracking and recognition is challenging because targets of interest do not always appear the same and can have different signatures based on their pose, camouflage, etc. In addition, the sensors used to acquire information are affected by many intrinsic (focal length, IR sensitivity, etc.) and extrinsic factors (temperature, reduced visibility, etc.). Further, there are problems associated with varying backgrounds, presence of clutter, occlusion, interaction between various targets, etc.

In this chapter, we will focus specifically on the problem of signature variation due to changes in pose and vehicle type, as shown in Figure 6.1. First a compact appearance representation is developed that can reconstruct signature variations of a number of targets. Further, the fact that different vehicle types have varied motion patterns is exploited as an additional cue for tracking and recognition purposes.

We address the issue of simultaneous vehicle tracking and recognition by incorporating joint motion-appearance generative models. In particular, an integrated graphical model to encapsulate all relevant factors, that is, the vehicle type, motion, and appearance models, as well as their cause-and-effect dependencies, is presented. The appearance model is parameterized by the vehicle type and kinematics (position and pose), whereas the motion model explains the underlying dynamics by which a certain vehicle type can exhibit a given evolution or trajectory in kinematics. These dependencies are fused into a probabilistic graphical model, where the motion and appearance components interact synergistically for tracking and recognition due to their common

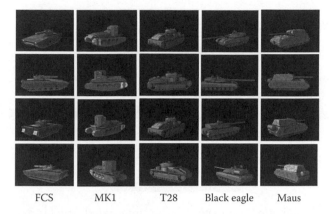

FCS MK1 T28 Black eagle Maus

Figure 6.1 3D vehicle models of the five tanks used in the experiments. Each column depicts four different poses for a particular type of tank. (From Venkataraman, V. et al., Integrated target tracking and recognition using joint appearance-motion generative models, in *Proceedings of the 5th IEEE International Workshop on Object Tracking and Classification in and beyond Visible Spectrum (OTCBVS08), in Conjunction with CVPR08*, Anchorage, Alaska, 2008. With permission. © 2008 IEEE.)

direct dependency on the vehicle type. Tracking and recognition are formulated jointly and naturally as a probabilistic inference problem. We resort to an auxiliary particle filter–based inference method in which a Kalman filter is embedded to further take advantage of the motion cue for hypothesis generation regarding the vehicle type. A number of informative experiments on simulated infrared video sequences are presented, which demonstrate the advantages and potential of the proposed approach for joint vehicle tracking and recognition.

6.2 JOINT TRACKING AND RECOGNITION FRAMEWORK

This section introduces a probabilistic framework to integrate joint appearance-motion generative models for vehicle tracking and recognition. This framework is capable of jointly estimating the vehicle type l_t and kinematics (including position \boldsymbol{p} and pose ϕ) of a moving vehicle from an image sequence $\boldsymbol{Z}_{1:t}$ in an online sequential fashion. The key

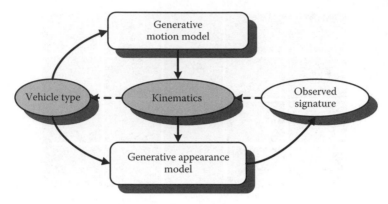

Figure 6.2 Schematic overview of the integrated tracking and recognition framework.

issue for achieving integrated tracking and recognition is to resolve the temporal and appearance variations caused by the coupled latent factors, that is, vehicle type and movements. Important dependencies exist between the vehicle type, motion, and image signatures, as illustrated in Figure 6.2. The solid arrows in this figure are directed from "cause" factors to their respective "effects" in the model, whereas the dashed arrows depict the inference process that estimates latent factors (grey ellipses) from the observed signatures (white ellipses). The generative appearance model encodes how the vehicle type and kinematics determine the image signatures, while the generative motion model explains vehicle-specific maneuvering behaviors. Intuitively, the stream along the solid arrows can form a hypotheses generation process. Thus, joint type and kinematics estimation can be achieved by hypothesis validation using observations along the dashed arrows. A graphical model is used to aggregate all the cause-and-effect factors into a probabilistic framework. We then implement the hypothesis-generation validation with particle filtering–based techniques developed for the graphical model.

The graphical model, which integrates all the factors along with their conditional dependencies, is shown in Figure 6.3, where three latent variables are estimated, including the vehicle type, $l_t \in \{1, ..., N_T\}$, the zero-order kinematics \boldsymbol{x}_t (position and pose), and the first-order

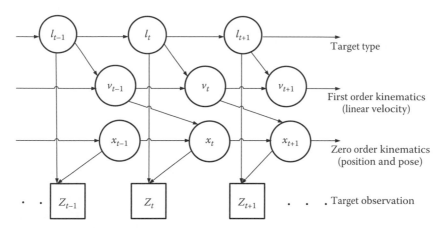

Figure 6.3 Graphical model for integrated tracking and recognition. (From Venkataraman, V. et al., Integrated target tracking and recognition using joint appearance-motion generative models, in *Proceedings of the 5th IEEE International Workshop on Object Tracking and Classification in and beyond Visible Spectrum (OTCBVS08), in Conjunction with CVPR08*, Anchorage, Alaska, 2008. With permission. © 2008 IEEE.)

kinematics v (linear velocity). The joint tracking and recognition problem is then one of estimating the posterior probability $p(l_t, \boldsymbol{x}_t, v_t | \boldsymbol{Z}_t)$.

Figure 6.3 implies the probabilistic dependencies of the joint distribution of the current observation and latent states, $p(l_t, \boldsymbol{x}_t, v_t, \boldsymbol{Z}_t | \boldsymbol{\Theta}_{t-1})$, given those in previous time step, $\boldsymbol{\Theta}_{t-1}$. The directional arcs between l_t, \boldsymbol{x}_t, and \boldsymbol{Z}_t as well as those between l_t, v_t, and \boldsymbol{x}_t show the cause-and-effect relationships that correspond to the generative appearance and motion models, respectively. The conditional dependency implies the assumption that, given the vehicle type, current position, and pose, the current observation is independent of the current kinematics, previous states, and observations; for example,

$$p(\boldsymbol{Z}_t | l_t, \boldsymbol{x}_t, v_t, \boldsymbol{\Theta}_{t-1}) = p(\boldsymbol{Z}_t | l_t, \boldsymbol{x}_t). \tag{6.1}$$

Thus, the joint probability can be factorized as

$$p(l_t, \boldsymbol{x}_t, v_t, \boldsymbol{Z}_t | \boldsymbol{\Theta}_{t-1}) = p(\boldsymbol{Z}_t | l_t, \boldsymbol{x}_t) p(l_t, \boldsymbol{x}_t, v_t | \boldsymbol{\Theta}_{t-1}), \tag{6.2}$$

where $p(\mathbf{Z}_t|l_t,\mathbf{x}_t)$ is the observation likelihood conditioned on the appearance model. Similarly, applying the conditional independence between two time steps, the last term in (6.2) becomes

$$p(l_t,\mathbf{x}_t,\upsilon_t|\Theta_{t-1}) = p(\mathbf{x}_t|\mathbf{x}_{t-1},\upsilon_{t-1})p(\upsilon_t|l_t,\upsilon_{t-1})p(l_t|l_{t-1}) \qquad (6.3)$$

where $p(\mathbf{x}_t|\mathbf{x}_{t-1}, \upsilon_{t-1})$ and $p(\upsilon_t|l_t, \upsilon_{t-1})$ are related to a generative motion model and $p(l_t|l_{t-1})$ is defined by a vehicle-type transition matrix. Due to the non-Gaussian nature of l_t and nonlinearity in the evolution of the state \mathbf{x}_t, we resort to a particle filtering framework where the theoretical posterior probability density is approximated empirically by a weighted sample set (Arulampalam et al. 2002). In this chapter, two auxiliary particle filter (APF)–based inference algorithms are developed to jointly estimate the vehicle type and zero-order kinematics. In the interest of convenience and clarity, a list of the variables used in this chapter is provided in Table 6.1.

6.3 JOINT APPEARANCE-MOTION GENERATIVE MODEL

There are two generative models involved in Figures 6.2 and 6.3, namely, the appearance model and the motion model. The former relates the latent states with the observations, whereas the latter specifies the evolution of latent states over time. The conditional dependencies among the variables in Figure 6.3 are derived from the generative models, which encode the cause-and-effect relationships between variables. These two models that share the same identity (cause) variable are together called *joint appearance-motion generative models*.

6.3.1 *Generative Appearance Model*

One major challenge in tracking and recognition is the variability of the observed target signature due to continuous pose variations and multiple target types. The nonlinearity and high dimensionality of appearance variations always encumber vehicle tracking and recognition

TABLE 6.1 Variables Used in This Chapter

B	Mapping coefficient matrix $(d \times N_c)$ between manifold and vehicle silhouette
d	Vehicle silhouette dimension
$g(\cdot)$	Projection mapping from the 3D scene to 2D image plane
i^l	Vector (1 by N_T) of vehicle-type factor
l	Vehicle type
\boldsymbol{m}_ϕ	Manifold coordinate corresponding to pose ϕ
N_c	Number of mapping kernels
N_p	Number of particles
N_T	Number of vehicle types
ω	Additive noise in kinematics evolution
\boldsymbol{p}	Vehicle position coordinates
ϕ	Vehicle pose
$\psi(\cdot)$	Nonlinear mapping with N_c kernels
Θ	Variable set including l, \boldsymbol{x}, υ, and \boldsymbol{Z}
\boldsymbol{T}	Vehicle-type transition matrix $(N_T \times N_T)$
\mathcal{T}	Core tensor $(d \times N_c \times N_T)$
u	Angular velocity
υ	Linear velocity
$\hat{\upsilon}$	Approximate linear velocity obtained from position estimates
x	Zero-order kinematics including \boldsymbol{p} and ϕ
\boldsymbol{y}_ϕ^l	Vehicle silhouette vector (1 by d) of type l under pose ϕ
\boldsymbol{Z}	Observed vehicle signature (silhouette)

tasks. A nonlinear dimensionality reduction technique is used to develop a compact target representation that can be specified by two latent variables: the pose and the identity. Specifically, we construct a generative model that employs a bilinear decomposition on nonlinear manifolds to separate vehicle-type and pose factors embedded in appearance variations. This approach is inspired by (Elgammal and Lee 2004; Lee and Elgammal 2007).

It is assumed that the appearances associated with different poses lie on a conceptual pose manifold represented by a 2D circle that is shared by all vehicles, as shown in Figure 6.4. The generative model

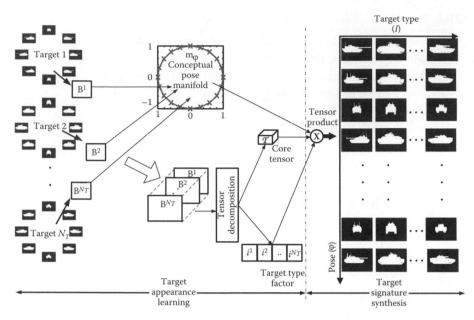

Figure 6.4 Generative appearance model for multi-pose vehicle representation. (From Venkataraman, V. et al., Integrated target tracking and recognition using joint appearance-motion generative models, in *Proceedings of the 5th IEEE International Workshop on Object Tracking and Classification in and beyond Visible Spectrum (OTCBVS08), in Conjunction with CVPR08*, Anchorage, Alaska, 2008. With permission. © 2008 IEEE.)

can be learned from a small set of training data which include vehicle signatures (i.e., silhouettes) of multiple vehicles under different poses. The learning of this model results in a mapping function from a point on the low-dimensional manifold to a high-dimensional silhouette image. This is usually accomplished by approximating the function using a few training examples (poses and corresponding silhouette images). The task of learning from examples is an ill-posed inverse problem having an infinite number of solutions; regularization is required to stabilize the solution. Nonlinear Gaussian radial basis functions (GRBF) are used to obtain the following mapping (Poggio and Girosi 1990):

$$\mathbf{y}^l_\phi = \mathbf{B}^l \psi(\mathbf{m}_\phi). \qquad (6.4)$$

For N_T different vehicle types, we can obtain the corresponding mapping functions \mathbf{B}^l for $l \in \{1, 2, \ldots, N_T\}$ that can be stacked together to

form a matrix $C=[B^1\,B^2\ldots B^{N_T}]$, as shown in Figure 6.4. The matrix C contains information about vehicle-dependent signatures pertaining to different poses. An asymmetrical bilinear decomposition is applied to the matrix C such that we separate meaningful factors such as vehicle type and pose (Tenenbaum and Freeman 2000). The tensor-based vehicle representation is then written as

$$y_\phi^l = \mathcal{T} \times_3 i^l \times_2 \psi(m_\phi).$$ (6.5)

As shown in Figure 6.4, there are two steps involved in the generative model: appearance learning and signature synthesis. The former is accomplished by finding B^l in (6.4) followed by a bilinear decomposition to obtain \mathcal{T} and i^l. The latter is characterized by (6.5), which may be used to reconstruct a vehicle signature (silhouette) of any type and pose. Once the learning is accomplished, we only need to store \mathcal{T} and i^l to provide a general vehicle representation. In addition to aiding the tracker by accounting for inter-frame appearance changes, this model can also facilitate recognition by generating distinct type-specific appearances with any pose.

6.3.2 Generative Motion Model

The generative motion model in Figures 6.2 and 6.3 specifies the evolution of the kinematic state variables over time. Motion models play an important role in traditional vehicle tracking (Li and Jilkov 2005). Multiple-model approaches have often been used to model the motion of maneuvering vehicles for tracking purpose, where a discrete process is introduced to generate switches among a finite set of linear models (Doucet et al. 2001; Li and Jilkov 2005). Graphical models can be used to capture the probabilistic dependencies underlying multiple switching models, which are typically referred to as switching linear dynamic systems (Oh et al. 2006). These methods are mainly applied for tracking highly maneuverable vehicles (Doucet et al. 2001; Oh et al. 2006; Fan et al. 2010) and for detecting changes or faults in dynamic systems (Freitas de 2001; Li and Kadirkamanathan 2001).

In practice, different vehicles are expected to exhibit widely varying kinematics and maneuverability due to the physical characteristics and

constraints of their various engines and mechanical drive systems (Fan et al. 2010). Using type-specific motion models improves our ability to capture the kinematics and maneuvering actions of different vehicles. Moreover, the use of type-specific models provides additional evidence for recognizing vehicle types. Therefore, we consider multiple 3D rigid motion models that are associated with different vehicle types.

For ground vehicles, we introduce a type dependency into the variable v which models the linear velocity along the direction of motion (x' in Figure 6.5). This dependency is given by

$$v_t = v_{t-1} + f(l_t) + s(l_t)\omega_v, \tag{6.6}$$

where $\omega_v \sim N(0,1)$, $f(l_t)$, and $s(l_t)$ are two variables specifying vehicle-dependent accelerations. It is worth noting that the dynamics of v_t are linear and Gaussian given l_t, making it possible to update the related probabilities using a Kalman filter. It now remains to specify models for the dynamics of the zero-order kinematics, namely, pose and position. The pose variable φ follows a simple dynamic model given by

$$\phi_t = \phi_{t-1} + u + \omega_\phi, \tag{6.7}$$

where $\omega_\phi \sim N(0, \sigma_\phi^2)$. This model is capable of capturing subtle rotational dynamics of a rigid vehicle. The vehicle is assumed to move only on the

Figure 6.5 3D coordinate systems associated with a ground vehicle. The axes $x'y'z'$ define the body frame, where the vehicle is assumed to move along the x'-direction and rotates about the z'-axis to avoid unrealistic motion. The xyz-axes define the observer's frame of reference, where the plane xoy is parallel to $x'o'y'$. (From Venkataraman, V. et al., Integrated target tracking and recognition using joint appearance-motion generative models, in *Proceedings of the 5th IEEE International Workshop on Object Tracking and Classification in and beyond Visible Spectrum (OTCBVS08)*, in Conjunction with CVPR08, Anchorage, Alaska, 2008. With permission. © 2008 IEEE.)

ground plane. The position of the vehicle in the observer's coordinate system is related to the velocity v and pose ϕ according to

$$\boldsymbol{p}_t = \boldsymbol{p}_{t-1} + \boldsymbol{R}(\phi_{t-1})v_{t-1} + \omega_p \qquad (6.8)$$

where \boldsymbol{R} is a rotational vector defined by $\boldsymbol{R}(\phi)=[\cos\phi \ \sin\phi]'$ and $\omega_p \sim N(0, \text{diag}(\sigma_x^2, \sigma_y^2))$. The nonlinearity introduced by the state transition equation (6.8) requires a sampling based inference. Since the type-dependent velocity appears in (6.8), N_T distinct models are needed to characterize the type-specific motion patterns.

6.3.3 Examples

A comprehensive vehicle database that includes 3D models of many ground vehicles, mainly tanks, was acquired for this research. This section examines the generative appearance model in terms of its capability of synthesizing unknown signatures, that is, silhouettes not available in the training database. Five tank models from this database—FCS, MK1, T28, Eagle, and Maus—were used and are shown in Figure 6.1. From these 3D models, we obtain silhouettes of dimension 60×80 corresponding to different poses (1°–360°) of a particular tank. These silhouettes are transformed into gray-scale images using the signed distance transform as in Elgammal and Lee (2004) and Lee and Elgammal (2007) to impose smoothness of the distance between poses and incorporate shape information. For each vehicle k, the mapping (\boldsymbol{B}^k) is found using 24 silhouettes corresponding to poses spaced 15° apart. For a detailed discussion on learning the mapping coefficients of the generative model see (Elgammal and Lee 2007).

Once the model has been learned, we can synthesize a silhouette of any vehicle type at any given pose. Figure 6.6 shows the mean square error (MSE) of such a synthesis when using the generative model (G15) and compares it to the case of using templates (T15) sampled 15° apart. It is observe that synthesized silhouettes have much lower MSE than the template-based approach. Figure 6.7 illustrates the reconstructed silhouettes for a few untrained poses. The reconstructions closely resemble the true templates for most view angles, even in the cases where the reconstruction error is relatively high. However, it should be noted in both figures that significantly larger errors occur for pose

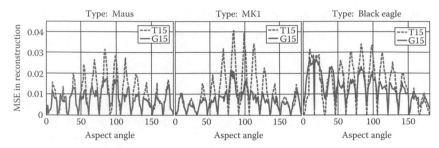

Figure 6.6 (See color insert following page 332.) Comparison of reconstruction MSE for the generative model (G15) and the template model (T15). The solid and dashed lines denote the reconstruction errors of G15 and T15, respectively. The errors obtained using G15 are significantly lower than that of T15 for poses unavailable in the training set. The range of poses shown is limited to 180° due to the inherent symmetry of the reconstruction error. (From Venkataraman, V. et al., Integrated target tracking and recognition using joint appearance-motion generative models, in *Proceedings of the 5th IEEE International Workshop on Object Tracking and Classification in and beyond Visible Spectrum (OTCBVS08), in Conjunction with CVPR08*, Anchorage, Alaska, 2008. With permission. © 2008 IEEE.)

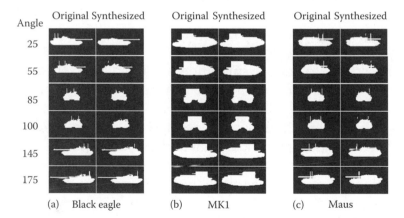

Figure 6.7 Reconstructed vehicle silhouettes using the generative appearance model. Three vehicle types are shown with 12 pose angles that were not included in the training set. (From Venkataraman, V. et al., Integrated target tracking and recognition using joint appearance-motion generative models, in *Proceedings of the 5th IEEE International Workshop on Object Tracking and Classification in and beyond Visible Spectrum (OTCBVS08), in Conjunction with CVPR08*, Anchorage, Alaska, 2008. With permission. © 2008 IEEE.)

angles near 90° due to the fact that there is more perceived change per degree of rotation around this angle. This suggests that a uniformly sampled circular manifold may not be an optimal representation of the true underlying structure of the view manifold.

6.4 INFERENCE ALGORITHM FOR JOINT TRACKING AND RECOGNITION

In our framework, joint vehicle tracking and recognition is formulated as inference of the posterior density $p(l_t, \boldsymbol{x}_t, v_t | \boldsymbol{Z}_t)$. Regarding statistical inference algorithms, Blom's interacting multiple-model (IMM) algorithm is one of the most widely used inference algorithms for multiple models under Gaussian assumptions (Blom and Bar-Shalom 1988). Sample-based approximations, specifically particle filters (Gordon et al. 1993), are often employed in non-Gaussian cases with multiple motion models (Doucet et al. 2001; McGinnity and Irwin 2001). In order to improve the performance of particle filters, intensive research has been focused on devising better proposal densities for sampling to provide efficient and robust state estimation. For example, the APF (Pitt and Shephard 1999) introduces auxiliary variables to enable the current observation to be considered in the proposal generation, whereas the Rao-Blackwellised particle filter (RBPF) uses a Kalman filter to analytically estimate Gaussian variables and approximate non-Gaussian variables by sampling (Nando de et al. 2004).

This section presents an APF for inferring $p(l_t, \boldsymbol{x}_t, v_t | \boldsymbol{Z}_t)$ in the graphical model framework. The samples of the probability $p(l_t, \boldsymbol{x}_t, v_t | \boldsymbol{\Theta}_{t-1})$ in (6.3) can be generated from carefully designed proposal densities and weights are then assigned by (6.2). A straightforward choice for sampling $p(l_t, \boldsymbol{x}_t, v_t | \boldsymbol{\Theta}_{t-1})$ is to directly employ the generative motion model that provides $p(\boldsymbol{x}_t | \boldsymbol{x}_{t-1}, v_{t-1})$ and $p(v_t | l_t, v_{t-1})$, as well as the predefined type-transition matrix $p(l_t | l_{t-1})$ appearing on the right side of (6.3). In the APF-based algorithm, a better proposal is developed to generate the samples for position and pose (\boldsymbol{x}_t) by incorporating the current appearance observation (Pitt and Shephard 1999). Samples of the vehicle type and velocity variables are obtained from a transition matrix with an annealing-like strategy and from the type-dependent motion model $p(v_t | l_t, v_{t-1})$, respectively.

6.4.1 Auxiliary Particle Filter Algorithm

Dynamics: The dynamics of velocity v_t, pose ϕ_t, and position \boldsymbol{p}_t are defined in (6.6) through (6.8), respectively. In order to maintain multiple hypotheses about the vehicle identity, the dynamics of the identity variable l_t are defined as

$$p(l_t = i \,|\, l_{t-1} = j) = \boldsymbol{T}_t(i, j); \quad i, j \in \{1, 2, ..., N_T\}, \tag{6.9}$$

The function $\boldsymbol{T}_t(i, j)$ in (6.9) follows an annealing-like strategy defined by

$$\boldsymbol{T}_t(i, j) = \begin{cases} 1 - \exp(-at) & \text{if } i = j, \\ \dfrac{\exp(-at)}{N_T - 1} & \text{if } i \neq j, \end{cases} \tag{6.10}$$

where a is a fixed positive constant. This empirical formulation of $\boldsymbol{T}_t(i, j)$ gradually reduces the probability of an identity switch over time and is based on the expectation that we become increasingly confident of the identity estimation as time progresses. However, the value of a must be tuned based on the reliability of the observations.

Observation likelihood: We assume that a vehicle of a particular identity is moving in a 3D scene according to its dynamics and is observed using a stationary, precalibrated perspective camera with known parameters. Given the vehicle type, pose, and position, we can synthesize the vehicle silhouette using the generative model (6.5). This silhouette is then appropriately placed on the 2D image plane with specific scale and position by a projection mapping using the camera parameters. Assuming that the observed image sequences are corrupted by additive i.i.d. Gaussian noise distributed as $N(0, \sigma_{\text{obs}}^2)$, the likelihood function $p(\boldsymbol{Z}_t \,|\, l_t, x_t)$ of the current observation \boldsymbol{Z}_t is given by

$$p(\boldsymbol{Z}_t \,|\, l_t, \boldsymbol{x}_t) \propto \exp\left[-\frac{\left\| \boldsymbol{Z}_t - g(\boldsymbol{y}_{\phi_t}^{l_t}, \boldsymbol{p}_t) \right\|}{2\sigma_{\text{obs}}^2} \right]. \tag{6.11}$$

TABLE 6.2 Pseudo-Code for One-Time Step of the APF Algorithm

Input: The current observation \mathbf{Z}_t and the particle set at time $t-1$ represented by $\{\Phi_{t-1}^j\}_{j=1}^{N_p} = \{\mathbf{x}_{t-1}^j, v_{t-1}^j, l_{t-1}^j\}_{j=1}^{N_p}$.

Output: The particle set at time t represented by $\{\Phi_t^j\}_{j=1}^{N_p}$ the estimates of $\hat{\mathbf{p}}_t$, $\hat{\phi}_t$, and identity \hat{I}_t.

1. Propagate the particle set $\{\Phi_{t-1}^j\}_{j=1}^{N_p}$ using the motion model equations (6.6) through (6.9) to obtain the particle set $\{\tilde{\Phi}_{t-1}^j\}_{j=1}^{N_p} = \{x_{t-1}^j, \tilde{v}_{t-1}^j, \tilde{l}_{t-1}^j\}_{j=1}^{N_p}$.

2. Assign weights $\{\tilde{w}_t^j\}_{j=1}^{N_p} \propto p(\mathbf{Z}_t | \tilde{\Phi}_t^j)$ as in (6.11).

3. Normalize weights $\{\tilde{w}_t^j\}_{j=1}^{N_p}$ such that $\sum_{j=1}^{N_p} \tilde{w}_t^j = 1$.

4. Draw auxiliary variable $\lambda^j \in \{1, 2, \ldots, N_p\}$ such that $p(\lambda^j = i) = \tilde{w}_t^i$ where $i = 1, 2, \ldots, N_p$.

5. Propagate the particle set $\{\Phi_{t-1}^{\lambda^j}\}_{j=1}^{N_p}$ using the motion model equations (6.6) through (6.9) to obtain the particle set $\{\Phi_t^j\}_{j=1}^{N_p} = \{\mathbf{X}_t^j, v_t^j, I_t^j\}_{j=1}^{N_p}$.

6. Assign weights $\{w_t^j\}_{j=1}^{N_p} \propto p(\mathbf{Z}_t | \Phi_t^j)/p(\mathbf{Z}_t | \tilde{\Phi}_t^{\lambda^j})$ as in (6.11).

7. Normalize weights $\{w_t^j\}_{j=1}^{N_p}$ such that $\sum_{j=1}^{N_p} w_t^j = 1$.

8. Estimate mean position $\hat{\mathbf{p}}_t$, pose $\hat{\phi}_t$, and MAP estimate of identity \hat{I}_t from $\{\Phi_t^j, w_t^j\}_{j=1}^{N_p}$.

9. Set $\{\Phi_t^j\}_{j=1}^{N_p} = $ Resample $[\{\Phi_t^j, w_t^j\}_{j=1}^{N_p}]$.

Source: Venkataraman, V. et al., Integrated target tracking and recognition using joint appearance-motion generative models, in *Proceedings of the 5th IEEE International Workshop on Object Tracking and Classification in and beyond Visible Spectrum (OTCBVS08), in Conjunction with CVPR08*, Anchorage, Alaska, 2008. With permission. © 2008 IEEE.

where $\|\cdot\|$ gives the MSE between the observation and the synthesized vehicle appearance in the tracking gate.

Algorithm pseudo-code: Having defined the required system and observation models, we can perform sequential state estimation using an APF. The pseudo-code for a single time step of the APF-based inference is given in Table 6.2, where the current observation is considered for drawing samples in step 4.

6.4.2 Examples

The joint tracking and recognition algorithm was evaluated using simulated sequences where the background was a real IR image with additive Gaussian noise (SNR=20 dB). Five sequences corresponding to five vehicles were generated using the motion model described in (6.6) through (6.8) and were imaged through a virtual camera. We set $f(l_t)=0.025$ to simulate a constant forward force and $s(l_t)=0.01 \cdot l_t$ to simulate type-dependent acceleration. We chose $u=\pi/180$ and $\sigma_\phi=\pi/60$ in (6.7). A few frames from one of these simulated IR sequence is shown in the top row of Figure 6.8.

At first, the tracking performance of the generative appearance model (G15) and template appearance model (T15) were compared head to head without considering type-dependent motion, that is, with $s(l_t)$ held constant in the APF inference algorithm. Sample tracking results for SEQ2 (Figure 6.8) are shown in Figure 6.9, where we see that the T15 model can suffer track loss due to its limited ability to accurately match intermediate poses that were not present in the training set. On the other hand, the G15 model, which is capable of

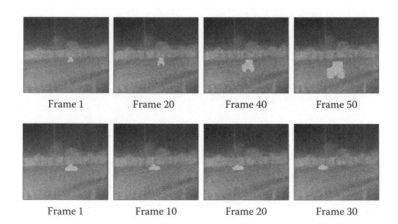

Frame 1 Frame 20 Frame 40 Frame 50

Frame 1 Frame 10 Frame 20 Frame 30

Figure 6.8 Sample frames from simulated IR sequence. Top row: SEQ2. Bottom row: SEQc.

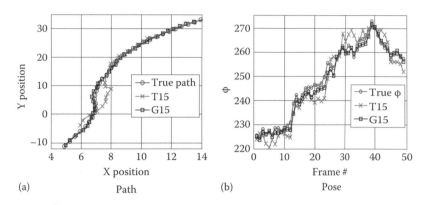

(a) Path (b) Pose

Figure 6.9 (See color insert following page 332.) Sample tracking result for the sequence SEQ2: (a) path estimate and (b) pose estimate. (From Venkataraman, V. et al., Integrated target tracking and recognition using joint appearance-motion generative models, in *Proceedings of the 5th IEEE International Workshop on Object Tracking and Classification in and beyond Visible Spectrum (OTCBVS08), in Conjunction with CVPR08*, Anchorage, Alaska, 2008. With permission. © 2008 IEEE.)

TABLE 6.3 RMS Error in the Pose and Position Estimates over 50 Frames, Averaged over 20 Monte Carlo Runs

Algorithms		SEQ1	SEQ2	SEQ3	SEQ4	SEQ5
T15	ϕ	3.271	3.824	2.948	5.331	5.428
	p_x	0.115	0.248	0.106	0.263	0.231
	p_y	0.541	1.573	0.208	1.192	1.413
G15	ϕ	3.397	2.325	2.519	3.468	3.057
	p_x	0.106	0.153	0.116	0.145	0.200
	p_y	0.637	0.870	0.337	0.605	1.222
G15-M	ϕ	2.768	2.258	2.007	3.801	2.785
	p_x	0.094	0.117	0.099	0.185	0.232
	p_y	0.323	0.560	0.238	0.454	1.174

Source: Venkataraman, V. et al., Integrated target tracking and recognition using joint appearance-motion generative models, in *Proceedings of the 5th IEEE International Workshop on Object Tracking and Classification in and beyond Visible Spectrum (OTCBVS08), in Conjunction with CVPR08*, Anchorage, Alaska, 2008. With permission. © 2008 IEEE.

synthesizing intermediate poses on the fly, improves both the position and pose estimation, as shown in Table 6.3.

Next, the tracking performance of the G15 model along with type-dependent motion, that is, the joint appearance-motion generative model (G15-M), was evaluated. To accommodate different motion models, we set $s(l_t) = 0.01 \cdot l_t$ in the inference algorithm. After obtaining the position and pose estimates from the noisy video sequence using the three algorithms, we rendered the tracking results in a 3D environment with a top-down view to better illustrate the performance differences between algorithms, as shown in Figure 6.10. The solid boxes in each row represent the tracking gates at the indicated frames of SEQ2. It can be seen that the algorithm with the template model slowly loses the track lock from the 10th frame onward and that the G15 model produces inaccurate tracking when the vehicle exhibits maneuvering actions. In contrast to the template model and G15 model, the appearance generative model coupled with type-dependent motion model is able to provide better kinematics prediction, resulting in superior tracking performance. Quantitative data for the root mean square (RMS) estimation error of all three approaches

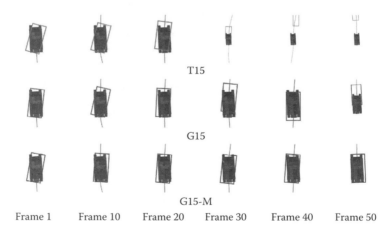

Figure 6.10 Sample tracking results obtained with the template model (T15), generative appearance model (G15), and joint appearance-motion model (G15-M) from a top-down view for SEQ2. The boxes represent the tracking gate in each case. The line underneath the tank is its true path. Camera has been zoomed out in the last few frames of T15 and G15 to show the tracking gate, making the target appear smaller.

are listed in Table 6.3. In most cases, G15-M shows the best tracking performance, proving the usefulness of the joint generative models in pose and position estimation. The three methods result in comparable recognition performance, and for all five sequences the identity estimation converges to the true vehicle type within a few time steps.

6.5 ENHANCED INFERENCE ALGORITHM FOR JOINT TRACKING AND RECOGNITION

Compared to a standard SIR particle filter, the APF algorithm incorporates the current appearance observation in order to obtain better proposals, especially for position and pose states. However, due to the lack of velocity measurements, there is no direct contribution of a velocity observation to the velocity proposal v_t and identity proposal l_t in the APF algorithm. However, there exists an opportunity for velocity to play an important role in the estimation of \boldsymbol{x}_t and l_t, particularly when the different vehicle types exhibit different maneuvering characteristics. In this section, we enhance the velocity estimation and apply it to improve the state inference efficiency in two ways. Firstly, the velocity estimate is used to generate more samples of the most likely vehicle type and secondly to generate improved velocity hypotheses for the next time step. The underlying idea of the APF is to use the effect (current observations) to generate more plausible cause samples (position/pose hypothesis). Here, we use the effect (position estimate) to derive a velocity observation, which is then used to generate more likely cause (velocity) samples. Unlike (Zhou et al. 2004), where the change in high-dimensional appearance is used for velocity update, here position estimates are used to update the velocity using a 1D Kalman filter based on the assumed Gaussianity of the type-dependent probability $p(v_t | l_t, v_{t-1})$.

6.5.1 Kalman-Enhanced Auxiliary Particle Filter (KAPF)

New proposal: In the spirit of RBPF, the derivation given in Doucet et al. (2001), Murphy and Russell (2001), and Nando de et al. (2004)

is used to insert a new proposal generation scheme for vehicle type l_t and velocity v_t between steps 8 and 9 of Table 6.2. Provided that Gaussian noise is assumed in (6.6), then $p(v_t | l_t, v_{t-1})$, the velocity evolution given the vehicle type, follows a linear Gaussian process. We sample the probability density of the vehicle type l_t and assign a single Kalman filter for each type to update the velocity distribution. In addition to the particle set $\{\Phi_t^j\}_{j=1}^{N_p}$ in Table 6.2, a second set of particles $\{\Phi_t^j\}_{j=1}^{N_p} = \{l_t^j, \mu_{v,t}^j, \Sigma_{v,t}^j\}_{j=1}^{N_p}$ is maintained, where type samples l_t^j are from the particle set $\{\Phi_t^j\}_{j=1}^{N_p}$, the mean $u_{v,t}^j$ and variance $\Sigma_{v,t}^j$ characterize the Gaussian velocity probability density for each particle. The procedure for sampling and updating a single particle is discussed in the following, where the particle superscript j is omitted for notational brevity.

The velocity observation is considered in generating vehicle-type samples, which is similar in philosophy to the "look-ahead" RBPF in Nando de et al. (2004). The vehicle type with a motion model that fits the current velocity observation most closely is given higher preference. Thus, the proposal of the type variable is assigned as the predictive density of velocity according to

$$p(l_t | l_{t-1}, \hat{v}_{1:t}) \propto p(\hat{v}_t | \hat{v}_{t-1}, l_t), \tag{6.12}$$

where \hat{v}_t is obtained from the velocity effect variables via

$$\hat{v}_t = \left\| \hat{\boldsymbol{p}}_t - \hat{\boldsymbol{p}}_{t-1} \right\|. \tag{6.13}$$

We assume the velocity observation equation is also linear and Gaussian, that is, $p(\hat{v}_t | v_t) \sim N(v_t, \sigma_b^2(l_t))$, where $\sigma_b^2(l_t)$ is the estimated variance of \hat{v}_t. Together with the Gaussian assumption on the velocity evolution in (6.6), which states that $p(\hat{v}_t | \hat{v}_{t-1}, l_t) \sim N(f(l_t)_t, s^2(l_t))$, it may be shown that the predictive density of \hat{v}_t is Gaussian, that is, $p(\hat{v}_t | \hat{v}_{t-1}, l_t) \sim N(\mu_{\hat{v},t}, \Sigma_{\hat{v},t})$. This Gaussian predictive density can be evaluated using 1D Kalman filtering equations:

$$\mu_{\hat{v},t}(l_t) = \mu_{\hat{v},t-1}(l_t) + f(l_t),$$

$$\Sigma_{\hat{v},t}(l_t) = \Sigma_{\hat{v},t-1}(l_t) + s^2(l_t) + \sigma_b^2(l_t), \tag{6.14}$$

where $f(l_t)$ and $s(l_t)$ appeared in (6.6) to characterize maneuverability on a type-by-type basis. Recalling (6.12), we obtain the samples of the type variable l_t based on the Gaussian distribution $N(\mu_{\hat{v},t}, \Sigma_{\hat{v},t})$.

In addition, the Kalman filter can also be used to update the density of the velocity using the conditional Gaussian. For simplicity, omitting the identity variable l_t, the 1D Kalman equations then become

$$\mu_{v,t} = \mu_{v,t-1} + (\Sigma_{v,t-1} + s^2)\Sigma_{\hat{v},t}^{-1}(\hat{v}_t - \mu_{\hat{v},t}),$$

$$\Sigma_{v,t} = (\Sigma_{v,t-1} + s^2)\sigma_b^2 \Sigma_{\hat{v},t}^{-1}. \tag{6.15}$$

Therefore, new velocity samples are generated from $N(\mu_{v,t}, \Sigma_{v,t})$, each associated with one type particle and used for position prediction.

Algorithm pseudo-code: The KAPF algorithm that is embedded between steps 8 and 9 of Table 6.2 is given in Table 6.4. The output containing the identity and velocity samples $\{l_t^j, v_t^j\}_{j=1}^{N_p}$ replace the ones generated by step 9 in Table 6.2 as priors for the position prediction in the next time step. The elements of the transition matrix used in (6.9) are set to $1/N_p$ to avoid any possible bias.

6.5.2 Examples

Five more sequences corresponding to each of the five vehicles shown in Figure 6.1 were generated with $f(l_t)=0.0025 \cdot l_t$ and $s(l_t)=0.01 \cdot l_t$ in (6.6) and with random turning actions $u=\pi/80$, $\sigma_\phi=\pi/60$ in (6.7). A few frames from one of these sequences (SEQc) are depicted in the bottom row of Figure 6.8. In this experiment, the appearance model was trained from 36 silhouettes corresponding to $10°$ pose changes for each of the five vehicle types. The tracking performance of the KAPF was compared to that of APF* (APF with fixed transition matrix) to avoid any prior bias.

As may be seen in Table 6.5, the KAPF algorithm shows improvement over the APF* method since the Kalman filter used for velocity estimation is optimal in the MSE sense under Gaussian assumptions. The improvement in the tracking performance is also demonstrated by the top-down vehicle images generated from SEQc with tracking gates superimposed that are shown in Figure 6.11. The APF* algorithm

TABLE 6.4 Pseudo-Code for Motion Cue-Based Proposal Generation

Input: Position estimates $\hat{\boldsymbol{p}}_t$ and $\hat{\boldsymbol{p}}_{t-1}$, and the particle set
$\{\phi_{t-1}^j\}_{j=1}^{N_p} = \{l_{t-1}^j, \mu_{v,t-1}^j, \Sigma_{v,t-1}^j\}_{j=1}^{N_p}$.

Output: The particle set at time t represented by $\{\varphi_t^j\}_{j=1}^{N_p}$ and the velocity samples
$\{v_t^j\}_{j=1}^{N_p}$.

- Compute \hat{v}_t based on (6.11)
 For $j = 1, \ldots, N_p$
 For $l = 1, \ldots, N_T$

- Calculate $\mu_{\hat{v},t}^j(l)$ and $\Sigma_{\hat{v},t}^j(l)$ using (6.12)
- Evaluate $p(l_t | l_{t-1}^j, \hat{v}_t) \propto N(\hat{v}_t; \mu_{\hat{v},t}^j, \Sigma_{\hat{v},t}^j)$
 End
- Sample $l_t^j \sim p(l_t | l_{t-1}^j, \hat{v}_t)$.
- Update $\mu_{v,t}^j$ and $\Sigma_{v,t}^j$ using (6.13)
 End
- Draw samples $\{v_t^j\}_{j=1}^{N_p} \sim N(\mu_{v,t}^j, \Sigma_{v,t}^j)$.

Source: Venkataraman, V. et al., Integrated target tracking and recognition using joint appearance-motion generative models, in *Proceedings of the 5th IEEE International Workshop on Object Tracking and Classification in and beyond Visible Spectrum (OTCBVS08), in Conjunction with CVPR08,* Anchorage, Alaska, 2008. With permission. © 2008 IEEE.

TABLE 6.5 RMS Error in the Pose, Position, and Velocity Estimates over 30 Frames Averaged over 20 Monte Carlo Runs

Algorithms		SEQa	SEQb	SEQc	SEQd	SEQe
APF*	ϕ	6.307	2.195	3.874	6.021	2.188
	p_x	0.146	0.105	0.378	0.132	0.135
	p_y	0.729	0.697	1.265	0.692	0.319
	v	0.035	0.054	0.239	0.075	0.106
KAPF	ϕ	4.659	2.209	3.412	5.355	2.314
	p_x	0.089	0.098	0.161	0.106	0.128
	p_y	0.412	0.681	0.653	0.524	0.273
	v	0.030	0.036	0.096	0.054	0.127

Source: Venkataraman, V. et al., Integrated target tracking and recognition using joint appearance-motion generative models, in *Proceedings of the 5th IEEE International Workshop on Object Tracking and Classification in and beyond Visible Spectrum (OTCBVS08), in Conjunction with CVPR08,* Anchorage, Alaska, 2008. With permission. © 2008 IEEE.

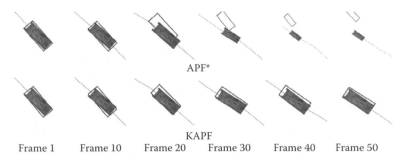

APF*

KAPF

Frame 1 Frame 10 Frame 20 Frame 30 Frame 40 Frame 50

Figure 6.11 Sample tracking results using APF* and KAPF visualized from a top-down view for SEQc. The boxes represent the tracking gate in each case. The line underneath the tank is its true path.

results in loss of track when the vehicle moves along the y-direction from the 20th frame, yielding vehicle scale variations in the video sequences projected onto the 2D imaging plane. The appearance-based likelihood defined in (6.11) is not very sensitive to the variation of scene depth (p_y) (that is only reflected by scale of the vehicle signature) compared with that of translation (p_x). In addition to the appearance likelihood, the KAPF also exploits motion cues to improve the position estimates, especially for depth. These improvements imply that the KAPF is able to generate velocity samples closer to the true states and thereby provide better prediction for the position samples, as compared to the APF* technique.

The KAPF also performs better than the APF* in terms of recognition, with fewer misclassifications as a result of its ability to provide well-distributed type samples l_t^i. Figure 6.12 shows histograms of the vehicle-type variables for the APF* and KAPF particle populations in the last six time steps of SEQc. In this sequence, the true vehicle type is T28, which has a silhouette that is significantly similar to that of the MK1. It is observed that the fixed transition matrix of the APF* maintains two modes corresponding to the vehicle types T28 and MK1. Especially at time step 29, the APF* associates more samples with the incorrect vehicle type MK1 than the correct type T28. The KAPF, which exploits both appearance and velocity information to generate more samples of the true vehicle type, has an advantage over that APF* that uses only appearance information. Moreover, the KAPF maintains the possibility of switching to a new type even late

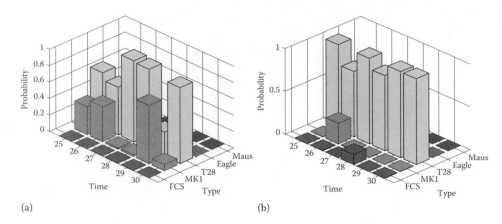

(a) (b)

Figure 6.12 (See color insert following page 332.) Sample distribution of the vehicle type when using (a) fixed transition matrix in APF* and (b) KAPF during last few frames of SEQc.

in the sequence if the observations support the switch strongly. This prevents the vehicle-type samples from being trapped in an incorrect hypothesis, which provides a good balance between diversity and focus during inference. Hence, the KAPF achieves a better approximation of the true vehicle-type distribution by utilizing both appearance and motion cues, which is a major advantage of our integrated framework.

6.6 SUMMARY

A unified framework for integrated vehicle tracking and recognition was proposed, where joint appearance-motion generative models are incorporated into a graphical model. The vehicle type and kinematics are jointly estimated by a particle filter–based inference algorithm embedded with Kalman filters. The experimental results demonstrate that the joint appearance-motion models improve both tracking accuracy and recognition performance as compared to the template-based appearance model with a single motion model. Also, it was shown that the embedded Kalman filters provide better samples for both kinematics and the vehicle type by exploiting type-dependent motion

models to obtain improvements in both the tracking and recognition performances. It is worth mentioning that the integrated framework given in this chapter is capable of supporting the incorporation of other type-dependent appearance and motion cues beyond the ones considered here.

6.7 BIBLIOGRAPHICAL AND HISTORICAL REMARKS

Joint vehicle tracking and recognition is a prevalent and challenging issue in many civilian and military surveillance applications that is of great interest in both the computer vision and signal processing communities. Traditionally, vision research has focused on the development of powerful appearance models (Ozcanli et al. 2006; Shaik and Iftekharuddin 2003) (i.e., the observation model), while signal processing research has tended to place more emphasis on the system model by focusing on the maneuvering vehicle dynamics (Maskell 2004; Angelova and Mihaylova 2006). Nevertheless, these two different approaches typically share several common threads when the problem is formulated in terms of a dynamic state-space system involving explicit observation and system models. Due to their complementary nature, there is a growing trend to combine both the appearance and motion cues into a joint tracking and recognition flow (Zhou et al. 2004; Lee et al. 2005). In this chapter, "we seek to exploit the inherent synergy between appearance and motion cues by fusing them in an integrated probabilistic framework that leverages their mutual interaction to achieve joint tracking and recognition." This approach is especially advantageous when the vehicles of interest exhibit poor visibility (as in, e.g., IR imagery) and high maneuverability. The proposed approach can be considered as a model-based and knowledge-based automatic target recognition (ATR) system where physical principles, dimension reduction, and statistical techniques are involved. This work follows in the spirit of the evolution of ATR research over the past decade (Bhanu et al. 1997), and is fueled by recent advances in several technical areas. In the following, we present a brief overview of recent related works on appearance and motion modeling for vehicle tracking and recognition.

One major challenge in vehicle appearance modeling is that of representing appearance variability both within a vehicle class and across different vehicle classes. For example, appearance models, in particular, must accommodate the variation in appearance over time that occurs due to pose variation or partial occlusion. Traditional template-based representations can only deal with a limited number of pose variations. In Ozcanli et al. (2006), shape information was exploited along with the object appearance in order to classify vehicles according to type, where only a few representative poses were considered for each type. Lou et al., proposed the use of a predefined 3D shape model to track the position and pose of a vehicle in Lou et al. (2005). In Zhang et al. (2007), the shape and pose were characterized explicitly using a deformable model with multiple parameters that must be optimized continuously for localization and recognition. To represent the continuous appearance changes that occur with varying pose, several template update schemes for the vehicle features have been considered (Collins et al. 2005; Mei et al. 2006; Venkataraman et al. 2007). In the context of face tracking and recognition, appearance models adaptive to pose changes were also studied extensively, including principal component analysis (PCA)-based models (Jepson et al. 2003; Zhou et al. 2004; Nguyen et al. 2007) and nonlinear manifold-based methods (Lee et al. 2005; Lee and Kriegman 2005). Recently, multi-linear analysis was combined with manifold learning to provide a generative model-based human shape representation, which is specified by multiple factors including the identity (body shape), pose, and view (Lee and Elgammal 2007). The major advantage of this model is that it is able to synthesize an unseen observation under an arbitrary view given an identity and a pose, which can aid the tracker in accounting for inter-frame appearance variation that occurs due to changes in pose or view. Moreover, this approach also facilitates vehicle tracking and recognition with a built-in identity variable (Venkataraman et al. 2008). This appearance generative model is one of the two major components in our research that can be easily connected with a type-dependent motion model by sharing a single identity variable.

Motion modeling is the second important component of joint tracking and recognition. For example, multiple motion models have been widely adopted to accommodate different maneuvering actions in vehicle tracking (Li and Jilkov 2005). In reality, a vehicle is equipped with a specific engine and mechanical system that generates a unique motion pattern and maneuverability. This inspires researchers to develop multiple type-dependent motion models to achieve joint vehicle tracking and recognition (Maskell 2004; Angelova and Mihaylova 2006). However, these approaches require sensors capable of providing direct measurements of the kinematics (radar, for example), and do not consider the vehicle appearance captured by passive imaging sensors such as electrooptical (EO)/IR sensors. We recently proposed a generative model-based maneuvering vehicle tracking approach that is able to capture the underlying physical constraints in the mechanical system of a maneuvering vehicle and requires only passive imaging sensors (Fan et al. 2010).

Integrating motion and appearance cues for joint tracking and recognition is attractive because of their complementary nature. In the context of activity recognition, for example, object trajectories aggregated from past tracking history have been employed as important cues for classification of high-level object activities (Rosales and Sclaroff 1999; Bashir et al. 2007; Hu et al. 2009). In addition, recent face tracking and expression recognition algorithms have incorporated multiple temporal models of facial features conditioned on the variable to be recognized, that is, facial expression (Chang et al. 2006; Dornaika and Davoine 2008). However, in these methods there is no *direct* dependence between the identity (object activity or facial expression) and the object appearance; thus the appearance contributes only indirectly to recognition through tracking crucial signatures (trajectories and facial features) that determine the identity. On the other hand, identity-dependent appearance models are widely used in joint face tracking and recognition (Zhou et al. 2003; Lee and Kriegman 2005; Kim et al. 2008), but no identity-dependent multiple dynamic (motion) models have been used. Motion models are used for appearance update in Zhou et al. (2004), Lee et al. (2005), and Lee and Kriegman (2005),

but these have no direct impact on recognition. In this chapter, we presented and demonstrated the performance advantages of a new approach where both appearance and motion models are dependent on the vehicle identity and are integrated into an unified probabilistic framework.

ACKNOWLEDGMENTS

This work was supported in part by the U.S. Army Research Laboratory and the U.S. Army Research Office under grants W911NF-04-1-0221 and W911NF-08-1-0293, the National Science Foundation (NSF) under Grant IIS-0347613, and the 2009 Oklahoma NASA EPSCoR Research Initiation Grant (RIG).

REFERENCES

Angelova, D. and L. Mihaylova. 2006. Joint target tracking and classification with particle filtering and mixture Kalman filtering using kinematic radar information. *Digit. Signal Process.*, 16(2): 180–204.

Arulampalam, S., S. Maskell, N. Gordon, and T. Clapp. 2002. A tutorial on particle filters for online non-linear/non-Gaussian Bayesian tracking. *IEEE Trans. Signal Process.*, 50(2): 174–188.

Bashir, F. I., A. A. Khokhar, and D. Schonfeld. 2007. Object trajectory-based activity classification and recognition using hidden Markov models. *IEEE Trans. Image Process.*, 16(7): 1912–1919.

Bhanu, B., D. E. Dudgeon, E. G. Zelnio, A. Rosenfeld, D. Casasent, and I. S. Reed. 1997. Guest editorial introduction to the special issue on automatic target detection and recognition. *IEEE Trans. Image Process.*, 6(1): 1–5.

Blom, H. A. P. and Y. Bar-Shalom. 1988. The interacting multiple model algorithm for systems with Markovian switching coefficients. *IEEE Trans. Automat. Contr.*, 33: 780–783.

Chang, Y., C. Hu, R. Feris, and M. Turk. 2006. Manifold based analysis of facial expression. *Image Vision Comput.*, 24: 605–614.

Collins, R. T., Y. Liu, and M. Leordeanu. 2005. Online selection of discriminative tracking features. *IEEE Trans. Pattern Anal.*, 27(10): 1631–1643.

Dornaika, F. and F. Davoine. 2008. Simultaneous facial action tracking and expression recognition in the presence of head motion. *Int. J. Comput. Vision*, 76: 257–281.

Doucet, A., N. J. Gordon, and V. Krishnamurthy. 2001. Particle filters for state estimation of jump Markov linear systems. *IEEE Trans. Signal Process.*, 49(3): 613–624.

Elgammal, A. and C. S. Lee. 2004. Separating style and content on a nonlinear manifold. *Proc. IEEE Int. Conf. Comput. Vision Pattern Recogn.*, 1: I-478–I-485.

Elgammal, A. and C. S. Lee. 2007. Nonlinear manifold learning for dynamic shape and dynamic appearance. *Comput. Vis. Image Und.*, 106(1): 31–46.

Fan, X., G. Fan, and J. P. Havlicek. 2010. Generative graphical models for maneuvering target tracking. *IEEE Trans. Aerospace Electron. Syst.*, 46(2) (tentative).

Freitas de, N. 2001. Rao-Blackwellised particle filtering for fault diagnosis, *IEEE Aerospace Conf.*, 4: 4-1767–4-1772.

Gordon, N., D. Salmond, and A. F. Smith. 1993. Novel approach to nonlinear/non-Gaussian Bayesian state estimation. *IEEE Proc. F.*, 140: 107–113.

Hu, Z., X. Fan, Y. Song, and D. Liang. 2009. Joint trajectory tracking and recognition based on bi-directional nonlinear learning. *Image Vision Comput.*, 27(9):1302–1312.

Jepson, A. D., D. J. Fleet, and T. F. El-Maraghi. 2003. Robust online appearance models for visual tracking. *IEEE Trans. Pattern Anal.*, 25(10): 1296–1311.

Kim, M., S. Kumar, V. Pavlovic, and H. Rowley. 2008. Face tracking and recognition with visual constrains in real-world videos. *Proceedings of the IEEE International Conference on Computer Vision and Pattern Recognition (CVPR)*, Anchorage, AK, pp. 1–8.

Lee, C. S. and A. Elgammal. 2007. Modeling view and posture manifold for tracking. *Proceedings of the IEEE International Conference on Computer Vision and Pattern Recognition (CVPR)*, Rio de Janeiro, Brazil, 1–8.

Lee, K. C., J. Ho, M. H. Yang, and D. Kriegman. 2005. Visual tracking and recognition using probabilistic appearance manifolds. *Comput. Vis. Image Und.*, 99: 303–331.

Lee, K. C. and D. Kriegman. 2005. Online learning of probabilistic appearance manifolds for video-based recognition and tracking. *Proc. IEEE Int. Conf. Comput. Vision Pattern Recogn.*, 1: 852–859.

Li, P. and V. Kadirkamanathan. 2001. Particle filtering based likelihood ratio approach to fault diagnosis in nonlinear stochastic systems. *IEEE Trans. Syst. Man Cyber. C: Applic. Rev.*, 31(3): 337–343.

Li, X. R. and V. P. Jilkov. 2005. Survey of maneuvering target tracking. Part V: Multiple-model methods. *IEEE Trans. Aerospace Electron. Syst.*, 41(4): 1255–1321.

Lou J., T. Tan, W. Hu, H. Yang, and S. J. Maybank. 2005. 3-D model-based vehicle tracking. *IEEE Trans. Image Process.*, 14(10): 1561–1569.

Maskell, S. 2004. Joint tracking of maneuvering targets and classification of their maneuverability. *EURASIP J. Appl. Signal Process.*, 2004(1): 2339–2350.

McGinnity, S. and G. W. Irwin. 2001. Maneuvering target tracking using a multiple-model bootstrap filter. *Sequential Monte Carlo Methods in Practice*. A. Doucet, N. de Freitas, and N. Gordon (eds). Springer, New York, 479–497.

Mei, X., S. K. Zhou, H. Wu, and F. Porikli. 2006. Integrated detection, tracking and recognition for IR video-based vehicle classification. *Proc. IEEE Int. Conf. Acoust., Speech Signal Process.*, 5(14–19): V–V.

Murphy, K. and S. Russell. 2001. Rao-Blackwellised particle filtering for dynamic bayesian networks. *Sequential Monte Carlo Methods in Practice*. A. Doucet, N. de Freitas, and N. Gordon (eds.). Springer, New York.

Nando de, F., R. Dearden, F. Hutter, R. Morales-Menendez, and J. Mutch. 2004. Diagnosis by a waiter and a Mars explorer. *Proc. IEEE*, 92(3): 455–468.

Nguyen, H. T., Q. Ji, and A. W. M. Smeulders. 2007. Spatio-temporal context for robust multitarget tracking. *IEEE Trans. Pattern Anal.*, 29(1): 52–64.

Oh, S. M., J. M. Rehg, T. Balch, and F. Dellaert. 2006. Parameterized duration modeling for switching linear dynamic systems. *Proc. IEEE Int. Conf. Comput. Vision Pattern Recogn.*, 2: 1694–1700.

Ozcanli, O. C., A. Tamrakar, B. B. Kimia, and J. L. Mundy. 2006. Augmenting shape with appearance in vehicle category recognition. *Proc. IEEE Int. Conf. Comput. Vision Pattern Recogn.*, 1: 935–942.

Pitt, M. and N. Shephard. 1999. Filtering via simulation: Auxiliary particle filters. *J. Amer. Statist. Assoc.*, 94(446): 590–599.

Poggio, T. and F. Girosi. 1990. Networks for approximation and learning. *Proc. IEEE*, 78(9): 1481–1497.

Rosales, R. and S. Sclaroff. 1999. 3D trajectory recovery for tracking multiple objects and trajectory guided recognition of actions. *Proc. IEEE Int. Conf. Comput. Vision Pattern Recogn.*, 2: 123.

Shaik, J. and K. Iftekharuddin. 2003. Automated tracking and classification of infrared images. *Proc. Int. Joint Conf. Neural Networks*, 2: 1201–1206.

Tenenbaum, J. B. and W. T. Freeman. 2000. Separating style and content with bilinear models. *Neural Comput.*, 12(6): 1247–1283.

Venkataraman, V., G. Fan, and X. Fan. 2007. Target tracking with online feature selection in FLIR imagery. *Proceedings of the IEEE International Workshop on Object Tracking and Classification in and beyond Visible Spectrum (OTCBVS07), in Conjucation with CVPR07*, 1–8.

Venkataraman, V., X. Fan, and G. Fan. 2008. Integrated target tracking and recognition using joint appearance-motion generative models. *Proceedings of the IEEE International Workshop on Object Tracking and Classification in and beyond Visible Spectrum (OTCBVS08), in Conjunction with CVPR08*, 1–8.

Zhang, Z., W. Dong, K. Huang, and T. Tan. 2007. EDA approach for model based localization and recognition of vehicles. *Proceedings of the IEEE International Conference on Computer Vision and Pattern Recognition (CVPR)*, Minneapolis, MN, 1–8.

Zhou, S., V. Krueger, and R. Chellappa. 2003. Probabilistic recognition of human faces from video. *Comput. Vis. Image Und.*, 91: 214–245.

Zhou, S. K., R. Chellappa, and B. Moghaddam, 2004. Visual tracking and recognition using appearance-adaptive models in particle filters. *IEEE Trans. Image Process.*, 13(11): 1491–1506.

7

Articulated Human Motion Tracking

Gang Qian and Feng Guo

CONTENTS

7.1 INTRODUCTION

Reliable recovery and tracking of articulated human motion from video is a very challenging problem in computer vision, due to the versatility of human movement, the variability of body types, various movement styles and signatures, and the 3D nature of the human body. Vision-based tracking of articulated motion is a temporal inference problem. There exist numerous computational frameworks addressing this problem. Some of the frameworks make use of training data (e.g., Urtasun et al., 2006) to inform the tracking, while some attempt to directly infer the articulated motion without using any training data (e.g., Deutscher et al., 2000). When training data are available, the articulated motion tracking can be cast into a statistical learning and inference problem. Using a set of training examples, a learning and inference framework needs to be developed to track both seen and unseen movements performed by known or unknown subjects. In terms of the learning and inference structure, existing 3D tracking algorithms can be roughly clustered into two categories, namely, generative-based and discriminative-based approaches. Generative-based approaches (e.g., Deutscher et al., 2000; Kakadiaris and Metaxas, 2000; Sidenbladh et al., 2000), usually assume the knowledge of a 3D body model of the subject and dynamical models of the related movement, from which kinematic predictions and

corresponding image observations can be *generated*. The movement dynamics are learned from training examples using various dynamic system models, e.g., autoregressive (AR) models (Agarwal and Triggs, 2004), hidden Markov models (Pavlovic et al., 2000), Gaussian process dynamical models (Urtasun et al., 2006), and piecewise linear models in the form of mixture of factor analyzers (Li et al., 2007). A recursive filter is often deployed to temporally propagate the posterior distribution of the state. Especially, particle filters have been extensively used in movement tracking to handle nonlinearity in both the system observation and the dynamic equations. Discriminative-based approaches (e.g., Mori and Malik, 2002; Grauman et al., 2003; Sminchisescu et al., 2005a,b; Agarwal and Triggs, 2006; Thayananthan et al., 2006) treat kinematics recovery from images as a regression problem from the image space to the body kinematics space. Using training data, the relationship between image observation and body poses is obtained using machine learning techniques. When compared against each other, both approaches have their own pros and cons. In general, generative-based methods utilize movement dynamics and produce more accurate tracking results, although they are more time consuming, and usually the conditional distribution of the kinematics given the current image observation is not utilized directly. On the other hand, discriminative-based methods learn such conditional distributions of kinematics given image observations from training data and often result in fast image-based kinematic inference. However, movement kinematics are usually not fully explored by discriminative-based methods. Thus the rich temporal correlation of body kinematics between adjacent frames is unused in tracking.

In this chapter, we present a 3D tracking framework that integrates the strengths of both generative and discriminative approaches. The proposed framework explores the underlying low dimensional manifolds of silhouettes and poses using nonlinear dimension reduction techniques such as Gaussian process latent variable models (GPLVM) (Lawrence, 2005) and Gaussian process dynamic models (GPDM) (Wang et al., 2006). Both Gaussian process models have been used for people tracking (Urtasun et al., 2005, 2006; Ek et al., 2007; Hou et al., 2007). The Bayesian mixture of experts (BME) and relevance vector machine (RVM) are then used to construct bidirectional mappings

between these two manifolds, in a manner similar to Sminchisescu et al. (2005a). A particle filter defined over the pose manifold is used for tracking. Our proposed tracker is self-initializing and capable of tracking multiple kinematic trajectories due to the BME-based multi-modal silhouette-to-kinematics mapping. In addition, because of the bidirectional inter-manifold mappings, the particle filter can draw kinematic samples using the current image observation, and evaluate sample weights without projecting a 3D body model. To overcome noise present in silhouette images, a low dimensional-vectorized silhouette descriptor is introduced based on Gaussian mixture models. Our proposed framework has been tested using both synthetic and real videos with different subjects and movement styles from the training. Experimental results show the efficacy of the proposed method.

7.1.1 System Architecture

An overview of the architecture of our proposed system is presented in Figure 7.1, consisting of a training phase and a tracking phase.

The training phase contains training data preparation and model learning. In data preparation, synthetic images are rendered using animation software from motion capture data, e.g., Maya. The model learning process has five major steps as shown in Figure 7.1a. In the first step, key frames are selected from synthetic images using multidimensional scaling (MDS) (Borg and Groenen, 1997; Burges, 2005) and k-means. In the second step, silhouettes in the training data are then vectorized according to its distances to these key frames. Then, in the following step, GPLVM is used to construct the low dimensional manifold S of the image silhouettes from multiple views using their vectorized descriptors. The fourth step is to reduce the dimensionality of the pose data and obtain a related motion dynamical model. GPDM is used to obtain the manifold Θ of full body pose angles. This latent space is then augmented by the torso orientation space Ψ to form the *complete* pose latent space $C=(\Theta, \Psi)$. Finally in the last step, the forward and backward nonlinear mappings between C to S are constructed in the learning phase. The forward mapping from C to S is established using RVM, which will be used to efficiently evaluate sample weights in the tracking phase. The multimodal (one-to-many) backward mapping from S to C is obtained using BME.

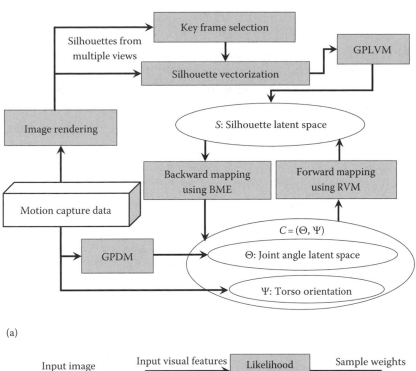

(a)

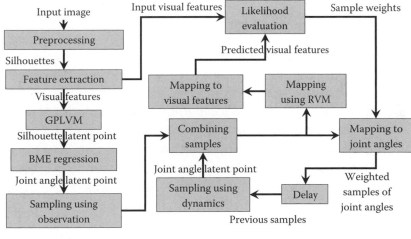

(b)

Figure 7.1 An overview of the proposed framework: (a) training phase; (b) tracking phase.

The essence of tracking in our proposed framework is the propagation of weighted movement particles in C based on the image observation up to the current time instant and learned movement dynamic models. In tracking, the body silhouette is first extracted from an input image and then vectorized. Using the learned GPLVM, its corresponding latent position is found in S. Then BME is invoked to find a few plausible pose estimates in C. Movement samples are drawn according to both the BME outputs and learned GPDM. The sample weights are evaluated according to the distance between the observed and predicted silhouettes. The empirical posterior distribution of poses is then obtained as the weighted samples. The details of the learning and tracking steps are described in the following sections.

7.1.2 Preparation of Training Data

To learn various models in the proposed framework, we need to construct training data sets including complete pose data (body joint angles, torso orientation), and the corresponding images. In our experiments, we focus on the tracking of gait. Three walking sequences (07_01, 16_16, 35_03) from different subjects were taken from CMU motion capture database, with each sequence containing two gait cycles. These sequences were then downsampled by a factor of 4, constituting 226 motion capture frames in total. There are 56 original local joint angles in the original motion capture data. Only 42 major joint angles are used in our experiments. This set of local joint angles is denoted as Θ_T.

To synthesize multiple views of one body pose defined by a frame of motion capture data, 16 frames complete pose data were generated by augmenting the local joint angles with 16 different torso orientation angles. To obtain silhouettes from diverse view points, these orientation angles are randomly altered from frame to frame. Given one frame of motion capture data, these 16 torso orientation angles were selected as follows. A circle centered at the body centroid in the horizontal plane of the human body can be found. To determine the 16 body orientation angles, this circle is equally divided into 16 parts, corresponding to 16 cameras views. In each camera view, an angle is uniformly drawn in an angle interval of 22.5°. Hence for each given motion capture frame, there are 16 complete pose frames with different torso orientation

angles, resulting in 3616 (226×16) complete pose frames in total. This training set of complete poses is denoted as \mathbf{C}_T. Using \mathbf{C}_T, corresponding silhouettes were generated using animation software. We denote this silhouette training set \mathbf{S}_T. Three different 3D models (one female and two males) were used for each subject to obtain a diverse silhouette set with varying appearances.

7.2 IMAGE FEATURE REPRESENTATION

7.2.1 Gaussian Mixture Model-Based Silhouette Descriptor

Assume that silhouettes can be extracted from images using background subtraction and refined by morphological operation. The remaining question is how to represent the silhouette robustly and efficiently. Different shape descriptors have been used to represent silhouettes. In Poppe and Poel (2006), Fourier descriptor, shape context, and Hu moments were computed from silhouettes and their resistance to variations in body built, silhouette extraction errors, and viewpoints were compared. It is shown that both Fourier descriptor and shape context perform better than the Hu moment. In our approach, Gaussian mixture models (GMM) are used to represent silhouettes and it performs better than shape context descriptor. We have used GMM-based shape descriptor in our previous work on single-image-based pose inference (Guo and Qian, 2006).

GMM assumes that the observed unlabeled data are produced by a number of Gaussian distributions. The basic idea of GMM-based silhouette descriptor is to consider a silhouette as a set of coherent regions in the 2D space such that the foreground pixel locations are generated by a GMM. Strictly speaking, foreground pixel locations of a silhouette do not exactly follow the Gaussian distribution assumption. Actually a uniform distribution confined to a closed area given by the silhouette contour would be a much better choice. However due to its simplicity, GMM is selected in the proposed framework to represent silhouettes. From Figure 7.2, we can see that the GMM can model the distribution of the silhouette pixels well. It has good locality to improve the robustness compared to the global descriptor such as shape moment. The reconstructed silhouette points look very similar to the original silhouette image.

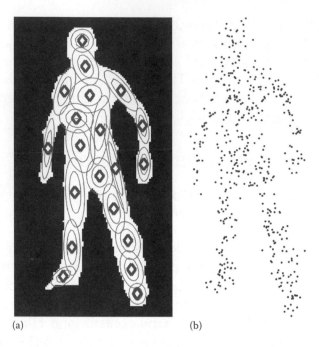

(a) (b)

Figure 7.2 (a) Learned Gaussian mixture components using EM superimposed on the original binary body silhouette and (b) 500 point samples drawn from such a GMM.

Given a silhouette, the GMM parameters can be obtained using an EM algorithm. Initial data clustering can be done using the k-means algorithm. The full covariance matrices of the Gaussian are estimated. In our implementation, a GMM with 20 components is used to represent one silhouette. It takes about 600 ms to extract the GMM parameters from an input silhouette (~120 pixel-high) using MATLAB®.

7.2.2 Kullback–Leibler Divergence-Based Similarity Measure

It is critical to measure the similarities between silhouettes. Based on the GMM descriptor, the Kullback–Leibler divergence (KLD) is used to compute the distance between two silhouettes. Similar approaches have been taken for GMM-based image matching for content-based

image retrieval (Goldberger et al., 2002). Given two distributions p_1 and p_2, the KLD from p_1 to p_2 is

$$D(p_1 \| p_2) = \int p_1(x) \log \frac{p_1(x)}{p_2(x)} \, dx \qquad (7.1)$$

The symmetric version of the KLD is given by

$$d(p_1, p_2) = \frac{1}{2} \big[D(p_1 \| p_2) + D(p_2 \| p_1) \big] \qquad (7.2)$$

In our implementation, such symmetric KLD is used to compute the distance between two silhouettes, and the KLDs are computed using a sampling-based method.

GMM representation can handle noise and small shape model differences. For example, Figure 7.3 has three columns of images. In each column, the bottom image is a noisy version of the top image. The KLDs between the noisy and clean silhouettes in the left, middle, and right columns are 0.04, 0.03, and 0.1, respectively. They are all below 0.3, which is an empirical KLD threshold indicating similar silhouettes. This threshold was obtained according to our experiments running over a large number of image silhouettes of various movements and dance poses.

Figure 7.3 Clean (top row) and noisy silhouettes of some dance poses.

7.2.3 Vectorized Silhouette Descriptor

Although GMM and KLD can represent silhouettes and compute their similarities, sampling-based KLD computation between two silhouettes is slow, which harms the scalability of the proposed method when a large number of training data are used. To overcome this problem, in the proposed framework a vectorization of the GMM-based silhouette descriptor is introduced. The non-vectorized GMM-based shape descriptor has been used in our previous work on single-image-based pose inference (Guo and Qian, 2006). The vector representation of silhouette is critical since it will simplify and expedite the GPLVM-based manifold learning and mapping from silhouette space to its latent space.

To obtain a vector representation for our GMM descriptor, we use the relative distances of one silhouette to several key silhouettes to locate this point in the silhouette space. The distance between this silhouette and each key silhouette is one element in the vector. The challenge here is to determine how many of them will be sufficient and how to select these key frames.

In our proposed framework, we first use MDS (Borg and Groenen, 1997; Burges, 2005) to estimate the underlying dimensionality of the silhouette space. Then the k-means algorithm is used to cluster training data and locate the cluster centers. Silhouettes that are the closest to these cluster centers are then selected as our key frames. Given training data, the distance matrix D of all silhouettes is readily computed using KLD. MDS is a nonlinear dimension reduction method if one can obtain a good distance measure. An excellent review of MDS can be found in Borg and Groenen (1997) and Burges (2005). Following MDS, $\bar{D} = -P^e D P^e$ can be computed. When D is a distance matrix of a metric space (e.g., symmetric, nonnegative, satisfying triangle inequality), \bar{D} is positive semi-definite (PSD), and the minimal embedding dimension is given by the rank of \bar{D}. Here $P^e = 1 - ee^T/N$ is the centering matrix, where N is the number of training data and ee^T is an $N \times N$ matrix of all ones. Due to observation noise and errors introduced in the sampling-based KLD calculation, the KLD matrix D we obtained is only an approximate distance matrix and \bar{D} might not be purely PSD in practice. In our case, we just ignored the negative eigenvalues of \bar{D} and only

Figure 7.4 Some of the 46 key frames selected from the training samples.

considered the positive ones. Using the 3616 training samples in \mathbf{S}_T described in Section 7.1.3, 45 dimensions are kept to count over 99% of the energy in the positive eigenvalues. To remove a representation ambiguity, distances from 46 key frames are needed to locate a point in a 45-dimensional space. To select these key frames, all the training silhouettes are clustered into 46 groups using the *k*-means algorithm. The closest silhouette to the center of each cluster is chosen as the key silhouette. Some of these 46 key frames are shown in Figure 7.4. Given these key silhouettes, we obtain the GMM vector representation as $[d_1, ..., d_i, ..., d_N]$, where d_i is the KLD distance between this silhouette and the *i*th key silhouette.

7.2.4 Comparison of Common Shape Descriptors

To validate the proposed vectorized silhouette representation based on GMM, extensive experiments have been conducted to compare GMM descriptor, vectorized GMM descriptor, shape context, and the Fourier descriptor. To produce shape context descriptors, a code book of the 90-dimensional shape context vectors is generated using the 3616 walking silhouettes from different views in \mathbf{S}_T described in Section 7.1.3. Two hundred points are uniformly sampled on the contour. Each point has a shape context (5 radial, 12 angular bins, size range 1/8 to 3 on log scale). The code book center is clustered from the shape context of all sampling points. To compare these four types of shape descriptor, distance matrices between silhouettes of a walking sequence are computed based on these descriptors. This sequence has 149 side views of a person walking parallel to a fixed camera over about two and half gait

cycles (five steps). The four distance matrices are shown in Figure 7.5. All distance matrices are normalized with respect to the corresponding maxima. Dark blue pixels indicate small distances. Since the input is a side-view walking sequence, significant inter-frame similarity presents, which results in a periodic pattern in the distance matrices. This is caused by both repeated movement in different gait cycles and the half cycle ambiguity in a side-view walking sequence in the same or different gait cycles (e.g., it is hard to tell the left arm from the right arm from a side-view walking silhouette even for humans). Figure 7.6 presents the distance values from the 10th frame to the remaining frames according to the four different shape descriptors. It can be seen from Figure 7.5 that

Figure 7.5 (See color insert following page 332.) Distance matrices of a 149-frame sequence of (a) side-view walking silhouettes computed using GMM, (b) vectorized GMM using 46 key frames, (c) shape context, and (d) Fourier descriptor.

Figure 7.6 Distances between the 10th frame of the (a) side-view walking sequence and all the other frames computed using GMM, (b) vectorized GMM using 46 key frames, (c) shape context, and (d) Fourier descriptor.

the distance matrix computed using KLD based on GMM (Figure 7.5a) has the clearest pattern as a result of smooth similarity measure as shown by Figure 7.6a. The continuity of the vectorized GMM is slightly deteriorated comparing to the original GMM. However, it is still much better than that of the shape context as shown by Figures 7.5b, c and 7.6b, c. The Fourier descriptor is the least robust among the four shape descriptors. It is difficult to locate similar poses (i.e., find the valleys in Figure 7.6). This is because the outer contour of a silhouette can change suddenly between successive frames. Thus the Fourier descriptor is discontinuous over time. Other than these four descriptors, the columnized vector of the raw silhouette is actually also a reasonable

shape descriptor. However, the huge dimensionality (~1000) of the raw silhouette makes the dimension reduction using GPLVM very time consuming and thus computationally prohibitive.

To take a close look at the smoothness of the three shape descriptors, original GMM, vectorized GMM, and shape context, we examine the resulting manifolds after dimension reduction and dynamic learning using GPDM. A smooth trajectory of latent point in the manifold indicates the smoothness of the shape descriptor. Figure 7.7 shows three trajectories corresponding to these three shape descriptors. It can be seen that the vectorized GMM has a smoother trajectory than that of the shape context, which is consistent with our findings based on distance matrices.

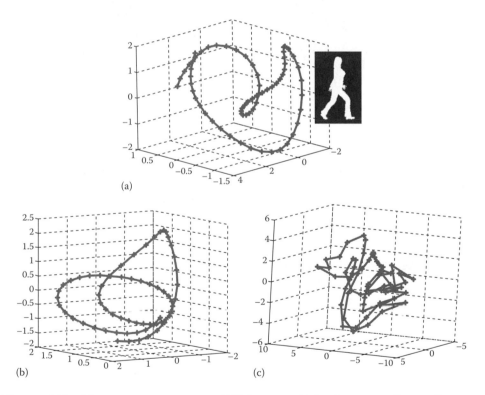

Figure 7.7 Movement trajectories of 73 frames of (a) side-view walking silhouette in the manifold learned using GPDM from three shape descriptors, including GMM, (b) vectorized GMM using 46 key frames, and (c) shape context.

7.3 DIMENSION REDUCTION AND MOVEMENT DYNAMICS LEARNING

7.3.1 Dimension Reduction of Silhouettes Using Gaussian Process Latent Variable Model

GPLVM (Lawrence, 2003) provides a probabilistic approach to nonlinear dimension reduction. In our proposed framework, GPLVM is used to reduce the dimensionality of the silhouettes and to recover the structure of silhouettes from different views. A detailed tutorial on GPLVM can be found in Lawrence (2005). Here we briefly describe the basic idea of the GPLVM for the sake of completeness.

Let $\mathbf{Y} = [y_1, ..., y_i, ..., y_N]^T$ be a set of D-dimensional data points and $\mathbf{X} = [x_1, ..., x_i, ..., x_N]^T$ be the d-dimensional latent points associated with \mathbf{Y}. Assume that \mathbf{Y} is already centered and $d < D$. \mathbf{Y} and \mathbf{X} are related by the following regression function

$$y_i = W\varphi(x_i) + \eta_i \tag{7.3}$$

where $\eta_i \sim N(0, \beta^{-1})$ and the weight vector $W \sim N(0, \alpha_W^{-1})$. $\varphi(x_i)$'s are a set of basis functions. Given \mathbf{X}, each dimension of \mathbf{Y} is a Gaussian process. By assuming independence among different dimensions of \mathbf{Y}, the marginalized distribution of \mathbf{Y} over W given \mathbf{X} is

$$P(\mathbf{Y} \mid \mathbf{X}) \propto \exp\left(-\frac{1}{2} \text{tr}(\mathbf{K}^{-1}\mathbf{Y}\mathbf{Y}^T)\right) \tag{7.4}$$

where \mathbf{K} is the gram matrix of the $\varphi(x_i)$'s. The goal in GPLVM is to find \mathbf{X} and the parameters that maximize the marginal distribution of \mathbf{Y}. The resulting \mathbf{X} is thus considered as a low dimensional embedding of \mathbf{Y}. By using the kernel trick, instead of defining what $\varphi(x)$ is, a kernel function over \mathbf{X} and compute \mathbf{K} can be defined so that $\mathbf{K}(i, j) = k(x_i, x_j)$. In our approach, the following radial basis function (RBF) kernel is used:

$$k(x_i, x_j) = \alpha \exp\left(-\frac{\gamma}{2} \| x_i - x_j \|^2\right) + \beta^{-1}\delta_{x_i, x_j} \qquad (7.5)$$

where

α is the overall scale of the output

γ is the inverse width of the RBFs

The variance of the noise is given by β^{-1}. $\Lambda = (\alpha, \beta, \gamma)$ are the unknown model parameters. We need to maximize (7.4) over Λ and \mathbf{X}, which is equivalent to minimizing the negative log of the objective function

$$L = \frac{D}{2}\ln|\mathbf{K}| + \frac{1}{2}\operatorname{tr}(\mathbf{K}^{-1}\mathbf{Y}\mathbf{Y}^T) + \frac{1}{2}\sum_i \| x_i \|^2 \qquad (7.6)$$

with respect to the Λ and \mathbf{X}. The last term in (7.6) is added to take care of the ambiguity between the scaling of \mathbf{X} and γ by enforcing a low energy regularization prior over \mathbf{X}. Once the model is learned, given a new input data y_n its corresponding latent point x_n can be obtained by solving the likelihood objective function

$$L_m(x_n, y_n) = \frac{\| y_n - \mu(x_n) \|^2}{2\sigma^2(x_n)} + \frac{D}{2}\ln \sigma^2(x_n) + \frac{1}{2} \| x_n \|^2 \qquad (7.7)$$

where

$$\mu(x_n) = \mu + \mathbf{Y}^T\mathbf{K}^{-1}k(x_n) \qquad (7.8)$$

$$\sigma^2(x_n) = k(x_n, x_n) - k(x_n)^T\mathbf{K}^{-1}k(x_n) \qquad (7.9)$$

and $\mu(x_n)$ is the mean pose reconstructed from the latent point x_n, and $\sigma^2(x_n)$ is the reconstruction variance. μ is the mean of the training data \mathbf{Y}. $k(x_n)$ is the kernel function of x_n evaluated over all the training data. Given input y_n, the initial latent position is obtained as $x_n = \arg\min_{x_n} L_m(x_n, y_n)$. Given x_n, the mean data reconstructed in high dimension can be obtained using Equation 7.8. In our implementation,

we make use of the FGPLVM MATLAB toolbox (http://www.cs.man.ac.uk/neill/gpsoftware.html) and the fully independent training conditional (FITC) approximation software (Lawrence, 2007) provided by Dr. Neil Lawrence for GPLVM learning and bidirectional mapping between **X** and **Y**. Although the FITC approximation was used to expedite the silhouette learning process, it took about five hours to process all the 3616 training silhouettes. As a result, it will be difficult to extend our approach to handle multiple motions simultaneously.

When applying GPLVM to silhouettes modeling, the image feature points are embedded in a 5D latent space S. This is based on the consideration that three dimensions is the minimum representation of walking silhouettes (Elgammal and Lee, 2004). One more dimension is enough to describe view changes along a body-centroid-centered circle in the horizontal plane of the subject. We then add the fifth dimension to allow the model to capture extra variations, e.g., introduced by body shapes of different 3D body models used in synthetic data generation.

7.3.2 Learning Movement Dynamic Using Gaussian Process Dynamic Model

GPDM simultaneously provides a low dimensional embedding of human motion data and dynamics. Based on GPLVM, Wang et al. (2006) proposed GPDM to add a dynamic model in the latent space. It can be used for the modeling of a single type of motion. Urtasun et al. (2006) extended the GPDM to balanced-GPDM to handle multiple subjects' stylistic variation by raising the dynamic density function. GPDM defines a Gaussian process to relate latent points x_t to x_{t-1} at time t. The model is defined as

$$x_t = A\varphi_d(x_{t-1}) + n_x \tag{7.10}$$

$$y_t = B\varphi(x_t) + n_y \tag{7.11}$$

where
 A and B are regression weights
 n_x and n_y are Gaussian noise

The marginal distribution of \mathbf{X} is given by

$$p(\mathbf{X} \mid \Lambda_d) \propto \exp\left(-\frac{1}{2}\operatorname{tr}(\mathbf{K}_x^{-1}(\hat{\mathbf{X}} - \tilde{\mathbf{X}})(\hat{\mathbf{X}} - \tilde{\mathbf{X}})^{\mathsf{T}})\right) \qquad (7.12)$$

where
$\hat{\mathbf{X}} = [x_2, \ldots, x_t]^{\mathsf{T}}$
$\tilde{\mathbf{X}} = [x_1, \ldots, x_{t-1}]^{\mathsf{T}}$
Λ_d consists of the kernel parameters, which will be introduced later
\mathbf{K}_x is the kernel associated with the dynamics Gaussian process and
 is constructed on $\tilde{\mathbf{X}}$

We use an RBF kernel with a white noise term for the dynamics as in Lawrence (2005):

$$k_x(x_t, x_{t-1}) = \alpha_d \exp\left(-\frac{\gamma_d}{2}\|x_t - x_{t-1}\|^2\right) + \beta_d^{-1}\delta_{t,t-1} \qquad (7.13)$$

where $\Lambda_d = (\alpha_d, \gamma_d, \beta_d)$ are parameters of the kernel function for the dynamics. GPDM learning is similar to GPLVM learning. The objective function is given by two marginal log-likelihoods:

$$L_d = \frac{d}{2}\ln|\mathbf{K}_X| + \frac{1}{2}\operatorname{tr}(\mathbf{K}_x^{-1}(\hat{\mathbf{X}} - \tilde{\mathbf{X}})(\hat{\mathbf{X}} - \tilde{\mathbf{X}})^{\mathsf{T}})$$

$$+ \frac{D}{2}\ln|\mathbf{K}| + \frac{1}{2}\operatorname{tr}(\mathbf{K}^{-1}\mathbf{Y}\mathbf{Y}^{\mathsf{T}}) \qquad (7.14)$$

$(\mathbf{X}, \Lambda, \Lambda_d)$ are found by maximizing L_d. Based on Λ_d, one is ready to sample from the movement dynamics, which is important in particle filter-based tracking. Given x_{t-1}, x_t can be inferred from the learned dynamics $p(x_t | x_{t-1})$ as follows:

$$\mu_x(x_t) = \hat{\mathbf{X}}^{\mathsf{T}}\mathbf{K}_X^{-1}k_x(x_{t-1}) \qquad (7.15)$$

$$\sigma_x^2(x_t) = k_x(x_{t-1}, x_{t-1}) - k_x(x_{t-1})^{\mathsf{T}}\mathbf{K}_X^{-1}k_x(x_{t-1}) \qquad (7.16)$$

where $\mu_x(x_t)$ and $\sigma_x^2(x_t)$ are the mean and variance for prediction. $k_x(x_{t-1})$ is the kernel function of x_{t-1} evaluated over \hat{X}.

7.3.3 Examples

By using the FGPLVM toolbox, we obtained the corresponding manifold of the training silhouette data set \mathbf{S}_T described in Section 7.1.3. In Figure 7.8, the first three dimensions of 640 silhouette latent points from \mathbf{S}_T are shown. They represent 80 poses of one gait cycle (two steps) with 8 views for each pose. It can be seen in Figure 7.8 that silhouettes in different ranges of view angles are generally in different parts of the latent space with certain levels of overlapping. Hence, the GPLVM can partly capture the structure of the silhouettes introduced by view changes.

In our implementation of GPDM, the balanced GPDM (Urtasun et al., 2006) is adopted to balance the effect of the dynamics and the reconstruction. As a data preprocessing step, we first center the motion capture data and then rescale the data to unit variance (Taylor et al., 2006). This preprocessing reduces the uncertainty in high dimensional pose space. In addition, we follow the learning procedure in Lawrence (2005) so that the kernel parameters in Λ_d are prechosen instead of being learned for the sake of simplicity. This is also due to the fact that these parameters carry clear physical meanings so that they can

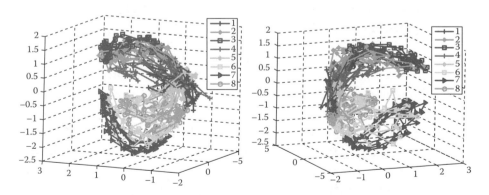

Figure 7.8 (See color insert following page 332.) The first three dimensions of the silhouette latent points of 640 walking frames.

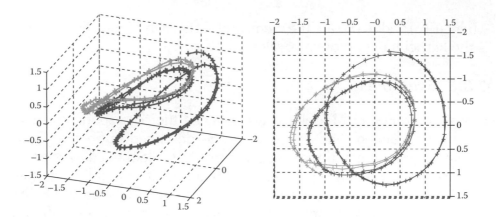

Figure 7.9 (See color insert following page 332.) Two views of a 3D GPDM learned using gait data set Θ_T (see Section 7.1.3), including six walking cycles' frames from three subjects.

be reasonably selected by hand (Lawrence, 2005). In our experiment, $\Lambda_d = (0.01, 10^6, 0.2)$. The local joint angles from motion capture are projected to joint angle manifold Θ. By augmenting Θ with the torso orientation space Ψ, we obtain the complete pose latent space \mathcal{C}. A 3D movement latent space learned using GPDM from the joint angle data set Θ_T described in Section 7.1.3 (six walking cycles from three subjects) is shown in Figure 7.9.

7.4 HUMAN BODY POSE INFERENCE USING BAYESIAN MIXTURE OF EXPERTS

7.4.1 Bayesian Mixture of Experts

The backward mapping from the silhouette manifold \mathcal{S} to the joint space of the pose manifold and the torso orientation \mathcal{C} is needed to conduct both autonomous tracking initialization and sampling from the most recent observation. Different poses can generate the same silhouette, which means this backward mapping is one-to-many from a single-view silhouette.

The BME-based pose learning and inference method we use here mainly follows our previous work in (Guo and Qian, 2006). Let $s \in \mathcal{S}$

be the latent point of an input silhouette and $c \in C$ the corresponding complete pose latent point. In our BME setup, the conditional probability distribution $p(c|s)$ is represented as a mixture of K predictions from separate experts:

$$p(c \mid s, \Xi) = \sum_{k=1}^{K} g(z_k = 1 \mid s, V) p(c \mid s, z_k = 1, U_k) \qquad (7.17)$$

where $\Xi = \{\mathbf{V}, \mathbf{U}\}$ denotes the model parameters. z_k is a latent variable such that $z_k = 1$ indicates that s is generated by the kth expert, otherwise $z_k = 0$. $g(z_k = 1|s, \mathbf{V})$ is the *gate* variable, which is the probability of selecting the k th expert given s. For the k th expert, we assume that c follows a Gaussian distribution

$$p(c \mid s, z_k = 1, U_k) = N(c; f(s, \mathbf{W}_k), \Omega_k) \qquad (7.18)$$

where $f(s, \mathbf{W}_k)$ and Ω_k are the mean and variance matrix of the output of the kth expert. $U_k \equiv \{W_k, \Omega_k\}$ and $\mathbf{U} \equiv \{U_k\}_{k=1}^K$. Following Xu et al. (1995), in our framework we consider the joint distribution $p(c, s|\Xi)$ and assume that the marginal distribution of s is also a mixture of Gaussian. Hence the gate variables are given by the posterior probability

$$g(z_k = 1| s, \mathbf{V}) = \frac{\lambda_k N(s; \mu_k, \Sigma_k)}{\sum_{l=1}^{K} \lambda_l N(s; \mu_l, \Sigma_l)} \qquad (7.19)$$

where
 $\mathbf{V} = \{V_k\}_{k=1}^K$
 $V_k = (\lambda_k, \mu_k, \Sigma_k)$ and λ_k, μ_k, Σ_k are the mixture coefficient, the mean, and the covariance matrix of the marginal distribution of s for the kth expert, respectively
The mixture coefficients $\{\lambda_k\}_{k-1}^K$ are positive and add up to one.

Given a set of training samples $\{(s^{(i)}, c^{(i)})\}_{i=1}^N$, the BME model parameter vector Ξ needs to be learned. Similar to Sminchisescu (2005a,b), in our framework the expectation–maximization (EM) algorithm is used

to learn Ξ. In the E-step of the nth iteration, we first compute the *posterior gate* $h_k^{(i)} = p(z_k = 1 \mid s^{(i)}, c^{(i)}, \Xi^{(n-1)})$ using the current parameter estimate $\Xi^{(n-1)}$. $h_k^{(i)}$ is basically the posterior probability that $(s^{(i)}, c^{(i)})$ is generated by the kth expert. Then in the M-step, the estimate of Ξ is refined by maximizing the expectation of the log-likelihood of the complete data including the latent variables. It can be easily shown Xu et al. (1995) that the object function can be decomposed into two sub-functions: one related to gate parameters \mathbf{V} and the other one to the expert parameters \mathbf{U}. Details about the update of \mathbf{V} can be found in Xu et al. (1995), which are essentially the basic equations in the M-step for Gaussian mixture modeling of $\{s^{(i)}\}_{i=1}^N$ using EM.

7.4.2 Experts Learning Using Weighted Relevant Vector Machine

In this section, we present our method for the learning of the expert parameters $\mathbf{U} = \{U_k\}_{k=1}^K$. There are K data pair clusters in BME. For each cluster, we need to construct an expert for the mapping from sil-houette latent point s to the complete pose latent point c. The learning process of the parameters for all of the K experts is identical. We now consider the learning of $U_k = (\mathbf{W}_k, \Omega_k)$. The input to the learning algo-rithm is $\{(s^{(i)}, c^{(i)}), h_k^{(i)}\}_{i=1}^N$, including the original training data pairs and their associated posterior gate values with respect to the kth expert. $h_k^{(i)}$'s are the outputs of the E-step of the BME learning mentioned in the previous section. Following Xu et al. (1995), the objective function for the optimization of the expert parameters is given by

$$L_e = \sum_{i=1}^N h_k^{(i)} p(c^{(i)} \mid (s^{(i)}, U_k) \tag{7.20}$$

In our proposed framework, we deployed RVM (Tipping, 2001) to solve this maximization problem. In our current implementation, individual dimensions of c are considered separately assuming independence between dimensions. To be concise in notation, in the remaining of this section we assume that c is a scalar. When c is a vector, the expert

learning processes in all dimensions are identical. Denote $\mathbf{S} = \{s^{(i)}\}_{i=1}^{N}$, $\mathbf{C}=[c^{(1)}, ..., c^{(i)}, ..., c^{(N)}]^{\mathrm{T}}$, and $\mathbf{H}=\mathrm{diag}(h_i)$, $i=1, ..., N$. The RVM regression from s to c takes the following form:

$$c \sim N(c; \phi(s)^{\mathrm{T}}\mathbf{W}_k, \Omega_k) \qquad (7.21)$$

where $\phi(s)=[1, k(s,s^{(1)}), ..., k(s,s^{(N)})]^{\mathrm{T}}$ is a column vector of known kernel functions. Hence the likelihood of \mathbf{C} is

$$p(\mathbf{C}|\mathbf{S}, \mathbf{W}_k, \Omega_k) \propto \exp\left\{ -\frac{(\mathbf{C} - \Phi\mathbf{W_k})^{\mathrm{T}}\mathbf{H}(\mathbf{C} - \Phi\mathbf{W_k})}{2\Omega_k} \right\} \qquad (7.22)$$

where $\Phi=[\phi(s^{(1)}), ..., \phi(s^{(N)})]^{\mathrm{T}}$ is the kernel matrix. To overfitting, a diagonal hyper-parameter matrix \mathbf{A} is introduced to model the prior of $\mathbf{W_k}$: $p(\mathbf{W_k}|\mathbf{A})=N(\mathbf{W_k}; \mathbf{0}, \mathbf{A}^{-1})$. Following the derivation in Tipping (2001), it can be easily shown that in the case of weighted RVM, the conditional probability distribution of \mathbf{W} is given by

$$p(\mathbf{W_k} \mid \mathbf{C}, \mathbf{S}, \mathbf{H}, \mathbf{A}, \Omega_k) = N(\mathbf{W_k}; \hat{\mathbf{W}}_k, \Sigma) \qquad (7.23)$$

$\hat{\mathbf{W}}_k$, Σ are computed through the following iterative procedure:

$$\Sigma = (\Omega_k^{-1}\Phi^{\mathrm{T}}\mathbf{H}\Phi + \mathbf{A})^{-1} \qquad (7.24)$$

$$\hat{\mathbf{W}}_k = \Omega_k^{-1}\Sigma\Phi^{\mathrm{T}}\mathbf{H}\mathbf{C} \qquad (7.25)$$

$$\alpha_i^{(\mathrm{new})} = \frac{1 - \Sigma_{ii}}{\hat{w}_i^2} \qquad (7.26)$$

$$\Omega_k^{(\mathrm{new})} = \frac{(\mathbf{C} - \Phi\hat{\mathbf{W}}_k)^{\mathrm{T}}\mathbf{H}(\mathbf{C} - \Phi\hat{\mathbf{W}}_k)}{N - \sum_{i=1}^{N}(1 - \alpha_i\Sigma_{ii})} \qquad (7.27)$$

where
 \hat{w}_i is the ith element of $\hat{\mathbf{W}}_k$
 α_i and Σ_{ii} are the ith diagonal terms of \mathbf{A} and Σ, respectively

Once the parameters have been estimated, given a new input s^*, the conditional probability distribution of the output from the kth expert is given by

$$c_k^* \sim N\left(c_k^*; c_{k,\mu}^*, \Omega_k^*\right) \qquad (7.28)$$

where

$$c_{k,\mu}^* = \phi^T(s^*)\hat{\mathbf{W}}_k \qquad (7.29)$$

$$\Omega_k^* = \Omega_k + \phi^T(s^*)\Sigma\phi(s^*) \qquad (7.30)$$

7.4.3 Examples

To demonstrate the validity of the above BME-based pose inference framework, some experimental results are included in this section. The resulting BME constitutes a mapping from \mathcal{S} to \mathcal{C}. The training data used include the projection of silhouette training set \mathbf{S}_T onto \mathcal{S} using GPLVM and the projection of the pose data \mathbf{C}_T on \mathcal{C} using GPDM. The number of experts in BME is the number of mappings from \mathcal{S} to \mathcal{C}. When the local body kinematics is fixed, usually five mappings are sufficient to cover the variations introduced by different torso orientations. When the torso orientation is fixed, the number of mappings needed to handle changes due to different body kinematics depends on the complexity of the actual movement. In the case of gait, three mappings are sufficient. Therefore, in our experiment when both torso orientation and body kinematics are allowed to vary, 15 experts were learned in BME for the pose inference of gait.

Synthetic testing data were generated using different 3D human models and motion sequences from different subjects. Some reconstructed poses for the first two most probable outputs, i.e., the outputs with the first two largest gate values computed using (7.19), are shown in Figure 7.10. It is clear that BME can handle ambiguous poses.

A real video (40 frames, two steps' side-view walking) was also used to evaluate this approach. Due to observation noise, the silhouettes

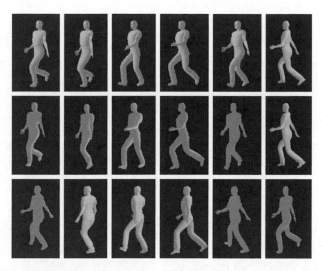

Figure 7.10 BME-based pose inference results of a synthetic walking sequence. Top row: input images; middle row: the most probable poses; bottom row: the second most probable poses.

extracted from this video were not as clean as the synthesized ones. However, BME can still produce perceptually sound results. Some recovered poses are shown in Figure 7.11.

7.5 HUMAN MOTION TRACKING

A particle filter defined over C is used for the 3D tracking of articulated motion. The state parameter at time t is $c_t = (\theta_t, \psi_t)$, where θ_t is the latent point of the body joint angles, and ψ_t is the torso orientation. Given a sequence of latent silhouette points $s_{1:t}$ obtained from input images using GPLVM, the posterior distribution of the state is approximated by a set of weighted samples $\{w_t^{(i)}, c_t^{(i)}\}_{i=1}^{M}$. The importance weights of the particles are propagated over time as follows:

$$w_t^{(i)} \propto w_{t-1}^{(i)} \frac{p\left(s_t \mid c_t^{(i)}\right) p\left(c_t^{(i)} \mid c_{t-1}^{(i)}\right)}{q\left(c_t^{(i)} \mid c_{t-1}^{(i)}, s_t\right)} \tag{7.31}$$

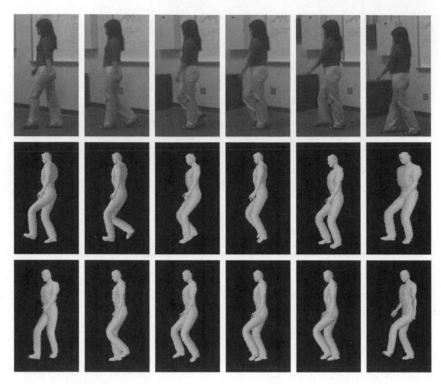

Figure 7.11 BME-based pose inference results of a real walking video. top row: input video images; middle row: the most probable poses; The third row: The second most probable poses.

Pose estimation results from BME are used to initialize the tracking. BME cannot disambiguate; however, it provides multiple possible solutions. In our experiments, the first three most probable solutions from BME are selected as tracking seeds according to their gate values. Then samples are drawn around these seeds. Generally a wrong initialized branch will merge with the correct ones after several frames estimation. But in some situations, due to inherent ambiguity, an ambiguous solution might also stay. For example, multiple tracking trajectories are shown in Figures 7.13 and 7.9.

7.5.1 Motion Sampling

Particles are propagated over time from a proposal distribution q. To take into account both the movement dynamics and the most recent

observation s_t, in our approach we select q to be the mixture of two distributions as follows:

$$q(c_t| c_{t-1}, s_t) = \pi q_b(c_t| s_t) + (1 - \pi)p(c_t| c_{t-1}) \qquad (7.32)$$

where $q_b (c_t|s_t)$ is chosen as the BME output $p(c\,|\,s,\Xi)$ given by (7.17) and (7.33).

$$p(c\,|\,s,\Xi) = \sum_{k=1}^{K} g(z_k = 1\,|\,s,V)N(c;\phi(s)^{\mathrm{T}}\hat{\mathbf{W}}_k,\hat{\Omega}_k) \qquad (7.33)$$

In our experiment, we only use the first three most probable components of the 15 BME outputs and draw samples according to the regression covariance. The second term in (7.32) is from movement dynamics learned using GPDM and a first-order AR model for the torso orientation

$$p(c_t\,|\,c_{t-1}) = p(\theta_t\,|\,\theta_{t-1})p(\psi_t\,|\,\psi_{t-1}) \qquad (7.34)$$

In (7.32), π is the mixture coefficient of the BME-based prediction and the dynamics-based prediction components. In our experiments, $\pi = 0.5$. Because C is a 5D space, only 100 particles were used in tracking, which makes the tracking computationally efficient.

7.5.2 Likelihood Evaluation

In our framework, we take RVM as the regression function to construct a forward mapping from C to \mathbf{S}. The hypothesized pose latent point c^* is first projected to s^*, and then to the image feature space using the inverse mapping in GPLVM. In the RVM learning, we used the same training set as that in the BME learning described in Section 7.4.3. The final number of the relevance vectors account about 10%–20% of the total data. To evaluate the effectiveness of the RVM-based mapping, it was compared against a model-based approach, in which the hypothesized torso orientation and body kinematics were obtained from c^*, and then Maya was used to render the corresponding silhouettes of the 3D body model. The silhouette distance is measured in the vectorized GMM feature space. Comparison results using five walking images are

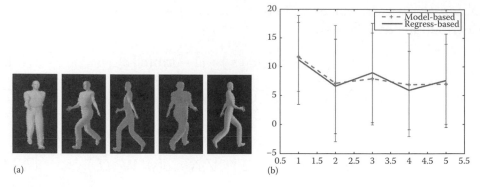

(a) (b)

Figure 7.12 (a) Sample silhouettes from view #1 through view #5, indexed starting from the left-most figure. (b) **(See color insert following page 332.)** RMS error results using rendering and regression approaches. The average error is close for both approaches.

included in this section. For each input silhouette, 15 poses were inferred using BME learned according to the method presented in Section 7.4.3. Given a pose, two vectorized GMM descriptors were obtained using both the RVM- and model-based approaches. The root mean square errors (RMSE) between the predicted and true image features were then computed. Figure 7.12a shows exemplar input silhouettes from view #1 through view #5, indexed starting from the left-most figure. For each view and each method, given an input silhouette we found the smallest RMSE among all of the 15 candidate poses provided by BME. We then compute the average of the smallest RMSE over all the input silhouettes. The average RMSE of all the five views from both methods are shown in Figure 7.12b. It can be seen that the average RMSE is close for these two approaches, which indicates that the likelihoods of a good pose candidate computed using both methods are similar. Hence we can use the example-based approach for computation efficiency. In addition, the example-based approach does not need a 3D body model of the subject, which also simplifies the problem.

7.5.3 Examples

The proposed framework has been tested using both synthetic and real image sets. The system was trained using training data described in Section 7.1.3.

During tracking, the preprocessing of the input image takes about 800 ms per frame, including silhouette extraction, GMM, and vectorization. Out of these three operations, GMM is the most time consuming, taking about 600 ms. The mapping from vectorized GMM to the silhouette manifold S is the most time-consuming operation in our current implementation, which takes about 3 s per frame. BME inference, sampling, and sample weight evaluation is fairly fast, taking about 200 ms per frame. The total time to process one frame of input image is about 4 s.

We first used synthetic data to evaluate the accuracy of our tracking system. The test sequence was created using motion capture data (sequence 08_02 in the CMU database) of a new subject not included in training sets and a new 3D body model. Some of the camera views are also new. This test sequence has 63 frames of two walking cycles. The five camera views used to create the testing data are the same as those shown in Figure 7.12a. The RMSE between the ground-truth and the estimated joint angles is given to show the tracking accuracy. The tracking results based only on sampling from the GPDM movement dynamics are also included for comparison purposes. One hundred particles were used in both cases. The average RMS error from different views is shown in Figure 7.13a. The tracking from view #1 (frontal view) is rather ambiguous. The frame-wise RMSE of view #5 (side-view walking from left to right) is given in Figure 7.13b. Figure 7.13c presents some input silhouettes from view 5 (top row) and their estimated poses (the second and third rows). To show the effectiveness of the proposed framework, results from the static image estimation using only BME and results from sampling from dynamics are also shown in the fourth and fifth rows, respectively. It can be seen that our proposed framework provided the most accurate tracking results among all three methods. The result obtained using the proposed method successfully describes the inherent left-and-right ambiguity present in the input silhouette. It can been seen that the initial and the continuous silhouettes are difficult to be distinguished from the left and the right. The proposed framework returned both admissible results, although we cannot tell which one corresponds to the true movement. Both movement trajectories tracked in Θ are shown in Figure 7.13d.

A real video sequence of 42 frames of two steps' walking along diagonal direction to the camera was used to evaluate the proposed

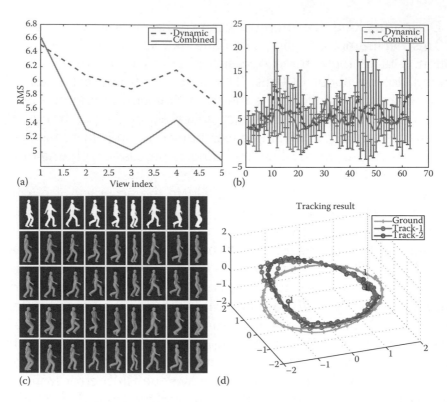

Figure 7.13 Experimental results obtained using synthetic data. (a) Average RMS errors obtained using synthetic testing sequences from different views. (b) **(See color insert following page 332.)** Frame-wise RMS from the side view. (c) Exemplar input silhouettes of view 5 and tracking results. top row: some input silhouettes; the second and third rows: two plausible solutions obtained using our framework; the fourth row: the recovered poses directly from the observed image using BME; bottom row: the recovered poses obtained using only dynamic prediction. (d) **(See color insert following page 332.)** The tracked movement trajectories in the joint angle manifold Θ.

system. The subject was not seen in the system training. One hundred particles were used in the tracking. Due to observation noise in the video, the extracted silhouettes were not as clean as the synthesized ones. However, the proposed approach can still produce plausible results. Some recovered poses are shown in Figure 7.14.

Another real video sequence (40 frames, two steps' side-view walking) was used to evaluate the proposed system. This video is slightly

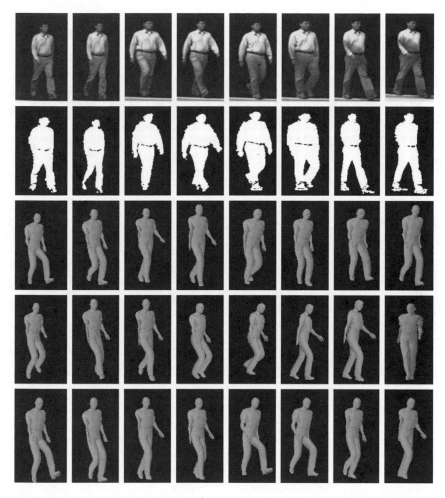

Figure 7.14 Reconstructed poses for a real image sequence of 42 frames. top row: sample input images; the second row: extracted silhouettes; the third row: recovered poses using the proposed framework; the fourth row: recovered poses directly from the observed image using only BME; bottom row: recovered poses obtained using only dynamic prediction.

more challenging than the previous one because there is a jump between frame 29 and frame 30 due to missing frames caused by a misoperation during the video recording. One hundred particles were used in the tracking. The proposed framework still recovered two reasonable movement trajectories. Some of the results are shown in Figure 7.15a. Both admissible tracking trajectories in the joint angle

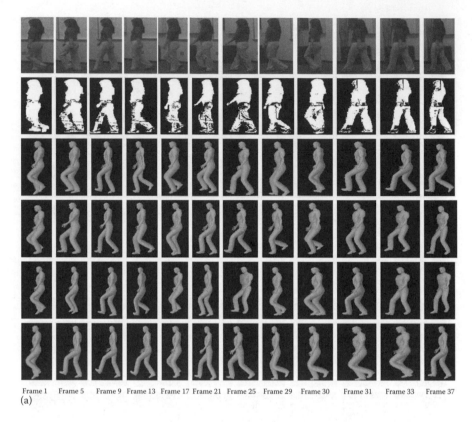

Frame 1 Frame 5 Frame 9 Frame 13 Frame 17 Frame 21 Frame 25 Frame 29 Frame 30 Frame 31 Frame 33 Frame 37

(a)

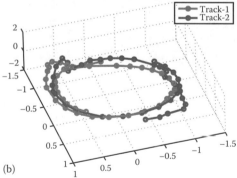

(b)

Figure 7.15 Pose tracking results obtained using a real image sequence of 40 frames, where there is a movement jump between frame 29 to frame 30. (a) Top row: sample input images; the second row: extracted silhouettes; the third and fourth rows: two plausible solutions tracked using our framework; the fifth row: recovered poses directly from the corresponding images using BME; bottom row: recovered poses obtained using only dynamic prediction. (b) **(See color insert following page 332.)** The tracked movement trajectories in the joint angle manifold Θ.

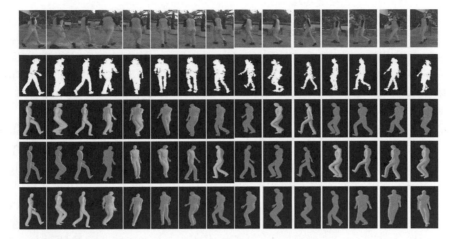

Figure 7.16 Pose tracking results using a real image sequence of circular walking; top row: sample input images; the second row: extracted silhouettes; the third row: recovered poses using the proposed framework; the fourth row: recovered poses directly from the corresponding images using only BME; bottom row: recovered poses obtained using only dynamic prediction.

manifold Θ are shown in Figure 7.15b. The last set of experimental results included here shows the generalization capability of our proposed tracking framework. A video of a circular walking from Sidenbladh et al. (2000) was used. Two hundred particles were used in the tracking. The number of samples used in this experiment was more than the other experiments because of the increased movement complexity present in a circular walking. The corresponding results are shown in Figure 7.16. It can been seen that our proposed framework can track this challenging video fairly well. Our results are much better than those obtained either using only BME or direct sampling from movement dynamics.

7.6 SUMMARY

This chapter presents a 3D articulated human motion-tracking framework using a single camera based on manifold learning, nonlinear regression, and particle filter-based tracking. Experimental results show that once properly trained, the proposed framework is able to track patterned motion, e.g., walking. A number of improvements

can be made as part of our future work. In the proposed framework, there are two separate low dimensional manifolds for silhouettes and poses, which require a number of forward–backward mappings. In our future work, we will try to construct a joint silhouette-pose manifold, which will greatly simplify the mapping procedure from the input silhouette to the corresponding latent 46-pose point, in a way similar to Ek et al. (2007). In the proposed framework, we assume that all the entries of the vectorized GMM are independent given the latent variables. This might not be true in reality. We will investigate possible errors carried by this assumption. In our current implementation, we only learn the parameters for a first-order Markov process. To explore higher order Markov processes will be another interesting research problem to work on as well. In our current BME learning, experts for different dimensions of C are learned separately using univariate RVM. In our future work, we would like to adopt the multivariate RVM framework proposed in Thayananthan et al. (2006) for BME learning and pose inference. We will also compare the final tracking results obtained using univariate RVM and multivariate RVM. Finally, we are working on extending our proposed framework in this paper into a multiple-view setting. Research challenges include the optimization of a fusion scheme of input from multiple cameras.

7.7 BIBLIOGRAPHICAL AND HISTORICAL REMARKS

Among existing methods on integrating generative-based and discriminative-based approaches for articulated motion tracking, the 2D articulated human motion tracking system proposed by Curio and Giese (Curio and Giese, 2005) is the most relevant to our framework. The system in Curio and Giese (2005) conducts dimension reduction in both image and pose spaces. Using training data, one-to-many support vector regression (SVR) is learned to conduct view-based pose estimation. A first-order AR linear model is used to represent state dynamics. A competitive particle filter defined over the hidden state space is deployed to select plausible branches and propagate state posteriors over time. Due to SVR, this system is capable of autonomous initialization.

It draws samples using both current observation and state dynamics. However, there are four major differences between the approach in Curio and Giese (2005) and our proposed framework. Essentially, Curio and Giese (2005) presents a tracking system for 2D articulated motion, while our framework is for 3D tracking. In addition, in Curio and Giese (2005) a 2D patch-model is used to obtain the predicted image observation, while in our proposed framework this is done through nonlinear regression without using any body models. Furthermore during the initialization stage of the system in Curio and Giese (2005), only the best body configuration obtained from the view-based pose estimation and the model-based matching is used to initialize the tracking. It is obvious that using a single initial state has the risk of missing other admissible solutions due to the inherent ambiguity. Therefore in our proposed system multiple solutions are maintained in tracking. Finally, BME is used in our proposed framework for view-based pose estimation instead of SVR as in Curio and Giese (2005). BME has been used for kinematic recovery (Sminchisescu et al., 2005a). In summary, our proposed framework can be considered as an extension of the system in Curio and Giese (2005) to better address the integration of generative-based and discriminative-based approaches in the case of the 3D tracking of human movement, with the advantages of tracking multiple possible pose trajectories over time and removing the requirement of a body model to obtain predicted image observations.

The dimension reduction of the image silhouette and pose spaces has also been investigated using kernel principle component analysis (KPCA) (Scholkopf and Smola, 2002; Sminchisescu et al., 2005b) and probabilistic PCA (Tipping and Bishop, 1999; Grauman et al., 2003). In Li et al. (2006, 2007), a mixture of factor analyzers is used to locally approximate the pose manifold. Factor analyzers perform nonlinear dimension reduction and data clustering concurrently within a global coordinate system, which makes it possible to derive an efficient multiple hypothesis tracking algorithm based on distribution modes. Recently, nonlinear probabilistic generative models such as GPLVM (Lawrence, 2005) have been used to represent the low dimensional full body joint data (Grochow et al., 2004; Urtasun et al., 2005) and upper body joints (Tian et al., 2005) in a probabilistic framework. Urtasun et al. (2005) introduces the scaled-GPLVM to learn the dynamical

models of human movements. As variants of GPLVM, GPDM (Moon and Pavlovic, 2006; Wang et al., 2006) and balanced-GPDM (Urtasun et al., 2006) have been shown to be able to capture the underlying dynamics of movement, and at the same time to reduce the dimensionality of the pose space. Such GPLVM-based movement dynamical models have been successfully used as priors for the tracking of various types of movement, including walking (Urtasun et al., 2006) and golf swing (Urtasun et al., 2005). Recently Lawrence and Moore (2007) presented a hierarchical GPLVM to explore the conditional independencies, while Wang et al. (2007) extended GPDM into a multifactor analysis framework for style-content separation. In our proposed framework, we follow the balanced-GPDM presented in Urtasun et al. (2006) to learn movement dynamics due to its simplicity and demonstrated ability to model human movement. Furthermore, we adopt GPLVM to construct the silhouette manifold using silhouette images from different views, which has been shown to be promising in our experiments. Additional results using GPLVM for 3D tracking have been reported recently. In Hou et al. (2007), a real-time body-tracking framework is presented using GPLVM.

Since image observations and body poses of the same movement essentially describe the same physical phenomenon, it is reasonable to learn a joint image-pose manifold. In Ek et al. (2007) GPLVM has been used to obtained a joint silhouette and pose manifold for pose estimation. Sminchisescu et al. (2006) presents a joint learning algorithm for a bidirectional generative–discriminative model for 2D people detection and 3D human motion reconstruction from static images with cluttered background by combining the top-down (generative-based) and bottom-up (discriminative-based) processing. The combination of top-down and bottom-up approaches in Sminchisescu et al. (2006) is promising for solving simultaneous people detection and pose recovery in cluttered images. However, the emphasis of Sminchisescu et al. (2006) is on the parameter learning of the bidirectional model and movement dynamics is not considered. Comparing with Ek et al. (2007) and Sminchisescu et al. (2006), the separate kinematics and silhouette manifold learning is a limitation of our proposed framework.

View-independent tracking and handling of ambiguous solutions is critical for monocular-based tracking. To tackle this challenge, Lee

and Elgammal (2006) represent shape deformations according to view and body configuration changes on a 2D torus manifold. A nonlinear mapping is then learned between torus manifold embedding and visual input using empirical kernel mapping. Ong et al. (2006) learned a clustered exemplar-based dynamic model for the viewpoint invariant tracking of the 3D human motion from a single camera. This system can accurately track large movements of the human limbs. However, neither of the above approaches explicitly considers multiple solutions and only one kinematic trajectory is tracked, which results in an incomplete description of the posterior distribution of poses. To handle the multimodal mapping from the visual input space to the pose space, several approaches (Rosales and Sclaroff, 2002; Agarwal and Triggs, 2005; Sminchisescu et al., 2005a) have been proposed. The basic idea is to split the input space into a set of regions and approximate a separate mapping for each individual region.

These regions have *soft* boundaries, meaning that data points may lie simultaneously in multiple regions with certain probabilities. The mapping in Rosales and Sclaroff (2002) is based on the joint probability distribution of both the input and the output data. An inverse mapping function is used to formulate an efficient inference. In Agarwal and Triggs (2005) and Sminchisescu et al. (2005a), the conditional distribution of the output given the input is learned in the framework of mixture of experts. Agarwal and Triggs (2005) also use the joint input–output distribution and obtain the conditional distribution using Bayes' rule while Sminchisescu et al. (2005a) learn the conditional distribution directly. In our proposed framework, we adopt the extended BME model (Xu et al., 1995) and use RVM as experts (Sminchisescu et al., 2005a) for multimodal regression. A related work that should be mentioned here is the extended multivariate RVM for multimodal multidimensional 3D body tracking (Thayananthan et al., 2006). The impressive full body tracking results of human movement have been reported in Thayananthan et al. (2006).

Another highlight of our proposed system is that predicted visual observations can be obtained directly from a pose hypothesis without projecting a 3D body model. This feature allows efficient likelihood and weight evaluation in a particle-filtering framework. The 3D-model-free approaches for image silhouette synthesis from movement data reported

in Elgammal and Lee (2004) and Lee and Elgammal (2007) are most related to our proposed approach. The main difference is that our approach achieves visual prediction using RVM-based regression, while in Elgammal and Lee (2004) and Lee and Elgammal (2007) multilinear analysis (Vasilescu and Terzopoulos, 2003) is used for visual synthesis.

ACKNOWLEDGMENT

The authors would like to thank Dr. Neil Lawrence for making the GPLVM and related toolboxes freely available online to the community. This paper is based upon work partly supported by the U.S. National Science Foundation (NSF) on CISE-RI no. 0403428 and IGERT no. 0504647.

Any opinions, findings, and conclusions or recommendations expressed in this material are those of the authors and do not necessarily reflect the views of the U.S. NSF.

REFERENCES

Agarwal, A., Triggs, B., 2004. Tracking articulated motion using a mixture of autoregressive models. In: *European Conference on Computer Vision*, Prague, Czech Republic, pp. III 54–65.

Agarwal, A., Triggs, B., 2005. Monocular human motion capture with a mixture of regressors. In: *Proceedings of the IEEE International Conference on Computer Vision and Pattern Recognition*, San Diego, CA.

Agarwal, A., Triggs, B., 2006. Recovering 3D human pose from monocular images. *IEEE Transactions on Pattern Analysis & Machine Intelligence* 28(1), 44–58.

Borg, I., Groenen, P., 1997. *Modern Multidimensional Scaling: Theory and Applications*, Springer, New York.

Burges, C. J., 2005. Geometric methods for feature extraction and dimensional reduction. In: Maimon, O., Rokach, L. (Eds.), *Data Mining and Knowledge Discovery Handbook: A Complete Guide for Practitioners and Researchers*. Springer, New York.

Curio, C., Giese, M. A., 2005. Combining view-based and modelbased tracking of articulated human movements. In: *Proceedings of the IEEE Workshop on Motion and Video Computing*, Orlando, FL.

Deutscher, J., Blake, A., Reid, I., 2000. Articulated body motion capture by annealed particle filtering. In: *Proceedings of the IEEE International Conference on Computer Vision and Pattern Recognition*, San Diego, CA, pp. 126–133.

Ek, C. H., Laurence, N., Torr, P., 2007. Gaussian process latent variable models for human pose estimation. In: *4th Joint Workshop on Multimodal Interaction and Related Machine Learning Algorithms*, Brno, Czech Republic.

Elgammal, A., Lee, C.-S., 2004. Inferring 3D body pose from silhouettes using activity manifold learning. In: *Proceedings of the IEEE International Conference on Computer Vision and Pattern Recognition*, Washington DC.

Goldberger, J., Gordon, S., Greenspan, H., 2002. From image Gaussian mixture models to categories. In: *Proceedings of European Conference on Computer Vision*, Copenhagen, Denmark.

Grauman, K., Shakhnarovich, G., Darrell, T., 2003. Inferring 3D structure with a statistical image-based shape model. In: *Proceedings of the IEEE International Conference on Computer Vision*, Nice, France.

Grochow, K., Martin, S. L., Hertzmann, A., Popovi, Z., 2004. Stylebased inverse kinematics. *ACM Transactions on Graphics* 23(3), 522–531.

Guo, F., Qian, G., 2006. Learning and inference of 3D human poses from Gaussian mixture modeled silhouettes. In: *Proceedings of International Conference on Pattern Recognition*, Hong Kong.

Hou, S., Galata, A., Caillette, F., Thacker, N., Bromiley, P., 2007. Real-time body tracking using a Gaussian process latent variable model. In: *IEEE International Conference on Computer Vision*, Rio de Janeiro, Brazil.

Kakadiaris, I., Metaxas, D., 2000. Model-based estimation of 3D human motion. *IEEE Transactions on Pattern Analysis and Machine Intelligence* 22(12), 1453–1459.

Lawrence, N. D., 2003. Gaussian process latent variable models for visualization of high dimensional data. In: *Advances in Neural Information Processing Systems*, Vancouver, British Columbia, Canada.

Lawrence, N., 2005. Probabilistic non-linear principal component analysis with Gaussian process latent variable models. *Journal of Machine Learning Research* 6, 1783–1816.

Lawrence, N. D., 2007. Learning for larger datasets with the Gaussian process latent variable model. In: *International Workshop on Artificial Intelligence and Statistics*, San Juan, Puerto Rico.

Lawrence, N. D., Moore, A. J., 2007. Hierarchical Gaussian process latent variable models. In: *Proceedings of the 24th International Conference on Machine Learning*, Corvalis, OR, pp. 481–488.

Lee, C.-S., Elgammal, A. M., 2006. Simultaneous inference of view and body pose using torus manifolds. In: *Proceedings of International Conference on Pattern Recognition*, Hong Kong.

Lee, C.-S., Elgammal, A. M., 2007. Modeling view and posture manifolds for tracking. In: *International Conference on Computer Vision*, Rio de Janeiro, Brazil.

Li, R., Yang, M.-H., Sclaroff, S., Tian, T.-P., 2006. Monocular tracking of 3D human motion with a coordinated mixture of factor analyzers. In: *Proceedings of European Conference on Computer Vision*, Graz, Austria, pp. 137–150.

Li, R., Tian, T.-P., Sclaroff, S., 2007. Simultaneous learning of nonlinear manifold and dynamical models for high-dimensional time series. In: *International Conference on Computer Vision*, Rio de Janeiro, Brazil.

Moon, K., Pavlovic, V., 2006. Impact of dynamics on subspace embedding and tracking of sequences. In: *Proceedings of the IEEE International Conference on Computer Vision and Pattern Recognition*, New York.

Mori, G., Malik, J., 2002. Estimating human body configurations using shape context matching. In: *Proceedings of European Conference on Computer Vision*, Vol. 3, Copenhagen, Denmark, pp. 666–680.

Ong, E.-J., Micilotta, A. S., Bowden, R., Hilton, A., 2006. Viewpoint invariant exemplar-based 3D human tracking. *Computer Vision and Image Understanding* 104(2), 178–189.

Pavlovic, V., Rehg, J. M., MacCormick, J., 2000. Learning switching linear models of human motion. In: *Proceedings of the Neural Information Processing Systems*, Denver, CO.

Poppe, R., Poel, M., 2006. Comparison of silhouette shape descriptors for example-based human pose recovery. In: *Proceedings of the IEEE International Conference on Automatic Face and Gesture Recognition*, Southampton, U.K.

Rosales, R., Sclaroff, S., 2002. Learning body pose via specialized maps. In: *Advances in Neural Information Processing Systems*, Vancouver, British Columbia, Canada.

Scholkopf, B., Smola, A., 2002. *Learning with Kernels*, MIT Press, Cambridge, MA.

Sidenbladh, H., Black, M. J., Fleet, D. J., 2000. Stochastic tracking of 3D human figures using 2D image motion. In: *Proceedings of the European Conference on Computer Vision*, Dublin, Ireland, pp. 702–718.

Sminchisescu, C., Kanaujia, A., Li, Z., Metaxas, D., 2005a. Discriminative density propagation for 3D human motion estimation. In: *Proceedings of the IEEE International Conference on Computer Vision and Pattern Recognition*, San Diego, CA.

Sminchisescu, C., Kanujia, A., Li, Z., Metaxas, D., 2005b. Conditional visual tracking in kernel space. In: *Advances in Neural Information Processing Systems*, Vancouver, BC, Canada.

Sminchisescu, C., Kanaujia, A., Metaxas, D., 2006. Learning joint top-down and bottom-up processes for 3D visual inference. In: *Proceedings of the IEEE International Conference on Computer Vision and Pattern Recognition*, New York, pp. 1743–1752.

Taylor, G., Hinton, G., Roweis, S., 2006. Modeling human motion using binary latent variables. In: *Advances in Neural Information Processing Systems*, Vancouver, BC, Canada.

Thayananthan, A., Navaratnam, R., Stenger, B., Torr, P. H. S., Cipolla, R., 2006. Multivariate relevance vector machines for tracking. In: *Proceedings of European Conference on Computer Vision*, Graz, Austria.

Tian, T.-P., Li, R., Sclaroff, S., 2005. Articulated pose estimation in a learned smooth space of feasible solutions. In: *Proceedings of the IEEE International Conference on Computer Vision and Pattern Recognition*, San Diego, CA.

Tipping, M. E., 2001. Sparse Bayesian learning and the relevance vector machine. *Journal of Machine Learning Research* 1, 211–244.

Tipping, M. E., Bishop, C. M., 1999. Mixtures of probabilistic principal component analysers. *Neural Computation* 11(2), 443–482.

Urtasun, R., Fleet, D. J., Hertzmann, A., Fua, P., 2005. Priors for people tracking from small training sets. In: *Proceedings of the IEEE International Conference on Computer Vision*, Beijing, China.

Urtasun, R., Fleet, D. J., Fua, P., 2006. 3D people tracking with Gaussian process dynamical models. In: *Proceedings of the IEEE International Conference on Computer Vision and Pattern Recognition*, New York.

Vasilescu, M., Terzopoulos, D., 2003. Multilinear subspace analysis of image ensembles. *Computer Vision and Pattern Recognition* 2, 93–99.

Wang, J. M., Fleet, D. J., Hertzmann, A., 2006. Gaussian process dynamical models. In: *Proc. NIPS 2005*, Vancouver, BC, Canada, pp. 1441–1448.

Wang, J. M., Fleet, D. J., Hertzmann, A., 2007. Multifactor Gaussian process models for style-content separation. In: *Proceedings of the 24th International Conference on Machine Learning*, Corvalis, OR, pp. 975–982.

Xu, L., Jordan, M. I., Hinton, G. E., 1995. An alternative model for mixtures of experts. In: Tesauro, G., Touretzky, D., Leen, T. (Eds.), *Advances in Neural Information Processing Systems*. Vol. 7, MIT Press, Cambridge, MA, pp. 633–640.

Part III

Activity Recognition

Part III

Activity Recognition

Human Action Recognition

Xinyu Xu and Baoxin Li

CONTENTS

8.1 INTRODUCTION

Being able to recognize human activities in video is a critical capability of an intelligent vision system in many applications including video

surveillance. On this task, human vision still outperforms any existing automatic techniques. Humans tend to describe, remember, perform, and compare an action as a sequence of key poses of the body. Most of the existing vision techniques attempt to mimic this to a certain degree, explicitly or implicitly, by modeling and classifying human actions based on key poses and their orders. Unfortunately, such techniques typically rely on sophisticated feature extraction (e.g., explicit detection and tracking of body parts, or doing so implicitly by complex representation and detection of the body motion through high-dimensional spatiotemporal features), which is a challenging task on its own especially considering the wide variability of the acquisition condition.

In this chapter, we present an approach to video-based recognition of human actions using simple visual features: motion captured in direct frame differencing. While using such simple features help to avoid sophisticated feature extraction, in practice, supervised learning is difficult due to the high dimensionality of the input, the complexity of the dynamics of the time-varying data, and (typically) the small amount of available training data. To address these challenges, we develop a discriminative Gaussian process dynamic model (D-GPDM) and the corresponding learning and inference algorithms, which achieve simultaneously latent manifold discovery of the high-dimensional, dynamic input, and discriminative learning in the latent space.

GPDM (Wang et al. 2005) has been used to discover the low-dimensional manifolds of the high-dimensional data while incorporating the temporal structure in the latent space. Urtasun and Darrell presented discriminative GPLVM (D-GPLVM) (Urtasun and Darrell 2007) where the linear discriminative analysis (LDA) criterion is exploited to add discriminative ability to the GPLVM. But D-GPLVM is not a dynamical model; rather, it assumes that data are generated independently, ignoring temporal structure of the inputs. Our work aims at developing a new method that learns a discriminative, probabilistic low-dimensional latent space so that the advantages of the above-mentioned techniques can be simultaneously achieved. The objective of this study is more on the development of the basic idea and the core algorithms rather than its extensive evaluation with large-scale real databases, although we will illustrate the performance of the method with a widely used human action data set.

8.2 DISCRIMINATIVE GAUSSIAN PROCESS DYNAMIC MODEL

The GPDM (Wang et al. 2005, 2008) is a latent variable model. It comprises a generative mapping from a latent space \mathbb{R}^d to the observation space \mathbb{R}^D and a dynamical model in the latent space. These mappings are in general nonlinear. For instance, for human action recognition, a vector \mathbf{y} in the observation space corresponds to a vector of image measurements such as silhouette or other features, and a sequence of image measurements forms the measurement trajectory in the input space. The latent dynamical model accounts for the temporal dependence between observations. (For clarity, Table 8.1 summarizes the key notations used in the chapter.) GPDM is obtained by marginalizing the parameters of the two mappings and optimizing the latent coordinates of the training data. The two models are defined as

$$\mathbf{x}_t = \sum_i \mathbf{a}_i \phi_i(\mathbf{x}_{t-1}) + \mathbf{n}_{x,t}$$

$$\mathbf{y}_t = \sum_j \mathbf{b}_j \varphi_j(\mathbf{x}_t) + \mathbf{n}_{y,t}$$

where
$\mathbf{A} = [\mathbf{a}_1, \mathbf{a}_2, \ldots]$ and $\mathbf{B} = [\mathbf{b}_1, \mathbf{b}_2, \ldots]$ are the regression weights
ϕ_i and φ_j the basis functions
$\mathbf{n}_{x,t}$ and $\mathbf{n}_{y,t}$ the zero-mean Gaussian noise

With an isotropic Gaussian prior on the columns of \mathbf{B}, GPDM marginalizes \mathbf{B} in closed form (MacKay 2003) to yield a multivariate Gaussian density over the observations $\mathbf{Y} \equiv [\mathbf{y}_1, \ldots, \mathbf{y}_N]^\mathrm{T} \in \mathbb{R}^{N \times D}$

$$p(\mathbf{Y} \mid \mathbf{X}, \bar{\beta}, \mathbf{W}) = \frac{|\mathbf{W}|^N}{\sqrt{(2\pi)^{ND} |\mathbf{K}_Y|^D}} \exp\left(-\frac{1}{2} \mathrm{tr}\left(\mathbf{K}_Y^{-1} \mathbf{Y} \mathbf{W}^2 \mathbf{Y}^\mathrm{T}\right)\right) \quad (8.1)$$

TABLE 8.1 Notations of Key Symbols Used in the Chapter

Symbols	Notations
\mathbb{R}^k	k dimensional space
\mathbf{x}_t, \mathbf{y}_t	Latent variable and observation variable, respectively, at time t
\mathbf{a}_i, \mathbf{b}_j	Regression weights
Φ_i, φ_i	Regression basis functions
\mathbf{K}, k	Kernel matrix and function, respectively
\mathbf{W}, w_i	Scaling matrix and scaling parameter, respectively
β_1	The output scale of the observation RBF kernel
β_2^{-1}	The support width of observation RBF kernel
β_3^{-1}	The variance of the isotropic additive noise
$\delta_{\mathbf{x},\mathbf{x}'}$	The additive noise
$\mathbf{X}_{2:N}$	The dynamic data matrix from second to last data points
$\mathbf{X}_{1:N-1}$	The dynamic data matrix from first to second to last data points
\mathbf{K}_X	Latent dynamic kernel matrix
k_X	Latent dynamic kernel function
α_1	The output scale of the dynamic RBF kernel
α_2^{-1}	The support width of dynamic RBF kernel
α_3	The output scale of the linear kernel
α_4^{-1}	The variance of the noise term
G	LDA transformation matrix
\mathbf{S}_w	LDA within-class matrix
\mathbf{S}_b	LDA between-class matrix
\mathbf{S}_t	The total scatter matrix
J	The class discrimination function
σ_d^2	A global scaling of the discriminative prior
L_X, L_Y	The negative log density of the dynamics and observations
Γ	The learned Gaussian process model

where \mathbf{K}_Y is a kernel matrix. The elements of \mathbf{K}_Y are defined by a kernel function, $(\mathbf{K}_Y)_{i,j} = k_Y(\mathbf{x}_i, \mathbf{x}_j)$. For the observation mapping, we use the RBF kernel

$$k_Y(\mathbf{x}, \mathbf{x}') = \beta_1 \exp\left(-\frac{\beta_2}{2}\|\mathbf{x} - \mathbf{x}'\|^2\right) + \frac{\delta_{\mathbf{x},\mathbf{x}'}}{\beta_3}$$

The scaling matrix $\mathbf{W} \equiv \mathrm{diag}(w_1, \ldots, w_D)$ is used to account for the different variance in the different data dimensions. $\bar{\beta} = \{\beta_1, \beta_2, \beta_3\}$ comprises the kernel hyperparameters that control the output scale, the RBF support width (β_2^{-1}), and the variance of the additive noise.

The dynamic mapping on the latent coordinates $\mathbf{X} \equiv [\mathbf{x}_1, \ldots, \mathbf{x}_N]^T \in \mathbb{R}^{N \times d}$ is similar; that is, the joint density over latent positions and weights \mathbf{A} is formed, and then \mathbf{A} is marginalized out. With an isotropic prior on the \mathbf{a}_i, the density over latent trajectories reduces to

$$p(\mathbf{X}|\bar{\alpha}) = \frac{p(\mathbf{x}_1)}{\sqrt{(2\pi)^{(N-1)d}|\mathbf{K}_X|^d}} \exp\left(-\frac{1}{2}\mathrm{tr}\left(\mathbf{K}_X^{-1}\mathbf{X}_{2:N}\mathbf{X}_{2:N}^T\right)\right) \qquad (8.2)$$

where
$\mathbf{X}_{2:N} = [\mathbf{x}_2, \ldots, \mathbf{x}_N]^T$
\mathbf{K}_X is the $(N-1) \times (N-1)$ kernel matrix constructed from $\mathbf{X}_{1:N-1} = [\mathbf{x}_1, \ldots, \mathbf{x}_{N-1}]^T$
\mathbf{x}_1 is assumed to have isotropic Gaussian prior

The dynamic kernel matrix has elements defined by a "linear + RBF" kernel with parameters α_i:

$$k_X(\mathbf{x}, \mathbf{x}') = \alpha_1 \exp\left(-\frac{\alpha_2}{2}\|\mathbf{x} - \mathbf{x}'\|^2\right) + \alpha_3 \mathbf{x}^T\mathbf{x}' + \frac{\delta_{\mathbf{x},\mathbf{x}'}}{\alpha_4}$$

This model extends naturally to multiple sequences $\mathbf{Y}^{(1)}, \ldots, \mathbf{Y}^{(P)}$, with lengths N_1, \ldots, N_P. Each sequence has associated latent coordinates $\mathbf{X}^{(1)}, \ldots, \mathbf{X}^{(P)}$ within a shared latent space.

The GPDM is a generative model, which does not encourage trajectories of different classes to be far from each other in the latent space for better classification. In the following text, we develop a D-GPDM, using an informative prior that encourages latent positions of the same class to be close and those of different classes to be away from each other. While several discriminative criterions are possible, we have used a prior based on LDA.

8.2.1 The LDA Criterion

LDA finds a transformation that maximizes between-class separability and minimizes within-class variability, thus achieving maximum class discrimination (Ye 2007). Let $\mathbf{X}=[\mathbf{x}_1, ..., \mathbf{x}_N]^T$ be the latent coordinates of the input data of *all the classes* $\mathbf{Y}=[\mathbf{y}_1, ..., \mathbf{y}_N]^T$. The label of the input data is given by $L \in \mathbb{R}^N$. LDA finds the transformation G that maximizes between-class separability and minimizes within-class variability by maximizing

$$\text{trace}\left((G^T\mathbf{S}_b G)(G^T\mathbf{S}_w G)^{-1}\right)$$

where \mathbf{S}_w and \mathbf{S}_b are the within-class and between-class matrices:

$$\mathbf{S}_w = \frac{1}{N}\sum_{k=1}^{C}\sum_{\mathbf{x} \in \mathbf{X}_k}(\mathbf{x} - \mu_k)(\mathbf{x} - \mu_k)^T \qquad (8.3)$$

$$\mathbf{S}_b = \frac{1}{N}\sum_{k=1}^{C}N_k(\mu_k - \mu)(\mu_k - \mu)^T \qquad (8.4)$$

where
 μ is the mean of all the data points
 μ_k is the mean of class k
 N_k denotes the number of data points in class k
 C denotes the number of classes

In our work, our objective is to find the latent positions that achieve maximum discrimination, instead of looking for G. Thus, we modify the original formulation of LDA to find *the latent positions* that achieves maximum class discrimination in the latent space. That is, we maximize

$$J(\mathbf{X}) = \text{tr}\left(\mathbf{S}_t^{-1}\mathbf{S}_b\right) \qquad (8.5)$$

where $\mathbf{S}_t = \mathbf{S}_w + \mathbf{S}_b$ denotes the total scatter matrix.

8.2.2 Discriminative Gaussian Process Dynamic Model

The LDA energy function in (8.5) is a function of the latent positions, **X**, and can be interpreted as a prior over latent configurations that force the latent points of the same class to be close together and far from those of other classes. So we introduce the discriminative prior as

$$p(\mathbf{X}) = \frac{1}{Z_d} \exp\left(-\sigma_d^2 J^{-1}\right)$$

where
 Z_d is a normalization constant
 σ_d^2 represents a global scaling of the prior

After we introduce this discriminative prior over the latent positions, the joint distribution over the latent positions (8.2) in GPDM becomes

$$p\left(\mathbf{X}|\bar{\alpha}\right) = \frac{p(\mathbf{x}_1)}{\sqrt{(2\pi)^{(N-1)d} \left|\mathbf{K}_X\right|^d}}$$

$$\times \exp\left(-\frac{1}{2} \mathrm{tr}\left(\mathbf{K}_X^{-1} \mathbf{X}_{2:N} \mathbf{X}_{2:N}^\mathsf{T}\right) - \sigma_d^2 \left[\mathrm{tr}\left(\mathbf{S}_b \mathbf{S}_t^{-1}\right)\right]^{-1}\right) \quad (8.6)$$

8.2.3 Learning D-GPDM

Following (Wang et al. 2008), we adopt simple prior distributions over the hyperparameters, that is, $p(\bar{\alpha}) \propto \prod_i \alpha_i^{-1}$ and $p(\bar{\beta}) \propto \prod_i \beta_i^{-1}$, with which the GPDM posterior becomes

$$p\left(\mathbf{X}, \bar{\alpha}, \bar{\beta}, \mathbf{W}|\mathbf{Y}\right) \propto p\left(\mathbf{Y}|X, \bar{\beta}, \mathbf{W}\right) p\left(\mathbf{X}|\bar{\alpha}\right) p(\bar{\alpha}) \, p(\bar{\beta}) \, p(\mathbf{W})$$

In the training phase of D-GPDM, we minimize the negative log posterior to find $\bar{\alpha}$, $\bar{\beta}$, **W**, and **X**, as done in (Wang et al. 2008). The negative log posterior is given by

$$L = -\ln p\left(\mathbf{X}, \bar{\alpha}, \bar{\beta}, \mathbf{W} \mid \mathbf{Y}\right)$$

$$= L_Y + L_X + \sum_j \ln \beta_j + \frac{1}{2\kappa^2} \mathrm{tr}(\mathbf{W}^2) + \sum_j \ln \alpha_j \qquad (8.7)$$

where

$$L_Y = \frac{D}{2} \ln |\mathbf{K}_Y| + \frac{1}{2} \mathrm{tr}\left(\mathbf{K}_Y^{-1} \mathbf{Y} \mathbf{W}^2 \mathbf{Y}^\mathsf{T}\right) - N \ln |\mathbf{W}|$$

$$L_X = \frac{d}{2} \ln |\mathbf{K}_X| + \frac{1}{2} \mathrm{tr}\left(\mathbf{K}_X^{-1} \mathbf{X}_{2:N} \mathbf{X}_{2:N}^\mathsf{T}\right) + \frac{1}{2} x_1^\mathsf{T} x_1 + \sigma_d^2 \left[\mathrm{tr}\left(\mathbf{S}_b \mathbf{S}_t^{-1}\right)\right]^{-1} \qquad (8.8)$$

L_Y comes from the negative log density of (8.1) and L_X comes from the negative log density of (8.6). Note that L_X in (8.8) has included the discriminative prior term.

Note that (8.8) can be interpreted as a regularized GPDM, where the regularizer is an LDA-based criterion, or as a regularized LDA, where the regularizer is a GPDM. The choice of the σ_d^2 reflects a trade-off between the method's ability to discriminate (large σ_d^2) and its ability to generalize (small σ_d^2).

The negative log posterior is a highly nonlinear function of the latent positions and the parameters. We are therefore forced to turn to gradient-based optimization of the objective function. Scaled conjugate gradient (SCG) (Moller 1993) is an approach to optimization, which implicitly considers second-order information while using a scale parameter to regulate the positive definitiveness of the Hessian at each point. We make use of SCG for our work. The D-GPDM learning algorithm is given in Figure 8.1.

Since SCG requires both the objective function and the gradient function to be given, in the following, we discuss how to compute the gradient of (8.7) with respect to the unknown variables. Note that the gradients of (8.7) with respect to the latent points \mathbf{X} can be found through first taking the gradient with respect to the kernel and then combining it with the gradient of the kernel with respect to the \mathbf{X} through the chain rule:

D-GPDM Learning Algorithm

Input: Data **Y**. Integers $\{d, I, J\}$
Output: MAP estimation of $\{\mathbf{X}, \bar{\alpha}, \bar{\beta}, W\}$

 1. Initialize **X** with PCA on **Y** with d dimensions
 Initialize $\bar{\alpha}, \bar{\beta}, \{w_k\} \Leftarrow 1$
 2. for $i = 1 : I$ do
 for $j = 1 : D$ do
 $d \Leftarrow [(\mathbf{Y})_{1j}, ..., (\mathbf{Y})_{Nj}]^T$

$$w_j^2 \Leftarrow N\left(d^T \mathbf{K}_Y^{-1} d + \frac{1}{k^2}\right)^{-1}$$

 end for
 $\{\mathbf{X}, \bar{\alpha}, \bar{\beta}\} \Leftarrow$ optimize Equation 8.7 with respect to $\{\mathbf{X}, \bar{\alpha}, \bar{\beta}\}$
 using SCG for J interations
 end for

Figure 8.1 The D-GPDM learning algorithm with the training data.

$$\frac{\partial L}{\partial X} = \frac{\partial L_Y}{\partial X} + \frac{\partial L_X}{\partial X}$$

$$= \frac{\partial L_Y}{\partial \mathbf{K}_Y} \frac{\partial \mathbf{K}_Y}{\partial X} + \frac{\partial L_X}{\partial \mathbf{K}_X} \frac{\partial \mathbf{K}_X}{\partial X} + \frac{\partial L_X}{\partial J^{-1}} \frac{\partial J^{-1}}{\partial J} \frac{\partial J}{\partial X}$$

where

$$\frac{\partial L_Y}{\partial \mathbf{K}_Y} = D\mathbf{K}_Y^{-1} - \mathbf{K}_Y^{-1}(Y W)(Y W)^T \mathbf{K}_Y^{-1}$$

and

$$\frac{\partial L_X}{\partial \mathbf{K}_X} = d\mathbf{K}_X^{-1} - \mathbf{K}_X^{-1}\mathbf{X}_{2:N}\mathbf{X}_{2:N}^T\mathbf{K}_X^{-1}$$

The computation of the gradient of LDA discriminative prior $J(\mathbf{X}) = \text{tr}(\mathbf{S}_t^{-1}\mathbf{S}_b)$ with respect to **X** needs special care. Because \mathbf{S}_w and \mathbf{S}_b in (8.3) and (8.4) do not give us explicit solutions of the gradient of J with respect to **X**, we now introduce a more compact matrix form of \mathbf{S}_t and \mathbf{S}_b so that the gradient can be computed straightforward.

As proposed in (Ye 2007), we construct a class indicator matrix $R=R(ij)_{ij} \in \mathbb{R}^{N \times C}$ as follows:

$$R_{\mathbf{X}}(ij) = \begin{cases} \sqrt{N/N_j} - \sqrt{N_j/N} & \text{if } L_i = j \\ -\sqrt{N_j/N} & \text{otherwise} \end{cases}$$

where $L \in \mathbb{R}^N$ denotes the label of the training inputs \mathbf{Y}. N_j is the summation of the length of each sequence that belongs to class j, that is, the total number of data points in class j. And we also define

$$P = I - \frac{1}{N} ee^{\mathrm{T}}, \quad \text{with } e = [1, 1, \ldots, 1]^{\mathrm{T}} \in \mathbb{R}^N$$

where I denotes the $N \times N$ identity matrix. It was shown in (Ye 2007) that

$$\mathbf{S}_t = \mathbf{X}^{\mathrm{T}} P \mathbf{X} \qquad \mathbf{S}_b = \mathbf{X}^{\mathrm{T}} R R^{\mathrm{T}} \mathbf{X} \tag{8.9}$$

Plug (8.9) into $J(\mathbf{X}) = \mathrm{tr}\left(\mathbf{S}_t^{-1} \mathbf{S}_b\right)$, we get

$$J(\mathbf{X}) = \mathrm{tr}\left(\mathbf{S}_t^{-1} \mathbf{S}_b\right) = \mathrm{tr}\left(\left(\mathbf{X}^{\mathrm{T}} P \mathbf{X}\right)^{-1} \mathbf{X}^{\mathrm{T}} R R^{\mathrm{T}} \mathbf{X}\right) \propto \mathrm{tr}\left(\mathbf{X}^{-1} P^{-1} R R^{\mathrm{T}} \mathbf{X}\right)$$

Then we get

$$\frac{\partial J}{\partial X} = \left(\mathbf{X}^{-1} P^{-1} R R^{\mathrm{T}}\right)^{\mathrm{T}} = R R^{\mathrm{T}} \left(\left(P \mathbf{X}\right)^{-1}\right)^{\mathrm{T}}$$

The gradient of the objective function with respect to the hyperparameters can be calculated similarly.

8.2.4 Inference Using D-GPDM

Given new test points $\mathbf{Y}^* \in \mathbb{R}^{M \times D}$, we need to estimate its latent trajectory $\mathbf{X}^* \in \mathbb{R}^{M \times d}$ conditional on the model $\Gamma = \{\mathbf{Y}, \mathbf{X}, \bar{\alpha}, \bar{\beta}, \mathbf{W}\}$. To do

that, we form the joint distribution over both the new and the training sequences:

$$p(\mathbf{Y}^*,\mathbf{X}^*|\Gamma)= p(\mathbf{Y}^*|\mathbf{X}^*,\Gamma)p(\mathbf{X}^*|,\Gamma)\propto p(\mathbf{Y},\mathbf{Y}^*|\mathbf{X},\mathbf{X}^*,\bar{\beta},\mathbf{W})p(\mathbf{X},\mathbf{X}^*|\bar{\alpha})$$

The joint density over both \mathbf{Y}^* and \mathbf{Y} can be formed in similar way to (8.1) but replaces the kernel matrix \mathbf{K}_Y in (8.1) with

$$\mathbf{K}_{Y,Y^*} = \begin{bmatrix} [\mathbf{K}_Y] & [\mathbf{A}] \\ [\mathbf{A}^T] & [\mathbf{B}] \end{bmatrix}$$

where $(\mathbf{A})_{ij} = k_Y\left(\mathbf{x}_i,\mathbf{x}_j^*\right)$ and $(\mathbf{B})_{ij} = k_Y\left(\mathbf{x}_i^*,\mathbf{x}_j^*\right)$ are elements of $N\times M$ and $M\times M$ kernel matrices, respectively. We also need to replace the data matrix \mathbf{Y} in (8.1) with $\mathbf{Z}_Y=[\mathbf{Y}^T, \mathbf{Y}^{*T}]^T$.

For forming the joint density over both \mathbf{X}^* and \mathbf{X}, we can use two different methods. In the first method, we form the joint density without considering the label of the testing sequence. This leads to the generative inference similar to plain GPDM inference. In this case, the joint density is similar to (8.2), but we need to replace the kernel matrix \mathbf{K}_X in (8.2) with

$$\mathbf{K}_{X,X^*} = \begin{bmatrix} [\mathbf{K}_X] & [\mathbf{C}] \\ [\mathbf{C}^T] & [\mathbf{D}] \end{bmatrix} \tag{8.10}$$

where $(\mathbf{C})_{ij} = k_X\left(\mathbf{x}_i,\mathbf{x}_j^*\right)$ and $(\mathbf{D})_{ij} = k_X\left(\mathbf{x}_i^*,\mathbf{x}_j^*\right)$ are elements of $(N-P)\times(M-1)$ and $(M-1)\times(M-1)$ kernel matrices. And, we replace the training latent trajectory matrix in (8.2) with $\mathbf{Z} = \left[\mathbf{X}_{2:N}^T, \mathbf{X}_{2:N}^{*T}\right]^T$.

In reality, the class label of the new inputs is not available. However, in order to encourage class discrimination over the latent trajectory of the new inputs, it may be necessary to associate trial label to the testing inputs such that discriminative LDA criterion can be incorporated in the join density over both \mathbf{X}^* and \mathbf{X}. The benefit of doing this is that when the optimization of \mathbf{X}^* converges, the trajectory of \mathbf{X}^* will be more likely to be far away from the trajectories of other classes, and

the trajectory of \mathbf{X}^* will be more likely to fall into the region where the training latent trajectories of the same class are located. This leads to the second method of forming the joint density.

Specifically, we assign a trial label $L_{X^*} \in \mathbb{R}^M$ to the testing sequence \mathbf{Y}^*. There are C possible configurations of L_{X^*}, where C denotes the number of classes. And for each possible trial label, we compute the discriminative term $J(\mathbf{Z}) = \mathrm{tr}(\mathbf{S}_t^{-1}\mathbf{S}_b)$, and then form the joint density as follows

$$p(\mathbf{Z}|\bar{\alpha}) = \frac{p(\mathbf{z}_1)}{\sqrt{(2\pi)^{(N+M-P-1)d}}\,|\mathbf{K}_Z|^d}$$

$$\times \exp\left(-\frac{1}{2}\mathrm{tr}\left(\mathbf{K}_Z^{-1}\mathbf{Z}_{2:N}\mathbf{Z}_{2:N}^\mathrm{T}\right) - \sigma_d^2\left[\mathrm{tr}\left(\mathbf{S}_b\mathbf{S}_t^{-1}\right)\right]^{-1}\right)$$

where $\mathbf{Z} = \left[\mathbf{X}_{2:N}^\mathrm{T}, \mathbf{X}_{2:N}^{*\mathrm{T}}\right]^\mathrm{T}$ and \mathbf{K}_Z are the same as in (8.10). \mathbf{z}_1 comprises the first latent coordinates of each sequence.

The latent trajectory \mathbf{X}^* associated with the input sequence \mathbf{Y}^* can be found by minimizing the negative log of the joint density $p(\mathbf{Y}^*, \mathbf{X}^*|\Gamma)$ with training \mathbf{Y}, \mathbf{X} and the kernel hyperparameters fixed. The objective function is given by

$$L^* = -\ln p\left(\mathbf{Y}^*, \mathbf{X}^*|\Gamma\right)$$

$$= \frac{D}{2}\ln|\mathbf{K}_{Y,Y^*}| + \frac{1}{2}\mathrm{tr}\left(\mathbf{K}_{Y,Y^*}^{-1}\mathbf{Z}_Y\mathbf{W}^2\mathbf{Z}_Y^\mathrm{T}\right)$$

$$+ \frac{d}{2}\ln|\mathbf{K}_{X,X^*}| + \frac{1}{2}\mathrm{tr}\left(\mathbf{K}_{X,X^*}^{-1}\mathbf{Z}_X\mathbf{Z}_X^\mathrm{T}\right) + \frac{1}{2}\mathbf{z}_1^\mathrm{T}\mathbf{z}_1 + \sigma_d^2\left[\mathrm{tr}\left(\mathbf{S}_b\mathbf{S}_t^{-1}\right)\right]^{-1}$$

$$\tag{8.11}$$

Similar to the D-GPDM training phase, we resort to SCG for the optimization. The gradient of (8.11) with respect to \mathbf{X}^* can be computed in a similar way, as discussed before. The optimization of (8.11) requires the initialization of the \mathbf{X}^* at the first iteration. In the training phase,

the latent trajectory is initialized with PCA on \mathbf{Y}. In the testing phase, in order to prevent the algorithm from converging into a region that is far away from the latent trajectory of any classes, we propose to initialize the latent trajectory \mathbf{X}^* with the training latent trajectory whose corresponding inputs \mathbf{Y} is closest to the new inputs \mathbf{Y}^*. This ensures that the initial testing latent trajectory falls into roughly the same region as the latent trajectory of the training sequence that is closest to the testing inputs.

8.2.5 Examples

We now present experiments based on synthetic data to illustrate how the proposed D-GPDM framework works. In the simulation, we first create three classes of dynamics in 2D space, where the trajectories of the three classes exhibit as the shape of a sinusoid function, a circle, and a line, respectively. We then map the dynamics of the three classes into a higher dimensional observation space using a nonlinear mapping. The dynamics reside in a 2D space, and can be viewed as the latent dynamics that govern the observed time series data. The observations lie in a 5D space. In order to simulate the noise that is common in the real-life application, we add zero-mean Gaussian random noise to both the dynamics and observation mapping.

The dynamics for the three classes are given by Figure 8.2a through c, respectively, where a, b, c, d, e, f, g, h, and i are the mapping parameters, n_t^{\sin}, n_t^{circle}, and n_t^{line} are the Gaussian random noise added to the three classes, respectively.

$$x^{\sin}(t,1) = a \cdot x^{\sin}(t-1,1) + b$$
$$x^{\sin}(t,2) = \sin^{\sin}\left(c \cdot x(t,1) + d\right)$$
$$x^{\sin}(t,:) = x^{\sin}(t,:) + n_t^{\sin}$$

(a)

$$x^{\text{circle}}(t,1) = r\cos\left(\theta(t)\right) + h$$
$$x^{\text{circle}}(t,2) = r\sin\left(\theta(t)\right) + i$$
$$\theta(t) = \theta(t-1) + (2\pi)/T$$
$$x^{\text{circle}}(t,:) = x^{\text{circle}}(t,:) + n_t^{\text{circle}}$$

(b)

$$x^{\text{line}}(t,1) = x^{\text{line}}(t-1,1) + e$$
$$x^{\text{line}}(t,2) = f \cdot x^{\text{line}}(t,1) + g$$
$$x^{\text{line}}(t,:) = x^{\text{line}}(t,:) + n_t^{\text{line}}$$

(c)

Figure 8.2 The dynamic mappings for the (a) sine, (b) circle, and (c) line classes.

The ground truth latent trajectories of the three classes used in D-GPDM training and testing are shown in Figure 8.3. Note that the direction of the arrow in the figure indicates the temporal order of the sequence. And we intentionally make the latent trajectories of the three classes overlap with each other; this is to check, in the case when the ground truth dynamics of different classes already overlap with each other in terms of their values (but their temporal shape still differ), whether the D-GPDM can separate the two classes in the *learned* latent space by inferring from input observations.

The observations are created by (8.12) which map the 2D \mathbf{x}_t to 5D \mathbf{y}_t space, where ϕ and φ are two mappings that generates each dimension of \mathbf{y}_t separately. The final value of \mathbf{y}_t is a weighted summation of the two mappings plus some zero-mean Gaussian random noise. Note that in our simulation, all the classes share the same observation mapping (including the functional form and the parameters). This makes it even challenging for D-GPDM learning and inference because the same observation mapping across different classes may create observations that are highly inseparable in the observation space even the underlying dynamics differ from each other.

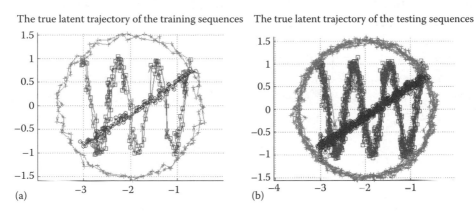

The true latent trajectory of the training sequences The true latent trajectory of the testing sequences

(a) (b)

Figure 8.3 (See color insert following page 332.) The ground truth latent trajectories for the sin (square marker), circle (plus marker), and line (circle marker) classes used in D-GPDM training (a) and testing (b). In (a), there are six training sequences in total, two for each class. In (b), there are 30 testing sequences in total, 10 for each class.

$$\boldsymbol{y}_t = w_1\phi(\boldsymbol{x}_t) + w_2\varphi(\boldsymbol{x}_t) + \tau_t$$

$$\phi(\boldsymbol{x}_t) = \begin{bmatrix} \sin(x(t,1)) & \cos(x(t,2)) & x(t,1)^2 & x(t,2)^2 & x(t,1)x(t,2) \end{bmatrix}^{\mathrm{T}}$$

$$\varphi(\boldsymbol{x}_t)_j = \exp\left(-\frac{\|\boldsymbol{x}_t - \mu_j\|^2}{\sigma^2}\right), \quad j = 1, \ldots, 5 \tag{8.12}$$

We create 2 sine, 2 circle, and 2 line training dynamic sequences with the equations in Figure 8.2 as well as their corresponding training observation sequences with (8.12). We also create 10 sine, 10 circle, and 10 line testing dynamic sequences as well as their corresponding testing observation sequences. The total number of data points in training is 358, and the total number of data points in testing is 1725. The D-GPDM is trained with the 6 training *observation* sequences along with their labels. The discovered latent trajectories by D-GPDM are then compared with the ground truth dynamics to see if the D-GPDM can achieve class discrimination in the latent space.

Simulation results: In our D-GPDM algorithm, the choice of σ_d^2 reflects a trade-off between the method's ability to discriminate (large σ_d^2) and its ability to generalize (small σ_d^2). This is confirmed by the training results shown in Figure 8.4, where the latent trajectories discovered by D-GPDM and GPDM for the training sequences of the three classes are shown. The three figures in Figure 8.4 demonstrate the results obtained with different values of σ_d^2.

Sine class is represented with a square marker, circle class is represented with a plus marker, and line class is represented with a circle marker.

As shown in Figure 8.4a, GPDM ($\sigma_d^2 = 0$) is not able to differentiate the dynamics of the three classes. In contrast, the proposed D-GPDM clearly separates the three classes, meanwhile discovers the latent temporal structure. As σ_d^2 is increased from 10^6 to 10^7, D-GPDM is able to distinguish the three classes with a large margin between them. It also shows that large σ_d^2 leads to increased discrimination ability. But as will be shown later, large σ_d^2 results in decreased generalization

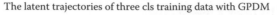

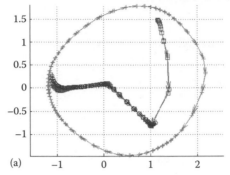

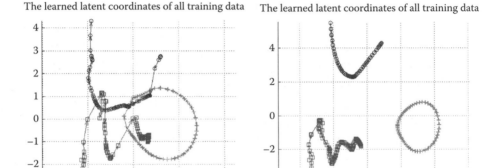

Figure 8.4 (See color insert following page 332.) The latent trajectory discovered by D-GPDM for the training sequences with varying σ_d^2. (a) $\sigma_d^2 = 0$, GPDM. (b) $\sigma_d^2 = 10^6$. (c) $\sigma_d^2 = 10^7$.

ability because the testing performance with large σ_d^2 is poorer than with small σ_d^2.

Figure 8.5 shows the change of value $J(\mathbf{X})=\mathrm{tr}(\mathbf{S}_t^{-1}\mathbf{S}_b)$ with each SCG iteration under two configurations of σ_d^2. This figure verifies that, with each SCG iteration, J becomes larger and larger. And, J increases at roughly the same rate with $\sigma_d^2 = 10^6$ and $\sigma_d^2 = 10^5$. However, when the SCG optimization converges, the value of J trained with larger σ_d^2 is significantly larger than the value of J with smaller σ_d^2, this implies that the larger the σ_d^2, the more discriminative the D-GPDM will be.

Figure 8.5 The change of value J with each SCG iteration under two configurations of σ_d^2.

8.3 HUMAN ACTION RECOGNITION USING DISCRIMINATIVE GAUSSIAN PROCESS DYNAMIC MODEL

We now apply the method to solve the problem of human action recognition with challenging real data. Our task is to recognize the type of an action based on high-dimensional image measurements. The task is challenging due to various reasons. First of all, useful, discriminating features must be extracted from the images, and the image features usually reside in a very high dimensional space. Second, the algorithm must be able to distinguish fine motions exhibited in different classes. Third, the underlying temporal dynamics can be very complex, preventing us to directly observe their temporal structure from the image observations. For human action recognition, one of the state-of-the-art approaches (Niebles et al. 2008) achieves 83% average accuracy on the KTH database (Schuldt et al. 2004) that has six actions (walking, jogging, running, boxing, hand clapping, and hand waving) performed several times by 25 subjects in different scenarios of outdoor and indoor environment with scale change. Some sample images are shown in Figure 8.6. In our experiment, we used

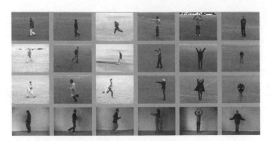

Figure 8.6 Example images from video sequences in the KTH dataset.

the outdoor sequences without scale variations and we processed three types of actions: boxing, hand clapping, and hand waving. These form a subset that involves mainly only the hand movements, which are easily confused with each other. (As a matter of fact, these classes are never confused with other classes in the results of Niebles et al. (2008).)

The rows illustrate different scenarios, and the columns illustrate different actions. The following Web site gives a complete description of the dataset: http://www.nada.kth.se/cvap/actions/.

We extract per-2-frame difference of the raw image data as the input observations. We process the data as follows. Starting from the raw image data, we first compute the frame difference between the adjacent frames with interval 2. Next, we align the images such that the region with movement has the same size across all the sequences of all the classes. This is to ensure that the dimensions of the feature vectors are the same for all the sequences. Then, the fixed-size motion region is cropped out from the image; after that, we perform down-sampling to reduce the dimension of the features. Finally, we normalize the data by dividing each pixel value by 255. The normalization may prevent numerical difficulty to occur during D-GPDM optimization. Figure 8.7 illustrates some sample results from the above simple processing steps, where each image is of resolution of 25×25 and will be used as the feature for the subsequence action recognition.

From top to bottom, the three rows correspond to the frame difference of boxing, hand clapping, and hand waving, respectively.

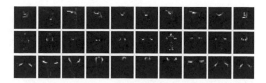

Figure 8.7 The processed image observations.

8.3.1 Nearest Neighbor Classification in the Latent Space

Using the simple feature from frame differencing, we may train the D-GPDM, as presented previously, and then compute the latent trajectory of a giving testing sequence. After that, we use a Nearest Neighbor (NN) classifier to classify the testing sequence. The NN classifier compares the latent trajectory of the testing sequence to all of the training latent trajectories, and the testing sequence will be classified to the class which its nearest training neighbor belongs to. This idea, when tested on the synthetic data described in Section 8.2.5, gives a 96.67% accuracy (29 among 30 testing sequences are correctly labeled) with $\sigma_d^2 = 10^6$, and a 93.33% accuracy (28 among 30 testing sequences are correctly labeled) with $\sigma_d^2 = 10^7$. The accuracy obtained with larger σ_d^2 is lower than the accuracy obtained with smaller σ_d^2, indicating that the generalization ability of the D-GPDM may decrease if σ_d^2 is too large.

With the NN classifier defined, the process flow and the data flow of the entire method are summarized in Figure 8.8. In the following, we present the results for using the approach to classify real human action videos in the KTH dataset described above.

8.3.2 Examples

We used six sequences to train the D-GPDM, two from each of the three actions chosen above. The number of frames used in the D-GPDM training is 360. And we used 30 sequences to test the performance of the proposed D-GPDM, with 10 sequences from each class of actions. The number of frames of the testing data is 1800. The input observations are 625-dimensional, with the difference frame size being 25×25.

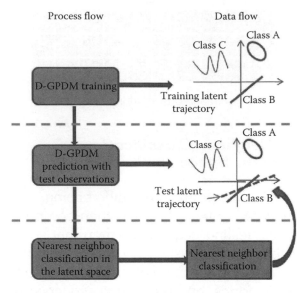

Figure 8.8 The process flow and data flow of the entire framework.

Figure 8.9 shows the latent trajectory of the training data learned by GPDM and D-GPDM. It can be seen that GPDM cannot separate the three classes in the latent space. In contrast, D-GPDM with small discriminative term does a better job in distinguishing the classes, though small portions of the latent trajectory of the hand-waving class are still

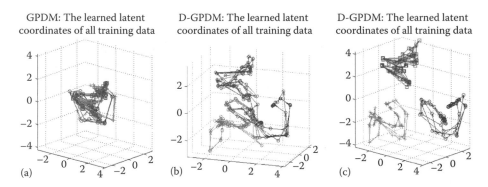

Figure 8.9 (See color insert following page 332.) The latent trajectory of the training data learned by GPDM (a) and D-GPDM (b and c). (a) Latent trajectory learned by GPDM, $\sigma_d^2 = 0$. (b) Latent trajectory learned by D-GPDM with small σ_d^2. (c) Latent trajectory learned by D-GPDM with large σ_d^2. Square, plus, and circle curves represent boxing, hand clapping, and hand waving, respectively.

TABLE 8.2 The Confusion Matrix for the Human Action Recognition Experiment

Action	Boxing	Hand Clapping	Hand Waving
Boxing	10/10	0/10	0/10
Hand clapping	0/10	10/10	0/10
Hand waving	0/10	3/10	7/10

overlapped with the trajectory of the hand-clapping class. In Figure 8.9c, D-GPDM with large σ_d^2 clearly separates the three classes while revealing the temporal structure of the data.

It was found that the latent trajectory of the testing sequences generally falls into one of the three clusters. The NN classifier was able to correctly classify 27 sequences among 30 sequences, yielding 90% accuracy. Three hand-waving sequences are wrongly classified as hand clapping due to the similar image observations of these two classes. The confusion matrix is given in Table 8.2. This performance is comparable to the performance presented in (Niebles et al. 2008) (accuracy 92.33%) and is significantly better than (Schuldt et al. 2004) (accuracy 77.07%). We emphasize again that our results do not require sophisticated feature extraction, which is a key part of most existing work including (Niebles et al. 2008), and thus the comparable performance is believed to be a significant improvement.

8.4 SUMMARY

We presented a D-GPDM for the classification of high-dimensional time series data by employing a discriminative prior distribution over the latent space derived from the LDA discriminative criterion. The D-GPDM has the desirable properties of the generative models in that it can discover the temporal shape of the dynamics in a low-dimensional space, and it also has strong discriminative power as the latent trajectories of different classes are made to be far away from each other in the latent space. Based on the locality distribution of the latent trajectories, we employ NN to classify the novel sequences in the latent space. Our synthetic data and real data experiments show

that D-GPDM gives high classification accuracy in classifying challenging observation sequences that are inseparable in the original high-dimensional observation space.

The current study also identifies several directions that are worth future exploration. First, we currently resort to sequence-based NN to classify the sequences with Euclidean distance. This may cause potential problem where majority of the frames in a testing sequence find a single or very few number of frames in a training sequence to be their NN, leading to degeneracy. To overcome this problem, a probabilistic classification approach that combines the shape and the locality of the latent trajectory is needed. Second, the discriminative term σ_d^2 is currently manually specified during D-GPDM training and testing; it would be very interesting to automatically learn the σ_d^2 such that the D-GPDM has balanced capacity of discrimination and generalization. Third, we foresee that the proposed D-GPDM might be useful in tracking continuous multi-activities, for example, tracking a person who is walking, then jogging, and then running.

8.5 BIBLIOGRAPHICAL AND HISTORICAL REMARKS

There have been a large number of papers on dimensionality reduction and dynamic modeling in the literature. Here we review only the work that is related directly to classification tasks. LDA is a well-known method for dimensionality reduction and classification that projects high-dimensional data onto a low-dimensional space where the data achieves maximum class separability (Hastie et al. 2001). It has been applied successfully in many applications. In recent years, several authors have proposed methods to take advantage of the low-dimensional intrinsic nature of class labeled data. Iwata et al. proposed parametric embedding (PE) (Iwata et al. 2005), a technique based on stochastic neighbor embedding (SNE) (Hinton and Roweis 2002), to simultaneously embed objects and their classes. This was extended to the semi-supervised case by modeling the pair-wise relationships between the objects and the embedding (Zien and Candela 2005). But these methods do not work in practice when the training set is small.

Bissocco and Soatto (2006) used switching autoregressive (AR) to model dynamics for classification, and they estimate the posterior distribution of the AR model parameters given the observations, then a metric based on Wasserstein distance (for discrete distributions, the Wasserstein distance is equivalent to Earth's movers distance) is defined to classify the system. Kim and Pavlovic (2007) proposed to learn generative linear dynamic models with discriminative cost function, and demonstrate its effectiveness in 3D human pose tracking from monocular videos. This school of approach has been well studied in classification settings: learning generative models such as tree-augmented naive (TAN) Bayes or HMMs discriminatively via maximizing conditional likelihoods yield better prediction performance than the traditional maximum likelihood estimator (Jing et al. 2005, Kim and Pavlovic 2006, Pernkopf and Bilmes 2005).

A considerable amount of previous work has addressed the question of human action recognition. Some of the works extract informative spatiotemporal features to facilitate classification; the features include space–time shapes (Blank et al. 2005), motion history volumes (Weinland et al. 2006), space–time interest points (Schuldt et al. 2004, Dollar et al. 2005), and optical flow (Efros et al. 2003). Some other works model dynamics in either a generative setting or discriminative setting. Generative models, like hidden Markov models and their various extensions have been successfully used for recognizing human motion based on both 2D observations (Brand et al. 1996, Bregler 1997, Gong and Xing 2003) and 3D observations (Vogler and Metaxas 2001, Ramanan and Forsyth 2003). Other generative approaches (Blake et al. 1999, Pavlovic and Rehg 2000) have also been proposed for tracking and motion classification where the variation within each motion class is represented as an autoregressive process, or a linear dynamical system, whereas learning and inference are based on condensation and variational techniques, respectively. However, these generative models assume that observations are conditionally independent. This restriction makes it difficult to accommodate long-range dependencies among observations or multiple overlapping features of the observations. Discriminative models, like conditional random field (CRF) (Lafferty et al. 2001) and hidden conditional random field (Wang et al. 2006) have been used for action recognition. A CRF conditions

on the observation without modeling it, therefore it avoids indepen-
dence assumptions and can accommodate long-range interactions
among observations at different time steps. Sminchisescu et al. (2005)
applied CRFs to classify human motion activities; their model can also
discriminate subtle motion styles like normal walk and wander walk.
In the proposed D-GPDM, we do not make independent observation
assumption; rather, the dependencies among the temporal observations
are captured by the explicit modeling of the temporal-dynamic map-
ping and the observation-dynamic mapping, therefore the proposed
D-GPDM can capture the temporal interactions among observations.

REFERENCES

Bissocco, A. and S. Soatto. 2006. Classifying human dynamics without contact
 forces. Paper presented at the *IEEE Computer Society Conference on
 Computer Vision and Pattern Recognition (CVPR)*, New York, Vol. 2, pp.
 1678–1685.
Blake, A., B. North, and M. Isard. 1999. Learning multi-class dynamics. In *Advances
 in Neural Information Processing Systems (NIPS)*, MIT Press, Cambridge,
 MA, Vol. 11, pp. 389–395.
Blank, M., L. Gorelick, E. Shechtman, M. Irani, and R. Basri. 2005. Actions as
 space-time shapes. Paper presented at the *IEEE International Conference on
 Computer Vision (ICCV)*, Beijing, China, Vol. 2, pp. 1395–1402.
Brand, M., N. Oliver, and A. Pentland. 1996. Coupled hidden Markov models
 for complex action recognition. Paper presented at the *IEEE International
 Conference on Computer Vision and Pattern Recognition (CVPR)*, Vienna,
 Austria, p. 994.
Bregler, C. 1997. Learning and recognizing human dynamics in video sequences.
 Paper presented at the *IEEE International Conference on Computer Vision
 and Pattern Recognition (CVPR)*, San Juan, Puerto Rico, p. 568.
Dollar, P., V. Rabaud, G. Cottrell, and S. Belongie. 2005. Behavior recogni-
 tion via sparse spatio-temporal features. Paper presented at the *Joint IEEE
 International Workshop on Visual Surveillance and Performance Evaluation
 of Tracking and Surveillance (VS-PETS)*, Beijing, China.
Efros, A. A., A. C. Berg, G. Mori, and J. Malik. 2003. Recognizing action at a dis-
 tance. Paper presented at the *IEEE International Conference on Computer
 Vision (ICCV)*, Nice, France.
Gong, S. and T. Xing. 2003. Recognition of group activities using dynamic proba-
 bilistic networks. Paper presented at the *IEEE International Conference on
 Computer Vision (ICCV)*, Nice, France.

Hastie, T., R. Tibshirani, and J. Friedman. 2001. *The Elements of Statistical Learning: Data Mining, Inference, and Prediction*, Springer, New York.

Hinton, G. and S. Roweis. 2002. Stochastic neighbor embedding, *Advances in Neural Information Processing Systems (NIPS)*, Vol. 18, MIT Press, Cambridge, MA.

Iwata, T., K. Saito, N. Ueda, S. Stromsten, T. L. Griffiths, and J. B. Tenenbaum. 2005. Parametric embedding for class visualization. *Advances in Neural Information Processing Systems (NIPS)*, Vol. 18, MIT Press, Cambridge, MA.

Jing, Y., V. Pavlovic, and J. M. Rehg. 2005. Efficient discriminative learning of Bayesian network classifier via boosted augmented naive Bayes. Paper presented at the *International Conference on Machine Learning (ICML)*, Bonn, Germany, pp. 369–376.

Kim, M. and V. Pavlovic. 2006. Discriminative learning of mixture of Bayesian network classifiers for sequence classification. Paper presented at the *IEEE Computer Society Conference on Computer Vision and Pattern Recognition (CVPR)*, New York, Vol. 1, pp. 268–275.

Kim, M. and V. Pavlovic. 2007. Discriminative learning of dynamical systems for motion tracking. Paper presented at the *IEEE Computer Society Conference on Computer Vision and Pattern Recognition (CVPR)*, Minneapolis, MN, pp. 1–8.

Lafferty, J., A. McCallum, and F. Pereira. 2001. Conditional random fields: Probabilistic models for segmenting and labeling sequence data. Paper presented at the *International Conference on Machine Learning (ICML)*, Williamstown, MA.

MacKay, D. J. C. 2003. *Information Theory, Inference, and Learning Algorithms*. Cambridge University Press, Cambridge, U.K.

Møller, M. F. 1993. A scaled conjugate gradient algorithm for fast supervised learning. *Neural Networks* 6(4): 525–533.

Niebles, J. C., H. Cheng, and L. Fei-Fei. 2008. Unsupervised learning of human action categories using spatial-temporal words. *International Journal of Computer Vision* 79(3): 299–318.

Pavlovic, V. and J. Rehg. 2000. Impact of dynamic model learning on the classification of human motion. Paper presented at the *IEEE International Conference on Computer Vision and Pattern Recognition (CVPR)*, Hilton Head Island, SC.

Pernkopf, F. and J. Bilmes. 2005. Discriminative versus generative parameter and structure learning of Bayesian network classifiers. Paper presented at the *International Conference on Machine Learning (ICML)*, Bonn, Germany, pp. 657–664.

Ramanan D. and D. Forsyth. 2003. Automatic annotation of everyday movements. Paper presented at the *Neural Information Processing Systems (NIPS) Conference*, Vancouver, Canada.

Schuldt, C., I. Laptev, and B. Caputo. 2004. Recognizing human actions: A local SVM approach. Paper presented at the *International Conference on Pattern Recognition (ICPR)*, San Diego, CA, pp. 32–36.

Sminchisescu, C., A. Kanaujia, Z. Li, and D. Metaxas. 2005. Conditional models for contextual human motion recognition. Paper presented at the *IEEE International Conference on Computer Vision (ICCV)*, Beijing, China, Vol. 2, pp. 1808–1815.

Urtasun, R. and T. Darrell. 2007. Discriminative Gaussian process latent variable model for classification. Paper presented at the *International Conference on Machine Learning (ICML)*, Corvallis, OR, pp. 927–934.

Vogler, C. and D. Metaxas. 2001. A framework for recognizing the simultaneous aspects of ASL. *Computer Vision and Image Understanding* 81(3): 358–384.

Wang, J., D. J. Fleet, and A. Hertzmann. 2005. Gaussian process dynamical models. *Advances in Neural Information Processing Systems (NIPS)*, Vol. 18, MIT Press, Cambridge, MA.

Wang, J., D. J. Fleet, and A. Hertzmann. 2008. Gaussian process dynamical models for human motion. *IEEE Transaction on Pattern Analysis and Machine Intelligence* 30(2): 283–298.

Wang, S. B., A. Quattoni, L.-P. Morency, D. Demirdjian, and T. Darrell. 2006. Hidden conditional random fields for gesture recognition. Paper presented at the *IEEE International Conference on Computer Vision (CVPR)*, New York, Vol. 2, pp. 1521–1527.

Weinland, D., R. Ronfard, and E. Boyer. 2006. Free viewpoint action recognition using motion history volumes. *Computer Vision and Image Understanding* 104(2): 1077–3142.

Ye, J. 2007. Least squares linear discriminant analysis. Paper presented at the *International Conference on Machine Learning (ICML)*, Corvallis, OR, pp. 1087–1093.

Zien, A. and J. Q. Candela. 2005. Large margin non-linear embedding. Paper presented at the *International Conference on Machine Learning (ICML)*, Bonn, Germany.

9

Complex Activity Recognition

Justin Muncaster and Yunqian Ma

CONTENTS

9.1 INTRODUCTION

In Chapter 8, we saw how simple activity recognition is being handled. In this chapter, we discuss complex activity recognition. Our approach will focus on how to represent complex activities in terms of a sequences of simpler activities. We present a general framework for constructing models for complex activity recognition. The models are

hierarchically structured and represent events at different granularities. We also show how to partition the observation space so that low-level, simple events are defined automatically according to the statistics of the training data.

Many applications stand to benefit from the use of algorithms that can automate the detection of complex activities. In public safety, for example, advanced activity classification algorithms could be used to ubiquitously monitor areas such as pools, subways, and elderly care centers for problems that require the attention of emergency personel, and could substantially decrease the time it takes for first-responders to arrive on scene. Further progress in activity recognition also has the potential to revolutionize the way we interact with computers by making the elusive "perceptual user interface" a reality. While many applications of activity recognition can be imagined, security systems, are probably the ones that are most likely to immediately benefit from automated activity classification. With algorithms for the detection and tracking of individuals becoming more mature, the demands for higher-level reasoning are being pushed more and more to the forefront. Also, the rapid decline in the cost of cameras has allowed for vast areas to be under continuous surveillance. Thus, shopping malls, office buildings, hospitals, banks, and military bases all stand to benefit from systems that can identify suspicious, threatening, abnormal, or criminal activity and generate an alert to the appropriate security personnel.

To recognize complex activities it is important to have a strategy that allows for the efficient encoding of relevant domain knowledge, yet can flexibly model uncertainty. Let us consider a surveillance camera set up outside of a store, as shown in Figure 9.1a. Suppose we

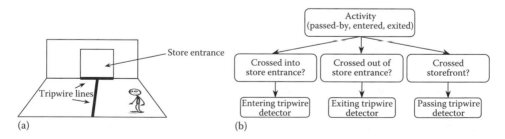

Figure 9.1 (a) Example activity recognition problem. (b) A notional Bayesian network for modeling the activity.

have algorithms for detecting and tracking persons who move in the scene and we wish to classify the activity of each person as having entered the store, exited the store, or passed by the store. Such a system might be useful for doing market research, for example. We could create a Bayesian network to encode certain random variables that are relevant to decide the activity of a particular person. Figure 9.1b shows a notional Bayesian network. In this network, we could encode relevant domain knowledge, such as the fact that an individual who exits the store must come out through the doorway of the store. This corresponds to fixing the model parameter Pr(CameOutDoorway= yes|Activity=exited)=1. Other parameter values are not necessarily known—such as the probability of correctly detecting that the person came out of the doorway and over a tripwire—and must be estimated using training data.

The approach we will describe in the remainder of this chapter will detail how one can recognize the activities of individuals using probabilistic models. This approach attempts to strike a balance between allowing the user to enter in domain knowledge and not overwhelming the developer with too many parameters and details. Observations will come in the form of track position and velocity estimates, although they can in fact contain low-level image feature information as well without affecting the structure of the algorithm. Activities will be modeled hierarchically; however, the only data required to learn the parameters of the model are the observations and a a single label of the high-level activity for a given sequence.

9.2 PROBABALISTIC MODELING OF ACTIVITIES

We denote a set of N random variables by $X^{(1:N)}=(X^{(1)}, X^{(2)},...,X^{(N)})$. The probability of any particular assignment to these random variables is denoted by $Pr(X^{(1:N)}=j)$, where j is an index that refers to a joint assignment to a set of random variables. One way to represent this probability distribution is to exhaustively enumerate each possibility and assign a parameter to represent the probability. However, such a listing of probabilities is troublesome in practice because the amount of training data required to reliably estimate the parameters will be

prohibitively large. For many distributions, there would be a lot of redundant information in an exhaustive list of parameter values. We can use the Bayesian networks to eliminate the redundancies by modeling the inherent structure of the joint distribution.

A Bayesian network consists of a directed, acyclic graph (DAG) G and a parameter set Θ. In G, each vertex is in one-to-one correspondence with a random variable in the probabilistic model. The lack of edges corresponds to conditional independencies between variables, and thus G serves to describe the structure present in $\Pr(X^{(1:N)})$. Using the conditional independencies implied by G, the distribution $\Pr(X^{(1:N)})$ can be factored as $\Pr(X^{(1:N)} = j) = \prod_{i=1}^{N} \Pr(X^{(i)} = j^{(i)} | \mathrm{pa}(X^{(i)}) = j^*)$, where $\mathrm{pa}(X^{(i)})$ returns to the parent nodes of $X^{(i)}$ in G and j^* refers to the subset of the assignment to j that pertains to $\mathrm{pa}(X^{(i)})$. The parameter set Θ contains the parameters to each conditional probability distribution $\Pr(X^{(i)} | \mathrm{pa}(X^{(i)}))$. For discrete variables, these are refered to as *conditional probabilitity tables* (CPTs). The earlier factorization can efficiently represent a probabilistic model by reducing the number of parameters to something manageable.

9.2.1 Dynamic Bayesian Networks

In an ordinary static Bayesian network, such as the one in Figure 9.1b, variables do not change their value over time. A Bayesian network that has been extended to time-varying processes is referred to as a dynamic Bayesian network (DBN). Algorithms for learning and inference have been developed by Dean and Kanazawa (1989), Murphy (2002). A DBN is a Bayesian network that is repeated for some discrete number of time slices T. It can be defined using two slices of a standard Bayesian network and adding additional "temporal" edges from nodes in $X_{t-1}^{(1:N)}$ to nodes in $X_t^{(1:N)}$ that specify how the variables change over time. The parameters associated with variables in the "prior" time slice $X_{t-1}^{(1:N)}$ will have parameters that specify the initial distribution $\Pr(X_1^{(1:N)})$ and the parameters in the "current" time slice, $X_t^{(1:N)}$ will be used to define the transition model from the previous state to the current state, or $\Pr(X_t^{(1:N)} | X_{t-1}^{(1:N)})$. Using the DBN framework we can specify complex probabilistic models, and we can use

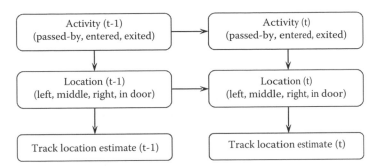

Figure 9.2 An example dynamic Bayesian network for activity recognition.

any of a range of exact and approximate inference algorithms to do inference with them (Boyen and Koller 1998, Doucet et al. 2000, Murphy 2002).

In Figure 9.2, we show an example DBN that could be used to model activity in the store surveillance scenario discussed earlier. The activity is modeled as able to change from one moment to the next with probability specified by $\Pr(\text{Activity}_t = j \mid \text{Activity}_{t-1} = i) = p_{i \to j}^{\text{Activity}}$. Similarly, the location of the person can change but how it changes is also based upon the higher-level activity. In this model, the estimate of the person's location is used as the low-level evidence, and will be used to infer location as well as the high-level activity being performed.

9.2.2 Enforcing Hierarchy

Many activities can be natuarally decomposed in a coarse-to-fine manner. To capture this representation, we require a type of structure that can model hierarchy. In this section, we discuss the basic properties of a hierarchical DBN (HDBN). This class of DBNs will be suitable for modeling hierarchical states that can change over time. Such models have been seen in Fine et al. (1998) as the hierarchical hidden Markov model (HHMM) and later cast in the DBN framework by Murphy (2002). Here we identify and isolate the portions of the model relevant for enforcing hierarchy. We will use this as our base model and will then add other dependencies that are relevant for activity recognition.

We define a HDBN as a (discrete) DBN where variables can be grouped into D levels. At a given time each level has two particular variables $X_t^{(d)}$ and $E_t^{(d)}$ that will control the hierarchical structure. At time t, the variable $X_t^{(d)}$ represents the state of the system at the dth level and the binary-valued variable $E_t^{(d)}$ represents whether or not the process for the d th level has run until its end. A HDBN then must enforce the following constraints:

- *Blocking constraint*: The state of the dth level cannot change until the $(d+1)$th level has terminated. That is, for all $d<D$, $E_{t-1}^{(d+1)} = 0 \Rightarrow X_t^{(d)} = X_{t-1}^{(d)}$.
- *Termination constraint*: The dth level may not terminate until the $(d+1)$th level has terminated. This is to say that for all $d<D$, $E_t^{(d+1)} = 0 \Rightarrow E_t^{(d)} = 0$.

The earlier constraints give a hierarchical representation to the state sequences. The constraints can be represented in a DBN by adding dependencies and requiring certain parameter values in the CPTs. The dependencies are specified by the following edges:

$$\left\{ X_{t-1}^{(d)} \rightarrow X_t^{(d)}, E_t^{(d+1)} \rightarrow E_t^{(d)}, E_{t-1}^{(d+1)} \rightarrow X_t^{(d)} \right\}$$

The constraints are enforced with the following constraints on CPT values for all $d<D$

$$\Pr\left(X_t^{(d)} = j \mid X_{t-1}^{(d)} = i, E_{t-1}^{(d+1)} = 0 \right) = \delta_{i,j}, \qquad (9.1)$$

and,

$$\Pr\left(E_t^{(d)} = 0 \mid E_t^{(d+1)} = 0 \right) = 1,$$

where $\delta_{i,j}$ equals 1 if i equals j and 0 otherwise. We show a bare bones HDBN in Figure 9.3a. In Figure 9.3b we show a more useful example

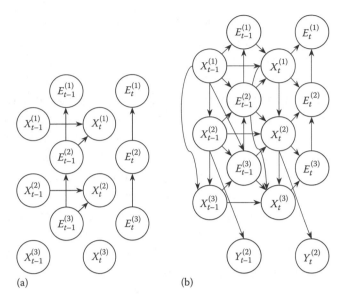

Figure 9.3 (a) The "bare-bones" HDBN which we have defined. (b) A more typical example of an hierarchical DBN. (From Muncaster, J. and Ma, Y., Activity recognition using dynamic Bayesian networks with automatic state selection, in *IEEE Workshop on Motion and Video Computing*, Austin, TX, p. 30, 2007. With permission.)

that has additional dependencies. For this more general case, the CPT must satisfy for $d < D$

$$\Pr\left(X_t^{(d)} = j \mid X_{t-1}^{(d)} = i, E_{t-1}^{(d+1)} = 0, \text{pa}^*(X_t^{(d)}) = \cdot\right) = \delta_{i,j},$$

$$\Pr\left(E_t^{(d)} = 0 \mid E_t^{(d+1)} = 0, \text{pa}^*(E_t^{(d)}) = \cdot\right) = 1,$$

where $\text{pa}^*(X)$ denotes the rest of the parents of X that have not already appeared in the list of conditioning variables.

Starting with a basic model for a probabilistic represention of a hierarchy of events, we can extend the model for activity modeling. In this section we start with a three-level "bare-bone" HDBN (Figure 9.3a) and add various constraints that are useful for modeling activities. We will define the semantics of each level and

add appropriate dependencies. Our graphical model is shown in Figure 9.4. Our first level has the variable X_t^{HL}, which represents the high-level activity that we are attempting to classify. The number of states for the high-level activity will be equal to the number of predefined activities. On the second level is X_t^{LL}, representing lower-level activities that occur and generate observations. It is always hidden and will not be labelled in the training data; however, we expect to have an observed variable, Y_t^{LL}, that depends on it. The last level X_t^{PH}, represents further subdivisions of the low-level activity and serves as the duration model for the low-level activity. We require that each low-level activity go through a sequence of *phases*, allowing us to model varying time-durations for low-level events.

The augmentations to the base HDBN model, along with the relevant conditional probability distributions, are

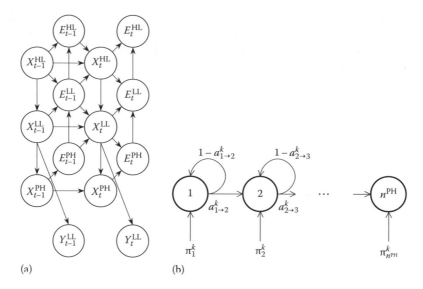

(a) (b)

Figure 9.4 (a) Model specific HDBN for activity recognition. (b) Visualization of Coxian distribution in low-level context k. Low-level event is modeled such that it is required to go through a number of phases. (From Muncaster, J. and Ma, Y., Activity recognition using dynamic Bayesian networks with automatic state selection, in *IEEE Workshop on Motion and Video Computing*, Austin, TX, p. 30, 2007. With permission.)

1. *End of each level depends on state of the level*: For each level d we will add the edges $X_t^{(d)} \rightarrow E_t^{(d)}$, which assumes that the end-of-sequence marker depends on the state of the sequence. This completes the set of dependencies for the variable representing the end of the high-level sequence, $E_t^{(d+1)}$, and so we give its CPT here:

$$\Pr\left(E_t^{HL} = 1 \mid X^{HL} = i, E_t^{LL} = 1\right) = p_{i \rightarrow \text{end}}^{HL} \qquad (9.2)$$

The parameter $p_{i \rightarrow \text{end}}^{HL}$ represents the probability of ending a high-level sequence given that we are at high-level state i and all of the previous low-level states have ended. This parameter will be given a value during the training phase.

2. *End of low-level sequence depends on the higher-level context*: We add an edge $X_t^{HL} \rightarrow E_t^{LL}$ to model our assumption that whether or not a particular low-level event marks the end of a sequence depends on the high-level state. This dependency may exist when two high-level events both have the same low-level event in their sequences. With this dependency the CPT for E_t^{LL} will have the following parameters:

$$\Pr\left(E_t^{LL} = 1 \mid X_t^{LL} = i, X_t^{HL} = k, E_t^{PH} = 1\right) = p_{i \rightarrow \text{end}}^{LL,k} \qquad (9.3)$$

where $p_{i \rightarrow \text{end}}^{LL,k}$ represents the probability of ending the low-level sequence from state i while in context k.

3. *Lower-level states depend on immediate context*: We will add the edge $X_t^{(d)} \rightarrow X_t^{(d+1)}$ for $d < D$ to model the assumption that the way a lower-level event transitions depends directly on the level immediately above it. From this we have the following prior distributions for each level:

$$\Pr\left(X_1^{HL} = j\right) = \pi_j^{HL} \qquad (9.4)$$

$$\Pr\left(X_1^{\mathrm{LL}} = j \mid X_1^{\mathrm{HL}} = k\right) = \pi_j^{\mathrm{LL},k} \qquad (9.5)$$

$$\Pr\left(X_1^{\mathrm{PH}} = j \mid X_1^{\mathrm{LL}} = k\right) = \pi_j^{\mathrm{PH},k}. \qquad (9.6)$$

4. *Low-level- and high-level-transition probabilities depend on whether the sequence has just ended*: We will place the edges $E_{t-1}^{\mathrm{HL}} \rightarrow X_t^{\mathrm{HL}}$ and $E_{t-1}^{\mathrm{LL}} \rightarrow X_t^{\mathrm{HL}}$ to model the assumption that our transition probabilities are different if we just ended a sequence. This gives the following transition model parameters for the high-level transition:

$$\Pr\left(X_t^{\mathrm{HL}} = j \mid X_{t-1}^{\mathrm{HL}} = i, E_{t-1}^{\mathrm{HL}} = 0, E_{t-1}^{\mathrm{LL}} = 1\right) = a_{i \rightarrow j}^{\mathrm{HL}}, \qquad (9.7)$$

$$\Pr\left(X_t^{\mathrm{HL}} = j \mid X_{t-1}^{\mathrm{HL}} = i, E_{t-1}^{\mathrm{HL}} = 1, E_{t-1}^{\mathrm{LL}} = 1\right) = \pi_j^{\mathrm{HL}}. \qquad (9.8)$$

The low-level CPT is similar; however, it also depends on the high-level context:

$$\Pr\left(X_t^{\mathrm{LL}} = j \mid X_{t-1}^{\mathrm{LL}} = i, X_t^{\mathrm{HL}} = k, E_{t-1}^{\mathrm{HL}} = 0, E_{t-1}^{\mathrm{LL}} = 1\right) = a_{i \rightarrow j}^{\mathrm{LL},k}, \qquad (9.9)$$

$$\Pr\left(X_t^{\mathrm{LL}} = j \mid X_{t-1}^{\mathrm{LL}} = i, X_t^{\mathrm{HL}} = k, E_{t-1}^{\mathrm{HL}} = 1, E_{t-1}^{\mathrm{LL}} = 1\right) = \pi_j^{\mathrm{LL},k}. \qquad (9.10)$$

Here, in high-level context k, $a_{i \rightarrow j}^{\mathrm{LL},k}$ is the transition probability of going from low-level state i to low-level state j and $\pi_j^{\mathrm{LL},k}$ is the probability of starting a low-level sequence in state j.

5. *Lowest-level follows a Coxian phase-distribution that depends on low-level context*: To model complex durations of low-level events we use the discrete Coxian distribution. This means that every low-level event must pass through some number of *phases* before it is allowed to transition to the next low-level event. We fix the number of phases n^{PH} for each low-level event. Next, we

insist that phase model ends exactly when it reaches the final phase. This gives the parameters

$$\Pr\left(E_t^{PH}=1|\,X_t^{PH}=i\right)=\delta_{i,n^{PH}},\qquad(9.11)$$

and,

$$\Pr\left(X_t^{PH}=j|\,X_{t-1}^{PH}=i,X_t^{LL}=k\right)=\begin{cases}1-a_{i\to i+1}^{PH,k}, & j=i,i<n^{PH}\\ a_{i\to i+1}^{PH,k}, & j=i+1,i<n^{PH}\\ \pi_j^{PH,k}, & i=n^{PH}\\ 0, & \text{otherwise.}\end{cases}$$

$$(9.12)$$

where, in context k, $a_{i\to i+1}^{PH,k}$ is a free parameter representing the probability of advancing to the next phase from phase i and $\pi_j^{PH,k}$ is the probability of starting the sequence in phase j. This CPT is illustrated in Figure 9.4b.

6. *Observations are multivariate Gaussian and are based on the low-level state*: In order to do any sort of inference on our model we will need some observations. Thus we add a new variable, Y_t^{LL}, which represents an observation of the low-level event. Typically, our observations are some continuous-valued feature-vector, \mathbf{y}_t^{LL}. During the training phase we will take all of our feature vectors and partition the feature space into clusters, where each cluster represents a low-level state. We then assume that a particular observation, \mathbf{y}_t^{LL}, is drawn from a Gaussian distribution, whose parameters are determined by the low-level state, that is,

$$\Pr\left(Y_t^{LL}=\mathbf{y}_t^{LL}|\,X_t^{LL}=k\right)=\eta\left(\mathbf{y}_t^{LL};\boldsymbol{\mu}_k^{LL},\boldsymbol{\Sigma}_k^{LL}\right),\qquad(9.13)$$

where $\boldsymbol{\mu}_k^{LL}$ is the mean vector and $\boldsymbol{\Sigma}_k^{LL}$ is the covariance matrix parameters to the multivariate Gaussian distribution of observations of low-level context k. These parameters will be estimated by our clustering methods in the next section.

9.3 FEATURE SPACE PARTITIONING

9.3.1 Clustering

When using feature vectors to infer low-level activity, we wish to ignore subtle variations, yet still capture information relevant to the activity. For example, in the store surveillance scenario, if we wish to recognize an individual entering the store we do not care if the individual enters the scene from the left or to the right, or with what speed the individual walks, or the subtle nuances of the individual's trajectory. We simply would like to divide the feature space up in a way that captures only coarse events of a person traveling successively closer to the store. We could divide up the feature space into evenly sized cells and use those cells to represent low-level events; however, this method might assign too much detail to regions, which should be coarse and not enough detail to regions that require more precision. Therefore, we will use a data-driven method to partition the feature space.

To partition the feature space we perform a clustering of the entire set of feature points. This clustering gives us μ_k^{LL} and Σ_k^{LL} in Equation 9.13, which describes various low-level events. The entire process is illustrated as follows. First, we take a large set of feature points from our training data (as shown in Figure 9.5a). We then run a clustering algorithm to represent the space as a small set representative points, as shown in Figure 9.5b. These clusters will be interpreted as the low-level states in our model, which we show in Figure 9.5c. Finally, we will use the clustering results to estimate our observation likelihoods by fitting a Gaussian to each cluster, illustrated pictorially in Figure 9.5d.

In the following, we describe the deterministic annealing clustering algorithm, which we use to partition the feature space. Given a distortion measure $d(\mathbf{x}, \mathbf{y})$ and a set of training data $\mathbf{Y} = \{\mathbf{y}_1, ..., \mathbf{y}_N\}$, we wish to find a set of up to K cluster centers $\mathbf{X} = \{\mathbf{x}_1, ..., \mathbf{x}_K\}$ that will minimize

$$D = \sum_{\mathbf{y} \in \mathbf{Y}} \Pr(\mathbf{y}) d(\mathbf{y}, nc(\mathbf{y})),$$

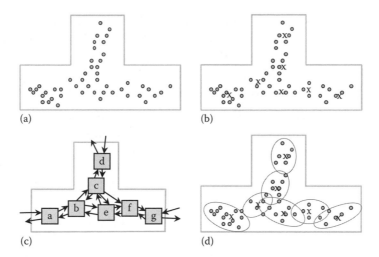

Figure 9.5 Using clustering to define low-level events. (a) We have as input many points in the feature space. (b) We run a clustering algorithm to partition the space. (c) Each cluster center represents a low-level state from which we can learn transition probabilities. (d) We fit a Gaussian to each cluster center to represent the observation likelihood for each low-level event.

where $nc(y)$ denotes the cluster center \mathbf{x}_j that is nearest to \mathbf{y} according to $d(\mathbf{x}, \mathbf{y})$. The deterministic annealing approach to clustering as given in Rose (1998) attempts to find a set of cluster centers that achieve a global minimum to the earlier cost function. To do this, problem constraints are relaxed and each point is required to be assigned to *all* clusters with probability $\Pr(\mathbf{x}|\mathbf{y})$. Then, the following modified distortion function is minimized

$$\tilde{D} = \sum_{\mathbf{y} \in Y} \Pr(\mathbf{y}) \sum_{\mathbf{x} \in X} \Pr(\mathbf{x} \mid \mathbf{y}) d(\mathbf{x}, \mathbf{y})$$

To compute the cluster centeroids that minimize this function, we start off by using an assignment that is very cautious about the certainty with which a data point is associated to a particular cluster center. This effect is achieved by adding a "temperature" term to the algorithm that causes data points to be assigned, to some degree, to every cluster under consideration. The "fuzziness" of the association probabilities is

controlled in an outer loop that gradually lowers the temperature term from very high (soft associations) to very low (hard associations), while an inner loop does a local optimization at a given temperature.

In the inner loop, the cost function \tilde{D} is optimized by a familiar two-step updating algorithm. In the first step data points are associated with cluster centers, and in the second step cluster centers are updated based on the associations. During the association step, each data point is associated with each cluster with the probability

$$\Pr(\mathbf{x}_j | \mathbf{y}_i) = \frac{1}{Z_x} \exp\left(-\frac{d(\mathbf{x}_i, \mathbf{y}_j)}{T}\right), \qquad (9.14)$$

where
 T is the temperature term
 Z_x is the normalization constant

After the association step, the centroid update step updates the locations of the cluster centers. For a squared Euclidean distance measure, the update is given by

$$\mathbf{x}_j = \frac{1}{N \times \Pr(\mathbf{x}_j)} \sum_{i=1}^{N} \Pr(\mathbf{x}_j | \mathbf{y}_i) \mathbf{y}_i \qquad (9.15)$$

which is just the mean of the data points weighted by the association probabilities. This process is iterated until the cluster centers do not change much from interation to iteration. Then, the temperature is lowered and the process repeats.

At high temperatures, each data point will be associated almost exactly equally with each cluster center, regardless of initialization. The centroid update will, at high temperature, then place each cluster at the center of mass of the distribution. As temperature is lowered, association probabilities get stronger and the cluster centroids begin to split apart and settle into new locations in which \tilde{D} is minimized. Finally, at $T=0$ we arrive back at the original problem, which we solve using the

same algorithm only data points are assigned completely to the nearest cluster.

An interesting aspect of annealing is that the natural number of effective clusters arise at various temperatures. For example, at very high T there is effectively a single cluster, as all cluster centers will coincide on a single point. At intermediate temperatures, the cluster centers will drift apart and settle down again into a new discrete set of effective clusters. Thus, if the process is stopped early at some T_{min}, we may end up in a case where many clusters centers are covering the same point; effectively, this means we end up with a number of clusters less than K. This is a favorable side effect of annealing because we are less inclined to over-fit data with extraneous clusters. Note that if we did wish to tightly fit the training data, we can always lower T_{min} to a point where all K clusters split apart.

For more in-depth details about deterministic annealing, see Rose (1998). For our purposes the algorithm provides a way to estimate the *number low-level states* and the parameters $\mu_{1:n^{LL}}^{LL}$ and $\Sigma_{1:n^{LL}}^{LL}$ to the observation density. Combining this algorithm with the model specified in the previous section, Table 9.1 shows the notation for the input and output of the algorithm. Table 9.2 presents the method for constructing a model for activity recognition.

TABLE 9.1 Notatation for the Input and Output of the Model Construction Algorithm

TrainActivityModel (n^{HL}, n_{max}^{LL}, n^{PH}, T_{min}, α, S)

Inputs:

n^{HL}, the number of high-level states.

n_{max}^{LL}, the maximum number of low-level states.

n^{PH}, the number of phase-transitions for a given low-level state.

T_{min}, the minimum annealing temperature.

α, annealing temperature decay factor.

$S = \left\{ S_{1:\ell_1}^{1}, \ldots, S_{1:\ell_{|S|}}^{L} \right\}$, the L input sequences, where $S_t^i = \left(\mathbf{x}_t^{HL}, \mathbf{y}_t^{LL} \right)$ is an observation at time t in the ith sequence.

Output: A DBN activity model \mathcal{M} with learned model probabilities.

TABLE 9.2 Algorithm for Construction of a Probabilistic Model for Activity Recognition

TrainActivityModel(n^{HL}, n^{LL}_{max}, n^{PH}, T_{min}, α, \mathcal{S})

1. Partition feature space:

 a. Gather all observed features y^{HL}_t into one list.

$$\mathbf{Y} \leftarrow \text{GatherFeatures}\,(\mathcal{S})$$

 b. Cluster features using deterministic annealing with maximum number of clusters n^{LL}_{max} and minimum temperature T_{min}.

$$\left(n^{LL}, \boldsymbol{\mu}^{LL}_{1:n^{LL}}, \boldsymbol{\Sigma}^{LL}_{1:n^{LL}}\right) \leftarrow \text{ClusterDA}\,\left(\mathbf{Y}, n^{LL}_{max}, T_{min}, \alpha\right)$$

2. Create three-level HDBN model with X^{HL}_t, X^{LL}_t, and X^{PH}_t representing the state of each level and E^{HL}_t, E^{LL}_t, and E^{PH}_t representing the end-of-sequence marker for each level.

$$\mathcal{M}_0 \leftarrow \text{CreateDbnModel}\,(n^{HL}, n^{LL}, n^{PH})$$

3. Set conditional probability distribution prior probabilities for the EM algorithm. Initialize unknown parameters to random values.

 a. Observations: Use $\boldsymbol{\mu}^{LL}_{1:n^{LL}}$ and $\boldsymbol{\Sigma}^{LL}_{1:n^{LL}}$ from clustering result as parameters to a mixture of Gaussians distribution with n^{LL} components.

 b. Initial time slice:

$$\Pr\left(X^{HL}_{t-1} = j\right) = \pi^{HL}_j$$

$$\Pr\left(X^{LL}_{t-1} = j \mid X^{HL}_{t-1} = k\right) = \pi^{LL,k}_j$$

$$\Pr\left(X^{PH}_{t-1} = j \mid X^{LL}_{t-1} = k\right) = \pi^{PH,k}_j$$

 c. Transition probabilities:

$$\Pr\left(X^{HL}_t = j \mid X^{HL}_{t-1} = i, E^{LL}_{t-1} = e^{LL}, E^{HL}_{t-1} = e^{HL}\right) = \begin{cases} \delta_{i,j}, & e^{LL} = 0 \\ a^{HL}_{i \to j}, & e^{LL} = 1, e^{HL} = 0 \\ \pi^{HL}_j, & e^{LL} = 1, e^{HL} = 1. \end{cases}$$

$$\Pr\left(X^{LL}_t = j \mid X^{LL}_{t-1} = i, X^{HL}_{t-1} = k, E^{PH}_{t-1} = e^{PH}, E^{LL}_{t-1} = e^{LL}\right) = \begin{cases} \delta_{i,j}, & e^{PH} = 0 \\ a^{LL,k}_{i \to j}, & e^{PH} = 1, e^{LL} = 0 \\ \pi^{LL,k}_j, & e^{PH} = 1, e^{LL} = 1. \end{cases}$$

TABLE 9.2 (continued) Algorithm for Construction of a Probabilistic Model for Activity Recognition

d. End-of-sequence probabilities:

$$\Pr\left(E_t^{HL}=1 | X_{t-1}^{HL}=i, E_t^{LL}=e^{LL}\right) = \begin{cases} 0, & e^{LL}=0 \\ p_{i \to end}^{HL}, & e^{LL}=1. \end{cases}$$

$$\Pr\left(E_t^{LL}=1 | X_{t-1}^{LL}=i, E_t^{PH}=e^{PH}\right) = \begin{cases} 0, & e^{PH}=0 \\ p_{i \to end}^{LL}, & e^{PH}=1. \end{cases}$$

$$\Pr\left(E_t^{PH}=1 | X_{t-1}^{PH}=i\right) = \delta_{i,n^{PH}}$$

4. Run EM algorithm until convergence.

$$\mathbf{M} \leftarrow \text{LearnParamsEM}(\mathbf{M}_0, S)$$

9.3.2 Examples

Hierarchically structured DBNs have been used to classify basic activities at a shopping center in Portugal using the CAVIAR (2001) dataset. A frame of video from this data is shown in Figure 9.6a. We identify three high-level activities: entering the shop, leaving the shop, and

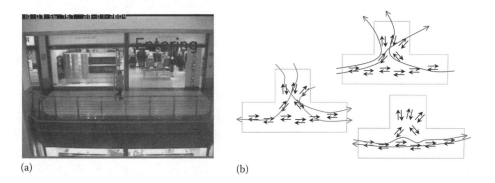

(a) (b)

Figure 9.6 (See color insert following page 332.) (a) A frame of video with activity label for one track. (b) An illustration of how we expected our features to cluster both in position and direction. (From Muncaster, J. and Ma, Y., Activity recognition using dynamic Bayesian networks with automatic state selection, in *IEEE Workshop on Motion and Video Computing*, Austin, TX, p. 30, 2007. With permission.)

passing the shop. We used a four-dimensional feature space: x-position, y-position, x-velocity, y-velocity. This feature is provided to the algorithm by the object tracker. Since people tend to walk at approximately the same speed, clustering of the feature space amounts to only considering few regions on common paths and a small number of directions. Figure 9.6b shows a visualization of how features can cluster into low-level events.

The clustering was performed and 16 clusters were chosen to represent the low-level events. Next, the rest of the DBN was set up for learning. Experimentally, four phases were chosen for the Coxian model. The training data consisted only of feature points from tracks of persons in video and a number denoting the high-level label of the activity. The Expectation–Maximization (EM) algorithm was used to learn the DBN parameters, initializing unknown paramaters to random values and using the Boyen–Koller smoothing algorithm for inference. To test the performance of the algorithm, feature points were extracted from the tracker and the filtered marginal probabilities for each frame were computed using the Boyen–Koller filtering algorithm found in Boyen and Koller (1998). In the results, the probability reported at time t for an activity is the probability that the individual is doing the high-level activity given all of the measurements up until time t only. The results for the "entering" and "passing" activities are shown in Figure 9.7.

Consider the sequence for the "Entering" track in Figure 9.7a. In this sequence, the person walks along the pathway and approaches the door from frame 0 to around frame 150. As expected, during this time we are unsure as to whether the user is entering the store or merely passing. It appears we favor the possibility that the user is entering the store, which is due to the fact that the individual's velocity is in fact pointing toward going in the store. Eventually, the person has turned the corner at the entryway and almost immediately the algorithm is able to classify the activity as "entering" with a high degree of certainty.

The results of a "passing" event are shown in Figure 9.7b. This figure shares characteristics with the entering event in that there are clear points where one event is discerned from another. In this clip the individual passes the store from right to left. Initially there is uncertainty between "entering" and "passing," which gets quickly resolved

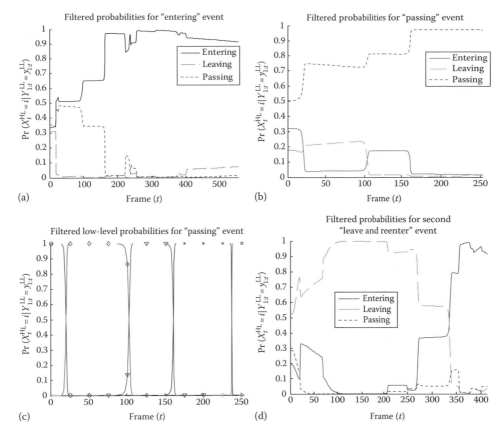

Figure 9.7 (See color insert following page 332.) Results for tests on user (a) entering the store, (b) leaving the store, and (c) passing the store. In (d) we show the low-level event probabilties for the "passing" event. Notice how jumps in probability in (c) correspond to low-level changes in (d). (From Muncaster, J. and Ma, Y., Activity recognition using dynamic Bayesian networks with automatic state selection, in *IEEE Workshop on Motion and Video Computing*, Austin, TX, p. 30, 2007. With permission.)

as the individual passes the doorway. As the person goes past the doorway the uncertainty between "passing" and "leaving" increases; however, the activity is resolved without a problem. In Figure 9.7c, the filtered probabilities for the *low-level* events of the passing person are shown. Here we can see the person passing from one cluster to another. Notice how each low-level transition has a corresponding

jump in probability for the high-level event, suggesting that we have successfully decomposed the activity into simpler sub-events.

Figure 9.7d shows the results of the algorithm on slightly abnormal video. In this video, a person first exits the store, walks out, and turns the corner. Next, the person stops, pauses for a moment, and turns around and goes back into the store. Although the trajectory is different from the types of trajectories used for training, the algorithm is able to "change its mind" about the observed activity.

9.4 SUMMARY

In this chapter we discussed complex activity recognition. In the case where there is a predefined dictionary and training data available, we provided a broad technique for modeling activity. The technique is based on the creation of a hierarchical probabilistic model and on an automatic partitioning of the feature space. This technique has been successful in classifying high-level activities in a store surveillance environment by decomposing the activities into simpler events. The algorithm worked well on a simple store-surveillance example, and may be applied to more complex scenarios. The algorithm was also successful on mildly abnormal video sequences in which the individuals changed from one activity to another.

9.5 BIBLIOGRAPHICAL AND HISTORICAL REMARKS

Activity recognitoin can be described as inferring the state of the time-varying behavior of individuals or groups. A recent survey (Turaga et al. 2008) reviewed the major approaches that have been pursued over the last 20 years. For the complex activity recognition described in this chapter, one can also use rules to define low-level states and test if sequences of these states are accepted by a finite automata or context-free grammar, as in Cupillard et al. (2004), Ryoo and Aggarwal (2006), and Ivanov and Bobick (2000), respectively. To better handle uncertainty, one may choose representations that models activities probabilistically, such as a hidden Markov model, a Bayesian network, or a DBN (Hongeng et al. 2004, Duong et al. 2005). Additionally,

some representations can model complex activities as being composed high-level events, lower-level events, and so forth, inducing a hierarchy of events to be recognized.

For the predefined activity recognition, in Cupillard et al. (2004) the authors analyzed surveillance video in a subway and sought to identify people vandalizing the ticketing machine, blocking the entrance to the train, or otherwise entering and leaving the area as normal. Specific domain knowledge can aid in the development of highly customized algorithms, although general applicability of such algorithms is often limited. In other applications, one simply wants to know what types of activity occur in a scene. The dictionary is learned by analyzing the scene and doing a clustering of the types of activity involved. In Stauffer and Grimson (2000), for example, the authors performed a clustering of low-level features to discover patterns of activity. Such systems are useful for identifying abnormal behavior that deviates significantly from a set of learned activities.

REFERENCES

Boyen, X. and D. Koller. 1998. Tractable inference for complex stochastic processes. In *Proceedings of the 14th Annual Conference on Uncertainty in Artificial Intelligence*, Madison, WI, pp. 33–42.

CAVIAR. 2001. CAVIAR dataset. http://groups.inf.ed.ac.uk/vision. EC Funded CAVIAR project/IST 2001 37540. Accessed on June 2007.

Cupillard, F., A. Avanzi, F. Bremond, and M. Thonnat. 2004. Video understanding for metro surveillance. In *IEEE International Conference on Networking, Sensing and Control*, Taipei, Taiwan.

Dean, T. and K. Kanazawa. 1989. A model for reasoning about persistence and causation. *Computational Intelligence*, 5(3):142–150.

Doucet, A., N. de Freitas, K. Murphy, and S. Russell. 2000. Rao-Blackwellised particle filtering for dynamic Bayesian networks. In *Proceedings of the 16th Conference on Uncertainty in Artificial Intelligence*, Stanford, CA, pp. 176–183.

Duong, T., H. Bui, D. Phung, and S. Venkatesh. 2005. Activity recognition and abnormality detection with the switching hidden semi-Markov model. In *IEEE Conference on Computer Vision and Pattern Recognition*, San Diego, CA.

Fine, S., Y. Singer, and N. Tishby. 1998. The hierarchical hidden Markov model: Analysis and applications. *Machine Learning*, 32(1):41–62.

Hongeng, S., R. Nevatia, and F. Bremond. 2004. Video-based event recognition: Activity representation and probabilistic recognition methods. *Computer Vision and Image Understanding*, 96:129–162.

Ivanov, Y. and A. Bobick. 2000. Recognition of visual activities and interactions by stochastic parsing. *IEEE Transactions on Pattern Analysis and Machine Intelligence*, 22:852–872.

Muncaster, J. and Y. Ma. 2007. Activity recognition using dynamic Bayesian networks with automatic state selection. In *IEEE Workshop on Motion and Video Computing*, Austin, TX, p. 30.

Murphy, K. P. 2002. Dynamic Bayesian networks: Representation, inference and learning. PhD thesis, University of California, Berkeley, CA.

Rose, K. 1998. Deterministic annealing for clustering, compression, classification, regression, and related optimization problems. *Proceedings of the IEEE*, 86(11):2210–2239.

Ryoo, M. and J. Aggarwal. 2006. Recognition of composite human activities through context-free grammar based representation. In *IEEE Conference on Computer Vision and Pattern Recognition*, New York, pp. 1709–1718.

Stauffer, C. and W. Grimson. 2000. Learning patterns of activity using real-time tracking. *IEEE Transactions on Pattern Analysis and Machine Intelligence*, 22(8):747–757.

Turaga, P., R. Chellappa, V. S. Subrahmanian, and O. Udrea. 2008. Machine recognition of human activities: A survey. *IEEE Transactions on Circuits and Systems for Video Technology*, 18(11):1473–1488.

10

Multi-Level Human Interaction Recognition

Sangho Park and Mohan M. Trivedi

CONTENTS

10.1 INTRODUCTION

Understanding human interaction is important in computer vision for a wide range of potential applications including visual surveillance, security enforcement, intelligent environments, and human–computer interaction. Human activity and interaction in the real world occur in a three-dimensional space and typically involve multiple persons or objects moving in the 3D space. In comparison, computer-vision-based understanding of human interaction deals with 2D image-based representation(s) of the persons and objects. The analysis of multi-person interaction raises difficult issues in computer vision: occlusion between objects and body deformation during the interaction.

Figure 10.1 illustrates various situations of multi-person interactions from the viewpoint of camera imaging conditions. In a simple two-person interaction situation (Figure 10.1a), a single-camera system with viewing direction V1 may be sufficient for monitoring the interaction A between persons P1 and P2, given the imaging condition is optimal with the fronto-parallel imaging of the interaction. As the imaging configuration becomes suboptimal with the free movements of the persons in the space (Figure 10.1b), monitoring with the existing camera V1 gets more difficult and unreliable due to the occlusion and the change in the

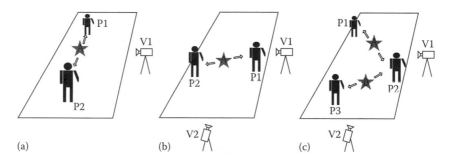

Figure 10.1 A schematic view of various multi-perspective configuration options for monitoring multi-person interaction. (From Park, S. and Trivedi, M.M., *Comput. Vision Image Understand*, 111, 3, 2008. With permission.)

appearance of the persons. We would need an alternative camera view V2 for better monitoring. If the multi-person interaction involves more than two persons (Figure 10.1c), a multi-view system may be inevitably required. In this situation, the viewing directions, V1 and V2, would be more suitable for monitoring the interaction, A, between persons P1 and P2, and the interaction B, between persons P2 and P3, respectively. As the situation becomes more complicated with the arbitrary movements of the involved persons, dynamic selection and coordination of the multiple views become important in order to keep track of their interaction across the multiple views. An intelligent mechanism for data fusion is needed. The primary challenge in the data fusion from multiple cameras is how to decide when and which camera inputs to fuse. We call it the "multi-view fusion" problem.

An integrated understanding of human activity may involve multiple levels of detail in data analysis. In this chapter, we consider two stages of detail in the representation of the persons: *track-level* and *body-level* representations. At the track level, human activity is analyzed in terms of the tracks of moving bounding boxes representing individual persons. At the body level, human activity is analyzed in more detail using the salient features associated with the coordinated posture and gesture of the interacting human body. A major challenge in the two-stage analysis is how to maintain the coherence between the two analysis levels; how can a vision system adaptively switch between the different analysis levels depending on the observability of the persons under occlusion? We call it the "two-stage fusion" problem. The problems of the multi-view fusion and the two-stage fusion are hard to solve with a simple unidirectional bottom-up or top-down vision process. Indeed, bidirectional processing with some feedback mechanism is desirable, since this would integrate the top-down contextual hypotheses about human interactions with the data-driven bottom-up vision processes.

For the analysis of multi-person activities in a distributed vision system, we present a new framework, called Track-Body Synergy (TBS), which achieves a synergistic integration of track- and body-level representations of the scene across the multiple views. An overview of the TBS system architecture is shown in Figure 10.2. The proposed framework is geared toward versatile and easily deployable systems that do not require a careful calibration of camera.

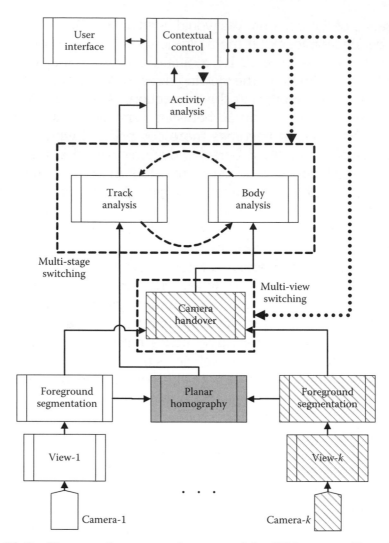

Figure 10.2 The overall system architecture of the TBS system. (From Park, S. and Trivedi, M.M., *Comput. Vis. Image Und.*, 111, 3, 2008. With permission.)

Clear rectangles in Figure 10.2 denote the modules for the basic single-view system, while the hashed rectangles compose the add-on modules for multi-view functionality. The gray module can work either in single- or multi-view modes, but using more cameras can increase the overall accuracy. In the single-view mode, the planar *homography*

mapping (explained in Section 10.2) generates a virtual top-down view of the ground plane overlaid with warped foreground images, whereas in the multi-view mode, the virtual top-down view of the ground plane is overlaid with multiple foreground warping that results from the various views. Using multiple views not only increases the reliability, but also provides new information about view-invariant features such as object size (Park and Trivedi 2006a). Currently, two ($K=2$) cameras are used for synchronized views, which are foreground segmented and combined to form a planar-homography map for 3D footage locations of the persons. The homography map is used for the track-level analysis (Section 10.5.1), whereas the view switching for unoccluded views of people is used for the body-level analysis (Section 10.5.2). Both the track- and body-level analysis can be used for the activity analysis depending on analysis task. Dynamic contextual control with optional user involvement is incorporated with activity analysis, and provides constraints to other processing modules as feedback. The top-down feedback flows in the system are marked as dotted thick arrows in Figure 10.2.

10.2 GENERATION OF VIRTUAL VIEW BY HOMOGRAPHY BINDING

The complication due to the visual occlusion may be alleviated if we can obtain the virtual top-down view (i.e., planview) of the interacting persons in the scene as shown in Figure 10.3.

The view-invariant position of moving object's footage on the world coordinate system can be calculated by planar homography (Greenhill

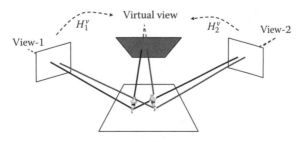

Figure 10.3 Diagram for generating the top-down virtual view by planar homography.

et al. 2005, Hu et al. 2006). A planar *homography*, represented by matrix H, is a linear projection that maps the corresponding points between two image coordinate systems. The four-point algorithm (Criminisi et al. 1999) can effectively compute homography matrix H from the corresponding points $[x_i, y_i]^T$ and $[x'_i, y'_i]^T$ sampled from each camera view, respectively, as follows:

$$AH = \begin{bmatrix} x_1 & y_1 & 1 & 0 & 0 & 0 & -x'_1 x_1 & -x'_1 y_1 & -x'_1 \\ 0 & 0 & 0 & x_1 & y_1 & 1 & -y'_1 x_1 & -y'_1 y_1 & -y'_1 \\ x_2 & y_2 & 1 & 0 & 0 & 0 & -x'_2 x_2 & -x'_2 y_2 & -x'_2 \\ 0 & 0 & 0 & x_2 & y_2 & 1 & -y'_2 x_2 & -y'_2 y_2 & -x'_2 \\ x_3 & y_3 & 1 & 0 & 0 & 0 & -x'_3 x_3 & -x'_3 y_3 & -x'_3 \\ 0 & 0 & 0 & x_3 & y_3 & 1 & -y'_3 x_3 & -y'_3 y_3 & -y'_3 \\ x_4 & y_4 & 1 & 0 & 0 & 0 & -x'_4 x_4 & -x'_4 y_4 & -x'_4 \\ 0 & 0 & 0 & x_4 & y_4 & 1 & -y'_4 x_4 & -y'_4 y_4 & -y'_4 \end{bmatrix} \begin{bmatrix} h_{11} \\ h_{12} \\ h_{13} \\ h_{21} \\ h_{22} \\ h_{23} \\ h_{31} \\ h_{32} \\ h_{33} \end{bmatrix} = \begin{bmatrix} 0 \\ 0 \\ 0 \\ 0 \\ 0 \\ 0 \\ 0 \\ 0 \\ 0 \end{bmatrix}$$

$$(10.1)$$

If we denote H_m^n as the homography that maps points from view m to view n, then multiple camera views can be registered by the concatenated homography matrices given in Equation 10.2.

$$H_m^n = H_{n+1}^n H_{n+2}^{n+1} \cdots H_{m-1}^{m-2} H_m^{m-1} \qquad (10.2)$$

The homography-based view-invariant localization of two persons is shown in Figure 10.4. The first row shows view-1's (on the left) and view-2's (on the right) raw images. The second row shows view-1's and view-2's foreground segmented images. The third row shows view-1's and view-2's homography projections on the common ground map. We exploit the planar homography constraint (Ma et al. 2003), which assumes that all the points lie on the same plane (i.e., the ground plane in 3D world). The homography mapping of the points that violate this assumption results in skewed mapping to a location along the epipolar lines on the virtual view of the ground plane (as shown in the third row in Figure 10.4). In general, the epipolar line l_j^i of the ith person in

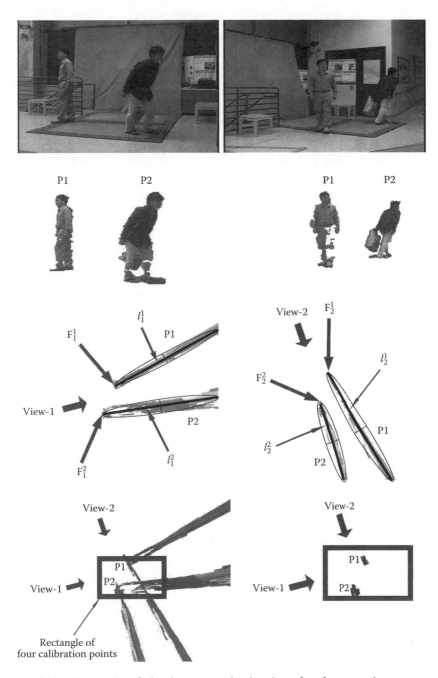

Figure 10.4 Example of the homography binding for footage detection in 3D and the camera poses estimation. See the text for more details. (From Park, S. and Trivedi, M.M., *Comput. Vis. Image Und.*, 111, 3, 2008. With permission.)

the jth view corresponds to the major axis of the warped foreground image of the person, and is represented as $l_j^i = (a_j^i, b_j^i, c_j^i)^T$ in the homogeneous coordinate system. The superscript i and the subscript j denote the ith person from the jth view, respectively. The homography projection is overlaid with epipolar lines $l_j^{i'}$'s and footage position $F_j^{i'}$'s. The fourth row of Figure 10.4 shows the superimposition of the two warped foreground maps and footage regions detection by the intersection of the two views. (We call this intersection process "homography binding.") By intersecting the multiple projection maps of the same object (Figure 10.4: fourth row), we can estimate the object's common footage region that satisfies the assumption. The embedded rectangles in the fourth row depict the carpet regions in the raw images of the first row, which provide the four calibration points used in Equation 10.1.

10.3 ADAPTIVE SELECTION OF THE BEST VIEW

The view-invariant localization of persons on the common ground by the homography binding enables efficient camera switching for best-view selection. The best view depends on the camera perspectives and the individual body posture, which can be determined by bottom-up image analysis. The "best" view also depends on recognition; for example, the recognition of *hand shaking* would be more reliable with a profile view than a front view of the persons, while the recognition of *face* may be more reliable with the front view of the person than a profile view. The current system uses two versions of the best-view selection process: (1) estimation of the *separation between persons* (called "dispersedness" Δ defined below) and (2) task-dependent selection of views in specific body orientation.

The adaptive selection of the best view is based on multiple-view geometry (Hartley and Zisserman 2000), and starts with the estimation of camera pose from each view. We use the two epipolar lines l_j^L and l_j^R determined by the leftmost and rightmost margins of the image captured with the jth camera in order to estimate the camera pose of the jth view (i.e., the camera rotation and translation) (R_j', T_j') as follows:

$$T_j' = l_j^L \times l_j^R \tag{10.3}$$

$$R_j' = \frac{1}{2}\left(\angle\left(l_j^L\right) + \angle\left(l_j^R\right)\right) \tag{10.4}$$

where

$$\angle\left(l_j^L\right) = \arctan\left(-\frac{a_j^L}{b_j^L}\right)$$

$$\angle\left(l_j^R\right) = \arctan\left(-\frac{a_j^R}{b_j^R}\right)$$

Note that the camera pose (R_j', T_j') is the degenerate form of the true 3D camera pose (R, T) obtainable from the full calibration of the camera; (R_j', T_j') represents the pan angle and translated position of the jth camera with respect to the world origin on the ground plane that was used in the homography binding.

The *apparent* footage point F_j^i of the ith person on the virtual ground plane of the jth view is represented as $F_j^i = (x_j^i, y_j^i, 0)^T$ in the homogeneous coordinate system. The *estimated* footage point \tilde{F}_j^i of the ith person on the jth virtual ground plane (Figure 10.4: the fourth row) is chosen from the cross product $\tilde{F}_j^{m,n} = (l_1^m \times l_2^n)$ of the mth epipolar line l_1^m from view-1 and the nth epipolar line l_2^n from view-2 that generates the closest estimation from F_j^i:

$$\tilde{F}_j^i = \arg\min_{m,n}\left\|\tilde{F}_j^{m,n} - F_j^i\right\|, \quad \text{such that } \left\|\tilde{F}_j^{m,n} - F_j^i\right\| \leq \delta_F \tag{10.5}$$

where the maximum-allowable distance δ_F is determined experimentally.

The *dispersedness* $\Delta_j^{i,k}$ (i.e., the separation) between the ith and kth persons viewed from the jth camera is defined by the projected length of the distance vector $d_j^{i,k}$ between the persons' estimated footage positions on the ground plane as follows:

$$d_j^{i,k} = \tilde{F}_j^i - \tilde{F}_j^k \tag{10.6}$$

$$\Delta_j^{i,k} = \left\|d_j^{i,k}\right\|\sin\left(R_j' - \angle\left(d_j^{i,k}\right)\right) \tag{10.7}$$

We obtain the minimum Δ_j of the dispersedness value $\Delta_j^{i,k}$ from all the pairs of persons for the jth view, and select the best view J that has the maximum dispersedness Δ_j from all the available views

$$\Delta_j = \min_{i,k} \Delta_j^{i,k}, \quad \forall i,k, i \neq k \tag{10.8}$$

$$J = \arg\max_j \Delta_j \tag{10.9}$$

The benefit of using the homography binding for the estimation of the dispersedness of persons is the estimation of the view-invariant distance between the persons and the cameras.

10.4 LEARNING THE HUMAN ACTIVITY

Human activity understanding from video imagery attempts to extract semantic information from visual evidence. It requires data association between the salient visual features (called "body-appearance features") and the semantic description of events that comprise the activity (Kojima et al. 2002). Human activities involving multiple persons and/or object(s) may constitute a very complicated set of events. Our approach to the multi-person activity understanding is based on an *event hierarchy* (Park and Aggarwal 2004b) where a human interaction may be composed of multiple *sub-events*. A human *interaction* is a combination of single-person actions, and the single-person *action* is composed of multiple *gestures* that comprise the *unit-actions*.

Our two-level approach with TBS efficiently supports the event hierarchy. At the track level, the recognition system monitors individual person's body translation represented in terms of the track on a virtual planview domain. Our method binds multi-view-based planar homography maps on the virtual planview domain, which provides more robust and reliable tracking performance compared to the conventional single-view-based tracking in image domain. The redundancy in the multiple views effectively resolves the uncertainty caused by the occlusion and reduces the artifacts from imaging noise. The track-level analysis provides the coarse-level recognition of human activity and interactions, and serves as a baseline recognition process.

The detailed-level recognition of human activity is achieved by the body-level analysis, which may be more error prone and unreliable compared to the track-level analysis. Therefore, the body-level analysis needs to be supported by the recent history of the track-level analysis as indicated by the two-level switching process in Figure 10.5.

This motivates the integration of track- and body-level analysis results, in the form of the TBS. With the aid of the track-level analysis results, the body-level analysis achieves more reliable recognition of detailed human activity and interactions at higher level.

The detailed-level recognition of human activity is achieved by analyzing the temporal evolution of the body-appearance features of each person along the sequence. (The body-appearance features are explained in more detail in Section 10.5.2.)

We use a bank of discrete hidden Markov models (dHMMs) to learn and test the body-appearance features, which are discretized by vector quantization as a preprocessing. Discrete HMMs with the left–right HMM structure (Rabiner 1989) are parameterized in terms of the number of hidden states N, the number of transition links from a hidden state L, the number of observation symbols M, and probability distributions $\lambda = (\pi, A, B)$. The initial probabilities of the N states, π, is chosen from a uniform random distribution. The transition probability matrix A and the observation probability matrix B are estimated by the standard Baum–Welch algorithm using training data (Rabiner 1989). The continuous body-appearance features as the initial input features are discretized by the Linde–Buzo–Gray vector-quantization

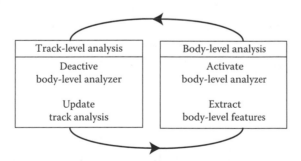

Figure 10.5 Diagram of the switching mechanism between the track- and body-level analyses. (From Park, S. and Trivedi, M.M., *Comput. Vis. Image Und.*, 111, 3, 2008. With permission.)

algorithm (Sayood 1996). The vector quantization process clusters the high-dimensional input-feature space into M codewords. The input video stream data simultaneously captured from synchronized multiple color cameras are used to extract continuous features, such as torso translation and arm/leg gesture, which are converted to a series of observation symbols 1, ..., M. With the trained HMM models, new input video sequences are processed for recognizing person activity patterns by applying a sliding moving window along time. A maximum-likelihood (ML)-based classifier detects person activity patterns that have a likelihood over a trained threshold. If the ML value is far lower than the trained levels, then the HMM bank receives an updated observation stream by moving a sliding window in the frame accumulator. This process iterates as long as there exist more inputs from the camera sensors.

10.5 TRACK-BODY SYNERGY FRAMEWORK

The TBS framework for analyzing human interaction may represent body motion at multiple levels of detail: i.e., in terms of bounding box, 2D ellipse, and segmented body parts.

The representation of the human body in terms of the bounding box and the 2D ellipse is related to the footage trajectory of the overall body translation on the floor (we call it "track-level analysis"). The representation of the human body in terms of the segmented body parts is related to the appearance features of the coordinated posture and the gesture of the body (we call it "body-level analysis"). The main challenge is how to deal with the visual occlusion. The proper handling of the body parts during occlusion from a single-view perspective is still an open question in computer vision. The visual occlusion during human interaction degrades the body part segmentation, while the trajectory of the bounding box is usually better maintained. There is a trade-off; the track-level analysis can survive the occlusion but the analysis is not detailed, whereas the body-level analysis provides rich information but it may fail under occlusion. The proposed TBS framework provides an adaptive mechanism to switch the track-level analysis and the body-level analysis depending on imaging quality.

10.5.1 Track-Level Analysis

The main interest in the track-level analysis includes the estimation of a moving person's speed, perimeter sentry for specific secured regions in a scene, the estimation of proximity between persons, etc.

We represent the individual track pattern Γ_i^k of the ith person at time k as

$$\Gamma_i^k = \left[P_i^k, d_{ij}^k, \dot{d}_{ij}^k, \|v_i\|, \angle v_i \right]^{\mathrm{T}} \tag{10.10}$$

In the above equation, P_i^k is *the coordinate values of the current track position* determined by the footage trajectory \widetilde{F}^i. The track points can be rectified by available methods such as camera calibration, planar homography, etc. to unwarp the lens distortions. d_{ij}^k is the *relative distance* between the ith person and the most adjacent jth person at frame k. The adjacency d_{ij}^k is truncated by a predicate that represents whether the distance is within a certain proximity. \dot{d}_{ij}^k is the *derivative of the relative distance*. $\|v_i\|$ is the *magnitude of the track velocity*. $\angle v_i$ is the *orientation of the track velocity*. These feature values are smoothed by the least square-based second-order polynomial regression curve (Williams 1959, Duda et al. 2001) of the track points computed along a moving window of size ρ seconds ($\rho = 0.5$ in the current setting).

The track-level analysis is basically targeting the moving persons; it may not be effective to discriminate human activity performed by *stationary* persons: e.g., *turning, dropping/picking an object, shaking hands, pushing/kicking*, etc. The discrimination of such activities requires the analysis of human body pose and gesture at a detailed body level.

10.5.2 Body-Level Analysis

The body-pose estimation starts by extracting the foreground map using the background subtraction. We adopt a codebook-based background modeling method (Kim et al. 2005). The background subtraction is followed by the color modeling of the segmented foreground

image. We use the Gaussian mixture model in Park and Aggarwal (2006) for color learning.

The Hue-Saturation-Value (HSV) color values of a pixel at location (x, y) are represented by a random variable $v=[v_H, v_S, v_V]^T$ with a vector dimension $d=3$. The color distribution of the foreground pixels is then modeled as a mixture of K Gaussians weighted by prior probability $P(\omega_r)$, given by

$$p(v) = \sum_{r=1}^{K} p(v|\omega_r)P(\omega_r) \qquad (10.11)$$

where the rth conditional probability is assumed as a Gaussian, as follows:

$$p(v|\omega_r) = (2\pi)^{-d/2} |\Sigma_r|^{-1/2} \exp\left[-\frac{1}{2}(v - \mu_r)^T \Sigma_r^{-1}(v - \mu_r)\right] \quad (10.12)$$

Each Gaussian component θ_j represents the prior probability $P(\omega_r)$ of the rth color class ω_r, a mean vector μ_r of the pixel color component, and a covariance matrix Σ_r of the color components; $\theta_j=\{\mu_j, \Sigma_j, C_0, P(\omega_j)\}$. The expectation–maximization (EM) algorithm in Duda et al. (2001) is used to train the Gaussian parameters.

We consider the major body parts (i.e., the head, the upper body, and the lower body) of each person from the segmented foreground map for the body-level analysis.

The segmented foreground map is projected onto the horizontal image axis, and the principal axis of a person is detected from the projection profile (Figure 10.6). The body is then segmented into three parts, the head, the upper body, and the lower body along the principal axis, according to the body part ratios (i.e., head height=0.15×height, leg height=0.5×height) which are manually specified for the initialization of the body part. The initialization is performed for each person when the person walks into the scene; afterward, the ratios of the body parts are relaxed and updated by the tracker (Park and Aggarwal 2006). As the people move, the Gaussian parameters are updated along

Figure 10.6 Bounding boxes/ellipses for the body-appearance features and the body-part dissimilarity measure Bh(*).

the sequence in a frame-by-frame manner. Updating these Gaussian parameters amounts to tracking the whole body translation of each person on the 2D image domain (Park and Trivedi 2005).

For the body-level activity analysis, we extract the associated *body-appearance feature* Ψ_j^k for the *j*th person at frame *k* as follows:

$$\Psi_j^k = \left[O_j^k,\, W_j^k,\, L_j^k,\, R_j^k,\, V_j^k,\, H_j^k,\, U_j^k,\, \phi_j^k\right]^{\mathrm{T}} \qquad (10.13)$$

In Equation 10.13, O_j^k is the *number of the foreground pixels* of person *j* divided by the area of the bounding box surrounding the person at frame *k*. W_j^k is the *width of the bounding box* of person *j* divided by the height of the bounding box. L_j^k is the *leftward span from the vertical major axis* divided by the height. R_j^k is the *rightward span from the vertical major axis* divided by the height. V_j^k is the *velocity* of the *j*th bounding box along the x-axis of the image divided by the height. H_j^k is the *ratio of the head height* to the whole body height. U_j^k is the *ratio of the upper-body height* to the whole body height. ϕ_j^k is the *orientation of the 2D Gaussian* that represents the spatial distribution (x, y) of the *j*th foreground map with centroid $(\overline{X}, \overline{Y})$; that is,

$$\phi_j^k = \frac{1}{2}\arctan\left(\frac{2\mu_{11}}{\mu_{20} - \mu_{02}}\right),$$

where

$$\mu_{pq} = \sum_x \sum_y (x - \bar{X})(y - \bar{Y}) \quad \text{for } p,q = 0,1,2$$

10.5.3 Person Reidentification

In the body-level analysis of human activities, visual occlusion may occur frequently and it is nontrivial to track individual persons reliably along the video sequence. The traditional models that assume linear or piecewise-linear dynamics easily fail in such situations due to occlusion and abrupt changes in body posture. If the occlusion lasts in many consecutive frames, it may be more practical to reidentify the individual persons after they get unoccluded rather than to keep track of the estimated positions of the occluded persons.

For the purpose of the reidentification of persons across distant frames, the association of persons is performed by comparing the similarity of their appearance represented by the Gaussian mixture models. In general, the Bhattacharyya coefficient $C_B(p, p')$ provides a useful metric for similarity between two probability distribution functions (PDFs) $p(x)$ and $p'(x)$

$$C_B(p, p') = \int_{-\infty}^{\infty} \sqrt{p(x)p'(x)}dx \tag{10.14}$$

which ranges 0 for nonoverlapping PDFs to 1 for identical PDFs. If $p(v)$ and $p'(v)$ are Gaussian mixture models, the logarithmic Bhattacharyya-based distance $\mathrm{Bh}(p, p')$ (Sfikas et al. 2005) can be used for the comparison of $p(v)$ and $p'(v)$:

$$\mathrm{Bh}(p, p') = \sum_{i=1}^{N} \sum_{j=1}^{M} \pi_i \pi_j' B(p_i, p_j') \tag{10.15}$$

where

 p, p' are Gaussian mixture models consisting of N and M kernels, respectively

 π, π' are the mixing weights

B denotes the logarithmic Bhattacharyya distance between two Gaussian kernels, defined as

$$B(p, p') = \frac{1}{8}(\mu - \mu')^{\mathrm{T}}\left(\frac{\Sigma + \Sigma'}{2}\right)^{-1}(\mu - \mu') + \frac{1}{2}\ln\left(\frac{|\Sigma + \Sigma'|}{2\sqrt{|\Sigma||\Sigma'|}}\right) \qquad (10.16)$$

where μ, Σ and μ', Σ' stand for the means and covariance matrices of Gaussian kernels p, p', respectively.

 We represent the individual body parts (i.e., the head, the upper body, and the lower body) of a person with independent PDFs: P_{H}, P_{U}, and P_{L} for the head, the upper body, and the lower body, respectively (Figure 10.6).

 The dissimilarity $D(P_m, P_n)$ of two persons P_m and P_n is defined by the weighted summation of the dissimilarities of the individual body parts as follows:

$$D(P_m, P_n) = \alpha_1 \cdot \mathrm{Bh}(P_{\mathrm{H}}, P_{\mathrm{H}}') + \alpha_2 \cdot \mathrm{Bh}(P_{\mathrm{U}}, P_{\mathrm{U}}') + \alpha_3 \cdot \mathrm{Bh}(P_{\mathrm{L}}, P_{\mathrm{L}}') \qquad (10.17)$$

$$W_\alpha = [\alpha_1, \alpha_2, \alpha_3]^{\mathrm{T}}, |W_\alpha| = 1 \qquad (10.18)$$

The weight coefficients, α_i, are proportional to the areas of the corresponding body parts in the image.

10.5.4 Switching between Analysis Levels

The track-level analysis represents human activity in terms of the trajectories of the body centroid. The body-level analysis represents more detailed information about the human body activity indicated by the body shape deformation. The sensitivity of the body-level analysis

is, however, affected by many sources of uncertainty including the occlusion, articulation, camera perspective, and imaging noise. In comparison, the track-level analysis is more robust in these conditions, and it is regarded as the TBS systems' baseline analysis mode, which is always available. Our adaptive algorithm (Park and Trivedi 2007) switches from the track-level analysis to the body-level analysis when the fidelity of the body appearance is high, and switches back to the track-level analysis whenever the body-part appearance quality degrades. This feedback-based iterative process is illustrated in Figure 10.5.

The body-appearance quality is evaluated by comparing the body-appearance fidelity feature $\Psi_j^k = [O_j^k, W_j^k, L_j^k, R_j^k, V_j^k, H_j^k, U_j^k, \phi_j^k]^T$ for person j at frame k with a recent history learned from the previous frames. Visual occlusion usually causes drastic change in some elements of the features in Ψ_j^k. For simplicity, we assume the independence among the elements of Ψ_j^k at frame k. We assign weights for each of the feature components with

$$W = [w_O, w_W, w_L, w_R, w_V, w_H, w_U, w_\theta]^T, \quad |W| = 1 \qquad (10.19)$$

The deviation of the appearance fidelity between consecutive frames is defined as

$$D_F = \Omega\left(\left|W^T \cdot \left(\Psi_j^k - \Psi_j^{k-1}\right)\right|\right) \qquad (10.20)$$

where $\Omega(x)$ is the function that returns the largest element of the vector x. Therefore, if any feature element in Ψ_j^k changes abruptly from Ψ_j^{k-1} beyond the threshold, the switching between the two stages is triggered.

10.5.5 Examples

We have implemented a system that performs multi-view tracking of individual persons and recognition of human interactions.

We conducted three experiments: (1) person reidentification between distant frames beyond occlusion in a single view, (2) single-person action from multiple views, and (3) two-person interaction from multiple views.

10.5.5.1 Person Reidentification beyond Occlusion

We conducted the person reidentification test with six subjects sampled across distant frames at multiple times beyond occlusions. Figure 10.7 shows some examples of the participants; each column shows the same person captured before (the first row) and after (the second row) the occlusion during interactions.

Figure 10.8 shows the summary of the dissimilarity $D(P_m, P_n)$ of persons P_m and P_n ($m, n \in \{1,\ldots,10\}$) from 110 samples.

For simplicity, we label the same person before and after the occlusion with different ID numbers. The diagonal cells denote the dissimilarity of the identical images (i.e., ID-1 vs. ID-1), which is out of consideration. The off-diagonal cells denote the comparison between non-identical images. The overall tendency of the darkest cells being aligned adjacent to the diagonal cells implies that the same persons (i.e., ID-1 vs. ID-2, or ID-5 vs. ID-6) are successfully reidentified across distant frames beyond the occlusion.

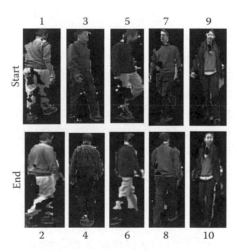

Figure 10.7 Sample images of the person before ("start") and after ("end") occlusion.

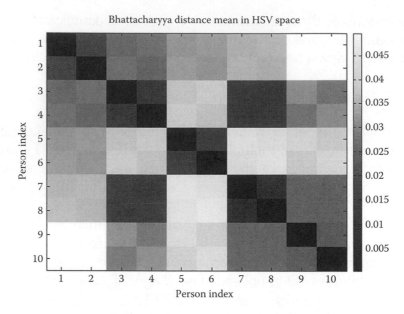

Figure 10.8 Dissimilarity measure for person reidentification.

10.5.5.2 Single-Person Action from Multiple Views

We have built the HMM-based classifier for four activity patterns: *walk-left*, *drop-object*, *pick-object*, and *walk-right*. Example image frames are shown in Figure 10.9.

Walk-right. The first and second rows show the synchronized views from camera-1 and camera-2, respectively.

The videos were manually observed to determine the start and end frames for specific activities. This annotation procedure ensured the registration of the ground-truth segments of specific activities in terms of frame indices. A set of left-right HMMs were designed with parameters of three hidden nodes ($N=3$), two transition links ($L=2$), and 64 code words ($M=64$) in the vector quantizer. The parameter values were selected experimentally. Training and testing data were randomly selected from a pool of activity videos containing the four activity patterns. Total numbers of activity sequences were 16 for *walk-left*, 8 for *drop-object*, 9 for *pick-object*, and 16 for *walk-right*, respectively. The performance of the HMM classifiers was evaluated by the *leave-K-out*

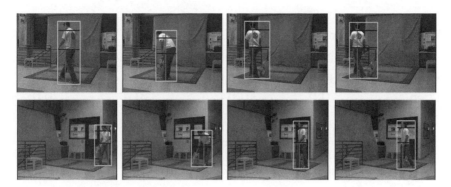

Figure 10.9 Example frames of the sequential actions: walk-left, drop-object, pick-object, and walk-right. The first and second rows show the synchronized views from camera-1 and camera-2, respectively. (From Park, S. and Trivedi, M.M., *Comput. Vis. Image Und.*, 111, 3, 2008. With permission.)

cross-validation scheme in which K out of J sequences (\gg) was used as testing samples. (This process defines one *epoch* of the classification experiment.) A total of 20 epochs were made by randomly choosing different sequences for the test data.

The confusion matrices for the first and second cameras are shown in Tables 10.1 and 10.2.

The overall accuracy with the first camera was 95%, while the accuracy with the second camera was 80%; the recognition accuracy of the identical actions differs significantly for different views. In the current setup, view-1 is better than view-2 for the current experiment, because it provides more distinguishable features of body parts and the object.

TABLE 10.1 Confusion Matrix of the Single-Person Activity Recognition from View-1

	Walk-Left	Drop-Object	Pick-Object	Walk-Right
Walk-left	83.3	0.0	0.0	16.7
Drop-object	0.0	100.0	0.0	0.0
Pick-object	0.0	0.0	100.0	0.0
Walk-right	0.0	0.0	0.0	100.0

Source: Park, S. and Trivedi, M.M., *Comput. Vis. Image Und.*, 111, 3, 2008. With permission.

TABLE 10.2 Confusion Matrix of the Single-Person Activity Recognition from View-2

	Walk-Left	Drop-Object	Pick-Object	Walk-Right
Walk-left	80.0	0.0	20.0	0.0
Drop-object	0.0	100.0	0.0	0.0
Pick-object	0.0	25.0	75.0	0.0
Walk-right	14.3	14.3	0.0	71.4

Source: Park, S. and Trivedi, M.M., *Comput. Vis. Image Und.*, 111, 3, 2008. With permission.

Therefore, the proper choice of the camera view can enhance the overall recognition performance.

10.5.5.3 Two-Person Interaction from Multiple Views

In this experiment, we tested the proposed system's ability to correctly detect occlusion instances and to perform view switching for constant monitoring of the two-people interactions. Figure 10.10 shows an example of two-person interaction involving object handing. Person 1 (P1) with a bag leaves the bag on the floor, and Person 2 (P2) approaches and takes the bag away. The multi-view image-domain analysis of the interaction, view switching for best-view selection, and the overall recognition results are presented at each row in Figure 10.10.

The first two rows of Figure 10.10 show the raw image frames from each view, and the third row shows the synchronized version of the foreground-segmented image frames. A modified version of the ARG-MMT tracker (Park and Aggarwal 2006) with the new dissimilarity measure $D(P_m, P_n)$ in Equation 10.17 is used for data association and tracking. Two independent instantiations of the tracker track the individual persons during their interaction subject to occlusion. The best-view selection is made at each frame according to the homography mapping and the change of the appearance profile. The activity recognition results are shown in the bottom row of Figure 10.10. Figure 10.11 shows the track-level analysis of the two-people interaction in Figure 10.10.

The first plot of the first row in Figure 10.11 shows the XY plot of the two interacting persons represented on the homography-mapped

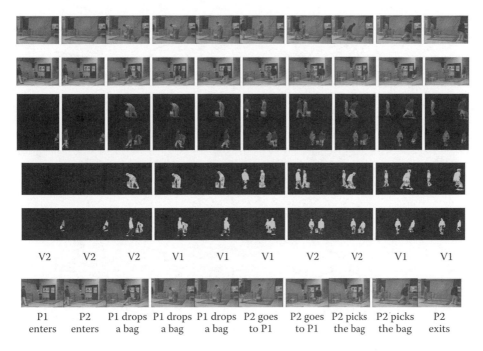

Figure 10.10 View switching and the recognition of two person interactions. (From Park, S. and Trivedi, M.M., *Comput. Vis. Image Und.*, 111, 3, 2008. With permission.)

virtual top-down view. The shortest and bright (green in color) track corresponds to the track of the bag laid on the floor, and the moving directions of P1 and P2 are depicted by the tracks with the corresponding arrows. The second plot of the first row shows more detailed information in the XYT plot, which can be detailed into the YT and XT plots as shown on the second row. The time axis of the YT plot reveals that the bag was laid by P1 at frame 30 and picked by P2 at frame 67 as indicated by the two arrows. The XT plot reveals that there was a gap between P2's track and the bag's track. This obscurity is due to the fact that P2 took the bag by stretching his arm at a certain distance (in Figure 10.10), which can only be detected at the body level represented in the image domain (as opposed to the track level on the virtual plan-view domain). This example highlights the significance of the proposed TBS framework for human activity analysis.

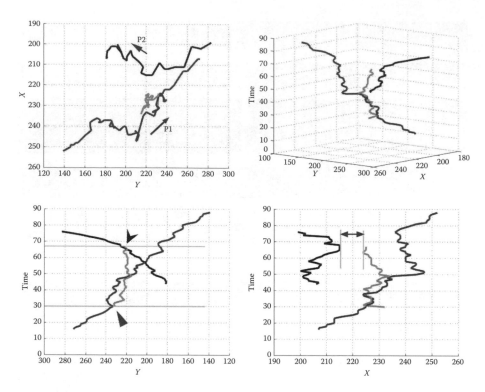

Figure 10.11 Track-level analysis of two-person interaction on the homography mapping plane.

10.6 SUMMARY

We have presented a multi-perspective multi-level analysis framework (called TBS framework) for understanding human activity and interactions in a distributed vision system. The current analysis levels involve the track- and body-level representations of the human body from two different views. The track-level analysis is conducted at the view-independent virtual planview domain by homography binding. The body-level analysis is conducted as a discriminative approach to pattern recognition using the body appearance profile as the input features. Our system does not require the cumbersome procedure for cameras calibration. Experimental evaluation shows the efficacy of the proposed system for analyzing multi-person interactions. The advantages of the TBS framework are (1) context-dependent view switching

for occlusion handling, (2) switching the multi-level analysis between track- and body-level representations, and (3) integration of data-driven bottom-up process and context-driven top-down process for human activity understanding. Our current implementation uses two cameras, but the extension to more cameras is straightforward as indicated in the system architecture.

10.7 BIBLIOGRAPHICAL AND HISTORICAL REMARKS

The analysis of human activity has a long history in computer vision. Reviews of general research on human motion understanding can be found in Aggarwal and Cai (1999), Gavrila (1999), Moeslund and Granum (2001), Yilmaz et al. (2006), Morris and Trivedi (2008b). Most human monitoring systems have been targeting specific environmental situations: i.e., scenarios involving a specific time, place, activity, and application domain (Haritaoglu et al. 2000, McKenna et al. 2000, Sato and Aggarwal 2004, Zhao and Nevatia 2004, Trivedi et al. 2005a, Gandhi and Trivedi 2008). Most of the surveillance systems have been either based on track analysis (Oliver et al. 2000, Remagnino et al. 2004, Sato and Aggarwal 2004, Velastin et al. 2005, Morris and Trivedi 2008a) or body analysis (Haritaoglu et al. 2000, Park and Aggarwal 2004a, Park and Aggarwal 2006). Track-level analysis is usually applied to wide-area surveillance of multiple moving objects in an open space such as a parking lot or a pedestrian plaza. In some wide-area surveillance situations, a coarse representation of the human body in terms of a moving bounding box or an ellipse may be enough for tracking (Oliver et al. 2000, Makris et al. 2004). Other researchers have applied more detailed representation of a human body, such as a moving region or a blob (Remagnino et al. 2004, Velastin et al. 2005, Krotosky and Trivedi 2008). Body-level analysis usually involves the detection of body parts such as the head, arms, torso, and legs. The body parts can be detected either by analyzing the silhouette contour of a person (Haritaoglu et al. 2000) or by estimating the configuration of the segmented image regions of a person (Park and Aggarwal 2004a). Body-level analysis focuses on more detailed activities of individual persons than on simple tracking of the persons.

One of the recent developments in video surveillance is the use of distributed systems of multiple cameras to cover multiple monitored scenes with either overlapping or nonoverlapping field of view (FOV). A review of distributed surveillance systems can be found in Valera and Velastin (2005). Distributed surveillance systems have many advantages. For example, distributed systems with multiple cameras can provide a more accurate model of the monitored scenes by using multiple-view geometry (Hartley and Zisserman 2000) to recover the world coordinates for perspective compensation (Mittal and Davis 2003, Huang and Trivedi 2005, Trivedi et al. 2005b). The robust tracking of multiple interacting persons is, however, a challenging problem in computer vision. The tracking of multiple human bodies from multiple views has drawn researchers' interest in handling occlusion with calibrated cameras (Utsumi et al. 1998, Dockstader and Tekalp 2001, Mittal and Davis 2003) or uncalibrated cameras (Khan and Shah 2003, Hu et al. 2006, Khan and Shah 2006, Park and Trivedi 2006b). The robustness and reliability of the tracking system can also be enhanced by the active communication between multiple processing modules with redundant video inputs; Remagnino et al. (2004) presented a modular multi-agent-based surveillance system with decentralized intelligence. Some multi-camera systems use the heterogeneous sensors such as color and infrared cameras and the fusion of the sensory data into stereo imaging for robust tracking (Krotosky and Trivedi 2008).

Another important categorization of surveillance systems is related to indoor versus outdoor setup. Indoor environments usually have more stable lighting conditions and stable background clutters, but human bodies may be easily occluded by other objects. Indoor surveillance systems have a narrow FOV and can provide a relatively high-resolution image of people. The detailed representation of the human body may enable it to distinguish the delicate interactions such as friendly vs. hostile interactions between persons (Park 2004). In comparison, the coarse representation of human motion in terms of the track patterns in a structured indoor environment may also provide useful features for the recognition of activity. For example, Oliver et al. (2002) showed a system that recognizes human–object interactions in a living room by analyzing track patterns. Structural advantages of indoor environments can also make the space an intelligent environment embedded with

multiple sensors and processors. Shivappa et al. (2008) studied the role of audiovisual cues and their fusion in person tracking and activity analysis. It is also possible to automatically find obstacle locations for semantic analysis of the scene by the analysis of long-term observations from the scene (Greenhill et al. 2005).

The image fidelity used in the studies mentioned above lies along a continuum. At one extreme, a high-fidelity representation of objects and persons may be required for the reconstruction of the 3D structure, which may involve many cameras carefully positioned, synchronized, and calibrated around the space. At the other extreme, a coarse representation of objects and persons in the 2D image space could be used for surveillance with a single fixed camera. Both of these extremes usually adopt a fixed set of features for the analysis and representation of human behavior; once the feature set is formulated, it is usually fixed throughout the video sequence. However, the occlusion and imaging noise cause by dynamic movements of objects and persons may deteriorate the fidelity of the given feature set along the time. The methods for multi-view tracking and view switching presented in this chapter can alleviate the occlusion problem, and the methods can be combined with activity recognition methods for the robust analysis of human activity, which is the goal of the study presented in this chapter.

ACKNOWLEDGMENT

This material is based in part on the following article of the authors, with permission from Elsevier Inc.: Park, Sangho and Mohan M. Trivedi. 2008. "Understanding human interactions with track and body synergies (TBS) captured from multiple views." *Computer Vision and Image Understanding: Special Issue on Intelligent Visual Surveillance*, 111(1): 2–20.

REFERENCES

Aggarwal, J.K. and Q. Cai. 1999. Human motion analysis: A review. *Computer Vision and Image Understanding* 73(3): 295–304.

Criminisi, A., I. Reid, and A. Zisserman. 1999. A plane measuring device. *Image and Vision Computing* 17(8): 625–634.

Dockstader, S. and A.M. Tekalp. 2001. Multiple camera tracking of interacting and occluded human motion. *Proceedings of the IEEE* 89: 1441–1455.

Duda, R., P. Hart, and E. Stork. 2001. *Pattern Classification*, 2nd edition. New York: Wiley, Chapter 10, pp. 517–583.

Gandhi, T. and M.M. Trivedi. 2008. Computer vision and machine learning for enhancing pedestrian safety. *Computational Intelligence in Automotive Applications of Studies in Computational Intelligence* 132: 59–77.

Gavrila, D. 1999. The visual analysis of human movement: A survey. *Computer Vision and Image Understanding* 73(1): 82–98.

Greenhill, D., J. Renno, J. Orwell, and G. Jones. 2005. Learning the semantic landscape: Embedding scene knowledge in object tracking. *Real Time Imaging, Special Issue on Video Object Processing* 11: 186–203.

Haritaoglu, I., D. Harwood, and L.S. Davis. 2000. W4: Real-time surveillance of people and their activities. *IEEE Transactions on Pattern Analysis and Machine Intelligence* 22(8): 797–808.

Hartley, R.I. and A. Zisserman. 2000. *Multiple View Geometry in Computer Vision*. Cambridge, U.K.: Cambridge University Press.

Hu, W., M. Hu, X. Zhou, T. Tan, and S. Maybank. 2006. Principal axis based correspondence between multiple cameras for people tracking. *IEEE Transactions on Pattern Analysis and Machine Intelligence* 28: 663–671.

Huang, K.S. and M.M. Trivedi. 2005. 3D shape context based gesture analysis integrated with tracking using omni video array. *Proceedings of the IEEE Workshop on Vision for Human-Computer Interaction (V4HCI)*, San Diego, CA.

Khan, S. and M. Shah. 2003. Consistent labeling of tracked objects in multiple cameras with overlapping fields of view. *IEEE Transactions on Pattern Analysis and Machine Intelligence* 25(10): 1355–1360.

Khan, S.M. and M. Shah. 2006. A multiview approach to tracking people in crowded scenes using a planar homography constraint. *European Conference on Computer Vision*, Graz, Austria.

Kim, K., T. Chalidabhongse, D. Harwood, and L. Davis. 2005. Real-time foreground-background segmentation using codebook model. *Real-Time Imaging* 11(3): 167–256.

Kojima, A., T. Tamura, and K. Fukunaga. 2002. Textual description of human activities by tracking head and hand motions. *International Conference on Pattern Recognition*, Quebec, Canada, Vol. 2, pp. 1073–1077.

Krotosky, S.J. and M.M. Trivedi. 2008. Person surveillance using visual and infrared imagery. *IEEE Transactions on Circuits and Systems for Video Technology* 18(8): 1096–1105.

Ma, Y., S. Soatto, J. Kosecka, and S.S. Sastry. 2003. *An Invitation to 3D Vision: From Images to Geometric Models*. New York: Springer-Verlag.

Makris, D., T. Ellis, and J. Black. 2004. Learning scene semantics. *ECOVISION 2004 Early Cognitive Vision Workshop*, Isle of Skye, Scotland, U.K.

McKenna, S.J., S. Jabri, Z. Duric, and H. Wechsler. 2000. Tracking interacting people. *IEEE International Conference on Automatic Face and Gesture Recognition (FG 2000)*, Grenoble, France, pp. 348–353.

Mittal, A. and L.S. Davis. 2003. M2tracker: A multi-view approach to segmenting and tracking people in a cluttered scene. *International Journal of Computer Vision* 51(3): 189–203.

Moeslund, T. and E. Granum. 2001. A survey of computer vision-based human motion capture. *Computer Vision and Image Understanding* 81(3): 231–268.

Morris, B. and M.M. Trivedi. 2008a. Learning and classification of trajectories in dynamic scenes: A general framework for live analysis. *IEEE International Conference on Advanced Video and Signal Surveillance*, Santa Fe, NM.

Morris, B.T. and M.M. Trivedi. 2008b. A survey of vision-based trajectory learning and analysis for surveillance. *IEEE Transactions on Circuits and Systems for Video Technology* 18(8): 1114–1127.

Oliver, N.M., B. Rosario, and A.P. Pentland. 2000. A Bayesian computer vision system for modeling human interactions. *IEEE Transactions on Pattern Analysis and Machine Intelligence* 22(8): 831–843.

Oliver, N., E. Horvitz, and A. Garg. 2002. Layered representations for human activity recognition. *Proceedings of the IEEE International Conference on Multimodal Interfaces*, Pittsburg, PA, pp. 3–8.

Park, S. 2004. A hierarchical graphical model for recognizing human actions and interactions in video, PhD dissertation, University of Texas at Austin, Austin, TX.

Park, S. and J.K. Aggarwal. 2004a. A hierarchical Bayesian network for event recognition of human actions and interactions. *Multimedia Systems: Special Issue on Video Surveillance* 164–179.

Park, S. and J.K. Aggarwal. 2004b. Semantic-level understanding of human actions and interactions using event hierarchy. *IEEE Workshop on Articulated and Nonrigid Motion*, Washington, DC.

Park, S. and J.K. Aggarwal. 2006. Simultaneous tracking of multiple body parts of interacting persons. *Computer Vision and Image Understanding* 102(1): 1–22.

Park, S. and M.M. Trivedi. 2005. A track-based human movement analysis and privacy protection system adaptive to environmental contexts. *IEEE International Conference on Advanced Video and Signal Based Surveillance*, Como, Italy.

Park, S. and M.M. Trivedi. 2006a. Analysis and query of person-vehicle interactions in homography domain. *IEEE Conference on Video Surveillance and Sensor Networks*, Santa Barbara, CA.

Park, S. and M.M. Trivedi. 2006b. Multi-perspective video analysis of persons and vehicles for enhanced situational awareness. *IEEE International Conference on Intelligence and Security Informatics (ISI2006)*, San Diego, CA, *LNCS* 3975: 440–451.

Park, S. and M.M. Trivedi. 2007. Multi-person interaction and activity analysis: A synergistic track- and body- level analysis framework. *Machine Vision and Applications Journal: Special Issue on Novel Concepts and Challenges for the Generation of Video Surveillance Systems* 18(3): 151–166.

Park, S. and M.M. Trivedi. 2008. Understanding human interactions with track and body synergies (TBS) captured from multiple views. *Computer Vision and Image Understanding: Special Issue on Intelligent Visual Surveillance* 111(1): 2–20.

Rabiner, L. 1989. A tutorial on hidden Markov models and selected applications in speech recognition. *Proceedings of the IEEE* 77(2): 257–286.

Remagnino, P., A. Shihab, and G. Jones. 2004. Distributed intelligence for multi-camera visual surveillance. *Pattern Recognition: Special Issue on Agent-based Computer Vision* 37(4): 675–689.

Sato, K. and J.K. Aggarwal. 2004. Temporal spatio-velocity transform and its application to tracking and interaction. *Computer Vision and Image Understanding* 96(2): 100–128.

Sayood, K. 1996. *Introduction to Data Compression*. San Francisco, CA: Morgan Kaufmann Publishers.

Sfikas, G., C. Constantinopoulos, A. Likas, and N.P. Galatsanos. 2005. An analytic distance metric for Gaussian mixture models with application in image retrieval. *Proceedings of the International Conference on Artificial Neural Networks (ICANN'05)*, Warsaw, Poland, *LNCS* 3697: 835–840.

Shivappa, S.T., M.M. Trivedi, and B.D. Rao. 2008. Person tracking with audio-visual cues using the iterative decoding framework. *IEEE International Conference on Advanced Video and Signal Surveillance*, Santa Fe, NM.

Trivedi, M.M., T. Gandhi, and K. Huang. 2005a. Distributed interactive video arrays for event capture and enhanced situational awareness. *IEEE Intelligent Systems, Special Issue on Artificial Intelligence for Homeland Security* 20(5): 58–66.

Trivedi, M.M., K.S. Huang, and I. Mikic. 2005b. Dynamic context capture and distributed arrays for intelligent spaces. *IEEE Transactions on Systems, Man and Cybernetics, Special Issue on Ambient Intelligence* 35(1): 145–163.

Utsumi, A., H. Mori, J. Ohya, and M. Yachida. 1998. Multiple-view-based tracking of multiple humans. *International Conference on Pattern Recognition*, Brisbane, Australia, Vol. 1, pp. 597–601.

Valera, M. and S. Velastin. 2005. Intelligent distributed surveillance systems: A review. *IEEE Proceedings Vision, Image and Signal Processing* 152(2): 192–204.

Velastin, S., B. Boghossian, B. Lo, J. Sun, and M. Vicencio-Silva. 2005. Prismatica: Toward ambient intelligence in public transport environments. *IEEE Transactions on Systems, Man, and Cybernetics—Part A* 35(1): 164–182.

Williams, E. 1959. *Regression Analysis*. New York: Wiley Inc.

Yilmaz, A., O. Javed, and M. Shah. 2006. Object tracking: A survey. *ACM Journal of Computing Surveys* 38(4): Article 13.

Zhao, T. and R. Nevatia. 2004. Tracking multiple humans in complex situations. *IEEE Transactions on Pattern Analysis and Machine Intelligence* 26(9): 1208–1221.

Part IV

Camera Networks

Part IV

Advanced Features

11

Multi-Camera Calibration and Global Trajectory Fusion

Nadeem Anjum and Andrea Cavallaro

CONTENTS

11.1 INTRODUCTION

In recent years, ensembles of cameras have been used to monitor objects'
activities at a wide scale in several applications such as sport analysis,

remote sensing, and video surveillance (Lee et al. 2000, Jinchang et al. 2008). As humans have limited ability to effectively observe multiple objects simultaneously in multiple cameras, computer vision algorithms are needed to analyze information from multiple streams and to summarize the results in a compact form to the users. Typical operational steps include camera calibration, object detection and tracking, and object association across multiple cameras.

Camera calibration defines the correspondence between points in the image plane and points in the 3D space (Batista et al. 1999) and can be divided into *intrinsic calibration* and *extrinsic calibration*. Intrinsic calibration establishes the relationship between camera-centric coordinates and images coordinates (Wei and Ma 1994, Anjum and Cavallaro 2007). First, images of an object with known Euclidean structure are acquired. Then a camera matrix is estimated that minimizes the error between the imaged object and its re-projection. Extrinsic calibration defines the relationship between a scene-centric coordinate system and a camera-centric coordinate system. The scene-to-camera transformation has six degrees of freedom and consists of a rotation (three degrees of freedom) and a translation (three degrees of freedom) (Bourgeous et al. 2006). The concept of calibration extends to multiple cameras to establish an automatic mechanism to fuse the various streams and to generate a global view (Funiak et al. 2006). For *nonoverlapping cameras*, the relative orientation and translation of each camera is usually estimated on a common ground plane (Taylor et al. 2006). The position of the objects in regions that are not covered by the field of view (FOV) of the cameras can be estimated by extrapolating the observations in each FOV and then can be used to find the relative position of the cameras (Anjum et al. 2007). For *overlapping cameras*, the estimation of epipolar geometry is a popular choice for camera calibration and view registration (Xu and Zhang 1996): candidate corresponding points are first extracted from the scene; then a model is learnt that minimizes the images and their re-projections (Jiangbo et al. 2007).

Once the cameras are calibrated, objects are tracked across the network. Typically, tracking algorithms estimate the location and/or the shape of objects over time. Object tracking is a challenging task due to appearance and view changes, nonrigid structures and occlusions (Polat and Ozden 2006, Qu and Schonfeld 2007). Moreover,

there is the challenge to establish object correspondence across cameras (Yinghao et al. 2007). Although, early trackers primarily focused on color and appearance (Nummiaro et al. 2003), cameras may have different photometric properties (e.g., brightness adjustment, contrast), which reduce the effectiveness of these features in the matching process. Moreover, varying lighting conditions further decrease the reliability of these features. In case of nonoverlapping cameras, the expected transition times across sensors may be used to associate objects across the network (Javed et al. 2003). More recently, trajectory-based object correspondence approaches have been proposed, where each camera tracks objects independently and then the correspondence is established using learned motion features (Sheikh and Shah 2008, Kayumbi et al. 2008). These approaches also simplify the extrapolation of object motion in unobserved regions.

In this chapter, we propose a generalized framework for camera-network calibration and for the reconstruction of global trajectories across the entire monitored area. The main contributions of this work include (a) a camera localization algorithm for nonoverlapping networks, (b) trajectory estimation strategy for unobserved regions, (c) a multi-feature analysis approach for trajectory association across multiple cameras, and (d) reconstruction of global trajectories by integrating the fused trajectory segments in overlapping regions and estimated trajectory segments in unobserved regions. Section 11.2 formulates the multi-camera calibration and the global trajectory reconstruction problems. Section 11.3 covers in detail the calibration of nonoverlapping cameras, whereas Section 11.4 focuses on overlapping cameras. Finally, Section 11.5 summarizes the contributions of the chapter and draws conclusions.

11.2 PROBLEM FORMULATION

Let a scene be observed by a network $C = \{C^1, C^2, ..., C^N\}$ of N synchronized cameras and trajectory segment T_k^i of the kth object, O^k, within C^i be represented as

$$T_k^i = \left\{ \left(x_k^i(c), y_k^i(c) \right): 0 < c < M_k^i \quad i = 1, ..., N \right\}, \qquad (11.1)$$

where

$(x_k^i(c), y_k^i(c))$ is the observed position of the target in the image plane

M_k^i is the number of target observations from camera C^i

The intrinsic parameters for single camera calibration are estimated as

$$\begin{pmatrix} u \\ \upsilon \\ 1 \end{pmatrix} = \begin{pmatrix} \phi_u f & 0 & \phi_u t_u \\ 0 & \phi_\upsilon f & \phi_\upsilon t_\upsilon \\ 0 & 0 & 1 \end{pmatrix} \begin{pmatrix} X \\ Y \\ Z \end{pmatrix}, \quad (11.2)$$

where

$(u, \upsilon, 1)$ are the homogeneous coordinates of the 2D projection on the image plane of the 3D point (X, Y, Z)

f is the focal length

(t_u, t_υ) is the translation of the origin of image plane from the principal axis (Figure 11.1)

If the origin of the image plane coincides with the principal axis, then $t_u = 0$ and $t_\upsilon = 0$; (ϕ_u, ϕ_υ) defines the pixel density (pixel/inch) along the u and υ directions. Given the intrinsic parameters, the goal is to estimate the extrinsic (localization) parameters Θ^i

$$\Theta^i = \left[p_x^i, p_y^i, \phi^i \right], \quad (11.3)$$

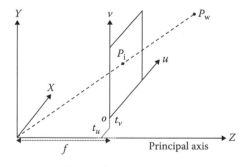

Figure 11.1 An illustration of the relationship between 3D point in the real world, P_w, and its corresponding projection, P_i, on the image plane.

composed of the location (p_x^i, p_y^i) (on a common plane G) and the orientation ϕ^i of each camera C^i. Figure 11.2 illustrates an example of network of nonoverlapping cameras and an example of network of a partially overlapping cameras with a common ground plane, G. The

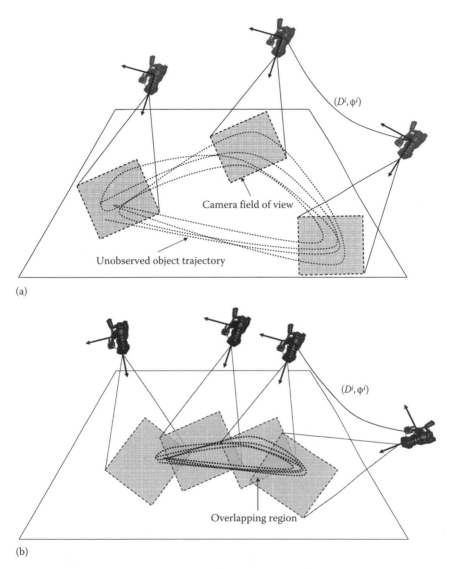

(a)

(b)

Figure 11.2 Examples of camera networks with (a) nonoverlapping and (b) partially overlapping fields of view.

final objective is to construct a complete trajectory, T_k^G, by integrating the estimated trajectory segments, \hat{T}_k^G, in the unobserved regions, $U_{l,m}$, and the fused trajectory segments, \tilde{T}_k^G, in the overlapping regions, $\Omega_{m,n}$, that is,

$$T_k^G = \bigcup_{a=1}^{\kappa_1} \bigcup_{b=1}^{\kappa_2} \left(\left\{ \hat{T}_k^G \right\}_a, \left\{ \tilde{T}_k^G \right\}_b \right), \tag{11.4}$$

where κ_1 and κ_2 are the number of nonoverlapping and overlapping regions, respectively. The next sections detail the network localization process for both nonoverlapping and partially overlapping cameras as well as the reconstruction of global trajectories.

11.3 NONOVERLAPPING CAMERAS

This section describes how to localize sensors in a network of nonoverlapping cameras. To estimate the network localization using trajectory information from each camera, first smooth the available observations in each camera's view and then use them to estimate the segments in the unobserved regions (Figure 11.3). In order to estimate the objects' positions in the *unobserved region* between a pair of cameras, C^i, C^j with $(i \neq j)$, a wavelet-based preprocessing step is used to reduce noisy observations from the input trajectories, which can distort the overall estimation results (Mallat 1989):

$$\bar{T}_k^i = \rho(T_k^i), \tag{11.5}$$

where \bar{T}_k^i is a smoothed version of T_k^i, by first employing wavelet decomposition to split the input trajectory into its frequency contents,

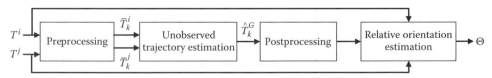

Figure 11.3 Flow diagram of the calibration process for a network of nonoverlapping cameras.

and then filtering out high frequency components using $\rho(\cdot)$. After preprocessing, the next step is to reconstruct the complete global trajectories across the unobserved regions. Assume that the motion model (Anjum et al. 2007) of object O^k is

$$\hat{T}_k^i(t) = F\left(\hat{T}_k^i(t-1), \vartheta(t-1)\right), \qquad (11.6)$$

where
 \hat{T}_k^i is estimated from \bar{T}_k^i
 ϑ is the noise with covariance Q_ϑ

For trajectory estimation between two nonoverlapping cameras, estimate the sequence of positions $\hat{T}_k^i(t+1), ..., \hat{T}_k^i(t+\tau)$ where t is the time stamp of the last state known in C^i and $t+\tau$ is the time stamp of the first state known in C^j. A possible way to achieve the task is to use MAP (Rahimi et al. 2004, Taylor et al. 2006). Even with MAP the motion of the target is not constrained and there is a possibility that the solution may place the target inside the FOV of another camera for which no observations are available at that particular time instance. As an alternative, we split the motion into *forward* and *backward* motion models. This means that there exists a function F_f, for which $\hat{T}_k^i(t) = F_f(\hat{T}_k^i(t-1), \vartheta(t-1))$. This function computes the current state of the object given the previous state. Similarly, $\hat{T}_k^j(t) = F_b(\hat{T}_k^j(t+1), \vartheta(t+1))$ is the current state of the object given the next state information. The forward model estimates the object's state from C^i to C^j, while the backward model estimates the state in the opposite direction. The next step is to combine $\hat{T}_k^i(t)$ and $\hat{T}_k^j(t)$ to have an estimate of the current state $\hat{T}_k^G(t)$. As conventional averaging may result in a location inconsistent with the motion model (Anjum et al. 2007), a dynamic weighted averaging can be applied that would respect both the forward and backward models as

$$\hat{T}_k^G(t) = \omega_f(t)\hat{T}_k^i(t) + \omega_b(t)\hat{T}_k^j(t), \qquad (11.7)$$

where $\omega_f(t) = t/(t+\tau)$ and $\omega_f(t) = 1 - (t/(t+\tau))$ with $t = 1, ..., t+\tau$. This weighting scheme gives higher weights to \hat{T}_k^i at the beginning of an

estimated trajectory and to \hat{T}_k^j at the end of the estimated trajectory. The assumptions here are that the initial state (exit point in C^i) and end state (entrance point in C^j) are with minimum error. As for long unobserved trajectories, it is likely that one is more robust than the other, we use a Kalman filter to correct the forward and backward trajectories before they are combined. The filter propagates the state using a prediction and an update step. The state *prediction* equation and error covariance matrix are defined as

$$\hat{T}_k^i(t + 1) = S\left(\hat{T}_k^i(t), Q_{\vartheta}(t)\right), \tag{11.8}$$

where $\hat{T}_k^i(t + 1)$ is the state estimate. S translates the object's current state to the next state. The filter is updated by computing the Kalman gain, $K(t)$, as

$$K(t) = Q_{\vartheta}(t)\gamma[\gamma^T Q_{\vartheta}(t)\gamma + W(t)]^{-1}, \tag{11.9}$$

where
 W is the covariance of the observation noise
 γ maps the state vector with the measurements

The object state is updated using

$$\begin{cases} \hat{T}_k^i(t + 1) = \hat{T}_k^i(t) + K(t)(Z_o(t) - \gamma\hat{T}_k^i(t)) \\ Q_{\vartheta}(t + 1) = [I - K(t)\gamma]Q_{\vartheta}(t) \end{cases}, \tag{11.10}$$

where Z_o is the observational model. Here, $Z_o(t)$ is replaced with \hat{T}_k^j in case of forward estimation, that is,

$$\hat{T}_k^i(t + 1) = \hat{T}_k^i(t) + K(t)\left(\hat{T}_k^j(t) - \gamma\hat{T}_k^i(t)\right), \tag{11.11}$$

This modification ensures that an object will be in the correct state at $t+\tau$ in accordance with the observation in C^j. Similarly, for backward estimation, \hat{T}_k^j, replace $Z_o(t)$ with \hat{T}_k^i, that is,

$$\hat{T}_k^j(t) = \hat{T}_k^j(t+1) + K(t)\left(\hat{T}_k^i(t) - \gamma\hat{T}_k^j(t+1)\right), \qquad (11.12)$$

Equation 11.12 ensures that the estimation results in the correct object state at instant t is in accordance with the observation in C^i. Figure 11.4 shows a comparison between trajectory estimation with and without Kalman filter corrections. It is visible that without Kalman corrections, both the forward and the backward estimates end far from the original state of the object in the cameras' fields of view. In this particular example, the forward estimation performs poorer than the backward estimation using Kalman filtering ensures that both forward and backward estimations result in correct object states that are then fused together. An optional postprocessing step can be applied to smooth the overall trajectory.

The relative position of C^j with respect to C^i can be approximated by using the difference between the initial end state $(\hat{x}_k^i(\text{end}), \hat{y}_k^i(\text{end}))$ and the estimated end state $(\hat{x}_k^j(1), \hat{y}_k^j(1))$ of the object as

$$\begin{cases} p_x^j = p_x^i + D_x^{i,j} \\ p_y^j = p_y^i + D_y^{i,j} \end{cases}, \qquad (11.13)$$

where $D^{i,j} = (\hat{x}_k^i(\text{end}) - \hat{x}_k^j(1), \hat{y}_k^i(\text{end}) - \hat{y}_k^j(1))$. Furthermore, the *relative orientation*, $\phi^{i,j}$, between two adjacent cameras, C^i and C^j, is computed

Figure 11.4 (See color insert following page 332.) An example of improvements in trajectory estimation using Kalman filter. The solid line is the input trajectory. Dash lines are the estimations without the Kalman filter's corrections. Dash-dot lines are the estimations with Kalman filter's corrections. Arrow head shows the direction of estimation.

by calculating the angle between the observed object position, $(x_k^j(t+\tau)$, $y_k^j(t+\tau))$, and the corresponding estimated object position, $(\hat{x}_k^j(t+\tau)$, $\hat{y}_k^j(t+\tau))$, in camera C^j, that is,

$$\phi^{i,j} = \cos^{-1}\left(\frac{(x_k^j(t+\tau), y_k^j(t+\tau))\,(\hat{x}_k^j(t+\tau), \hat{y}_k^j(t+\tau))}{\left|x_k^j(t+\tau), y_k^j(t+\tau)\right|\left|\hat{x}_k^j(t+\tau), \hat{y}_k^j(t+\tau)\right|}\right). \tag{11.14}$$

However, for more accurate and stable results, instead of single state, the position estimation of the target in C^j must be updated iteratively until the object changes its direction of motion. To this end, the direction of motion can be calculated for the entire trajectory segment as

$$E = \tan^{-1}\left(\frac{T_k^j(t+\tau+q)}{T_k^j(t+\tau+q-1)}\right), \tag{11.15}$$

where $q = 1, \ldots, M_k^j$ and the instant of change can be calculated as

$$t_c = \begin{cases} t+\tau+q & \text{if } |E(q)-E(q+1)| > \varepsilon_c \\ t+\tau+M_k^{i+\eta} & \text{otherwise} \end{cases}, \tag{11.16}$$

The trajectory estimate must be extrapolated from instant $t+\tau$ to t_c and the observed interval rotated to all possible angles between $-\pi$ and $+\pi$ with an increment of $\pi/180$ and then the final relative orientation $\phi^{i,j}$ between cameras C^i and C^j is calculated as

$$\phi^{i,j} = \arg\max_{\theta} \frac{1}{d\left(\hat{T}_{k,c}^j, R_\theta(T_{k,c}^j)\right)}, \tag{11.17}$$

where $\theta = -\pi, \ldots, \pi$; $\hat{T}_{k,c}^j$ and $T_{k,c}^j$ are intervals of estimated and observed points in C^j to the instant t_c and $R_\theta(.)$ rotates $T_{k,c}^j$ at an angle θ and $d(.,.)$ calculates the L_2 norm between the estimated and (rotated) observed trajectory segments.

Figure 11.5 shows an example of network localization along with the complete reconstructed trajectory. Figure 11.5a shows a nonoverlapping

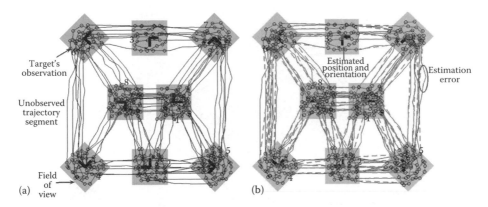

Figure 11.5 (a) A nonoverlapping eight-camera network and (b) corresponding estimated trajectory in unobserved regions (dash-line) along with position and orientation of cameras.

eight-camera network, where squares represent the FOV of each camera and circles within each square show the observations of an object. The position of each camera corresponds to the center of the FOV. The object can move freely in the environment. The limited target observations and nonavailability of the contextual information makes the dataset challenging. Figure 11.5b shows the estimated complete trajectory (dash line) containing both the observed and estimated trajectory segments and the location of the cameras (cross). The use of Kalman filter corrections makes it possible to have a convergence of the estimated trajectory close to the observed data, even if a considerable estimation error exists in the unobserved regions. This estimation error can be reduced further by including more cameras optimally distributed by providing contextual information about the environment or by imposing constraints on the motion patterns (Soro and Heinzelman 2005).

11.4 OVERLAPPING CAMERAS

11.4.1 *Calibration*

This section describes the calibration process of a network of cameras with overlapping fields of view. Overlapping cameras cover a common region from different points of view (Figure 11.6a through c), thus

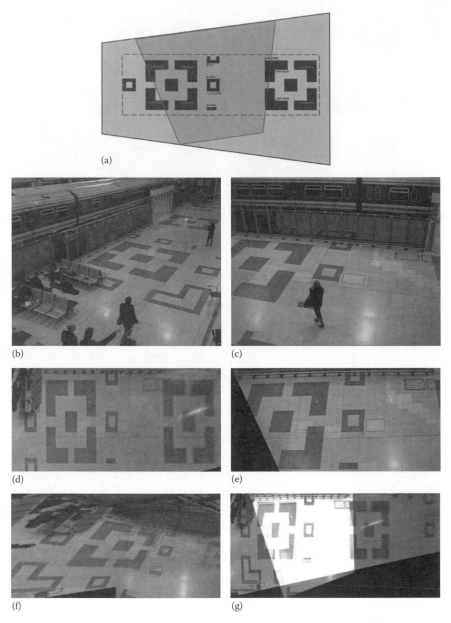

Figure 11.6 Wide view generated from a pair of overlapping cameras: (a) camera layout (shaded region: FOV of a camera; dash line: region of interest); (b and c) sample frames from each view; (d and e) corresponding image- to ground-plane projections; (f) wider view using image stitching; and (g) wider view using ground-plane views.

making it possible to extract prominent features that are visible across cameras. Features for finding corresponding points between two views may be estimated using a SIFT detector (Lowe 2004), Hessian-Affine detector (Mikolajczyk and Schmid 2004), or a Maximally Stable External Regions (MSER) detector (Cheng et al. 2008). Given the intrinsic calibration parameters (Section 11.2), these corresponding features help in the calibration of the cameras using homography (Kanatani et al. 2000). The homography transforms the image coordinates P^m, in C^m, to that of P^n, in C^n, or on the ground plane as

$$P^m = HP^n, \tag{11.18}$$

where H is the homography matrix. In order to estimate $H=(h_{mn})$, we can rewrite Equation 11.18 as

$$\begin{pmatrix} X^m \\ Y^m \\ Z^m \end{pmatrix} = \begin{pmatrix} h_{11} & h_{12} & h_{13} \\ h_{21} & h_{22} & h_{23} \\ h_{31} & h_{32} & h_{33} \end{pmatrix} \begin{pmatrix} X^n \\ Y^n \\ Z^n \end{pmatrix}, \tag{11.19}$$

If $Z^n=1$ and $Z^m=1$, then Equation 11.19 can be rewritten as

$$\begin{cases} X^m = \dfrac{h_{11}X^n + h_{12}Y^n + h_{13}}{h_{31}X^n + h_{32}Y^n + h_{33}}, \\ Y^m = \dfrac{h_{21}X^n + h_{22}Y^n + h_{23}}{h_{31}X^n + h_{32}Y^n + h_{33}} \end{cases} \tag{11.20}$$

Equation 11.20 becomes

$$\begin{cases} X^m(h_{31}X^n + h_{32}Y^n + h_{33}) = h_{11}X^n + h_{12}Y^n + h_{13}, \\ Y^m(h_{31}X^n + h_{32}Y^n + h_{33}) = h_{21}X^n + h_{22}Y^n + h_{23} \end{cases} \tag{11.21}$$

Finally, Equation 11.21 can be written as

$$\begin{cases} \alpha_x^\mathsf{T} H = 0 \\ \alpha_y^\mathsf{T} H = 0 \end{cases} \tag{11.22}$$

where
$$H = (h_{11}, h_{12}, h_{13}, h_{21}, h_{22}, h_{23}, h_{31}, h_{32}, h_{33})^\mathsf{T}$$
$$\alpha_x = (-X^n, -Y^n, -1, 0, 0, 0, X^m X^n, Y^m Y^n, X^m)$$
$$\alpha_y = (0, 0, 0, -X^n, -Y^n, -1, Y^m X^n, Y^m Y^n, Y^m)$$

By employing a set of corresponding points, Equation 11.22 can be solved using homogeneous linear least squares (Hartley and Zisserman 2004).

Figure 11.6f shows an example where multiple views are stitched together using homography. Note that, in general, this type of stitching cannot handle perspective deformations that are present in the input images. This figure also highlights the misalignments that occur during the stitching of two views in the image plane. A better visualization is to first map the input images to the ground plane (Figure 11.6d and e) and then to stitch the transformed images together, as shown in Figure 11.6g.

11.4.2 Global Trajectory Reconstruction

For the reconstruction of the global trajectory across views, trajectories from each camera can be mapped on the common plane. However, this does not guarantee a one-to-one correspondence as the trajectories belonging to the same object and observed in two cameras have considerable differences when projected (Figure 11.7). This is primarily due to occlusions or limitations of existing detection and tracking algorithms. Every T_p^N has, therefore, to be associated with each T_e^M (where e is the index of trajectories observed in C^m) in the overlapping region $\Omega_{m,n}$. Note that from this point onwards, the capital superscript identifies the projection of a particular trajectory from camera view onto the ground plane.

Figure 11.7 Example of an image to ground-plane projection, with visible difference (zoom-in) in tracks observed in two cameras of the same object.

To establish the correspondence between transformed trajectory segments in the overlapping regions on the ground plane, several trajectory similarity techniques use single features (Gaffney and Smyth 1999, Amasyali and Albayrak 2003, Antonini and Thiran 2006). Even when more features are used, they are generally not processed simultaneously (Bashir et al. 2007). Alternatively, multiple spatiotemporal feature (STF) analysis can result in a more accurate association (Anjum and Cavallaro 2008).

Various STF can be used, such as the *average object velocity*, v_k^M, to distinguish objects very close to each other on the ground plane but moving with different velocities; the *directional distance*, d_k^M, to distinguish longer trajectories from shorter ones and trajectories in

opposite directions; the *trajectory mean*, m_k^M, to disambiguate the trajectories that overlap in time but fall in different regions of the ground plane; the *polynomial regression coefficients*, β_k^M, to model the shape of a trajectory irrespective of its length and sample rate; *Principal Component Analysis (PCA) components*, p_k^M, to encode the variation information in the trajectory; and *directional histograms*, θ_k^M, to consider the sharpness of turns. The final normalized feature vector is

$$V_k^M = \left(v_k^M,\, d_k^M,\, m_k^M,\, \beta_k^M,\, p_k^M,\, \theta_k^M \right)^{\mathrm{T}}, \qquad (11.23)$$

where the T denotes the transpose of the vector. Because of its robustness to scale variation, cross correlation is used as proximity measure. For T_k^N and T_r^M in $\Omega_{m,n}$, the association matrix A is calculated as

$$A_\Omega \left(T_k^M,\, T_r^N \right) = \varsigma \left(V_k^M,\, V_r^N \right), \qquad (11.24)$$

where ς is the correlation function (Antonini and Thiran 2006, Anjum and Cavallaro 2008). A trajectory T_k^M will be associated to any trajectory T_r^N for which it has maximum correlation, that is,

$$\Xi_\Omega = \arg\max_r \left(A_\Omega \left(T_k^M, T_r^N \right) \right) \quad \forall O_r^m. \qquad (11.25)$$

The more similar two trajectory segments, the higher the correlation score.

11.4.3 Trajectory Fusion

The next step is to fuse trajectory pairs that belong to the same object in an overlapping region. To this end, an adaptive weighting method is used to fuse T_k^M and T_r^N as

$$\tilde{T}_k^G = \begin{cases} w_1 T_k^M + w_2 T_k^M & \in \Omega_{n,m} \\ T_r^N & \in \Omega_n \\ T_r^N & \in \Omega_m \end{cases}, \qquad (11.26)$$

where $\Omega_{m,n}$ is the region where observations from both T_r^N and T_k^M are available. Ω_n and Ω_m are the regions where the observation is available from either T_r^N or T_k^M, respectively. Within $\Omega_{m,n}$, when the observations from both trajectories are available, the trajectory segment which has more observations is given higher weight; otherwise, use only the available observation from one of the trajectories. The weights, w_1 and w_2, are calculated as function of the number of observations for each trajectory.

$$w_1 = \frac{\left|T_r^N\right|}{\left|T_r^N + T_k^M\right|}, \quad w_2 = \frac{\left|T_k^M\right|}{\left|T_r^N + T_k^M\right|}, \qquad (11.27)$$

where $|\cdot|$ is the number of observations in a trajectory and $w_1 + w_2 = 1$. Finally, the segments are linked together using Equation 11.4.

Figure 11.8 shows object tracking examples from partially overlapping cameras in the hall of a train station (Ferryman 2006). Objects are detected and tracked independently in each view using the approach presented in Taj et al. (2006). Figure 11.9 visualizes the accumulated trajectories from both cameras on the ground-plane mosaic view, where each trajectory segment is represented by a unique color.

The inter-camera transformations and objects' association using maximum likelihood (MLE) are estimated, as presented in Sheikh and Shah (2008). Figure 11.10 shows an example of trajectory fusion across multiple cameras. This approach accurately estimates the corresponding trajectories even if they are short in one or all of the cameras and/or for the sparse trajectories. However, this approach is not suitable for crowded scenes due to its processing time and to the limitation of reprojection error, as two trajectories may fall close to each other on image plane even if they are located far in real world. Figure 11.11 shows the error in association for very close trajectories.

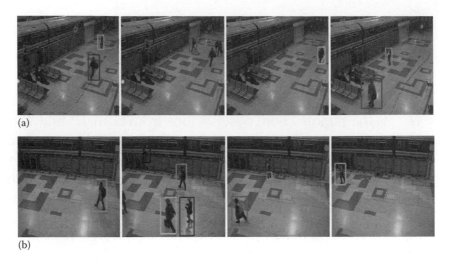

(a)

(b)

Figure 11.8 (See color insert following page 332.) Object tracking across a network of cameras. Tracking results for (a) camera-1 and (b) camera-2.

Figure 11.9 (See color insert following page 332.) Objects trajectories on the wider ground plane.

The STF perform better on the ground plane for association with densely populated and highly occluded objects. For further analysis, a crowded scene is also included, as shown in Figure 11.12. This video sequence consists of footage of 3000 frames of a football scene

(a) (b)

Figure 11.10 (See color insert following page 332.) An example of trajectory reconstruction in multi-camera setup: (a) set of several trajectory segments and (b) corresponding global trajectory (red, bold) reconstruction.

(a) (b)

Figure 11.11 (See color insert following page 332.) Example of association error. Trajectories in camera-1 are starting and ending with circles and the trajectories in camera-2 are starting and ending with squares. (a) Ground truth: dash lines—the first pair and dash dot lines—the second pair of corresponding trajectories. (b) Estimated results with visible errors.

simultaneously recorded by six cameras located at different viewpoints. Figure 11.13 shows the complete trajectories obtained from the local camera projections. A comparison of the trajectory association results between STF and MLE are compiled in Table 11.1 using precision (P) and recall (R) measures (Zanibbi et al. 2005):

$$\begin{cases} P = \dfrac{|\Psi_G \cap \Psi_E|}{\Psi_E} \\ R = \dfrac{|\Psi_G \cap \Psi_E|}{\Psi_G} \end{cases}, \qquad (11.28)$$

Figure 11.12 (See color insert following page 332.) A scene of football sequence: trajectories from each camera are shown with different color and style.

Figure 11.13 (See color insert following page 332.) Reconstruction of global trajectories from local projections.

where ψ_G and ψ_E are manually and estimated pair of concurrent trajectories. On average, the proposed approach outperforms MLE by 9% and 4% for R and P, respectively. This is primarily due to the variety of the feature set used and verification of matching before making final

TABLE 11.1 Comparison of Trajectory Association Results

Algorithm	$\Omega_{1,2}$		$\Omega_{3,4}$		$\Omega_{5,6}$		$\Omega_{1,3}$		$\Omega_{2,4}$		$\Omega_{3,5}$		$\Omega_{4,6}$		Average	
	R	P	R	P	R	P	R	P	R	P	R	P	R	P	R	P
MLE	.76	.81	.81	.92	.78	.99	.89	.92	.84	.97	.87	.96	.82	.85	.82	.92
STF	.96	.98	.95	1.00	.96	1.00	.93	.95	.85	.98	.87	.98	.82	.85	.91	.96

association. When the segments are close on the image plane, they cannot be separated using the reprojection error criterion and MLE fails to distinguish the segments that belong to different objects exhibiting similar motion patterns.

11.5 SUMMARY

This chapter discussed the fusion of trajectory information from multiple overlapping and nonoverlapping cameras. Camera calibration is the foremost step in handling a network: for overlapping setups, where cameras share one or more common regions, it is easy to identify few control points or features for computing the homography to transform an image from one camera to other cameras or to a common ground plane. For nonoverlapping setups, inter-camera calibration cannot be done directly from the image sequences; we presented a calibration framework that uses either temporal or statistical inferences and an estimation process for unobserved trajectory segments. For the correspondence of objects across multiple cameras, once the trajectories are associated, they are fused together in overlapping regions and then integrated to the segments in nonoverlapping regions to have a unique, complete trajectory belonging to a physical object. The proposed framework is demonstrated on multi-camera video sequences of an underground train station and a soccer match.

The framework can be extended to perform activity analysis by clustering object trajectories (Qu and Schonfeld 2007, Bashir et al. 2007, Anjum and Cavallaro 2008, Piciarelli et al. 2008) also by incorporating contextual information.

11.6 BIBLIOGRAPHICAL AND HISTORICAL REMARKS

Camera calibration plays a fundamental role in single and multi-camera scene analysis for consistent and uniform display. Basic calibration techniques require only 2D point matches in multiple views and work for known cameras parameters or 3D knowledge of the

scene (Maybank and Faugeras 1992, Basu 1993, Ji and Dai 2004). A detailed discussion in this area can be found in Hartley and Zisserman (2004). However, in the case of a single camera or a multi-camera network with nonoverlapping views, these approaches cannot be used for camera calibration. Single camera calibration involves finding the values of the translation offset of the imaging sensor relative to the optical axis and the removal of the lens distortion. To perform single camera calibration, we can assume a monitored scene as being embedded in an affine or even projective space (Faugeras 1995). Under this assumption, Liebowitz and Zisserman (1998) describe the geometry, constraints, and algorithmic implementation for metric rectification of planes (Liebowitz and Zisserman 1998). The information of a vanishing line and a structure with known angle and height ratio is sufficient for metric rectification that can be performed as a sequence of inverse transformations such as projection, affine, and similarity (Anjum and Cavallaro 2007).

For nonoverlapping camera networks, a semiautomatic process based on a moving calibration device (Xiaotao et al. 2006) or a set of feature points with unknown locations can be used (Mantzel et al. 2004). Alternatively, a moving target can provide marker information that can be used (Arulampalam et al. 2002). Each camera views the target for some time instants and a maximum a posterior (MAP) estimation technique simultaneously estimates the trajectory of the target and the parameters of the camera. A related framework uses a robot mounted with a calibration pattern, which moves in the FOVs of the cameras (Taylor et al. 2006). An extended Kalman filter (EKF) can compute the pose of the robot and of the cameras. However, this approach requires a procedure to refine the estimated pose of the cameras. If objects move in a straight line in the unobserved regions, then velocity extrapolation can be employed to project the FOV of one camera onto the others (Javed et al. 2003). Alternatively, vanishing points can also be incorporated to find the relative orientation of the cameras (Junejo et al. 2007).

Assuming the calibration of the cameras is complete, the next step is to generate global trajectories using a supervised or an unsupervised algorithm. Supervised techniques depend either upon the information

contained in training samples or supplied by users. Several authors proposed supervised association approaches (Huang and Russell 1997, Kettnaker and Zabih 1999, Dick and Brooks 2004, Wang et al. 2008) for object correspondence. Unlike supervised techniques, unsupervised techniques do not require training samples or manual selection of the parameters (Kayumbi et al. 2008, Sheikh and Shah 2008).

Kettnaker and Zabih (1999) presented a Bayesian solution to track people across multiple cameras. The system requires prior information about the environment and the way people move across it. Huang and Russell (Huang and Russell 1997) presented a probabilistic approach for tracking cars across two cameras on a highway, where transition times were modeled as Gaussian distributions. Like in Kettnaker's work, they assumed that the initial transition probabilities were known. This approach is application-specific, using only two calibrated cameras with vehicles moving in one direction on a single lane. Dick and Brooks (Dick and Brooks 2004) use a stochastic transition matrix to describe patterns of motion for both intra- and inter-camera correspondence. The correspondence between cameras has to be supplied as training data. Wang et al. (2008) connect trajectories observed in multiple cameras based on their temporal information. Trajectories are considered to be corresponding, if they overlap in time for an empirically preselected interval.

Kayumbi et al. (2008) establish correspondence between the image planes and a virtual ground plane. Trajectory association is performed on the ground plane using shape, length, and temporal information. The MLE for association is calculated by cross-correlating STF vectors. However, this approach cannot differentiate two objects moving with varying speed in the environment. In the approach presented in Sheikh and Shah (2008), airborne cameras are used with the assumption of the simultaneous visibility of at least one object by two cameras and by taking time-stamped trajectories as input from each view, the algorithm estimates the inter-camera transformations. A pair of trajectories is considered as generated by the same object based on the minimization of the reprojection error.

REFERENCES

Amasyali, F. and Albayrak, S., Fuzzy C-means clustering on medical diagnostic systems, in *Proceedings of the International 12th Turkish Symposium on Artificial Intelligence and Neural Networks*, Canakkale, Turkey, 2003.

Anjum, N. and Cavallaro, A., Single camera calibration for trajectory-based behavior analysis, in *Proceedings of the IEEE Conference on Advanced Video and Signal Based Surveillance*, London, U.K., 2007.

Anjum, N. and Cavallaro, A., Multi-feature object trajectory clustering for video analysis, *IEEE Transactions on Circuits and Systems for Video Technology*, 18(11), 1555–1564, November 2008.

Anjum, N., Taj, M., and Cavallaro, A., Relative position estimation of non-overlapping cameras, in *Proceedings of the IEEE International Conference on Acoustics, Speech and Signal Processing*, Honolulu, HI, 2007.

Antonini, G. and Thiran, J., Counting pedestrians in video sequences using trajectory clustering, *IEEE Transactions on Circuit and Systems for Video Technology*, 16(8), 1008–1020, August 2006.

Arulampalam, M. S., Maskell, S., Gordon, N., and Clapp, T., A tutorial on particle filters for online nonlinear/non-Gaussian Bayesian tracking, *IEEE Transactions on Signal Processing*, 50(2), 174–188, February 2002.

Bashir, F., Khokhar, A., and Schonfeld, D., Real-time motion trajectory based indexing and retrieval of video sequences, *IEEE Transactions on Multimedia*, 9, 58–65, January 2007.

Basu, A., Active calibration: Alternative strategy and analysis, in *Proceedings of the IEEE Conference on Computer Vision and Pattern Recognition*, New York, June 1993.

Batista, J., Araujo, H., and de Almeida, A.T., Iterative multistep explicit camera calibration, *IEEE Transactions on Robotics and Automation*, 15(5), 897–917, October 1999.

Bourgeous, W., Ma, L., Pengyu, C., and Chen, Y. Q., Simple and efficient extrinsic camera calibration based on a rational model, in *Proceedings of the IEEE International Conference on Mechatronics and Automation*, Bangkok, Thailand, 2006.

Cheng, L., Gong, J., Yang, X., Fan, C., and Han, P., Robust affine invariant feature extraction for image matching, *IEEE Geoscience and Remote Sensing Letters*, 5(2), 246–250, April 2008.

Dick, A. R. and Brooks, M. J., A stochastic approach to tracking objects across multiple cameras, *Lecture Notes on Computer Science*, Vol. 3339, pp. 160–170, Springer-Verlag, Berlin, November 2004.

Faugeras, O., Stratification of 3-dimensional vision: Projective, affine, and metric representations, *JOSAA*, 12(3), 465–484, March 1995.

Ferryman, J. M., Performance evaluation of tracking and surveillance, in *Proceedings of the IEEE Workshop on PETS*, New York, 2006.

Funiak, S., Guestrin, C., Paskin, M., and Sukthankar, R., Distributed localization of networked cameras, in *Proceedings of the International Conference on Information Processing in Sensor Networks*, Nashville, TN, 2006.

Gaffney, S. and Smyth, P., Trajectory clustering with mixtures of regression models, in *Proceedings of the International Conference on Knowledge Discovery and Data Mining*, San Diego, CA, 1999.

Hartley, R. and Zisserman, A., *Multiple View Geometry in Computer Vision*, 2nd edition, Cambridge University Press, Cambridge, U.K., ISBN: 0521540518, 2004.

Huang, T. and Russell, S., Object identification in a Bayesian context, in *Proceedings of the International Joint Conference on Artificial Intelligence*, Nagoya, Japan, August 1997.

Javed, O., Rasheed, Z., Alatas, O., and Shah, M., KNIGHT: A real time surveillance system for multiple overlapping and non-overlapping cameras, in *Proceedings of the International Conference on Multimedia and Expo*, Baltimore, MD, 2003.

Ji, Q. and Dai, S., Self-calibration of a rotating camera with a translational offset, *IEEE Transactions on Robotics and Automation*, 20(1), 1–14, February 2004.

Jiangbo, L., Hua, C., Jian-Guang, L., and Jiang, L., An epipolar geometry-based fast disparity estimation algorithm for multiview image and video coding, *IEEE Transactions on Circuits and Systems for Video Technology*, 17(6), 737–750, June 2007.

Jinchang, R., Ming, X., Orwell, J., and Jones, G. A., Real-time modeling of 3-D soccer ball trajectories from multiple fixed cameras, *IEEE Transactions on Circuits and Systems for Video Technology*, 18(3), 350–362, March 2008.

Junejo, I. N., Cao, X., and Foroosh, H., Autoconfiguration of a dynamic nonoverlapping camera network, *Transactions on Systems, Man and Cybernetics, Part B*, 37, 803–816, August 2007.

Kanatani, K., Ohta, N., and Kanazawa, Y., Optimal homography computation with a reliability measure, *IEICE Transactions on Information and Systems*, E-83-D(7), 1369–1374, July 2000.

Kayumbi, G., Anjum, N., and Cavallaro, A., Global trajectory reconstruction from distributed visual sensors, in *Proceedings of the International Conference on Distributed Smart Cameras*, Stanford, CA, 2008.

Kettnaker, V. and Zabih, R., Bayesian multi-camera surveillance, in *Proceedings of the IEEE International Conference on Computer Vision and Pattern Recognition*, Fort Collins, CO, June 1999.

Lee, L., Romano, R., and Stein, G., Monitoring activities from multiple video streams: Establishing a common coordinate frame, *IEEE Transactions on Pattern Analysis and Machine Intelligence*, 22(8), 758–767, August 2000.

Liebowitz, D. and Zisserman, A., Metric rectification for perspective images of planes, in *Proceedings of the IEEE Conference on Computer Vision and Pattern Recognition*, Santa Barbara, CA, June 1998.

Lowe, G. D., Distinctive image features from scale-invariant keypoints, *International Journal of Computer Vision*, 60(2), 91–110, 2004.

Mallat, S., A theory for multiresolution signal decomposition: The wavelet representation, *IEEE Transactions on Pattern Analysis and Machine Intelligence*, 11(7), 674–693, July 1989.

Mantzel, W. E., Hyeokho, C., and Baraniuk, R. G., Distributed camera network localization, in *Proceedings of the Asilomar Conference on Signals, Systems and Computers*, Pacific Grove, CA, 2004.

Maybank, S. J. and Faugeras, O. D., A theory of selfcalibration of moving camera, *International Journal of Computer Vision*, 8(2), 123–151, August 1992.

Mikolajczyk, K. and Schmid, C., Scale and affine invariant interest point detectors, *International Journal of Computer Vision*, 60(1), 63–86, 2004.

Nummiaro, K., Koller-Meier, E., Svoboda, T., Roth, D., and Gool, L. V., Color-based object tracking in multi-camera environments, *Lecture Notes in Computer Science*, Vol. 2781, pp. 591–599, Springer-Verlag, Berlin, September 2003.

Piciarelli, C., Micheloni, C., and Foresti, G. L., Trajectory-based anomalous event detection, *IEEE Transactions on Circuits and Systems for Video Technology*, 18(11), 1544–1554, November 2008.

Polat, E. and Ozden, M., A nonparametric adaptive tracking algorithm based on multiple feature distributions, *IEEE Transactions on Multimedia*, 8(6), 1156–1163, December 2006.

Qu, W. and Schonfeld, D., Real-time decentralized articulated motion analysis and object tracking from videos, *IEEE Transactions on Image Processing*, 16(8), 2129–2138, August 2007.

Rahimi, A., Dunagan, B., and Darrell, T., Simultaneous calibration and tracking with a network of non-overlapping sensors, in *Proceedings of the IEEE Conference on Computer Vision and Pattern Recognition*, Washington, DC, 2004.

Sheikh, Y. and Shah, M., Trajectory association across multiple airborne cameras, *IEEE Transactions on Pattern Analysis and Machine Intelligence*, 30(2), 361–367, February 2008.

Soro, S. and Heinzelman, W. B., On the coverage problem in video-based wireless sensor networks, in *Proceedings of the Conference on Broadband Networks*, Boston, MA, 2005.

Taj, M., Maggio, E., and Cavallaro, A., Multi-feature graph-based object tracking, CLEAR 2006, *Lecture Notes on Computer Science*, Vol. 4122, pp. 190–199, Springer-Verlag, Berlin, April 2006.

Taylor, C., Rahimi, A., Bachrach, J., Shrobe, H., and Grue, A., Simultaneous localization, calibration, and tracking in an adhoc sensor network, in *Proceedings of the International Conference on Information Processing in Sensor Networks*, Nashville, TN, 2006.

Wang, X., Tieu, K., and Grimson, W., Correspondence free multi-camera activity analysis and scene modeling, in *Proceedings of the IEEE Conference on Computer Vision and Pattern Recognition*, Anchorage, AK, June 2008.

Wei, G. Q. and Ma, S. D., Implicit and explicit camera calibration: Theory and experiments, *IEEE Transactions on Pattern Analysis and Machine Intelligence*, 16(5), 469–480, May 1994.

Xiaotao, L., Kulkarni, P., Shenoy, P., and Ganesan, D., Snapshot: A self-calibration protocol for camera sensor networks, in *Proceedings of the International Conference on Broadband Communications, Networks and Systems*, San Jose, CA, 2006.

Xu, G. and Zhang, Z. (eds), *Epipolar Geometry in Stereo, Motion and Object Recognition: A Unified Approach,* Computational Imaging and Vision Series, Kluwer Academic Press, Dordrecht, the Netherlands, ISBN: 978-0-7923-4199-4, 1996.

Yinghao, C., Wei, C., Huang, K., and Tan, T., Continuously tracking objects across multiple widely separated cameras, *Lecture Notes in Computer Science*, Vol. 4843, pp. 843–852, Springer-Verlag, Berlin, November 2007.

Zanibbi, R., Blostein, D., and Cordy, J. R., Historical recall and precision: Summarizing generated hypotheses, in *Proceedings of the International Conference on Document Analysis and Recognition*, Seoul, Korea, 2005.

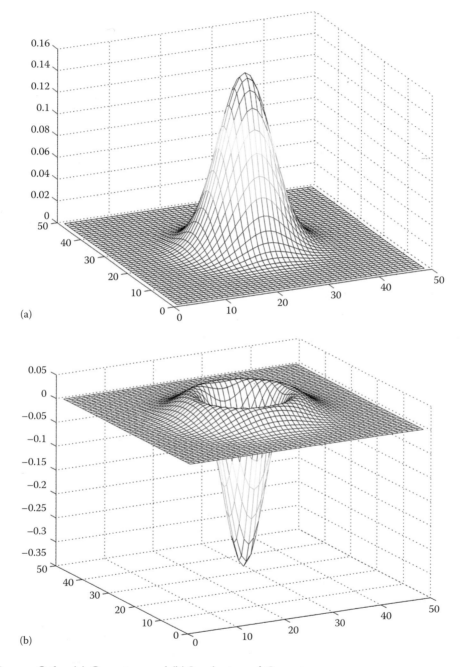

(a)

(b)

Figure 2.1 (a) Gaussian and (b) Laplacian of Gaussian.

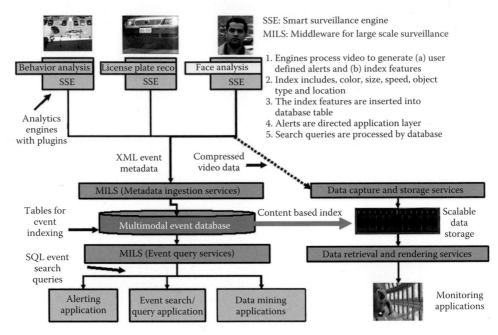

Figure 3.1 IBM SSS architecture.

Videos	Ground Truth		People Detection		Vehicle Detection	
	People	*Vehicles*	*True Positives*	*False Positives*	*True Positives*	*False Positives*
PETS D1TeC1	6	2	6	0	2	0
PETS D1TeC2	5	1	5	0	1	0
PETS D2TeC1	6	3	6	0	3	0
PETS D2TeC2	7	2	6	0	2	1
PETS D3TeC1	16	0	10	0	0	6
PETS D3TeC2	13	0	6	0	0	7
Sequence HW1	16	82	14	1	81	2
Sequence HW2	67	22	66	0	22	1
Traffic complex	125	696	121	0	696	4
Traffic video D	44	46	40	1	45	4
Shadow	3	1	3	0	1	0

Figure 3.4 Results for our object classification approach and some testing video frames.

Figure 3.5 HSL color space showing saturation/lightness curves and threshold points.

Outer patches
$P_0^1,...,P_0^m$

Inner patches Radius
$P_I^1,...,P_I^m$ r

Figure 3.11 A graphical illustration of the ABT. Ground patches are generated to model the appearance and motion patterns of the tripwire region.

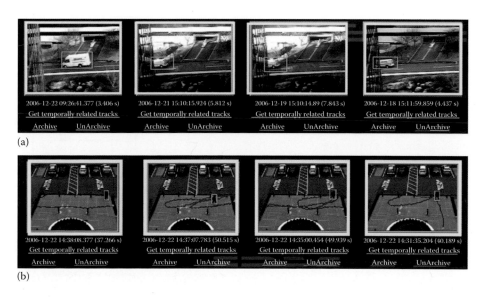

(a)

2006-12-22 09:26:41.377 (3.406 s)
Get temporally related tracks
Archive UnArchive

2006-12-21 15:10:15.924 (5.812 s)
Get temporally related tracks
Archive UnArchive

2006-12-19 15:10:14.89 (7.843 s)
Get temporally related tracks
Archive UnArchive

2006-12-18 15:11:59.859 (4.437 s)
Get temporally related tracks
Archive UnArchive

(b)

2006-12-22 14:38:08.377 (37.266 s)
Get temporally related tracks
Archive UnArchive

2006-12-22 14:37:07.783 (50.515 s)
Get temporally related tracks
Archive UnArchive

2006-12-22 14:35:00.454 (49.939 s)
Get temporally related tracks
Archive UnArchive

2006-12-22 14:31:35.204 (40.189 s)
Get temporally related tracks
Archive UnArchive

Figure 3.13 Composite search in our system: (a) Finding DHL trucks based on object type, size, and color, and (b) finding people loitering based on object type and duration.

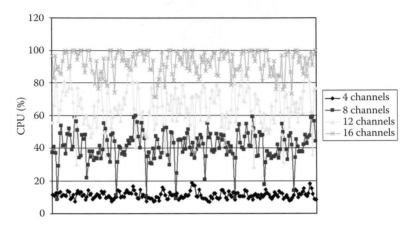

Figure 3.15 CPU load according to the number of channels in a single IBM blade.

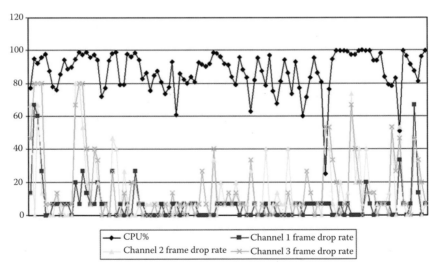

Figure 3.16 CPU load according to frame drop rate.

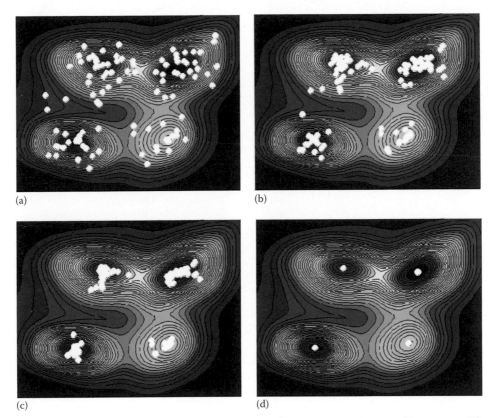

Figure 4.1 Illustration of mean-shift mode-finding procedure in 2D space. The original density function is constructed with 100 Gaussian kernels and 4 modes are detected after convergence (a) Initial density function. (b) $t=1$. (c) $t=2$. (d) $t=14$. (From Han, B. et al., *IEEE Trans. Pattern Anal. Mach. Intell.*, 30(7), 1186, 2008. With permission.)

Figure 4.4 Comparison between KDE and KDA with 200 samples in 2D. (a) Original. (b) KDE. (MISE$=1.6684 \times 10^6$). (c) KDA. (MISE$=3.0781 \times 10^6$). (From Han, B. et al., *IEEE Trans. Pattern Anal. Mach. Intell.*, 30(7), 1186, 2008. With permission.)

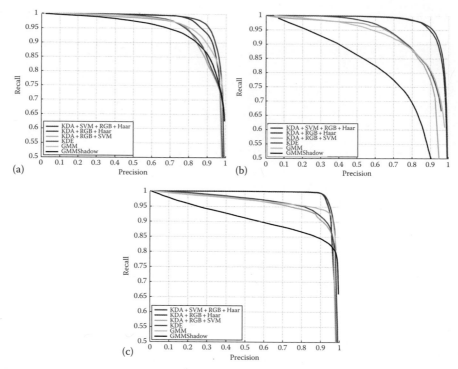

(a)

(b)

(c)

Figure 4.8 Precision–recall curve for six algorithms. (a) Subway sequence. (b) Fountain sequence. (c) Caviar sequence.

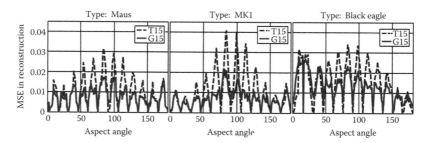

Figure 6.6 Comparison of reconstruction MSE for the generative model (G15) and the template model (T15). The solid and dashed lines denote the reconstruction errors of G15 and T15, respectively. The errors obtained using G15 are significantly lower than that of T15 for poses unavailable in the training set. The range of poses shown is limited to 180° due to the inherent symmetry of the reconstruction error. (From Venkataraman, V. et al., Integrated target tracking and recognition using joint appearance-motion generative models, in *Proceedings of the 5th IEEE International Workshop on Object Tracking and Classification in and beyond Visible Spectrum (OTCBVS08), in Conjunction with CVPR08*, Anchorage, Alaska, 2008. With permission. ©2008 IEEE.)

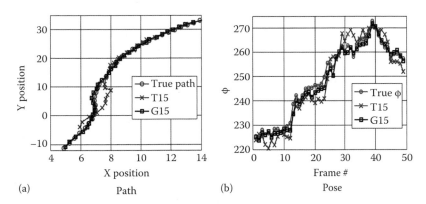

(a) Path (b) Pose

Figure 6.9 Sample tracking result for the sequence SEQ2: (a) path estimate and (b) pose estimate. (From Venkataraman, V. et al., Integrated target tracking and recognition using joint appearance-motion generative models, in *Proceedings of the 5th IEEE International Workshop on Object Tracking and Classification in and beyond Visible Spectrum (OTCBVS08), in Conjunction with CVPR08*, Anchorage, Alaska, 2008. With permission. © 2008 IEEE.)

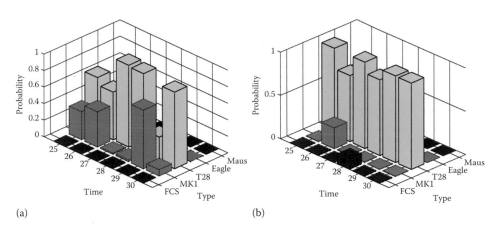

(a) (b)

Figure 6.12 Sample distribution of the vehicle type when using (a) fixed transition matrix in APF* and (b) KAPF during last few frames of SEQc.

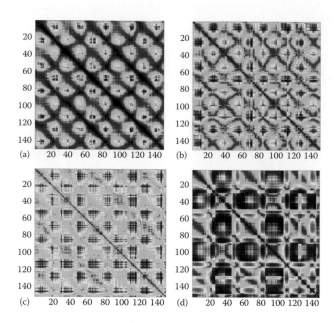

Figure 7.5 Distance matrices of a 149-frame sequence of (a) side-view walking silhouettes computed using GMM, (b) vectorized GMM using 46 key frames, (c) shape context, and (d) Fourier descriptor.

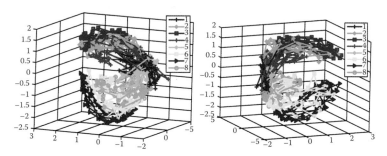

Figure 7.8 The first three dimensions of the silhouette latent points of 640 walking frames.

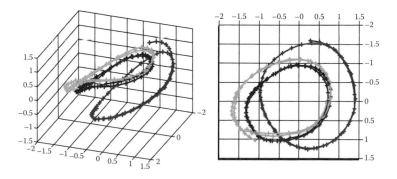

Figure 7.9 Two views of a 3D GPDM learned using gait data set Θ_T (see Section 7.1.3), including six walking cycles' frames from three subjects.

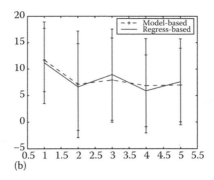
(b)

Figure 7.12 (b) RMS error results using rendering and regression approaches. The average error is close for both approaches.

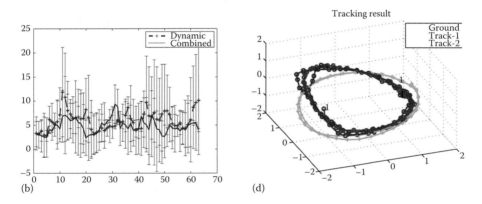
(b) (d)

Figure 7.13 (b) Frame-wise RMS from the side view. (d) The tracked movement trajectories in the joint angle manifold Θ.

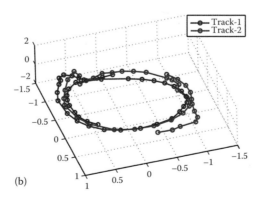
(b)

Figure 7.15 (b) The tracked movement trajectories in the joint angle manifold Θ.

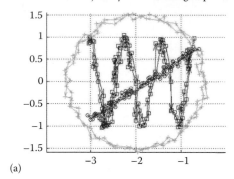
The true latent trajectory of the training sequences

(a)

The true latent trajectory of the testing sequences

(b)

Figure 8.3 The ground truth latent trajectories for the sin (square marker), circle (plus marker), and line (circle marker) classes used in D-GPDM training (a) and testing (b). In (a), there are six training sequences in total, two for each class. In (b), there are 30 testing sequences in total, 10 for each class.

The latent trajectories of three cls training data with GPDM

(a)

The learned latent coordinates of all training data

(b)

The learned latent coordinates of all training data

(c)

Figure 8.4 The latent trajectory discovered by D-GPDM for the training sequences with varying σ_d^2. (a) $\sigma_d^2 = 0$, GPDM. (b) $\sigma_d^2 = 10^6$. (c) $\sigma_d^2 = 10^7$.

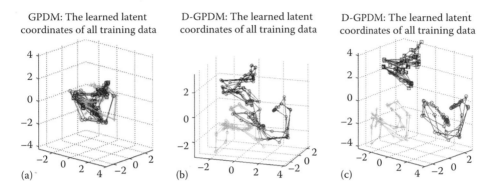

Figure 8.9 he latent trajectory of the training data learned by GPDM (a) and D-GPDM (b and c). (a) Latent trajectory learned by GPDM, $\sigma_d^2 = 0$. (b) Latent trajectory learned by D-GPDM with small σ_d^2. (c) Latent trajectory learned by D-GPDM with large σ_d^2. Square, plus, and circle curves represent boxing, hand clapping, and hand waving, respectively

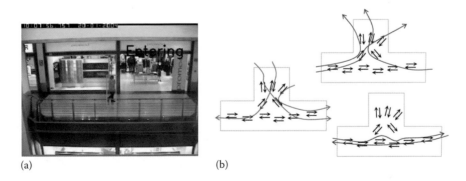

Figure 9.6 (a) A frame of video with activity label for one track. (b) An illustration of how we expected our features to cluster both in position and direction. (From Muncaster, J. and Ma, Y., Activity recognition using dynamic Bayesian networks with automatic state selection, in *IEEE Workshop on Motion and Video Computing*, Austin, TX, p. 30, 2007. With permission.)

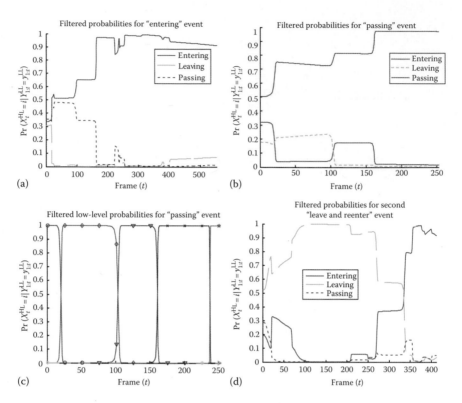

Figure 9.7 Results for tests on user (a) entering the store, (b) leaving the store, and (c) passing the store. In (d) we show the low-level event probabilties for the "passing" event. Notice how jumps in probability in (c) correspond to low-level changes in (d). (From Muncaster, J. and Ma, Y., Activity recognition using dynamic Bayesian networks with automatic state selection, in *IEEE Workshop on Motion and Video Computing*, Austin, TX, p. 30, 2007. With permission.)

Figure 11.4 An example of improvements in trajectory estimation using Kalman filter. The solid line is the input trajectory. Dash lines are the estimations without the Kalman filter's corrections. Dash-dot lines are the estimations with Kalman filter's corrections. Arrow head shows the direction of estimation.

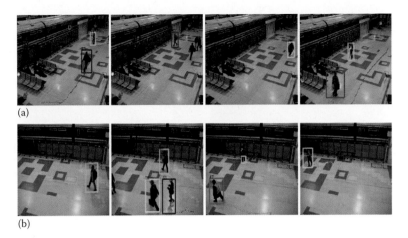

(a)

(b)

Figure 11.8 Object tracking across a network of cameras. Tracking results for (a) camera-1 and (b) camera-2.

Figure 11.9 Objects trajectories on the wider ground plane.

(a) (b)

Figure 11.10 An example of trajectory reconstruction in multi-camera setup: (a) set of several trajectory segments and (b) corresponding global trajectory (red, bold) reconstruction.

Figure 11.11 Example of association error. Trajectories in camera-1 are starting and ending with circles and the trajectories in camera-2 are starting and ending with squares. (a) Ground truth: dash lines—the first pair and dash dot lines—the second pair of corresponding trajectories. (b) Estimated results with visible errors.

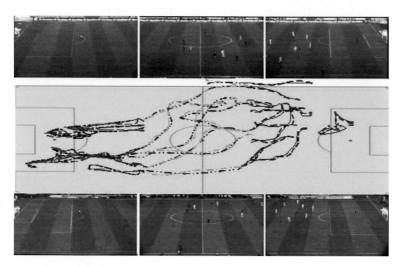

Figure 11.12 A scene of football sequence: trajectories from each camera are shown with different color and style.

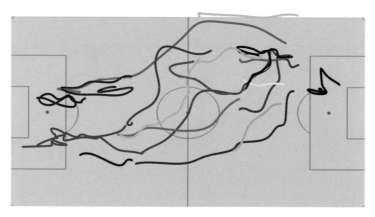

Figure 11.13 Reconstruction of global trajectories from local projections.

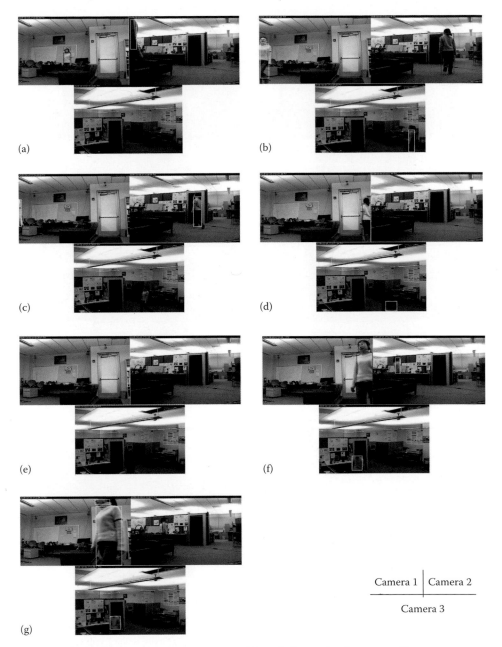

(a)

(b)

(c)

(d)

(e)

(f)

(g)

Camera 1	Camera 2
Camera 3	

Figure 12.2 Camera assignments and handoffs in the 1 person 3 cameras case. The camera in which the bounding box is the dark color is selected to track the person.

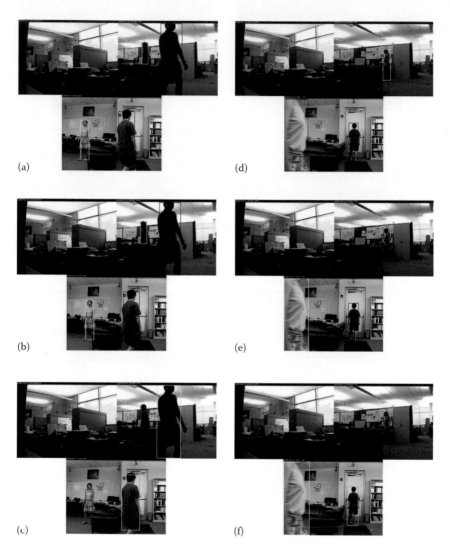

Figure 12.3 A comparison for using different criteria. The left column and the right column are for two time instants respectively. The first row through the third row are using criterion 1 to criterion 3, respectively.

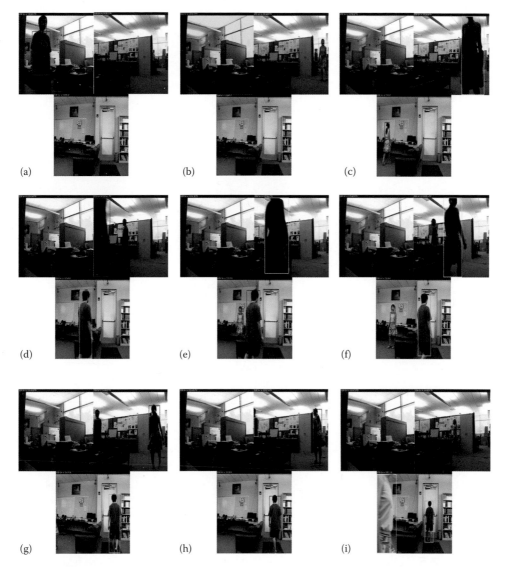

Figure 12.4 All camera handoffs when applying the combined criterion for 2 persons and 3 cameras case.

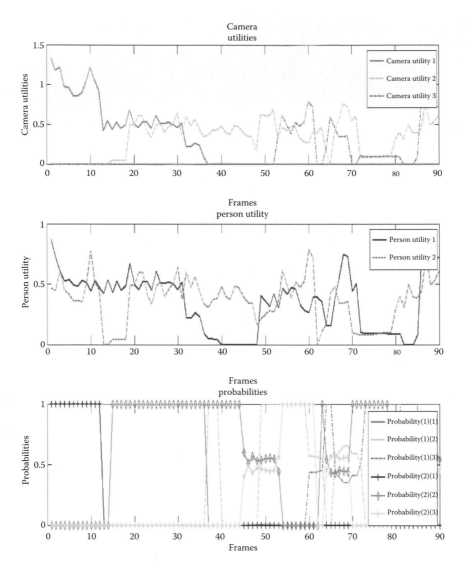

Figure 12.5 Utilities and assignment probabilities for each processed frame when using the combined criterion. Probability[*i*][*j*] stands for the probability that camera *j* is selected to track person *i*.

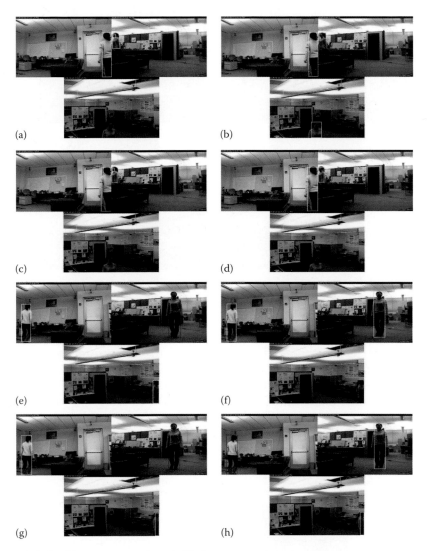

Figure 12.9 Two camera handoffs by using the co-occurrence to occurrence ratio (COR) approach and the comparison with our approach. The left column are the results by our approach and the right column are the results by the COR approach.

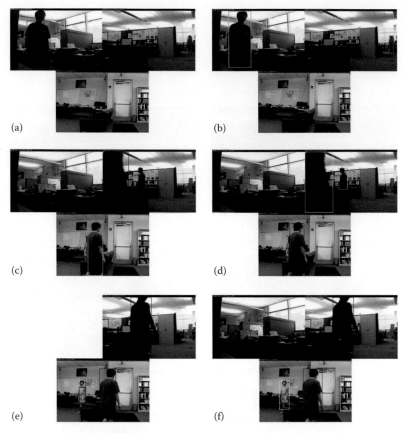

(a) (b)

(c) (d)

(e) (f)

Figure 12.10 Some camera handoff errors by the co-occurrence to occurrence ratio (COR) approach and handoffs in a single-person case. In (b), since there is no identification mechanism, the COR approach mismatches the two persons and loses track one of the two persons. In (d) the system fails to calculate the co-occurrence to occurrence ratio and, thus, loses the person in the light color although it is available in camera 2. In (f), the COR approach mismatches the person and loses to track one of the persons.

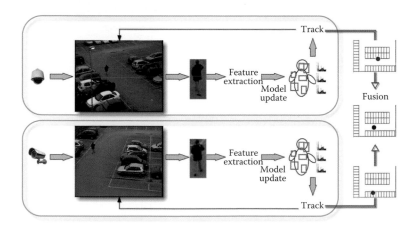

Figure 13.1 Sketch of the logical architecture of the system.

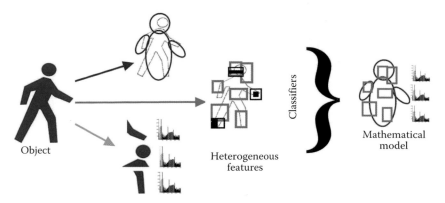

Figure 13.2 Heterogeneous features describe a moving object.

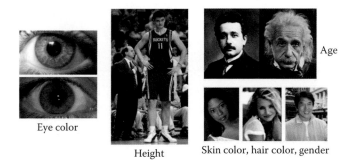

Figure 15.1 Some soft biometrics traits (images are from Internet search, courtesy of owners).

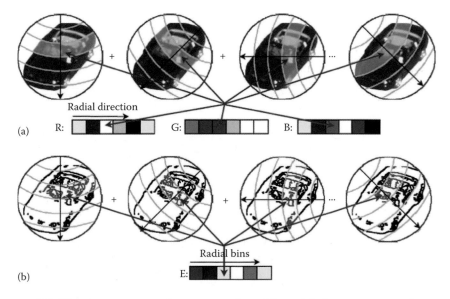

Figure 16.13 Appearance descriptor of tracklets. (a) Appearance color model and (b) appearance shape model.

(a) (b)

(c) (d)

Figure 16.14 (a–d) Simulation result $L=200$, $N=7$, $FA=7$, and $T=50$. Color rectangles indicate the IDs of targets. Targets may split or merge when they appear.

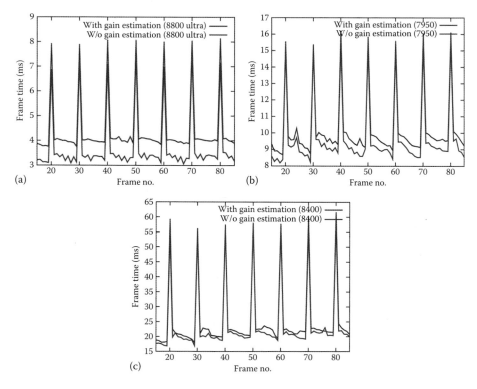

Figure 17.4 Runtimes per frame with and without gain estimation on different GPUs for PAL resolution (720×576). (From Zach, C. et al., In *Computer Vision on GPUs (CVPR Workshop)*, Anchorage, AK, 2008. With permission. © 2008 IEEE.)

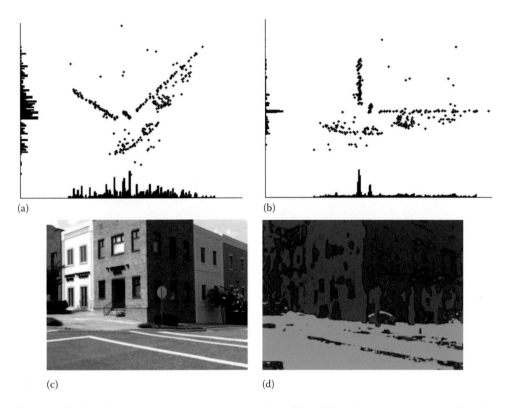

(a)

(b)

(c)

(d)

Figure 17.8 Minimum entropy optimization. The 3D points are projected in the direction of gravity. Then they are rotated into the basis formed by u and v and histograms are generated. (a) Arbitrary rotation and (b) minimum entropy. The histograms of (a) have more entropy than those of (b). The histograms of (b) correspond to the correct surface normals. (c) Input frame image from original viewpoint. (d) Best-cost labels selection. Ground points are labeled green, and facade points are labeled red or blue. (From Pollefeys, M. et al., *Int. J. Comput. Vision*, 78, 143, 2008. With permission. © 2008 Springer.)

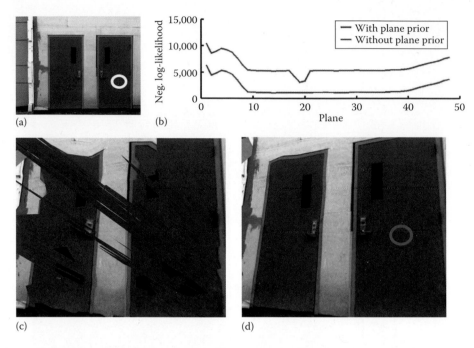

(a) (b)

Figure 17.10 Illustration of the effectiveness of the prior term in stereo. (a,b) Reference image and matching costs with and without the prior (in red and blue respectively) for the pixel in the white circle. (c,d) Without the prior, matching costs are ambiguous and the reconstruction is noisy; the prior correctly disambiguates the cost function in (d). (From Pollefeys, M. et al., *Int. J. Comput. Vision*, 78, 143, 2008. With permission. © 2008 Springer.)

(b) (c)

Figure 17.15 (b) Overlapping meshes as wireframes. Triangles in red are generated by the side camera and the ones in blue by the upward camera. (c) Results of duplicate surface removal. (From Pollefeys, M. et al., *Int. J. Comput. Vision*, 78, 143, 2008. With permission. © 2008 Springer.)

12

Dynamic Camera Assignment and Handoff

Bir Bhanu and Yiming Li

12.1 INTRODUCTION

Due to the broad coverage of an environment and the possibility of coordination among different cameras, video sensor networks have attracted much interest in recent years. Although the field-of-view (FOV) of a single camera is limited and the cameras may have overlapping or nonoverlapping FOVs, seamless tracking of moving objects can be achieved by exploiting the handoff capability of multiple cameras. *Camera handoff* is the process of finding the next best camera to see the target object when it is leaving the FOV of the current camera that is being used to track it. This will provide a better situation assessment of the environment under surveillance. Multiple cameras enable us to have different views of the same object at the same time, such that we can choose one or some of them to monitor a given environment. This can help to solve the occlusion problem to some extent, as long as the FOVs of the cameras have some overlaps. However, since multiple cameras may be involved over long physical distances, we have to deal with the handoff problem as well. It is evident that the manual camera handoff will become unmanageable when the number of cameras is large. Therefore, we need to develop surveillance systems that can automatically carry out the camera assignment and handoff task.

In this chapter, we provide a new perspective to the camera handoff problem that is based on game theory. The merit of our approach is that it is independent of the topology of how the cameras are placed. When multiple cameras are used for tracking and where multiple cameras can "see" the same object, the algorithm can automatically provide an optimal as well as stable solution of the camera assignment quickly. Since game theoretic approach allows dealing with multiple criteria optimization, we are able to choose the "best" camera based on multiple criteria that are selected *a priori*. The detailed camera calibration or 3D scene understanding is not needed in our approach.

Our approach differs from the earlier traditional approaches. We propose a game theoretic approach for camera assignment and handoff using the vehicle-target model (Arslan et al. 2007). We model camera assignment and handoff as a multiplayer game and allow for both coordination and conflicts among these players. Multiple criteria, which are used to evaluate the tracking performance, are used in the

utility functions for the objects being traced. The equilibrium of the game provides the solution of the camera assignment.

The following sections are devoted to describing the proposed game-theory-based method. Section 12.2 formulates the camera assignment and handoff problem and then constructs the utilities and bargaining steps. The implementation of this approach and some experimental results are also shown in this section. The conclusions are given in Section 12.3. Some related works in this area are reviewed in Section 12.4.

12.2 TECHNICAL APPROACH

12.2.1 Motivation and Problem Formulation

Game theory can be used for analyzing the interactions as well as conflicts among multiple agents. Analogously, in a video sensor network, collaborations as well as competitions among cameras exists simultaneously. This concept enlightens us to view the camera assignment problem in a game theoretic manner. The interactive process is called a game, while all the participants of the game are called players, who strive to maximize their *utilities*. In our problem for each person to be tracked, there exists a multiplayer game, with the available cameras being the players. If there are multiple persons in the system, this becomes a multiple of multiplayer game being played simultaneously.

Vehicle-target assignment (Arslan et al. 2007) is a multiplayer game that aims to allocate a set of vehicles to a group of targets and achieve an optimal assignment. Viewing the persons being tracked as "vehicles" while the cameras as "targets," we can adopt the vehicle-target assignment model to choose the "best" camera for each person. In the following, we propose a game-theory-based approach that is well suited to the task at hand.

12.2.2 Game Theoretic Framework

Game theory involves utility, which refers to the amount of "welfare" an agent derives in a game (Myerson 1991, Li and Bhanu 2008). We are concerned with three different utilities:

1. *Global utility*: The overall degree of satisfaction for tracking performance.
2. *Camera utility*: How well a camera is tracking the persons assigned to it based on the user-supplied criteria.
3. *Person utility*: How well the person is satisfied with being tracked by the current selected camera.

Our objective is to maximize the global utility as well as to make sure that the "best" camera tracks each person. Moving objects are detected in multiple video streams. Their properties, such as the size of the minimum bounding rectangle and other region properties (color, shape, view, etc.) are computed. Various utilities (camera utility, person utility, predicted person utility, and global utility) are computed based on the user-supplied criteria and *bargaining process* among available cameras are executed based on the prediction of person utilities (the so-called *predicted person utility*) in each step. The results obtained from the strategy execution are in turn used for updating the camera utilities and person utilities until the strategies converge. Finally, those cameras with the highest converged probabilities will be used for tracking and this assignment of persons to the "best" cameras leads to the solution of the handoff problem in multiple video streams.

 A set of symbols are used in the discussion for our approach and their descriptions are given in Table 12.1.

12.2.2.1 Computation of Utilities

We first define the following properties of our system:

1. A person P_i can be in the FOV of more than one camera. The available cameras for P_i belong to the set A_i. C_0 is assumed to be a virtual (null) camera.
2. A person can only be assigned to one camera. The assigned camera for P_i is named as a_i.
3. Each camera can be used for tracking multiple persons.

For some person P_i, when we change its camera assignment from a' to a'' while assignments for other persons remain the same, if

TABLE 12.1 Notations of Symbols Used in the Chapter

Symbols	Notations
P_i	Person i
C_j	Camera j
N_P	Total number of persons in the entire network at a given time
N_C	Total number of cameras in the entire network at a given time
A_i	The set of cameras that can see person i, $A_i = \{a_1, a_2, \ldots, a_{nc}\}$
n_C	Number of cameras that can see object i, number of elements in A_i
n_P	Number of persons currently assigned to camera C_j
a_i	The assigned "best" camera for person i
a_{-i}	The assignment of cameras for the persons excluding person i
a	Assignment of cameras for all persons, $a = (a_i, a_{-i})$
$U_{C_j}(a)$	Camera utility for camera j
$U_{P_i}(a)$	Person utility for person i
$U_g(a)$	Global utility
$\overline{U}_{P_i}(k)$	Predicted person utility for person i at step k, $\overline{U}_{P_i}(k) = [\overline{U}_{P_i}^1(k), \ldots, \overline{U}_{P_i}^l$ $\ldots, \overline{U}_{P_i}^{nc}(k)]^T$, where $\overline{U}_{P_i}^l$ is the predicted person utility for P_i if camera a_l is used
$p_i(k)$	Probability of person i's assignment at step k, $p_i(k) = [p_i(k) = [p_i^1(k), \ldots, p_i^l(k), \ldots, p_i^{nc}(k)]$, where $p_i^l(k)$ is the probability for camera a_l to track person P_i

$$U_{P_i}(a_i', a_{-i}) < U_{P_i}(a_i'', a_{-i}) \Leftrightarrow U_g(a_i', a_{-i}) < U_g(a_i'', a_{-i}) \qquad (12.1)$$

the person utility U_{P_i} is said to be aligned with the global utility U_g, where a_{-i} stands for the assignments for persons other than P_i, that is, $a_{-i} = (a_1, \ldots, a_{i-1}, a_{i+1}, \ldots, a_{N_P})$. So, we can also express a as $a = (a_i, a_{-i})$. We define the global utility as

$$U_g(a) = \sum_{C_j \in C} U_{C_j}(a) \qquad (12.2)$$

where $U_{C_j}(a)$ is the camera utility and defined to be the utility generated by all the engagements of persons with a particular camera. Now, we define the person utility as

$$U_{P_i}(a) = U_g(a_i, a_{-i}) - U_g(C_0, a_{-i}) = U_{C_j}(a_i, a_{-i}) - U_{C_j}(C_0, a_{-i}) \qquad (12.3)$$

The person utility $U_{P_j}(a)$ can be viewed as a marginal contribution of to the global utility, that is, the difference of the utility gained by assigning camera to track person compared with is tracked by a virtual camera (no camera). To calculate (12.3), we have to construct a scheme to calculate the camera utility $U_{C_j}(a)$. We assume that there are N_{Crt} criteria to evaluate the quality of a camera used for tracking an object. Thus, the camera utility can be built as

$$U_{C_j}(a_i, a_{-i}) = \sum_{s=1}^{n_P} \sum_{l=1}^{N_{Crt}} Cr \tag{12.4}$$

where n_P is the number of persons that are currently assigned to camera for tracking. Plugging (12.4) into (12.3) we can obtain

$$U_{P_j}(a_i, a_{-i}) = \sum_{s=1}^{n_P} \sum_{l=1}^{N_{Crt}} Crt_{sl} - \sum_{\substack{s=1 \\ s \neq P_i}}^{n_P} \sum_{l=1}^{N_{Crt}} Cr \tag{12.5}$$

where $s \neq P_i$ means that we exclude person from the those who are being tracked by camera C_j. One thing to be noticed here is that when designing the criteria, we have to normalize them.

12.2.2.2 Bargaining among Cameras

As stated previously, our goal is to optimize each person's utility as well as the global utility. Competition among cameras finally leads to the Nash equilibrium. Unfortunately, this Nash equilibrium may not be unique. Some of them are not stable solutions, which are not desired. To solve this problem, a *bargaining mechanism* among cameras is introduced, to make them finally come to a compromise and generate a stable solution.

When bargaining, the assignment in the kth step is made according to a set of probabilities

$$p_i(k) = [p_i^1(k), \ldots, p_i^l(k), \ldots, p_i^{n_C}(k)]$$

where n_C is the number of cameras that can "see" the person and $\sum_1^{n_C} p_i^l(k) = 1$, with each $0 \le p_i^l(k) \le 1, l = 1, \ldots, n_C$. We can generalize $p_i(k)$ to be

$$p_i(k) = [p_i^1(k), \ldots, p_i^l(k), \ldots, p_i^{N_C}(k)]$$

by assigning a zero probability for those cameras that cannot "see" the person, meaning that those cameras will not be assigned according to their probability. Thus, we can construct an $N_P \times N_C$ probrablity matrix

$$\begin{bmatrix} p_1^1(k) & \cdots & p_1^{N_C}(k) \\ \vdots & \ddots & \vdots \\ p_{N_P}^1(k) & \cdots & p_{N_P}^{N_C}(k) \end{bmatrix}$$

At each bargaining step, we will assign a person to the camera that has the highest probability. Since in most cases a person has no information of the assignment before it is made, we introduce the concept of *predicted person utility* $\bar{U}_{P_i}(k)$: Before we decide the final assignment profile, we predict the person utility using the previous person's utility information in the bargaining steps. As shown in (12.5), person utility depends on the camera utility, so, we predict the person utility for every possible camera that may be assigned to track it. Each element in $\bar{U}_{P_i}(k)$ is calculated by (12.6)

$$\bar{U}_{P_i}^l(k+1) = \begin{cases} \bar{U}_{P_i}^l(k) + \dfrac{1}{p_i^l(k)}(U_{P_i}(a(k))) - \bar{U}_{P_i}^l(k), & a_i(k) = A_i^l \\ \bar{U}_{P_i}^l(k), & \text{otherwise} \end{cases} \tag{12.6}$$

with the initial state $\bar{U}_{P_j}^l(1)$ to be assigned arbitrarily as long as it is within the reasonable range for $\bar{U}_{P_i}(k)$, for $l = 1, \ldots, n_C$. Once these predicted person utilities are calculated, it can be proved that the equilibrium for the strategies lies in the probability distribution that maximizes its perturbed predicted utility (Arslan et al. 2007),

$$P_i(k)' \bar{U}_{P_i}(k) + \tau H(p_i(k)) \tag{12.7}$$

where

$$H(p_i^l(k)) = -p_i^l(k)' \log (p_i^l(k)) \qquad (12.8)$$

is the entropy function and τ is a positive parameter belonging to [0,1] that controls the extent of randomization. The larger the τ is, the faster the bargaining process converges; the smaller the τ is, the more accurate result we can get. So, there is a trade-off when selecting the value of τ and we select τ to be 0.5 in our experiments. The solution of (12.7) is proved (Arslan et al. 2007) to be

$$p_i^l(k) = \frac{e^{(1/\tau)\bar{U}_{P_i}^l(k)}}{e^{(1/\tau)\bar{U}_{P_i}^l(k)} + \cdots + e^{(1/\tau)\bar{U}_{P_i}^{n_C}(k)}} \qquad (12.9)$$

After several steps of calculation, the result of p_i tends to converges (refer to Figure 12.8). Thus, we finally get the stable solution, which is proved to be at least suboptimal (Arslan et al. 2007). This overall algorithm is summarized in Algorithm as follows:

Algorithm: Game Theoretic Camera Assignment and Handoff

Input: Multiple video streams.
Output: A probability matrix according to which camera assignments are made.

Algorithm description:

- At a given time, perform motion detection and get the selected properties for each person that is to be tracked.
- For each person and each camera, decide which cameras can "see" a given person P_i.
- For those that can "see" the person P_i, initialized the predicted person utility vector $U_{P_i}(1)$.

Repeat

1. Derive the Crt_{sl} for each available camera.
2. Compute the camera utilities $U_{C_j}(a)$ by (4).
3. Compute the person utilities $U_{P_i}(a)$ by (5).
4. Compute the predicted person utilities $U_{P_i}(k)$ by (6).
5. Derive the strategy by $P_i(k)$ using (9).

Until the strategies for assignment converge.

- Do the camera assignment and handoff based on the converged strategies.

12.2.3 Experimental Results

12.2.3.1 Data

In this section, we test the proposed approach for both a single person and two persons who are walking through three Axis 215 PTZ cameras. The experiments are carried out with no camera calibration needed. The cameras are placed arbitrarily. An illustration for the camera configuration for the experiment is shown in Figure 12.1. To fully test whether the proposed approach can help to select the "best" camera based on the user-supplied criteria, some of the FOVs of these cameras are allowed to intersect intentionally while some of them are nonoverlapping. This is important for tracking various people in a camera network.

A person observer selects the walking person manually when he first enters the FOV of a camera and detected by background subtraction around the edges when he leaves and re-enters the FOV (we suppose that there are no doors in the FOVs). The tracking is done by using the Continuous Adaptive Mean-Shift Algorithm proposed by Bradski

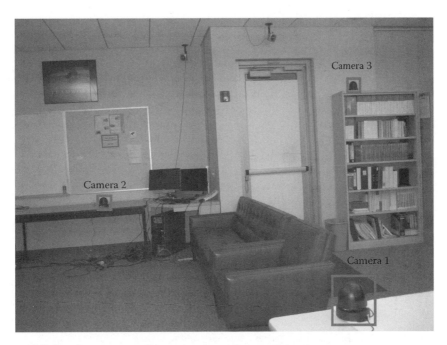

Figure 12.1 Camera configuration in our experiments.

in Bradski (1998). Different persons are identified by calculating the correlation of the hue histograms of the pixels inside their bounding boxes using the OpenCV function CompareHist (http://opencv.willow garage.com/wiki/CvReference). In our experiment, we compare the colors of the upper bodies (around 1/2 size of the bounding box) first, when the colors of the upper bodies are similar, then, we continue to compare the colors of the lower body and identify persons by the color combination of the upper body and the lower body.

For the sake of privacy, we perform only simulations for large numbers of cameras and persons instead of doing the experiments with real data.

12.2.3.2 Criteria for Camera Assignment and Handoff

A number of criteria, including human biometrics, can be used for camera assignment and handoff. For easier comparison between the computed results and the intuitive judgment, four criteria are used for a camera selection:

1. The **size** of the tracked person. It is measured by the ratio of the number of pixels inside the bounding box of the person to that of the size of the image plane. Here, we assume that neither a too large nor a too small object is convenient for observation. Assume that λ is the threshold for best observation, that is, when $r=\lambda$ this criterion reaches its peak value,

 where $r = \dfrac{\text{\# of pixels inside the boundary box}}{\text{\# of pixels inside the image plane}}$.

 $$Crt_{i1} = \begin{cases} \lambda r, & \text{when } r < \dfrac{1}{\lambda} \\ \dfrac{1-r}{1-\lambda}, & \text{when } r \geq \dfrac{1}{\lambda} \end{cases} \qquad (12.10)$$

2. The **position** of the person in the FOV of a camera. It is measured by the Euclidean distance that a person is away from the center of the image plane

$$Crt_{i2} = \frac{\sqrt{(x - x_c)^2 + (y - y_c)^2}}{\frac{1}{2}\sqrt{x_c^2 + y_c^2}} \qquad (12.11)$$

where (x, y) is the current position of the person and (x_c, y_c) is the center of the image plane.

3. The **view** of the person, as measured by the ratio of the number of pixels on the detected face to that of the whole bounding box, which is similar to criterion 1. We assume that the threshold for best frontal view is, i.e. when $R=\xi$ the view of the person is the best, where $R = \dfrac{\text{\# of pixels on the face}}{\text{\# of pixels on the entire body}}$.

$$Crt_{i3} = \begin{cases} \xi r, & \text{when } R < \dfrac{1}{\xi} \\ \dfrac{1 - R}{1 - \xi}, & \text{when } R \geq \dfrac{1}{\xi} \end{cases} \qquad (12.12)$$

4. **Combination** of criteria 1, 2, and 3, which is called the *combined criterion* is given by the following equation,

$$Crt_{i4} = \sum_{m=1}^{3} w_m Crt_{im} \qquad (12.13)$$

where w_m are the weights for different criteria.

It is to be noticed that all these criteria are normalized for calculating the corresponding camera utilities.

In our experiments, we give value to the parameters empirically. $\lambda = (1/15)$, $\xi = (1/6)$, $w_1 = 0.2$, $w_2 = 0.1$, and $w_3 = 0.7$. This is because we prefer a frontal view of the person whenever it is available, while a continuous tracking is the bottom line when the frontal view is not detected.

12.2.3.3 Evaluation Measurements

In our experiments, the bottom line is to track walking persons seamlessly whenever they appear in the FOV of any of the cameras. In the case where more than one camera can "see" the persons, those ones that can "see" the persons' face are always the most preferable. Based on this goal, if we define the error in our experiments as either failing to track a person or failing to get the frontal-view of the person whenever it is available. The performances for using criterion 1, criterion 2, or criterion 3 alone in a two-person experiment are 25.56%, 10.00%, and 30.00% respectively. We can notice that based on our error definition, single criterion incurs a high error rate. Hence, we introduce the combined criterion to overcome this error rate.

12.2.3.4 Analysis for Experiments with Different Criteria

- A single-person case

Figure 12.2 gives the camera handoffs based on the combined criterion in a single-person experiment. The camera with a dark bounding box is the one to be chosen. As shown in Figure 12.2, a frontal-view person (whenever it is available) is selected for most of the frames. Sometimes, the frontal view is not selected because the face is not detected. In some frames, such as in Figure 12.2b, although the frontal view is available, the person is too close to the edge of the image or the size of the person is far from the "good size" threshold. In this case, the system will choose some other available camera. All the handoffs and interesting events are listed in Table 12.2, where we use **E** denoting that the person is entering the FOV of a camera while **L** denoting that the person is leaving the FOV of a camera. **A** implies that the camera can see the object and, thus, it is available for tracking, while **N** implies that there is no object in the FOV of a camera. The last column in Table 12.2, **Used**, gives the camera that is selected to track the person. There are altogether 600 frames. It shows that camera handoff is carried out correctly especially when the person is entering or leaving the FOV of some cameras.

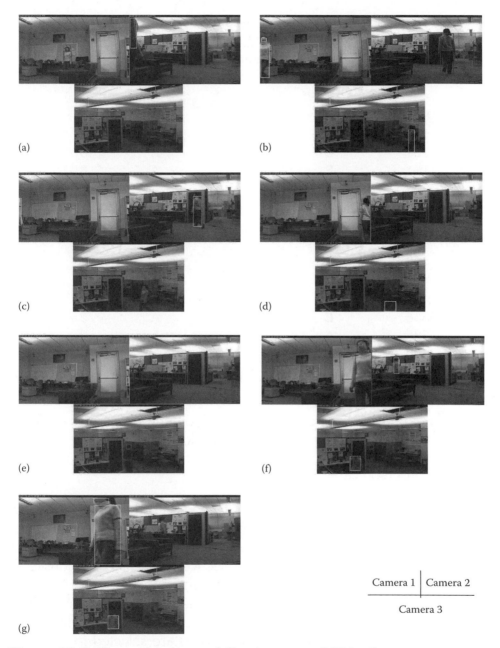

Figure 12.2 (See color insert following page 332.) Camera assignments and handoffs in the 1 person 3 cameras case. The camera in which the bounding box is the dark color is selected to track the person.

TABLE 12.2 Handoffs among 3 Cameras during 20 s for the 1 Person 3 Cameras Case

Frame	Camera 1	Camera 2	Camera 3	Used
1	A	A	N	1
69	A	A	**E**	1
88	A	A	A	2
120	A	A	A	3
121	**L**	A	A	3
131	**E**	A	A	3
209	A	**L**	A	3
226	A	N	**L**	1
357	A	N	**E**	3
379	A	**E**	A	3
409	A	A	A	1
427	A	A	A	2
483	**L**	A	A	2
556	**E**	A	A	2
585	A	A	**L**	2
600	A	A	N	END

Note: **A**, available; **E**, entering; **L**, leaving; **N**, not available.

A more detailed discussion for choosing different criteria is analyzed in the two person case as discussed in the following text.

- A two-person case

Different experiments are carried out to compare the results for using the three different single criteria mentioned previously with the combined criterion. The weights we use to combine the three criteria, in our experiments, are 0.2, 0.1, and 0. 7 respectively, as stated previously. To make it convenient for a comparison, we show the tracking results of other cameras as well, no matter whether they are selected for tracking or not. Similar to the single person experiment, the cameras, for which the bounding boxes are drawn in dark color, are selected for tracking while the ones in the light color are not as good as the dark ones.

A comparison for using criterion 1, criterion 2, and criterion 3 respectively at two time instants is shown in Figure 12.3. We can

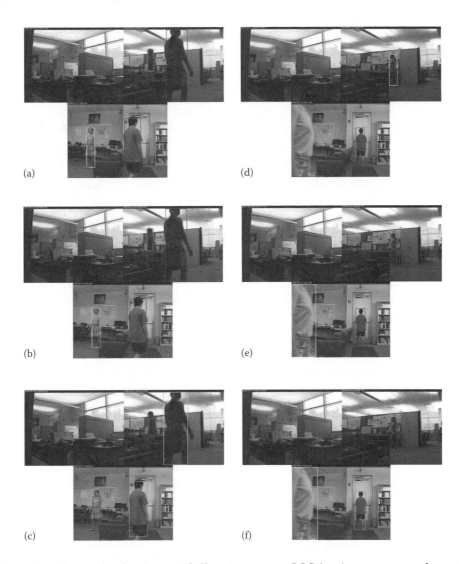

(a) (d)

(b) (e)

(c) (f)

Figure 12.3 (See color insert following page 332.) A comparison for using different criteria. The left column and the right column are for two time instants respectively. The first row through the third row are using criterion 1 to criterion 3, respectively.

observe that in Figure 12.3a through c uses criterion 1 through 3 in time instant 1 while Figure 12.3d through f uses criterion 1 through 3 at time instant 2. It can be noticed from Figure 12.3d that the problem for using criterion 1 only is that when the objects are getting

close to the cameras, the size of the bounding box will increase to a non-desirable size for observation any more. Meanwhile, there are often some cases that when the person is entering the scene, its size is not small but only part of the body is shown, which should not be preferred as well if some other cameras can give a full view of the body. Thus, we introduce criterion 2, considering the relative position of the objects in the FOVs of the cameras. The closer the centroid of the person is to the center of the FOV, the higher the camera utility is generated. We can observe that when applying criterion 2 in Figure 12.3e, the camera with the object near the center is chosen and we can, thus, obtain a higher resolution of the person compared with the results for using criterion 1 in Figure 12.3d. However, the problem for using criterion 1 or criterion 2 only is that in many frames we reject the cameras that can see a person's face, which is of general interest. This case is shown in Figure 12.3a, b, and d. To solve this problem, we come up with criterion 3. So, when applying criterion 3, we can obtain a more desirable camera with a frontal view of the person in Figure 12.3c and f. Whereas criterion 3 can successfully select a camera with a frontal-view person, it may fail to track a person when no face can be detected. For instance, as shown in Figure 12.3f, although the person is in the FOV of some camera, it is "lost" based on criterion 3.

So, finally, we come up with a weighted combination of these three criteria. As stated previously, we use 0.2, 0.1, and 0.7 as the weights for these three criteria respectively so that, in most cases, the system will choose the camera that can "see" a person's face. For those frames where there is a person with no face detected, the combination criterion can also provide a "best" camera based on criteria 1 and 2 and, thus, realize a continuous tracking. All the camera handoffs, when applying the combined criterion, are shown in Figure 12.4a through i. The error rate (as defined in Section 12.2.3.3) in this case is 5.56%. This combined criterion provides camera assignments and handoffs with a minimum error rate among the four criteria defined in Section 12.2.3.2. Camera utilities, person utilities, and the corresponding assignment probabilities for the using the combined criterion is shown in Figure 12.5, where Probability[i][j] stands for the probability that Camera j is assigned to track Person i.

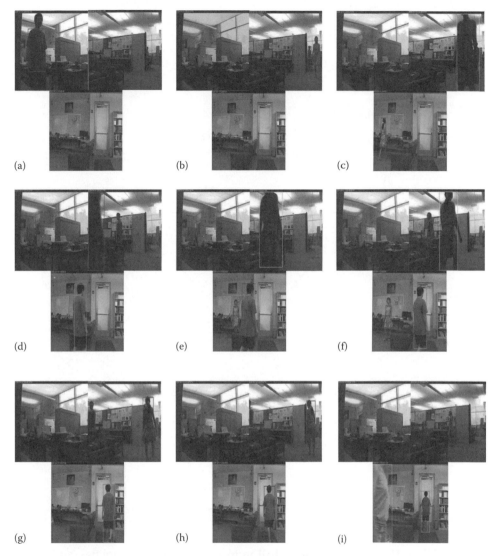

(a) (b) (c)

(d) (e) (f)

(g) (h) (i)

Figure 12.4 (See color insert following page 332.) All camera handoffs when applying the combined criterion for 2 persons and 3 cameras case.

In an n-camera n-person case, we can expect that the number of iteration of the proposed approach will go up much slower than that of the exhaustive approach. So, the computational time-saving advantage of the proposed approach will be more obvious as the situation of the task becomes more complicated, as shown in our simulation result in Figure 12.6.

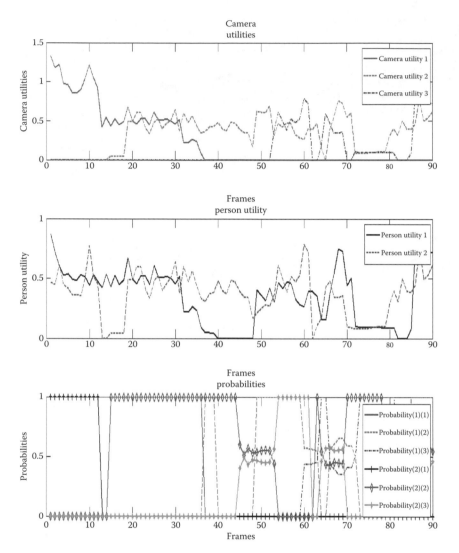

Figure 12.5 (See color insert following page 332.) Utilities and assignment probabilities for each processed frame when using the combined criterion. Probability[i][j] stands for the probability that camera j is selected to track person i.

12.2.3.5 Convergence of Results for Bargaining

In our experiments, in most cases, the probabilities for making the assignment profile converges (with $\varepsilon < 0.05$, where ε is the difference between the two successive results) within 5 iteration. So, we use 5

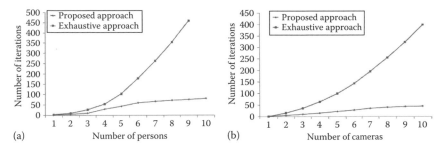

(a) Number of persons (b) Number of cameras

Figure 12.6 Simulation result for more cameras and persons. (a) The result for a fixed number of cameras. (b) The result for a fixed number of persons.

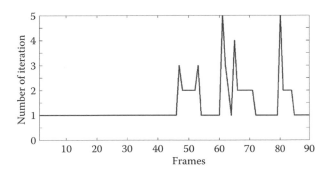

Frames

Figure 12.7 Number of iteration for the bargaining mechanism in each.

as the iteration threshold when bargaining. Thus, for those cases that will not converge within 5 iterations, there may be an assignment error based on the unconverged probabilities, as discussed in Section 12.2.3.2. In Figure 12.7, we plot the number of iteration with respect to every processed frame. It turns out that the average iteration number for the case in our experiment is 1.37. As the numbers of persons and cameras increase, this bargaining system will save a lot of computational cost to get the optimal camera assignments. A typical convergence for one of the assignment probabilities in a bargaining among cameras is given in Figure 12.8.

12.2.3.6 Comparison with Another Related Approach

In this section, we will compare our approach with another camera assignment approach by Jo and Han in (2006). The authors

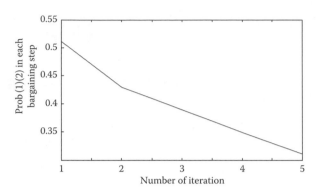

Figure 12.8 A typical convergence in bargaining.

perform camera handoffs by calculating the COR (the co-occurrence to occurrence ratio). We will call this the COR approach.

In Jo and Han (2006), the mean probability that a moving object is detected at a location x in the FOV of a camera is called an occurrence at x. The mean probability that moving objects are simultaneously detected at x in the FOV of one camera and x' in the FOV of another camera is called a co-occurrence of x and x'. The COR approach decides whether two points are in correspondence with each other by calculating the COR. If the COR is higher than some predefined threshold, then the two points are decided to be in correspondence with each other. When one point is getting close to the edge of the FOV of one camera, the system will handoff to another camera that has its corresponding point. However, the COR approach in Jo and Han (2006) has been applied to two cameras only. We generalize this approach to the cases with more cameras by comparing the accumulated COR in the FOVs of multiple cameras. We randomly select 100 points on the detected person, train the system for 10 frames to construct the correspondence for these 100 points, calculate the cumulative CORs in the FOVs of different cameras, and select the one with the highest value for handoff.

Experiments have been done to compare the COR approach with our approach for the 1 person 3 cameras case and the 2 persons 3 cameras case.

- The 1 person 3 cameras case

The handoff process by using the COR approach and the corresponding frames by using our approach (may not be the handoff frames) are shown in Figure 12.9. In Figure 12.9f through h, the COR approach

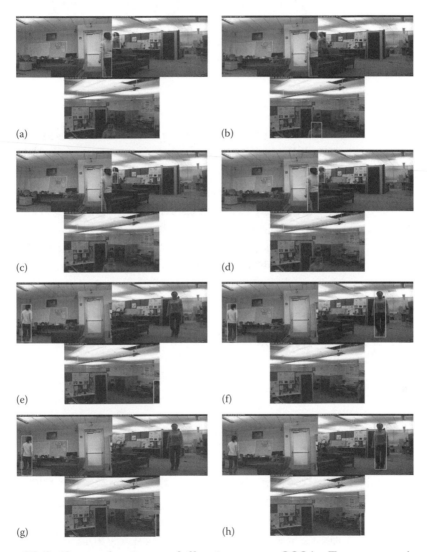

(a) (b)

(c) (d)

(e) (f)

(g) (h)

Figure 12.9 (See color insert following page 332.) Two camera handoffs by using the co-occurrence to occurrence ratio (COR) approach and the comparison with our approach. The left column are the results by our approach and the right column are the results by the COR approach.

switches to camera 1, while our proposed approach sticks to camera 2 to get the frontal view of the person. The COR approach needs a time period to construct the correspondence between views of different. As stated earlier, we let this period to be 10 frames. As a result, there is some time delay for the handoff. For instance, in Figure 12.9a through d, our approach has already switched to camera 3 in Figure 12.9a as long as the size of the person is unacceptable, but the COR approach does this in Figure 12.9d.

- The 2 person 3 cameras case

In Figure 12.10, we show the comparison of results in this case. We can notice that the COR approach produces more errors. Whenever there is occlusion in one of the FOVs, there is a high probability that the COR approach will provide the wrong points in another FOV and this causes loss of track for some persons. Examples are Figure 12.10b, d, f. By the comparison, we can notice that the COR approach can only switch the camera to another one when the person is about to leave the FOV, but cannot select the "best" camera based on other criteria. So, the number of handoffs by our approach is larger than that of the COR approach (see Table 12.3). If we use the definition of error as stated in the Section 12.2.3.3, the error rates for these two cases are compared in Table 12.3.

12.3 SUMMARY

In this paper, we proposed a new principled approach based on game theory for camera assignment and handoff problem. The approach is independent of the spatial and geometrical relationships among the cameras. It is robust with respect to multiple criteria for tracking are considered. The key merit of the proposed approach is that we use the game theory framework with bargaining mechanism for camera assignment in a video network so that we can obtain a stable solution with a small number of iterations. This makes our approach computationally more efficient and robust with respect to other existing approaches,

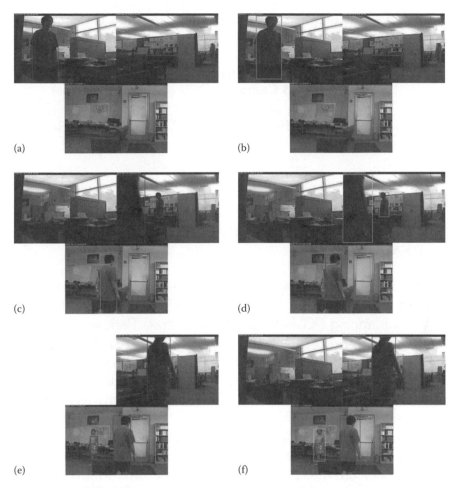

(a) (b)

(c) (d)

(e) (f)

Figure 12.10 (See color insert following page 332.) Some camera handoff errors by the co-occurrence to occurrence ratio (COR) approach and handoffs in a single-person case. In (b), since there is no identification mechanism, the COR approach mismatches the two persons and loses track one of the two persons. In (d) the system fails to calculate the co-occurrence to occurrence ratio and, thus, loses the person in the light color although it is available in camera 2. In (f), the COR approach mismatches the person and loses to track one of the persons.

such as Jo and Han (2006). Future work will allow communications among cameras, which will make the computational framework and computational resources decentralized and distributed.

TABLE 12.3 Comparison of Error Rates for the Co-Occurrence to Occurrence Ratio (COR) Approach and Our Proposed Approach

	Case 1 (1 Person 3 Cameras)		Case 2 (2 Person 3 Cameras)	
	Number of Handoffs	Error Rate (%)	Number of Handoffs	Error Rate (%)
The COR approach	4	38.77	5	45.62
Our approach	6	2.87	8	5.56

12.4 BIBLIOGRAPHICAL AND HISTORICAL REMARKS

There have been many papers discussing approaches for camera assignments in a video network. Javed et al. (2000) focus on finding out the limits of overlapping FOVs of multiple cameras. Park et al. (2006) create distributed look-up tables according to how well the cameras can image a specific location. Jo and Han (2006) construct a handoff function by computing the ratio of co-occurrence to occurrence for several pairs of points in the FOVs of two corresponding cameras. This kind of approaches rely on obtaining the spatial topology of the camera network and calculating the geometrical relationships among cameras, which tends to be quite complicated when the topology becomes complex and it is difficult to learn the topology based on the random traffic patterns. Statistics-based methods (Kettnaker and Zabih 1999, Chang and Gong 2001, Kang et al. 2003, Javed et al. 2005, Song and Roy-Chowdhury 2007) provide an optimal solution with respect to object trajectories, while other factors, such as orientation, shape, and face, which are also very important for tracking, are not considered. Also, many researchers have used calibrated cameras, an example is Cai and Aggarwal (1999).

REFERENCES

Arslan, G., Marden, J.R., and Shamma, J.S. 2007. Autonomous vehicle-target assignment: A game-theoretical formulation. *ASME Journal of Dynamic Systems, Measurement, and Control*, special issue on *Analysis and Control of Multi-Agent Dynamic Systems*, 129, 584–596.

Bradski, G.R. 1998. Computer vision face tracking for use in a perceptual user interface. *Intel Technology Journal*, Q2, 1–15.

Cai, Q. and Aggarwal, J.K. 1999. Human motion in structured environments using a distributed camera system. *IEEE Transaction on Pattern Analysis and Machine Intelligence*, 21(11), 1241–1247.

Chang, T. and Gong, S. 2001. Bayesian modality fusion for tracking multiple people with a multi-camera system. In *European Workshop on Advanced Video-Based Surveillance Systems*, Vancouver, Canada.

http://opencv.willowgarage.com/wiki/CvReference#Histograms

Javed, O., Khan, S., Rasheed, Z. and Shah, M. 2000. Camera handoff: Tracking in multiple uncalibrated stationary cameras. In *IEEE Workshop on Human Motion*, Austin, TX, pp. 113–118, 212.

Javed, O., Shafique, K., and Shah, M. 2005. Appearance modeling for tracking in multiple non-overlapping cameras. In *International Conference on Computer Vision and Pattern Recognition*, San Diego, CA, Vol. 2, pp. 26–33.

Jo, Y. and Han, J. 2006. A new approach to camera handoff without camera calibration for the general scene with non-planar ground. In *ACM International Workshop on Video Surveillance and Sensor Networks*, Santa Barbara, CA, pp. 195–202.

Kang, J., Cohen, I., and Medioni, G. 2003. Continuous tracking within and across camera streams. In *International Conference on Computer Vision and Pattern Recognition*, Madison, WI, Vol. 1, pp. 267–272.

Kettnaker, V. and Zabih, R. 1999. Bayesian multi-camera surveillance. In *International Conference on Computer Vision and Pattern Recognition*, Fort Collins, CO, p. 259.

Li, Y. and Bhanu, B. 2008. Utility-based dynamic camera assignment and handoff in a video network. In *International Conference on Distributed Smart Cameras*, Stanford, CA.

Myerson, R.B. 1991. *Game Theory-Analysis of Conflict*. Harvard University Press, Cambridge, MA.

Park, J., Bhat, P.C., and Kak, A.C. 2006. A look-up table based approach for solving the camera selection problem in large camera networks. In *IEEE Workshop on Distributed Smart Cameras*, Boulder, CO.

Song, B. and Roy-Chowdhury, A. 2007. Stochastic adaptive tracking in a camera network. In *International Conference on Computer Vision*, Rio de Janeiro, Brazil, pp. 1–8.

13

Quality-Based Multisensor Fusion

Lauro Snidaro, Ingrid Visentini,
and Gian Luca Foresti

CONTENTS

13.1 INTRODUCTION

Video surveillance systems have always been based on multiple sensors since their first generation (CCTV systems) (Regazzoni et al. 2001). Video streams from analog cameras were multiplexed on video terminals in control rooms to help human operators monitor entire buildings or wide open areas. The last generation makes use of digital equipment to capture and transmit images that can be viewed virtually everywhere using the Internet.

In recent years, scientific research has been very active in designing and developing automatic systems that could ease the burden of human operators by automatically detecting potential distress situations where immediate intervention is required to avoid injuries and/or damage (e.g., ongoing crime acts, vehicle stopped in a tunnel or on railway crossings, etc.) (Regazzoni et al. 2001).

Key initial steps that provide useful information for the understanding of observed scenes are detection, tracking, and classification of moving objects (Regazzoni et al. 2001, Foresti et al. 2005). Additional processing steps may be required when multiple sensors observe the same target. Initially, multisensor systems were employed to extend surveillance coverage over wide areas. The recent advances in sensor and communication technology, in addition to lower costs, allow to use multiple sensors for the monitoring of the same area (Snidaro et al. 2007, Aghajan and Cavallaro 2009). Multiple and possibly heterogeneous sensors observing the same scene provide redundant data that can be exploited to improve robustness and monitoring performance (Snidaro et al. 2007).

The possibility to perform data fusion is one of the most interesting features available to multisensor systems, because a greater system robustness and performance is in fact achievable with a suite of sensors and through data-fusion techniques (Hall and Llinas 1997). However, if data coming from different sensors have to be fused (i.e., to improve the confidence in tracking estimates by reducing the error covariance (Snidaro et al. 2007)), then the "garbage in → garbage out" pathological case of data-fusion systems should be avoided (Hall and Llinas 1997) by estimating accurately the quality of the available sensors. For example, in sensor selection and target tracking, where one of the

phases is to choose the most appropriate sensor or set of sensors to perform a certain task (i.e., close-up video recording of a target) at a given time instant.

In this chapter, we discuss the problem of assessing the performance of video sensors for data fusion in multi-camera systems for video surveillance purposes. We propose a framework for quality-based multi-cue multisensor fusion based on ensembles of classifiers built on multiple features for target detection. Each target is tracked by online-trained ensembles, one for each camera observing the target. The presented framework inherently yields a confidence value for each detection that can be employed both for selecting the most informative sensor and for weighting the fusion of redundant data. Experimental results are shown on real-world video sequences.

13.2 SYSTEM ARCHITECTURE

The logical architecture of the proposed multi-camera video surveillance system is sketched in Figure 13.1. An ensemble of classifiers is trained online for each target in each image plane, as described in Section 13.3, for both detection and tracking tasks. Each classifier

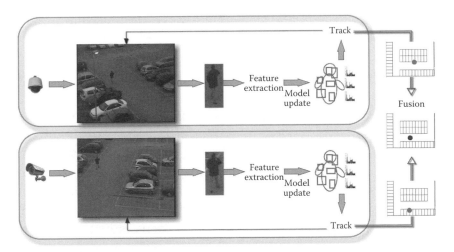

Figure 13.1 (See color insert following page 332.) Sketch of the logical architecture of the system.

in the ensemble is built on the values provided by a feature extracted from the image.

We employ multiple heterogeneous features, detailed in Section 13.3.3, in order to achieve robust tracking performance. The homographic transformations between camera planes and the ground plane are determined during the initial setup of the system. The operator establishes the correspondences between salient points on the image planes and the ground plane. Details on homographic transformations can be found in Hartley and Zisserman (2004). At each frame, the ensemble provides the most probable position on the image of the target for which it was trained. This position is then projected to the top-view map of the area through the appropriate homographic transformation (Hartley and Zisserman 2004). Positions projected by the sensors on the area map originating from the same target have to be matched by a data association algorithm. Many matching algorithms are available in the literature: Nearest Neighbor (NN), Joint Probabilistic Data Association (JPDA), Multiple Hypothesis Tracking (MHT), and S-D assignment, to name a few. Here, since the focus is not on multi-target tracking, a simple approach based on the closest positions falling within a gating region has been adopted (Mitchell 2007). The transformed positions provided for each frame by the sensors observing the scene are then fused into one estimate that can be fed to anomaly detection modules (Snidaro et al. 2006). The processing steps will now be discussed in more detail in the following sections.

13.3 TARGET DETECTION USING FUSION

The first processing steps of our proposed approach involve object detection and tracking performed for each target and each sensor. We employ heterogeneous features to describe a moving object (Figure 13.2) and we learn the target's appearance by online trained classifiers. The tracking is therefore performed by a classification module following the idea detailed in Grabner and Bischof (2006) and Avidan (2007). In Parag et al. (2008), the focus is instead at a higher level of integration of responses: the authors merge the confidence maps coming from a feature extraction step in order to find the target position. They recall the approach presented in Avidan (2007), where

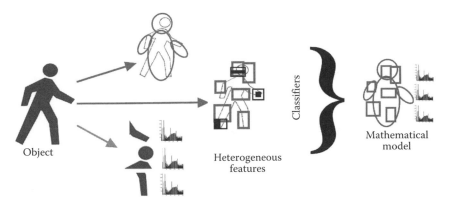

Figure 13.2 (See color insert following page 332.) Heterogeneous features describe a moving object.

a set of weak classifier is employed to track an object via confidence maps. In Parag et al. (2008), the authors aim to combine heterogeneous weighted data without involving classifiers and without maintaining a model of the object, but performing a frame-to-frame tracking with salient features extracted at each epoch, while Avidan uses a set of classifiers that are integrated and updated through time.

The problem of fusing different classifiers to provide a more robust and accurate detection has been studied since the early 1990s, when the first approaches to the problem were detailed. Boosting (Freund and Schapire 1996, Freund 2001), bagging (Breiman 1996), and other forms of classifier combination (Kittler et al. 1998, Kuncheva 2002, Kuncheva and Whitaker 2003) give an experimental confirmation and a strong theoretical explanation that diverse hypotheses joined together produce a strong ensemble, whose error is lower than the single classifiers. The strategies to fuse the classifiers output are numerous and varied, from simple rules to oracles, from mixtures of experts to low-level combinations (see Polikar (2006) for a recent tractation).

In this work, we propose to use a uniform framework to manage different types of features, yielding thus to a heterogeneous fusion of classifiers. A simple but effective classifier combination is used to localize the object in a single sensor frame and the classification step is exploited as a tracker as suggested in Avidan (2007). Then, for every sensor, a trained set of classifiers provides a confidence map that

indicates the probability of the target's occurrence in the frame; the maximum gives the object position and the value of the confidence indicates the probability of detection. This value can be exploited as a quality measure to weight the results coming from the sensors: to select them or to combine the outputs to give a more reliable estimate.

13.3.1 Classifier Combination

Consider two possible classes $\{\omega_1, \omega_2\} = \Omega$ so that $\omega_1 = +1$ represents the target, and $\omega_2 = -1$ the background, and let f be a feature extractor that takes as input an image patch \mathbf{x}. With h being a binary classifier, $h: \Re^d \rightarrow \{-1, +1\}$, we apply the Bayesian classifier h to the descriptor provided by the feature extractor. The pattern \mathbf{x} is assigned to class ω_j if the latter has the maximum posterior probability:

$$h(f(\mathbf{x})) = \arg\max_{\omega_j \in \Omega} P(\omega_j \mid f(\mathbf{x})) \propto \arg\max_{\omega_j \in \Omega} P(\omega_j) P(f(\mathbf{x}) \mid \omega_j) \qquad (13.1)$$

with $j = 1, 2$. We consider a classifier ensemble H based on the average combination rule so that M (weak) classifiers are fused together as $H(\mathbf{x}) = \sum_{m=1}^{M} \alpha_m h_m(\mathbf{x})$. Considering $\alpha_m = \log(1 - \varepsilon_m / \varepsilon_m)$ with $\varepsilon_m = w_{sw} / w_{sc} + w_{sw}$ being error of the mth classifier that depends on the number of incorrectly recognized samples, w_{sw}, and on the amount of correct hits w_{sc}, we obtain

$$H(\mathbf{x}) = \left(\sum_{m=1}^{M} \log\left(\frac{1 - \varepsilon_m}{\varepsilon_m} \right) h_m(f_m(\mathbf{x})) \right) \qquad (13.2)$$

When a zero crossing threshold is used on the ensemble output, we have

$$\hat{H}(\mathbf{x}) = \text{sign}\left(\sum_{m=1}^{M} \log\left(\frac{1 - \varepsilon_m}{\varepsilon_m} \right) h_m(f_m(\mathbf{x})) \right) \qquad (13.3)$$

which is the online boosting classifier combination formula. In this case, the learning is demanded to the weights that are adjusted considering the behavior of the classifiers on the training set (Oza 2005).

For the construction of a strong ensemble starting from a training base, diversity-driven methods (Giacinto and Roli 2001, Kuncheva and Whitaker 2003), bagging, boosting, online boosting (Oza 2005, Pelossof et al. 2008) (that implicitly promotes the diversity between classifiers), or classifier trees (Shannon and Banks 1999) can be used. All these techniques use a training set of couples $\{x_i, \omega_i\}$, where $x_i \in X$ is the pattern and $\omega_i \in \Omega$ is the correspondent label, to teach the classifiers to discriminate between the different classes. We employ the online boosting technique, presented before, linearly combining the classifiers with weights to establish their importance.

This classifier combination refers to a single detector in our multi-camera system; for each view, every target has its own ensemble classifier. It is then important for the ensemble to be fast and accurate; we use the cascade method described in Snidaro and Visentini (2008) that builds a cascade of attention made of layers of hypotheses previously trained with the online boosting algorithm. In this way, the application is guaranteed to satisfy the real-time constraint, but at the same time the pool of experts is constantly updated.

To learn the target appearance, the parameters of the normal distributions $N_\omega(\mu_{m,t,\omega}, \sigma_{m,t,\omega})$, maintained by the classifiers for each class, are updated as follows:

$$\mu_{m,t,\omega} = (1 - \rho)\mu_{m,t-1,\omega} + \rho h(\mathbf{x}) \tag{13.4}$$

$$\sigma^2_{m,t,\omega} = (1 - \rho)\sigma^2_{m,t-1,\omega} + \rho(h(\mathbf{x}) - \mu_{m,t,\omega})^2 \tag{13.5}$$

where
 t is the epoch
 ω refers to the class
 ρ is a learning rate parameter

In our experiments, ρ was set to 0.25 taking into account the frame rate and the typical movement speed of observed objects; small fluctuations in its value produced no significant effects. At the same time, the negative distribution is updated with some background random samples taken from the current frame.

13.3.2 Quality Estimation and Fusion

The detection probability yielded by the classifier ensembles can be exploited as a quality measure to be used in the fusion of the positional data of the target in the common reference frame given by the top-view map of the area observed by multiple sensors.

The process is depicted in Figure 13.3 and can be formalized as follows. Let k be the index of the K cameras employed in our scenario, we define the detection quality of target \mathbf{x} at time t provided by sensor k as the posterior probability that sample \mathbf{x} belongs to the class $\omega=+1$.

$$Q_{k,t}(\mathbf{x}) = \frac{1}{M}\sum_{m=1}^{M} p(\omega=+1 \mid f_m(\mathbf{x})) \propto \frac{1}{M}\sum_{m=1}^{M} p(\omega=+1)\, p(f_m(\mathbf{x}) \mid \omega=+1)$$

$$(13.6)$$

Given the position $\vec{r}_{k,\mathbf{x}}=(x_k,y_k)$ of target \mathbf{x} for the kth sensor, the quality becomes the coefficient for a linear combination of all the cameras estimations, so that

$$\vec{r}_{\mathbf{x}} = \sum_{k=1}^{K}\left[\frac{Q_{k,t}(\mathbf{x})\,\vec{r}_{k,\mathbf{x}}}{\sum_{k=1}^{K} Q_{k,t}(\mathbf{x})}\right] \qquad (13.7)$$

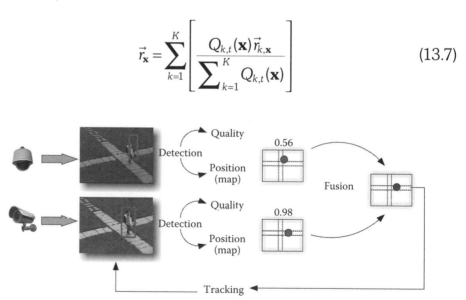

Figure 13.3 The detection probability is used as a quality measure for weighting the fusion process that combines the position of the target on the top-view map of the area observed by multiple sensors.

If the tracking process on the map plane is performed by applying a filter such as the Kalman filter, the quality measure can be employed to regulate the sensibility of the filter to the observations. The idea is to obtain from the Kalman filter a fused estimate more influenced by accurate estimates and almost unaffected by inaccurate ones. Unreliable sensors, namely, those whose detected targets have quality values below a given threshold, may be even completely discarded in the fusion process. In this way, the fused estimates are obtained only from the pool of sensors that are giving an acceptable performance. In Snidaro et al. (2007) this is achieved by dynamically adjusting the values of the measurement error covariance matrix of the filter through a function that involves the quality measure of the target at each iteration.

13.3.3 Examples

We show the application of our approach for weighted fusion of object positions in the following examples. The hardware employed is an AMD Athlon64 3500+with 1 GB of RAM. All the modules have been implemented in C++ using fast structures and optimizations to reduce computational requirements.

13.3.3.1 Features

In this work, we employed different types of features to describe an object: Haar features (Lienhart and Maydt 2002), local binary patterns (LBP) (Zhao and Pietikainen 2006), and color histograms (Porikli 2005) have been used.

The LBP operator is obtained applying the descriptor to eight neighbors around a centre (x_c, y_c) and has the form

$$LBP(x_c, y_c) = \sum_{i=0}^{7} \left(f(v_i, v_c) 2^i \right) \tag{13.8}$$

where v_i is the intensity value of the pixel at location (x_i, y_i) and

$$f(v_i, v_j) = \begin{cases} 1 & \text{if } (v_i < v_j) \\ 0 & \text{otherwise} \end{cases}$$

In our case, the use of the integral histograms combined with the modular approach suggested in Porikli (2005) is used to describe the texture of a generic block with reduced computational effort and to capture the image structure at larger scales. Therefore, v_i becomes the average of the intensities of gray-level values computed on the rectangle around (x_i, y_i) with radius r, and the intensity value in (x_c, y_c) acts as a threshold for the neighbors values.

As weak learners, for each hypothesis h_k two normal distributions were maintained over observed positive (target, $\omega_1 = +1$) and negative (background, $\omega_2 = -1$) samples, so that the final single classifier prediction is given by the class having the maximum posterior probability; therefore, the classifier confidence is the posterior probability given by the most probable class.

13.3.3.2 First Example

Two cameras placed on the top of the university building are observing three men walking in a courtyard. Here, we consider only one person as the target to simplify trajectory drawing.

We acquired more than 1200 frames with resolution 720×576 pixels at a frame rate of 25 fps, but only 820 of them contain the selected target. The output positions are plotted on a common ground plane, and the results are fused according to the confidence of the detectors. The placement of the cameras and their fields of view are shown in Figure 13.4. In this case, the two cameras are positioned very close but due to different optics the scene is acquired as seen at different zoom factors.

In Figure 13.5, some frames taken from the courtyard video sequences are presented. As target, we selected a pedestrian entering from the bottom of the image in both sensors; the person walks on the tiles path starting from the bottom-right corner of the image and walking toward the top-left one. The pedestrian enters the field of view of the first camera about 200 frames before being detected by the second one.

The three men meet around frame 720; the resulting partial occlusion can be a potential source of ambiguity for a simple change detection algorithm, since it wouldn't be able to discriminate the three targets.

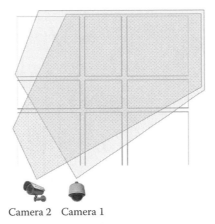

Camera 2 Camera 1

Figure 13.4 Deployment of the cameras in the courtyard sequence.

Figure 13.5 Frames from the courtyard video sequence. Three men walk in the university courtyard, meeting at some point; this event represents a potential ambiguity for the tracker. The top row shows the frames taken from the first sensor while the bottom row displays the corresponding frames from the second camera.

Instead, the employed framework based on online trained classifiers is able to resolve the ambiguity and correctly track the target.

Figure 13.6 shows the graphs of the confidence values of the two detectors tracking the target. We can notice a confidence drop around frame 720, which corresponds to the partial occlusion. The ambiguity is quickly recovered when the target separates from the group.

In Figure 13.7 are presented the trajectories of the target according to the two detectors; as far as it concerns the first sensor, that has

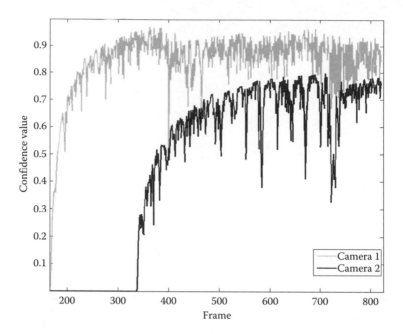

Figure 13.6 Confidence value of the detectors associated to the target observed from the first view (camera 1) and from the second one (camera 2). The target is detected by the second sensor about 200 frames after the first one due to the different fields of view. The confidence drop around the frame 720 is due to the partial occlusion with other pedestrians.

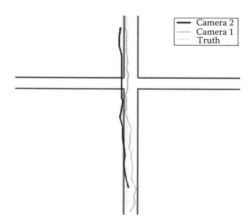

Figure 13.7 Trajectory of the target detected from two different cameras and ground truth (dotted line). The target was walking on a straight line and both detected trajectories appear to be close to the ground truth with a slight advantage of the first detector.

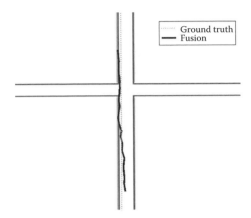

Figure 13.8 Fused trajectory of positions of Figure 13.7. In this case, the error is reduced. The final trajectory of the man walking on the tiles path is closer to the ground truth than those seen in Figure 13.7.

better sensibility, the trajectory provided by the tracker is more accurate and it remains on the tiles path.

The second detector, on the contrary, is less accurate and the positioning on the map is less precise. The fusion of the two, presented in Figure 13.8, returns an output that is closer to the ground truth. The central part of the trajectory does not seem to suffer from the ambiguity brought by the men meeting, thanks to the combined use of heterogeneous features to describe an object and to the quality measure as an effective system to weight the target location on the ground map.

13.3.3.3 Second Example

In this example, we acquired two videos of a man walking in a parking lot from two different angulations. There are a total of 665 frames taken at a resolution of 720×576 pixels with a frame rate of 25 fps. The tracking outputs coming from the two cameras are plotted on a common map, and the results are fused using the quality of the detection as weight. The position of the camera with respect to a general ground plane is shown in Figure 13.9.

In Figure 13.10 some frames are presented: a man enters from the bottom border of the image in both views, and walks toward the

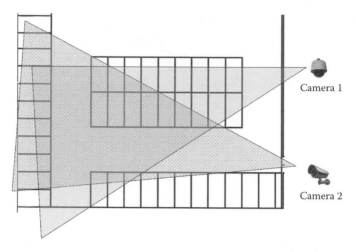

Figure 13.9 Deployment of the cameras in the first experiment video sequence.

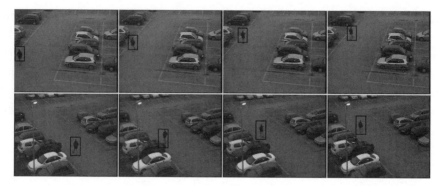

Figure 13.10 Frames from the parking lot video sequence. A man freely moves in the parking lot, walking toward the upper border of the image. Two different camera views are presented: in the first (top) row the first camera output is reported, while in the second (bottom) row the second camera video stream is shown.

top of the image; in the first (top) row, the first camera video stream is reported, while the second (bottom) row displays the correspondent frames from camera number two.

The illumination of the scene is different in the two views; the first sensor has a greater sensibility in low-light conditions. This is reflected in the quality of the detection, as shown in Figure 13.11. The target

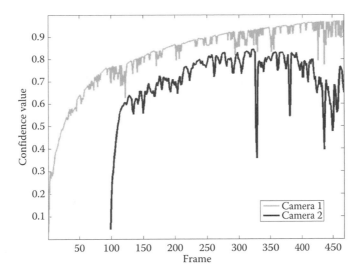

Figure 13.11 Confidence of two different detectors associated to the respective cameras while analyzing the parking lot video sequence. The detector of camera 2 has a higher confidence than the first one. At the end of the sequence both detectors show a confidence decrease; this reflects the difficulty while tracking a very small object that moves fast in very low lighting conditions.

enters in the scene at frame 98 in the second view, while it was already present in the first video stream.

Further examining the graph in Figure 13.11, it should be noted that the drops in the confidence of the second camera correspond to detection ambiguities given by the target walking close to the cars on the left. For example, around frame 330, the confidence of the detector tracking the target from the second video stream shows a consistent drop when the target is closer to the cars, as can be seen in the second image of the bottom row of Figure 13.10.

The confidence of the ensembles falls in the presence of partial occlusions and this behavior can conveniently be exploited to assess the quality of the detection. Since partial occlusions are likely to distract the classifier from the optimal detection position, this will probably translate into position errors when projecting the position of the bounding box (center point of the lower side of the bounding box) on the ground plane, as explained in Section 13.2.

A high confidence detection can be related to a high probability of having found the searched target. However, this does not guarantee the absence of tracking errors. In fact, for example, if the tracking is not properly initialized, the detector may not be correctly focused on the target. This can be seen in the first two images of the top row of Figure 13.10 where the first camera detector has been incorrectly initialized on the torso of the person. In Figure 13.12, the trajectories produced by the two cameras detectors are shown along with the ground truth (dotted line).

The second tracker, although less confident since it works on less contrasted images, provides a trajectory that is closer to the ground truth than the first one. This is mainly due to the incorrect initialization of the first tracker on the torso of the target that introduces an offset in the positioning of the bounding box that eventually translates in a positional error when projected on the ground plane.

The weighted fusion of the target's positional data is more influenced by the first sensor but takes advantage from the information provided by the second camera as well. The fusion of the target position is closer to the ground truth than the single camera view tracking results, as we can see from Figure 13.13.

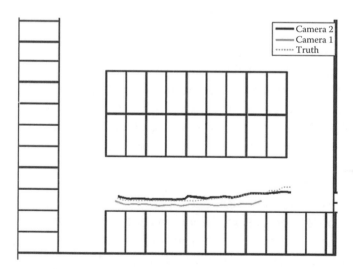

Figure 13.12 Trajectory of a target observed by two sensors and ground truth (dotted line). The trajectory of the second camera is closer to the ground truth.

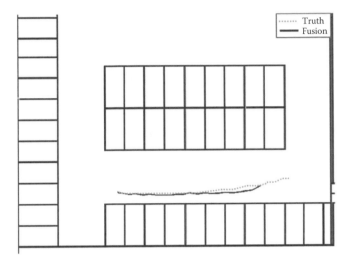

Figure 13.13 Fused trajectory of the target compared with the ground truth. The final trajectory is closer to the ground truth than those produced by the single trackers.

13.3.3.4 Third Example

This sequence temporally follows the previous example. It shows another condition that further justifies the use of fusion for estimating the trajectory of a target observed by multiple cameras.

As can be seen in Figure 13.14, the target reaches the limit of the field of view of the first sensor (top row) while being occluded by a street lamp in the second view (bottom row).

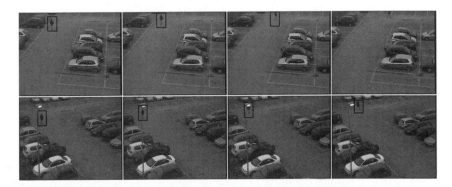

Figure 13.14 Parking lot sequence. The target is reaching the exit of the field of view of the first sensor and is being occluded in the second view.

The graph in Figure 13.15 shows the confidence values of the two trackers associated to the two video streams. The values are lower when compared to the previous example. This is because the first detector is losing the target as he is exiting the field of view of the camera.

In the second view, the target is being occluded by a street lamp and this is reflected in a significant drop of the confidence of the detector around frame 550. After the occlusion, the values start to increase again.

Figure 13.16 shows the trajectory of the target according to the two trackers and the ground truth. The trajectories are significantly different from the ground truth since the two detectors are experiencing the difficulties described above. In addition, calibration errors are particularly evident here as the target reaches the limits of the field of view of the two cameras.

Figure 13.17 shows the fused result and the ground truth trajectory. In this case also, fusion mitigates the errors of the two sensors

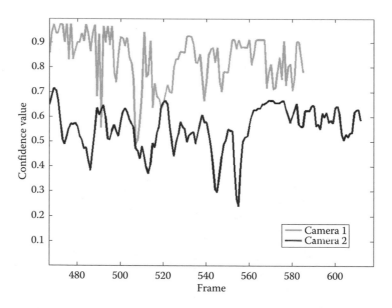

Figure 13.15 Confidence values of the two trackers in the third example. The values are lower when compared to the previous example. The first detector is losing the target as he is exiting the field of view of the camera. In the second view, the target is occluded by a street lamp and this is reflected by the drop in the confidence values of the second detector.

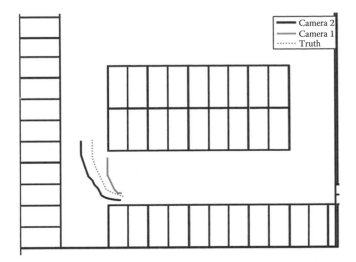

Figure 13.16 Trajectories observed by the two cameras and ground truth. The two trajectories appear significantly different from the ground truth.

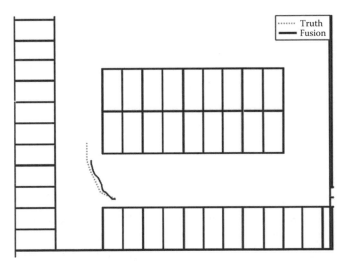

Figure 13.17 Third example. Fused trajectory and ground truth.

and produces a result closer to the ground truth. This experiment has provided another example of why fusion should be generally preferred to sensor selection in trajectory estimation for video surveillance.

13.4 DISCUSSION

To summarize the results, we have experimentally observed that the confidence values produced by ensemble classifiers for target tracking are a good indicator of the detection quality that can be exploited to weight the fusion process. In our case, the fusion process concerned the positional data of the target map, the top-view map of the area observed by multiple sensors. The confidence of the classifiers successfully captures several tracking difficulties such as partial occlusions and scarce separability between the target and the background by assigning low values to the detection. Since these conditions generally mean an inaccurate detection on the image plane that eventually translates into a positional error on the ground plane, the confidence value can be employed to associate a low weight to position estimates deriving from poor detections. However, we have shown that the contrary is not always true: a high confidence value does not necessarily imply an error-free detection. This is because other types of errors, such as tracker initialization and camera calibration, can be present. Therefore, selecting the "best" sensor relying only on detection confidence values can be misleading. Nevertheless, using these values in the fusion process, the errors are mitigated most of the times under the condition that not all detectors are performing poorly since that would call for the unavoidable "garbage in → garbage out" data-fusion pathological condition (Hall and Llinas 1997).

13.5 SUMMARY

In this work, we have presented the problem of estimating the performance of video sensors for data fusion in multi-camera systems for video surveillance. We have presented a framework for combining multiple features within ensembles of classifiers and providing thus a principled way for yielding detection probability that could be exploited as a quality measure for fusion positional in target tracking. The proposed approach adaptively combines, according to the performance of each sensor, the position of a target resulting in a fused estimate. This quality measure can be used by a video surveillance system also to automatically select the most informative sensor for acquiring data on

a detected target. Experimental results carried out on real-world video sequences have shown the effectiveness of the presented approach in terms of tracking accuracy in comparison with single camera systems. In our experiments, we have observed that sensor fusion is generally preferable to sensor selection under the proposed framework for video surveillance.

13.6 BIBLIOGRAPHICAL AND HISTORICAL REMARKS

Evaluating the performance of a video sensor can be a difficult task. It depends on the application and on the type of information that needs to be extracted from the sensors (Snidaro and Foresti 2007). Historically, most of the work has concentrated on metrics used to estimate the quality of images corrupted by noise or compression in comparison with the flawless original image (Avcibaş et al. 2002, Wang et al. 2004, Snidaro et al. 2007). Unfortunately, these algorithms are not really applicable for the online evaluation of the source images produced by the sensors in a surveillance system since no reference images are generally available.

In the case of video surveillance applications, the evaluation of the results obtained after the source images have been processed (i.e., the output of change detection algorithms (Regazzoni et al. 2001)) could be an interesting alternative to assess the performance of a sensor. That is, the sensor could be evaluated indirectly by evaluating the results obtained from it down in the processing pipeline. The evaluation can be performed globally on the entire scene or individually for each detected object (Correia and Pereira 2003). The former computes a global quality index for all detected objects in the scene, while the latter expresses a quality figure for each one of them.

As already mentioned, the result provided by the segmentation could be used for assessing detection quality. Segmentation is, here, intended as the result of thresholding the difference between the current image and a reference image for motion detection. The result of the segmentation is a binary image where pixels are classified either as foreground (belonging to a moving region) or as background (belonging to stationary regions).

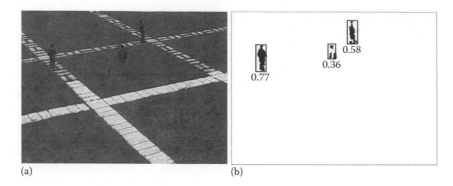

Figure 13.18 (a) Source image and (b) detected blobs with segmentation quality below bounding boxes.

Again, a number of measures can be found in the literature for off-line comparison between a segmentation and a reference binary mask (Erdem et al. 2004). Only recently the problem of estimating segmentation quality without ground truth as been addressed (Correia and Pereira 2003, Erdem et al. 2004, Snidaro et al. 2007). For example, the approach proposed in Snidaro et al. (2007) relies on a comparison between the pixels of the detected object and those of the background and takes into account the connectivity of the binary blobs as well.

Figure 13.18 shows an example of segmentation quality estimation using the approach described in Snidaro et al. (2007). The quality is estimated individually for each detected object based on the difference between the current frame (Figure 13.18a) and the background. The connectivity of the blobs is also taken into account: the person at the center of the image is partially occluded by a bush thus resulting in a cracked blob (note that the focus of attention algorithm was instructed to box together "close enough" separate connected components depending on a given threshold) that is given a low-quality score. The score was ranging between zero (poorest quality) and one (maximum quality).

The quality measure can be used in the fusion process of redundant (given by multiple sensors) position data to improve localization accuracy, as explained in this chapter. Another use is shown in Figure 13.19 where the score can be used to select the best (most informative) sensor for acquiring data on a detected target. The image shown

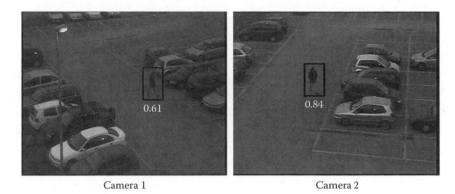

Camera 1 Camera 2

Figure 13.19 The second camera has greater sensibility and provides a more contrasted image in low-light conditions. This is reflected by the quality measure (Snidaro et al. 2007) computed for the detected target.

in Figure 13.19b is produced by a sensor with better low-light capabilities compared to the one shown in Figure 13.19a. Figure 13.19b is in fact brighter, provides more accurate colors, and is more contrasted.

The quality can become a criterion to prefer high-quality video sources instead of those with a weak detection, provided that multiple sensors are observing the same scene. For example, this can be used to multiplex the video stream to a human operator by automatically switching to the camera that provides the most informative content.

In addition to the evaluation of the segmentation results, other techniques may involve the comparison between two consecutive frames of the color histogram of the object or of its motion vectors (Correia and Pereira 2003). A feature selection mechanism such as the one presented in Collins et al. (2005) can also be used to estimate the performance of the sensor in detecting a given target. The approach is able to select the most discriminative color features to separate the target from the background by applying a two-class variance ratio-to-log likelihood distributions computed from samples of object and background pixels. The approach generates a likelihood map for each feature, ranks the map according to its variance ratio value, and then proceeds with a mean-shift tracking system that adaptively selects the top-ranked discriminative features for tracking. The idea was further developed in Zhaozheng et al. (2008) where additional features were considered and fused via likelihood maps.

The techniques described so far evaluate detection quality for each frame independently. They do not take into account the history of previous frames. In this work, we have proposed a framework for quality-based multi-cue multisensor fusion based on ensembles of classifiers built on the features for target detection. The ensembles are trained online and allow every type of feature to be included and fused and a principled way of obtaining a quality measure as the ensemble provides posterior detection probability that can be employed in the fusion of positional data for target tracking.

REFERENCES

Aghajan, H. and A. Cavallaro (eds.). 2009. *Multi-Camera Networks*. Amsterdam, the Netherlands: Elsevier.

Avcibaş, I., B. Sankur, and K. Sayood. 2002. Statistical evaluation of image quality measures. *Journal of Electronic Imaging* 11(2):206–223.

Avidan. S. 2007. Ensemble tracking. *IEEE Transactions on Pattern Analysis and Machine Intelligence* 29(2):261–271.

Breiman, L. 1996. Bagging predictors. *Machine Learning* 24:123–140.

Collins, R. T., Y. Liu, and M. Leordeanu. 2005. Online selection of discriminative tracking features. *IEEE Transactions on Pattern Analysis and Machine Intelligence* 27(10):1631–1643.

Correia, P. L. and F. Pereira. 2003. Objective evaluation of video segmentation quality. *IEEE Transactions on Image Processing* 12(2):186–200.

Erdem, Ç. E., B. Sankur, and A. M. Tekalp. 2004. Performance measures for video object segmentation and tracking. *IEEE Transactions on Image Processing* 13:937–951.

Foresti, G. L., C. Micheloni, L. Snidaro, P. Remagnino, and T. Ellis. 2005. Active video-based surveillance systems. *IEEE Signal Processing Magazine* 22(2):25–37.

Freund, Y. 2001. An adaptive version of the boost by majority algorithm. *Machine Learning* 43:293–318.

Freund, Y. and R. E. Schapire. 1996. Experiments with a new boosting algorithm. In *13th International Conference on Machine Learning*, Bari, Italy, pp. 148–156.

Giacinto, G. and F. Roli. 2001. Dynamic classifier selection based on multiple classifier behaviour. *Pattern Recognition* 34:1879–1881.

Grabner, H. and H. Bischof. 2006. On-line boosting and vision. In *Proceedings of the IEEE Conference on Computer Vision and Pattern Recognition (CVPR)*, New York, pp. 260–267.

Hall, D. L. and J. Llinas. 1997. An introduction to multisensor data fusion. *Proceedings of the IEEE* 85(1):6–23.

Hartley, R. and A. Zisserman. 2004. *Multiple View Geometry in Computer Vision*. Cambridge, U.K.: Cambridge University Press.

Kittler, J., M. Hatef, R. P. W. Duin, and J. Matas. 1998. On combining classifiers. *IEEE Transactions on Pattern Analysis and Machine Intelligence* 20(3):226–239.

Kuncheva, L. 2002. A theoretical study on six classifier fusion strategies. *IEEE Transactions on Pattern Analysis and Machine Intelligence* 24:281–286.

Kuncheva, L. I. and C. J. Whitaker. 2003. Measures of diversity in classifier ensembles. *Machine Learning* 51:181–207.

Lienhart, R. and J. Maydt. 2002. An extended set of Haar-like features for rapid object detection. In *Proceedings of the IEEE International Conference on Image Processing*, Rochester, NY, pp. 900–903.

Mitchell, H. B. 2007. *Multi-Sensor Data Fusion: An Introduction*. Berlin, Germany: Springer-Verlag.

Oza, N. C. 2005. Online bagging and boosting. *IEEE International Conference on Systems, Man and Cybernetics* 3:2340–2345.

Parag, T., F. Porikli, and A. Elgammal. 2008. Boosting adaptive linear weak classifiers for online learning and tracking. In *International Conference on Computer Vision and Pattern Recognition*, Anchorage, AK.

Pelossof, R., M. Jones, I. Vovsha, and C. Rudin. 2008. Online coordinate boosting. TR2008-069.

Polikar, R. 2006. Ensemble based systems in decision making. *IEEE Circuits and Systems Magazine* 6(3):21–45.

Porikli, F. 2005. Integral histogram: A fast way to extract histograms in Cartesian spaces. In *Proceedings of the IEEE Computer Society Conference on Computer Vision and Pattern Recognition (CVPR)*, San Diego, CA, pp. 829–836.

Regazzoni, C. S., R. Visvanathan, and G. L. Foresti. 2001. Scanning the issue/technology. Special issue on video communications, processing and understanding for third generation surveillance systems. *Proceedings of the IEEE* 89:1355–1367.

Shannon, W. D. and D. Banks. 1999. Combining classification trees using MLE. *Statistics in Medicine* 18:727–740.

Snidaro, L. and G. L. Foresti. 2007. Sensor performance estimation for multi-camera ambient security systems: A review. In Lefebvre, E., (Ed.), *Advances and Challenges in Multisensor Data and Information Processing*, NATO Security through Science Series, D: Information and Communication Security, vol. 8, pp. 331–338. Amsterdam, the Netherlands: IOS Press.

Snidaro, L. and I. Visentini. 2008. Fusion of heterogeneous features via cascaded on-line boosting. In *Proceedings of the Eleventh International Conference on Information Fusion*, Cologne, Germany, pp. 1340–1345.

Snidaro, L., C. Piciarelli, and G. L. Foresti. 2006. Activity analysis for video security systems. In *Proceedings of the IEEE International Conference on Image Processing*, Atlanta, GA, pp. 1753–1756.

Snidaro, L., R. Niu, G. Foresti, and P. Varshney. 2007. Quality-based fusion of multiple video sensors for video surveillance. *IEEE Transactions on Systems, Man, and Cybernetics, Part B* 37(4):1044–1051.

Wang, Z., A. C. Bovik, H. R. Sheikh, and E. P. Simoncelli. 2004. Image quality assessment: From error visibility to structural similarity. *IEEE Transactions on Pattern Analysis and Machine Intelligence* 13(4):600–612.

Zhao, G. and M. Pietikainen. 2006. Local binary pattern descriptors for dynamic texture recognition. In *Proceedings of the 18th International Conference on Pattern Recognition*, Hong Kong, pp. 211–214.

Zhaozheng, Y., F. Porikli, and R. T. Collins. 2008. Likelihood map fusion for visual object tracking. In *IEEE Workshop on Applications of Computer Vision*, Copper Mountain, CO.

Part V

Systems and Applications

14

Attribute-Based People Search

Daniel A. Vaquero, Rogerio S. Feris, Lisa Brown,
Arun Hampapur, and Matthew Turk

CONTENTS

We propose a novel framework for searching for people in surveillance videos. Rather than relying on face-recognition technology, which is known to be sensitive to typical surveillance conditions such as lighting changes, face pose variations, and low-resolution imageries, we approach the problem in a different way: we search for people based on a parsing of human parts and their attributes, including facial hair, eyewear, clothing color, etc. These attributes can be extracted using detectors learned from large amounts of training data. A complete system that implements our framework is presented. At the interface, the user can specify a set of personal characteristics, and the system then retrieves events that match the provided description. For example, a possible query is "show me the bald people who entered a given building last Saturday wearing a red shirt and sunglasses." This capability is useful in several applications, such as finding suspects or missing people. We also present experiments on surveillance video, which demonstrate the benefits of our approach.

14.1 INTRODUCTION

In traditional surveillance scenarios, users are required to watch video footage corresponding to extended periods of time in order to find events of interest. However, this process is resource consuming, and suffers from high costs of employing security personnel. The field of intelligent visual surveillance (Hu et al. 2004) seeks to address these issues by applying computer vision techniques to automatically detect specific events in long video streams. The events can then be indexed into a database to allow queries such as "show me the red cars that entered a given parking lot from 7 pm to 9 pm on Monday" or "show me the faces of people who left a given train station last week."

In this chapter, we are interested in the analysis of people and in using the extracted information to search for them in surveillance videos. Current research on this topic focuses on approaches based on face recognition (Sivic et al. 2005, Cognitec), where the goal is to establish the identity of a person given an image of a face. However, face recognition is still a very challenging problem, especially in low-resolution images with variations in pose and lighting, which is often the case in surveillance data. State-of-the-art face-recognition systems

(Face Recognition Vendor Test) require a fair amount of resolution in order to produce reliable results, but in many cases, this level of detail is not available in surveillance applications.

We jump over those hurdles in an alternative way, by avoiding face recognition and proposing a framework for finding people based on parsing the human body and exploiting part attributes. Those include visual attributes such as facial hair type (beards, mustaches, absence of facial hair), type of eyewear (sunglasses, eyeglasses, absence of glasses), hair type (baldness, hair, wearing a hat), and clothing color. We have an extensible architecture that could include nonvisual attributes as well, such as temperature and voice obtained from other sensors. Our approach falls into the category of *short-term recognition* methods (Anguelov et al. 2007), taking advantage of features present in brief intervals in time, such as clothing color, hairstyle, and makeup, which are generally considered an annoyance in face-recognition methods.

While face recognition is still a difficult problem, very accurate and efficient face detectors based on machine learning (Viola and Jones 2001, Huang et al. 2005) are available. Those have been demonstrated to work on challenging low-resolution images, with variations in pose and lighting. In our system, we employ this technology to design detectors for personal attributes from large sets of training data. This enables efficient search in situations where face recognition does not perform well; in scenarios suited for the application of face-recognition algorithms, the detected attributes could be integrated with face-recognition approaches, making them more powerful.

There are several applications that naturally fit within a short-term recognition framework. An example is in crime investigation, when the police are interested in locating a suspect. In those cases, eyewitnesses typically fill out a *suspect description form*, where they indicate personal traits of the suspect as seen at the moment when the crime was committed. Those include facial hair type, hair color, clothing type, gender, age, height, etc. Based on that description, the police manually scan the entire video archive looking for a person with similar characteristics. This process is tedious and time consuming, and it could be drastically accelerated by the use of our approach. Another application is in finding missing people. Parents looking for their children in an amusement park could provide a description including clothing and

Figure 14.1 First search results obtained from a query for "bald people." The facial details have been intentionally blurred for privacy.

eyewear type, and videos from multiple cameras in the park would then be automatically searched for children matching those characteristics. Finally, the personal attributes could be used for tracking and correspondence across multiple related cameras, as it is very unlikely that people would change clothes or shave as they walk between two different places during a short time period.

In this chapter, besides introducing the framework for searching by attributes extracted from human parts, we describe our implementation, as part of the IBM Smart Surveillance System, of a proof-of-concept system that enables search based on facial attributes and clothing colors. The system receives queries such as "show me the bearded people who entered a given building on Saturday wearing a hat" as input, and then retrieves the results that match the provided description. Figure 14.1 shows a query for "bald people," where key frames for each video segment are displayed. We also present results from deploying the system to a real surveillance environment, and discuss the issues involved.

14.2 A PARTS-AND-ATTRIBUTES FRAMEWORK

In this section, we introduce a general framework for searching for people in surveillance data. The framework is composed of three main elements: sensors, body parts in multiple scales, and their attributes.

Sensors: These are responsible for collecting data from the environment where people may appear. The most obvious example is a video

camera, but the concept can be generalized to include other sensors, such as temperature, voice, odor, and heartbeat rate. This allows composite search across multiple modalities.

Body parts: Given a set of data streams captured from multiple sensors, techniques to detect and locate people are applied. Once people are found, a parsing of the human body is performed to segment its subparts (in streams where this is possible, such as video data). The parsing of the subparts may be further refined as long as resolution is sufficient to recognize the relevant details, in order to obtain a multiscale model of a person. Multiple sensors in different resolutions may be combined to allow parsing in increasing levels of detail.

Attributes: Finally, attributes from segments of the parsed body are extracted. They describe and form the signature of a person associated with a timestamp, and queries are made by specifying those. Considering an odor sensor, fragrance types can identify a person. In video cameras, considering the entire body as a single part, attributes such as height, body shape, actions and behavior detected during a short period could be useful cues for finding specific people. In a more detailed level, by parsing the body into head, torso, and legs, the colors of the torso and legs provide information about the clothes that a person was wearing. Face analysis algorithms may be used to infer the person's gender, age, ethnicity, and face shape, attributes that can be searched for. By increasing the resolution of the parsing, face subparts can be analyzed to extract additional information, such as facial hair type (in the mouth region), type of eyewear (in the eyes region), hair type, and skin color. Similarly, hat and hair colors, and eyewear shape, could be further obtained.

14.3 A PROOF-OF-CONCEPT IMPLEMENTATION

We have created a proof-of-concept system that implements the framework described in the previous section. A particular case of the general framework is considered, where the sensor is a low-resolution (320×240) color video camera. People are detected by applying a face detector, and are further parsed to determine three major regions: face, torso, and legs. We then divide the face region into three sub

regions: upper part, middle part, and lower part. Starting from this segmentation of the body, we extract the following attributes:

- Upper face part: hair type (bald, hair, wearing a hat)
- Middle face part: eyewear type (sunglasses, eyeglasses, absence of glasses)
- Lower face part: facial hair type (beard, mustache, absence of facial hair)
- Torso: dominant color
- Legs: dominant color

Figure 14.2 illustrates the parts and attributes considered in our implementation. In this section, we describe our implementation of a body-parsing algorithm and the attribute detectors. In the current system, we have chosen to use readily available algorithms, as the purpose was to demonstrate our search framework. To extract facial attributes, we used well-known Viola–Jones detectors (Viola and Jones 2001) trained from frontal face images, based on Haar features and grayscale images. However, more sophisticated and robust classifiers (Huang et al. 2005) could have been used for this purpose. Viewpoint variations

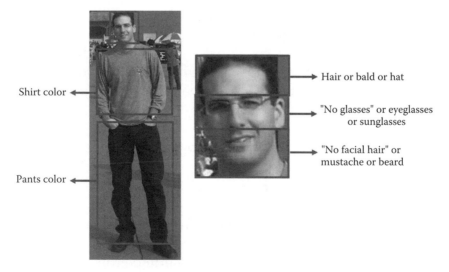

Figure 14.2 Body parts and attributes considered in our implementation.

could be handled with multiple detectors specifically trained for each of the views, along the same lines of multi-view face detection approaches (Wang and Ji 2005), and more advanced methods for body parsing (Ramanan et al. 2005) also could have been applied. We now proceed to the description of the techniques used to extract attributes from individual video frames, and then show how those components are applied to videos and integrated with the IBM Smart Surveillance System.

14.3.1 Face

For face detection, we use a cascade of Adaboost classifiers (Viola and Jones 2001) based on Haar features, trained from image patches (of 20×20 size) containing faces. We refer the reader to (Viola and Jones 2001) for more details about the Viola–Jones detectors. Once a face is found, its bounding box is enlarged to the left, right, above and below in order to generate a region likely to contain all attributes of interest. The upper boundary is enlarged by half of the detected face's height, while the left, right, and lower boundaries are enlarged by 0.1 times the detected face's height or width. This ensures that the bounding box includes the forehead, hair, and chin. Choosing different scale factors may affect the facial attribute detection rate, as a bounding box larger than optimal may lead to a higher false positive rate, while a bounding box smaller than optimal decreases the detection rate. The selected values worked well in our experiments.

The resulting rectangle is then divided into three rectangular regions that overlap. The upper region starts at the top of the rectangle, and its height is given by 70% of the rectangle's height; the middle region is given by a strip comprising the region between 35% and 75% of the rectangle's height; and the lower region corresponds to the lower 70% of the rectangle's height. The upper and lower regions overlap with the middle region so that the eye region is included in both, as the eyes constitute important features for alignment while detecting the upper and lower region attributes.

In order to extract attributes from the three face parts described above, we have trained an additional Viola–Jones detector for each attribute to be found. The detectors were trained from a large dataset of about 9800 frontal face images (with slight pose variations) collected

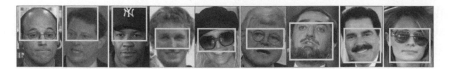

Figure 14.3 Examples of labelings for each facial attribute. From left to right: bald, hair, hat, "no glasses," sunglasses, eyeglasses, beard, mustache, "no facial hair."

from the Labeled Faces in the Wild dataset (Huang et al. 2008) and from Internet sites. The images have been manually labeled by indicating bounding boxes for a given attribute to be detected. Figure 14.3 shows examples of labelings for each of the face attributes (images taken from the Labeled Faces in the Wild dataset). Table 14.1 displays the attribute distribution within the labeled images. Starting from the labeled images, slight variations of the samples were created by randomly rotating and shifting the original images, resulting in a set with approximately 39,000 images.

TABLE 14.1 Distribution of the Labeled Images in the Training Set, and Patch Sizes Used for Training Each Detector

Facial Attribute	Number of Labeled Examples	Detector Size (Width×Height)
Beard	1028	20×20
Mustache	1094	
No facial hair	1717	
Sunglasses	677	30×20
Eyeglasses	618	
No glasses	2273	
Bald	562	20×20
Hair	1106	
Hat	682	

Note: For each of these samples, three variants are generated by means of random rotation and translation. Thus, the number of available training examples for each facial attribute was four times the value shown in the second column.

To train each classifier, the labeled image patches were cropped, converted to grayscale and rescaled to the size listed in Table 14.1 in order to generate positive examples. Negative examples were generated from images of the two other classes from the same face region by cropping a slightly enlarged version of the labeled area (e.g., while training the beard detector, negatives were selected from the mustache and "no facial hair" datasets). Nine cascade classifiers were trained, three for each face region. In the feature selection process, Haar features based on gray-level intensities were used. Each level of the cascade was designed to reject about half of the number of negative examples while correctly accepting 99.5% of the true positive examples. About 3000 positive examples were used for each classifier when this number was available (this holds for most attributes—see Table 14.1); otherwise, we used all available examples. 4000 negative examples were obtained through bootstrap for training each level of the cascade.

When applying the detectors to the face search regions, a sliding window is scanned through the corresponding portion of the image. The width of the windows considered in the detection is restricted to be greater than or equal to 55% of the enlarged face's width. Since the application of the classifiers is constrained to regions near faces, training the classifiers with negative examples constrained in the same way (as described in the previous paragraph) led to better results when compared to training using negative examples that included, besides faces, general background images.

14.3.2 Torso and Legs

In addition to the extraction of facial attributes, we also determine the location and dominant color of the person's torso and legs, allowing search based on clothing colors, such as "red shirts" and "blue pants."

The torso and legs are represented as rectangles with fixed aspect ratio, whose position and size are roughly estimated from the position and size of the detected face. Since people have different heights and body shapes, the estimated rectangles will not precisely outline the torso and legs region. However, this is not a problem, as for the sake of this implementation we are interested only in obtaining the dominant color attribute for these parts.

Our dominant color classifier method is based on acquiring a normalized color histogram for each body part (torso or legs) in biconic (hue, saturation, luminance) HSL space. Euclidean distances in this color space closely map to human perception color differences.

We first quantize the HSL space into eight colors—red, green, blue, yellow, orange, purple, black, and white. Given the estimated rectangle for a body part, each pixel inside the rectangle is quantized into one of these colors, and a histogram with eight bins is built. The color corresponding to the bin that receives the majority of votes is then assigned as the dominant color for the body part. Notice that these colors were chosen for simplicity reasons, but, more generally, the space could have been quantized into more bins.

In the process above it is left to explain how we quantize the HSL space. This is done in a two-stage process. In the first stage, we partition the color space using hue information alone, by computing the hue angular cutoffs between the colors. Then, in the second stage, pixels may be relabeled as either white or black depending on whether they lie outside the lightness/saturation curve above or below the horizontal mid-plane. This is related to earlier work in color segmentation (Tseng and Chang 1994).

When dealing with multiple cameras, we refer to the works on color matching by Wu et al. (2006) and Javed et al. (2005), which learn the inter-camera brightness transfer functions.

14.3.3 Integration with the IBM SSS

The techniques described in the previous sections have been integrated with the IBM Smart Surveillance System (SSS) in order to enable video indexing. Each frame of the video stream is processed by first applying a background subtraction algorithm (Tian et al. 2005) to detect objects in motion, and then scanning a Viola–Jones face detector through the image, constrained to the motion regions. This avoids false positives, and significantly reduces the processing time. Detected faces are tracked through multiple frames in the following way: if, for a given frame, there is a detection from the Viola–Jones detector, the face location is assumed to be at the detected location; otherwise, the most recent face detection result is matched to its neighboring regions based

on correlation. The tracker determines that a person left the scene when the face detector fails to detect a face through a given number of frames (typically 10). Each person who leaves the scene is assigned a unique identifier ("track ID"). This is important, as we are interested in combining the results of individual attribute detectors at multiple frames in order to assign a single set of attributes to a given person.

Given a face's bounding box, the torso and legs detector is run to find the corresponding bounding boxes. The attribute detectors are then applied to the regions delimited by each box, i.e., the facial feature classifiers are applied to the three face sub regions, and the colors are computed from the regions that correspond to the torso and legs. An integrator module collects the results from all detectors and keeps track of the detection history for the multiple frames for each track ID. Once the face tracker determines that a given person left the scene, the integrator combines the attribute results from all frames from that track to produce the final classification for that person. For the facial attributes, the final result is determined by voting, by choosing, for each face sub region, the attribute with the largest number of detections during the entire track. The integrator also collects the color histograms of each body part and builds a single cumulative histogram (for each part) to determine the final dominant colors.

The computer vision operations described above have been implemented as an *analytics engine* in the IBM Smart Surveillance System (see Chapter 3). The engine receives a video stream as input, and outputs tuples represented by (track ID, a face key frame, a short video of the track, facial hair type, eyewear type, hair type, torso color, legs color), which are sent to the database backend using a metadata format in order to be stored along with a timestamp. A HTML search interface allows the user to query the database in a way similar to a suspect description form. Figure 14.4 illustrates the multiple components of the system architecture and their interactions.

14.4 DEPLOYMENT TO A REAL SCENARIO

We deployed our system to a real surveillance environment at the entrance of a research facility. In this section, we present the results and discuss the challenges and lessons learned.

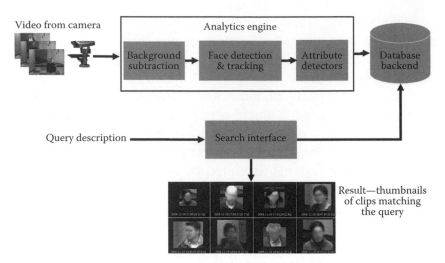

Figure 14.4 High-level view of our surveillance system's architecture (results intentionally blurred for privacy).

14.4.1 Environment Characteristics

We used our surveillance system to process a 320×240 video stream during a 2.5 month period. The video was captured by a camera placed at the entrance of the IBM Research building in Hawthorne, New York. The camera is located at the ceiling and points at a door from where people enter. The environment has strong direct illumination (which casts shadows), and people who walk through the scene show high variability in face pose—many are facing left or right, or looking down. This can prevent the camera from seeing all facial features in some cases. In other words, the statistical nature of the face images captured at this scene (such as the images in Figures 14.1 and 14.5) greatly differs from that of the images used for training our detectors (Figure 14.3). Even the quasi-frontal faces captured by the surveillance camera usually have characteristics different from the faces in the training set, as we often see shadows cast over the neck due to the camera's placement and the lighting conditions. Our experience with the application of face-recognition systems in surveillance (including a few of the best systems from the Face Recognition Vendor Test) shows that the algorithms fail miserably in this scenario, due to variations in

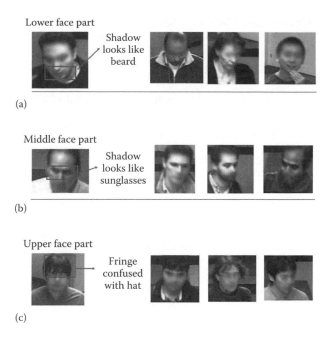

Figure 14.5 Examples of failure cases in our system. Notice the differences in pose and lighting as compared to the images from Figure 14.3, representative of our training set. The images have been intentionally blurred for privacy.

pose and lighting. Some face-recognition systems cannot even be run because the minimum resolution requirements are not met.

14.4.2 Quantitative Evaluation

We computed the confusion matrix for the facial attributes extracted from 2095 people captured by the face detector. It is shown in Table 14.2, along with the precision and recall statistics for each facial attribute.

In order to evaluate the performance of the color classifier, we analyzed the results obtained for torso (shirt) color. The classifier thresholds were especially tuned for the conditions of our environment. Table 14.3 displays the confusion matrix for colored shirts for people whose torsos were visible. The results are excellent, and the performance of the leg color classifier is similar.

TABLE 14.2 Confusion Matrices for the Facial Attribute Classifiers in Surveillance Video, along with Their Precision and Recall Statistics

Ground Truth	Classification Result			Precision (%)	Recall (%)
	Beard	Mustache	No facial hair		
Beard	139	6	59	56	68
Mustache	1	28	23	50	54
No facial hair	108	22	1863	96	93
	Sunglasses	Eyeglasses	No glasses		
Sunglasses	23	1	41	85	35
Eyeglasses	0	45	463	90	8.9
No glasses	4	4	1668	77	99.5
	Bald	Hair	Hat		
Bald	31	68	6	100	42
Hair	0	1906	183	97	91
Hat	0	0	55	29	100

TABLE 14.3 Confusion Matrix for Shirt Color Classification

Ground Truth	Classification Result							
	Red	**Green**	**Blue**	**Yellow**	**Orange**	**Purple**	**Black**	**White**
Red	49/51	0	0	0	0	0	2	0
Green	0	0/2	0	0	0	0	2	0
Blue	0	0	83/104	0	0	0	18	3
Yellow	0	0	0	5/7	0	0	1	1
Orange	0	0	0	0	1/1	0	0	0
Purple	0	0	0	0	0	1/3	2	0
Black	0	0	0	0	0	0	1263/1263	0
White	0	0	3	0	0	0	0	87/90

Note: Each row corresponds to the classification results for a given color. The leg color classification accuracy is similar.

14.4.3 Discussion

We can see in Table 14.2 that some facial attribute detectors perform well, while others are not at the same level. The main problem faced by the eyeglasses detector is the lack of resolution. Thus, faces in this category had often been mistaken for "no glasses." For sunglasses, beards, and mustaches, shadows cast by the direct light source are the main source of errors. Notice that the illumination can cause shadows along the neck, generating a pattern that is very similar to a beard. Also, many faces of people looking slightly down are found due to the camera's placement, and clothing can be similar in appearance to a beard. The light sources can also cast a small shadow along the nose, generating features that resemble mustaches. In the upper face part, we notice that many fringe hairs are misclassified as hats. The pose variability in this environment was also very different than in our training set. Figure 14.5 illustrates the main causes for failure cases.

These issues could be addressed by training multi-view attribute detectors, and by combining features in the infrared domain with features in the visible domain. In the infrared domain, the transparency of the eyeglasses is no longer an issue, as they become similar to sunglasses, while the visible domain can still be used to distinguish between sunglasses and eyeglasses. In addition, the infrared image accentuates the contrast between skin color and hair regions, and is less sensitive to problems caused by illumination.

While the Viola–Jones face detector achieves real-time performance (30 Hz) running on 320×240 images, the face attribute detectors are composed of a larger number of features and do not run in real time. To overcome this problem, a multithreaded system could be implemented, where a main thread would execute the background subtraction, face detection, and face tracking steps, and other threads running in parallel would receive the bounding boxes for each frame and apply the attribute detectors. In this way, the result would be generated with a very short delay, but the face tracker and capture subsystem would run with real-time performance, avoiding frame drops.

14.5 SUMMARY

We have proposed a novel framework for people search in surveillance data. The framework is characterized by three main elements: sensors, body parts, and their attributes. In addition, we have described a proof-of-concept system that implements our framework. This is the first video-based surveillance system with the capability of searching for people based on their fine-grained body parts and attributes. Our implementation is relatively simple, considering only facial attributes and clothing colors, but effectively demonstrates the usefulness of our framework for finding people in surveillance videos. Part of this success is due to the power of learning-based object detectors trained from large amounts of data.

In the future, we plan to improve the performance of the attribute detectors by combining features in the visible domain with features in the infrared domain, and by training detectors from data collected from our surveillance environment. We also would like to integrate additional attributes into the system, such as gender, age, skin color, and clothing texture, in order to expand the range of search possibilities. Activity-recognition algorithms may also be incorporated, enabling search by specific actions.

14.6 BIBLIOGRAPHICAL AND HISTORICAL REMARKS

Our framework shares many aspects with short-term person-recognition techniques, which use features present in short time periods, but that are not sufficient to establish the identity of an individual in a longer term. Soft biometrics techniques (Jain et al. 2004) are examples of methods in this category. Clothing features (Anguelov et al. 2007, Gallagher and Chen 2008) have also been used to improve the accuracy of face recognition, and to cluster face images together when labeling large face sets (Ramanan et al. 2007). Wu et al. (2006) suggested the usefulness of clothing color in surveillance scenarios, and Wang et al. (2005) mentions its application to tracking across multiple cameras.

Although many content-based retrieval methods have been proposed to search for objects in large image and video databases, our method is unique in the search based on fine-grained body parts and attributes. The MIT Photobook (Pentland et al. 1994) is an interactive search tool that allows the browsing of face images and other objects based on image content. Other works (Sridharan et al. 2005, Kumar et al. 2008) proposed the use of facial attributes to search for faces. However, they only deal with static face images.

Human parsing techniques (Ramanan et al. 2005) aim to segment the regions corresponding to individual body parts in images of people. Recently, some attention has been devoted to detecting specific facial features, such as hair (Yacoob and Davis 2006), eyeglasses (Wu et al. 2004) and beards (Nguyen et al. 2008). Our framework for searching based on body parts introduces the use of semantic information (attributes) from the multiple parts in order to search for people in videos.

ACKNOWLEDGMENTS

This work was supported in part by the National Science Foundation under award number IIS-0535293.

REFERENCES

Anguelov, D., K.-C. Lee, S. B. Göktürk, and B. Sumengen. 2007. Contextual identity recognition in personal photo albums. *IEEE Conference on Computer Vision and Pattern Recognition* (*CVPR*), Minneapolis, MN.

Cognitec. http://www.cognitec-systems.de/ (accessed on April 9, 2009).

Face Recognition Vendor Test. http://www.frvt.org/ (accessed on April 9, 2009).

Gallagher, A. C. and T. Chen. 2008. Clothing cosegmentation for recognizing people. In *IEEE Conference on Computer Vision and Pattern Recognition* (*CVPR*), Anchorage, AK.

Hu, W., T. Tan, L. Wang, and S. Maybank. 2004. A survey on visual surveillance of object motion and behaviors. *IEEE Transactions on Systems, Man and Cybernetics, Part C*, 34(3):334–352.

Huang, C., H. Ai, Y. Li, and S. Lao. 2005. Vector boosting for rotation invariant multi-view face detection. In *IEEE International Conference on Computer Vision* (*ICCV*), San Diego, CA.

Huang, G., M. Mattar, T. Berg, and E. Learned-Miller. 2008. Labeled faces in the wild: A database for studying face recognition in unconstrained environments. In *ECCV Workshop on Faces in Real-Life Images*, Marseille, France.

Jain, A. K., S. C. Dass, and K. Nandakumar. 2004. Soft biometric traits for personal recognition systems. In *International Conference on Biometric Authentication*, Hong Kong, pp. 731–738.

Javed, O., K. Shafique, and M. Shah. 2005. Appearance modeling for tracking in multiple non-overlapping cameras. In *IEEE Conference on Computer Vision and Pattern Recognition (CVPR)*, San Diego, CA.

Kumar, N., P. N. Belhumeur, and S. K. Nayar. 2008. FaceTracer: A search engine for large collections of images with faces. In *European Conference on Computer Vision (ECCV)*, Marseille, France.

Nguyen, M. H., J.-F. Lalonde, A. A. Efros, and F. De la Torre. 2008. Image-based shaving. *Computer Graphics Forum Journal (Eurographics 2008)*, 27(2):627–635.

Pentland, A., R. Picard, and S. Sclaroff. 1994. Photobook: Content-based manipulation of image databases. In *SPIE Storage and Retrieval for Image and Video Databases II*, San Jose, CA.

Ramanan, D., D. A. Forsyth, and A. Zisserman. 2005. Strike a pose: Tracking people by finding stylized poses. In *IEEE Conference on Computer Vision and Pattern Recognition (CVPR)*, San Diego, CA.

Ramanan, D., S. Baker, and S. Kakade. 2007. Leveraging archival video for building face datasets. In *IEEE International Conference on Computer Vision (ICCV)*, Rio de Janeiro, Brazil.

Sivic, J., M. Everingham, and A. Zisserman. 2005. Person spotting: Video shot retrieval for face sets. In *International Conference on Image and Video Retrieval*, Singapore.

Sridharan, K., S. Nayak, S. Chikkerur, and V. Govindaraju. 2005. A probabilistic approach to semantic face retrieval system. *Lecture Notes in Computer Science*, Vol. 3546, pp. 977–986, Springer-Verlag, Berlin.

Tian, Y., M. Lu, and A. Hampapur. 2005. Robust and efficient foreground analysis for real-time video surveillance. In *IEEE Conference on Computer Vision and Pattern Recognition (CVPR)*, San Diego, CA.

Tseng, D.-C. and C.-H. Chang. 1994. Color segmentation using UCS perceptual attributes. *Proceedings of the National Science Council: Part A*, 18:305–314.

Viola, P. and M. Jones. 2001. Rapid object detection using a boosted cascade of simple features. In *IEEE Conference on Computer Vision and Pattern Recognition (CVPR)*, Kauai, HI.

Wang, P. and Q. Ji. 2005. Learning discriminant features for multi-view face and eye detection. In *IEEE Conference on Computer Vision and Pattern Recognition (CVPR)*, San Diego, CA.

Wang, Y.-F., E. Y. Chang, and K. P. Cheng. 2005. A video analysis framework for soft biometry security surveillance. In *ACM International Workshop on Video Surveillance & Sensor Networks*, Singapore.

Wu, B., H. Ai, and R. Liu. 2004. Glasses detection by boosting simple wavelet features. In *International Conference on Pattern Recognition*, Cambridge, U.K.

Wu, G., A. Rahimi, K.-S. Goh et al. 2006. Identifying color in motion in video sensors. In *IEEE Conference on Computer Vision and Pattern Recognition (CVPR)*, New York.

Yacoob, Y. and L. S. Davis. 2006. Detection and analysis of hair. *IEEE Transactions on Pattern Analysis and Machine Intelligence*, 28(7):1164–1169.

15

Soft Biometrics for Video Surveillance

Yun Fu, Guodong Guo, and Thomas S. Huang

CONTENTS

15.1 INTRODUCTION

Soft biometric traits such as gender, age, height, weight, eye color, and ethnicity are important visual cues for human-centered video surveillance systems (Jain et al. 2004, Fu and Huang 2008a,b, Fu et al. 2008a–d, 2009). Figure 15.1 shows some examples of soft biometrics traits. For most existing biometric systems, only the identification or recognition of personal identities is focused by using hard biometric traits such as face, iris, fingerprint, and hand-geometry. However, in many real-world video surveillance systems, especially for the noncooperative scenario, the limitations of database collection, the large variations of uncontrollable environment conditions, and the difficulties of capturing spontaneous positions of subjects under surveillance, may significantly degrade system performances. A fuzzy description of the biometric traits of the subjects under surveillance may play an important role for the cases of unconfident decision, open-set recognition, security control, surveillance monitoring, and computer vision–based Electronic Customer Relationship Management (ECRM). Soft biometrics is also an effective way to improve the performance of the primary biometric systems for surveillance purposes by multiple feature fusion and decision model fusion (Ramanathan and Chellappa 2006a,b).

The current soft biometric systems (modules) mainly use two cases of sensory setups. For the long-distance camera setup, where the camera

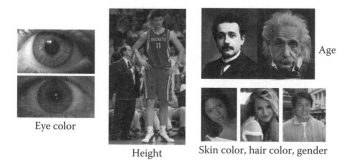

Figure 15.1 (See color insert following page 332.) Some soft biometrics traits (images are from Internet search, courtesy of owners).

and objects in the scene are far away from each other (without camera zoom in/out), the human body is captured as the main visual cue. Such kinds of systems involve human detection, human tracking, feature extraction, image representation, and decision models. For the short-distance camera setup, where the camera and objects in the scene are close to each other (without camera zoom in/out), the human face is captured as the main visual cue. Face detection, face/head tracking, feature extraction, and decision models are designed to integrate the system. Gender recognition is a two-class classification problem. Many existing techniques, such as the Support Vector Machine (SVM) and Artificial Neural Networks (ANN), can be used for this purpose. Other soft biometrics problems could be multi-class classification problems that can be solved by different multi-class classifiers. Age, height, and weight are continuous labels, and the estimation problems for such traits can be handled by regression methods.

The main challenges of using soft biometrics in video surveillance systems lie in the database collection, the reliable detection and tracking, and the alignment of sensory input, which are general challenges for any surveillance systems. So, in this chapter, we will particularly focus on techniques and algorithms for feature extraction and decision models. Comprehensive survey of state-of-the-art works will be presented as well as our experiences and contributions in the field, such as face-image-based age estimation, gender recognition from face, and gender recognition from body, etc.

15.2 SOFT BIOMETRICS–BASED VIDEO SURVEILLANCE SYSTEM

A general video surveillance system (Jain et al. 2004) based on soft biometrics is shown in Figure 15.2. The sensory input, such as video, collects the visual information of gender, age, height, weight, eye color, and ethnicity. The feature is extracted with different techniques either by fusion or multichannel classification. Multimodal pattern classification is performed in the next step to make the decisions. The results of soft biometrics are sent to the existing surveillance

Figure 15.2 Soft biometrics–based video surveillance system.

system to aid the monitoring display and the scene analysis. The soft biometrics modules are also in a loop to iteratively update the system performance in real time.

15.3 FEATURE EXTRACTION BY UNIFIED DISCRIMINATIVE SUBSPACE LEARNING

Feature extraction can be realized by many existing algorithms, especially subspace learning. As proposed by Fu (2008), a general framework of unified discriminative subspace learning is illustrated in Figure 15.3. This framework consists of three levels in a top–down manner. Level 1 and level 2 are concatenated to provide general concepts of discriminative subspace learning. Level 1 defines basic subspace learning

Figure 15.3 Framework of unified discriminative subspace learning (Fu, 2008).

strategies, global learning or local learning, while level 2 specifies them into the data space, feature space, and learning space. When fixing the concepts, level 3 provides four algorithm criteria—manifold learning, Fisher graph, similarity metric, and high-order data structure—for particular algorithm design. When going through different paths from level 1 to level 3, the concepts and criteria in the framework can be applied separately or jointly to formulate new algorithms.

Specifically, we have the following six general concepts (Fu et al. 2008b, Fu 2008):

1. Feature-Globality (FG): FG takes each training image as a single feature with each pixel being a dimension of the feature vector/ matrix.
2. Feature-Locality (FL): FL selects local parts or local patches in the global feature space to build multiple models.
3. Sample-Globality (SG): SG, like conventional methods, applies all training sample points to build the global model.
4. Sample-Locality (SL): SL partitions the training sample space or searches local neighborhoods of a query to build a linear model in local sample sets.
5. Learning-Globality (LG): In a graph embedding view, LG constructs a globally connected graph to measure the data affinity for learning the low-dimensional representation.
6. Learning-Locality (LL): LL constructs a partially connected graph embodying local connectivity.

A common question is: which is better, globality or locality? This question can be answered in Fu et al. (2008b) by defining the Discriminating Power Coefficient (DPC) in terms of the graph embedding theory. The conclusions are that locality manner outperforms the globality manner in many cases of biometrics systems and these cases to choose locality instead of globality can be summarized as follows.

1. For the small training sample case, we can choose learning locality or feature locality.
2. For the large training sample case, we can choose sample locality+feature locality, or sample locality+learning locality, or sample locality+feature locality+learning locality.

When we fix the path in levels 1 and 2, we can combine different criteria in level 3. For a particular manifold learning design, according to the graph embedding theory (Yan et al. 2007a,b), dimensionality reduction and subspace learning are often intertwined. To combine with the Fisher graph criterion, two such kinds of formulations will be used to maximize the between-class measure and at the same time minimize the within-class measure. Different similarity metrics can be adopted to modify the formulations too. Four examples of algorithm designs corresponding to different combinations of the four criteria in level 3 shown in Figure 15.3 are Locally Embedded Analysis (LEA) (Fu and Huang 2005), Discriminant Simplex Analysis (DSA) (Fu et al. 2008c), Correlation Embedding Analysis (CEA) (Fu et al. 2008d), and Correlation Tensor Analysis (CTA) (Fu and Huang 2008b).

15.4 AGE ESTIMATION FROM FACE

There are two face-aging stages during the human life (Mark et al. 1980). From infancy to puberty, the craniofacial growth (shape change) shows the greatest change. From adulthood to old age, the skin aging (texture change) becomes the most perceptible change. The shape change may still continue with a small range.

Age estimation has many real-world applications (Fu et al. 2009). In the field of Electronic Customer Relationship Management (ECRM), companies' customer service/relationship agents want to use information technology and multimedia interaction tools for effectively managing relationships with all customers and responding directly to each individual. Obviously, customized products or services may yield more profits. These products or services require the automatic capture of customers' consuming habit, preferences, responsiveness, and expectation to marketing by analyzing personal information of all customer groups in a legal way. Computer-based age estimation via face images is an effective technique since we can capture an individual's age by latent analysis without violating anyone's privacy. For example, the advertisers want to collect demographics information of potential customers in terms of age groups by counting the audiences for a specific advertisement; a window display in a mall might show household ads

as adults walk by or game ads as teenagers walk by; a restaurant may want to know which age group is more interested in a dish.

Another application of age estimation is the security control and surveillance monitoring (Guo et al. 2008a,b, Lanitis et al. 2004). Security issue is always important when more and more information and data are easily accessible in these days. With the input of a surveillance camera, age estimation system can warn or stop underage drinkers from entering bars or wineshops; deny children access to online adult Web sites or restricted contents; refuse the aged when they want to try dangerous games in a theme park. The third application is biometrics (Jain et al. 2004). Since age estimation is a type of soft biometrics, it can be used to complement the primary biometric features to improve the performance of a hard biometrics system, such as in the applications of face recognition and identification (Ricanek and Boone 2005, Ricanek et al. 2006, Patterson et al. 2006, 2007).

A general age estimation framework, as illustrated in Figure 15.4, consists of four modules: image input (face image), face detection (Viola and Jones 2004), feature extraction (Fu 2008), and estimation (classification or regression) (Guo et al. 2008a,b), which are concatenated. A camera first captures photos of subject faces, crops out face areas with pose correction (warp to the frontal view), extracts features, reduces dimensions, and finally automatically labels the face by an age label or a particular age group.

There are many challenges for the age estimation task (Fu 2008, Guo et al. 2008a,b). Face aging is uncontrollable and personalized (Ramanathan and Chellappa 2006a,b, Ling et al. 2007, Geng et al. 2007). People are aging in different rates and determined by their genes. Health condition, living style, working environment, sociality, and all kinds of factors may affect the aging process. Interestingly, males and females show different aging patterns in their face images due to the different extent in using makeups and accessories. Many

Figure 15.4 Age estimation framework.

female face images may show younger appearances than male images. Moreover, multiple attributes of the face, such as gender, ethnicity, expression, degrade the age estimation performance since extracting general discriminative aging features becomes difficult. Database collection is another issue. Most statistical models need large-scale database that can cover enough aging variations and individual variations. It is often a difficult or even impractical work to collect sufficient data.

There are several existing face-aging databases for age estimation test (Ramanathana et al. 2009). Some are public available, some are not. (1) The public available FG-NET aging database contains 1002 high-resolution color or grey scale face images of 82 multiple-race subjects with variations of lighting, pose, and expression. The age range is from 0 to 69 years with chronological aging images available for each subject (on average 12 images per subject). The aging features can be a shape model with 68 key points, the Active Appearance Models (AAMs) with 200 model parameters, or the pure appearance. (2) The MORPH database (Ricanek and Tesafaye 2006) is also available for the public. It was collected by the face-aging group in the University of North Carolina at Wilmington, for the purpose of face biometrics applications. This database records individuals' metadata, such as age, gender, ethnicity, height, weight, ancestry, and organizes into two albums. Album 1 contains 1,724 face images of 515 subjects taken between 1962 and 1998. The ages range from the average of 27.3 to maximum 68 years for 294 images of females and 1,430 images of males. The age spans from 46 days to 29 years. Album 2 contains more than 20,000 face images obtained from more than 4,000 individuals. (3) The Yamaha Gender and Age (YGA) (Fu et al. 2007, Fu and Huang 2008a) database contains 8,000 high-resolution outdoor color images of 1,600 Asian subjects, 800 females and 800 males, with ages ranging from 0 (newborn) to 93 years. Each subject has about 5 near frontal images at the same age and a ground truth label of his or her approximate age as an integer. The photos contain large variations in illumination, facial expression, and makeup.

15.4.1 Aging Feature Extraction

There are four existing aging feature extraction techniques (Fu et al. 2009). The anthropometric model was used earlier by Kwon and Lobo

(Kwon and Lobo 1999) for age group classification using cranio-facial development theory (Alley 1988). It adopts the mathematical model—"revised" cardioidal strain transformation model—to describe the growth of a person's head from infancy to adulthood. Farkas (1994) defined the face anthropometry in terms of measurements taken from 57 landmarks or fiducial points on human faces over different ages. The distance ratios measured from facial landmarks are often used to represent age growth, for example, Kwon and Lobo (1999) used six ratios of distances on frontal face images to differentiate babies from adults. Ramanathan and Chellappa (2006a,b) proposed to improve face recognition across age progression. They used eight ratios of distance measures to model age progression in young faces. Gunay and Nabiyev (2007) proposed a variant of such method for anthropometric feature extraction.

The anthropometric model–based representations is only effective to deal with faces from infancy to adulthood because the human head shape only changes significantly during this period. After the adulthood, the texture change will dominate. But, this model only considers the facial geometry and does not consider any texture information. Since the ratios of distances are sensitive to the head pose in 2D images, in existing studies, only frontal faces were used to measure facial geometries.

The Active Appearance Model (AAM) (Cootes et al. 2001), a statistical model for coding face images, learns shape and texture representations separately from a set of training face images using the Principal Component Analysis (PCA). Lanitis et al. (2002, 2004) used an AAM model–based aging function for face aging. There are 50 raw model parameters predefined to describe the face image. The real age of individuals and the model parameters are connected by the aging function. Three formulations of the aging function, linear, quadratic, and cubic, and different classifiers are investigated, respectively. Compared with the anthropometry model, the AAM-based approach represents face images with both shape and texture, which make it possible to represent any ages instead of just from infancy to adulthood. From Lanitis's study, quadratic function is demonstrated to be more accurate than other multiple linear regression functions. However, such kind of regression model is usually not sufficient to fit high-dimensional parameters and cannot deal with outliers.

When more face images in different ages of most individuals are available, the AGing pattErn Subspace (AGES) (Geng et al. 2006, 2007) is a good choice. The AGES is defined as a sequence of personal face images from the same person, sorted in the temporal order. If the face images of all ages are available for an individual, the corresponding aging pattern is called a complete aging pattern, otherwise, it is called an incomplete aging pattern. For the incomplete aging pattern, most cases in real-world databases, the AGES method synthesize the missing ages using an EM-like iterative learning algorithm to minimize the reconstruction error characterized by the difference between the available age images and the reconstructed face images. The PCA technique is used here to obtain an aging pattern subspace representation. The average of available face images is used to initialize the reconstruction of the missing age image. For age estimation, a best age position in the aging pattern for a test image is determined by the minimum reconstruction error of all possible positions. Notice the AGES method assumes that several images of the same individual at different ages are available in the training database. However, most existing aging databases cannot provide enough data to make this assumption practical.

Since most aging databases are not sufficient, some subjects only have a single image at a particular age and some may have a few more images at different ages. For such kind of databases, if the entire database is large, age manifold learning (Fu et al. 2007, Fu and Huang 2008a) is a possible method to consider which is more flexible and has fewer constraints on the database. There is no need to collect several different ages for each individual which is often impossible. Since the aging process shows a low-dimensional pattern, a particular manifold learning method can be applied to reduce the dimension of the raw feature and capture the low-dimensional trend of aging. The manifold learning methods can be either the nonlinear ones or the linear ones (linearization of the nonlinear objective functions). Since the nonlinear methods mainly focus on the visualization results, which need extra computation for the test data, the linear methods are often adopted in real applications. Such kind of linear manifold learning methods are actually subspace learning algorithms that consider the manifold criteria and nonparametric assumption, such as the Locally Embedded Analysis (LEA) (Fu and Huang 2005), Locality Preserving Projections (LPP)

(He and Niyogi 2003), Orthogonal Locality Preserving Projections (OLPP) (Cai et al. 2006), and Conformal Embedding Analysis (CEA) (Fu et al. 2008a–d).

The appearance model is also generally used in several age estimation systems, in which both global and local features can be extracted. For example, Hayashi et al. (2001, 2002) reported an appearance-based (global feature) age and gender estimation system in which both texture (wrinkle) and shape (geometry) features are considered. A multiple age group classification scheme is performed with 5 year intervals. Gender estimation is also implemented to improve the age estimation module. In addition to the global feature, local feature is also evidently useful. Yan et al. (2008a,b) proposed to use Spatially Flexible Patch (SFP) as the feature descriptor, which considers local patches and their position information. Gaussian Mixture Model (GMM) is adopted for the probabilistic modeling. This position-encoded local-patch representation can tolerate small misalignment, occlusion, and head pose variations. It also provides more discriminating power for the small sample size case.

15.4.2 Age Estimation Algorithms

Age estimation algorithm works on the extracted aging features. Since age labels can be group numbers or sequential values, the age estimation can be viewed as either a classification problem or a regression problem. In some real-world cases, combining the two schemes is a good way to improve the age estimation accuracy and system robustness.

For a classification scheme, Lanitis et al. (2004) evaluated different classifiers, such as nearest neighbor, the Artificial Neural Networks (ANNs), and a quadratic function, for age estimation. Aging features are represented by AAM. The quadratic function classifier accuracy turns out to be a little lower than the nearest neighbor classifier, but higher than the ANNs and the Self-Organizing Map (SOM) method. As an extension, a hierarchical fashion can be adopted to refine the age estimation on the clustering results. Ueki et al. (2006) built 11 Gaussian models in a low-dimensional 2DLDA+LDA feature space on the WIT-DB database using the EM Algorithm. The age-group

classification is determined by fitting the test image to each Gaussian model and comparing the likelihoods. Guo et al. (2008a,b) proposed to use Support Vector Machines (SVMs) for age estimation on the large-size YGA database. Kanno et al. (2001) presented to use ANNs for the 4-class age-group classification that performed on 110 young male faces.

For the regression scheme, Fu et al. (2007, 2008a–d) used a multiple linear regression function to fit the CEA aging manifold that achieves significant improvements over some existing techniques. Guo et al. (2008a,b) used the Support Vector Regression (SVR) on the OLPP aging manifold, which yields the MAEs of 7.00 years and 7.47 years on the YGA database for females and males, respectively, and 5.16 for the FG-NET aging database. Yan et al. (2007a,b) formulated a Semi-Definite Programming (SDP) solution to the age regression problem, which achieves the Mean Absolute Error (MAE) of 9.79 years and 10.36 years for the females and males, respectively, on the YGA database. Since the SDP is computationally very expensive, an Expectation-Maximization (EM) algorithm was used to solve the regression problem and speed up the optimization process that can achieve 6.95 years for both female and male on the YGA database, and 5.33 for the FG-NET aging database. Zhou et al. (2005) presented the generalized image-based regression for multiple-output settings using a boosting scheme to select Haar-like features. It significantly reduces the computational cost and achieves a MAE of 5.81 with fivefold cross validation test on the FG-NET database.

Guo et al. (2008a,b) have demonstrated that a hybrid approach of both classification and regression is more promising, because the classification-based age estimation can be much better or much worse than the regression-based approach in different cases. The hybrid approach may take the advantages from both and improve robustness. For example, they proposed the Locally Adjusted Robust Regressor (LARR) that achieves a consistently better performance than the pure classification or regression approach, such that the MAEs can be reduced to 5.25 and 5.30 years for the female and male respectively on the YGA database, and 5.07 years on the FG-NET database. It first computes a regression on all the training data and then builds local classifiers along the regression curve. To improve this method by providing automatic

local range selection, a probabilistic approach is a better choice (Guo et al. 2008a,b) as it provides the MAEs of 5.11 and 5.12 years for female and male on the YGA database, and 4.97 years on the FG-NET database.

15.5 GENDER RECOGNITION FROM FACE

Gender recognition from face images is becoming more and more accurate when face detection is getting more effective and efficient. There are many potential applications of gender recognition from face. In the ECRM scenario, a shopping mall may want to show different advertisement contents in the window display for male and female. For example, an advertisement about cosmetic will pop out when a female walks by or a car advertisement will pop out when a male walks by.

Most existing techniques use frontal faces and appearances as features (Guo et al. 2009a–d). Some early works use neural network for gender recognition, such as the SEXNET reported by Golomb et al. (1991) with an accuracy of 91.9% obtained from the experiments on 90 photos of 45 males and 45 females, the HyperBF networks presented by Brunelli and Poggio (1992) with an accuracy of 79% obtained from the experiments on 168 images of 21 males and 21 females, the hybrid classifier based on neural networks and decision trees by Gutta et al. (1998) with an accuracy of 96% on the FERET database (Phillips et al. 2000). The SVM technique lately dominated many gender recognition systems using face images as sensory inputs. For example, Moghaddam and Yang (2002) used nonlinear SVM for gender recognition on the FERET database with an accuracy of 96.6% on 1,755 images of 1044 males and 711 females. Dimensionality reduction is also popular for feature extraction in the gender recognition. Graf and Wichmann (2002) combined dimensionality reduction, such as PCA and LLE, with SVM classifiers. Jain and Huang (2004) used ICA and Linear Discriminant Analysis (LDA) for discriminant feature extraction. Costen et al. (2004) presented a SVM-like sparse regularization function for sparse classifiers design. The AdaBoost is demonstrated to be another effective tool for gender recognition. For example, Shakhnarovich et al. (2002) reported a real gender recognition system with unconstrained conditions, which reveals better performance than SVM. Baluja and Rowley (2007)

reported an accuracy of 94.4% on 2,409 face images of 1,495 males and 914 females from FERET used AdaBoost classifier. Wu et al. (2003) presented a Look Up Table (LUT) weak classifier-based AdaBoost. Xu and Huang (2007) presented the SODA-Boosting for gender classification, a variant of AdaBoost, with an accuracy of 92.82% on 4,109 face images (703 males and 498 females) from FERET database used five-fold cross validation. Yang and Ai (2007) combined Local Binary Patterns (LBP) feature and AdaBoost classifier for age, gender, and ethnicity classification. They reported an accuracy of 93.3% on 3,540 images from FERET. Sun et al. (2002) tried Genetic Algorithms (GA) for optimal feature selection that also shows promising performance.

15.6 GENDER RECOGNITION FROM BODY

When the camera is far away from the subjects, detecting faces will be difficult and sometimes even intractable. Even if the face can be detected, the low-resolution image may degrade the gender recognition performance dramatically. A more applicable idea is to consider the full body images as the sensory input to mitigate the degrading factors.

15.6.1 Gender Recognition from Single Body Image

Gender recognition from body images is a difficult task that has not been widely studied in the past. The varieties of human bodies captured in the images, large body pose and gesture variations, inevitable occlusions, and unpredictable clothing patterns all aggravate the difficulties of gender recognition from body images (Cao et al. 2008, Guo et al. 2009c). Some common facts may clearly show this situation, for example, human body detection is technically harder than face detection; both females and males can be dressed in the same color and even the same clothes; both females and males may have the same hair style and wear the same hat, sunglasses, or shoes; different people may have the same height, body pose, and gesture.

Suppose the body detection can be well handled, the next two crucial steps are feature representation and classification. Cao et al. (2008) proposed some valuable results in the study of the gender recognition

from a single body image. They discussed three kinds of visual features for body pattern representation. The appearance of raw pixels is easy to use, but too sensitive to deal with the clothe colors. The edge map calculated by the Canny edge detector (Canny 1986) is an effective way to compensate by providing the shape cues. However, the edge maps may not tolerate changes of illumination and position. To further improve the robustness of the feature representation, Histogram of Oriented Gradients (HOG) (Dalal and Triggs 2005) feature can be considered. HOG represents the edges with a magnitude-weighted histogram, grouped according to edge directions. As a result, each body area is divided into 3×3 blocks, and each block is encoded by a HOG representation, as a vector (length 8) describing the gradient in 8 orientations.

Three popular classification algorithms can be used in terms of the available visual features. One of the most popular learning algorithms, AdaBoost, combines many weak classifiers with weighting schemes to build strong classifiers. The most discriminative decision stumps are chosen as the weak classifiers. The training algorithm[*] is summarized as follows:

1. Given n_+ male images and n_- female images with the image label y_i, 1 for male and -1 for female. The image features are denoted by $\mathbf{x}_i = (x_i(1), x_i(2), \ldots, x_i(d))^T$, where d is the feature dimension and i is the image index with $1 \leq i \leq n_+ + n_-$.
2. Initialize the weights of training samples $W_1(i) = 0.5/|n_+|$ if $y_i = 1$, or $W_1(i) = 0.5/|n_-|$ if $y_i = -1$.
3. For $t = 1, \ldots, T$, based on W_1, select the weak classifier $h_t(\mathbf{x}) = h_t(x(k_t))$, where k_t is the optimal feature position; compute the training error ε_t of the weak classifier h_t; compute the voting weight $\alpha_t = 0.5 \log((1 - \varepsilon_t)/\varepsilon_t)$; update $W_{t+1}(i) = W_t(i)\exp(-\alpha_t y_i h_t(\mathbf{x}_i))/Z_t$, where Z_t is a normalization factor.
4. Output the final decision with classifier $C(\mathbf{x}) = \text{sign}(\alpha_1 h_1 + \alpha_2 h_2 + \cdots + \alpha_T h_T)$.

The Random Forests (RF) (Freund and Schapire 1996, Breiman 2001) train successive decision trees independently using a bootstrap sample

[*] From Cao, L. et al., Gender recognition from body, *ACM Conference on Multimedia*, Vancouver, Canada, pp. 725–728. With permission.

of the data set and combine them for prediction. They maximize the independence of features, while keeping individual classifiers as accurate as possible. This algorithm has the advantages of tolerating overfitting and fast in both training and testing. The training algorithm* is described as three steps.

1. Draw bootstrap samples from the original data.
2. For each bootstrap sample, randomly draw a subset of all the predictors, and grow an unpruned classification tree using the selected subset.
3. The trained random forest is the majority voting of the decision trees.

The Part-Based Gender Recognition (PBGR) (Cao et al. 2008) algorithm is another way to improve the classification performance. Since it is hard to describe the gender traits from the whole body image, the basic idea of PBGR is to partition the body image and consider local parts as the feature representation. Some local appearances may be more discriminative for gender recognition. For example, a person with spiky hair and jacket is more like a male; a person with long curly hair and skirt is more like a female. The grid sampling (6×19) was used to partition the body images with overlapped patches with each patch represented by an HOG feature vector. The classification part of PBGR algorithm is a variant of AdaBoost algorithm. Differently, the weak classifiers are based on the body parts not the whole. In each round, it first selects the most discriminative patch position, and then computes the optimal classifier using the patch features of the selected position. The training algorithm* is summarized as follows:

1. In each image i, extract part-based features \mathbf{x}_i, where $\mathbf{x}_i = \{x_i(p)\}$, with index $1 \leq p \leq P$.
2. For $t = 1, \ldots, T$, select a body part p_t, find weak classifier $h_t(\mathbf{x}) = h_t(x(p_t))$, compare the voting weight α_t from Adaboost.
3. Output the final decision with classifier $C(i) = \text{sign}(\alpha_1 h_1 + \alpha_2 h_2 + \cdots + \alpha_T h_T)$.

* From Cao, L. et al., Gender recognition from body, *ACM Conference on Multimedia*, Vancouver, Canada, pp. 725–728. With permission.

The database of human body pictures with gender labels is very few. This study uses the publicly available MIT pedestrian database (Oren et al. 1997). All pedestrian images are 128×64. The subjects are centered and aligned with height of 100 pixels. There are 600 images labeled as male and 288 images as female with 53% back views and 47% frontal views.

The experiments test the performances of all the three features and three classification algorithms with five-fold cross validation with pre-separated views. It concludes that the HOG feature performs better than the edge map and the raw feature. Random forest performs better for front views, while AdaBoost performs better for back views. The PBGR achieves the best accuracy of $76.0\% \pm 1.2\%$ for the frontal view and $74.6\% \pm 3.4\%$ for the back view. For non-fixed view case, this algorithm can still achieve the accuracy of $75.0\% \pm 2.9\%$. This study also revealed that the patches in the head and body positions play more important roles for gender recognition.

15.6.2 Gender Recognition from Gait

Gait is the human walking manner (Sarkar et al. 2005), which includes both appearance and motion. In the user noncooperative surveillance scenario, using gait to identify human or even recognize gender is very useful when long-distance video is available. However, in the "wild" data acquisition case, capturing and representing human gait in general ways is still an open problem, since large varieties of subject motions and cluttered scene can be observed when the scenario constraints are relaxed. To mitigating the degrading factors and varieties, most existing methods use a silhouette sequence, a gait energy image (averaged gait image), or a motion structure model. Lee and Grimson (Lee and Grimson 2002, Lee 2003) extracted scale-normalized binary silhouette, calculated the centroid, and partitioned it into head/shoulder, arms/torso, thighs, and calve/feet, used moment-based features for the gait representation on each partition. Yoo et al. (2005) used body contour to extract a stick figure with eight sticks and six joint angles. As a result, the gait is represented by the motion parameters in a stick figure sequence.

In the most recent work, Li et al. (2008) presented to use part-based silhouettes for gait pattern representation in the application of gender

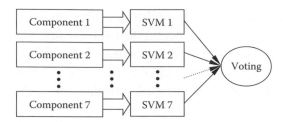

Figure 15.5 System framework of gender recognition from gait in Li et al. (2008).

recognition. The human silhouette sequence is first averaged to the average gait image. It is then segmented into seven components—head, arm, trunk, thigh, front-leg, back-leg, and feet. A linear SVM is trained on each component separately. The final classification result is based on the voting scheme from each individual classifier. Figure 15.5 illustrates the system framework proposed in Li et al. (2008). As used for experiments, the USF HumanID outdoor gait database contains 1,870 sequences of 122 subjects (85 males and 37 females), with view point change, shoe type change, walking surface change, carrying condition change, and elapsed time change between sequences being compared (Sarkar et al. 2005). Extensive experiments have been conducted in the study to show the effectiveness of the proposed framework. Some interesting conclusions about the performances of different components are also drawn. For example, the gait of the head, arm, trunk, and back-leg are important for averaged gait-based human recognition.

15.7 GENDER RECOGNITION BY FUSING GAIT AND FACE

For robust system design, Shan et al. (2008) presented to fuse both gait and face in the feature level for gender recognition. Since the gait and face modality are complementary, the fusion of the two can mitigate degrading factors and significantly improve the system performance and robustness. In this study, they assumed the gait and face features are correlated in terms of the gender trait. The face feature is extracted as the original 30×22 pixels from each image. The Gait Energy Image (GEI) (Han and Bhanu 2006) is used to represent the gait feature. The Canonical Correlation Analysis (CCA) (Hotelling et al. 1936) is

finally used as a general tool to fuse the two features. After the feature representation, the SVM is used as a classifier for gender recognition. The CASIA gait database (Dataset B) (Yu et al. 2006) was used in the study which consists of 124 subjects with 93 males and 31 females. Eleven video sequences from different views were captured simultaneously from eleven cameras. There are ten sequences for each subject including six normal walking, two walking with a coat, and two walking with a bag. They chose frontal view for facial feature extraction and side view for gait feature extraction. In total, there are 119 subjects (88 males and 31 females) selected for the experiments. With a five-fold cross-validation test, this work achieves an accuracy of 97.2%.

15.8 SUMMARY

In this chapter, we survey the state-of-the-art research results in the soft biometrics field for the purpose of video surveillance, including age estimation from face, gender recognition from face, and gender recognition from human body. The advanced techniques and algorithms developed in soft biometrics may significantly contribute to developing robust video surveillance systems.

15.9 BIBLIOGRAPHICAL AND HISTORICAL REMARKS

Soft biometrics has been widely studied recently, especially by Moghaddam and Yang (2002), Jain et al. (2004), Lanitis et al. (2004), Ramanathan and Chellappa (2006a,b), Ricanek and Boone (2005), Ricanek et al. (2006), Patterson et al. (2006, 2007), Geng et al. (2006, 2007), Xu and Huang (2007), Fu et al. (2008a–d), Guo et al. (2008a,b), Shan et al. (2008), Li et al. (2008), which can improve the performance of the primary biometrics systems for surveillance purpose. It has been effectively applied to many real-world applications such as unconfident decision, open-set recognition, security control and surveillance monitoring, computer vision–based ECRM, and entertainment and media industry.

REFERENCES

Alley, T. R. 1988. *Social and Applied Aspects of Perceiving Faces*, Lawrence Erlbaum Associates, Hillsdale, NJ.

Baluja, S. and Rowley, H. A. 2007. Boosting sex identification performance. *International Journal of Computer Vision* 71(1):111–119.

Breiman, L. 2001. Random forests. *Machine Learning* 45(1):5–32.

Brunelli, R. and Poggio, T. 1992. HyperBF networks for gender classification. In *DARPA Image Understanding Workshop*, San Diego, CA, pp. 311–314.

Cai, D., He, X., Han, J., and Zhang, H.-J. 2006. Orthogonal Laplacianfaces for face recognition. *IEEE Transactions on Image Processing* 15(11):3608–3614.

Canny, J. 1986. A computational approach to edge detection. *IEEE Transactions on Pattern Analysis and Machine Intelligence* 8(6):679–698.

Cao, L., Dikmen, M., Fu, Y., and Huang, T. S. 2008. Gender recognition from body. In *The ACM Conference on Multimedia*, Vancouver, Canada, pp. 725–728.

Cootes, T., Edwards, G., and Taylor, C. 2001. Active appearance models. *IEEE Transactions on Pattern Analysis and Machine Intelligence* 23(6):681–685.

Costen, N.P., Brown, M., and Akamastu, S. 2004. Sparse models for gender classification. In *IEEE International Conference on Automatic Face and Gesture Recognition*, Seoul, Korea.

Dalal, N. and Triggs, B. 2005. Histograms of oriented gradients for human detection. In *IEEE Conference on Computer Vision and Pattern Recognition*, San Diego, CA, pp. 886–893.

Electronic Customer Relationship Management (ECRM), http://en.wikipedia.org/wiki/ECRM

Farkas, L. 1994. *Anthropometry of the Head and Face*, Raven Press, New York.

Freund, Y. and Schapire, R. 1996. Experiments with a new boosting algorithm. In *International Conference on Machine Learning*, Desenzano sul Garda, Italy.

Fu, Y. 2008. Unified discriminative subspace learning for multimodality image analysis. PhD thesis, University of Illinois at Urbana-Champaign, Urbana, IL.

Fu, Y., Guo, G., and Huang, T. S. 2009. Age synthesis and estimation via faces: A survey. *IEEE Transactions on Pattern Analysis and Machine Intelligence*, to appear.

Fu, Y. and Huang, T. S. 2005. Locally linear embedded eigenspace analysis. Technical Report IFP-TR, University of Illinois at Urbana-Champaign, Urbana, IL, http://www.ifp.uiuc.edu/~yunfu2/papers/LEA-Yun05.pdf

Fu, Y. and Huang, T. S. 2008a. Human age estimation with regression on discriminative aging manifold. *IEEE Transactions on Multimedia* 10(4):578–584.

Fu, Y. and Huang, T. S. 2008b. Image classification using correlation tensor analysis. *IEEE Transactions on Image Processing* 17(2):226–234.

Fu, Y., Li, Z., Huang, T. S., and Katsaggelos. A. K. 2008a. Locally adaptive subspace and similarity metric learning for visual clustering and retrieval. *Computer Vision and Image Understanding* 110(3):390–402.

Fu, Y., Li, Z., Yuan, J., Wu, Y., and Huang, T. S. 2008b. Locality versus globality: Query-driven localized linear models for facial image computing. *IEEE Transactions on Circuits and Systems for Video Technology* 18(12):1741–1752.

Fu, Y., Xu, Y., and Huang, T. S. 2007. Estimating human age by manifold analysis of face pictures and regression on aging features. In *IEEE International Conference on Multimedia and Expo*, Beijing, China, pp. 1383–1386.

Fu, Y., Yan, S., and Huang, T. S. 2008c. Classification and feature extraction by simplexization. *IEEE Transactions on Information Forensics and Security* 3(1):91–100.

Fu, Y., Yan, S., and Huang, T. S. 2008d. Correlation metric for generalized feature extraction. *IEEE Transactions on Pattern Analysis and Machine Intelligence* 30(12):2229–2235.

Geng, X., Zhou, Z.-H., and Smith-Miles, K. 2007. Automatic age estimation based on facial aging patterns. *IEEE Transactions on Pattern Analysis and Machine Intelligence* 29(12):2234–2240.

Geng, X., Zhou, Z.-H., Zhang, Y., Li, G., and Dai, H. 2006. Learning from facial aging patterns for automatic age estimation. In *ACM Conference on Multimedia*, Santa Barbara, CA, pp. 307–316.

Golomb, B. A., Lawrence, D. T., and Sejnowski, T. J. 1991. Sexnet: A neural network identifies sex from human faces. In *Advances in Neural Information Processing Systems*, Denver, CO, pp. 572–577.

Graf, A. B. A. and Wichmann, F. A. 2002. Gender classification of human faces. In *International Workshop on Biologically Motivated Computer Vision*, Tübingen, Germany, pp. 491–500.

Gunay, A. and Nabiyev, V. V. 2007. Automatic detection of anthropometric features from facial images. In *IEEE Conference on Signal Processing and Communications Applications*, Eskişehir, Turkey.

Guo, G., Dyer, C., Fu, Y., and Huang, T. S. 2009d. Is gender recognition affected by age? In *IEEE International Conference on Computer Vision, Workshop on Human-Computer Interaction*, Kyoto, Japan.

Guo, G., Fu, Y., Dyer, C., and Huang, T. S. 2008a. Image-based human age estimation by manifold learning and locally adjusted robust regression. *IEEE Transactions on Image Processing* 17(7):1178–1188.

Guo, G., Fu, Y., Huang, T. S., and Dyer, C. 2008b. A probabilistic fusion approach to human age prediction. In *IEEE CVPR'08-SLAM Workshop*, Anchorage, AK.

Guo, G., Mu, G., Fu, Y., Dyer, C., and Huang, T. S. 2009a. A study on automatic age estimation using a large database. In *IEEE International Conference on Computer Vision*, Kyoto, Japan.

Guo, G., Mu, G., Fu, Y., and Huang, T. S. 2009b. Human age estimation using bio-inspired features. In *IEEE Conference on Computer Vision and Pattern Recognition*, Miami Beach, Florida.

Guo, G., Mu, G., and Fu, Y. 2009c. Gender from body: A biologically-inspired approach with manifold learning. In *The Ninth Asian Conference on Computer Vision*, Xi'an, China.

Gutta, S., Wechsler, H., and Phillips, P. 1998. Gender and ethnic classification. In *IEEE International Workshop on Automatic Face and Gesture Recognition*, Nara, Japan, pp. 194–199.

Han, J. and Bhanu, B. 2006. Individual recognition using gait energy image. *IEEE Transactions on Pattern Analysis and Machine Intelligence* 28(2): 316–322.

Hayashi, J., Yasumoto, M., Ito, H., and Koshimizu, H. 2001. Method for estimating and modeling age and gender using facial image processing. *In Seventh International Conference on Virtual Systems and Multimedia*, Berkeley, CA, pp. 439–448.

Hayashi, J., Yasumoto, M., Ito, H., Niwa, Y., and Koshimizu, H. 2002. Age and gender estimation from facial image processing. *SICE Annual Conference*, Osaka, Japan, 1:13–18.

He, X. and Niyogi, P. 2003. Locality preserving projections. In *Advances in Neural Information Processing Systems*, Whistler, BC.

Hotelling, H. 1936. Relations between two sets of variates. *Biometrika* 8:321–377.

Jain, A. K., Dass, S. C., and Nandakumar, K. 2004. Soft biometric traits for personal recognition systems. In *International Conference on Biometric Authentication*, Hong Kong, pp. 731–738.

Jain, A. and Huang, J. 2004. Integrating independent component analysis and linear discriminant analysis for gender classification. In *IEEE International Conference on Automatic Face and Gesture Recognition*, Seoul, Korea.

Kanno, T., Akiba, M., Teramachi, Y., Nagahashi, H., and Agui, T. 2001. Classification of age group based on facial images of young males by using neural networks. *IEICE Transactions on Information and Systems* E84-D(8):1094–1101.

Kwon, Y. and Lobo, N. 1999. Age classification from facial images. *Computer Vision and Image Understanding* 74(1):1–21.

Lanitis, A., Draganova, C., and Christodoulou, C. 2004. Comparing different classifiers for automatic age estimation. *IEEE Transactions on Systems, Man and Cybernetics Part B* 34(1):621–628.

Lanitis, A., Taylor, C., and Cootes, T. 2002. Toward automatic simulation of aging effects on face images. *IEEE Transactions on Pattern Analysis and Machine Intelligence* 24(4):442–455.

Lee, L. 2003. Gait analysis for classification. Technical Report 2003-014. MIT AI Lab.

Lee, L. and Grimson, W. E. L. 2002. Gait analysis for recognition and classification. In *IEEE International Conference on Automatic Face and Gesture Recognition*, Washington, DC, pp. 155–162.

Li, X., Maybank, S. J., Yan, S., Tao, D., and Xu, D. 2008. Gait components and their application to gender recognition. *IEEE Transactions on Systems, Man and Cybernetics Part C* 38(2):145–155.

Ling, H., Soatto, S., Ramanathan, N., and Jacobs, D. 2007. A study of face recognition as people age. In *IEEE International Conference on Computer Vision*, Rio de Janeiro, Brazil.

Mark, L. S., Pittenger, J. B., Hines, H., Carello, C., Shaw, R. E., and Todd, J. T. 1980. Wrinkling and head shape as coordinated sources of age-level information. *Perception and Psychophysics* 27(2):117–124.

Moghaddam, B. and Yang, M.-H. 2002, Learning gender with support faces. *IEEE Transactions on Pattern Analysis and Machine Intelligence* 24(5): 707–711.

MORPH face database, http://faceaginggroup.com/

Oren, M., Papageorgiou, C., Sinha, P., Osuna, E., and Poggio, T. 1997. Pedestrian detection using wavelet templates. In *IEEE Conference on Computer Vision and Pattern Recognition*, San Juan, Puerto Rico, pp. 193–199.

Patterson, E., Ricanek, K., Albert, M., and Boone, E. 2006. Automatic representation of adult aging in facial images. In *The IASTED International Conference on Visualization, Imaging, and Image Processing*, Palma de Mallorca, Spain, pp. 171–176.

Patterson, E., Sethuram, A., Albert, M., Ricanek, K., and King, M. 2007. Aspects of age variation in facial morphology affecting biometrics. In *IEEE Conference on Biometrics: Theory, Applications, and Systems*, Washington, DC.

Phillips, P., Moon, H., Rizvi, S., and Rauss, P. 2000. The feret evaluation methodology for face recognition algorithms. *IEEE Transactions on Pattern Analysis and Machine Intelligence* 22(10):1090–1104.

Ramanathan, N. and Chellappa, R. 2006a. Face verification across age progression. *IEEE Transactions on Image Processing* 15(11):3349–3361.

Ramanathan, N. and Chellappa, R. 2006b. Modeling age progression in young faces. In *IEEE Conference on Computer Vision and Pattern Recognition*, Southampton, U.K., pp. 387–394.

Ramanathana, N., Chellappa, R., and Biswas, S. 2009. Computational methods for modeling facial aging: A survey. *Journal of Visual Languages and Computing* 20(3): 131–144.

Ricanek, K. and Boone, E. 2005. The Effect of normal adult aging on standard PCA face recognition accuracy rates. In *International Joint Conference on Neural Networks*, Montreal, Canada, pp. 2018–2023.

Ricanek, K., Boone, E., and Patterson, E. 2006. Craniofacial aging on the Eigenface biometric. In *The IASTED International Conference on Visualization, Imaging, and Image Processing*, Palma de Mallorca, Spain, pp. 249–253.

Ricanek, K. and Tesafaye, T. 2006. MORPH: A longitudinal image database of normal adult age-progression. In *IEEE International Conference on Automatic Face and Gesture Recognition*, Southampton, U.K., pp. 341–345.

Sarkar, S., Phillips, P., Liu, Z., Vega, I., Grother, P., and Bowyer, K. 2005. The humanid gait challenge problem: Data sets, performance, and analysis. *IEEE Transactions on Pattern Analysis and Machine Intelligence* 27(2): 162–177.

Shakhnarovich, G., Viola, P. A., and Moghaddam, B. 2002. A unified learning framework for real time face detection and classification. In *IEEE International Conference on Automatic Face and Gesture Recognition*, Washington, DC, pp. 14–21.

Shan, C., Gong, S., McOwan, P.W. 2008. Fusing gait and face cues for human gender recognition. *Neurocomputing* 71(10–12):1931–1938.

Sun, Z., Bebis, G., Yuan, X., and Louis, S. J. 2002. Genetic feature subset selection for gender classification: a comparison study. In *IEEE Workshop on Application of Computer Vision*, Orlando, FL.

The FG-NET Aging database, http://www.fgnet.rsunit.com/ http://www-prima.inrialpes.fr/FGnet/

Ueki, K., Hayashida, T., and Kobayashi, T. 2006. Subspace-based age-group classification using facial images under various lighting conditions. In *IEEE International Conference on Automatic Face and Gesture Recognition*, Southampton, U.K.

Video Surveillance, http://www.videosurveillance.com/

Viola, P. and Jones, M. 2004. Robust real-time face detection. *International Journal of Computer Vision* 57(2):137–154.

Wu, B., Ai, H., Huang, C., and Lao, S. 2003. LUT-based Adaboost for gender classification. In *International Conference on Audio and Video-Based Biometric Person Authentication*, Guildford, U.K.

Xu, X. and Huang, T. S. 2007. Soda-boosting and its application to gender recognition. In *IEEE International Workshop on Analysis and Modeling of Faces and Gestures. Lecture Notes in Computer Science*, Vol. 4778, Springer-Verlag, Berlin, pp. 193–204.

Yan, S., Liu, M., and Huang, T. S. 2008a. Extracting age information from local spatially flexible patches. In *IEEE International Conference on Acoustics, Speech, and Signal Processing*, Las Vegas, NV, pp. 737–740.

Yan, S., Wang, H., Huang, T. S., and Tang, X. 2007a. Ranking with uncertain labels. In *IEEE International Conference on Multimedia and Expo*, Beijing, China, pp. 96–99.

Yan, S., Wang, H., Tang, X., and Huang, T. S. 2007b. Learning auto-structured regressor from uncertain nonnegative labels. In *IEEE International Conference on Computer Vision*, Rio de Janeiro, Brazil.

Yan, S., Zhou, X., Liu, M., Hasegawa-Johnson, M., and Huang, T.S. 2008b. Regression from patch-kernel. In *IEEE Conference on Computer Vision and Pattern Recognition*, Anchorage, AK.

Yang, Z. and Ai, H. 2007. Demographic classification with local binary patterns. In *International Conference on Biometrics*, Seoul, Korea, pp. 464–473.

Yoo, J.-H., Hwang, D., and Nixon, M. S. 2005. Gender classification in human gait using support vector machine. In *Proceedings of Advanced Concepts for Intelligent Vision Systems*, Antwerp, Belgium, pp. 138–145.

Yu, S., Tan, D., and Tan, T. 2006. A framework for evaluating the effect of view angle clothing and carrying condition on gait recognition. In *International Conference on Pattern Recognition*, Hong Kong, pp. 441–444.

Zebrowitz, L. A. 1997. *Reading Faces: Window to the Soul?* Westview Press, Boulder, CO.

Zhou, S. K., Georgescu, B., Zhou, X. S., and Comaniciu, D. 2005. Image based regression using boosting method. In *IEEE International Conference on Computer Vision*, Beijing, China, pp. 541–548.

16

An Efficient System of Detection and Tracking of Moving Objects from Airborne Videos

Qian Yu, Yuping Lin, and Gérard Medioni

CONTENTS

We present a system to detect and track moving objects from an airborne platform. This application involves many important techniques in computer vision. We first discuss the motion detection on a moving platform. A sliding window–based method is used to build the dynamic background model of an airborne camera. This approach is robust to accumulated errors in image registration. We then present a 2D geo-registration method to register UVA images with a satellite image, where motion model of objects is more physically meaningful than in image coordinates. Mutual information is used to find correspondences between these two different modalities. After motion detection and geo-registration, tracking is performed in a hierarchical manner: at the temporally local level, moving image blobs acquired by motion segmentation are associated into tracklets by using the Markoc chain Monte Carlo data association (MCMC-DA) algorithm; at the global level, tracklets are linked by their appearance and spatiotemporal consistence on the global map. To achieve efficient time performance, graphics processing unit (GPU) techniques are applied in motion detection, which is the bottleneck of the whole system.

16.1 INTRODUCTION

The detection and tracking of multiple objects is a fundamental task in surveillance, which provides information for further analysis, e.g.,

in event analysis. In this chapter, we discuss the methods of detection and tracking multiple moving vehicles from airborne cameras. This application involves many important techniques in computer vision, including image registration, motion detection and segmentation, tracking, etc. We focus on motion detection, geo-registration, multiple target tracking, and real-time implementation in this chapter.

Detecting moving vehicles from airborne cameras is difficult. First, the 2D size of the object from airborne imagery may be very small; thus, a pattern-based detector usually may fail due to the lack of resolution and blurry images. Second, motion segmentation may be very noisy, due to erroneous registration, illumination changes, and parallax. To achieve this goal, we need to use a set of techniques and make full use of both motion and appearance information. Also, this application requires real-time or near-real-time performance.

To track moving objects from a moving camera, we need to describe the motion of objects in common coordinates. The mosaic space, which is derived from image coordinates of one fixed frame, is usually selected as the tracking coordinates. Without further refinement, accumulated errors are inevitable if fixed coordinates are selected. More importantly, object motion in image coordinates is not physically meaningful. Here, we use a global map (a satellite image) as the reference frame. By registering images with a satellite image, we can generate the absolute geo-location of targets. Also, tracking in geo-coordinates provides physically meaningful mensuration of object motion.

In airborne surveillance applications, long-term occlusion is common. We introduce a hierarchical procedure to track moving objects with occlusion. In temporally local association, detected regions within a sliding window are associated to generate tracklets. In a large temporal span, the tracklets are associated to form longer tracks and maintain track IDs. Local association is critical for successful tracking since errors in local association cannot be rectified in the global one. We formulate the local association as finding the best partition of observations. In the global association, given the knowledge of the maximum speed and acceleration of targets in the geo-coordinates, we define the compatibility of tracklets and this reduces ambiguity in tracklet association. In addition, we adopt a rotation invariant appearance descriptor to represent both color and shape distributions of targets in

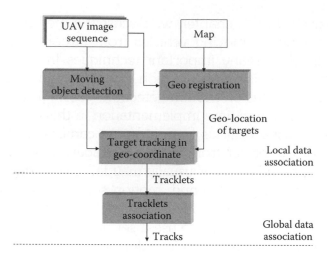

Figure 16.1 Overview of the framework.

each tracklet. To achieve an efficient time performance, we resort to using GPU to implement the bottlenecks of the whole system, which is the background modeling module. The flowchart of our framework is shown in Figure 16.1.

This chapter is organized as follows. The method to detect moving objects from a moving camera and its GPU implementation are presented in Section 16.2. We present the two-step geo-registration approach in Section 16.3. Hierarchical tracking approaches at the temporally local and global levels are presented in Section 16.4. Experimental results for real data sets and the overall time performance are presented at the end of Section 16.4.

16.2 MOTION DETECTION FROM A MOVING PLATFORM

Motion detection for a stationary camera has been extensively studied (please refer to Chapter 4 of this book for details) compared to a moving camera. The most widely used procedure for motion detection algorithm is as follows. First characterize background model, either by image difference or background-learning methods, and then cluster pixels, which do not belong to the corresponding background model. The critical step in various detection algorithms is the collection of good

statistics representing the background model (i.e., the fixed part of the scene). The simplest case of detection algorithm is when we extract moving regions from a stationary camera since the background model process can be simplified as a process of collecting the dominant pixel value (either intensity or color values) per corresponding pixel position through the given sequence.

Motion detection from a moving camera is inherently more complex, since the camera motion induces motion on all the pixels of the image. Therefore, we need to first establish the correspondence for each pixel before actually collecting the statistics of the background model. A solution for this problem consists of first estimating the camera motion and compensate for it, so that the detection of moving objects from a moving camera becomes similar to the detection problem from a static camera, and various stationary camera detection techniques can be applied.

16.2.1 Image Stabilization

The stabilization of a camera motion is a necessary step for motion detection from a moving camera (sometime, stabilization is also needed for fixed cameras since jittering happens very often in outdoor environments). In our unmanned aerial vehicle (UAV) environment, we assume the scene to be a planar surface. This is a reasonable assumption while the structure on the ground plane is relatively small compared with the camera height to the ground plane. Under this assumption, we use a homography to represent the transformation between UAV images (Equation 16.1).

$$x^{I_j} = W(x^{I_i}; H_{i,j}) \qquad\qquad (16.1)$$

where
$W(x; H)$ is a warping function
x^{I_i} is the pixel in the coordinate frame of image I_i

To estimate the homography transformation, we start by extracting features in pair-wise images. The correspondences between extracted features in adjacent frames are established. In our system, Harris

corners (Harris 1992) are used as feature points and sum of squares distance (SSD) is used to find the correspondences. Sub-pixel technique is used to refined the correspondences. Given three or more pairs of correspondences, we use the linear least squares method to compute the parameters. In order to remove outliers in the correspondence, we employ random sample consensus (RANSAC) (Fischler and Bolles 1981) to filter outliers among the set of correspondences and derive $H_{i,i-1}$.

16.2.2 Background Modeling in a Sliding Window

Suppose we know the transformation between two frames, a sequence of frames can be warped to a reference frame. In the warped frames, the camera motion is stabilized relative to the reference frame. Then, the background model is computed by collecting good statistics among the appearance of each 2D location. Given the homography $H_{i-1,i}$ estimated using technique as described in Section 16.2.1, we can compute the homography between any two frames by concatenating the estimated pair-wise transformations as:

$$H_{i,j} = \begin{cases} \prod\limits_{k=i}^{j-1} H_{k,k+1} & i < j \\ I & i = j \\ (H_{j,i})^{-1} & i > j \end{cases} \qquad (16.2)$$

A simple way is to select the first frame as the reference frame, and all the following frames are registered according to the first frame. Equation 16.2 shows that if there exists a small transformation error in each $H_{k,k-1}$, these errors are accumulated and result in a significant error in a long sequence. To avoid accumulated errors, we adopt Kang's sliding window–based method (Kang et al. 2003), where a number of frames are warped to a dynamic reference frame. The center frame of a sliding window is used as the reference frame. This reduces the

accumulated errors by half in terms of the length of the sliding window. A wrong registration result will not influence the motion detection in the entire sequence, but only within the sliding window.

After motion compensation, the decision is made according to the statistics on the corresponding pixels. Suppose the size of the sliding window is w, the background model I_{bg} for the reference frame I_r is

$$I_{bg} = \text{mode}(H_{r-w/2,r}I_r, \ldots, I_r, \ldots, H_{r+w/2,r}I_r) \tag{16.3}$$

Figure 16.2a illustrates the correspondence of pixel locations prior to the characterization of the background model. Figure 16.2b through g shows warped images and the reference image. From Figure 16.2b through g, as we can see, the 2D image motion induced by the moving camera is compensated.

Illumination change is another issue in background modeling. Thus, before we estimate the background model, we first apply the method proposed in Yalcin et al. (2005) to compensate the global illumination change by using a 1D affine model on the intensity or color. Global illumination change means the relation of intensity or color between two images is independent of the location of the pixels. Thus, the affine model proposed in Yalcin et al. (2005) assumes that the relation between the intensity in two frames of the same scene complies with the affine transformation $I_i = aI_j + b$, where $a, b \in R$. For color images, the three R, G, and B channels are compensated independently. In practice, this simple compensation of global illumination works very well, especially in infra-red video sequences. One example is shown in Figure 16.3.

Although the sliding window approach is robust to registration errors, this method is quite computationally expensive, as the reference frame changes when the sliding window moves and all the warped images have to be recomputed. This involves many float-precision interpolation operations, which is a heavy burden for central processing unit (CPU), such as a 91-frame sliding window used in our system.

16.2.3 GPU Implementation

We show an implementation of the sliding window–based method using the general purpose graphics processing unit (GPGPU). In the GPGPU

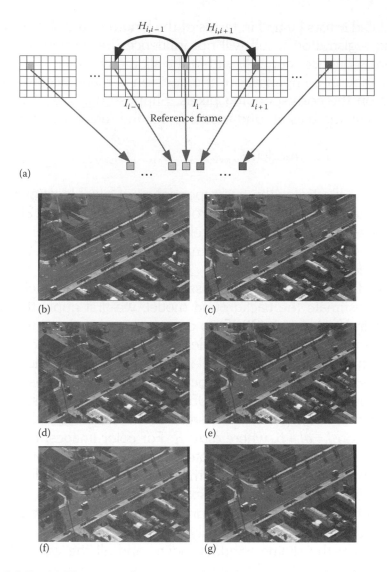

Figure 16.2 (a) The warped images in the sliding window, (b) 1st frame, (c) 25th frame, (d) 46th frame (reference), (e) 65th frame, (f) 72th frame, and (g) 91st frame.

framework, the fully programmable vertex and fragment processors provides powerful computational tools for general purpose computations. Vertex shaders allow us to manipulate the data that describes a vertex. Fragment shaders serve to manipulate a pixel. In order to

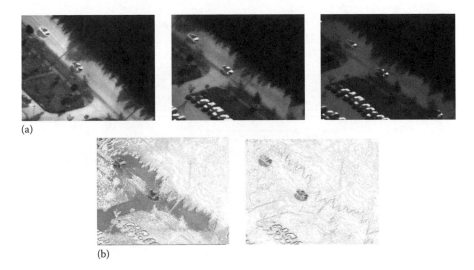

(a)

(b)

Figure 16.3 Compensation of global illumination changes. (a) Obvious illumination changes in three frames of the sliding window and (b) difference image before and after the compensation of illumination changes.

implement an algorithm on the GPU, different computational steps are mapped to different vertex and fragment shaders. We separate the sliding window method into two steps, warping images in the vertex profile and computing the background model in the fragment profile. Also, we minimize memory transfer between GPU and CPU: the inputs for our implementation include a sequentially input image frame and the corresponding homography transformation, and the output is the background image for each frame. The overview structure of the implementation is shown in Figure 16.4.

Our implementation stores sequential frames in the sliding window as 2D textures in the GPU memory. The most recent frame is loaded and the oldest frame is moved out of the texture pool. The warping involves changing the texture coordinates and is implemented in the vertex profile. The vertex profile takes the 3×3 homograph matrix as input and outputs the warped texture coordinates by a simple matrix multiplication. The transformed texture coordinates are used in the fragment profile.

To compute the background model, different statistic functions can be applied in Equation 16.3, such as the mode, the median, and the

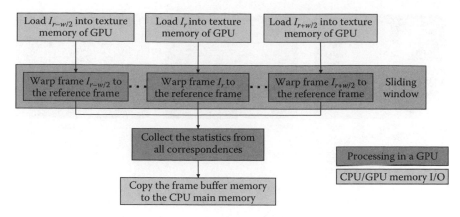

Figure 16.4 Overview of the GPU-based implementation.

mean of the samples in the sliding window. For motion detection from a moving platform, the mode is usually preferred to the other two. This is due to limited samples that can be collected for each pixel. The mean and the median do not differentiate the foreground and background pixels and lead to a biased background model when limited samples are available. The computation of the mode requires building a histogram and then finding the bin with the largest number of samples (there is another way to establish a dynamic histogram by constructing a binary search tree, which involves too many branching operations, thus not proper for GPU implementation).

One histogram is built for each location in the reference frame and each bin records the number of intensity over time (in the sliding window). This is different from the normal concept of a histogram that is built over the whole image. We use a fixed number of bins $n = 16$ to construct a histogram. By using an *RGBA* texture, a histogram in each channel of n bins leads to a tile size of $\sqrt{n/4} \times \sqrt{n/4}$ texture elements. For each pixel, we need to construct such a histogram, therefore the size of the RGBA texture is $W\sqrt{n/4} \times H\sqrt{n/4}$, where W and H are the width and the height of original images, respectively. Suppose $n = 16$ (this is enough for an eight bit dynamic range), the histogram texture memory is 4 times the size of the original one. In an RGBA texture with $n = 16$, $(H(0), H(4), H(8), H(12))$ is stored in a *float4* vector in GPU with the same texture coordinates. After one frame texture

is loaded, the hits in each bin are updated. A bin is indexed by an intensity value, between 0 and 15 for $n=16$. It is not efficient to use "if-else" type statements to determine the placement of one intensity value in the histogram. For efficiency, it is preferable to use standard Cg functions (Nvidia Tookkit) rather than using branching statements. We adopt the approach in Fung et al. (2005), which uses the function $\delta_b(x) = \cos^2(\alpha(x-b))$ to indicate whether the value x belongs to the bin b and α is used to keep $(x-b)$ within $(-\pi/2, \pi/2)$. The $\cos(\cdot)$ function can be squared repeatedly or filtered by a floor operation to yield a more concentrated impulse.

To find the mode of the histogram, we use the reduction operation as in Kruger and Westermann (2003). The required number of reduction iterations is $\log_2(\sqrt{n/4})$. The procedure of computing the mode is illustrated in Figure 16.5a and b, where each grid corresponds to

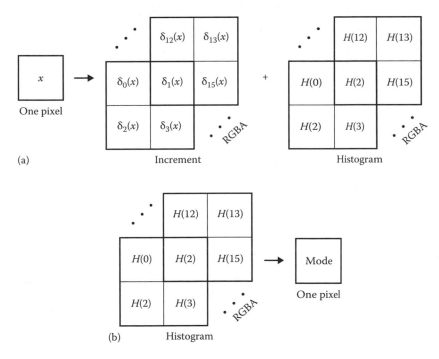

Figure 16.5 Procedure to compute the mode. (a) Construct a histogram: A 16-bin histogram is built in one *RGBA* texture with the doubled width and height and (b) compute the mode: The mode is computed among all bins in the RGBA histogram texture.

one bin. Updating the histogram is implemented in the "ping-pong" way (Fung et al. 2005). After we find the mode, the bin with the largest number of samples, we use the average of the samples that fall in the mode bin as the background model. This refinement is necessary to avoid the quantization error in building histograms. The difference between the background model and the reference image is the output that is transferred to CPU. For color videos, we compute the background model independently for each channel.

16.2.4 Examples

Here, we show one example of the comparison of CPU and GPU implementations. The GPU and CPU versions are implemented on a workstation with a Intel Xeon Qual-core CPU 3.0 GHz, 4G RAM DDR2 (667 MHz) and *NVIDIA Quadro FX 3500*. Both CPU and GPU versions take the same input, namely, original frames and precomputed homographies. The CPU version uses Intel image processing library 2.5 (IPL) to perform warping with linear interpolation (the interpolation method affects timing). For the GPU version, *RGBA* floating point textures are used for storing the frame textures on the GPU. This is supported by most GPU profiles. For color videos, we use three *RGBA* textures to compute the background model in RGB channels in parallel. Most of the modern GPUs support at least four texture attachments. For both CPU and GPU versions, 16 bins are used in constructing histograms. All time measures only focus on background modeling, exclude loading images from videos, extracting features, and estimating homography.

We first evaluate the quality of the background model computed by GPU. This evaluation is in general difficult to perform, as it would require ground truth background models. Hence, we compare the background model output by GPU with the one output by the CPU version. The average difference of 1000 frame GPU and CPU outputs $2abs(I_{GPU} - I_{CPU})/(I_{GPU} + I_{CPU})$ is 0.3%, and the variance is 0.1%. Thus, we can regard that GPU and CPU versions provide the same results. Some of the background model results are shown in Figure 16.6. We show a mosaic view of many background images over time to

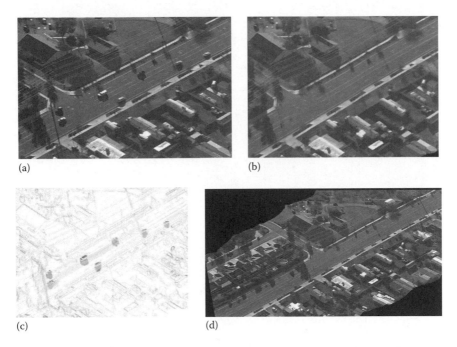

(a)

(b)

(c)

(d)

Figure 16.6 Visual results of background modeling using the mode approach. (a) Reference frame, (b) background model of the reference frame, (c) motion mask in the reference frame, and (d) mosaic view of the background models over time.

demonstrate the quality of background models in Figure 16.6d. When we generate the mosaic, we simply overwrite the mosaic view with new frames without any blending operation. From the mosaic view, we can see that the quality of the background model is consistently good over time. We evaluate the speedup that the GPU version achieves over the CPU implementation, with different sizes of sliding windows and at different resolutions. The timing comparison between the CPU and GPU implementations is shown in Figure 16.7. The timing of both methods is computed by averaging multiple runs. Figure 16.7 shows the time performance is basically proportional to the image size and the sliding window size. A larger sliding window provides more samples and generates a better background model (we usually use 91 frames in a sliding window). For 320×240 resolution videos, GPU version can run at 10 fps and achieve a speedup over CPU version by a factor of 15.

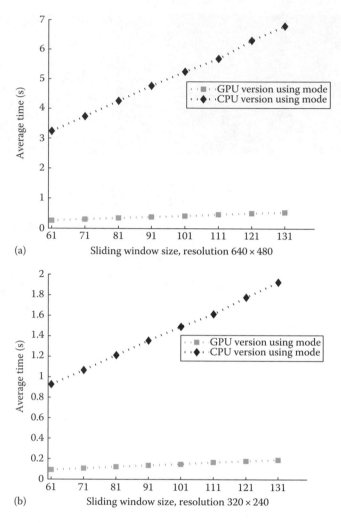

Figure 16.7 GPU timings compared with its CPU counterpart for a range of sliding window size and different resolutions. (a) Mode background models mode on 640×480 videos and (b) mode background models mode on 320×240 videos.

16.3 GEO-REGISTRATION

Given the motion detection in each frame, we aim to track each individual object over time. When we talk about tracking, it has to be defined within some coordinates. For stationary cameras, it is straightforward

to select the 2D image coordinates as tracking coordinates. However, for moving cameras, 2D image coordinates are relative and move with every frame, thus there is no meaningful motion information besides random walk we can use in image coordinates. Therefore, we need to select reference coordinates that can bring us meaningful kinematics states and motion model of objects. For our UAV scenario, we adopt a global map as the tracking coordinates. A satellite image is selected as the map. Homographies between UAV frames and the map are estimated by a geo-registration procedure. Compared with selecting 2D image coordinates, the motion model defined in the map coordinates has physical meaning. Moreover, as geo-registration refines the homography between a UAV frame and the global map, the accumulated error is reduced in contrast to concatenating the transformations from the first frame to the current frame. In this section, we present an efficient approach to perform 2D geo-registration between airborne videos and a satellite map.

16.3.1 Two-Step Approach

The geo-registration task aims at finding the best $H_{i,M}$ that aligns I_i and M together. This is challenging since the map and the UAV images are taken at different times, from different sensors and view points, and may have different dynamic contents, such as vehicles and shadows. As a result, it is difficult to directly match each incoming image to the map. In the first step, we register consecutive frames to estimate $H_{i,i-1}$ as discussed in Section 16.2.1 Given the frame I_{i-1} has already been registered to the map, $H_{i,M}$ can be estimated as

$$H_{i,M} \approx H_{i-1,M} \circ H_{i,i-1} \tag{16.4}$$

In the second step, with the estimated $H_{i,M}$, we first produce a partial local mosaic in the coordinate frame of I_i. Then we register it directly to M, and derive H_ε so that

$$H_{i,M} = H_\varepsilon \circ H_{i-1,M} \circ H_{i,i-1} \tag{16.5}$$

The key problem is to compute the tuning homography H_ε that removes the error introduced in the composition (Equation 16.5), so that the image is accurately aligned to the map. Given the approximated $H_{i,M}$, I_i is roughly aligned to the map, we then perform a local search for correspondences under the same scale and orientation. By using the two-step approach, the ambiguity of matching and the computation time is much less than directly registering I_i to the map.

16.3.2 Finding Correspondences by Mutual Information

To derive H_ε, we have to find correspondences between $\tilde{\mathbf{W}}_i$ and the map M, where $\tilde{\mathbf{W}}_i$ is the image by warping I_i using the approximated homography, i.e.,

$$\tilde{\mathbf{W}}_i = W(I_i; H_{i-1,M} \circ H_{i,i-1}) \qquad (16.6)$$

In practice, we find it is not easy to find correspondences between $\tilde{\mathbf{W}}_i$ and the map M due to significant differences in lighting conditions, resolution, and 3D viewpoints. Directly matching SIFT features (Brown and Lowe 2003) is not reliable for this task. Instead, we use mutual information (Viola and Wells 1997) to match patches robustly. For a patch in M, it is matched to a patch in $\tilde{\mathbf{W}}_i$ that has the highest similarity measure, namely,

$$\mathbf{x}' = \arg\max_l \mathcal{MI}(\mathbb{P}(l, \tilde{\mathbf{W}}_i), \mathbb{P}(\mathbf{x}, M)) \qquad (16.7)$$

where
 $\mathcal{MI}(\cdot)$ is the function that computes the mutual information of two image patches
 $\mathbb{P}(\mathbf{x}, I)$ is an image patch in I centers at pixel \mathbf{x}

The search can perform efficiently by looking at patches in the local area since $\tilde{\mathbf{W}}_i$ and M are roughly aligned. The use of mutual information as the similarity measure can be justified since the UAV images

and the reference map are captured at different times and in different views. The illumination and the dynamic content could be very different. Mutual information of two random variables measures the dependence of the two variables. Taking two images as the random variables, it measures how much information two images share, or how much an image depends on the other. It is more robust in the condition we have compared to measures such as cross-correlation or the sum of square differences.

From the information theory, the entropy of a random variable is defined as

$$h(v) = -\int p(v) \ln p(v)\, dv \qquad (16.8)$$

and the joint entropy of two random variable is defined as

$$h(u,v) = -\int p(u,v) \ln p(u,v)\, du\, dv \qquad (16.9)$$

The mutual information of two random variables u, v is then defined as

$$MI(u,v) = h(u) + h(v) - h(u,v) \qquad (16.10)$$

In Viola and Wells (1997), the probability density $p(v)$ is estimated using the *Parzen Window* method,

$$p(v) \approx \frac{1}{N_A} \sum_{v_j \in A} G_\psi(v - v_j) \qquad (16.11)$$

where
N_A is the number of samples in A
G_ψ denotes a Gaussian function with variance ψ

Parzen Window is a widely adopted technique to estimate the probability density since it directly uses the samples drawn from an unknown

distribution and uses Gaussian Mixture model to estimate its density, which is robust to noise.

Equation 16.8 can be expressed as a negative expectation of $\ln p(v)$, i.e., $h(v) = -E_v(\ln p(v))$. Together with Equation 16.11, the entropy of a random variable v is approximated as

$$h(v) \approx \frac{-1}{N_B} \sum_{v_i \in B} \ln \frac{1}{N_A} \sum_{v_j \in A} G_\psi(v_i - v_j) \qquad (16.12)$$

where B is another sample set.

The joint entropy can be approximated in the same manner by drawing pairs of corresponding samples from the two variables. Hence the mutual information is approximated as

$$MI(u,v) \approx \frac{-1}{N_B} \left\{ \sum_{u_i \in B} \ln \frac{1}{N_A} \sum_{u_j \in A} G_{\psi_u}(u_i - u_j) + \sum_{v_i \in B} \ln \frac{1}{N_A} \sum_{v_j \in A} G_{\psi_v}(v_i - v_j) \right.$$

$$\left. - \sum_{w_i \in B} \ln \frac{1}{N_A} \sum_{w_j \in A} G_{\psi_{uv}}(w_i - w_j) \right\} \qquad (16.13)$$

in which $w = [u,v]^T$. There exist other approximation formulas for computing mutual information (Studholme et al. 1999, Kim et al. 2003), which we have not considered here.

16.3.3 Examples

Here, we show a geo-registration example of 1000-frame UAV videos with a satellite map. Figure 16.8 shows a geo-registration of 1000 frames on a map.

In our experiments, the correspondences generated could be classified into three categories, which are the outliers, the correspondences not on the referenced planar surface, and the correspondences on the reference plane. For image patches in homogeneous areas, such

Figure 16.8 Geo-registration of 1000 frames on a map.

as those that contain only road or field, the similarity measurement is meaningless and tends to result in outliers. Even if the correspondences are correct, they may come from structures that do not belong to the reference plane, such as roofs, which should be discarded when deriving the homography. Therefore, we need to filter the first two types of correspondences and use only the correct ones on the ground plane in deriving H_ε. To achieve this, we rely on the approximated homography. As mentioned in Equation 16.7, with a good approximation of $H_{i,M}$, \mathbf{x} should have its correspondence \mathbf{x}' closely. Hence we only take the correspondences that have their spatial distances under a threshold in deriving H_ε. As shown in Figure 16.9, the red points illustrate the correspondences that are *not* close enough to each other. They are most likely to appear on structures that cause parallax or homogeneous regions.

(a) (b)

Figure 16.9 The correspondences between an UAV image and the map. The red points are correspondences whose spatial distances are over a threshold, which are excluded from the input for RANSAC. The bright points and dark points are the RANSAC inliers and outliers, respectively.

Instead of finding correspondences between each warped frame and map, we use a local mosaic patch to establish correspondences. There are several advantages in registering a partial local mosaic instead of registering only a single frame to the map. First, it provides a large number of correspondences as inputs to RANSAC, so the derived H_ε is more robust. Second, since we use correspondences in multiple frames to derive H_ε, the correspondences in I_i only have marginal effects, which implies that $H_{i,M}$ will not change abruptly. Most importantly, we can consider the correspondences in the previous frames as a prior knowledge to deriving H_ε, so even if the correct correspondences in I_i are not dominant after extracting good correspondences as described in Section 16.3.2, they will still stand out after performing RANSAC. As shown in Figure 16.10, registering only a single frame results in significant discontinuities, while registering a partial local mosaic results in a smooth transition.

As described earlier, the computation of mutual information is computational demanding. In Viola's approach (Viola and Wells 1997), the number of exponential computations is n^2, where n is the number of samples required to estimate the entropy of a variable. In order to reduce the number of exponential computations, we adopt a lookup-table technique to store precomputed Gaussian densities of all possible intensity values. For tracking purpose, the geo-registration can be

(a)　　　　　　　　　　　　　　　　(b)

Figure 16.10　(a) The registration result of registering only a single frame and (b) the result of registering a partial local mosaic in each iteration. Note the discontinuity area in (a).

done sparsely over time. In our system, refinement in geo-registration is done every 50 frames. For other applications that require strict geo-registration accuracy, GPU version mutual information can be easily derived from Equation 16.13. For example, a CUDA version of GPU implementation in Lin and Medioni (2008) achieves significant speedup (faster than the CPU version by a factor of 40) in computing mutual information-based matching.

16.4 HIERARCHICAL TRACKING OF MULTIPLE MOVING OBJECTS

We have presented the motion detection and geo-registration, which provide observation and coordinates for tracking, respectively. In this section, we present the tracking algorithm in our system. In airborne video analysis, long-term occlusion is common. Also, objects may fall out of the field of view (FoV) due to the camera motion. We introduce a hierarchical procedure for tracking to cope with these issues. The first step (local association) links detected moving regions within a sliding window and generates tracklets. The second step (global association) links the tracklets to form longer tracks and maintain tracks ID.

16.4.1 Local Data Association

The goal of the local data association is to form reliable tracklets from noisy motion segmentation. Local data association is important since the error in the local data association is difficult to be recovered in the global one. We formulate this problem as finding the best spatial and temporal associations of observations, which maximizes the consistency of both motion and appearance of trajectories. To avoid enumerating all possible solutions, we take a data driven Markov chain Monte Carlo (DD-MCMC) approach to sample the solution space efficiently. The sampling is driven by an informed proposal scheme controlled by a joint probability model combining motion and appearance. Note that the tracking algorithm presented here does not restrict to moving cameras.

Local data association is performed in sliding temporal window with a time interval T. Suppose there are K unknown targets in the scene within the time interval. The input for the tracking algorithm is a set of regions after foreground segmentation. Let y_t denote the set of foreground regions at time t, and $Y = \bigcup_{t \in [1,T]} y_t$ be the set of all available foreground regions within $[1,T]$. In the simplest case, a single target is perfectly segmented from the background, and tracking is straightforward. When there are multiple targets in the scene, and they never overlap, nor get fragmented, the one-to-one mapping, which is assumed by many tracking algorithms, holds: any track τ_k contains at most one observation at one time instant, and no observation belongs to more than one track. If the one-to-one mapping holds, tracking can be done by associating the foreground regions directly.

However, in the most general case, which is common in real data sets, one foreground region may correspond to multiple targets (one example is shown in Figure 16.11, and one target may correspond to multiple foreground regions). In this case, without using any model information, it is very difficult to segment the foreground regions in a single frame. However, if we consider this task in space-time, the smoothness in motion and appearance of targets can be used to solve this problem. One example of tracking from ground surveillance camera is shown in Figure 16.11, where the segmentation of the foreground regions becomes much easier than in Figure 16.11: if we look at

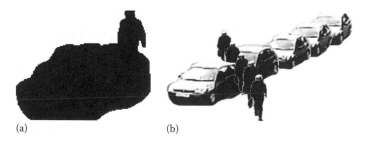

(a) (b)

Figure 16.11 Role of motion and appearance smoothness in segmentation of foreground regions in space-time. (a) Foreground region in one frame and (b) motion and appearance of two targets.

several observations over time, smoothness in motion and appearance of targets helps to disambiguate the targets.

The underlying constraint for tracking is that a good explanation of the foreground regions exhibits good consistency in motion and appearance over time. Formally, in an Bayesian formulation, the tracking problem is to find a cover to maximize a posterior (MAP) of a cover of foreground regions, given the set of observations Y

$$\omega^* = \arg\max(p(\omega|Y)) \tag{16.14}$$

In the MAP problem defined in Equation 16.14, the cover ω is denoted by a set of hidden variables. We make inference about ω from Y over a solution space $\omega \in \Omega$.

$$\omega \sim p(\omega|Y) \propto p(Y|\omega)p(\omega) \quad \omega \in \Omega \tag{16.15}$$

The likelihood $p(Y|\omega)$ represents how well the cover ω explains the foreground regions Y in terms of the spatial-temporal smoothness in both motion and appearance. The prior model regulates the cover to avoid overfitting the smoothness. In the following sections, we discuss the prior and likelihood models used in our method.

16.4.1.1 Motion and Appearance Model

Here targets are represented by image blobs. Once a partition ω is chosen, the tracks $\{\tau_1, ..., \tau_K\}$ and false alarms τ_0 are determined and for each track the assigned observations are determined. To make full use of the observations for target tracking, we consider a joint probability framework for incorporating both motion and appearance information. Therefore $p(Y|\omega)$ in Equation 16.15 can be represented as follows:

$$p(Y|\omega) = \prod_{i=1}^{|\tau_k|-1} L_M(\tau_k(t_{i+1})|\ \bar{\tau}_k(t_i)) L_A(\tau_k(t_{i+1})|\ t_i)) \tag{16.16}$$

Given the geo-registration result, we can map an image blob from UAV image to the map. We denote x_t^k as the state vector of the target k at time t to be $[l_x, l_y, w, h, \dot{l}_x, \dot{l}_y]$ (centroid's position, width, height, and velocity in the 2D map). We consider a linear kinematic model of constant velocity dynamics

$$x_{t+1}^k = A^k x_t^k + w^k \tag{16.17}$$

where A^k is the transition matrix, and we assume w^k to be a normal probability distribution, $w^k \sim N(0, Q^k)$. The observation $y_t^k = [l_x, l_y, w, h]$ contains the measurement of a target position and size in 2D map. Since observations often contain false alarms, the observation model is represented as

$$y_t^k = \begin{cases} H^k x_t^k + v^k & \text{if it belongs to a target} \\ \delta_t & \text{false alarm} \end{cases} \tag{16.18}$$

where y_t^k represents the measurement, which may arise either from a false alarm or from the target. We assume v^k to be normal probability distributions, $v^k \sim N(0, R^k)$. δ_t is a 2D random variable with uniform distribution on the map.

Let $\tau_k(t_i)$ and $\hat{P}_t(\tau_k)$ denote the posterior estimated states (i.e., x_f^t in Equation 16.17) and posterior covariance matrix of the estimated error at time t of τ_k. $\tau_k(t)$ is the associated observation (i.e., y_k^t in Equation 16.18) for track k at time t. The motion likelihood of track τ_k of one edge $(\tau_k(t_1), \tau_k(t_2)) \in E, t_1 < t_2$ can be represented as $L_M(\tau_k(t_2) | \hat{\tau}_k(t_1))$. Given the transition and observation model in a Kalman filter, the motion likelihood then can be written as

$$L_M(\cdot) = \frac{1}{(2\pi)^2 \det(\hat{P}_{t_2}(\tau_k))} \exp\left(\frac{-e^\mathsf{T} \hat{P}_{t_2}^{-1}(\tau_k) e}{2}\right) \tag{16.19}$$

where $e = \tau_k(t_2) - HA^{t_2-t_1}\tau_k(t_1)$ and $\hat{P}_{t_2}(\tau_k)$ can be computed recursively by a Kalman filter as $\hat{P}_{t_2}(\tau_k) = H(A\hat{P}_{t_2-1}(\tau_k)A^T + Q)H^T + R$. In Chapter 2, we have a detailed introduction of Kalman filters.

In order to model the appearance of each detected region, we adopt a histogram-based appearance of the image blobs. All RGB bins are concatenated to form a one-dimension histogram. The appearance likelihood between two connected image blobs $(\tau_k(t_1), \tau_k(t_2)) \in E, t_1 < t_2$ in track k, is measured using the symmetric Kullback–Leibler divergence (KLD) that is defined as follows, where $P(c)$ is the bin value of normalized histogram:

$$L_A(\cdot) = \exp\left(\frac{1}{2}\sum_{c=r,g,b}(P_i(c) - P_j(c))\log\left(\frac{P_i(c)}{P_j(c)}\right)\right) \qquad (16.20)$$

16.4.1.2 Prior Probability

The motion and appearance likelihood models provide the inner-smoothness constraint for each track independently. However, without an *a priori* knowledge of the number of targets, the inner-smoothness constraint favors shorter paths, and therefore tends to split a trajectory into a large number of sub-tracks. To overcome this overfitting problem, commonly a *prior* knowledge on the detection and the targets' behavior (such as detection and false alarm rate, termination, and birth rate) is assumed to be known (Bar-Shalom et al. 1980, Oh et al. 2004).

To find a cover with reasonable properties, we first define a prior model that considers the following criteria: we prefer a small number of long tracks with little overlap with other tracks. Accordingly, we adopt the prior probability of a cover ω as the product of the following terms:

$$p(\omega) = p(N)p(L)p(O) \qquad (16.21)$$

1. Number of tracks. Let K denote the number of tracks. We adopt an exponential model $p(N)$ to penalize the number of tracks:

$$p(N) = \frac{1}{z_0} \exp(-\lambda_0 K) \qquad (16.22)$$

2. Length of each track. We adopt an exponential model $p(L)$ of the length of each track. Let $|\tau_k|$ denote the length, i.e., the number of elements in τ_k:

$$p(L) = \prod_{k=1}^{K} \frac{1}{z_1} \exp(\lambda_1 | \tau_k |) \qquad (16.23)$$

3. Spatial overlap between different tracks. We adopt an exponential model to penalize overlap between different tracks, where $\Gamma(t)$ denotes the average overlap ratio of different tracks at time t:

$$p(O) = \prod_{t=0}^{T} \frac{1}{z_3} \exp(-\lambda_2 \Gamma(t)) \qquad (16.24)$$

where

$$\Gamma(t) = \frac{\displaystyle\sum_{\tau_i(t) \cap \tau_j(t) \neq \varnothing} \frac{\tau_i(t) \cap \tau_j(t)}{\tau_i(t) \cup \tau_j(t)}}{\left| \tau_i(t) \cap \tau_j(t) \neq \varnothing \right|}$$

In the solution space of Equation 16.15, the prior model is applied to prevent the adoption of a more complex model than necessary. For example, a short track usually has better smoothness than a long track. Merely considering the smoothness defined by the likelihood will segment a long track into short tracks. In an extreme condition,

each track contains a single observation and has the best smoothness. The prior penalizes such an extreme condition by all three terms, the number of tracks, length of each track, and overlap among different tracks.

With some manipulations, we combine the prior $p(\omega)$ and the likelihood $p(Y|\omega)$ to rewrite the posterior represented in Equation 16.25. The parameters in the prior model are hard to determine empirically. We will show how to determine the parameters appropriately for specific data sets.

$$p(\omega|Y) \propto \exp\{C_0 S_{\text{len}} - C_1 K - C_2 F - C_3 S_{\text{olp}} - C_4 S_{\text{app}} - C_5 S_{\text{mod}} - S_{\text{mot}}\}$$

$$S_{\text{len}} = \left(\sum_{k=1}^{K} l(\tau_k)\right), \quad S_{\text{olp}} = \left(\sum_{T=1}^{T} \Gamma(t)\right)$$

$$S_{\text{app}} = \sum_{k=1}^{K} \sum_{i=1}^{L_k-1} KLD(\tau_k(t_i), \tau_k(t_{i+1})) \tag{16.25}$$

$$S_{\text{mod}} = \sum_{k=1}^{K} \sum_{i=1}^{L_k} \log(L_P^{\tau_k}(i))$$

$$S_{\text{mot}} = \sum_{k=1}^{K} \sum_{i=1}^{L_k} \left(\log\left(\det(T_i)^{1/2}\right) + \frac{1}{2} e_i^T P_i^{-1} e_i\right)$$

16.4.1.3 MCMC Data Association Algorithm

Directly optimizing a posterior by enumerating all possible solutions in the solution space defined in Equation 16.3 is simply not feasible. We propose to use data-driven MCMC to estimate the best spatiotemporal cover of foreground regions. To ensure that detailed balance is

satisfied, the Markov chain is designed to be ergodic and aperiodic. It is also important to design samplers that converge quickly.

Due to ergodicity of the Markov chain, there is always a "path" from one state to another state with nonzero probability. However, sufficient flexibility in the transition of Markov chain significantly reduces the mixing time. In the design of the transition of Markov chain, we manage to give flexibility in two ways. First, we design 10 types of transitions, the first seven being temporal moves. They contain some redundancy, for example, merge (or split) can be implemented by death moves with extension moves and switch can be implemented by split and merge moves. Second, within a time span, the "future" and "past" information is symmetric: we can extend a track in both the positive and negative time directions. Thus, we select moves uniformly at random (u.a.r.) in both temporal directions: forward and backward. This bidirectional sampling has more flexibility and reduces the total number of samples. This differs from the temporal moves proposed in Oh et al. (2004), where only forward inference is used. In the following section, we only describe sampling in the positive time direction and the sampling in the other direction proceeds in a symmetric way.

The overview of our MCMC data association algorithm is shown in Algorithm 16.1. The input to the algorithm is the set of original foreground regions, initial tracks ω_0, and the total number of samples n_{mc}. In the proposal distribution, the sampler contains two types of moves: temporal and spatial moves. One move here means one transition of the state of the Markov chain. Temporal moves only change the label of rectangles in the cover. However, since detected moving regions do not always correspond to a single target (they may represent parts of a target or delineate multiple targets moving closely to each other), merely using temporal moves cannot probe the spatial cover of the foreground. Hence, we propose a set of spatial moves to segment, aggregate or diffuse detected regions to infer the best cover of the foreground. The spatial and temporal moves are interdependent: the result of a spatial move is evaluated within temporal moves, and the result of a temporal move guides subsequent spatial moves.

ALGORITHM 16.1 Spatiotemporal MCMC Data Association

Algorithm 1 Spatiotemporal MCMC Data Association

Input: Y, n_{mc}, \in, $\omega^*=\omega_o$
Output: ω^*
for $n=1$ to n_{mc} **do**
 if $n<\in$ * n_{mc} **then**
 Sample one temporal move.
 else
 Sample one move from all candidate moves.
 end if
 Propose ω' according to $q(\omega,\omega')$
 Sample U from Unif[0,1]
 if $U<A(\omega,\omega')$ **then**
 $\omega_n=\omega'$,
 Else
 $\omega_n=\omega$,
 end if
 if $p(\omega_n\,|\,Y)>p(\omega^*\,|\,Y)$ **then**
 $\omega^*=\omega_n$
 end if
end for

To make the sampling more efficient, we define the neighborhood in spatiotemporal space. Two objects are regarded as neighbors if their temporal distance and spatial distance is smaller than a threshold. The neighborhood actually forms a graph, where a object corresponds to a node. We use the following notations on the graph structure: $N(\cdot)$ is the neighbor set of an observation, i.e., $N(y_{t_1}^i)=\{y_{t_2}^j,(y_{t_1}^i,y_{t_2}^j)\in E\}$; Observation $y_{t_2}^j\in N(y_{t_1}^i)$ belongs to the parent set $N^c(y_{t_1}^i)$, child set $N^p(y_{t_1}^i)$; exclusively, when $t_2<t_1$ or $t_2>t_1$. Given the stationary distribution $\pi(\omega)=p(\omega|Y)$ in Equation 16.15, the acceptance $A(\omega,\omega')$ can be defined as follows.

$$A(\omega, \omega') = \min\left(1, \frac{\pi(\omega') q(\omega'|\omega)}{\pi(\omega) q(\omega|\omega')}\right) \qquad (16.26)$$

In rest part of this section, we show how to devise the Markov chain's transition by considering specific choices for the proposal distribution $q(\omega'|\omega)$. Dynamics 1–7 are temporal moves, which involve changing the label of rectangles. Dynamics 8–10 are spatial moves, which change the state of covering rectangles.

Dynamics 1–2: Extension/reduction. The purpose of the extension/ reduction move is to extend or shorten the estimated trajectories given a new set of observations. For the forward extension, we select *u.a.r* a track τ_k from K available tracks, τ_1, \dots, τ_K. Let τ_k (end) denote the last node in the track τ_k. For each node $y \in N^c(\tau_k \text{ (end)})$, we have the association probability $p(y) = \dfrac{p(y|\bar{\tau}_k(\text{end}))}{\sum_z p(y|\bar{\tau}_k(\text{end}))}$. We associate y and track τ_k according to this normalized probability, and then append the new observation y to τ_k with a probability γ, where $0 < \gamma < 1$. Similarly, for a backward extension, we consider a node $y \in N^p(\tau_k \text{ (start)})$ and use reverse dynamics for estimating the association probability $p(y)$.

The reduction move consists of randomly shortening a track τ_k (*u.a.r* from K available tracks, τ_1, \dots, τ_K), by selecting a cutting index r *u.a.r* from $2, \dots, |\tau_k| - 1$. In the case of a forward reduction the track τ_k is shortened to $\{\tau_k(t_1), \dots, \tau_k(t_r)\}$, while in a backward reduction we consider the sub-track $\{\tau_k(t_r), \dots, \tau_k(t_{|\tau_k|})\}$.

Dynamics 3–4: Birth/death. This move controls the creation of new track or termination of an existing trajectory. In a birth move, we select *u.a.r* a node $y \in \tau_0$, associate it to a new track and increase the number of tracks $K' = K + 1$.

The birth move is always followed by an extension move. From the node y we select the extension direction forward or backward *u.a.r* to extend the track $\tau_{K'}$. Similarly, in a death move we choose *u.a.r* a track τ_k and delete it. The nodes belonging to the deleted track are added to the unassigned set of measurements τ_0.

Dynamics 5–6: Split/merge. In a split move, we *u.a.r* select a track τ_k, and a split point t_s, which is selected according to the normalized

joint probability between two consecutive connected nodes in the track:

$$\left(1 - p(\tau_k(t_{i+1}) \mid \overline{\tau}_k(t_i))\right) \Big/ \sum_{i=1}^{|\tau_k|-1} \left(1 - p(\tau_k(t_{i+1}) \mid \overline{\tau}_k(t_i))\right) \qquad (16.27)$$

And we split τ_k into two new tracks

$$\tau_{s_1} = \left\{\tau(t_1), \ldots, \tau(t_s)\right\} \text{ and } \tau_{s_2} = \left\{\tau(t_{s+1}), \ldots, \tau(t_{|\tau_k|})\right\} \qquad (16.28)$$

Often, due to missing detection or erroneous detection, trajectories of objects are fragmented. The merge move provides the ability to link these fragmented sub-tracks according to their joint likelihood of appearance and motion and the interaction based on spatial overlapping. The merge move operates on the candidate set of track pairs, for which the start node of one track is the child node of the end node of the other track and is defined by the set:

$$C_{\text{merge}}^t = \left\{(\tau_{k_1}, \tau_{k_2}): \tau_{k_2}(\text{start}) \in N^c(\tau_{k_1}(\text{end}))\right\} \qquad (16.29)$$

We select u.a.r pairs of tracks from C_{merge}^t and merge the two tracks into a new track $\tau_k = \{\tau_{k_1}\} \cup \{\tau_{k_2}\}$.

Dynamics 7: Switch. In a switch move, we are probing the solution space for better labeling of nodes that belong to multiple tracks. We consider the following candidate set of track pairs:

$$C_{\text{switch}}^t = \left\{(\tau_{k_1}(t_p), \tau_{k_2}(t_q)): \tau_{k_1}(t_p) \in N^p(\tau_{k_2}(t_{q+1})),\right.$$

$$\left. \tau_{k_2}(t_q) \in N^p(\tau_{k_1}(t_{p+1}))\right\}, \quad k_1 \neq k_2 \qquad (16.30)$$

We *u.a.r* select a candidate node from C_{switch}^t and define two new tracks as:

$$\tau'_{k_1} = \left\{\tau_{k_1}(t_1), \ldots, \tau_{k_1}(t_p), \tau_{k_2}(t_{q+1}), \ldots, \tau_{k_2}(t_{|\tau_{k_2}|})\right\}$$

and

$$\tau'_{k_2} = \left\{ \tau_{k_2}(t_1),\ldots,\tau_{k_2}(t_q),\tau_{k_1}(t_{p+1}),\ldots,\tau_{k_1}(t_{|\tau_{k_1}|}) \right\}.$$

Dynamics 8: Diffusion. We select one covering rectangle $\tau_k(t_i)$ in a track according to the probability $q_{\text{dif}}(\tau_k(t_i)) = \dfrac{-\log L\left(\tau_k(t_i)\,|\,\tau_k(t_{i-1})\right)}{\sum_{k=1}^{K}\sum_{j=2}^{|\tau_k|} -\log L\left(\tau_k(t_i)\,|\,\tau_k(t_{i-1})\right)}.$ This probability prefers selecting a covering rectangle that has a low motion and appearance likelihood with its preceding neighbor. The low motion and appearance likelihoods indicate that the covering rectangle of the track in this frame may be erroneous. In order to update its state, we first obtain its estimated state $\bar{\tau}_k(t)$ from the motion model, and then update its position and size according to the appearance model: generate a new covering rectangle $\tau'_k(t)$ from the probability $S(\tau'_k(t)\,|\,\bar{\tau}_k(t))$,

$$S(\mathbf{y}'_t\,|\,\mathbf{y}_t) \sim N\left(\mathbf{y}_t + \alpha\frac{\mathrm{d}E}{\mathrm{d}\mathbf{x}}\big|_{\mathbf{x}=\mathbf{y}_t},u\right) \qquad (16.31)$$

where
 $E = -\log L_A(x\,|\,y_t)$ is the appearance energy function
 α is a scalar to control the step size
 u is a Gaussian white noise to avoid local minimum

In practice, we adopt the spatio-scale mean-shift vector to approximate the gradient of the negative appearance likelihood in terms of position and scale. A scale space is conceptually generated by convolving a filter bank of spatial DOG (difference of Gaussian) filters with a weight image. Searching the mode in such a 3D scale space is efficiently implemented by a two-stage mean-shift procedure that interleaves spatial and scale mode-seeking, rather than explicitly building a 3D scale space and then searching.

Dynamics 9–10: Segmentation and aggregation. If more than one track's prediction $\bar{\tau}_k(t)$ have enough overlap with one covering rectangle y at time t. This indicates that one covering rectangle may correspond

to multiple tracks. Such a rectangle is regarded as a candidate for a segmentation move. The tracks are *related tracks* of the candidate y. Randomly select such a candidate y and for each *related track* τ_k generate a new covering rectangle $\tau'_k(t)$ according to the probability $S(\tau'_k(t) | \bar{\tau}_k(t))$. The segmentation move is achieved through diffusion moves (each *related track* performs one diffusion independently).

If one track's prediction $\bar{\tau}_k(t)$ has enough overlap with more than one covering rectangle at time t, the observation of this track. This indicates that the observation of this track in this frame may be fragmented into multiple regions. This forms a candidate for an aggregation move. Randomly select such a candidate $\bar{\tau}_k(t)$, and for the track τ_k generate a new covering rectangle $\tau'_k(t)$ according to the probability $S(\tau'_k(t) | \bar{\tau}_k(t))$. The newly generated covering rectangle takes the place of $\tau_k(t)$. Note that both segmentation and aggregation moves are implemented by diffusion moves. In other words, the segmentation and aggregation moves are particular types of diffusion moves that address the merged and fragmented observations, respectively.

Properly selecting the parameters in Equation 16.25 is necessary to assure that the Markov chain converges to the correct distribution. To determine the parameters in a principled way is not a trivial task. First, the posterior can be only known up to a scale because the computation of the normalization factor over the entire ω is intractable. Second, the parameters, which encode a lot of specific domain knowledge, such as false alarms, overlap etc., are highly scenario-related. Empirical knowledge cannot help in determining the parameters in such a complex posterior, and otherwise would make the process not repeatable. Determining a proper setting of the parameters is a first-line problem before any stochastic optimization, and a casual setting of the parameters in the posterior makes all the efforts in searching a MAP solution meaningless. The global optimal solution, which is "optimal" to some oracle type of posterior, may not be more meaningful than some other inferior local maxima or even non-maxima at all. Here, we propose an automatic solution to determine the parameters in such a probabilistic model. Given one cover, according to Equation 16.25, the log function of the posterior $f(\mathbf{C}|\omega) \triangleq \log(p(\omega|Y))$ is a linear function in terms of the free parameters. We start with the best cover ω^* obtained from ground truth and use the temporal and spatial moves to degrade the best cover

to ω_i. For each ω_i, we have a constraint such that $\pi(\omega^*)/\pi(\omega_i) \geq 1$. This provides one linear inequation, i.e., $f(\mathbf{C}|\omega^*) - f(\mathbf{C}|\omega_i) \geq 0$. After collecting multiple constraints, we use linear programming to find a solution of positive parameters with a maximum sum as

$$
\begin{aligned}
&\text{Maximize:} \quad \mathbf{a}^\mathrm{T}\mathbf{C} \\
&\text{Subject to:} \quad A^\mathrm{T}\mathbf{C} \leq \mathbf{b}, \mathbf{C} \geq 0
\end{aligned}
\tag{16.32}
$$

where
$\mathbf{C} = [C_0, C_1, C_2, C_3, C_4]$
$\mathbf{a} = [1,1,1,1,1]^\mathrm{T}$
each row of $A^\mathrm{T}\mathbf{C} \leq \mathbf{b}$ encodes one constraint

16.4.2 Global Tracklets Association

Although merge/split dynamics in local data association can deal with missing detection, it only considers observations within a short time span. Some situations, such as long occlusions, may cause the tracker to lose target identification. Increasing the size of sliding window cannot solve the problem all the time and increases the complexity. Thus, we introduce the global data association to associate tracklets to maintain track identification.

16.4.2.1 Spatiotemporal Consistency

First we define the consistency of temporal and spatial relationship between tracklets. Given two tracklets τ_1 and τ_2, which start at time s_1, s_2 and terminate at time t_1, t_2. If the condition $s_1 \geq t_2$ or $s_2 \geq t_1$ holds, the two tracklets are temporally consistent. For two temporally consistent tracklets τ_1 and τ_2, say $s_2 \geq t_1$, the terminating position and velocity of τ_1 on the global map are P_{t_1} and V_{t_1}. The starting position and velocity of τ_2 on the global map are P_{s_2} and V_{s_2}. If the $\left\| P_{t_1} - P_{s_2} \right\| \leq v_{\max} \times (s_2 - t_1)$ and $\left\| V_{t_1} - V_{s_2} \right\| \leq a_{\max} \times (s_2 - t_1)$, the two are spatially consistent as well, where v_{\max} and a_{\max} represent the maximum speed and acceleration of objects on the map. For all spatiotemporal consistent candidates, we use a vote-casting method

Figure 16.12 Computing spatiotemporal consistency between two tracklets, derived from the concept of casting vote in tensor voting.

inspired from Tensor Voting (Tang et al. 2001) to calculate the spatiotemporal consistency between tracklets as shown in Figure 16.12.

Let O denote one end of a tracklet and \vec{N} denote its normal in 2D space. We want to compute its consistency with another end P from a different tracklet. The consistency should consider both orientation and strength. As can be seen in Figure 16.12, the ideal orientation $\vec{N}_{O \rightarrow P}$ (gray arrow starting from P) is given by drawing a big circle whose center C is in the line of \vec{N} and it passes both O and P while preserving the normal \vec{N}. The ideal orientation ensures the smoothest connection between two ends, O and P. The actual normal at P is \vec{N}_P. The consistency between O and P is computed by the following function:

$$S(O,P) = \exp(-|s|^2 - ck^2)(\vec{N}_{O \rightarrow P} \cdot \vec{N}_P) \qquad (16.33)$$

Here,
 $|s|$ is the arc length
 k is the curvature
 c is the decay rate

Note that besides the introduction of the dot product, the scale σ in Tensor Voting's decay function (Tang et al. 2001) is gone, since there is no concept of neighbors, i.e., any two ends from consistent candidate tracklets can be associated. Tracklets that are not consistent have zero spatiotemporal consistency.

16.4.2.2 Tracklet Descriptor

Besides motion (spatiotemporal) consistency, we adopt the appearance model proposed in (Kang et al. 2004) to represent appearance consistency. This descriptor is invariant to 2D rotation and scale change, and tolerates small shape variations. Instead of applying this descriptor on

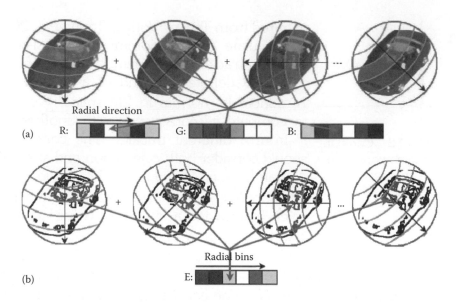

Figure 16.13 (See color insert following page 332.) Appearance descriptor of tracklets. (a) Appearance color model and (b) appearance shape model.

a single image blob, we use the descriptor on a tracklet, which contains a sequence of image blobs.

For each detected moving blob within a tracklet, the reference circle is defined as the smallest circle containing the blob. The reference circle is delineated as the 6 bin images in 8 directions depicted in Figure 16.13.

For each bin i, a Gaussian color model is built on all the pixels located in bin i for all eight directions and for all image blobs within the tracklet. Thus, the color model for each tracklet is then defined as a 6D vector by summing the contribution of each bin image in all eight directions and for all image blobs. We can similarly encode the shape properties of each blob by using a uniform distribution of the number of edge pixels within each bin, namely, a normalized vector $[E_1(\tau), E_2(\tau), \ldots, E_6(\tau)]$.

The appearance likelihood between two compatible tracklets can be defined as

$$p_{\mathrm{app}}(\tau_i, \tau_j) = \exp\left(-\lambda\left(d_{\mathrm{color}}(\tau_i, \tau_j) + d_{\mathrm{edge}}(\tau_i, \tau_j)\right)\right) \qquad (16.34)$$

where τ_i, τ_j are tracklets on which the appearance probability model is defined.

The appearance distance between two compatible tracklets is computed using the KLD. For the color descriptor, since each bin is modeled by a Gaussian model, the KLD is reduced to

$$d(\tau_i, \tau_j) = \frac{1}{2N} \sum_N \left\{ (\mu_i - \mu_j)^2 \left(\frac{1}{\sigma_j^2} + \frac{1}{\sigma_i^2} \right) + \frac{\sigma_i^2}{\sigma_j^2} + \frac{\sigma_j^2}{\sigma_i^2} \right\} \qquad (16.35)$$

where μ_i, μ_j, σ_i, and σ_j are the parameters of the color Gaussian model. For the edge descriptor we use the following similarity measure:

$$d_{edge}(\tau_i, \tau_j) = \frac{1}{2} \sum_{r=1}^{6} (E_r(\tau_i) - E_r(\tau_j)) \log \frac{E_r(\tau_i)}{E_r(\tau_j)} \qquad (16.36)$$

Due to the existence of both target motion and camera motion, the target's orientation could be quite different in different tracklets, thus the rotation-invariant property of the descriptor is quite important for our tracklets association.

After calculating the motion and appearance consistency between each pair of tracklets, we use the Hungarian algorithm (Kuhn 1955) to find the best associations. Suppose there are n tracklets, the similarity matrix $A_{2n \times 2n}$ used in the Hungarian algorithm is a matrix of size $2n \times 2n$. $A_{(1,\dots,n) \times (1,\dots,n)}$, except its diagonal elements, contains the similarity between any pair of tracklets, the diagonal of $A_{(n+1,\dots,2n) \times (1,\dots,n)}$ stores the termination probability; the diagonal of $A_{(1,\dots,n) \times (n+1,\dots,2n)}$ stores the birth probability. All the other elements in A are zero. By expanding the similarity matrix, we can deal with the cases that new tracks emerge and existing tracks terminate.

16.4.3 Examples

In order to evaluate our local data association, we design simulation experiments. In a $L \times L$ square region, there are K (unknown number) moving discs. Each disc presents an independent color appearance and

an independent constant velocity and scale change in the 2D region. False alarms (nonoverlapping with targets) are u.a.r. located in the scene and the number of false alarms is a uniform distribution on $[0, FA]$. If the number of existing targets in the square region is less than the upper bound N, a target is added randomly. We also add several bars as occlusions in the scene. This static occlusion causes a target to break into several foreground regions. This simulates real scenarios when foreground regions are fragmented due to noisy background modeling. The input to our tracking algorithm contains only foreground regions in each frame without any shape information. The design of this simulation experiment is through particular considerations for evaluating a method's ability to recover spatial data association. In such a simulation, if no occlusions between objects and no static occlusion occur, the decision of temporal data association is relatively easy to make without any ambiguity. It is just due to the lack of spatial completeness so that these sequences challenge many existing data association methods. Without jointly considering the spatial and temporal data association, a tracking algorithm cannot produce the correct segmentation of the foreground regions. Figure 16.14 shows the results of our spatiotemporal MCMC data association algorithm. Colored and black rectangles display the targets and false alarms, respectively. Red links indicate that spatial segmentation happens between nodes.

To evaluate the performance of our approach quantitatively, we adopt the metric "sequence tracking detection accuracy" (STDA) (Kasturi et al. 2004), which is a spatiotemporal-based measure penalizing fragmentation in the temporal and the spatial domains. To compute the STDA score, one needs to compute one-to-one match between the tracked targets and the ground truth targets. The matching strategy itself is implemented (in the evaluation software) by specifically computing the measure over all the ground truth and detected object combinations and to maximize the overall score for a sequence. Given M matched tracks and ground truth tracks $\{\tau_k(i)\}, \{G_k(i)\}$, $k = 1, \ldots, M$, $i = 1, \ldots, T$, STDA can be computed as

$$\text{STDA} = \sum_{i=1}^{M} \frac{\sum_{1}^{T} \left(\frac{G_i(t) \cap \tau_i(t)}{G_i(t) \cup \tau_i(t)} \right)}{N_{\text{frame}}(G_i \cup \tau_i \neq \varnothing)} \bigg/ \frac{N_G + N_T}{2} \qquad (16.37)$$

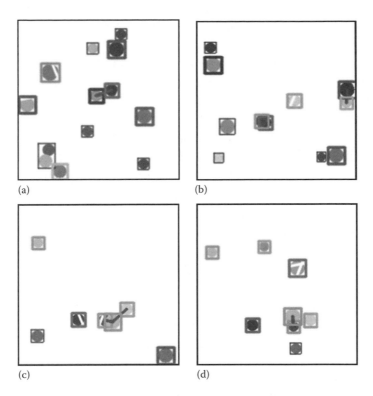

(a) (b)

(c) (d)

Figure 16.14 (See color insert following page 332.) (a–d) Simulation result $L=200$, $N=7$, $FA=7$, and $T=50$. Color rectangles indicate the IDs of targets. Targets may split or merge when they appear.

where the denominator for each track $N_{\text{frame}}(G_i \bigcup \tau_i \neq \varnothing)$ indicates the number of frames in which either a ground truth or a tracked target (or both) is present. The numerator for each track measures the spatial accuracy by computing the overlap of the matched tracking results over the ground truth targets in the sequence. The normalization factor is the average of number of tracked targets N_T and the number of ground truth targets N_G. STDA produces a real value number between 0 and 1 (worst and best possible performances, respectively).

As the target density and false alarm rate increase, tracking becomes increasingly difficult. For each different setting (i.e., number of targets and number of false alarms), we generate 20 sequences for comparison of the average performance. Each sequence contains $T=50$ frames. We compare our method with other methods, including a JPDAF-based

method from Kang et al. (2003), the MHT from Cox and Hingorani (1994) and our own algorithm with temporal moves only. All methods employ the same motion and appearance likelihood. To prune hypotheses, both JPDAF and MHT adopt the minimum ratio between the likelihood of the worst hypothesis to the likelihood of the best one. Any hypothesis with a likelihood lower than the product of this ratio and the likelihood of the best hypothesis is discarded. For JPDAF we use 1-scanback and keep at most 50 hypotheses at each scan. For MHT, we use 3-scanback and keep at most 300 group hypotheses. In fact, even if a larger scanback (5-scanback) is used, MHT does not show significant improvement in the simulation. This can be explained as temporal data association (when no occlusion happens) is quite straightforward in the simulation, and the ambiguities caused by errors in spatial relationship cannot be solved by simply increasing the number of scanback.

The MCMC sampler was run for a total of 10,000 iterations where the first 1,500 iterations consist solely of temporal moves. The average score from multiple runs of our method is reported. Figure 16.15a compares the performance when the number of targets increases. Figure 16.15b shows the tolerance to false alarms for different methods. Because we consider the spatial and temporal association seamlessly, the performance of our method dominates the other three methods. The other three methods work almost equally poorly since they often fail at similar cases when split or merged observations exist.

We show tracking results after local and global data association on the following two UAV sequences. Using the longitude and latitude information coming with image sequences, the map is acquired from Google Earth. The homography between the first frame and the map H_{0M} is manually computed offline. Figure 16.16 shows the tracking result on a sequence with one moving object. Considering the computation cost, the geo-registration refinement with the map is performed every 50 frames. The trajectory of tracklets in Figure 16.16a is generated using the initial homography between UAV image and map without refinement. Figure 16.16b is generated using our geo-registration. It is clear that the trajectories of tracklets without geo-registration are out of the road boundary. Since the target is fully occluded by the shadows of trees, the trajectory of the single target

breaks into tracklets. In real scenarios, the moving shadow may affect the target's appearance. We apply the deterministic non-model-based method (Prati et al. 2003) working in Hue-Saturation-Value (HSV) space to remove the strong moving shadow.

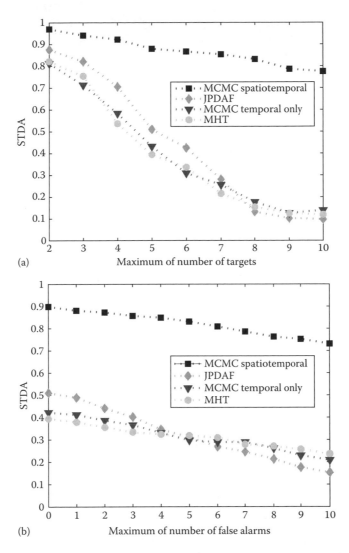

Figure 16.15 (a) STDA as the function of N, the maximum number of targets ($L=200$, $FA=0$, and $T=50$) and (b) STDA as the function of FA, the number of false alarms ($L=200$, $N=5$, and $T=50$).

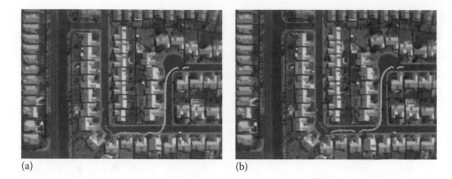

(a) (b)

Figure 16.16 Comparison of with and without geo-registration. (a) Trajectory of tracklets without geo-registration and (b) trajectory of tracklets with geo-registration.

Figure 16.17 shows tracking results on the sequence with multiple moving targets. When targets are occluded by shadows, local data association may lose track identification and thus tracklets are formed. The missing detection caused by occlusion even lasts for longer than the sliding window of local data association (45 frames). However in global data association, the tracklets are associated with correct ID throughout the video. The different tracks are listed in the Z direction in different colors.

The system is tested on a PC with a Intel Xeon Qual-core CPU 3.0 GHz, 4G RAM DDR2 (667 MHz), and *NVIDIA Quadro FX 3500*. Here, we show the overall time performance, as shown in Table 16.1. The geo-registration and motion detection, which were the bottlenecks

TABLE 16.1 Overall Time Performance of the Streamlined System

Procedure (Resolution=320×240)	Average Time (s)
Image registration	~0.25
Geo-registration	1.2=60/50 (every 50 frames)
Motion detection (GPU)	~0.10
Tracking	~0.25
Total	~1.80

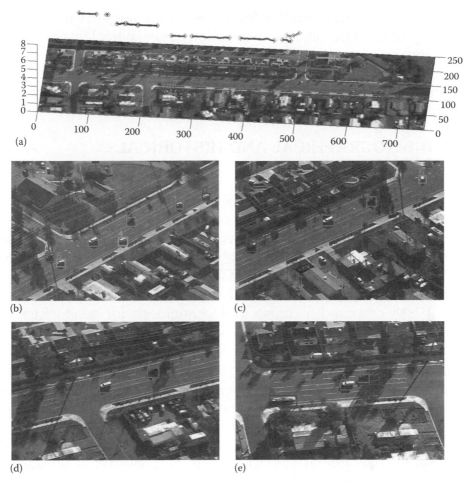

(a)

(b)

(c)

(d)

(e)

Figure 16.17 The tracklets and tracks obtained using the local and global data association framework. The UAV image sequence is overlaid on top of the satellite image. (a) The tracking result with geo-mosaicing the UAV images on the satellite image (the z-axis indicates track IDs) and (b)–(e) shows the tracking results in each frame.

of the whole system, are implemented on GPU. This improves the overall time performance of the system.

16.5 SUMMARY

We have present a framework to detect and track moving objects from a moving platform. The geo-registration with a global map

provides us reference coordinates to geo-locate targets with physical meaning. In geo-coordinates, association between tracklets produced in the local data association algorithm is evaluated using spatiotemporal consistency and similarity of appearance. Experiments show that the local and global association can maintain the track ID across long-term occlusion.

16.6 BIBLIOGRAPHICAL AND HISTORICAL REMARKS

Numerous algorithms and approaches have been proposed to address different aspects in airborne video analysis over decades. Irani (Irani et al. 1995) proposed to convert a video stream into a series of mosaics that provide a complete coverage of the whole video. The mosaics can be further applied to facilitate compression, storage, and indexing of the original video. Beyond 2D image registration, Hanna (Hanna et al. 1999) proposed a coarse to fine approach for geo-registration with depth information using digital elevation model (DEM). The coarse initialization is implemented with local appearance matching using normalized correlation. The fine geo-registration is acquired by estimating the projection matrix of camera-given DEM. Throughout this chapter, we assume that the scene is planar and only 2D geo-registration is considered. After compensating camera principal motion, motion detection and tracking techniques can be applied for airborne videos. For example, the background subtraction method in Javed et al. (2002) was applied in Ali and Shah (2006). Many specific approaches are proposed to deal with various aspects in airborne video analysis. In Yalcin et al. (2005), a global parametric method is proposed to compensate illumination changes, especially useful for thermal UAV videos. In Yin and Collins (2006), the authors proposed to use motion history image to detect and segment motion that is more robust than segmenting objects in one frame. Kang et al. (2003) proposed to use a sliding window method to establish dynamic background model. In this chapter, we adopt Kang's method for background modeling and use motion history image to segment objects. After motion segmentation, moving objects are represented as primitive rectangles, i.e., bounding boxes. UAV tracking approaches usually select the mosaic space as tracking coordinates,

such as in Ali and Shah (2006) and in Kaucic et al. (2005), where the first frame is used as the common coordinates in tracking. Instead, we use progressively updated geo-coordinates as the tracking coordinates.

Most of existing approaches address one particular issue in airborne video analysis. Not much attention has been paid on developing a complete system that can automatically and efficiently detect and track multiple moving objects in geo-coordinates. In this chapter, we aim to design a system that streamlines robust and efficient modules to achieve a complete capability to detect and track moving objects in geo-coordinates. Recently, GPGPU framework has been successfully applied in many computer vision problems to achieve high performance computation, for example, real-time stereo (Yang and Pollefeys 2003, Labatut et al. 2006), feature extraction and matching (Sinha et al. 2006), and foreground segmentation (Griesser et al. 2005). Some open source GPU-based libraries, such as OpenVidia (Fung et al. 2005), have come into the computer vision community. The video orbits algorithm (Mann and Picard 1997) has been implemented on GPU and parallel GPU in OpenVidia with real-time performance. The processes of feature extraction, feature matching, and parametric transformation estimation by RANSAC, which are involved in motion compensation, have GPU-based implementations as well, such as in Sinha et al. (2006) and Fung et al. (2005). Due to the computation cost in airborne video analysis, robust but complex methods suffer from slow time performance. Thus, we resort to using GPU to achieve efficient implementations of the bottlenecks in the whole system.

BIBLIOGRAPHY

Ali, S. and Shah, M. 2006. COCOA—Tracking in aerial imagery. In *SPIE Airborne Intelligence, Surveillance, Reconnaissance (ISR) Systems and Applications*, Orlando, FL.

Bar-Shalom, Y., Fortmann, T., and Scheffe, M. 1980. Joint probabilistic data association for multiple targets in clutter. In *Proceedings of the Fifth International Conference on Information Sciences and Systems*, Philadelphia. PA.

Brown, M. and Lowe, D. G. 2003. Recognizing panoramas. *ICCV '03*. In *Proceedings. Ninth IEEE International Conference on Computer Vision*, Nice, France, pp. 1218–1225.

Cox, I. and Hingorani, S. 1994. An efficient implementation of Reid's MHT algorithm and its evaluation for the purpose of visual tracking. In *International Conference on Pattern Recognition*, Jerusalem, Israel, pp. 437–443.

Fischler, M. A. and Bolles, R. C. 1981. Random sample consensus: A paradigm for model fitting with applications to image analysis and automated cartography. *Commun. ACM*, 24(6):381–395.

Fung, J., Mann, S., and Aimone, C. 2005. OpenVIDIA: Parallel GPU computer vision. In *Proceedings of the ACM Multimedia 2005*, Singapore, pp. 849–852.

Griesser, A. et al. 2005. Real-time, GPU-based foreground-background segmentation. In *Vision, Modeling, and Visualization*, Erlangen, Germany, pp. 319–326.

Hanna, K. J., Sawhney, H. S., Kumar, R., Guo, Y., and Samarasekara, S. 1999. Annotation of video by alignment to reference imagery. In *International Conference on Computer Vision 1999*, Corfu, Greece, pp. 253–264.

Harris, C. 1992. Geometry from visual motion. In A. Blake and A. Yuille (eds), *Active Vision*. MIT Press, Cambridge, MA.

Huang, X., Sun, Y., Metaxas, D., Sauer, F., and Xu, C. 2004. Hybrid image registration based on configural matching of scale-invariant salient region features. In *CVPRW '04: Proceedings of the 2004 Conference on Computer Vision and Pattern Recognition Workshop (CVPRW'04)*, Volume 11, Washington, DC, pp. 167.

Irani, M., Anandan, P., and Hus, S. 1995. Mosaic based representations of video sequences. In *International Conference on Computer Vision*, Boston, MA, pp. 605–611.

Javed, O., Shafique, K., and Shah M. 2002. A hierarchical approach to robust background subtraction using color and gradient information. In *Proceedings of the Workshop on Motion and Video Computing*, Orlando, FL, pp. 23–28.

Kang, J., Cohen, I., and Medioni, G. 2003. Continuous tracking within and across camera streams. In *IEEE Conference on Computer Vision and Pattern Recognition*, Madison, WI, pp. 267–272.

Kang, J., Cohen, I., and Medioni, G. 2004 Object reacquisition using invariant appearance model. In *International Conference on Pattern Recognition*, Cambridge, U.K., pp. 759–762.

Kasturi, P., Goldgof, D., and Manohar, V. 2004. Performance evaluation protocol for text and face detection and tracking in video analysis and content extraction. In (VACE-II). Technical Report, University of South Florida, Tampa, FL.

Kaucic, R., Perera, A. G., Brooksby, G., Kaufhold, J., and Hoogs, A. 2005. A unified framework for tracking through occlusions and across sensor gaps. In *International Conference on Computer Vision and Pattern Recognition*, San Diego, CA, pp. 990–997.

Khan, Z., Balch, T., and Dellaert, F. 2005. MCMC-based particle filtering for tracking a variable number of interacting targets. *IEEE PAMI*, 27 (11):1805–1918.

Kim, J., Kolmogorov, V., and Zabih, R. 2003. Visual correspondence using energy minimization and mutual information. In *International Conference on Computer Vision 2003*, Nice, France, pp. 1033.

Kruger, J. and Westermann, R. 2003. Linear algebra operators for GPU implementation of numerical algorithms. In *International Conference on Computer Graphics and Interactive Techniques*, San Diego, CA, pp. 908–916.

Kuhn, H. W. 1955. The Hungarian method for the assignment problem. *Nav. Res. Logist. Quar.*, 2(1–2):83–97.

Labatut, P., Keriven, R., and Pons, J.-P. 2006. A GPU implementation of level set multiview stereo. In *International Conference on Computational Science*, Reading, U.K., pp. 212–219.

Lowe, D. G. 2004. Distinctive image features from scale-invariant keypoints. *Int. J. Comput. Vision*, 60(2):91–110.

Lin, Y. and Medioni, 2008. G. Mutual information computation and maximization using GPU. In *Workshop of Computer Vision and Graphics Processing Unit (CVGPU)*, Anchorage, AK, pp. 1–6.

Mann, S. and Picard R. W. 1997. Video orbits of the projective group: A simple approach to featureless estimation of parameters. *IEEE Trans. Image Process.*, 6(9):1281–1295.

Medioni, G. 1982. Matching of a map with an aerial image. In *Proceedings of the Sixth International Conference on Pattern Recognition*, Munich, Germany, pp. 517–519.

NVIDIA CUDA Programming Guide 1.1. 2007. http://developer.nvidia.com/object/cg_toolkit.html

Oh, S., Russell, S., and Sastry, S. 2004. Markov chain Monte Carlo data association for general multiple-target tracking problems. In *Proceedings of the 43rd IEEE Conference on Decision and Control*, Atlantis, Bahamas, pp. 735–742.

Prati, A., Mikic, I., Trivedi, M. M., and Cucchiara, R. 2003. Detecting moving shadows: Algorithms and evaluation. *PAMI*, 25(7):918–923.

Sinha, S. N., Frahm, J.-M., Pollefeys, M., and Genc, Y. 2006. GPU-based video feature tracking and matching. Technical report, Department of Computer Science, University of North Carolina, Chapel Hill, NC.

Smith, K., Gatica-Perez, D., and Odobez, J.-M. 2005. Using particles to track varying numbers of interacting people. In *International Conference on Computer Vision and Pattern Recognition*, San Diego, CA, pp. 962–969.

Studholme, C., Hill, D. L. G., and Hawkes, D. J. 1999. An ovelap invariant entropy measure of 3D medical image alignment. *Pattern Recogn.*, 32(1):71–86.

Tang, C. K., Medioni, G., and Lee, M. S. 2001. *N*-dimensional tensor voting, application to epipolar geometry estimation. *PAMI*, 23(8):829–844.

Viola, P. and Wells III, W. M. 1997. Alignment by maximization of mutual information. *Int. J. Comput. Vision*, 24(2):137–154.

Yalcin, H., Collins R., and Hebert M. 2005. Background estimation under rapid gain change in thermal imagery. *Object Tracking and Classification in and Beyond the Visible Spectrum*, San Diego, CA.

Yang, R. and Pollefeys, M. 2003. Multi-resolution real-time stereo on commodity graphics hardware. In *International Conference on Computer Vision and Pattern Recognition*, Madison, WI, pp. 211–217.

Yin, Z. and Collins, R. 2006. Moving object localization in thermal imagery by forward-backward MHI. In *CVPR Workshop on Object Tracking and Classification in and Beyond the Visible Spectrum (OTCBVS)*, New York.

17

Urban 3D Reconstruction

Jan-Michael Frahm and Marc Pollefeys

CONTENTS

17.1 INTRODUCTION

The reconstruction of buildings and landscapes in 3D from 2D images and videos has long been a topic of research in computer vision and photogrammetry. In recent years, applications have been very successful in delivering effective visualizations of large-scale models based on aerial and satellite imagery to a broad audience. Visualizations using such data are possible in the form of panoramic mosaics (Teller et al. 2003, Román et al. 2004) or simplified geometric models (Cornelis et al. 2006), which require less data to be constructed but limit the user's ability to freely navigate the environment. To enable unconstrained navigation in the virtual environment, geometrically accurate and detailed 3D models are required. In the last years, commercial vendors have begun acquiring ground-based videos of primarily cities in most parts of the world. The massive amounts of captured data pose tremendous challenges for the collection, processing, and visualization of these data. Until now no ubiquitous, automatically reconstructed, high-quality models have been delivered to the general public due to the lack of fast fully automatic reconstruction methods.

This chapter introduces a large-scale 3D reconstruction system that processes 30 video frames per second on a single PC, delivering detailed 3D models in the form of textured polygonal meshes with settings optimized for speed and accurate camera motion data provided by an external sensor system. The system can efficiently incorporate data from a global positioning system (GPS) and an inertial navigation system (INS), if available, or alternatively it performs traditional structure from motion algorithms to obtain the camera motion information. The design of all system components allows real-time computation, as

the selected methods are particularly efficient on typical urban scenes, while preserving the ability to perform reconstructions of general 3D shapes. Additionally, the methods used are highly robust, enough to achieve automatic large-scale reconstructions.

The described system uses cameras that automatically adapt the gain (i.e., auto-exposure) to accommodate the capture of the large dynamic range of outdoor scenes spanning from scene parts in shadow to scene parts in bright sunlight despite the limited dynamic range of the cameras. To account for the related appearance change of the scene, the system deploys a 2D feature-tracking technique, which efficiently estimates the gain of the camera while tracking the 2D feature points (Kim et al. 2007, Zach et al. 2008).

To enhance the applicability of the system, the computation allows for uncalibrated cameras to perform camera pose estimation. It will perform auto-calibration if necessary to be able to perform the reconstruction from a variety of sources such as the video of a handheld camera, images/videos downloaded from the Internet or taken from archival sources. Alternatively, it can make effective use of calibrated cameras, which are optionally augmented with GPS and inertial measurements. A Kalman filter is used to fuse the image based measurements and the augmenting sensor information if available.

For the dense 3D reconstruction, a novel two-stage strategy is used, which allows the system to achieve high processing rates. Decoupling the problem into the reconstruction of depth maps from sets of images followed by the fusion of the depth maps enables simple and fast algorithms, which can be implemented on the graphics processing unit (GPU). The fast multi-view stereo algorithm utilized does not perform a costly global optimization. Accordingly, the resulting error can potentially be comparatively higher than for some computationally significantly more expensive stereo algorithms (Auclair et al. 2008). The efficient fusion step that follows combines multiple depth maps into one consistent depth map increasing the accuracy and decreasing the redundancy. It delivers a compact and geometrically consistent representation of the 3D scene, which is especially important for long video sequences. Figure 17.1 shows an aerial view of a model reconstructed from approximately 1.3 million frames of video, as well as some close-up views of parts of the model.

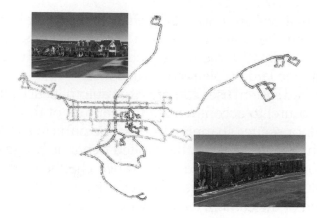

Figure 17.1 Bird's-eye view on a 3D model reconstructed from 1.3 million frames and two detail views.

17.2 OVERVIEW OF 3D RECONSTRUCTION FROM VIDEO

This section is a brief overview of the system. The core algorithms operate on the frames of a single video camera as it moves in space. The obtained 3D reconstructions of the static scene parts are based on frames captured at different time instances. The models of multiple cameras can be combined at the end, if the camera poses are registered with respect to each other or if GPS information is available and the poses are geo-registered.

The majority of the data shown in this chapter have been collected by one of two video recording systems. The first system consists of eight cameras mounted on a vehicle, with a quadruple of cameras looking to each side. Each camera has a field of view of approximately $42° \times 30°$, and within a quadruple the cameras are arranged with nearly no overlap in their field of view. Three of the four cameras are mounted in a plane to create a horizontal field of view of approximately 120°. The fourth camera is tilted upward to create an overall vertical field of view of approximately 60° with the other cameras (see Figure 17.2 for an illustration of the setup). The camera resolution of each of the eight cameras is 1024×768 pixels captured at a frame rate of 30 Hz. Additionally, the acquisition system deploys a highly accurate INS and

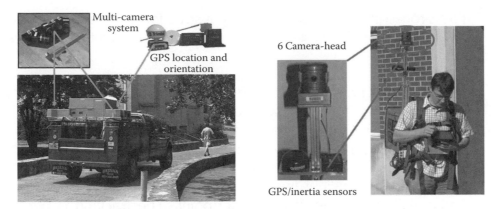

Figure 17.2 Capture systems: At left, the car mounted capture including two multi-camera systems, differential GPS, inertia measurement system; and on the right, the mobile capture system with six camera head GPS and inertia sensor.

GPS sensor system, which are synchronized with the cameras, to enable the geo-registration of the cameras and the obtained 3D reconstructions. The system records approximately 648 GB of raw video data per hour. The processing system consists of a 3 GHz dual core processor for each of the eight cameras with 4 GB RAM and an NVidia GTX 280 graphics card to achieve 30 Hz real-time performance for the processing.

The second recording system consists of a Point Grey Research Ladybug omnidirectional camera. The Ladybug is a multi-camera system consisting of six cameras, of which five form a ring with optical axes roughly parallel to the ground plane when mounted and the sixth camera's optical axis pointing upward. Each individual camera in the ring has a wide field of view covering roughly 73° horizontally and 89° vertically and a resolution of 1024×768 pixels with a capture rate of 30 Hz. When combined with the upward pointing camera, these provide video coverage of most of the sphere around the camera unit, except for the area directly below the camera. We use a mobile computer with striped RAID drives to handle the video data rate and the amount of data captured over time. This system is capable of recording 15 frames per second uncompressed video generating approximately 240 GB per hour of video.

The processing pipeline for 3D reconstruction from the obtained video of either capture system consists of several computation stages (see Figure 17.3):

- Reading and preparation of the video data and if available the GPS/INS data: this input step runs asynchronously to the main computation to improve performance. It efficiently converts the incoming Bayer-pattern video into grayscale pyramid data for later use in tracking and stereo.
- 2D tracking of salient image features provides 2D tracks that potentially belong to a salient 3D point. The tracking is performed on the GPU in less than 5 ms for images of the size of 1024×768 pixels when tracking approximately 1000 salient features (Sinha et al. 2007, Zach et al. 2008). It estimates the

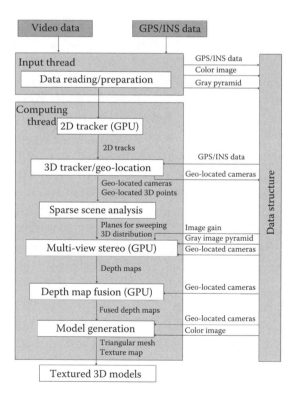

Figure 17.3 Processing modules and data flow. (From Pollefeys, M. et al., *Int. J. Comput. Vision*, 78, 143, 2008. With permission. © 2008 Springer.)

gain of the camera simultaneously to compensate for the auto exposure of the cameras (Zach et al. 2008).

- 3D tracking/geo-location estimates the camera pose from the video only or the geo-registered camera pose if the GPS is available. The video only system performs structure from motion including self-calibration from the video along the lines of Mendonca and Cipolla (1999). Alternatively, if GPS or INS measurements are available, the system deploys a Kalman filter, which uses the 2D correspondences jointly with the GPS/INS data to estimate geo-located camera projection matrices. Additionally, this module computes the 3D position of all tracked salient feature points.

- Sparse scene analysis examines the 3D feature points to determine three principal surface normals corresponding to the ground and the two dominant façade orientations. It also examines the distribution of feature points in 3D to determine the most likely planes of the scene. This information enhances the effectiveness, the quality, and the efficiency of our multi-way plane sweeping stereo module especially in urban environments.

- Stereo depth estimation computes depth maps from the camera images with given local pose using a fast GPU implementation of an advanced multi-view plane sweeping stereo algorithm. Our algorithm has provisions to deal with non-fronto-parallel surfaces, occlusions, and gain changes (Gallup et al. 2007).

- Depth map fusion combines multiple depth maps to reject erroneous depth estimates by seeking a consensus surface. Furthermore, it removes the redundancy from the data, resulting in a more accurate and smaller set of depth maps (Merrell et al. 2007).

- Model generation creates a triangular mesh for each fused depth map and determines the texture mapping. Additionally it removes duplicate representations of the same surface and fills some of the holes.

In the next sections, the modules of the system for real-time 3D reconstruction will be described in more detail.

17.3 2D TRACKING

After the asynchronous preparation of each video frame, our system first extracts the correspondences for the salient feature points observed in the scene. This is done using an extended KLT-tracker (Lucas and Kanade 1981), which simultaneously obtains the camera gain and the 2D motion of the salient feature points. The next section will introduce the traditional KLT-tracker as introduced in Lucas and Kanade (1981), Shi and Tomasi (1994). The extension to simultaneous gain estimation and tracking on the GPU is described afterward.

17.3.1 KLT Tracking

The KLT tracker is based on the assumption that the motion of the camera is small and the appearance of features stays constant between consecutive frames in the video sequence. The brightness constancy assumption is stated as follows:

$$J\left(\boldsymbol{x}+\frac{\boldsymbol{d}}{2}\right)-I\left(\boldsymbol{x}-\frac{\boldsymbol{d}}{2}\right)=0 \tag{17.1}$$

where
 J and I are images at time $\boldsymbol{t}+1$ and \boldsymbol{t}, respectively
 $\boldsymbol{x}=[x,y]^{\mathrm{T}}$ is the feature location
 $\boldsymbol{d}=[d_x,d_y]^{\mathrm{T}}$ is the displacement vector representing the motion of
 the feature \boldsymbol{x} between frame J and I

After linearizing the equation and minimizing the error over a patch P, the displacement for each feature is computed as follows (Birchfield 1997):

$$\sum_{x\in P}\underbrace{\begin{bmatrix} s_x^2 & s_xs_y \\ s_xs_y & s_y^2 \end{bmatrix}}_{U}\begin{bmatrix} d_x \\ d_y \end{bmatrix}=2\sum_{x\in P}\underbrace{\begin{bmatrix} s_\Delta s_x \\ s_\Delta s_x \end{bmatrix}}_{b} \tag{17.2}$$

with $s_x=J_x+I_x$ and $s_y=J_y+I_y$, where I_x and I_y are the image gradients in x and in y direction respectively and $s_\Delta=I(x)-J(x)$ is the intensity

difference over time equivalent to the temporal gradient. The matrix \mathbf{U} is called the structure tensor. Please, note that the summation is over the patch P surrounding the feature due to the assumption of the locally identical motion of features and the fact that Equation 17.2 can be solved independently for *every* salient feature point \mathbf{x}.

The dynamic range of cameras is usually too small to accommodate the large dynamic range of natural scenes. Accordingly, the exposure of the camera is adjusted causing the appearance of the features to change. Section 17.3.2 discusses an extension of KLT-tracking for cameras with changing gain as introduced in Kim et al. (2007).

17.3.2 Simultaneous Tracking and Radiometric Calibration

The radiometric response function defines the relationship between the image irradiance $E(\mathbf{x})$ and the image brightness $I(\mathbf{x})$ at pixel \mathbf{x} in regards to the exposure k_e as follows:

$$I(\mathbf{x}) = f\left(k_e E(\mathbf{x})\right) \tag{17.3}$$

Assuming equal irradiance $E(\mathbf{x})$ for corresponding points between images, the following equation shows how corresponding points \mathbf{x}_1, \mathbf{x}_2 in two images I, J are radiometrically related:

$$g\left(J(\mathbf{x}_2)\right) - g\left(I(\mathbf{x}_1)\right) = k \tag{17.4}$$

The response function g is the log-inverse of the radiometric response function f and k is the logarithm of the exposure ratio between the two images (see Kim et al. 2007 for a proof of invertability). For simplicity, g is considered as the response function and k as the exposure difference between the two images I and J.

17.3.3 Radiometric Calibration and Tracking

This section introduces the extension of the KLT Tracker from Section 17.3.1 for brightness invariant feature tracking. For details on how

to perform the radiometric calibration of the camera using a similar extension we refer to Kim et al. (2007), which provides a method to compute the radiometric camera response from multiple images. This method can be applied to a few video frames in the beginning of the video to obtain the radiometric camera response, since the radiometric camera response is fixed for the camera. The obtained radiometric response can be used to linearize the camera response. Accordingly a linear response is assumed in the following, meaning that the relation between irradiance $E(\mathbf{x})$ and the image brightness $I(\mathbf{x})$ is described through a linear function f. Given a video sequence with varying exposures and a linear radiometric camera response, the system simultaneously obtains the exposure difference between frames, and the feature tracks from frame to frame. In contrast to previous approaches, it models the global process that is responsible for changes in image brightness rather than adapting to the changes locally and linearly. In addition, the developed method is an online process not a batch process. The estimated gain change allows subsequent algorithms such as stereo matching to compensate for brightness changes.

Similar to the standard KLT tracker from Section 17.3.1 the gain adaptive symmetric version of the brightness constancy constraint from Equation 17.4 is linearized to obtain the tracking equations. The Taylor expansion of Equation 17.4 is given by

$$\left(k^0 + dk\right)I(x_1) - J(x_2) - \left\langle \frac{k^0 \nabla I + \nabla J}{2}, d \right\rangle \qquad (17.5)$$

Note, that the Taylor expansion is performed at some previous estimate k^0. A knowledge of both image gradients, $\nabla I = [I_x, I_y]$ and $\nabla J = [J_x, J_y]$ enables a better estimate for the gain ratio k, since under noise-free conditions we have

$$k|\nabla I| = \left(k^0 + dk\right)|\nabla I| = |\nabla J| \qquad (17.6)$$

due to the linear radiometric response function. Consequently, combining the brightness constancy requirement and the gradient equality leads to the following extended least squares energy E_L:

$$E_L\left(d_i,dk\right)=\gamma\sum_i\sum_{P_i}\left(\left(k^0+dk\right)|\nabla I|-|\nabla J|\right)^2$$

$$+\sum_i\sum_{P_i}\left(\left(k^0+dk\right)I\left(x_1^i\right)-J\left(x_2^i\right)-\left\langle\nabla\tilde{I},d_i\right\rangle\right)^2,\qquad(17.7)$$

where $\nabla\tilde{I}=(k^0\nabla I+\nabla J)/2$. The user specified parameter γ is determining the influence of the gradient term. Still, the occurrence of the global gain ratio k^0 and its incremental update dk prohibits the fully accelerated utilization of data-parallel computing devices. Obviously, using one global unknown k is equivalent to utilizing local counterparts k_i known to each feature patch and adding suitable equality constraints, $k_i=k_j\colon\forall i,j$. Incorporating the exact Lagrange multipliers still requires an undesired global reduction step, hence methods using user supplied Lagrange multipliers (such as the penalty methods or augmented Lagrangian approaches) are more practical. For simplicity, we just adopt the quadratic penalty method using $k_i=k_j$ for $j\in N_i$ as constraints, where N_i denotes a set of (not necessarily spatial) neighboring indices for i. Replacing k_i by its incremental update $k_i^0+dk_i$, and using the quadratic penalty method with parameter μ, the following expression is minimized:

$$E\left(d_i,dk_i\right)=\gamma\sum_i\sum_{P_i}\left(\left(k_i^0+dk_i\right)|\nabla I|-|\nabla J|\right)^2$$

$$+\sum_i\sum_{P_i}\left(\left(k_i^0+dk_i\right)I\left(x_1^i\right)-J\left(x_2^i\right)-\left\langle\nabla\tilde{I},d_i\right\rangle\right)^2$$

$$+\mu\sum_i\sum_{N_i}\left(k_i^0+dk_i-\left(k_j^0+dk_j\right)\right)^2\qquad(17.8)$$

Taking the derivatives with respect to d_i and dk_i, a system of linear equations with a symmetric and positive definite system matrix \mathbf{A} is obtained. The matrix \mathbf{A} has a specific shape: along its diagonal, it contains 3×3 blocks of symmetric and positive definite matrices. We

will denote this block diagonal matrix by $\tilde{\mathbf{U}}$. The remaining entries are gathered in the matrix \mathbf{M}, such that $\mathbf{A} = \tilde{\mathbf{U}} - \mathbf{M}$. Since $\tilde{\mathbf{U}}$ is easy to invert, a *block Jacobi method* is an appropriate choice for a data-parallel approach to solve this linear system. In Zach et al. (2008) the proof of the (global) convergence of this system of equations from (17.8) is given. Please note that Equation 17.8 is again solvable in a data parallel fashion enabling an efficient implementation on GPU, which is described in the next section.

17.3.4 2D Tracking on GPU

Our implementation consists of three main modules, namely image pyramid generation, corner detection, and the feature position update.

17.3.4.1 Generation of Image Pyramids

The creation of the respective image pyramid for the grayscale input frames uses essentially a straightforward implementation. As a preprocessing step, the current frame is smoothed with a small odd binomial kernel before building the full pyramid. The first pass along the image rows convolves the source image with the binomial kernel and its derivative, yielding the smoothed image and its horizontal derivative as two 32-bit floats packed in four 16-bit channels. The subsequent vertical pass generates three 16-bit float channels, the smoothed intensity image, and its x- and y-derivatives. The remaining levels of the image pyramid are obtained by recursive filtering with an even binomial kernel. In terms of memory bandwidth it appears to be more efficient not to generate the image derivatives while building the pyramid and to compute the derivatives on demand in the tracking step.

Image pyramids using 16 bit floats store the smoothed original image without loss in accuracy (since we employ a small binomial kernel). The reduction in precision in coarser pyramid levels is not a major concern, but increases the overall performance by approximately 30%. The performance is shown in Figure 17.4.

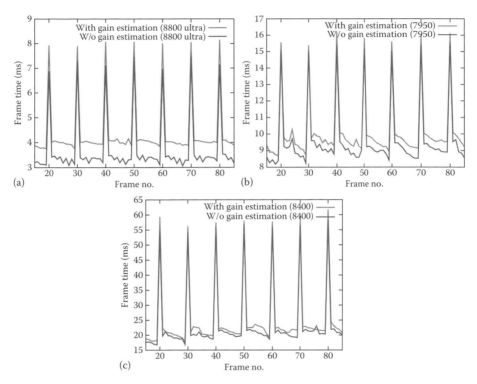

Figure 17.4 (See color insert following page 332.) Runtimes per frame with and without gain estimation on different GPUs for PAL resolution (720×576). (From Zach, C. et al., In *Computer Vision on GPUs (CVPR Workshop)*, Anchorage, AK, 2008. With permission. © 2008 IEEE.)

17.3.4.2 Corner Detection and Redetection

Good pixels to track have a rich structure tensor (Shi and Tomasi 1994) that is, the smaller eigenvalue of

$$\sum_{x \in W} (\nabla I(x))^{\mathsf{T}} \nabla I(x) \tag{17.9}$$

is sufficiently large. In order to track single point features, reliable corners need to be extracted. The generation of the image pyramid already provides us with the (smoothed) image gradients required for the structure tensor computation, and suitable box filtering exploiting the separability yields the complete structure tensor. The smaller eigenvalue,

that is, the cornerness, of a 2×2 matrix can be easily computed by a fragment shader, which additionally performs a thresholding operation and discards potential corners very close to the image border. The result of this operation is a floating point texture (encoded in an 8-bit per channel RGBA image using a packed representation[*]), which has positive values at potential corner pixels and zeros otherwise.

In order to avoid the concentration of extracted features at few highly textured image regions, a non-maximum suppression procedure is subsequently applied. We employ a modified column-wise and row-wise max-convolution procedure: after each of the two passes, a positive value in the resulting image buffer indicates that the respective position is a local maximum, whereas negative values depict pixels, where the maximum was propagated from the corresponding neighborhood. Thus, each pass of the convolution assigns the value largest in magnitude within the support window to the current position.

Keeping already detected and successfully tracked features during a redetection step is very simple: rendering points for the still valid features using a negative "color" with large magnitude precedes the non-maximum suppression step, hence those features are retained. It turns out that rendering of such small point sets does not affect the overall performance.

At this stage the GPU has efficiently determined a binary mask for the full image indicating additional corner points, which are suitable for further tracking. Generating a compact list representation of the respective feature positions used in the subsequent tracking steps is known to be a nontrivial task for data-parallel devices and usually referred to as *stream compaction* (Horn 2005). Note, that downloading the binary mask to the host (CPU) memory and to perform the (then trivial) stream compaction operation by the CPU is expensive, since only very few pixels in the mask indicate a corner positions (e.g., typically less than 1000 corners in a 1024×768 image). Hence, we employ a GPU-based stream compaction method (Ziegler et al. 2006, Roger et al. 2007, Sengupta et al. 2007).

[*] Only available on hardware supporting the NV_FRAGMENT_PROGRAM_OPTION OpenGL extension, which includes instructions to treat four 8-bit values as one floating point value and vice versa.

Currently we use the histogram pyramid approach proposed in Ziegler et al. (2006), since it is designed to operate in a shader-based environment such as Cg/OpenGL. Additionally, the authors claim that their approach is significantly faster than geometry shaders applied for stream compaction and even faster than CUDA versions. Essentially, stream compaction using histogram pyramids first computes a full mip-map pyramid by the successive parallel summation of 2×2 pixels similar to sum reduction by recursive doubling. Thus, the total number of relevant pixels, that is, newly detected feature points, can be reported immediately from the coarsest level of the pyramid (which consists of a single pixel). In a second phase, the compact list of positions is generated by a hierarchical search using the previously generated histogram pyramid. Finally, the minimal number of feature positions is transferred to the host (main) memory for further processing.

The layout of feature tracks in video (texture) memory is two-dimensional, for example, a 32×32 texture image if 1024 features are maintained at most. In order to avoid a spatial bias in gain estimation (see following text), the vector of newly detected features is randomly permuted.

17.3.4.3 Update of Feature Positions

The incorporation of the gain ratio k estimation replaces the typical 2×2 linear system from Equation 17.2 on the displacement updates by a 3×3 one from Equation 17.8. Hence, the corresponding fragment shader mainly gathers the pixels and derivatives in the floating windows and constructs the respective linear equation system and its right hand side. The incremental update of the displacement and the gain ratio is computed using Cramer's rule. The block Jacobi updates uses the eight neighboring values of k_j, which are not spatially related in the image due to earlier random shuffling.

The output of the fragment shader is a 3-vector of floats consisting of the refined position d_i and the updated gain ratio k_i. Note, that there are several conditions resulting in invalidating features: the updated position may be outside the image region, the image residual is too large, or the KLT iterations did not converge. In all these cases the feature track is signaled as invalid.

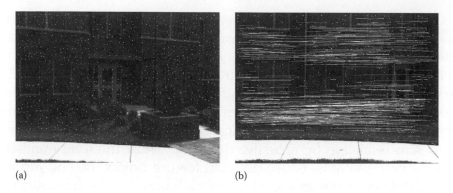

(a) (b)

Figure 17.5 (a) Selected interest salient feature points for tracking. (b) Tracking results for the selected features for several frames. Red line indicates the motion of the feature through the video.

In order to avoid weak local minima, the position and gain ratio updates are embedded into a coarse-to-fine scheme using the image pyramids. Along the lines of the GPU-KLT (Sinha et al. 2007) only the third level and the base level of the pyramid are used for the tracking computation. The quadratic penalty parameter μ enforcing the consistency among all values of β_i is initially set to a user-supplied value μ_0 and increased in every iteration by a factor τ, that is, $\mu^{(k+1)}=\tau\mu^{(k)}$. Thus, the magnitude of μ grows exponentially with the iterations unless $\tau=1$. Figure 17.5 shows some tracking results achieved with a processing rate of above 200 Hz on average.

The extended KLT-tracking delivers the set of potential 2D image correspondences along with the camera gain change. Section 17.4 discusses the use of the potential correspondences to obtain the relative camera motion and if required the camera calibration. The gain information is later used in the dense depth map computation described in Algorithm 17.1 to account for intensity change across different views.

17.4 CAMERA POSE ESTIMATION

Given the 2D feature correspondences across video frames, the next step in the processing pipeline is the estimation of camera poses.

Our system can obtain the camera motion in two different fashions. It can purely rely on the visual input, and thus the camera poses are obtained up to a scale (Frahm et al. 2009) or it can use accurate GPS and INS measurements of the camera motion available in conjunction with the observed 2D correspondences obtaining a fused measurement of the camera motion (Pollefeys et al. 2008). The following sections introduce both methods for camera motion estimation in more details.

17.4.1 Video-Based Motion Estimation

The camera motion estimation (also called visual odometry) is a well-studied problem, and we use efficient implementations of various techniques to perform the pose estimation. In particular, the camera tracker is initialized using the 5-point algorithm (Nister 2004), which computes the relative pose of three views, given the 2D correspondences between them. Following this, 3D points are triangulated and subsequent camera poses are estimated from 2D–3D correspondences by the 3-point method (Haralick et al. 1994).

To provide robustness to noise and outliers, we use ARRSAC (Raguram et al. 2008), which is a real-time RANSAC framework providing robust estimation within a fixed time budget. The technique combines the breadth-first paradigm of preemptive RANSAC (Nister 2003) with a depth-first strategy to quickly discard contaminated hypotheses (Matas and Chum, 2005). While traditional RANSAC techniques face the problem of having to generate a very large number of hypotheses for low inlier ratios, ARRSAC adopts a nonuniform sampling strategy (Chum and Matas, 2005) to preferentially generate better hypotheses early on in the sampling process. Since operating within a fixed time budget effectively places an upper limit on the maximum number of hypotheses that may be evaluated, incorporating prior knowledge into the sampling process allows us to perform reliable estimation in real time, even for very low inlier ratios. In practice, ARRSAC operates well within the enforced time budget, with estimation speeds ranging between 18–3 ms depending on the inlier ratio. We refer to Raguram et al. (2008) for a more detailed evaluation of ARRSAC.

In order to allow for the flexibility with respect to producing reconstructions from uncontrolled video sources, self-calibration to recover the camera intrinsics is deployed. It is performed as a preprocessing step, initially performed on a subset of the video sequence under the assumption of constant focal length. A commonly used technique for self-calibration consists of first building up a projective reconstruction and then upgrading this to a metric reconstruction by imposing constraints on the intrinsic camera parameters such as constant intrinsics (Faugeras et al. 1992, Triggs 1997) or assuming that some intrinsics are known and others vary (Pollefeys and Van Gool, 1999, Pollefeys et al. 1999). Employing a simpler technique based on Mendonca and Cipolla (1999), the system circumvents the maintenance of a projective reconstruction. It leverages the properties of the essential matrix to recover the camera intrinsics. In particular, it recovers the focal length of the camera (which is the major unknown parameter), while assuming that the principal point is the image center, the aspect ratio is one, and the skew is zero. The technique works by translating constraints on the essential matrix into constraints on the intrinsics, thus allowing a search in the space of intrinsic parameters in order to minimize a cost function related to the constraints. By considering a segment of video containing at least n frames, satisfying $nn_l+(n-1)$ $n_f \geq 8$, where n_l is the number of known intrinsics and n_f is the number of unknown but fixed, intrinsics, the set of fundamental matrices $F_{i,i+1} \ldots F_{i,i+h}$ is computed by matching points pairwise between cameras with overlapping views, where h is the number of cameras overlapping with camera i. Figure 17.6 illustrates the used fundamental

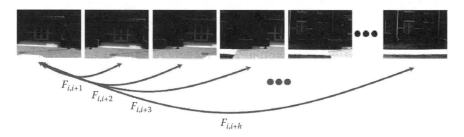

Figure 17.6 Calibration images used to compute the fundamental matrices of the self-calibration process.

matrices. Since for a pair of views i, j, the essential matrix is related to the fundamental matrix by $E_{i,j} = K_j^T F_{i,j} K_i$, constraints on the essential matrix are translated into constraints on the calibration matrices K_i and K_j. It is then possible to establish a cost function to be minimized in the entries of the calibration matrices K_i, $i = 1,...,n$. Additional details regarding this technique may be obtained from Mendonca and Cipolla (1999).

Note that the procedure described above does not account for radial distortion, which in practice significantly affects the quality of the reconstruction. The system uses bundle adjustment to perform efficient nonlinear optimization of intrinsic camera parameters, and also to account for the nonlinear radial-distortion of the camera lens. This bundle adjustment step is used on a subset of frames only to meet the performance goals. Sample results for the focal length estimation on two sequences are shown in Table 17.1.

After the computation of the intrinsic camera parameters and the two-view relations, a sparse Euclidian reconstruction is established as described below. This provides a camera path that globally accumulates drift over time but is locally virtually drift free. The system deploys this fact to estimate local geometry that is a correct approximation of the local 3D scene using efficient stereo explained in Section 17.5.3.

The initial sparse model generated by the methods described in the previous sections is obtained by using local information from the images and the weak camera calibration described above. Therefore, the reconstructed sparse 3D model and the estimated camera poses do not accurately match the measurements in the images, that is, the overall reprojection error is typically larger than one pixel. In order to obtain results with the highest possible accuracy, an additional refinement procedure, generally referred to as bundle adjustment, is necessary. Bundle adjustment is a nonlinear optimization method, which

TABLE 17.1 Calibration Results for Two Example Sequences

	Calibration Pattern	Self-Calibration	Refined Calibration
Focal length (seq. 1)	1316.1	1417.9	1337.2
Focal length (seq. 2)	1339.9	1092.6	1353.8

not only tackles the error in camera calibration and their respective poses, but also refines the inaccuracies in the 3D points and the 2D tracks (Hartley and Zisserman 2000). It incorporates all available knowledge—initial camera parameters and poses, image correspondences, and optionally other known applicable constraints—and minimizes a global error criterion over a large set of adjustable parameters, in particular the camera poses, the 3D structure, and optionally the intrinsic calibration parameters. In general, bundle adjustment delivers 3D models with sub-pixel accuracy; for example, an initial mean reprojection error in the order of pixels is typically reduced to 0.2 or even 0.1 pixels. Thus, the estimated view geometry is better aligned with the actual image features, and dense 3D models show a significantly higher precision. The major challenges with a bundle adjustment approach are the huge numbers of variables in the optimization problem and (to a lesser extent) the nonlinearity and non-convexity of the objective function. The first issue is addressed by the sparse representation of matrices and by utilizing the appropriate numerical methods in our implementation. Sparse techniques are still an active research topic in the computer vision and photogrammetry community (Dellaert and Kaess 2006, Engels et al. 2006, Ni et al. 2007, Kaess et al. 2008).

Our implementation of the sparse bundle adjustment largely follows (Dellaert and Kaess 2006) by utilizing sparse Cholesky decomposition methods in combination with a suitable column reordering scheme (Davis et al. 2004). For large data sets, this approach is considerably faster than the conventional bundle adjustment using dense matrix factorization after applying the Schur complement method (e.g., Lourakis and Argyros 2004). Our system requires less than 20 min performing a full bundle adjustment on a data set of 1700 images (which amounts to 0.7 s per image). This timing result refers to the full bundle adjustment for the complete data set, which is only required in combination with the loop detection. Additionally, the system performs a "streaming" version of bundle adjustment, which only optimizes the recently added views and 3D points. Such a reduced bundle adjustment optimizing the 10 most recently added poses and the respective 3D structure achieves 50 frames per second. Since only weak calibration information is available from camera self-calibration, it is an absolute necessity

to adjust the camera intrinsics as well. Often, the zoom of the camera does not vary appreciably within the sequence of interest and accordingly we can assume fixed intrinsics for the camera (or set of cameras). Enforcing common intrinsic parameters where appropriate is highly beneficial for the quality of the final reconstruction given the reduced degrees of freedom in the bundle adjustment. In the case where the camera parameters change over the duration of the sequence, we can optimize separate sets of parameters for each camera, which in turn though potentially increases the noise sensitivity of the estimation process.

17.4.2 Pose Estimation through Data Fusion

The purely image-based camera motion estimation described in Section 17.4.1 has two major drawbacks. The first limitation is the fact that the drift over time is unbounded due to the incremental nature of the estimation method. The second limitation is the ambiguity in the scale of the reconstruction. To overcome these limitations, the camera system needs to be augmented with other sensors such as the GPS and the inertial sensors in our second measurement system. The system deploys an extended Kalman filter to fuse the vision-based measurements jointly with the GPS/INS data to obtain geo-located camera poses. Please note that to enforce the constraints of those sensors onto the camera motion estimation, the lever-arm between the GPS/INS and the cameras needs to be known. Using this information, geo-registered cameras can be obtained. Additionally, the reconstructed models from different nonoverlapping cameras are automatically generated in the same coordinate system (world coordinate system) and can be viewed together.

Kalman filters are well known for the structure and motion estimation (Azarbayejani and Pentland 1995). Here, an extended Kalman filter is deployed to fuse the GPS/INS measurements and the 2D salient feature tracks into the pose of the cameras. The state of the extended Kalman filter consists of the data collection platform's translation, rotation, velocity, and rotation rate as well as the estimates of the 3D locations of the tracked salient features. The process model is a smooth motion model, assuming constant velocity in translation and rotation,

to model the camera motion over time. It is assumed that the scene is static and accordingly the 3D features are stationary with respect to the coordinate system. For the GPS/INS measurement model, the state's position and orientation map directly to the position and orientation of the GPS/INS. The measurement model of a 3D feature estimate is the projection of the 3D feature X into the camera that is tracking it.

$$x = \mathbf{P}_i X = \mathbf{T}_{P_i} \begin{bmatrix} \mathbf{R}_\mathrm{p}^\mathrm{T} & -\mathbf{R}_\mathrm{p}^\mathrm{T} C_\mathrm{p} \\ 0 & 1 \end{bmatrix} X, \qquad (17.10)$$

The camera's projection matrix \mathbf{P}_i is generated by left multiplying the matrix \mathbf{P}_p of the camera platform by the lever-arm transformation matrix \mathbf{T}_{P_i} for camera i. To obtain higher computational performance, the salient 3D features are assumed to be statistically independent leading to a significantly sparser covariance matrix. Hence the influence of the salient 3D feature points can be incorporated into the filter's state estimate sequentially rather than as a block (Brown and Hwang 1997).

The GPS/INS system used is an Applanix POS LV 420, providing highly accurate estimates of the poses, but they can still be improved upon. The extended Kalman filter improves the reprojection error of the salient features by 10% compared to purely relying on the Applanix system. The median improvement is 0.05 pixels that appears small but is approximately one half of the standard deviation of the GPS/INS measurement uncertainty. Under normal operating conditions, the feature estimates' contribution to reconstruction accuracy is relatively minor. However, incorporating 3D feature estimates into the pose estimation makes the reconstruction system robust to failures in the GPS/INS system.

In addition to the accuracy, the speed is important to reconstructing large urban scenes. The Kalman filter based 3D tracker delivers the pose estimates with an average of 31.1 Hz over a test sequence of 1000 frames. The measured reprojection errors of the tracked salient features were on average 0.4 pixels. To achieve this speed the total number of tracked 3D salient features was kept around 120. Even with

only 120 features, the filter is able to compensate for failures in the GPS/INS system.

Both of the camera motion estimation methods from Sections 17.4.1 and 17.4.2 deliver camera poses that are locally very accurate as well as the 3D positions of the salient feature points computed as a by-product of the camera motion estimation. Typical structure from motion systems do not use the knowledge about the scene represented through the 3D feature positions. In the following, we will exploit these to augment the dense 3D scene reconstruction to efficiently obtain an accurate 3D scene model.

17.5 DENSE SCENE RECONSTRUCTION

After computing the relative or the geo-referenced camera motion, the dense geometry of the scene is estimated using the camera poses, the computed gain change, and the images themselves. As mentioned in Section 17.2, the cameras in both capture systems have minimal overlap for the purpose of providing a wider field of view. Accordingly, stereo needs to be performed on consecutive frames of a single camera as it moves. The deployed real-time reconstruction algorithm uses a two-stage process for the depth estimation from video. In the first step, plane sweeping stereo (Collins 1996) is selected, which naturally maps to the graphics processor of commodity graphics cards (Yang and Pollefeys 2003). Since the traditional plane sweeping stereo is biased toward fronto-parallel surfaces, and in urban scenes the cameras generally observe some of the facades and the ground at oblique viewing angles, our system extends plane sweeping stereo to use multiple plane orientations aligned with the surface normals of the major façades and the ground. These directions are automatically extracted from the salient 3D features, which are computed during the camera pose estimation described in Section 17.4. Additionally, we incorporate priors from these sparse point correspondences into our depth estimation. We can significantly reduce the computation time by sweeping planes only in regions with high prior probability. During the second step, the system fuses the depth information from multiple frames into a consensus surface by deploying visibility constraints (see Section 17.5.6).

17.5.1 Multi-Way Plane Sweeping Stereo

In accordance to many other researchers, the absolute intensity difference is used as the dissimilarity or cost measure. Since the measurement at a single pixel is in general very sensitive to noise, several measurements from neighboring pixels are combined by summing the absolute intensity differences in a window centered at the pixel under consideration. This reduces the sensitivity to noise but introduces an additional requirement for the stereo system: in order to detect the best correspondence for the current pixel, all pixels in the window need to be in correspondence. This is not always the case in many stereo algorithms that use windows of constant disparity since these are optimal only for fronto-parallel surfaces, (parallel to the image plane). In plane sweeping stereo, the alignment between the actual surface and the hypothesized surface can be accomplished by modifying the direction of the sweep and thus the normal of the planes. Figure 17.7, shows the problems caused by sweeping fronto-parallel planes when the scene contains non-fronto-parallel surfaces and the solution through plane alignment. In the remainder of this section, we discuss the methods of detecting the appropriate sweeping directions.

Instead of exhaustively sampling the set of all surface orientations, we attempt to identify a much smaller set of likely surface normals by analyzing the sparse data that have been computed before stereo. For example, the motion of vehicle-mounted and even handheld cameras is generally constrained to be parallel to the ground plane. Also, sparse

(a) (b)

Figure 17.7 Implications of cost aggregation over a window. (a) Slanted surfaces with fronto-parallel plane-sweeping. Not all points over the window are in correspondence. (b) Surface-aligned sweeping plane to handle slanted surfaces correctly. (From Pollefeys, M. et al., *Int. J. Comput. Vision*, 78, 143, 2008. With permission. © 2008 Springer.)

features such as lines and points can determine a scene's planar structure. This is especially true in urban environments where, by examining lines in a single image, vanishing points can be recovered which in turn can be combined to give estimates of plane normals as those lines are typically aligned with the scene planes. Additionally, these 3D point or line features are computed as a by-product of the camera pose estimation and are typically not utilized in other stereo approaches due to the fact that most approaches do not integrate stereo and camera motion estimations. There is a variety of techniques that explored the possibility to recover planar surfaces from point and line correspondences and vanishing points (Werner and Zisserman 2002, Bosse et al. 2003, Schindler and Dellaert 2004, Hoiem et al. 2006) to obtain a denser scene geometry directly.

The system deploys an effective technique for recovering planar structures in urban environments by exploiting 3D point features obtained during the structure from motion computation from Section 17.4. First the vertical direction or gravity vector is found, which is either given by an INS system (Section 17.4.2) or if only video is available can be computed from vanishing points. Given that most facades are typically vertical, the most prominent vanishing point in urban scenes is corresponding to the gravity vector. We observed empirically that the ground plane has zero slope in the direction perpendicular to the computed camera motion. This fact can be used to obtain an estimate for the ground plane normal as:

$$g = \frac{(v \times m) \times m}{\|(v \times m) \times m\|} \tag{17.11}$$

where
 v is the gravity vector given by the inertia sensor or by the major
 vanishing point
 m is the camera motion direction

Obtaining the ground normal is particularly important, since the ground is imaged at a very oblique viewing angle and hence shows strong distortion.

Given that facades are normally upright, the system assumes for the computation of their normal direction, that they are perpendicular to the gravity vector, and are therefore determined by a rotation about the gravity vector. Additionally, the fact that facades are typically orthogonal to one another, leaves only one rotational degree of freedom, which determines their normal. This rotation of the facades is obtained as follows. First, the orthogonal projection of each 3D point in the direction of gravity is computed to obtain a set of 2D points. Please note that 3D points on a common vertical facade project to a line. Using the rotational symmetry the space of in-plane rotations between 0 and 90 degrees allows to determine the façade orientation. The sampling is performed evenly with a one degree step width and each of these rotations is tested. For each rotation $R=[\boldsymbol{u}\ \boldsymbol{v}]$, the set of 2D points is rotated to construct two histograms H_u and H_v along the two basis vectors $\boldsymbol{u},\boldsymbol{v}$ of the ground plane. Each bin in H_u (resp. H_v) counts the number of points with a similar \boldsymbol{u} (resp. \boldsymbol{v}) component. The histogram pair with the lowest entropy represents the optimal plane orientation (see Figure 17.8a and b).

17.5.2 Plane Selection

Plane-sweeping stereo (Algorithm 17.1) tests a family of plane hypotheses and records for each pixel in a reference view the best plane using a similarity measure. The algorithm works with any number of cameras, and images need not be rectified. The inputs to the algorithm are M 3D planes for the depth tests, $N+1$ images at different camera positions (images are assumed to have been corrected for radial distortion), and their respective camera projection matrices \mathbf{P}_i:

$$\mathbf{P}_i = \mathbf{K}_i[\mathbf{R}_i \quad -\mathbf{R}_i\mathbf{C}_i] \quad \text{with } i=1,\dots,N, \tag{17.12}$$

where
 \mathbf{K}_i is the camera calibration matrix
 \mathbf{R}_i and \mathbf{C}_i are the rotation and translation of camera \mathbf{P}_i with respect to a selected reference camera \mathbf{P}_{ref}

The reference camera is assumed to be the origin of the coordinate system and so its projection matrix is $\mathbf{P}_{\text{ref}} = \mathbf{K}_{\text{ref}}[\mathbf{I}_{3\times3}\ 0]$.

(a) (b)

(c) (d)

Figure 17.8 (See color insert following page 332.) Minimum entropy optimization. The 3D points are projected in the direction of gravity. Then they are rotated into the basis formed by u and v and histograms are generated. (a) Arbitrary rotation and (b) minimum entropy. The histograms of (a) have more entropy than those of (b). The histograms of (b) correspond to the correct surface normals. (c) Input frame image from original viewpoint. (d) Best-cost labels selection. Ground points are labeled green, and facade points are labeled red or blue. (From Pollefeys, M. et al., *Int. J. Comput. Vision*, 78, 143, 2008. With permission. © 2008 Springer.)

We define a set of planes Π_m with $m = 1,\dots, M$

$$\Pi_m = \begin{bmatrix} n_m^{\mathsf{T}} & -d_m \end{bmatrix} \quad \text{for } m = 1,\dots,M \qquad (17.13)$$

where
n_m is the unit length normal of the plane
d_m is the distance of the plane to the origin, which is set at the center of the reference camera

The normal $n_m^T = [0 \quad 0 \quad 1]$ is traditionally used for the sweeping planes. This assumes that the surfaces are parallel to the image plane (fronto-parallel). To account for non-fronto-parallel surfaces such as the ground and the facades in urban scenes, our system performs several plane-sweeps each with a different plane normals selected by the technique in Section 17.5.1. For the achieved quality gain see Figure 17.9.

Once the sweeping directions have been computed, a family of planes for each direction is generated. Hereby the distance $d_m \in [d_{near} \ d_{far}]$ of the plane to the origin parameterizes each family. The range $[d_{near} \ d_{far}]$ can be determined either by examining the points obtained from structure from motion or by applying useful heuristics. For example, in outdoor environments, it is usually not useful for the ground plane

Figure 17.9 Comparison to fronto-parallel plane sweep. (a) The original viewpoint. (b) The depth map triangulated into a polygonal mesh viewed from an elevated viewpoint. (c) A cross-section of the surface. Please note the scale. The standard deviation of the surface from the best-fit line was 1.31 cm for the fronto-parallel sweep and 0.61 cm for our algorithm. (From Pollefeys, M. et al., *Int. J. Comput. Vision*, 78, 143, 2008. With permission. © 2008 Springer.)

family to extend above the camera center. The spacing of the planes in the range can be uniform, as in Zabulis and Daniilidis (2004). However, it is best to place the planes to account for image sampling (pixels). Ideally, when comparing the respective image warpings induced by consecutive planes, the amount of pixel motion should be less than or equal to one (Szeliski and Scharstein 2004). This is particularly important when matching surfaces that exhibit high-frequency texture.

We ensure that the planes are properly spaced by computing the maximum disparity change between consecutive planes in a family. The planar mapping from the image plane of the reference camera \mathbf{P}_{ref} to the image plane of the camera P_k can be described by the homography H_{Π_m,P_k} induced by the plane Π_m:

$$\mathbf{H}_{\Pi_m,P_i} = \mathbf{K}_i\left(\mathbf{R}_i^{\mathrm{T}} + \frac{\mathbf{R}_i^{\mathrm{T}}\mathbf{C}_i n_m^{\mathrm{T}}}{d_m}\right)\mathbf{K}_{\text{ref}}^{-1} \qquad (17.14)$$

The location $([x_k, y_k])$ in image I_k of the mapped reference pixel $[(x,y)]$ is computed by:

$$[\tilde{x} \quad \tilde{y} \quad \tilde{w}]^{\mathrm{T}} = H_{\Pi_m,P_i}[x \quad y \quad 1]^{\mathrm{T}} \quad \text{with } x_i = \frac{\tilde{x}}{\tilde{w}}, \; y_i = \frac{\tilde{y}}{\tilde{w}} \qquad (17.15)$$

The disparity change between two planes Π_m and Π_{m+1} is defined to be the maximum displacement in all images:

$$\Delta D\left(\Pi_m, \Pi_{m+1}\right) = \max_{i=0,\ldots,N-1} \max_{(x,y)\in I_i} \sqrt{\left(x_i^m - x_i^{m+1}\right)^2 + \left(y_i^m - y_i^{m+1}\right)^2} \qquad (17.16)$$

where $[x_i^m, y_i^m]$ (resp. $[x_k^{m+1}, y_k^{m+1}]$) are obtained by (17.14). To avoid orientation inversions we do not use planes that intersect the convex hull of the camera centers. Typically the greatest displacement occurs at the boundaries of the most distant images. Thus, to compute the disparity, we warp the boundaries of image I_k with the planar homography H_{Π_m,P_k} into the reference view I_{ref}. We then compute the disparity change of the vertices of the common region. Since only those planes that do not

Input: Views I_i with $i = 1, \ldots, N$ & reference view I_{ref} and planes Π_m with $m = 1, \ldots, M$

Output: Plane $\tilde{\Pi}(x, y)$ and best cost $C(x,y)$ for each pixel (x,y)

1. A plane is swept through space in steps along a predefined direction
2. For each plane Π_m, all images I_i are projected on the plane and rendered in the reference view I_{ref}, and the matching cost is calculated for the left and right set of cameras as:

$$C_L(x, y, \Pi_m) = \sum_{i < ref} \left| I_{ref}(x, y) - k_{ref}^i I_i(x_i, y_i) \right|$$

$$C_R(x, y, \Pi_m) = \sum_{i > ref} \left| I_{ref}(x, y) - k_{ref}^i I_i(x_i, y_i) \right| \tag{17.17}$$

where
 I_i are the projected views, (x_i, y_i) are obtained by applying the homography $H(\Pi_m, \Pi_i)$ as shown in (17.15)
 k_{ref}^i is the gain ratio between image i and the reference image

The minimum of these two costs:

$$C(x, y, \Pi_m) = \min \left(C_L(x, y, \Pi_m), C_R(x, y, \Pi_m) \right) \tag{17.18}$$

is assigned in the cost volume as the cost for the pixel (x,y) to be on Π_m as in Kang et al. (2001). The dimensions of the cost volume are the image width times height times the number of planes.
3. Under the local smoothness assumption, a boxcar filter is applied on the slices of the cost volume. (Each slice of the cost volume corresponds to a plane.)

$$C^a(x, y, \Pi_m) = \sum_{x_i, y_i \in W(x,y)} C(x, y, \Pi_m) \tag{17.19}$$

where
 $W(x,y)$ is a square window centered around (x,y) in the reference image
 $C^a(x, y, \Pi_m)$ is the aggregated cost for the pixel

4. Depth values for each pixel are computed by selecting the plane that corresponds to the minimum aggregated cost:

$$C(x, y, \Pi_m) = \min \{ C^a(x, y, \Pi_m) \}, \quad \tilde{\Pi} = \operatorname{argmin}_{\Pi_m} \{ C^a(x, y, \Pi_m) \} \tag{17.20}$$

where
 $C(x, y)$ is the best cost for the pixel
 $\tilde{\Pi}$ is the corresponding plane

Algorithm 17.1: Plane-sweeping stereo

intersect the convex hull of the camera center are used, the common region is guaranteed to be convex. Accordingly the maximum disparity change is bounded by the maximum disparity change of its vertices. The family of planes is then constructed so that the disparity change of consecutive planes differs in magnitude by no more than one.

17.5.3 Plane Sweeping Stereo

To test the plane hypothesis Π_m for a given pixel $[x,y]$ in the reference view I_{ref}, the pixel is projected into the other images $i = 1, \ldots, N$ according to (17.14) and (17.15). If the plane is close to the surface that projects to pixel $[x,y]$ in the reference view and assuming the surface is Lambertian, the colors of $I_i (x_i, y_i)$ and $I_{ref}(x,y)$ are similar. The absolute intensity difference as the similarity measure and aggregate several measurements in a window $W(x,y)$ centered at the pixel $[x,y]$. To increase robustness against occlusion, the algorithm proposed in Kang et al. (2001) is adopted. For each pixel, the cost for each plane is computed for the left and the right subset of the cameras and selects the minimum as the cost of the pixel. This scheme is very effective against occlusions, since typically the visibility of a pixel changes at most once in a sequence of images. Therefore, the pixel should be visible in either the entire left or the right set of cameras.

Once the cost functions (17.20) for all pixels have been computed, the depth map may be extracted. Algorithm 17.1 illustrates the steps for a single sweeping direction. The same process is repeated for each direction. Although the algorithm can be generalized to any number of sweeping directions, for simplicity it is here described in terms of three sweeping directions labeled $L = \{l_g, l_{f_1}, l_{f_2}\}$. Each sweeping direction also has an associated surface normal n_L and a cost volume C. Please note that this does not require that surfaces of each direction are present in the scene. The first step is to select the best plane Π_l of every sweeping direction according to (17.17) and (17.18) at each pixel in the reference view. The plane of minimum cost over all sweeping directions is selected as the depth estimate $d_{(x,y)}$ for the pixel with

$$\tilde{\Pi}(x, y) = \text{argmin}_l\, C(x, y, 1) \qquad (17.21)$$

$\tilde{\Pi}(x, y)$ is also called the best-cost or winner-takes-all solution. For a given plane $\Pi_m = [n_m{}^T \quad - d_m]$, the coordinates of the 3D point that corresponds to a pixel can be computed by the intersection of Π_m and the ray through the pixel's center. For instance, the -coordinate of the 3D point is given by:

$$Z(x, y) = \frac{-d_m}{[x \quad y \quad 1]K_{\text{ref}}^{-T} n_m} \qquad (17.22)$$

The minimum-entropy histograms computed in Section 17.5.1 are used to find the location of the facades. They can also be used as a prior in a Bayesian formulation when selecting $\tilde{\Pi}^l$. The posterior probability of a plane Π_m^l at pixel $[x, y]$ is

$$P(\Pi_m^l | C(x, y, l)) = \frac{P(C(x, y, l) | \Pi_m^l) P(\Pi_m^l)}{P(C(x, y, l))} \qquad (17.23)$$

where
$\quad P(\Pi_m^l)$ is the prior probability of the surface being at plane Π_m^l
$\quad P(C(x, y, l) | \Pi_m^l)$ indicates the likelihood of the correct plane having matching cost $C(x, y, l)$
$\quad P(C(x, y, l))$ is the marginal likelihood of the cost

The prior is obtained by sampling the normalized histogram of the 3D feature points at the location of the plane assuming that the spatial distribution of the reconstructed 3D features points and the dense surfaces are correlated. For a plane Π_m^l chosen from sweeping direction l, the location in the histogram H_l is given by the plane depth d_m^l. The prior is

$$P(\Pi_m^l) = \frac{H_l(d_m^l)}{\Sigma_i H_l(i)}. \qquad (17.24)$$

The likelihood cost depends on image noise, camera pose error, the surface texture, and the alignment of the plane normal n_m^l with the

surface normal. This is extremely difficult to model correctly. Instead, we choose an exponential distribution:

$$P(C(x, y, l)|\Pi_m^l) = e^{\frac{-C(x, y, l)}{\sigma}} \qquad (17.25)$$

where σ is determined empirically. The exponential is self-similar, and so it does not rely on assumptions about the minimum cost, which is often difficult to determine beforehand. Since we are only interested in the maximum likelihood solution we ignore $P(C(x, y, l))$ and modify the plane selection Equation 17.20 as follows:

$$\tilde{\Pi}^l(x, y) = \mathrm{argmax}_{\Pi_m^l} \; e^{\frac{-C(x, y, l)}{\sigma}} P(\Pi_m^l) \qquad (17.26)$$

Maximizing this likelihood is equivalent to minimizing its negative logarithm:

$$\tilde{\Pi}^l(x, y) = \mathrm{argmin}_{\Pi_m^l} \left\{ -\log e^{\frac{-C(x, y, l)}{\sigma}} P(\Pi_m^l) \right\}$$

$$= \mathrm{argmin}_{\Pi_m^l} \left\{ C(x, y, l) - \sigma \log P(\Pi_m^l) \right\} \qquad (17.27)$$

Surfaces with little or no texture exhibit low matching costs over a range of planes. The minimum of the cost may be determined more by noise than by true correspondence. The depth prior $P(\Pi_m^l)$ helps to eliminate such ambiguities and to produce a smoother surface. To incorporate it in the depth selection we modify the cost function $\tilde{C}(x, y, l)$ to

$$C(x, y, l) = C(x, y, \tilde{\Pi}_l(x, y)) - \sigma \log P(\tilde{\Pi}_l(x, y)) \qquad (17.28)$$

This additional computation comes at little cost, but contributes significantly to the results (Figure 17.10).

The prior can be used to significantly reduce our computation time by not testing plane hypotheses with a low prior probability. A scene

(a) (b)

(c) (d)

Figure 17.10 (See color insert following page 332.) Illustration of the effectiveness of the prior term in stereo. (a,b) Reference image and matching costs with and without the prior (in red and blue respectively) for the pixel in the white circle. (c,d) Without the prior, matching costs are ambiguous and the reconstruction is noisy; the prior correctly disambiguates the cost function in (d). (From Pollefeys, M. et al., *Int. J. Comput. Vision*, 78, 143, 2008. With permission. © 2008 Springer.)

typically requires hundreds of planes for each direction to adequately sample the full disparity range. While our algorithm is able to compute many plane hypotheses at several frames per second, we have found that it is possible to obtain quality reconstructions in almost an order of magnitude faster by testing only a few dozen planes. The selected planes are those with the highest prior probability $P(\Pi_m^l)$. This is only effective when sweeping in multiple directions. For example, if the sweeping direction were not aligned to the ground and were instead fronto-parallel, it would require many plane hypotheses to reconstruct the ground. However, having determined the ground's surface normal and predicted its location from the prior, we can reconstruct it with only a few plane hypotheses.

The depth with the lowest cost may not be the true depth because of noise, occlusion, lack of texture, surfaces not aligned with the chosen plane families, and many other factors. Parts of the image that have little texture are difficult to accurately reconstruct using stereo. To evaluate the confidence in the stereo measurements, a measure of the accuracy of the depth of each pixel is important. In lieu of an objective measure, a heuristic is used. It assumes that the cost is perturbed by a Gaussian distributed noise. Let $C(x, y, \Pi_m)$ be the matching cost for plane Π_m at pixel $[x, y]$. We wish to estimate the likelihood that the depth with the lowest cost, which corresponds to plane $\tilde{\Pi}$, no longer has the lowest cost after the cost is perturbed. It is proportional to

$$e^{-(C(x,y,\Pi_m)-C(x,y,\tilde{\Pi}))^2/\sigma^2} \tag{17.29}$$

for σ from (17.25) that depends on the strength of the noise. Please note that this is purely based on the measurements and does not include the prior to avoid a bias in the confidence measure. Then, the confidence $c(x, y)$ is defined as the inverse of the sum of these probabilities for all possible depths:

$$c(x,y) = \left(\sum_{\Pi_m \neq \tilde{\Pi}} e^{\frac{-(C(x,y,\Pi_m)-C(x,y,\tilde{\Pi})^2}{\sigma}} \right)^{-1} \tag{17.30}$$

which produces a high confidence when the cost has a single sharp minimum and a low confidence when the cost has a shallow minimum or several low minima. The confidence is used in the depth map fusion process.

17.5.4 *Plane Sweeping Stereo on the GPU*

To achieve real-time performance, we use the graphics processing unit (GPU) for the plane sweeping technique. In Algorithm 17.1, we gain performance by executing steps 2, 3, and 4 on the GPU. Plane sweeping stereo assumes that the images are corrected for radial distortion.

Images typically contain radial distortion that needs to be corrected. In our processing system the only step that requires the radially undistorted images is stereo. Accordingly, it only needs to be compensated in the stereo processing. The input to the stereo module is a stream of images with known poses. Each new image is loaded on the GPU for stereo processing in a ring buffer of size equal to the number of images used in stereo. The first step performed on the GPU after loading is the radial undistortion of the incoming image through a vertex shader that performs a nonlinear mapping with bilinear interpolation essentially moving the pixels to the positions they would have in a pinhole camera. We now have images without radial distortion and all the following operations can be performed linearly.

In step 2 of Algorithm 17.1, for each view, for each plane Π_m all views I_i are projectively mapped with hardware support to the reference view I_{ref} by the homography H_{Π_m}, p_i that corresponds to the plane Π_m. In addition, since the graphics hardware is most efficient at processing 4-channel (RGB+alpha) color images, it allows us to compute four depth hypotheses at once. Once the projective mapping is completed, we use the pixel shader to calculate the gain corrected absolute differences of the projected views and the reference views according to Equation 17.17, the minimum of which is written to an output texture. Since the speed is bound by the projective texture mapping operations (mostly memory access), gain correction does not add a measurable overhead. One may observe that by delaying gain correction until after image warping we must perform the per-pixel multiplication for every plane hypothesis. The image could be normalized before warping, thus saving computation time. However, this would require higher precision for image storage to account for the possible dynamic range of natural scenes leading to higher required memory bandwidth. To avoid this overhead, intensity values are stored as 8-bit integers and only converted to higher precision floating point numbers during the computation of the dissimilarity. In our implementation, we have verified that there is no observable time penalty for applying gain correction after the image warping.

Cost aggregation is performed in step 3. We implement a GPU box-car filter with multiple passes. In the first pass, we take advantage of the graphics card's bilinear texture interpolation to compute the output of a

2×2 boxcar filter. For a given pixel $[x, y]$ we access the cost image \mathcal{C}^m (the slice corresponding to Π_m) at address $[x+0.5, y+0.5]$. The graphics card's built-in bilinear interpolation returns the average of four pixel costs, $1/4[(C(x,y,m) + C(x+1,y,m) + C(x,y+1,m) + C(x+1,y+1,m))]$, which we then multiply by 4 before storing the result in an 8-bit texture. This action avoids losing precision to discretization for low-cost regions while the potential saturation in high-cost regions has no impact on the best cost result. The result is written to an output texture \mathcal{C}_1 that stores the 2×2 boxcar result. In each subsequent pass, the results from previous boxcars are combined to produce a boxcar result of twice the size in each dimension. Thus in pass i for pixel $[x, y]$, we compute the $2^i \times 2^i$ boxcar result \mathcal{C}_i from the previous result as $\mathcal{C}_{i-1}(x,y) + \mathcal{C}_{i-1}(x+2^{i-1},y) + \mathcal{C}_{i-1}(x,y+2^{i-1}) + \mathcal{C}_{i-1}(x+2^{i-1},y+2^{1-1})$. Figure 17.11 summarizes the algorithm. The advantage of this approach is that the memory access is continuous. Although more texture memory accesses are required, this approach is faster than the alternative approach (Figure 17.11).

17.5.5 Depth Map Fusion

Due to the speed of the stereo algorithm from Section 17.5.4, the raw stereo depth maps contain errors and do not completely agree with each other. These conflicts and errors are identified and resolved in the fusion stage (Merrell et al. 2007). In this step, a set of depth maps from

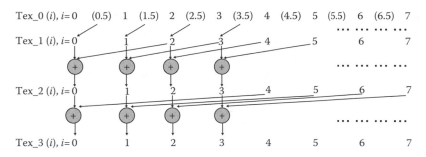

Figure 17.11 Cost aggregation scheme of the stereo estimation using the GPU interpolation in the first level. (From Pollefeys, M. et al., *Int. J. Comput. Vision*, 78, 143, 2008. With permission. © 2008 Springer.)

neighboring camera positions are combined into a single fused depth map for one of the views. Among the advantages of the fusion step is that it produces a more compact representation of the data because of the number of depth maps fused, which is a small fraction of the original number of depth maps. Much of the information in the original depth maps is redundant since many nearby viewpoints observe the same surface. We opted for this type of viewpoint-based approach since its computational complexity has a fixed upper-bound, regardless of the size of the scene to be modeled. Many of the surface fusion algorithms reported in the literature are limited to single objects and are not applicable to our datasets due to computation requiremtents, memory requirements, and the fact that in ground reconnaissance only the façade is seen and accordingly closed objects cannot be assumed.

After the fusion, a polygonal model is constructed by a simple module that produces a multi-resolution triangular mesh using a simplified version of the quad-tree approach of Pajarola (Pajarola et al. 2002). The same module also detects and merges overlapping surfaces between consecutive fused depth maps and fills holes.

17.5.6 Visibility-Based Depth Map Fusion

The input to the fusion step is a set of Q depth maps denoted by $D_1(\boldsymbol{x}), D_2(\boldsymbol{x}), ..., D_Q(\boldsymbol{x})$ that record the estimated depth of pixel $\boldsymbol{x}=[x,y]$. Each depth map has an associated confidence map labeled $c_1(\mathbf{x}), c_2(\mathbf{x}), ...,$ $c_Q(\mathbf{x})$ computed according to (17.30). One of the viewpoints, typically the central one, is selected as the reference viewpoint. We seek a depth estimate for each pixel of the reference view. The current estimate of the 3D point seen at pixel \boldsymbol{x} of the reference view is called $\hat{F}(\boldsymbol{x})$. $R_i=(\boldsymbol{X})$ is the distance between the center of projection of viewpoint i and the 3D point \mathbf{X}. To simplify the notation, we define the term $\hat{f}(\mathbf{x}) \equiv \boldsymbol{R}_{\mathrm{ref}}(\hat{\boldsymbol{F}}(\mathbf{x}))$, which is the distance of the current depth estimate $\hat{\boldsymbol{F}}(\mathbf{x})$ for the reference camera. The first step of fusion is to render each depth map into the reference view. Let D_i^{ref} be the depth map D_i rendered into the reference view and c_i^{ref} be the confidence map rendered in the reference view. When multiple depth values project onto the same pixel, the nearest depth is kept. Given a 3D point \mathbf{X}, we need

a notation to describe the value of the depth map D_i at the location where \mathbf{X} projects into view i. Let $P_i(\mathbf{X})$ be the image coordinates of the 3D point \mathbf{X} projected into view i. To simplify the notation, the following definition is used $D_i(\mathbf{X}) \equiv D_i(P_i(\mathbf{X}))$. $D_i(\mathbf{X})$ is likely to be different from $R_i(\mathbf{X})$, which is the distance between \mathbf{X} and the camera center.

The approach used considers three types of visibility relationships between hypothesized depths in the reference view and computed depths in the other views. These relations are illustrated in Figure 17.12a. The point A' observed in view i is behind the point A observed in the reference view. There is a conflict between the measurement and the hypothesized depth since view i would not be able to observe A' if there truly was a surface at A. We say that A violates the free space of A'. This occurs when $R_i(A) < D_i(A)$. In Figure 17.12a, B' is in agreement with B since they are in the same location. In practice, we define points B and B' as being in agreement when $\left| [R_{\mathrm{ref}}(B) - R_{\mathrm{ref}}(B')] / R_{\mathrm{ref}}(B) \right| < \varepsilon$.

The point C' observed in view i is in front of the point C observed in the reference view. There is a conflict between these two measurements

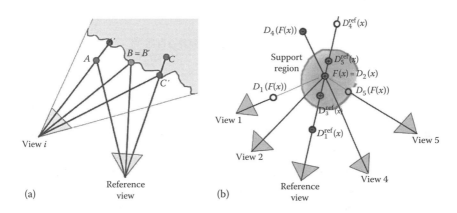

(a) (b)

Figure 17.12 (a) Visibility relations between points. The point A' seen in view i has its free space violated by A seen in the reference view. B' supports B. C seen in the reference view is occluded by C'. (b) Support estimation. Three measurements are close to the current estimate and add support to it. Outside the support region, there is one occlusion and one free-space violation that lower the support. (From Merrell, P. et al., In *IEEE International Conference on Computer Vision*, Rio de Janeiro, Brazil, 1–6, 1221, 2007. With permission. © 2007 IEEE.)

since it would be impossible to observe C if there truly was a surface at C'. We say that C' occludes C. This occurs when $D_i^{\text{ref}}(C') < \hat{f}(C) = D_{\text{ref}}(C)$. Note that operations for a pixel are not performed on a single ray, but on rays from all cameras. Occlusions are defined on the rays of the reference view, but free space violations are defined on the rays of the other depth maps. The reverse depth relations (such as A behind A' or C in front of C') do not represent visibility conflicts.

To obtain a consensus surface, the approach selects a likely candidate upfront based on the confidence and then verifies that this estimate agrees with most of the remaining data. Most of the computation time is spent rendering a depth map seen in one viewpoint into another viewpoint. These computations can be performed efficiently on the GPU.

The fusion would need to test $Q-1$ different depth hypotheses. In practice, most of these depth hypotheses are close to one another, since the true surface is likely to be visible and correctly reconstructed in several depth maps. Accordingly, our method combines multiple close depth estimates into a single estimate and then performs only one test. Due to the fact that there is only one hypothesis to test, there are only $O(Q)$ renderings that need to be computed.

17.5.7 Combining Consistent Estimates

The deployed confidence-based fusion renders all depth maps into the reference view. The depth estimate with the highest confidence is selected as the initial depth hypothesis for each pixel in the reference view. The method keeps track of two quantities for each pixel \boldsymbol{x}, which are updated iteratively: the current depth estimate and its level of support. Let $\hat{f}_0(\boldsymbol{x})$ and $\hat{c}_0(\boldsymbol{x})$ be the initial depth estimate and its confidence value. $\hat{f}_i(\boldsymbol{x})$ and $\hat{c}_i(\boldsymbol{x})$ are the depth estimate and its support at iteration i, while $\hat{F}(\boldsymbol{x})$ is the corresponding 3D point.

If another depth map $D_i^{\text{ref}}(\boldsymbol{x})$ produces a depth estimate within ε of the initial depth estimate $\hat{f}_0(\boldsymbol{x})$, it is very likely that the two viewpoints have correctly reconstructed the same surface. For example, the estimates $D_3(\hat{F}(\mathbf{x}))$ and $D_S(\hat{F}(\mathbf{x}))$ are close to the initial estimate in Figure 17.12b. These close observations are averaged into a single

estimate. Each observation is weighted by its confidence according to the following equations:

$$\hat{f}_{i+1}(\boldsymbol{x}) = \frac{\hat{f}_i(\boldsymbol{x})\hat{c}_i(\boldsymbol{x}) + D_j^{\mathrm{ref}}(\boldsymbol{x})c_j(\boldsymbol{x})}{\hat{c}_i(\boldsymbol{x}) + c_j(\boldsymbol{x})} \tag{17.31}$$

$$\hat{c}_{i+1}(\boldsymbol{x}) = \hat{c}_i(\boldsymbol{x}) + c_j(\boldsymbol{x}) \tag{17.32}$$

The result is a combined depth estimate $\hat{f}_i(\boldsymbol{x})$ at each pixel of the reference image and a support level $\hat{c}_i(\boldsymbol{x})$ measuring how well the depth maps agree with the depth estimate. The next step is to find how many of the depth maps contradict $\hat{f}_i(\boldsymbol{x})$ in order to verify its correctness.

17.5.8 Conflict Detection

The total amount of support for each depth estimate must be above the threshold c_{thres} or else it is discarded as an outlier and is not processed any further. The remaining points are checked using visibility constraints. Figure 17.12 shows that $D_1(\hat{F}(\boldsymbol{x}))$ and $D_3(\hat{F}(\boldsymbol{x}))$ occlude $\hat{F}(\boldsymbol{x})$. However, $D_3(\hat{F}(\boldsymbol{x}))$ is close enough (within ε) to $\hat{F}(\boldsymbol{x})$ to be within its support region and so this occlusion does not count against the current estimate. $D_1(\hat{F}(\boldsymbol{x}))$ is occluding $\hat{F}(\boldsymbol{x})$ outside the support region and thus contradicts the current estimate. When such an occlusion takes place the support of the current estimate is decreased by

$$\hat{c}_{i+1}(\boldsymbol{x}) = \hat{c}_i(\boldsymbol{x}) - c_j^{\mathrm{ref}}(\boldsymbol{x}) \tag{17.33}$$

When a free-space violation occurs outside the support region, as shown with the depth $D_4(\hat{F}(\boldsymbol{x}))$ in Figure 17.12, the confidence of the conflicting depth estimate is subtracted from the support according to

$$\hat{c}_{k+1}(\mathbf{x}) = \hat{c}_k(\mathbf{x}) - c_i(P_i(\tilde{F}(\mathbf{x}))) \tag{17.34}$$

Now the confidence contains all depth maps that support the current depth estimate and subtracted the confidence of all those that contradict it. If the support is positive, the majority of the evidence supports the depth estimate and it is kept. If the support is negative, the depth estimate is discarded as an outlier. The fused depth map at this stage contains estimates with high confidence and holes where the estimates have been rejected. An example fused depth map is shown in Figure 17.13.

17.5.9 Hole Filling in Fused Depth Map

After discarding the outliers, there are holes in the fused depth map due to largely inconsistent stereo estimations in the depth maps, for example, in the area of a window. In practice, the depth maps of most real-world scenes are piecewise smooth and we assume that any small missing parts of the depth map are most likely to have a depth close to their neighbors. To fill in the gaps, we find all inliers

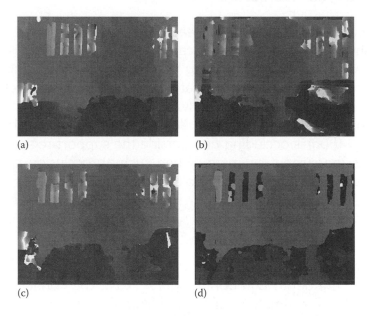

(a) (b)

(c) (d)

Figure 17.13 Left three depth maps are computed by the plane sweeping stereo. The right depth map is the fused depth map. Please note that the visually inconsistent windows get removed. (From Pollefeys, M. et al., *Int. J. Comput. Vision*, 78, 143, 2008. With permission. © 2008 Springer.)

within a $w \times w$ window centered at the estimated pixel. If there are enough inliers to support an estimate, the median of the inliers is assigned as the depth of the pixel otherwise the depth map is left blank. Essentially, this is a median filter robust to outliers. In the final step, a median filter with a smaller window w_s is used to smooth out the inliers.

17.5.10 Model Generation from the Depth Maps

In this section we show how to convert this viewpoint-based representation into a 3D model. Consecutive fused depth maps partially overlap one another and the overlapping surfaces are unlikely to be aligned perfectly. The desired output of our system, is a smooth and consistent model of the scene without artifacts in the form of small gaps that are caused by this misalignment. To this end, consistency between consecutive fused depth maps is enforced in the final model. Each fused depth map is compared with the previous fused depth map as it is being generated. If a new estimate violates the free space of the previous fused depth maps, the new estimate is rejected. If a new depth estimate is within ε of the previous fused depth map, the two estimates are merged into one vertex that is generated only once in the output. Thus the redundancy is removed along with any gaps in the model where two representations of the same surface are not connected. More than one previous fused depth map should be kept in memory to properly handle surfaces that disappear and become visible again. In most cases, two previous fused depth maps are sufficient.

After duplicate surface representations have been merged, a mesh is constructed taking into account the corresponding confidence map to suppress any remaining outliers. By using the image plane as a reference both for the geometry and the appearance, we can construct the triangular mesh very quickly. A multi-resolution quad-tree algorithm is used in order to minimize the number of triangles while the maintaining geometric accuracy as in Pajarola et al. (2002). To lower the number of triangles that need to be constructed and processed, a top down approach is deployed. Starting from a coarse resolution, triangles are formed and tested if the triangles correspond to nonplanar parts of the depth map, if they bridge depth discontinuities, or if points with low

confidence (below c_{thres}) are included in them. If any of these events occur, the quad, which is formed out of two adjacent triangles, is subdivided. The process is repeated on the subdivided quads up to the finest resolution. An example of a computed multi-resolution mesh can be seen in Figure 17.14.

We use a simple planarity test proposed by Pajarola et al. (2002) for each vertex of each triangle.

An illustration of the duplicate surface removal process can be seen in Figure 17.15. The model shown in Figure 17.15a was reconstructed using the side and upward camera. Since the cameras are synchronized and the relative transformation from one coordinate system to the other is known, the partial reconstructions can be registered in the same coordinate system. Figure 17.15b shows the overlapping meshes that are generated for different fused depth maps from the same video stream, and from different video streams. The system is able to remove most of the duplicate representations and produce a simpler mesh shown in Figure 17.15c.

Despite its simplicity, this scheme is effective when the camera maintains a dominant direction of motion. It does not handle, however, the case of a part of the scene being revisited in a later pass, since the entire reconstructed model cannot be kept in memory. A more efficient representation for parts of the model potentially in the form of a set of bounding boxes is among our future research directions.

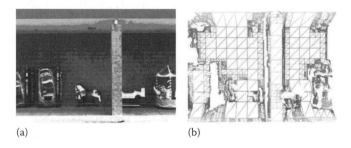

(a) (b)

Figure 17.14 (a) Input image. (b) Illustration of multi-resolution triangular mesh. (From Pollefeys, M. et al., *Int. J. Comput. Vision*, 78, 143, 2008. With permission. © 2008 Springer.)

Figure 17.15 (a) Screenshot of models after duplicate surface removal for the circled area of the model, which consists of six sub-models, three each from the side and upward cameras. (b) **(See color insert following page 332.)** Overlapping meshes as wireframes. Triangles in red are generated by the side camera and the ones in blue by the upward camera. (c) **(See color insert following page 332.)** Results of duplicate surface removal. (From Pollefeys, M. et al., *Int. J. Comput. Vision*, 78, 143, 2008. With permission. © 2008 Springer.)

17.6 SUMMARY

In this chapter we presented a real-time 3D scene reconstruction from video system. The described system is able to perform the reconstruction from a variety of data sources such as uncalibrated video cameras or a calibrated multi-camera system augmented with a GPS and an inertial sensor to obtain a geo-registered 3D model. The real-time performance of the system is achieved through the consequent use of the graphics processing unit for 2D tracking and the two stage dense scene reconstruction. The camera pose estimation is either performed using a real-time RANSAC approach or

Figure 17.16 Examples of reconstructed 3D scenes using the method described in this chapter. (From Pollefeys, M. et al., *Int. J. Comput. Vision*, 78, 143, 2008. With permission. © 2008 Springer.)

through a Kalman filter to fuse image based measurements with the sensor measurements. To achieve high accuracy reconstruction the system deploys a two-stage dense estimation process. It first performs plane sweeping stereo on the GPU and then uses temporal consistency to fuse the measurements over time into a consensus surface. The described system's performance was demonstrated on a variety of scenes shown Figure 17.16.

17.7 BIBLIOGRAPHICAL AND HISTORICAL REMARKS

Large scale 3D reconstruction has moved into the focus of many computer vision researchers in the last years. Here we will discuss the most related efforts. There are two classes of efforts. The first is using active sensor systems such as Lidar sensors augmented with cameras to obtain the appearance information. The second class is using cameras only to compute the scene information.

There has been a body of research in the combination of Lidar sensors for geometry processing and cameras for texture generation.

A recent approach has been proposed by Früh and Zakhor (Früh and Zakhor 2004). They proposed a vehicle mounted system, which is continuously capturing distance measurement with one Lidar sensor for map construction, one Lidar for geometry construction and a digital camera for texture data. Biber et al. proposed a smaller form factor system with similar characteristics (Biber et al. 2005).

The fields of computer vision and photogrammetry have mainly worked on the reconstruction from camera images/videos. The major advantage of these approaches is that the deployed capture system can be very economic in size and cost. The approaches vary from using handheld video cameras to camera systems driven or mounted on airplanes. The challenges of this class of approaches are the potential inaccuracies of the resulting reconstruction, for example, due to the lack of visual richness of the scene. In computer vision there has been a large body of research conducted in the last two decades (Faugeras 1993, Pollefeys et al. 2004, Pollefeys et al. 2008, Cornelis et al. 2006, Tomasi and Kanade 1992).

The approaches in computer vision and photogrammetry fall in two classes. Approaches for the estimation and (auto-)calibration of the camera's internal and external parameters and the approaches for the computation of the dense geometry of the scene assuming known camera positions and camera calibrations.

The camera motion estimation and calibration is performed in two principal ways. The first type of methods estimates the camera motion using the multi-view geometry constraints (Hartley and Zisserman 2000). This estimation is followed by a reconstruction of typically a sparse set to 3D feature points deploying the cameras and if needed a self-calibration of the cameras (Beardsley et al. 1997, Fitzgibbon and Zisserman 1998, Nister 2004, Nister et al. 2006). If necessary it is followed by a nonlinear optimization to overcome drift errors occurring due to the incremental nature of the process (American Society of Photogrammetry 2004). The other class of approaches uses a Kalman filter and a set of underlying motion assumptions to perform the camera motion estimation. Typically, the state of the Kalman filter contains the camera motion parameters and the sparse 3D scene information (Azarbayejani and Pentland 1995, Soatto et al. 1993, Clipp et al. 2007). These approaches naturally allow the incorporation of augmenting sensors.

The estimation of the dense scene geometry normally incorporates a stereo estimation method. In Werner and Zisserman (2002), an approach for the reconstruction of buildings based on lines and façade planes was proposed. To overcome insufficient measurements, a plane-sweeping is used to complete the information. Reconstruction through pre-warping to a ground plane is proposed in Burt et al. (1995) boosting the performance and the reconstruction accuracy. An approach using dynamic programming to solve the correspondence problem for scan-line segments was proposed in Ogale and Aloimonos (2004). Corrected planes in 3D instead of in the 2D image plane were used (Zabulis et al. 2006) to explicitly handle non-fronto-parallel surfaces. The advantage of these methods is the surface aligned correlation, which comes at the cost of adding two degrees of freedom (two rotations of the plane).

There have been some efforts on complete systems for large-scale urban reconstruction. A near real-time city reconstruction system is proposed in Cornelis et al. (2006). The system reconstructs the city environment as a combination of ruled surfaces. The ground is defined by the camera motion as a piecewise planar ruled surface and the facades are assumed to be general ruled surfaces vertical to the ground. A city reconstruction system including also the development of the city over time is proposed in Schindler et al. (2006, 2007). This system used the pattern of appearance and disappearance of urban structures to infer not only the spatial camera configuration but also the temporal camera configuration.

ACKNOWLEDGMENTS

The work presented in this chapter is the work of a large group of researchers. Contributions to the described work came from David Nister, Amir Akbarzadeh, Philippos Mordohai, Christopher Zach, Brian Clipp, Chris Engels, David Gallup, Seon Joo Kim, Paul Merrell, Christina Salmi, Sudipta Sinha, Brad Talton, Liang Wang, Qingxiong Yang, Henrik Stewenius, Changchang Wu, Ruigang Yang, Greg Welch, and Herman Towles.

REFERENCES

American Society of Photogrammetry. 2004. *Manual of Photogrammetry*, 5th edn. Falls Church, VA.

Auclair, A., Cohen, L., and Vincent, N. 2008. Using point correspondences without projective deformation for multi-view stereo reconstruction. In *International Conference on Image Processing*, San Diego, CA.

Azarbayejani, A. and Pentland, A.P. 1995. Recursive estimation of motion, structure, and focal length. *IEEE Transactions on Pattern Analysis and Machine Intelligence*, 17(6): 562–575.

Beardsley, P., Zisserman, A., and Murray, D. 1997. Sequential updating of projective and affine structure from motion. *International Journal of Computer Vision*, 23(3): 235–259.

Biber, P., Fleck, S., Staneker, D., Wand, M., and Strasser, W. 2005. First experiences with a mobile platform for flexible 3D model acquisition in indoor and outdoor environments—The waegele. *ISPRS Working Group V/4: 3D-ARCH*, Mestre-Venice, Italy.

Birchfield, S. 1997. Derivation of Kanade-Lucas-Tomasi Tracking Equation, Unpublished.

Birchfield, S. and Tomasi, C. 1999. Multiway cut for stereo and motion with slanted surfaces. In *International Conference on Computer Vision*, Los Alamitos, CA, pp. 489–495.

Bosse, M., Rikoski, R., Leonard, J., and Teller, S. 2003. Vanishing points and 3D lines from omnidirectional video. *The Visual Computer*, 19(6): 417–430.

Brown, R.G. and Hwang P.Y.C. 1997. *Introduction to Random Signals and Applied Kalman Filtering*, 3rd edn. John Wiley & Sons, New York.

Burt, P., Wixson, L., and Salgian, G. 1995. Electronically directed "focal" stereo. In *International Conference on Computer Vision*, Cambridge, MA, pp. 94–101.

Chum, O. and Matas, J. 2005. Matching with PROSAC—Progressive sample consensus. In *IEEE Conference on Computer Vision and Pattern Recognition (CVPR)*, San Diego, CA.

Clipp, B., Welch, G., Frahm, J.-M., and Pollefeys, M. 2007. Structure from motion via a two-stage pipeline of extended Kalman filters. In *Proceedings of British Machine Vision Conference*, Université Blaise Pascal, Clermont, France.

Collins, R.T. 1996. A space-sweep approach to true multi-image matching. In *International Conference on Computer Vision and Pattern Recognition*, San Francisco, CA, pp. 358–363.

Cornelis, N., Cornelis, K., and Van Gool, L. 2006. Fast compact city modeling for navigation pre-visualization. In *International Conference on Computer Vision and Pattern Recognition*, New York.

Davis, T.A., Gilbert, J.R., Larimore, S., and Ng, E. 2004. A column approximate minimum degree ordering algorithm. *ACM Transactions on Mathematical Software*, 30(3): 353–376.

Dellaert, F. and Kaess, M. 2006. Square root SAM: Simultaneous location and mapping via square root information smoothing. *International Journal of Robotics Research*, 25(12): 1181–1203.

Engels, C., Stewenius, H., and Nister, D. 2006. Bundle adjustment rules. In *Photogrammetric Computer Vision (PCV)*, Bonn, Germany.

Faugeras, O.D. 1993. *Three-Dimensional Computer Vision: A Geometric Viewpoint*. MIT Press, Boston, MA.

Faugeras, O.D., Luong, Q.-T., and Maybank, S.J. 1992. Camera self-calibration: Theory and experiments. In *European Conference on Computer Vision*, Santa-Margerita, Italy.

Fitzgibbon, A. and Zisserman, A. 1998. Automatic camera recovery for closed or open image sequences. *European Conference on Computer Vision*, Freiburg, Germany, pp. 311–326.

Frahm, J.-M., Pollefeys, M., Clipp, B., Gallup, D., Raguram, R., Wu, C., and Zach, C. 2009. 3D reconstruction of architectural scenes from uncalibrated video sequences. In *Proceedings of ISPRS Workshop 3DARCH*, Trento, Italy.

Früh, C. and Zakhor, A. 2004. An automated method for large-scale, ground-based city model acquisition. *International Journal of Computer Vision*, 60(1): 5–24.

Gallup, D., Frahm, J.-M., Mordohai, P., Yang, Q., and Pollefeys, M. 2007. Real-time plane-sweeping stereo with multiple sweeping directions. In *International Conference on Computer Vision and Pattern Recognition*, Minneapolis, MN.

Haralick, R., Lee, C., Ottenberg, K., and Nollei, M. 1994. Review and analysis of solutions of the three point perspective pose estimation problem. *International Journal of Computer Vision*, 13, 331–356.

Hartley, R. and Zisserman, A. 2000. *Multiple View Geometry in Computer Vision*. Cambridge University Press, Cambridge, U.K.

Hoiem, D., Efros, A.A., and Hebert, M. 2006. Putting objects in perspective. In *International Conference on Computer Vision and Pattern Recognition*, New York, pp. 2137–2144.

Horn, D. 2005. Stream reduction operations for GPGPU applications, *GPU Gems 2*. Addison Wesley, Reading, MA, pp. 621–636.

Kaess, M., Ranganathan, A., and Dellaert, F. 2008. iSAM: Incremental smoothing and mapping. *IEEE Transactions on Robotics*, 24(6): 1365–1378.

Kang, S.B., Szeliski, R., and Chai, J. 2001. Handling occlusions in dense multi-view stereo. *IEEE Conference on Computer Vision and Pattern Recognition*, 1: 103–I110.

Kim, S.J., Frahm, J.-M., and Pollefeys, M. 2007. Joint feature tracking and radiometric calibration from auto-exposure video. In *International Conference on Computer Vision*, Chapel Hill, NC.

Kim, S.J., Gallup, D., Frahm, J.-M., Akbarzadeh, A., Yang, Q., Yang, R., Nister, D., and Pollefeys, M. 2007. Gain adaptive real-time stereo streaming. In *International Conference on Vision Systems*, Bielefeld, Germany.

Lourakis, M.I.A. and Argyros, A.A. 2004. The design and implementation of a generic sparse bundle adjustment software package based on the Levenberg-Marquardt algorithm. Technical Report 340. Institute of Computer Science— FORTH.

Lucas, B.D. and Kanade, T. 1981. An iterative image registration technique with an application to stereo vision. In *International Joint Conference on Artificial Intelligence*, Vancouver, Canada pp. 674–679.

Matas, J. and Chum, O. 2005. Randomized RANSAC with sequential probability ratio test. In *IEEE International Conference on Computer Vision*, CTU Prague, Czech Republic.

Mendonca, P.R.S. and Cipolla, R. 1999 (June). A simple technique for self-calibration. In *IEEE Conference on Computer Vision and Pattern Recognition*, Fort Collins, CO.

Merrell, P., Akbarzadeh, P., Wang, L., Mordohai, P., Frahm, J.-M, Yang, R., Nister, D., and Pollefeys, M. 2007. Real-time visibility-based fusion of depth maps. In *IEEE International Conference on Computer Vision*, Rio de Janeiro, Brazil, Vols. 1–6, pp. 1221–1228.

Ni, K., Steedly, D., and Dellaert, F. 2007. Out-of-core bundle adjustment for large-scale 3D reconstruction. In *IEEE International Conference on Computer Vision*, Rio de Janeiro, Brazil.

Nister, D. 2003. Preemptive RANSAC for live structure and motion estimation. In *IEEE International Conference on Computer Vision (ICCV)*, Nice, France.

Nister, D. 2004. An efficient solution to the five-point relative pose problem. *IEEE Transactions on Pattern Analysis and Machine Intelligence*, 26(6): 756–777.

Nister, D., Naroditsky, O., and Bergen, J. 2006. Visual odometry for ground vehicle applications. *Journal of Field Robotics*, 23(1): 3–20.

Ogale, A.S. and Aloimonos, Y. 2004. Stereo correspondence with slanted surfaces: Critical implications of horizontal slant. In *IEEE Conference on Computer Vision and Pattern Recognition*, Washington, DC, pp. 568–573.

Pajarola, R., Meng, Y., and Sainz, M. 2002. Fast depth-image meshing and warping. Technical Report UCI-ECE-02-02. Information & Computer Science, University of California at Irvine, Irvine, CA.

Pollefeys, M. and Van Gool, L. 1999. Stratified self-calibration with the modulus constraint. *IEEE Transactions on Pattern Analysis and Machine Intelligence (PAMI)*, 21: 707–724.

Pollefeys, M., Koch, R., and Gool, L. Van. 1999. Self-calibration and metric reconstruction in spite of varying and unknown internal camera parameters. *International Journal of Computer Vision*, 32, 7–25.

Pollefeys, M., Van Gool, L., Vergauwen, M., Verbiest, F., Cornelis, K., Tops, J., and Koch, R. 2004. Visual modeling with a hand-held camera, *International Journal of Computer Vision*, 59(3), 207–232, 2004.

Pollefeys, M., Nister, D., Frahm, J.-M., Akbarzadeh, A., Mordohai, P., Clipp, B., Engels, C., Gallup, D., Kim, S.-J., Merrell, P., Salmi, C., Sinha, S., Talton, B.,Wang, L., Yang, Q., Stewenius, H., Yang, R.,Welch, G., and Towles, H. 2008. Detailed real-time urban 3D reconstruction from video. *International Journal of Computer Vision*, 78: 143–167, special issue on *Modeling Large-Scale 3D Scenes*.

Raguram, R., Frahm, J.-M., and Pollefeys, M. 2008. A comparative analysis of RANSAC techniques leading to adaptive real-time random sample consensus. In *European Conference on Computer Vision*, Marseille, France.

Roger, D., Assarsson, U., and Holzschuch, N. 2007. Efficient stream reduction on the GPU. In *Workshop on General Purpose Processing on Graphics Processing Units*, Grenoble University, Grenoble, France.

Román, A., Garg, G., and Levoy, M. 2004. Interactive design of multi-perspective images for visualizing urban landscapes. In *IEEE Visualization*, Austin, TX, pp. 537–544.

Schindler, G. and Dellaert, F. 2004. Atlanta world: An expectation maximization framework for simultaneous low-level edge grouping and camera calibration in complex man-made environments. In *International Conference on Computer Vision and Pattern Recognition*, Washington, DC, pp. 203–209.

Schindler, G., Krishnamurthy, P., and Dellaert, F. 2006. Line-based structure from motion for urban environments. In *3DPVT*, Chapel Hill, NC.

Schindler, G., Dellaert, F., and Kang, S.B. 2007. Inferring temporal order of images from 3D structure. In *International Conference on Computer Vision and Pattern Recognition*, Minneapolis, MN.

Sengupta, S., Harris, M., Zhang, Y., and Owens, J.D. 2007. Scan primitives for GPU computing. In *Graphics Hardware 2007*, San Diego, CA, pp. 97–106.

Shi, J. and Tomasi, C. 1994. Good features to track. In *IEEE Conference on Computer Vision and Pattern Recognition*, Seattle, WA, pp. 593–600.

Sinha, S., Frahm, J.-M., Pollefeys, M., and Genc, Y. 2007. Feature tracking and matching in video using programmable graphics hardware. *Journal of Machine Vision and Applications*. DOI 10.1007/s00138-007-0105-2.

Soatto, S., Perona, P., Frezza, R., and Picci, G. 1993. Recursive motion and structure estimation with complete error characterization. In *IEEE Conference on Computer Vision and Pattern Recognition*, New York, pp. 428–433.

Szeliski, R. and Scharstein, D. 2004. Sampling the disparity space image. *IEEE Transactions on Pattern Analysis and Machine Intelligence*, 26(3): 419–425.

Teller, S., Antone, M., Bodnar, Z., Bosse, M., Coorg, S., Jethwa, M., and Master, N. 2003. Calibrated, registered images of an extended urban area. *International Journal of Computer Vision*, 53(1), 93–107.

Tomasi, C. and Kanade, T. 1992. Shape and motion from image streams under orthography: A factorization method. *International Jouranl of Computer Vision*, 9 (2): 137–154.

Triggs, B. 1997. Autocalibration and the absolute quadric. In *IEEE Conference on Computer Vision and Pattern Recognition (CVPR)*, San Juan, Puerto Rico.

Werner, T. and Zisserman, A. 2002. New techniques for automated architectural reconstruction from photographs. In *European Conference on Computer Vision*, Copenhagen, Denmark, pp. 541–555.

Yang, R. and Pollefeys, M. 2003. Multi-resolution real-time stereo on commodity graphics hardware. In *IEEE Conference on Computer Vision and Pattern Recognition*, Madison, WI, pp. 211–217.

Zabulis, X. and Daniilidis, K. 2004. Multi-camera reconstruction based on surface normal estimation and best viewpoint selection. In *3DPVT*, Thessaloniki, Greece.

Zabulis, X., Kordelas, G., Mueller, K., and Smolic, A. 2006. Increasing the accuracy of the space-sweeping approach to stereo reconstruction, using spherical backprojection surfaces. In *International Conference on Image Processing*, Atlanta, GA.

Zach, C., Gallup, D., and Frahm, J.-M. 2008. Fast gain-adaptive KLT tracking on the GPU. In *Computer Vision on GPUs (CVPR Workshop)*, Anchorage, AK.

Ziegler, G., Tevs, A., Theobalt, C., and Seidel, H.-P. 2006. On the-fly point clouds through histogram pyramids. In *11th International Fall Workshop on Vision, Modeling and Visualization 2006 (VMV2006)*, Aachen, Germany, pp. 137–144.

Index